Letter Fountain

Joep Pohlen

Letter Fountain
[on printing types]

TASCHEN

A black raven on a fence,
Seated, stiff as a post,
Whilst dark clouds form shapes
In this silent landscape

And as he is seated there
in the middle of the countryside
Nothing else there in his place.
The world turns around this dark spot
And, who knows, even more deeply.

<div align="right">H.J. Pohlen</div>

Contents

Lectori Salutem

Before about 1990, a book like Letter Fountain *would have been aimed at the professional community of typesetters, publishers, typographers, graphic designers and advertising agencies; but times change. According to the cover of Dutch designer Mieke Gerritzen's manifesto, 'Everyone is a designer'; anyone who wants to can write, set, turn their hand to layout or graphic design and even design typefaces. So obviously, the avid computer user will do so. The consequence: an avalanche of printed material that is aesthetically and technically of a dubious quality. Fortunately, this proliferation has gradually subsided. Just as truly beautiful renovations remain the province of the real craftsman, despite the surge in DIY, so it is with legibility and good typography; they will only be achieved by knowing about and using the knowledge that has been built up over the past five hundred years. Therefore, this heavily revised edition is not only useful for professionals, but also for a new group of people interested in typography and typefaces.*

We felt there was a need for a reference work and have tried to meet that need. The table of contents is kept fairly concise, but there are extensive indices that can be accessed from different angles and with different purposes in mind. The book contains a general index, an index of typefaces, a designer index which also lists each designer's typefaces, an index of founders which places type designs and their designers in their time and provides the historical context; there is a dictionary to look up terms that were not clear while reading, and the book provides an elaborate bibliography for those who become interested in a certain aspect and want to read more. Most antiquarian books can now be found and ordered from all over the world online.

As *Letter Fountain* is also used in education, the history of writing and the transition to printing is included. The historical timeline, known from previous editions, is extended and supplemented with examples. The comparison, frequently used in education, between three seriffed types and three sans-serifs remains, and the chapter on the classification of typefaces has been greatly expanded. Finding the right type is after all no easy task, not even for an old hand. Furthermore, an important chapter has been added about the anatomy of the letter, in which the form of each letter of the alphabet is discussed.

The section in *Letter Fountain* about typefaces has been condensed but offers more choices. The most classic examples remain, but only gradations that are used in reading materials are shown. Added are six alternatives per letter, offering a quick overview as to which other, comparable typefaces might be suitable.

The author's collection was used to supply the typefaces, and type designers and founders very kindly made missing typefaces available. Images for the type founders index were drawn from the author's library, which includes type specimens dating back to the nineteenth century, and books that include older examples. For this part of *Letter Fountain*, *Printing Types* (1922) by Daniel Berkeley Updike deserves a special mention. It is a book based on lectures on printing techniques that Updike presented at Harvard University from 1911 to 1916. *Printing Types* consists of two volumes and has been reprinted countless times. The finest copies are the first edition from 1922 (with reprints in 1923 and 1927), and the second edition from 1937 (reprinted in 1951).
These editions are letterpress printed, which means the book examples and type specimens approximate the original and often rare copies very closely.

I hope this edition of *Letter Fountain* will be as successful as the previous one and I expect many readers to make comments and give notes so that inconsistencies, typing errors and editing bloopers can be taken out in a potential reprint. The quality of the source material is essential with a source-heavy book like this, and I am grateful for any opinions and literature or text references that offer a different perspective on the subject.

My special thanks go to Geert Setola for reading the manuscript, for his texts on the development of writing, his excerpt from the novella Par(ad)is Revisité, *his good advice and the co-authorship on* Letter Fountain's *first editions. Part of the previous editions' structure has been incorporated in this new edition and for this too, I am grateful to Geert Setola.*

Joep Pohlen, Roermond (NL), 2010

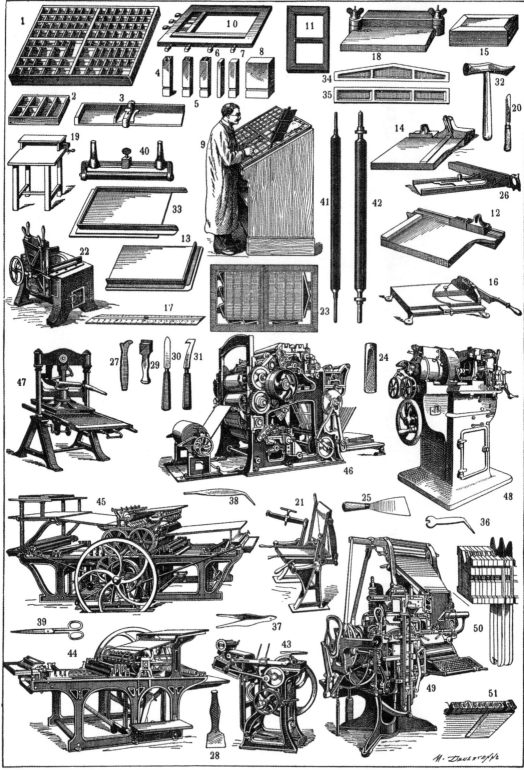

IMPRIMERIE : 1. Casse. — 2. Boîte à corrections. — 3. Composteur. — 4, 5. Caractères. — 6. Espace. — 7. Cadratin. — 8. Cadrat. — 9. Ouvrier typographe. — 10. Châssis à serrage à vis (clicherie). — 11. Châssis. — 12. Rabot (clicherie). — 13. Galée. — 14. Rabot à biseauter (clicherie). — 15. Taquoir. — 16. Coupoir avec rabot. — 17. Typomètre. — 18. Pont-calibre. — 19. Table à encrer, pour presse à bras. — 20. Couteau à plomb. — 21. Moule à bascule (clicherie). — 22. Fourneau-moule à clicher. — 23. Forme (serrage à coins métalliques). — 24. Décognoir en bois. — 25. Spatule à encre. — 26. Scie à coulisse. — 27. Décognoir en fer. — 28. Chasse-page. — 29. Chasse-griffe. — 30. Couteau à découpage. — 31. Gratte-filet. — 32. Marteau. — 33. Galée à double équerre ou « plateau ». — 34, 35. Cales en fonte pour machines. — 36. Clef. — 37. Pince de compositeur. — 38. Broche. — 39. Ciseaux à découpage. — 40. Rouleau à bras. — 41, 42. Rouleaux pour machines. — Presse à imprimer : 43. A pédale. — 44. En blanc. — 45. A retiration. — 46. Rotative. — 47. A bras. — 48. Monotype. — 49. Linotype. — 50. Linotype (matrices et espaces). — 51. Ligne composée et fondue à la linotype.

The Type

1

It all starts with the sign

Through myths and legends, spoken languages contribute to history. Although there are no audio recordings of ancient times that can tell us how people lived or what they told one another, there is a level of certainty about visual variants of language. A fleeting visual version exists until this day: sign language. Contrary to popular belief, sign language is not universal. As with spoken languages, most countries have their own sign language, complete with dialects. But this is beyond the scope of this book. We are dealing with the recorded version of language, specifically the western forms of writing and their resulting typography. This typography could only develop after a long history that eventually resulted in the Latin alphabet. The journey to those twenty-six letters, ten numbers and some added punctuation marks took more than 50,000 years. It all started with the 'sign'.

The drawing human The first forms of written communication were paintings such as those found in the caves of Lascaux in the south of France and, worldwide, in sites that date from the Stone Age. It was at least 50,000 years ago that humans started drawing on stones and clay tablets, animal skins and leather, dried leaves and papyrus, wood and bamboo, ivory and wax tablets. Signs and drawings, from simple lines that indicate quantities, directions and hunting territories, to amazing drawings of hunting scenes in caves, and figurines like the well-known Venus of Willendorf (± 24,000 BC), are evidence of the start of the development of both two and three dimensional reproduction techniques. At the same time they possess an aesthetic quality that still excites our admiration.

So the start of the recording of verbal communication constitutes the birth of both image and writing. Some of these images were used as recognisable symbols and were transferred to non-perishable materials as tangible evidence, for instance when striking a deal or when taking stock. The Latin saying 'scripta manent' (what is written, stays), which came into existence much later, immortalises this ancient administrative principle.

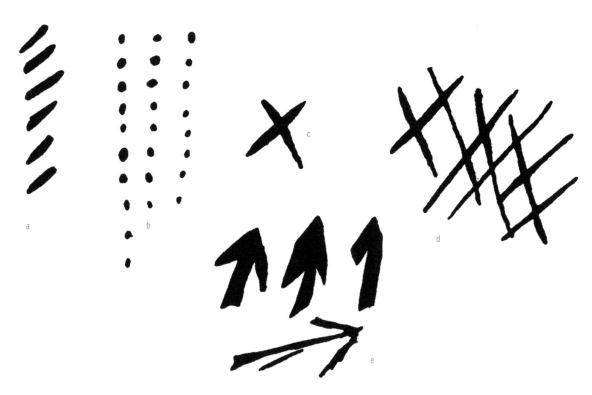

(a) 'glyphs' or grooves and
(b) dots that perhaps denote
enumeration units;
(c) and (d) crossed lines, perhaps
indications of places;
(e) arrows or spear-points.

Pictographic writing system The next step after depicting an object was the expansion of its meaning. A drawing of a sun, for instance, was used to depict the notion of warmth or day; the image of mountains was used to describe 'over the mountains', or foreign. By grouping such symbols together, 'legible' connections were formed. At the same time a figure of speech emerged, the pars pro toto, in which part of a symbol represents the whole: thus a vagina stands for a woman (see page 14). The image of this vaginal triangle was linked to the sign for mountains and together they formed the concept of female slave (as a female slave was a woman who was captured during a raid in the country over the mountains).

The ideogram or primal pictogram was born and it started its journey through the ages and civilisations to the graphic design of our times; from potter's and stonemason's signs, brands and tattoos, religious and magical symbols, gypsy picture writing and tags, to Indian symbols and pi fonts.
All these signs however had no connection whatsoever with spoken language, as is mainly the case in our modern writing, although our alphabets still contain signs without a sound relationship, such as the signs for percent (%),

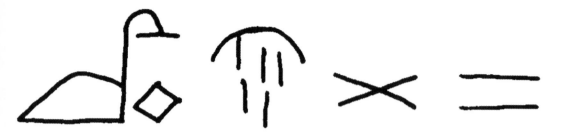

dollar ($) or euro (€). So a 'primitive typesetter' did not have a visual word image – let alone a visual letter image – only a concept.

The transition In the evolution from the pictographic system of writing to word image, Egyptian hieroglyphics are in a league of their own. The word hieroglyph is a compound of the Greek words hierós ('sacred') and glyphein ('to carve' or 'scribe') and illustrates that the writing system was used for the production of religious texts. Hieroglyphics emerged about thirty centuries ago and were initially a system, like any other writing system, of picture writing made up of series of stylised drawings of animals, humans and plants, and characters, which functioned as pictograms. Later, signs were added which represented a sound, called phonograms. With this, hieroglyphics developed from an ideographical writing system that exactly expressed each meaning, to an analytical writing system that made it easier to convey deeper meanings more elaborately.

This way, hieroglyphics transformed into a rudimentary form of the writing that we now know. Because of its beautiful styling, it can also be qualified as visual poetry in its purest form.

Besides the esthetical form of hieroglyphs there was also a more practical, prosaic, more esthetic, shorthand version. This was the cursive hieratic that was used for religious texts on papyrus. Later, the more popular, widespread Demotic script developed, shown here in the middle section of the Rosetta Stone. A relationship with the hieroglyphics at the top of this page is virtually indiscernible.

The cradle The Middle East of about three thousand years ago is the cradle of most contemporary forms of writing. As well as Egyptian hieroglyphics – based on ideograms – the Sumerian Cuneiform script and the early Semitic alphabetic script developed there.

Ideograms from left to right:
a bird plus an egg: the notion of fertility;
vertical stripes from an arc in the sky: night;
crossed lines: enmity, and parallel lines: friendship.

The stone illustrated on the facing page was found in Rosetta (Rashid). It contains the same text thrice: once in hieroglyphs, once in Demotic and once in Greek. By comparing these texts on this Rosetta Stone, Jean-François Champollion deciphered the Egyptian forms of writing. Reproduction from: Wallis Budge, *Books on Egypt and Chaldaea - Volume XVII, The Rosetta Stone,* London 1904.

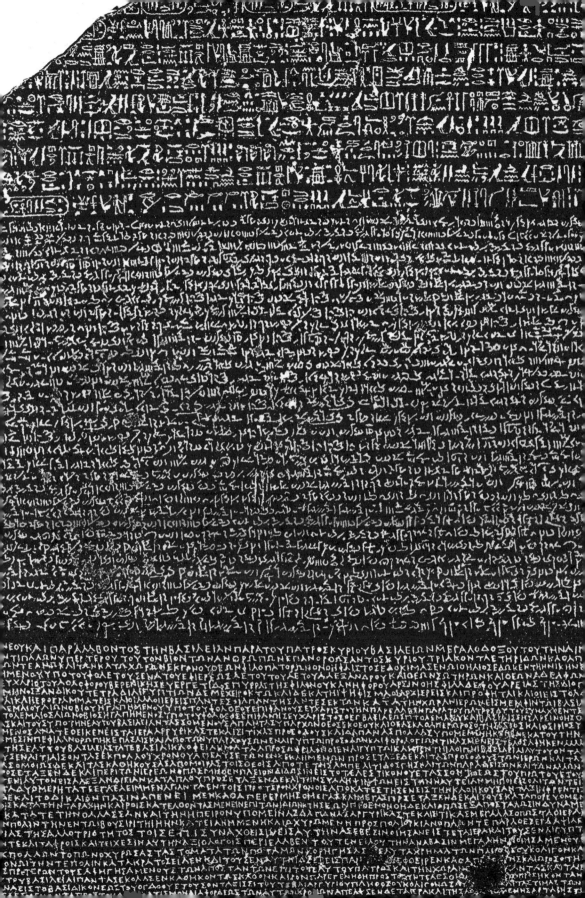

Influenced by the materials on which and with which ideograms were written, but also influenced by the desired speed of writing, several forms of pictographic writing systems started to develop. Mesopotamia, the land between the Tigris and Euphrates rivers, was inhabited by Sumerians and Acadians. It was a country which used clay and reed as base materials. As drawing round forms in clay was too difficult, the drawing was simplified to the Cuneiform script using a wedge formed stylus. Because papyrus, used in Egypt, was easy to draw on, hieroglyphics remained for the large part a picture script. In the Middle East, greatly abstracted signs were increasingly used to convey sounds instead of concepts and from the early Semitic script, a whole family tree of alphabetical systems sprouted up, branching out into the Far East and the present-day western world. The various Middle Eastern empires and city states exchanged written messages and so influenced each other's writing.

The Phoenicians, a seafaring and trading nation, are accredited with inventing the first alphabet, around 1250 BC. It consisted of 22 consonants and was written from right to left. It was a so-called consonantal alphabet, or abjad. This means that in reading, a suitable vowel needed to be added to each consonant. With their merchant mentality, the Phoenicians spread the alphabet to Greece and the rest of the Mediterranean world. In the homeland, the Phoenician language was replaced by Aramaic around the year 1 AD. Aramaic

Above: The schematic version of an ox head in a pictographic writing system turns 90 degrees in the reading direction (to the left) and in five stages becomes the cuneiform character for the word ox.

Middle: The triangle with the 'vagina'-line means woman and transforms in a similar way.

Below: The sign for woman, combined with that of three mountains, becomes the concept of woman-from-over-the-mountains, meaning slave woman.

The cuneiform script had over 600 signs for different concepts, so it is no wonder that in time this was replaced by the much simpler structures of Phoenician and Aramaic with their 22 consonants.

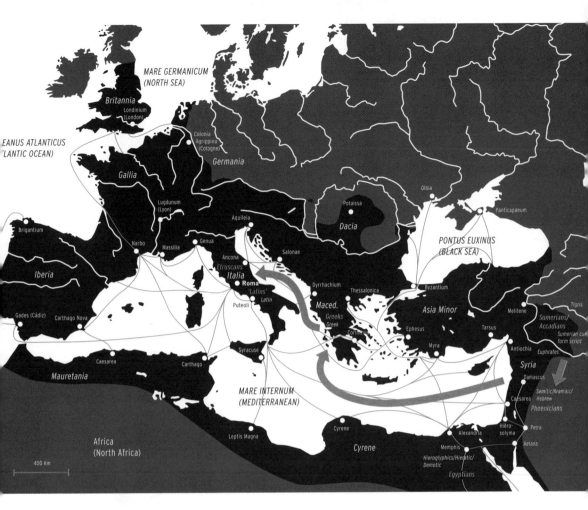

The following labels appear on the map:

MARE GERMANICUM
(NORTH SEA)

Britannia
Londinium
(London)

EANUS ATLANTICUS
'LANTIC OCEAN)

Colonia
Agrippina
(Cologne)

Germania

Gallia

Lugdunum
(Lyon)

Aquileia

Olbia

Potaissa

Dacia

Panticapaeum

PONTUS EUXINUS
(BLACK SEA)

Brigantium

Narbo

Genua

Massilia

Ancona

Etruscans

Italia

Roma

'Latins'

Latin

Salonae

Dyrrhachium

Thessalonica

Byzantium

Asia Minor

Melitene

Tigris

Sumerians/
Accadians

Sumerian cu
form script

Iberia

Gades (Cádiz)

Carthago Nova

Puteoli

Maced.

Greeks

Greek

Corinth

Ephesus

Tarsus

Antiochia

Euphrates

Syria

Caesarea

Carthago

Syracuse

Myra

Damascus

Semitic/Aramaic/
Hebrew

Caesarea

Phoenicians

Mauretania

MARE INTERNUM
(MEDITERRANEAN)

Leptis Magna

Cyrene

Cyrene

Alexandria

Hiero-
solyma

Petra

Aelana

Africa
(North Africa)

400 Km

Memphis

Hieroglyphics/Hieratic/
Demotic

Egyptians

was influenced by Phoenician and had the 22 consonants in common. Semitic Hebrew, which in 1948 became the official language of Israel, has its origins in both languages and is still written from right to left.

All roads lead to Rome After Phoenician and Aramaic, the Greeks took over the 'baton'. Our word 'alphabet' was formed from the Greek letters 'alpha' (a) and 'beta' (b), meaning ox and house. Around 800 BC, they were using the Phoenician consonantal alphabet plus the Aramaic vowels A (alpha), E (epsilon), O (omicron), Y (upsilon). The I (iota) was a Greek invention. They also started writing from left to right. Slowly but surely, this alphabet became the alphabet of the western world. First through the Etruscans, who ruled over what is now Tuscany, and after them through the Latins who conquered the Etruscans.

This map depicting Roman times (100 AD) shows the trade routes over water, from which we can deduce how writing systems spread. Of course trade routes over land existed as well, but the spread of writing systems happened much faster over water. The black area indicates the former Roman Empire. So it all started with the Sumerians in the land between the Tigris and Euphrates and it ended with the 'Latins'. Our alphabet is still called the Latin alphabet.
Illustration: Joep Pohlen

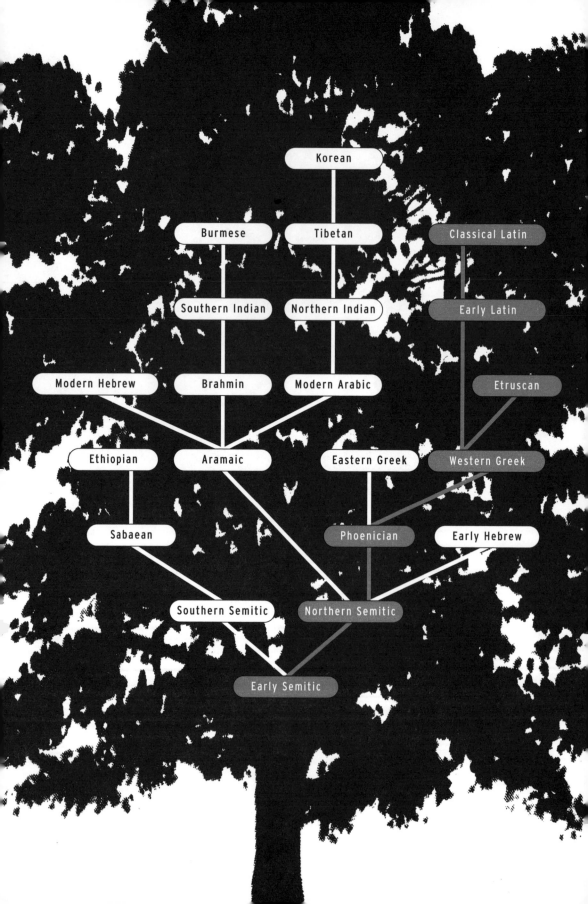

-1250	-1100	-800	-400	-300	-200	-100	0	2000
			A	A	A	A	A	A
			B			B	B	B
			Γ			C	C	C
			Δ			D	D	D
			E			E	E	E
						F	F	F
							G	G
			Z			H	H	H
			H					
			θ					
						I	I	I
								J
			K			K		K
			Λ			L	L	L
			M			M	M	M
			N			N	N	N
			Ξ					
			O			O	O	O
			Π			P	P	P
						Q	Q	Q
			P			R	R	R
			Σ			S	S	S
			T			T	T	T
			Y			V	V	U
								V
								W
							X	X
								Y
								Z

The alphabet's family tree

The map on page 15 shows the route the alphabet took to arrive at Classical Latin. The family tree on page 16 shows how this Latin came to be. Furthermore, a large number of other languages are grouped onto other branches, so that their influence and development can be seen.

It all remains pretty abstract when no examples are given. This page shows the schematic development from Northern Semitic to a modern sans-serif. Benchmark is the Imperial Roman Capital, grandfather of all western capital or majuscule scripts. The white squares in the last column mean that the original sign did not end up as a letter in our alphabet. The red lines indicate how some signs in a particular language have changed in meaning. In other languages, however, the form has developed further along the lines of its original meaning. Not until later were the 'V', the 'W' and the 'J' added to our alphabet. Composition page 16 and 17: Geert Setola.

The Roman and Holy Roman Empires

In the heyday of the Roman Empire, around the start of our western calendar era, the alphabet had matured into an extremely harmonious form. The peak of design technique in this development is the Roman capital, the Capitalis Romana *or the* Capitalis Monumentalis, *the grandfather of all western capital or majuscule scripts. The Capitalis Monumentalis was the letter used for recording the empire's glory in stone for eternity. A perfect example of this is Trajan's Column in Rome.*

The capital or majuscule alphabet The Capitalis Monumentalis was first drawn using ink and a flat brush, and then carved into marble or stone with a chisel. Through the centuries, it has retained its indestructible reputation as being perfect for 'monumental' designs with a classical feel and in 1989 it was digitally redrawn as Trajan by Carol Twombly. By using different writing materials and carriers, the form of the letters was strongly influenced. From 100 until about 600 AD, there was another majuscule script in circulation, the Capitalis Quadrata, an upright script, written mainly on papyrus using a broad-nibbed goose quill pen. The script was slightly less formal than the Monumentalis. Around 300 AD, a goose quill script arrived that would continue to be used until deep in the eleventh century: the Capitalis Rustica or rustic capitals. The quill was held at an angle, which increased writing speeds.

Half a century after the Capitalis Rustica, the uncial made its appearance and stayed until the thirteenth century. The uncial is a majuscule script used for writing on parchment and is characterised by round forms.

A distinct feature in Carol Twombly's Adobe Trajan is that the 'N' and 'M' have serifs only at their terminals. The difference with the Adobe Garamond 'N' below is clear to see. Also compare the shapes of the letters to the inscription on Trajan's Column on the right.

TRAJAN

Below: the Capitalis Quadrata, followed by the Capitalis Rustica and lastly, the uncial.

GARAMOND

TARDAQ ELEVSIN
POENARUMCELEBRES.
NOSCITISPROPE

The strokes that have been added to the capitals are clearly visible in the Roman cursive used in the fragment on the right, taken from the accounts of the Pompeian banker Lucius Caecillius Jucundus.

Text on Trajan's Column in Rome (detail), 113 AD.
The highest line is placed about two metres above eye height and the height of the letters decreases from top to bottom. The letters on the top line are 11 centimetres high, the ones at the bottom only 9 centimetres.

The first fast, cursive majuscule scripts Of course, the Romans and literati in their conquered regions also wrote little notes. They used a quick, cursive script, the Roman cursive, on papyrus or wooden boards covered with a layer of wax. In order for it to be legible, they let some letters extend below or above the lines. This is the most distant echo of the later cursive scripts, scripts in which capitals evolve into 'small' letters with 'ascenders' and 'descenders'.

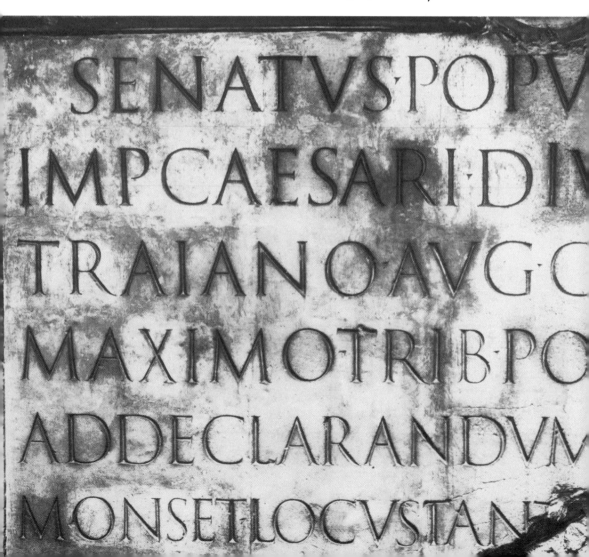

uincipias cumrobore nouissimum

locumtenere sed cum uocatus fueris

uade recumbe innouissimo loco ut

cum uenerit quite inuitauit dicatabi

amice ascende superius tunc eritabi

gloria coram simul discumbentab:

Iaomnis quiase exaltat humilia

bitur etquise humiliat exaltabitur

Cebat autem &ei quise inuitaue

rat. Cumfacis prandium aut

caenam noli uocare amicostuos neq:

fratrestuos neque cognatos neque

uicinos diuites neforte &ipsitere

inuitent &fiat abi retribuitio sedcu

facis conuiuium uoca pauperes de

biles claudos caecos &beatus eris

quia non habent retribuere tibi re

Two pages from the *Book of Kells* (folio 247 recto, 248 verso). A manuscript from the seventh century, written in a half uncial. With thanks to the 'Board of Trinity College Dublin'.

tribuitur enimtibi inresurrecaoe ius
torum · ḣec · cumaudiss & quidam
desimul discumbentabus opat illi be
atus quimanoucabit panem inregnodi :
A Ipse opat ei homo quidam fecit
caenam magnam &uocauit mul
tos &misit seruum suum adhoram
caenae dicere inuitatis ut uenirent
quia iam parataesunt omnia &
caeperunt simul omnes excusare
primus opat ei uillam emi &neces
se habeo exire &uidere illam rogo
te habeme excusatum &alter
opat iugabouum emi quinque &
eo probare illa &ideo uenire non
possum rogote habe me excusatum
&alius dxit uxorem duxi &ideo non

248

ABCDEFGHIJKLMNOPQRSTUVWXYZ

In the fifth century, uncial also started to be written faster, which resulted in the half uncial, a type consisting of majuscules and minuscules.
In various forms, the half-uncial remained in circulation until the end of the thirteenth century. Magnificent examples of the script are found in the Irish *Book of Kells*, two pages of which are depicted on the preceding pages.

minuscule

mIJuscuLe

MAJUSCULE

The Carolingian minuscule In the fourth century, at the same time that the Roman Empire was in decline, Christianity was proclaimed the state religion by emperor Constantine the Great. In Western Europe, the church became an important producer of texts, which were still drawn up in Latin. These needed to be distributed, which could only happen after they had been copied by hand. Writing was and remained the monopoly of monks for a good thousand years. They perfected the art of producing and adorning manuscripts. Few people knew how to read or write.
Even Charlemagne, who as emperor of the Holy Roman Empire was the most powerful man around 800 AD, was illiterate. He did not want to learn how to write himself – he had other people to do that for him – but to streamline the communication and administration of his vast empire and thus continue his vision and power, he decided in 768 to prescribe a new, official half uncial, composed by his secretary Alcuinus. As an abundance of often inaccurately copied texts were in circulation, Charlemagne had brand new, accurate copies made of the most authentic sources. These were marked 'ex authentico libro' (from the original work) and were written in the official handwriting, the Carolingian minuscule. Partly for its clarity and beauty it became the dominant letter in Western Europe until the end of the thirteenth century.

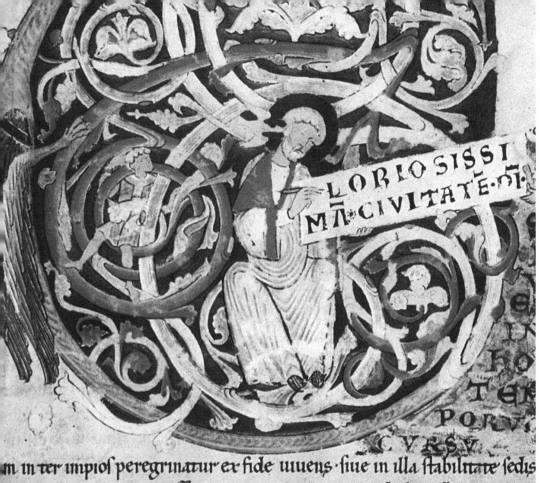

LORIOSISSI
MACIVITATE·DĪ·

CVRSV

m inter impios peregrinatur ex fide uiuens · siue in illa stabilitate sedis
ernę · quam nunc expectat per pacientiam · quoadusq; iusticia conuer
r̄ in iudiciū · deinceps adeptura per excellentē uictoriā ultimā & pacē
erfectā hoc opere ad te instituto · & mum̄ pmissione debito · defendere
duersus eos qui condiori eius deos suos preferunt fili kme Marcelline
scepi magnū opus &arduū · sed d̄s adiutor noster est · Nam scio quib̄

prima

That economic Gothic minuscule Copying manuscripts, a backbreaking and eye destroying task that was performed, day in, day out, by monks in scriptoria, did not only ask a lot from body and spirit, but also required a lot of expensive parchment, made from treated animal skins. Writers quickly learnt how to be more economical with the material by writing the letters smaller. At the same time, writing speeds were increased by adopting a more angular writing style. This is how the Gothic minuscule developed. After a short period of about two centuries in which the Gothic minuscule blossomed, hordes of other 'gothic hands' followed. These minuscules were called Gothic because they originated in the era later dubbed 'gothic'. The most important of the 'gothic hands' was the Textura (or Textualis) – so called because of its likeness to fabric – that surfaced around 1250. Other varieties appeared later, such as the Rotunda or Gothic round script and about a century later, the Schwabacher and the Fraktur. They held their place longer in German-speaking countries, where the Fraktur eventually became the standard. The movable type that Gutenberg used in 1455 for his Bible printing was a Textura type. A little over 500 years later, the fall of the Third Reich cut (the use of) this branch of the typographic development short.

Wilhelm Klingspor Gotisch
At the beginning of the previous century, Gothic scripts were still very popular in Germany. This typeface was published in 1925 by Schriftgießerei Gebr. Klingspor in Frankfurt. Designer Robert Koch based his design on fourteenth century manuscripts. In 1956, the Klingspor foundry was taken over by D. Stempel AG that would later merge with the Linotype Library.

Detail Gutenberg Bible. For the western world, Gutenberg was the inventor of printing with movable metal type. Printing had been done before, but with complete pages cut on woodblocks. For the design of his type Gutenberg used the manuscript hand that was common at the time, a Gothic hand of the Textura family.

The big turning point While the Gothic letter was at its peak in fourteenth and fifteenth century northwestern Europe, the Renaissance period erupted in Italy. In Italy, the Gothic forms never really took hold, not even in the typefaces, although the first printers who worked with movable type came from Germany. The rigid Gothic letter was seen as inelegant. The North Italians went back to the clarity of the Carolingian minuscule that in their minds was an older, more authentic and practical script, in closer proximity to the classical writers; they expanded the script with rounder and more graceful shapes. Classical texts were reborn in a form that in itself was a renaissance of the Carolingian minuscule: the Humanist minuscule.

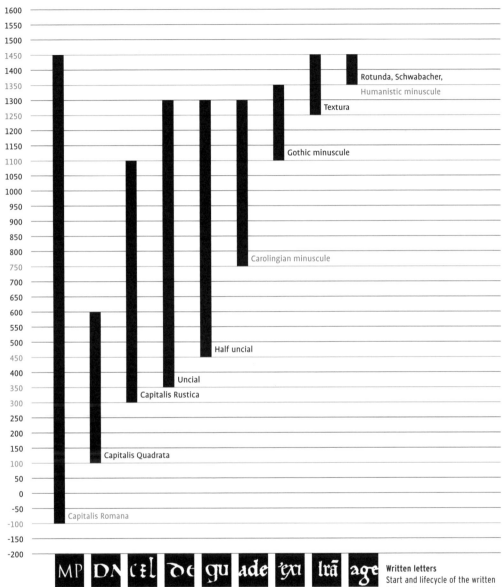

1600		
1550		
1500		
1450		Rotunda, Schwabacher,
1400		Humanistic minuscule
1350		
1300		Textura
1250		
1200		
1150		Gothic minuscule
1100		
1050		
1000		
950		
900		
850		
800		Carolingian minuscule
750		
700		
650		
600		
550		
500		Half uncial
450		
400		
350		Uncial
300		Capitalis Rustica
250		
200		
150		Capitalis Quadrata
100		
50		
0		
-50		
-100		Capitalis Romana
-150		
-200		

Written letters

Start and lifecycle of the written letters, from the Roman capital to the Humanist minuscule. Nine examples are shown in the black boxes at the bottom. The one on the far right is a Humanist minuscule and not a Rotunda or Schwabacher.

Timeline: Geert Setola.

The typographical era

For convenience's sake, we let the history of western typography start with the Gutenberg Bible of 1455. This Bible was the first monumental European book to be printed with individual metal letters. The letters were based on Gothic manuscript scripts, so it is no surprise that the first letter to be cut was the Textura with all the ligatures and abbreviations as featured in the manuscripts. Before the invention of movable type, books and texts were reproduced by copying them in scriptoria or by carving the mirror image of a complete, handwritten page in a wood block and printing from it. After the invention of movable type, printing and typefounding techniques did not fundamentally change for about four centuries. The most important technical developments to increase working speeds took place over the last hundred years, roughly from about 1880.

A humble role Over the past centuries, typography has mainly played a serving if not humble role, but there have been moments of pride in which it allowed itself to grow into an autonomous art form. Artistically, typography hitched a ride on the back of the visual arts, with a give and take of theoretical impulses between them.

From a technical point of view, there are two big evolutionary moments, distinguishable by the type of carrier: the typography of printed materials with its paper cradle started in the 1450's, and the screen typography which arose about five hundred years later.

These developments do not cancel each other out, but supplement each other. In the 'paper typography' there are three big technological developments after Gutenberg that changed the design and the production of the type and the printed materials.

Mechanical composition The first important development was the introduction of the Benton Pantograph in 1885 by the American Linn Boyd Benton. The machine allowed the mechanical cutting of a metal letter in any desired size. A point followed along the contours of the drawn letter. Engraving a mould for a 4 pt letter (or even smaller) by hand had soon become a thing of

For five hundred years, lead type-setting remained the norm. The alloy for manual type casting is harder than that of type casting machines like the Monotype. The founder machine's mixture only needs to last one impression and is then melted down. That of the manual letters needs to last longer. Composition of hand cast sorts: 64% lead, 23,88% antimony, 12,02% tin and copper traces. Composition Monotype casting: 78,3% lead, 15,9% antimony, 5,8% tin.

the past. In these days of industrialisation and mechanisation, the Monotype company developed a typesetting machine that cast individual metal letters and the Linotype company a typesetting machine that cast whole lines of text in metal. These machines used matrices to cast the letters or lines in an alloy predominantly of lead, tin and antimony, and dropped them into place. Text was fed in using mechanically operating keyboards. These machines and their operators replaced the traditional manual compositors who had worked in printing offices, often in large numbers. The manual compositors had set each letter manually in a composing stick and then assembled the lines to form a page. Since the letters were mirrored and could only be read after printing, knowing how to read mirror writing was a special skill for compositors.

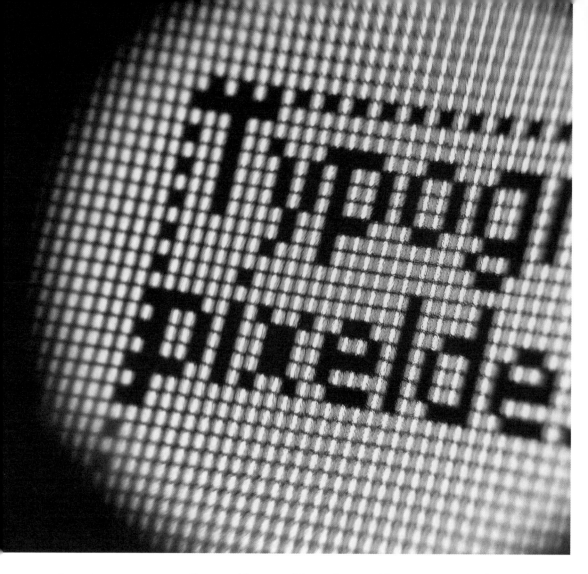

Close up, the screen type turns out to be less fluent than the metal type on the last page. Luckily we can expose it at much a higher resolution which makes the 'jaggies' or jagged edges invisible to the eye. Photo: Joep Pohlen.

Photographic composition The second important step was the introduction of photographic typesetting in the late fifties of the twentieth century. Metal was replaced by photographic film and photographic paper. This was a cheaper and less unhealthy way of working that allowed for free spacing and even overlapping of faces, that made continuous enlarging and reducing possible and, to the sorrow of purists, the photographic distortion of the letter.

At the same time, a different development had more of a social than a technological effect: the birth of dry transfer lettering (by Letraset and Mecanorma, among others) brought typography to the masses. This made it possible to freely and relatively cheaply transfer letters from a carrier onto a sheet of paper. They were only used for small amounts of text because the process was

pretty intricate. The fact that not every user of the dry transfer lettering system arrived at delicate typographical results does not mean that it did not democratise typography. But even this step is now one of the past.

Digital composition A third important development started in 1965, when the German company Hell introduced digital typesetting using the cathode ray tube. Other established providers had to follow suit and they, too, introduced digital typesetting.

An important consequence of this development was the introduction of the fairly affordable and user-friendly Apple Macintosh in 1984 – a machine that was, all on its own, responsible for the second wave of democratisation. The graphic designer him – or herself – could now set texts and edit them with digital typefaces in PostScript format, after which the texts were exposed to photographic film or photo paper with the appropriate laser exposure unit. This made professional typesetters a lot less influential. Their responsibility for the camera-ready copy transferred to the designer.

The Oakland Eight, a typeface designed by Zuzana Licko of Emigre, is based on the number of pixels available on an early Mac dot matrix printer. The number 8 indicates the cap height in pixels. The pixel fonts, called LoRes, are still available from Emigre.

Type design for the people In addition to setting text with a computer, the designing of typefaces has become more accessible, too. User-friendly type design programmes like Fontlab give every designer the possibility to create their own typefaces. Over the past five hundred years, designing letters has, however, not been an easy thing, and that hasn't changed. A solid knowledge of form and counterform, style characteristics, the correlation between the forms of letters, numbers and punctuation marks, the weight of the type, spacing: everything is important and has to be incorporated in the design. That's why the quality of the type designer and, often, the publisher remains decisive when it comes to usability of a new typeface. So-called fun fonts abound, but usually have a short life cycle. Well designed typefaces have sometimes existed for hundreds of years and are still being used. And although many typefaces undoubtedly look the same to an amateur, designers will choose typefaces carefully, based on specific characteristics and, of course, on taste and form.

Timeline The timeline on the next pages depicts the evolution of typography from 1450 to 2006, highlights technical innovations and biographical data, and dates the most important typefaces and typographical movements. In order to point out mutual influence, parallel pictorial movements and famous works are mentioned as well.

We learned from previous editions of *Letter Fountain* that the timeline was seen as especially helpful for educational purposes because art had such a big influence on the development of typography. Typographers were often involved in important avant-garde movements like Bauhaus, De Stijl and Art Deco.

Typographical developments

- Technical developments, important events and publications
- ➤ Important people
- ▼ Birth of typefaces

● **Circa 1450** reinvention in the western world of letterpress printing from movable type by Johann Gutenberg, Mainz

● **1465** Sweynheym & Pannartz cut the first Roman in Subiaco (Italy)

➤ **1394 – 1468** Johannes Gutenberg
➤ **1420 – 1480** Nicolas Jenson
➤ **1421 – 1491** William Caxton

Dr. John Fell **1625 – 1686** ➤

➤ **1450 – 1515** Aldus Manutius
➤ **? – 1515** Francesco Griffo

➤ **1510 – 1561** Claude Garamond

➤ **? – 1589** Christoffel Plantijn

Christoffel Van Dijck **1601-1669** ➤
➤ **1540 – 1651** the Elsevier family

▼ **1455 the Mainz Indulgence typeface and type of the 42-line Bible** by Johann Gutenberg

▼ **1557 Civilité** Robert Granjon
1621 Caractères de l'Université ▼ Jean Jannon

Examples

Except for Gutenberg's Textura, newly drawn digital versions of typefaces are shown here

Textura (Gutenberg) Adobe Garamond Storm Jannon Antiqua

Time indication

1450 60 70 80 90 **1500** 10 20 30 40 50 60 70 80 90 **1600** 10 20 30

Special paintings

- ● **Paolo Uccello** Saint George and the Dragon
- ● **Sandro Botticelli** La Primavera
- ● **Michelangelo Buonarotti** the frescoes in the Sistine Chapel
- ● **Tiziano Vecellio** Danaë
- ● **El Greco** View of Toledo
- ● **Leonardo da Vinci** Mona Lisa (La Gioconda)
- ● **Raffaello Sanzio** the Stanza frescoes
- ● **Caravaggio** Death of the Virgin
- ● **Annibale Carracci** The Assumption of the Virgin Mary

Developments in painting

The artists in this timeline are listed chronologically by year of birth, except in the case of Mannerism, for which the order is based on an artwork that was created in a certain year. 'Beyond category' includes artists whose oeuvre exceeds the style characteristics of its era.

- ● **Renaissance**
 Masaccio
 Fra Angelico
 Fra Filippo Lippi
 Paolo Uccello
 Andrea Mantegna
 Piero della Francesca
 Alessandro Botticelli
 Leonardo da Vinci
 Michelangelo Buonarotti
 Raffaello Sanzio
 Giovanni Bellini
 Andrea del Verrocchio
 Andrea del Sarto
 Giorgione
 Tiziano Vecello
 Jacopo Tintoretto
 Paolo Veronese
 Francisco de Zurbarán

- ● **Early-Dutch painting**
 Rogier van der Weyden
 Dieric Bouts
 Jean Fouquet
 Hugo van der Goes

- ● **Mannerism**
 Michelangelo Buonarotti
 Jacopo da Pontormo
 Rosso Fiorentino
 Il Parmigianino
 Jan Gossaert
 Barend van Orley
 Giuseppe Archimboldo
 El Greco
 Bartholomäus Spranger

- ● **Beyond category**
 Albrecht Dürer
 Hans Holbein
 Matthias Grünewald
 Hieronymus Bosch
 Pieter Bruegel de oude

1764 – 1766 *Manuale Typographique* ●
by Pierre Simon Fournier

1818 *Manuale Tipografico* ●
by Giambattista Bodoni

➤ 1692 – 1766 William Caslon I
➤ 1740 – 1813 Giambattista Bodoni
➤ 1706 – 1775 John Baskerville
➤ 1689 – 1836 the Didot family
● Introduction of the
Didot point ▼ 1800 Walbaum
Justus Erich Walbaum
➤ 1712 – 1768 Pierre Simon Fournier

▼ 1702 Romain du Roi
Philippe Grandjean
➤ 1768 – 1839 Justus Erich Walbaum

▼ 1757 **Baskerville** John Baskerville
Cut by John Handy
▼ 1789 **Bodoni** ▼ 1845 **Clarendon**
Giambattista Bodoni Benjamin Fox

▼ 1672 **Fell types** ▼ 1725 **Caslon** ▼ 1783 **Didot** ▼ 1817 **Egyptian**
John Fell William Caslon I Firmin Didot Vincent Figgins

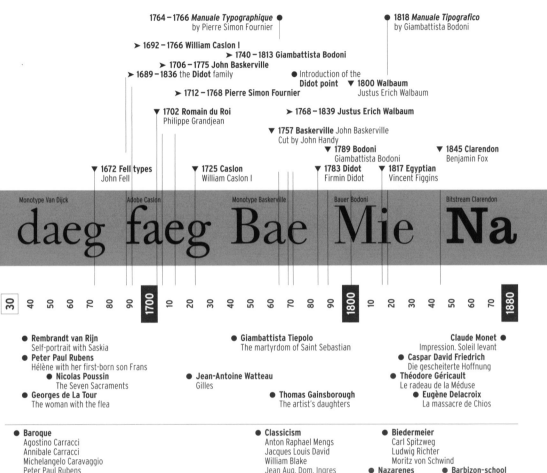

Monotype Van Dijck Adobe Caslon Monotype Baskerville Bauer Bodoni Bitstream Clarendon

daeg faeg Bae Mie Na

30 40 50 60 70 80 90 **1700** 10 20 30 40 50 60 70 80 90 **1800** 10 20 30 40 50 60 70 **1880**

● **Rembrandt van Rijn**
Self-portrait with Saskia
● **Peter Paul Rubens**
Hélène with her first-born son Frans
● **Nicolas Poussin**
The Seven Sacraments
● **Georges de La Tour**
The woman with the flea

● **Giambattista Tiepolo**
The martyrdom of Saint Sebastian

● **Jean-Antoine Watteau**
Gilles

● **Thomas Gainsborough**
The artist's daughters

Claude Monet ●
Impression. Soleil levant
● **Caspar David Friedrich**
Die gescheiterte Hoffnung
● **Théodore Géricault**
Le radeau de la Méduse
● **Eugène Delacroix**
La massacre de Chios

● **Baroque**
Agostino Carracci
Annibale Carracci
Michelangelo Caravaggio
Peter Paul Rubens
Frans Hals
Georges de La Tour
Nicolas Poussin
Anthony van Dyck
Rembrandt van Rijn
Charles Le Brun

● **Classicism**
Anton Raphael Mengs
Jacques Louis David
William Blake
Jean Aug. Dom. Ingres

● **Biedermeier**
Carl Spitzweg
Ludwig Richter
Moritz von Schwind
● **Nazarenes** ● **Barbizon-school**
Johann Hottinger Théodore Rousseau
Joh. Fr. Overbeck Jean-François Millet
Franz Pforr C.F. Daubigny
Philipp Veit Jean Baptiste Camille Corot
Peter von Cornelius

● **Rococo**
Jean-Antoine Watteau
Giambattista Tiepolo
Antonio Canal (Canaletto)
François Boucher
Francesco Guardi
Thomas Gainsborough
Francisco de Goya

Romanticism ●
Antoine-Jean Gros
Caspar David Friedrich
Théodore Géricault
Eugène Delacroix

Impressionism ●
Claude Monet
Edouard Manet
Camille Pissarro
Auguste Renoir
Alfred Sisley
Jean Frédéric Bazille
Berthe Morisot
Edgar Degas

● **Beyond category**
Jan Vermeer

● **Beyond category**
William Turner
Henri de Toulouse-Lautrec
Edvard Munch

● **Pre-Raphaelites**
Dante Gabriel Rossetti
John Everett Millais
Edward Burne-Jones
William Morris

● **Realism**
Gustave Courbet

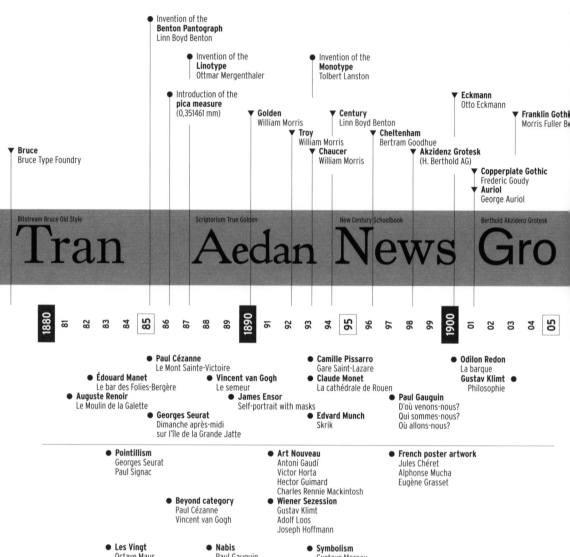

Invention of the
Benton Pantograph
Linn Boyd Benton

Invention of the
Linotype
Ottmar Mergenthaler

Invention of the
Monotype
Tolbert Lanston

Introduction of the
pica measure
(0,351461 mm)

▼ **Eckmann**
Otto Eckmann

▼ **Franklin Gothi**
Morris Fuller B

▼ **Golden**
William Morris

▼ **Century**
Linn Boyd Benton

▼ **Troy**
William Morris

▼ **Cheltenham**
Bertram Goodhue

▼ **Chaucer**
William Morris

▼ **Akzidenz Grotesk**
(H. Berthold AG)

▼ **Bruce**
Bruce Type Foundry

▼ **Copperplate Gothic**
Frederic Goudy
▼ **Auriol**
George Auriol

Bitstream Bruce Old Style Scriptorium True Golden New Century Schoolbook Berthold Akzidenz Grotesk

Tran Aedan News Gro

1880 81 82 83 84 **85** 86 87 88 89 **1890** 91 92 93 94 **95** 96 97 98 99 **1900** 01 02 03 04 **05**

● **Paul Cézanne**
Le Mont Sainte-Victoire

● **Camille Pissarro**
Gare Saint-Lazare

● **Odilon Redon**
La barque

● **Édouard Manet**
Le bar des Folies-Bergère

● **Vincent van Gogh**
Le semeur

● **Claude Monet**
La cathédrale de Rouen

● **Gustav Klimt** ●
Philosophie

● **Auguste Renoir**
Le Moulin de la Galette

● **James Ensor**
Self-portrait with masks

● **Paul Gauguin**
D'où venons-nous?
Qui sommes-nous?
Où allons-nous?

● **Georges Seurat**
Dimanche après-midi
sur l'île de la Grande Jatte

● **Edvard Munch**
Skrik

● **Pointillism**
Georges Seurat
Paul Signac

● **Art Nouveau**
Antoni Gaudí
Victor Horta
Hector Guimard
Charles Rennie Mackintosh

● **French poster artwork**
Jules Chéret
Alphonse Mucha
Eugène Grasset

● **Beyond category**
Paul Cézanne
Vincent van Gogh

● **Wiener Sezession**
Gustav Klimt
Adolf Loos
Joseph Hoffmann

● **Les Vingt**
Octave Maus
Fernand Knopff
James Ensor
Henri van de Velde
Theo van Rijsselberghe

● **Nabis**
Paul Gauguin
Paul Sérusier
Pierre Bonnard
Édouard Vuillard
Emile Bernard
Maurice Denis

● **Symbolism**
Gustave Moreau
Odilon Redon
Jan Toorop
K.P.C. de Bazel
J.L.M. Lauweriks

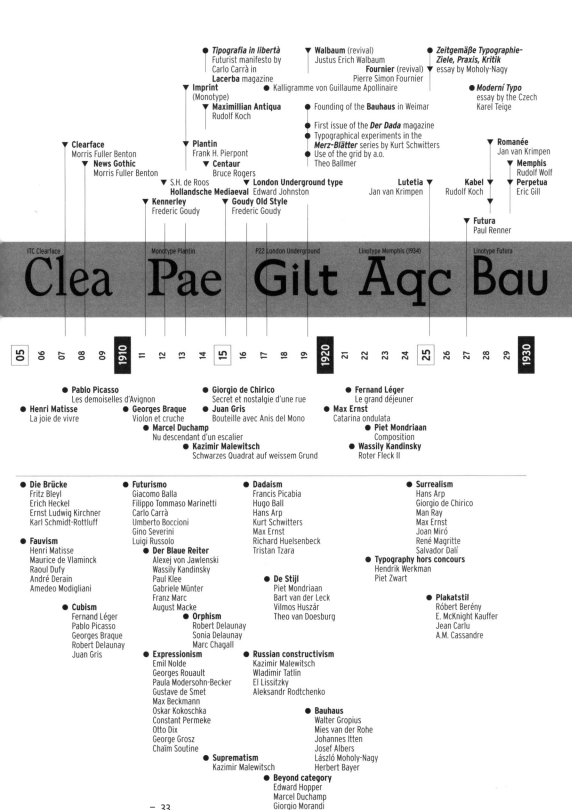

Tipografia in libertà Futurist manifesto by Carlo Carrà in **Lacerba** magazine

▼ **Walbaum** (revival) Justus Erich Walbaum

● **Zeitgemäße Typographie-Ziele, Praxis, Kritik** essay by Moholy-Nagy

▼ **Imprint** (Monotype)

Fournier (revival) Pierre Simon Fournier

● Kalligramme von Guillaume Apollinaire

● **Moderní Typo** essay by the Czech Karel Teige

▼ **Maximillian Antiqua** Rudolf Koch

● Founding of the **Bauhaus** in Weimar

▼ **Clearface** Morris Fuller Benton

▼ **Plantin** Frank H. Pierpont

● First issue of the **Der Dada** magazine

● Typographical experiments in the **Merz-Blätter** series by Kurt Schwitters

● Use of the grid by a.o. Theo Ballmer

▼ **Romanée** Jan van Krimpen

▼ **News Gothic** Morris Fuller Benton

▼ **Centaur** Bruce Rogers

▼ **Memphis** Rudolf Wolf

▼ **S.H. de Roos** Hollandsche Mediaeval

▼ **London Underground type** Edward Johnston

Lutetia ▼ Jan van Krimpen

Kabel ▼ Rudolf Koch

▼ **Perpetua** Eric Gill

▼ **Kennerley** Frederic Goudy

▼ **Goudy Old Style** Frederic Goudy

▼ **Futura** Paul Renner

ITC Clearface — Monotype Plantin — P22 London Underground — Linotype Memphis (1934) — Linotype Futura

Clea Pae Gilt Aqc Bau

05 06 07 08 09 **1910** 11 12 13 14 **15** 16 17 18 19 **1920** 21 22 23 24 **25** 26 27 28 29 **1930**

● **Pablo Picasso** Les demoiselles d'Avignon

● **Giorgio de Chirico** Secret et nostalgie d'une rue

● **Fernand Léger** Le grand déjeuner

● **Henri Matisse** La joie de vivre

● **Georges Braque** Violon et cruche

● **Juan Gris** Bouteille avec Anis del Mono

● **Max Ernst** Catarina ondulata

● **Marcel Duchamp** Nu descendant d'un escalier

● **Piet Mondriaan** Composition

● **Kazimir Malewitsch** Schwarzes Quadrat auf weissem Grund

● **Wassily Kandinsky** Roter Fleck II

● **Die Brücke**
Fritz Bleyl
Erich Heckel
Ernst Ludwig Kirchner
Karl Schmidt-Rottluff

● **Fauvism**
Henri Matisse
Maurice de Vlaminck
Raoul Dufy
André Derain
Amedeo Modigliani

● **Cubism**
Fernand Léger
Pablo Picasso
Georges Braque
Robert Delaunay
Juan Gris

● **Futurismo**
Giacomo Balla
Filippo Tommaso Marinetti
Carlo Carrà
Umberto Boccioni
Gino Severini
Luigi Russolo

● **Der Blaue Reiter**
Alexej von Jawlenski
Wassily Kandinsky
Paul Klee
Gabriele Münter
Franz Marc
August Macke

● **Orphism**
Robert Delaunay
Sonia Delaunay
Marc Chagall

● **Expressionism**
Emil Nolde
Georges Rouault
Paula Modersohn-Becker
Gustave de Smet
Max Beckmann
Oskar Kokoschka
Constant Permeke
Otto Dix
George Grosz
Chaïm Soutine

● **Suprematism**
Kazimir Malewitsch

● **Dadaism**
Francis Picabia
Hugo Ball
Hans Arp
Kurt Schwitters
Max Ernst
Richard Huelsenbeck
Tristan Tzara

● **De Stijl**
Piet Mondriaan
Bart van der Leck
Vilmos Huszár
Theo van Doesburg

● **Russian constructivism**
Kazimir Malewitsch
Wladimir Tatlin
El Lissitzky
Aleksandr Rodtchenko

● **Bauhaus**
Walter Gropius
Mies van der Rohe
Johannes Itten
Josef Albers
László Moholy-Nagy
Herbert Bayer

● **Beyond category**
Edward Hopper
Marcel Duchamp
Giorgio Morandi

● **Surrealism**
Hans Arp
Giorgio de Chirico
Man Ray
Max Ernst
Joan Miró
René Magritte
Salvador Dalí

● **Typography hors concours**
Hendrik Werkman
Piet Zwart

● **Plakatstil**
Róbert Berény
E. McKnight Kauffer
Jean Carlu
A.M. Cassandre

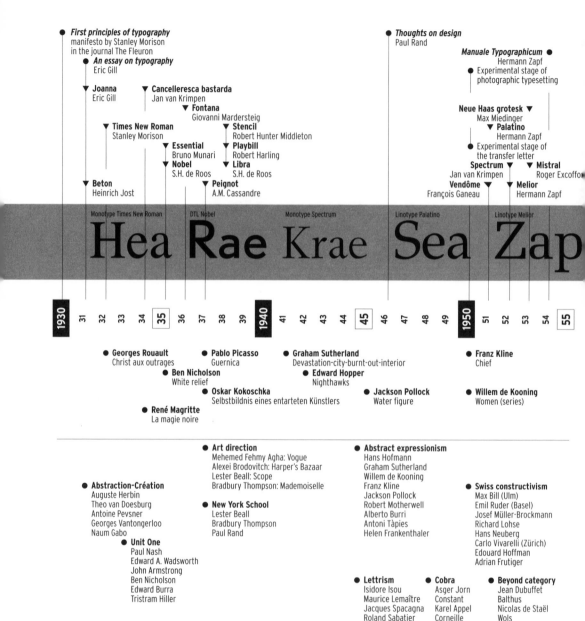

First principles of typography
manifesto by Stanley Morison
in the journal The Fleuron

An essay on typography
Eric Gill

Joanna
Eric Gill

Cancelleresca bastarda
Jan van Krimpen

Fontana
Giovanni Mardersteig

Times New Roman
Stanley Morison

Stencil
Robert Hunter Middleton

Essential
Bruno Munari

Playbill
Robert Harling

Nobel
S.H. de Roos

Libra
S.H. de Roos

Beton
Heinrich Jost

Peignot
A.M. Cassandre

Thoughts on design
Paul Rand

Manuale Typographicum
Hermann Zapf

Experimental stage of
photographic typesetting

Neue Haas grotesk
Max Miedinger

Palatino
Hermann Zapf

Experimental stage of
the transfer letter

Spectrum
Jan van Krimpen

Mistral
Roger Excoffon

Vendôme
François Ganeau

Melior
Hermann Zapf

Monotype Times New Roman DTL Nobel Monotype Spectrum Linotype Palatino Linotype Melior

Hea Rae Krae Sea Zap

1930 31 32 33 34 **35** 36 37 38 39 **1940** 41 42 43 44 **45** 46 47 48 49 **1950** 51 52 53 54 **55**

Georges Rouault
Christ aux outrages

Pablo Picasso
Guernica

Graham Sutherland
Devastation-city-burnt-out-interior

Franz Kline
Chief

Ben Nicholson
White relief

Edward Hopper
Nighthawks

Oskar Kokoschka
Selbstbildnis eines entarteten Künstlers

Jackson Pollock
Water figure

Willem de Kooning
Women (series)

René Magritte
La magie noire

Art direction
Mehemed Fehmy Agha: Vogue
Alexei Brodovitch: Harper's Bazaar
Lester Beall: Scope
Bradbury Thompson: Mademoiselle

Abstract expressionism
Hans Hofmann
Graham Sutherland
Willem de Kooning
Franz Kline
Jackson Pollock
Robert Motherwell
Alberto Burri
Antoni Tàpies
Helen Frankenthaler

Swiss constructivism
Max Bill (Ulm)
Emil Ruder (Basel)
Josef Müller-Brockmann
Richard Lohse
Hans Neuberg
Carlo Vivarelli (Zürich)
Edouard Hoffman
Adrian Frutiger

Abstraction-Création
Auguste Herbin
Theo van Doesburg
Antoine Pevsner
Georges Vantongerloo
Naum Gabo

New York School
Lester Beall
Bradbury Thompson
Paul Rand

Unit One
Paul Nash
Edward A. Wadsworth
John Armstrong
Ben Nicholson
Edward Burra
Tristram Hiller

Lettrism
Isidore Isou
Maurice Lemaître
Jacques Spacagna
Roland Sabatier

Cobra
Asger Jorn
Constant
Karel Appel
Corneille
Pierre Alechinski

Beyond category
Jean Dubuffet
Balthus
Nicolas de Staël
Wols

Abstract painting groups: Cercle et Carré / Art brut / Informel / Dau al Set / El Paso / Zero / American Abstract Artists
Artyści Rewolucyjni / Abstraction-Création / Fronte Nuovo delle Arti / Section d'Or

International Graphic School
Antonio Boggeri
Theo Ballmer
Xanti Schawinsky
Herbert Matter
Max Bill
Giovanni Pintori

Color field painting
Josef Albers
Mark Rothko
Clyfford Still
Barnett Newman

Calligraphic Expressionism
Henri Michaux
Georges Mathieu
Hans Hartung

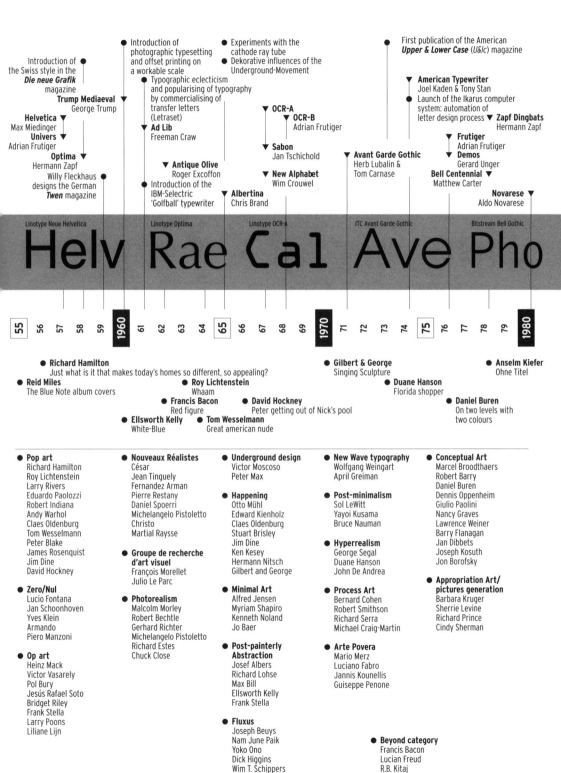

Introduction of
the Swiss style in the
Die neue Grafik
magazine

Introduction of
photographic typesetting
and offset printing on
a workable scale

Experiments with the
cathode ray tube

Dekorative influences of the
Underground-Movement

First publication of the American
Upper & Lower Case (*U&lc*) magazine

Trump Mediaeval ▼
George Trump

Typographic eclecticism
and popularising of typography
by commercialising of
transfer letters
(Letraset)

▼ **American Typewriter**
Joel Kaden & Tony Stan

Launch of the Ikarus computer
system: automation of
letter design process ▼ **Zapf Dingbats**
Hermann Zapf

Helvetica ▼
Max Miedinger

Univers ▼
Adrian Frutiger

Optima ▼
Hermann Zapf

Willy Fleckhaus
designs the German
Twen magazine

▼ **Ad Lib**
Freeman Craw

▼ **Antique Olive**
Roger Excoffon

Introduction of the
IBM-Selectric
'Golfball' typewriter

▼ **OCR-A**

▼ **OCR-B**
Adrian Frutiger

▼ **Sabon**
Jan Tschichold

▼ **New Alphabet**
Wim Crouwel

▼ **Albertina**
Chris Brand

▼ **Avant Garde Gothic**
Herb Lubalin &
Tom Carnase

▼ **Frutiger**
Adrian Frutiger

▼ **Demos**
Gerard Unger

Bell Centennial ▼
Matthew Carter

Novarese ▼
Aldo Novarese

Linotype Neue Helvetica Linotype Optima Linotype OCR-A ITC Avant Garde Gothic Bitstream Bell Gothic

Helv Rae Cal Ave Pho

| **55** | 56 | 57 | 58 | 59 | **1960** | 61 | 62 | 63 | 64 | **65** | 66 | 67 | 68 | 69 | **1970** | 71 | 72 | 73 | 74 | **75** | 76 | 77 | 78 | 79 | **1980** |

● **Richard Hamilton**
Just what is it that makes today's homes so different, so appealing?

● **Reid Miles**
The Blue Note album covers

● **Roy Lichtenstein**
Whaam

● **Francis Bacon**
Red figure

● **Ellsworth Kelly**
White-Blue

● **Tom Wesselmann**
Great american nude

● **David Hockney**
Peter getting out of Nick's pool

● **Gilbert & George**
Singing Sculpture

● **Duane Hanson**
Florida shopper

● **Anselm Kiefer**
Ohne Titel

● **Daniel Buren**
On two levels with
two colours

● **Pop art**
Richard Hamilton
Roy Lichtenstein
Larry Rivers
Eduardo Paolozzi
Robert Indiana
Andy Warhol
Claes Oldenburg
Tom Wesselmann
Peter Blake
James Rosenquist
Jim Dine
David Hockney

● **Zero/Nul**
Lucio Fontana
Jan Schoonhoven
Yves Klein
Armando
Piero Manzoni

● **Op art**
Heinz Mack
Victor Vasarely
Pol Bury
Jesús Rafael Soto
Bridget Riley
Frank Stella
Larry Poons
Liliane Lijn

● **Nouveaux Réalistes**
César
Jean Tinguely
Fernandez Arman
Pierre Restany
Daniel Spoerri
Michelangelo Pistoletto
Christo
Martial Raysse

● **Groupe de recherche
d'art visuel**
François Morellet
Julio Le Parc

● **Photorealism**
Malcolm Morley
Robert Bechtle
Gerhard Richter
Michelangelo Pistoletto
Richard Estes
Chuck Close

● **Underground design**
Victor Moscoso
Peter Max

● **Happening**
Otto Mühl
Edward Kienholz
Claes Oldenburg
Stuart Brisley
Jim Dine
Ken Kesey
Hermann Nitsch
Gilbert and George

● **Minimal Art**
Alfred Jensen
Myriam Shapiro
Kenneth Noland
Jo Baer

● **Post-painterly
Abstraction**
Josef Albers
Richard Lohse
Max Bill
Ellsworth Kelly
Frank Stella

● **Fluxus**
Joseph Beuys
Nam June Paik
Yoko Ono
Dick Higgins
Wim T. Schippers

● **New Wave typography**
Wolfgang Weingart
April Greiman

● **Post-minimalism**
Sol LeWitt
Yayoi Kusama
Bruce Nauman

● **Hyperrealism**
George Segal
Duane Hanson
John De Andrea

● **Process Art**
Bernard Cohen
Robert Smithson
Richard Serra
Michael Craig-Martin

● **Arte Povera**
Mario Merz
Luciano Fabro
Jannis Kounellis
Guiseppe Penone

● **Conceptual Art**
Marcel Broodthaers
Robert Barry
Daniel Buren
Dennis Oppenheim
Giulio Paolini
Nancy Graves
Lawrence Weiner
Barry Flanagan
Jan Dibbets
Joseph Kosuth
Jon Borofsky

● **Appropriation Art/
pictures generation**
Barbara Kruger
Sherrie Levine
Richard Prince
Cindy Sherman

● **Beyond category**
Francis Bacon
Lucian Freud
R.B. Kitaj

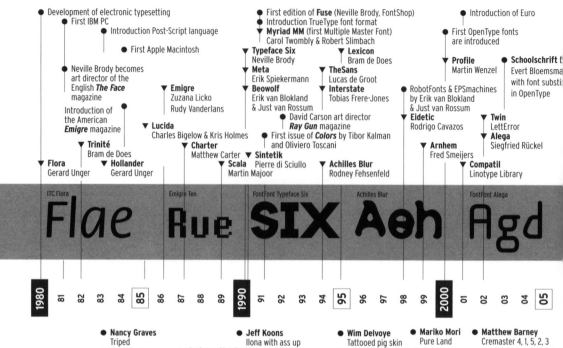

Development of electronic typesetting
First IBM PC
Introduction Post-Script language
First Apple Macintosh

First edition of *Fuse* (Neville Brody, FontShop)
Introduction TrueType font format
▼ **Myriad MM** (first Multiple Master Font) Carol Twombly & Robert Slimbach

Introduction of Euro
First OpenType fonts are introduced

Neville Brody becomes art director of the English *The Face* magazine

▼ **Emigre** Zuzana Licko Rudy Vanderlans

Introduction of the American *Emigre* magazine

▼ **Lucida** Charles Bigelow & Kris Holmes

▼ **Trinité** Bram de Does

▼ **Flora** Gerard Unger

▼ **Hollander** Gerard Unger

▼ **Charter** Matthew Carter

▼ **Scala** Martin Majoor

▼ **Typeface Six** Neville Brody
▼ **Meta** Erik Spiekermann
▼ **Beowolf** Erik van Blokland & Just van Rossum

David Carson art director *Ray Gun* magazine
First issue of *Colors* by Tibor Kalman and Oliviero Toscani

▼ **Sintetik** Pierre di Sciullo

▼ **Lexicon** Bram de Does
▼ **TheSans** Lucas de Groot
▼ **Interstate** Tobias Frere-Jones

▼ **Achilles Blur** Rodney Fehsenfeld

▼ **Profile** Martin Wenzel
● **Schoolschrift** Evert Bloemsma with font substi... in OpenType

RobotFonts & EPSmachines by Erik van Blokland & Just van Rossum

▼ **Eidetic** Rodrigo Cavazos
▼ **Twin** LettError
▼ **Alega** Siegfried Rückel

▼ **Arnhem** Fred Smeijers
▼ **Compatil** Linotype Library

ITC Flora — *Flae* | Emigre Ten — *Rue* | FontFont Typeface Six — *SIX* | Achilles Blur — *Aeh* | FontFont Alega — *Agd*

1980 81 82 83 84 **85** 86 87 88 89 **1990** 91 92 93 94 **95** 96 97 98 99 **2000** 01 02 03 04 **05**

● **Nancy Graves** Triped
● **Brad Davis** Evening shore
● **Julian Schnabel** Humanity asleep
● **Mimmo Paladino** It's always evening

● **Jeff Koons** Ilona with ass up
● **Andreas Slominski** Rat Trap
● **Thomas Locher** 1-Z
● **Andres Serrano** Piss Christ
● **Jeff Wall** Dead Troops Talk
● **Barbara Kruger** Installation View

● **Wim Delvoye** Tattooed pig skin
● **Henrik Plenge Jakobsen** Neutron Urinereactor
● **Damien Hirst** Cocaine Hydro Chloride
● **Georgina Starr** The Nine Collections of the Seventh Museum

● **Mariko Mori** Pure Land

● **Matthew Barney** Cremaster 4, 1, 5, 2, 3
● **Takashi Murakami** Superflat jellyfish
● **Wolfgang Tillmans** Wake

● **Transavantgarde/ Neo-expressionism in Italy**
Sandro Chia
Mimmo Paladino
Enzo Cucchi
Francesco Clemente

● **Neo-expressionism in Germany**
Georg Baselitz
A.R. Penck
Markus Lüpertz
Anselm Kiefer

● **Heftige Malerei**
Bernd Zimmer
Rainer Fetting
Helmut Middendorf
Salomé

● **Mühlheimer Freiheit**
Hans Peter Adamski
Peter Bömmels
Walter Dahn
Jiří Georg Dokoupil
Gerhard Naschberger
Gerard Kever

● **Neo Geo**
Peter Halley
Roni Horn
Philip Taaffe
Peter Schuyff
Ashley Bickerton

● **The new wild ones**
René Daniels
Henk Visch
Rob Scholte

● **Graffiti**
Keith Haring
Rammellzee
Jean-Michel Basquiat

● **Postmodernism/ Eclecticism**
Jenny Holzer
Jeff Koons
Donald Baechler

● **After Nature**
Peter Klashorst
Bart Domburg
Jurriaan van Hall

● **Young British Artists (YBA)**
Stephen Park
Gary Hume
Sarah Lucas
Michael Landy
Anya Gallaccio
Richard Patterson
Tracey Emin
Jake & Dinos Chapman
Marc Quinn
Damien Hirst
Angela Bulloch
Matt Collishaw
Ian Davenport
Angus Fairhurst
Abigail Lane
Chris Ofili

● **Computer art/ Pop reloaded/**
Micha Klein
Mariko Mori
Michel Majerus
Knowbotic Research

● **Post Human**
Paul McCarthy
Stelarc
Orlan
George Lappas
Yasumasa Morimura
Charles Ray
Robert Gober
Mike Kelley
Karen Kilimnik
Jeff Koons (Cicciolina-Periode)
Clegg & Guttmann
Wim Delvoye

● **Media Art**
Bill Viola
Gary Hill
Julia Scher
Steven Pippin
Pipilotti Rist
Gillian Wearing
Philippe Parreno
Jane & Louise Wilson (YBA)
General Idea
Sam Taylor-Wood
Matthew Barney

● **Urban Art**
Henning Eichinger
Gabriel Orozco
Yvonne Kendall
Nina + Torsten Römer
Barry McGee
Steve Powers
Todd James
Bernard Föll
Mauy Parivuhiphongs
Maggie McCormick
Christine Gillespie
Michael Capapas

A closer look at the type family

Over the course of time, different terms for the appearances and parts of typefaces have been invented in various countries and languages. And now that, in the computer era, English terms have been added to the mix, it is complete confusion. Is it cursive, oblique or italic; regular, normal or roman? Consensus on this front would be a good thing, but cannot be expected just yet. To at least provide clarity for the terms used by us in this book, we will here give their definitions.

Above right: the capital 'A' of the Linotype Compatil Letter Bold. This typeface belongs to the slab-serifs category, as does the Serifa, shown below in all its variants. Characteristic of the group are the heavy, rectangular serifs and little thick-thin contrast.

A typeface category is a named group of typefaces displaying similarities, for example script types. A typeface or type family is a group of types closely related in design, designed to be used together and usually bearing the same name (with various modifiers), such as Rockwell or Helvetica. A font is a variant of a typeface, also called grade, weight or type sort, such as the italic version of a standard typeface. So a typeface may include various fonts. This means that if we buy a font for our computer, we only buy one version of a typeface. Mostly, however, a number of fonts such as Regular, Italic, Bold and Bold Italic are sold as a set. A master font is a version as originally designed with a particular intent, i.e. a font designed for a particular size (the design size), though it may be used (with or without modification outside the original designer's control) for various sizes. A type family may, for instance, include three different master fonts to cover sizes from 6 to 72 pt, but other fonts may be interpolated between the masters.

Typeface or type family

Aa *Aa* **Aa** *Aa* **Aa** **Aa**

Font or variant

The Linotype typeface Serifa displayed in all available variants.

The names of the various fonts can differ quite a bit from each other, too. The normal version of a typeface is indicated as Roman, Normal, Medium or Regular. The italic version of a typeface is sometimes called Oblique. In this book, we use the names that type founders have given their own variants or fonts. The 26 letters of the alphabet are only the core characters in a font. Without numerals, punctuation marks, special characters and accented signs, a font is not complete. And each language has its specific punctuation marks and ligatures, which were added to some fonts by the type designer. The variants of a font are discussed separately on the following pages.

abcdefghijklmnopqrstuvwxyz – Poliphilus
abcdefghijklmnopqrstuvwxyz – Blado

RQ

The Trajan typeface, designed by Carol Twombly for Adobe, is based on the Roman inscriptions on Trajan's Column in Rome (consecrated in 113 AD).

UPPERCASE and lowercase letters In handwriting and manuscripts, these letters are also known as capitals or majuscules and small letters or minuscules. Many of the names used in typography derive from the time when people set cast metal type by hand. Type used for setting long texts were stored with the capitals in a separate case that was placed higher and further away on the composing frame. The case containing the small letters, since they appear more frequently, needed to be close by for efficient typesetting. The case of small letters was also emptied more quickly, so there might be more than one case of small letters for each case of capitals. The term 'capital letter' derives from Roman inscriptional lettering cut in stone, to which the letters often owe their straight and 'incised' features. Lowercase letters were only later added to handwriting. Gutenberg and his successors made a separate matrix for each character or sign in the manuscript hand used in the scriptoria at the end of the fifteenth century. The individual letter was then cast in metal. This is how the printing type evolved from manuscript hands.

The variants Although it seems that the italic version of a typeface was there from the beginning, this is definitely not the case. The italic only came into being around 1500, and is derived from the Italian humanistic handwriting and chancery hands of the time. The italic was initially used as a text letter, designed from the economic cursive script. It wasn't yet used as a stylistic device to accentuate words or sentences like we do nowadays. In other words, the roman and the italic were two separate typefaces. Contemporary italics are specially designed fonts that display the features of the typeface they belong to. They can, however, also deviate from the typeface in form, as is clear from the lowercase 'a' below. Some less sophisticated text editing programmes 'italicise' by electronically sloping the roman variant of a typeface; it is a thorn in the typographer's side. Although better software generally automatically links to the real italic (if installed on the computer), it is best to be sure and select the real cursive. In editing programmes, this can be established by means of so-called style sheets.

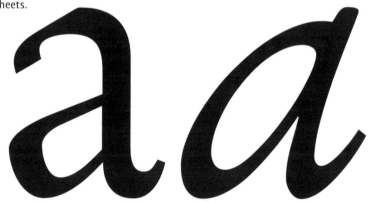

The Blado typeface was revived by Stanley Morison in 1923 after a 1526 italic by Ludovico Degli Arrighi. Although it was an independent typeface, it was also intended for use as a companion italic for the Poliphilus roman (shown on the right), which Morison also revived for Monotype. The Arrighi italics are seen as the first cursive typefaces for use in printed matter.

Stempel Garamond Roman shows that it is based on the roman, cut by Claude Garamond in the book *Hypnerotomachia Poliphili* (Jacques Kerver edition, 1546). Claude Garamond, for his part, had been inspired by the roman that Francesco Griffo cut about fifty years previously for the printer Aldus Manutius. The Poliphilus and the Blado from the example above right are, as it were, mixed together to form one typeface with one name, the Stempel Garamond. In the case of the popular Adobe Garamond, designed as a digital typeface by Robert Slimbach in 1989, the italic is designed to look more like the roman.

abcdefghijklmnopqrstuvwxyz
abcdefghijklmnopqrstuvwxyz

To meet the need to make texts more functional and dynamic, more variants were added to typefaces later. As a result, very extensive type families were created. In some cases there are so many variants available that one can no longer see the wood for the trees.

In such cases, the type menu shows so many possibilities that a sort of 'menu pollution' takes place, so to speak. These variants all have functions, of course; otherwise the designer would not have invented them. The disadvantage however is that a user needs a great deal of knowledge in order to make the right choice.

There are, for instance, smaller differences in weight between the Light, Book, Regular, Semi-bold and the Bold, and there are various design sizes for captions, text and display. The master font is adjusted for optimum legibility.

It becomes even more complex when there is a difference in the heights of ascenders and descenders as with Lexicon by designer Bram de Does (The Enschedé Font Foundry). This typeface, specially designed for use in dictionaries, comes in a no. 1 and a no. 2 version. The no. 1 ascenders and descenders are shorter, which means the line spacing can be smaller, thus resulting in more lines on a page. This means a considerable cost reduction, especially in large dictionaries.

Although they seem extreme examples, designing fonts for specific purposes has really taken off.

The illustration shows a detail of a page of a Dutch dictionary published by *Van Dale, Groot Woordenboek der Nederlandse taal*. The typeface used is the Lexicon no. 1 by Bram de Does. It is clear to see that ascenders and descenders are shorter than usual. Although lines are close together the text remains easy on the eye, and the ascenders and descenders in consecutive lines do not touch. Photo: Joep Pohlen.

ABCDEFGHIJKLMNOPQRSTUVWXYZ
ABCDEFGHIJKLMNOPQRSTUVWXYZ

Small capitals Small capitals are smaller versions of capital letters; not reduced capitals, but especially designed small capitals, which can often be ordered with a certain type family as a so-called Expert or SC font. In height, these SMALL CAPITALS are slightly bigger than the x-height of lowercase letters, and they have a matching weight. Generally, they are proportionately slightly wider than CAPITALS and are used in texts that include many abbreviations or successive capitals. Small capitals provide a better balanced appearance in cases where capitals would make the look of a block of text too busy. It must also be said that the reduced capital-setting, which is optional in most computer programmes, causes the appearance to become too light because the line thickness of the character is reduced. So in general, the use of small capitals is preferred. And in this case too, availability has greatly increased. Only the text letter (regular or book) used to have a small capital version, but nowadays all variants of most typefaces have one. Small capitals are now also available in italics. In OpenType versions of typefaces they are even included in the same font and can easily be accessed in the text menu.

Between 1995 and 1999, a large number of fonts were added to Syntax, a design by Hans Eduard Meier from 1954 that was released in 1968. Amongst others, the small capitals on the top left second line were added. The small capital was first introduced ca. 1525. It later became, like the italic, part of a typeface in form as well.

Ligatures, diphthongs and logotypes Ligatures are combinations of characters that were designed because, in metal typesetting, the overhanging ascender in the letter 'f' would crash into an ascender or the dot of an 'i' if it directly followed the 'f'. Of course, the sorts couldn't overlap as they can in photographic or digital typesetting. In combinations of for instance the 'f' and 'i', ligatures give better results in photographic or digital setting as well because the

Parts of a Monotype Bembo Semibold letter. On the right hand page in red: a ligature with the contours of the individual letters 'f' and 'i' superimposed.

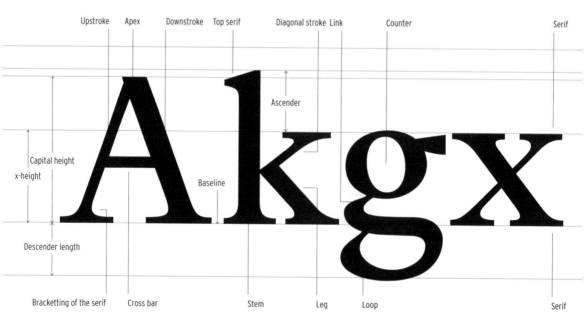

- 40

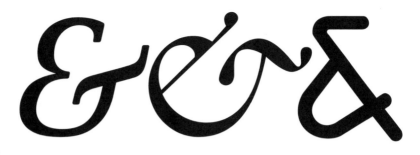

In the '&' symbol of the Demos Italic and the Galliard Italic, the separate letters (et) are still clearly visible. In the Alega on the far right, the designer has departed from a clear picture of the combination. Although this combination strictly speaking forms part of the logotypes, it is more correct to call the Demos and Galliard version a ligature.

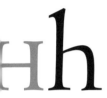

On the left page: a capital and a reduced capital side by side. The whole letter has become thinner. It is clear that the real small capital above much better matches the lowercase letter 'h' next to it. The typeface is the Monotype Centaur.

ascender of the 'f' and the dot of the letter 'i' are designed to join instead of arbitrarily overlapping. If extra letter spacing is used in a text, however, these combinations of characters have to be set separately. The image below gives an example. The ligature is indicated in red and the separate letters that inelegantly overlap are outlined with a black outline. This is not the case for all typefaces; with the sans-serifs this problem hardly ever occurs, although there are here too exceptions that prove the rule. The elegant sans-serif Monotype Gill has the same problem in its cursive variant while many other seriffed types don't. Logotypes are less clearly visible combinations of characters such as the ampersand or '&' symbol. This combination is also made up of ligatures. The '&' symbol was originally a ligature too, formed of the letters 'e' and 't', the Latin word 'et' which means 'and'. Some designers enjoy bringing out the letters in the ligatures again, as the above image shows. Typographic diphthongs or ligatured vowels are rarely used letter combinations. They mainly convey that a word has a special pronunciation. The French 'œil' (eye) is such an example.

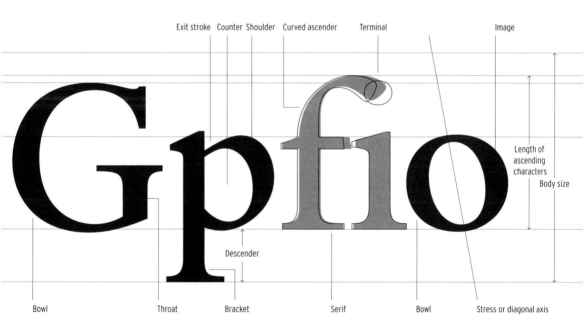

Exit stroke Counter Shoulder Curved ascender Terminal Image

Length of ascending characters

Body size

Descender

Bowl Throat Bracket Serif Bowl Stress or diagonal axis

Numerals It is generally held that when writing systems came into being, people felt a need to describe quantities. The first mathematical instrument was, of course, made up of our two hands. The next step (for bigger quantities) was a tally stick with which a shepherd counted his sheep. He slid a piece of string along the incisions to determine whether his flock was complete. To calculate more difficult numbers, the counting frame or abacus was used for a long time. A few centuries BC, the numbers we still use to this day popped up in India. At the time, they were used as a notation system in Hindu algebra. It was a highly evolved system which the Arabs adopted during trade missions and conquests. In the early Middle Ages, the Italian mathematician Fibonacci introduced the Hindu-Arabic numerals to our part of the world with his book *Liber Abaci*. These numbers are usually called Arabic numerals. Even though we would not be able to go without the zero nowadays, the earliest Hindu system had no symbol for it. Mathematicians initially refused to use this number, especially practical for merchants, because it has a value of 'nothing'. In the sixteenth century, negative numbers (less than nothing!) were used in calculations, too. It is still debated whether zero is an actual number or not. Roman, Arabic, tabular and old style (or non-lining or hanging) numerals: they are all names used by type designers to indicate the difference between various kinds

In several fonts of the Profile typeface, several kinds of numerals are supplied. They are normal tabular figures (second row) and hanging tabular figures (above), but also non-tabular figures that can be used in running text. These are proportionally spaced as the different widths show. In the case of tabular figures, the designer has added serifs to the '1' to avoid strange gaps. The Profile also has specially drawn (and not just reduced!) numerals for fractions, superior and inferior numerals.

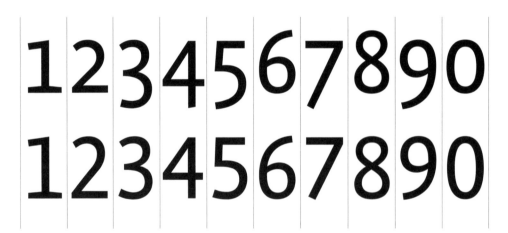

1234567890
1234567890
ab1234567890cd
1234567890/1234567890 ½ ¼ ¾

Monotype Gill Sans (36 pt) Monotype Gill Sans Alt One (36 pt) FontFont Profile (36 pt)

A classic example of number confusion occurs in the Gill Sans typeface. In the example, the character combination of a lower case 'L', the number '1' and the capital of the letter 'i' (this roundabout explanation is needed to avoid confusion). This problem is often seen as typical for sans-serif typefaces. With serifs, after all, a greater form distinction can be achieved. The Verdana and Profile examples show that this is not always necessarily true, although in case of the Verdana serifs actually have been used. To satisfy demand, Monotype has published an alternative font under the appropriate addition 'Alt One' (top middle).

1 I I
Monotype Centaur (36 pt)

1 1 I
Monotype Times (36 pt)

I 1 I
Verdana (32 pt)

1985 in Roman numerals in Adobe's Trajan typeface, an adaptation of the Roman letters on Trajan's Column in Rome.

of numerals. Apart from writing numerals with digits, we have the phonetic way in which numerals (or 'figures' as printers traditionally call them) from one to twelve, and some multiples like a hundred and a thousand, have proper names. From thirteen onwards they are composed of adaptations, like thirteen and fourteen. Numerals up to a certain point are often written phonetically to let running texts remain easy on the eye, but it is probably obvious that a number like 1,355,356 should not be written phonetically. This is also one of the elements that are prescribed in a house style's editorial guidelines or in a publisher's editing department.

When using Arabic numerals, the individual figures 1, 2 and 3 are different in value than their combinations such as 123 or 312. This is logical to us, but when we look at how Roman numerals are built up, this logic is no longer self-evident.
Roman numbers are built up by means of an additive system of addition and deduction. It is assumed that this system directly derives from the tally sticks mentioned earlier. This is why it is called an additive system. So as to make numbers not too long, a subtracting element is added and values are subtracted. Each symbol has a value, I = 1, V = 5, X = 10, L = 50, C = 100, D = 500 and M = 1000. When a symbol with a lower value is placed in front of a higher worth symbol, it means the lower symbol needs to be deducted from the higher one. When a value is followed by a lower value, the lower value needs to be added to the higher one: XC = 90, CX = 110. Roman numerals are still frequently used to number a book's preliminary pages or chapters (Chapter XI), or in names like Louis XIV. When they are frequently used in a text, it is recommended to set these numerals in small capitals. Roman numerals are capital letters and do not have a separate position on a keyboard.

MCMLXXXV

A font can include different sorts of Arabic numerals, for instance tabular figures and non-lining figures. Tabular figures mostly have the same height as capitals and they all have the same 'monospaced' width, so they are ideal to use in tables and calculations because they neatly align vertically. Non-lining figures (also old style figures or hanging figures) show some more resemblance with lowercase letters and are therefore more often used in running texts. Not all type families include non-lining figures. In general, lining figures are in the standard font and the non-lining figures in a separate one. Martin Majoor, designer of the Scala typeface, worked the other way around. He added non-lining figures to the standard font, while putting the tabular figures in the small capital variant. This choice is understandable when looking at the way the typeface was used. It was designed for the Vredenburg concert hall in Utrecht (Netherlands) that needed to incorporate a lot of dates and times in its programmes. Normally these figures would have to be converted, individually, to the hanging figures. With Scala, they were in the right format straight away.

H_2O

10^2

H_2O

10^2

Above, an example of the specially designed small numerals and below the reduced-size numerals. The difference in weight is clearly visible. Another difference is that the small numerals are drawn slightly smaller than the reduced numerals.

Some fonts or variants have specially drawn small numbers that are used for fractions, footnotes, formulas or for superior and inferior numerals. Superior numerals are set above the baseline, and inferior numerals below it. In most cases, reduced numerals are used, and they are about 75% of the normal numeral's size. A number of typefaces have a separate grade for it which includes both grade adapted superior and inferior numerals and fraction numerals. Fraction numerals are often provided in an Expert font or separate variant. If this is not the case, these numerals should be composed of superior and inferior numerals, and separated by a slash. The characters for percent and promille (%, ‰) are included in a standard keyboard layout.

Punctuation marks A font usually contains a large number of punctuation marks, some of which can have very divergent forms like the single quotation mark, pictured below in different typefaces.

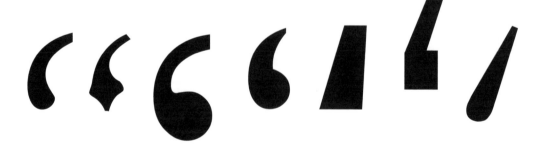

They all have the same point size and are all on 'the same' baseline. As you can see, size and placement in relation to the baseline are variable.
Punctuation marks, just like the Roman numerals, were used in our writing system before the Arabic numerals. Commas, full stops, paragraph marks and hyphens were already used in handwritten books to support readability. We will now propose some possibilities for using punctuation marks. The chances are, however, that opinions are divided. Although in many languages there is an official spelling, the use of punctuation marks is not always clearly defined. We will now discuss a few marks whose use influences a text's typography aesthetically. In other words, we will not go into the linguistic aspects of punctuation marks.

'English'
"American"
„German" or »German«
„Dutch old"
'Dutch new'
« French »
‹ Swiss ›

The prevalent quotation marks in the different languages.

cat‘s

cat's

cat’s

The two examples above are both wrong. Both the 'six' as the min-ute sign are wrong but both can regularly be seen in printed mat-ter as a substitute for the apos-trophe.

The biggest stumbling block is, surely, the quotation mark. There are 'single' and "double" quotation marks – sometimes called 'six-nine' because of their shape and order – but also « guillemets », of French origin, which in Germany are used »the other way around«. Most designers feel this is the most elegant solution because the visual impression of the text will look less distorted and it diminishes the number of obstacles. For a quotation within a quotation, a different solution needs to be found, and the most elegant one in this case is using the double quotation marks, the "sixty-six/ninety-nine", as the second set. So: 'a quotation "within" a quotation'.

The single quotation mark, particularly the 'nine', has yet another function. In a word like 'doesn't' or 'cat's', it is called an apostrophe. If a quotation mark is followed by an apostrophe, an en space should be added for the characters not to be too close. It is however best to avoid this combination altogether.

In a set text, things sometimes go wrong with the quotation mark or apostro-phe. The apostrophe is often a 'six' instead of a 'nine' and regularly, the 'prime' symbol and the "double prime" symbol are used as quotation marks. An ab-horrence to a typographer.

The full stop is the punctuation mark that is used the most. A full stop ends a sentence or an abbreviation. There is also a lot of confusion about the exact placement of the full stop. (In case of an entire sentence in brackets, for instance, the full stop is placed before the closing bracket.) If the sentence ends with a word or several words in brackets, however, the full stop is placed after the closing bracket (and not before). The same principle goes for quota-tions. If a sentence ends with a quotation mark, then the full stop is placed after the 'quotation'. 'If the entire sentence is a quotation, then the full stop comes before the closing quotation mark.'

Abbreviations may or may not end with a full stop. A full stop is needed for: ca. (circa), etc. (etcetera) or ibid. (ibidem, the same place). Abbreviations that consist of more than one word like e.g. (exempli gratia (Latin); for example) or i.e. (id est (Latin); that is) also get full stops. In this case, there are no spaces within the abbreviations. It is more elegant, however, to write out these word abbreviations. In the UK, common titles that are shortened versions of a word (contractions) are not followed by a full stop and are capitalised: Dr (Doctor), Mrs or St (Street). Full stops are used when the abbreviation does not end with the last letter of the word, like in prof.

Internationally recognised abbreviations or symbols of, for example, monetary units, measurements, weights and physical and chemical indicators are written without a full stop. A few of these abbreviations are: cm (centimetre), km (kilometre), °C (degree Celsius) and kg (kilogram). If a sentence ends in an abbreviation, it is obviously always followed by a full stop. Two full stops are, however, never used! See the sentence in the paragraph above that ends with prof. and has no additional full stop.

Another case is the abbreviations of names like BA, AA and BBC; these are usually capitalised and do not have full stops. Small capitals are preferable, however, in running texts.
If the abbreviation is an acronym (pronounced as a word), like Nasa, Nato or Unesco, the first letter is capitalised. If the term has become an accepted word like laser or sim card, lowercase letters are used. When abbreviating days and months, no full stop is used. The first letter is, however, capitalised. For days: Sun, Mon, Tue, Wed, Thu, Fri, Sat and Sun. For months: Jan, Feb, Mar, Apr, May, Jun, Jul, Aug, Sep, Oct, Nov and Dec.

The full stop is also used in number sequences. In English speaking countries, a full stop is used as a decimal point while the comma or, recently, a space is used to present large numbers in a more readable form. So, for instance: 14,300.90 and 22,356 or 22 356. When a number has a decimal point, a comma is only used when there are five or more numbers before the decimal point, so for instance: 50,000.25, but 1034.20. When no decimal point is used, there are differing opinions on whether to begin using a comma with four digit numbers or with five digit numbers. In case of time notation, either a full stop or a colon is used to separate hours and minutes: 10.30 pm or 10:30 pm. A colon is normally used to separate hours, minutes and seconds: 10:30:45 pm. When writing quantities in the UK, a full stop is again used as the decimal point, so: £10.50. For bigger quantities, a comma is used as a thousands separator, so: £10,000.25.

If a sentence ends on a word in bold, the full stop should never be set in bold. If the sentence is entirely set in bold, the full stop should be bold.

ibid.

A full stop usually ends abbreviations of words. It is, however, more elegant to write words in full.

BBC

A full stop is usually not used after abbreviations of names.

Nato

Abbreviations that are pronounced as a word (acronyms) have no full stops between letters and have a capitalised first letter.

Mon

When abbrevating days no full stop is used and the first letter is capitalised.

i.e.

Abbreviations that consist of more than one word also get full stops.

After the full stop, the comma is the most important punctuation mark. This is one of the most difficult punctuation marks to use because the right place-ment has a lot to do with a good sense of language. Therefore the author has primary responsibility. Comma usage increases readability, but practice shows that a comma is used too much, rather than too little. As a rule, a comma is placed there where a short pause is inserted when reading out loud. A comma is used to separate clauses when the subordinate clause comes before the main clause: 'Before I went to work, I ironed my shirt'. A non-restrictive relative clause also gets a comma: 'I painted all the doors, which were green'. Commas are also inserted to enclose parenthetical clauses, sentences or words that give information which are not essential to the meaning of the sentence. Multiple adjectives are separated by commas, too. When a sentence consists of two sub-sentences of which the first ends in a verb and the second starts with one, a comma is placed between the two verbs.

It is difficult to know when a semicolon should be used. Often, a full stop or comma is used instead, even when a semicolon would be the better choice. The semicolon serves two purposes. Firstly, it is used to indicate the connec-tion between two independent finite clauses. Secondly, it is used in lists that have internal punctuation. After each part of the list, a semicolon is inserted and the last part is closed off with a full stop. In a list that consists of single words, the semicolons are omitted, as is the full stop. If parts of the list start with a capital letter and consist of complete sentences, each part of the list ends with a full stop.

The colon is easier to use. It is used to introduce a quote, to indicate that an explanation, description, elucidation or conclusion follows, and prior to a list. In general, the text after the colon starts with a lowercase letter, except when it is a quote or proper name. As we saw before, the colon is used in some time notations as well.

The question mark is usually placed at the end of a sentence, with no space between the last word and the question mark. It replaces the full stop. If a quotation mark is used, the same rules as for a full stop apply.

The exclamation mark is used in two ways; after an exclamation and for emp-hasis. It is placed, with no space, at the end of a sentence. In a text an excla-mation mark is sometimes combined with a question mark to indicate that the question should be asked with emphasis.

Brackets or parentheses are used to clarify, elucidate or add, or to refer. For in-stance: Reuters (London) is recruiting intern(s) (m/f) online (www.uk.reuters.com). It is obviously not advisable to have this many parentheses in one sentence, but in this case they were used as an example. Besides parentheses, there are

square brackets. These are generally used to indicate [...] that part of a quote is omitted, or they are used insert an explanation that did not feature in the original text.

The oblique stroke or slash has seen a real revival since the advent of the internet. Although a slash online indicates a referral to a page deeper down in the hierarchy of a site, it has the following functions for running texts: to indicate a choice (m/f), in abbreviations (w/o) or as a linebreak when quoting from plays, poetry, etc. It is also used to replace the dash or hyphen when connecting words or sentences. The phonetic transcriptions of words are in some dictionaries placed between two slashes as well.

But naturally the dash can also be used as a layout element, to separate the parts of an address or to indicate page numbers in an index. The mirrored version of the slash, the backslash (\), is a symbol that was first added to an ASCII keyboard in 1961, to be used with the IBM stretch computer. The slightly more slanted version of the slash is the fraction (/). It is used for, indeed, fractions: 1/4, 2/16.

The vertical bar (|) nearly never occurs in normal texts but is sometimes used as a typographic styling element by designers.

And then there are the hyphens and dashes. They deserve a lot of attention as they are often misused. They come in a variety of sizes. Hyphens are, first off, used as a symbol to break words. Although every editing programme has a setting for automatic hyphenation, most designers will turn this setting off and insert soft returns manually. A soft return makes sure that, in case of corrections or text overflow, this break is cancelled. Adding a hyphen and then using a hard return is not recommended as the hyphen will remain in case of text overflow!

The reason for manual hyphenation is that compound words are best divided into their components, as in tele-vision or job-centre. The next step is to hyphenate prefixes and suffixes like pre-school. The knack is to keep the gaps on the right-hand side as small as possible with left-ranged text and, in case of justified text, to prevent big gaps and ugly breaks in a block of text.

The second use of a hyphen is as a trait d'union. A hyphen is added when two consonants or vowels are pronounced separately rather than as a diphthong, for instance in bowl-like or anti-intellectual. It is also inserted when there is a chance of misreading, as for instance with co-worker (people might think a cow had an orker). Hyphens are also used to form compounds and to connect numbers and words in adjectival phrases.

Finally, hypenation is sometimes used for dates (9-8-1956), although slashes or full stops are more frequently used.

The en dash is longer than a hyphen and is used to demarcate a parenthetical thought or to indicate a sudden change of direction as in, for instance: 'Unfortunately the document to be discussed – which you received via email – is no longer up to date'. Usually these dashes can be replaced by commas, or the phrase can be bracketed. It is therefore very important to decide which option is best. If dashes frequently occur – thereby disturbing the reading comfort – using commas might be the better option. If a sentence really needs to stand out, and if they are not used too often, dashes are the best choice. The dash at the start cannot be at the end of a line, and the closing dash not at the beginning of one. This makes frequent use problematic – especially in case of short text columns. Dashes can also be used to indicate that a sentence is unfinished, for instance in a case of interruptions.

The en dash is used to indicate a range of values, such as those between dates, times and numbers and approximately replaces the word 'to': 1914–1918 or 2–8 May, or in the meaning 'from ... to': the New York–New Haven train (but not in a New York-New Haven association); and for the minus sign: –5°C; but in lists, too, the en dash are sometimes used instead of a hyphen.

So:
– the en dash is used to indicate parenthetical thought;
– as a replacement for the word 'to';
– in the meaning 'from ... to';
– as a minus sign;
– as a bullet sign.

The em dash (—) is used to demarcate parenthetical thought in English texts, but the dashes are unspaced (without white spaces on either side).

The underscore (_) is a line that lies slightly below the baseline and has the same length as an en dash. This line is often used in names of websites.

£156.–

1914 – 1918

2 – 8 May

London – LA

– 5°C

In the above date, hyphens are used; in the other en dashes. When using a dash to replace the word 'to', half an en dash is added before and after the dash. A dash is added before the minus sign in case of degrees. An en dash cannot always be added with a key. By dividing the point size of the space in half, this becomes easier. The point size is 24 pt and the en space 12 pt.

Even though there are more punctuation marks to talk about, we have now discussed the ones that are most commonly used. It is advisable to look at these characters when choosing a typeface for a commission or a house style because they heavily feature in texts and so influence the styling. Because in a legal or illegal copy of a typeface at least 5% of the design must differ, the punctuation, easily overlooked when choosing a typeface, is often changed. It is therefore always advisable to use the original typefaces and to look also at the design of these characters in a typeface. As the example of the quotation marks showed, the difference between typefaces is already considerable. In typographical styling these marks belong to the so-called microtypography.

Accents These are called diacritics and they indicate a different sound or stress when used with a letter. There is a difference between widely used accents and special accents, used in for instance Central-European languages which are not readily or not at all available in some typefaces. Keyboards are also language specific. Although they are not aware of it, type designers often design for their own language. It is for instance common for American typefaces to have a large x-heights because US English does not use many accent signs. Accent signs therefore have a bit of a hard time in American typefaces. The table below gives an overview of a number of accent and other signs and their names.

é	acute		5'	minute sign
è	grave		2.5"	inch sign
ê	circumflex or caret		!	exclamation mark
ë/ï	umlaut or diaeresis		?	question mark
ç	cedilla		¡	Spanish exclamation mark
å	ring		¿	Spanish question mark
ñ	tilde		(hh)	left and right parentheses
¯	macron		[rr]	left and right square brackets
˘	breve		{aa}	left and right braces
˙	overdot		/	slash, oblique stroke, virgule
˝	double acute accent or Hungarumlaut		\	backslash
ˇ	caron or háček		⁄	solidus or fraction bar
˛	ogonek		\|	vertical bar
.	full stop		ß	eszett or German 'ss'
,	comma		&	ampersand or 'and' symbol
:	colon		%	percent sign
;	semicolon		‰	promille sign
…	ellipsis		¶	paragraph mark
-	hyphen		§	section
–	en dash		$	dollar sign
—	em dash		£	pound sign
's	apostrophe		€	euro sign
'ee'	single quotation marks or inverted commas		ƒ	florin or guilder sign
"dd"	double quotation marks		@	at sign
‹ ee ›	single French quotation marks		®	registered trademark
« dd »	double French quotation marks		™	trademark
»dd«	double German quotation marks		©	copyright
*	asterisk		#	number sign or hash
†	dagger		•	bullet
‡	double dagger		º	masculine ordinal indicator
24˚	degree sign		ª	ordinal indicator

Other commonly used characters Special pi fonts are developed for letters and characters that are not included in a font though still often used. Examples are: the Zapf Dingbats with all kinds of symbols, and Symbol, which includes a lot of characters for scientific applications.

αβχδεφγηιφκλμνοπθρστυϖωξψζ

There are symbols and dingbats for virtually everything. The most frequently used ones are the Greek letters and the mathematic symbols in the Symbol. It is not surprising that they are the standard font, supplied with most computers. Below right is an example of the Wingdings typeface.

Type measurement systems

In typography, several different measurement systems are used besides the metric system. On the European continent, the so-called Didot point system used to be a standard, derived from the metal type era. In Britain and America, however, the Anglo-American point system is used. The inch has always been used for type-writers and (dot matrix) printers. As a result of automation and the use of pin-feed paper, the inch was introduced in the graphic industry. So, a total of four graphic measurement systems are used.

Metric or decimal system The main difference with other measurement systems is that it is a decimal system. At an international congress held in Paris in 1795, the metre was established as the forty-millionth part of the earth's circumference (unfortunately we do not know who measured this). The French (platinum) standard metre gained international recognition in 1889, with the exception of Britain, the Commonwealth and the United States. In 1960, the metre was redefined because the standard metre was not suitable for precision measurement. The metric system is almost exclusively used for grid division, paper sizes, images and line intervals. For the indication of type sizes, the point system will remain in use because differences between successive sizes are in a neat sequence. If we were to use a quarter of a millimetre instead of a point, we would soon end up with three places after the decimal point for half values. The duodecimal system works better because it works with values that are smaller than a millimetre.

Didot point system The Parisian type founder Fournier established a point system which he based on his own non-standard foot. Fournier developed it into a duodecimal system. Later, Fournier's system was revised by the type founder Didot. The Fournier point was a bit smaller than the Didot point, which was based on the 'pied du roi', a linear measurement that was accepted in the whole of France. An augustin or cicero contains 12 Didot points. Designers hardly ever use this system for measurements anymore, but it was the prevalent measuring system on the European continent until the 1980's. Every designer had a typographic ruler that was composed of Didot points. In 1978, attempts were made to link the Didot point to the metre by establishing a Didot point at 0.375 mm. 12 points then equal exactly 4.5 mm. This adjustment never really got used because it was quickly superseded by the advent of the Apple Macintosh point or DTP point.

With the following conversion factors, every measurement system can be converted to another. The points are the 'new' ones, based on the inch.

1 mm
= 2.66 Didot points
= 2.845275 pica points
= 0.0393701 inch

1 Didot point
= 0.3759398 mm
= 1.07001 pica point
= 0.0148057 inch

1 pica point
= 0.352777 mm
= 0.938387 Didot point
= 0.013888 inch

1 inch
= 25.4 mm
= 67.564 Didot points
= 72 pica points

Pica system The pica system is the Anglo-Saxon counterpart of the Didot point system. The pica is also a duodecimal system which is divided into 12 points. However, the pica is somewhat smaller than the Didot. As it lacks international calibration, there is a lot of confusion about the pica. Because many printers in the graphic industry are American, the pica has become the type measurement unit which is most applied. According to the United Bureau of Standards a pica measures 0.351461 mm. However, the measurement units indicated in points in this book are expressed in pica points as used in computer software. There, an inch is divided into 72 pica points (making 1 point the equivalent of 0.352777 mm).

Inch An inch is the Anglo-Saxon measuring unit of the duodecimal system. The inch is defined as 25.4 millimetre. In the typewriter era, the term twelve pitch letter was used, meaning that twelve letters fit an inch width-wise. Because the line interval and set width for matrix printers (nowadays only used for printing forms) are measured in inches, it is advised to take this measurement system into account in the design phase.

An example of a (German) typographic ruler with which to measure metric sizes, inches and their linked pica sizes. Line spacing up to 15 pt can be measured; it can also be used to measure the type body size (Kegel in German).

For many typefaces, the baseline shown in the squares is not applicable. The result of the measurement is a reasonably accurate approximation of the type body size. This beautiful typographic ruler is a Verlag Hermann Schmidt edition (www.typografie.de).

In 1997, the measuring set Mackie M was launched, a metal and larger version of the *Letter Fountain* ruler. All four measurement systems (inch, DTP point, Didot point and mm) are displayed on the back and the front of the sandblasted, stainless steel rod.
In addition, the very precisely etched ruler can measure from zero. The ruler furthermore contains conversion tables and other interesting information. The box for the measuring set also contained a brass, chromium plated 6x magnifying glass (linen tester), a manual and four films for very accurate measurements. The German edition is pictured above. Photo: Joep Pohlen.

Type body size The type body size that we use to this day is a measuring unit that directly derives from metal type. In 1723, an official decree was issued in Paris, stating that all typefoundries needed to adhere to a uniform system. The typefounder Fournier cleverly capitalised on this and devised the above mentioned duodecimal system that was later adapted by Didot. When, in 1795, the metric system for measures and weights was introduced, the Didot point continued to be used for metal type. To prevent the ascenders and descenders of successive lines from touching each other, letters were cast on a body slightly larger than the ascender to descender distance.

The body size, in metal type, was indicated in points; in Anglo-Saxon countries using pica points, on the European continent Didot points (with a cicero of 12 points). An Anglo-American point is slightly smaller than a Didot point, which is why a 12 pt body size in the US is smaller than a French or Dutch 12 pt body size. This already results in a difference in type size. As type designers consid-

ered the space on the body to be the design area, characters with different image sizes occurred. Because variations arose between a character's ascender heights and descender lengths, and because the x-heights (the height of a lower-case 'x') became variable as a result, some characters of a certain type body size have much larger character images than others. The Berthold type company tried to develop a form of standardisation by using the heights of the capitals as basic dimensions. Only the cap height is measured, thus not taking the x-height into account, and that again results in a variable character image. This system, however, has not been adopted by other type companies, so that the dimension of a letter within a certain type body size can still vary a (very) great deal.

Measuring type body size and line spacing If, in metal type, more space between lines was called for, thin strips of lead of one or more point(s) in thickness were inserted in between the lines of metal type. This insertion of extra white space was called leading. The line spacing however is the measured distance between the baselines of consecutive lines. As characters are often so small that they can only be measured in hundredths of millimetres, it is difficult to determine the dimension of a printed type body or of the line spacing. Typographic rulers, using different measurement systems, are available to measure the line spacing. One way of measuring the line spacing is to measure ten lines (starting from the baseline of the first line to the baseline of the eleventh line) and then dividing the outcome by ten. If the line spacing has to be measured in points, it is advised to take 12 lines (because of the duodecimal system). It is difficult to measure the type body size, because of the variable character image mentioned before. In the typeface section of this book, each page contains grade marks to measure the type body size of the typeface concerned.

Adobe Garamond (below left) has a much smaller type image than the American sans-serif (or benton lineale) News Gothic on the right. Both have a body size of 145 pt. The example also shows the typically larger x-height that is characteristic for many American designs. This makes it obvious that 9 pt Adobe Garamond looks a lot smaller than 9 pt News Gothic. The light-red area represents a 145 pt body; the typeface remains within it but does not touch either top or bottom. There was usually a bit of space above and below the face in the metal body. In the computer era, the same measurements were transferred. This is why an ascender to descender measurement does not match the body size entered.

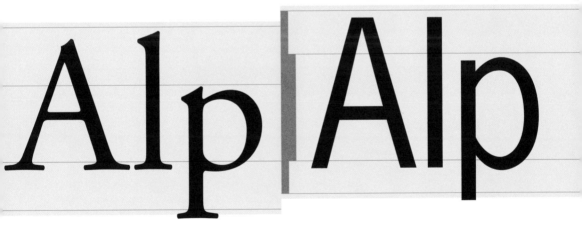

Typefaces and their classification

The various attempts that have been made to organise the multitude of typefaces into clear categories have produced some valuable type classifications, but all of them are only partly satisfactory. There are some methods that follow a chronological order, some that place the emphasis on the differences in form, and others look at whether a type derives from a manuscript or not. Categorisations of types may furthermore fill a purely theoretical need or may have a pragmatic search function. In this chapter a variety of classifications and divisions are discussed.

The most frequently used classification for the division of typefaces by the French Maximilien Vox in 1954 had six categories. Below the extended ATypI version of 1962 with ten categories.

There are a number of reasons that make the classification of typefaces problematic. It starts with the type designers who often base their new designs on historical examples or who produce amended versions of historical typefaces. Some of these new designs even bear the same names (such as the great many Garamonds) and others do not fit any existing category at all. There are also all

Humanists/Venetians (Schneidler)	Geraldes/Old Face (Caslon)	Transitionals (Baskerville)	Didones/Modern (Bodoni)	Slab-serifs/Egyptians (Rockwell)
e	e	d	d	n
Lineales/Sans-serifs (Syntax)	Glyphics (Amerigo)	Scripts (Kuenstler Script)	Graphics (Brush)	Gothic (Cloister Black)
k	b	*s*	*b*	f

kinds of transitionals and hybrid designs that pop up, like Optima (according to some) or the Copperplate Gothic types. Furthermore, type families are designed that contain several styles, like Linotype Compatil with its various seriffed variants and a sans-serif variant.

For this book we are using one widely accepted classification: that of the Frenchman Maximilien Vox from 1954. This classification is based on form differences, but also works chronologically. In 1962, the classification was accepted as a standard by the Association Typographique Internationale (ATypI). In Germany, it was set down as DIN 16518 (1964) and in the UK as British Standard 2961 (1967). It has to be added that specific subdivisions were made in each country; in Germany, for instance, for the Gothic types and in the UK for the sans-serif typefaces.

As a large number of typefaces are ignored in this classification, we have amended and extended it at various points to do justice to typefaces that were designed after 1954, particularly the great many sans-serif typefaces that have been added. This is why we have divided the sans-serifs into four groups, so as to restore the balance between the seriffed types and sans-serifs for our time.

As some typefaces contain various style variants they may appear in different groups. The size of the typefaces and that of the different variants in particular, have also expanded greatly. This has, however, no influence on their classification.

Thibaudeau classification

Historical letter classification

Venetian
One can still see that its origins lie in letters written with a broad pen.
Examples: Jenson, Centaur.
Old Face
The letters begin to be drawn more and have a greater thick-thin contrast.
Examples: Bembo, Garamond
Transitional
Typefaces that originated in France and England in the middle of the eighteenth century.
Examples: Baskerville, Fournier, Caledonia.
Modern
Typefaces that have a high thick-thin contrast. They have a vertical stress axis and thin serifs.
Examples: Bodoni, Didot.
Egyptians
Typefaces with heavy, rectangular serifs (almost as thick as the letter itself).
Examples: Clarendon, Rockwell, Beton.
Sans-serif
First came about at the beginning of the nineteenth century.
Examples: Akzidenz Grotesk, Syntax, Helvetica, Gill Sans.

M M M M

1 Le romain Elzévir (Garamond)
Triangular serif

2 Le romain Didot (Bauer Bodoni)
Linear serif

3 L'Egyptienne (Rockwell)
Slab-serif

4 L'Antique (Profile)
sans-serif

Other classifications
Top right-hand side: a historical or chronological classification of unknown origin that partly overlaps the Vox classification. Above: the Thibaudeau classification according to the form of serifs (empattement).

This page furthermore contains a short explanation of two other classifications. One is exclusively aimed at an historical classification, the other looks at the form of the serifs. New classifications are designed on a regular basis because there is not one classification, not even Vox's, that is able to exactly classify every single typeface. We are, however, still waiting for that final, definitive classification that applies to all typefaces ...

Vox+ On the following pages, an amended version of the Vox classification is discussed in detail. As names can differ in various countries, we have also added the French and German versions. As mentioned on the previous page, we have made some additions to the original classification as designed by Maximilien Vox. This is why we call it Vox+.

Vox+1

Vox+2

Vox+3

Vox+4

Vox+1 Since the beginning of the computer era, the use of sans-serif typefaces has greatly increased. We therefore thought it necessary to reserve more space in the division for these sans-serifs. Form differences play an even greater part in Vox+ than in the original version. This is why the chronology somewhat takes a back seat. The additions to the sans-serif typefaces go back to the form differences in the seriffed types and are therefore included in a similar order.

Over the past decades, the question of legibility of seriffed versus sans-serif typefaces has led to many heated debates. Part of the controversy has to do with the form and recognition of individual letters and about conditioning or habituation. A language is learned from birth and learning to read then starts by recognising letter forms on the basis of existing typefaces (often sans-serif!). A child taught Japanese characters recognises these just as easily as we recognise Gill Sans. Linked to this question of habituation is a discussion relating to the proposition that serifs bring out each separate letter's character while sans-serif letters are more alike in form. This certainly holds true for the minimalistic forms of a typeface like Futura. Now that sans-serifs are so popular, however, more and more typefaces appear with greater form richness and that in legibility measure up to the seriffed type. Obviously our habituation or conditioning plays a part here, too, although this time, it might be to the advantage of the sans-serif typefaces.

Research also shows that, in reading, not every letter is absorbed, but that part of a sentence is scanned which is then interpreted with those parts of the text that have already been taken in. This makes it possible to read quickly without having to absorb every detail. The text below shows the way the brain can be conditioned to read or understand language:

Arocdnicg to rsceearch at Cmabrigde Uinervtisy*, it deosn't mttaer in waht oredr the ltteers in a wrod are, the olny iprmoatnt tihng is taht the frist and lsat ltteer are in the rghit pcale.

Text and chat language have also given the discussion about form and legibility a boost. 'XOXO' for instance is very functional for a chatter to end a chat. It stands for 'kisses & hugs'. Language and form have become one. Here, the difference between seriffed and sans serif types is less important than is the fact that English has been mixed with the chatter's mother tongue.

* According to Cambridge University researchers, this story, although partly based on truth, is a 'hoax' that appeared on the internet in 2003. There are versions in different languages, even Russian.

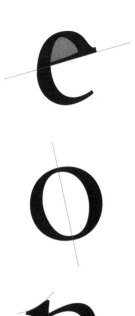

Omnibus Jenson Classico by
Franko Luin.

1.1 Humanistic [FR: Humanes, GE: Venezianische Antiqua]

Gutenberg, the inventor of European letterpress printing with movable metal type, used a gothic typeface: the Textura. This almost literally replaced the then in Germany commonly used handwriting system. A decade later, German printers introduced the art of printing to Italy, the artistic and commercial centre of the Renaissance. Italy was an epicentre that attracted a lot of creative spirits from surrounding countries. Although at first, variants of the gothic letter were used, soon a need arose for a letter that captured the spirit of the Renaissance and that was less formal and angular. The oldest Italian, mostly Venetian, printing type, designed at the end of the fifteenth century during the Italian Renaissance, are based on the handwriting of the humanists. This script went back to the Carolingian minuscule of the ninth century. In 1470, Nicolas Jenson, a French printer who worked in Venice, was one of the first to cut a refined humanistic typeface. This is generally seen as the prime example for the first group of types we use to this day: the humanists. Over the centuries, the typefaces in the humanist group have lost nothing of their attractiveness and are still widely used.

Characteristics: The axis of the thick-thin contrast slants to the left. The inclined cross-bar on the lowercase 'e' is one of the characteristic features. In general, the ascenders of the lowercase letters extend beyond the capitals. The top serifs are roof-shaped. The serifs often end with a firm, angular cut and are slightly rounded. The thick-thin contrast is less strong than in the garaldes. The overall picture of the humanists is one of remarkable lightness. The bolds and the italics were added later and often do not fit the character of these typefaces.

Examples: Jenson by Nicolas Jenson, the Golden Type by William Morris, Hollandsche Mediaeval by Sjoerd Hendrik de Roos, the Centaur by Bruce Rogers, the Schneidler by Friedrich Hermann Ernst Schneidler and the Kennerly Old Style by Frederic W. Goudy. More recent is the Guardi by Reinhard Haus.

ABCDEFGHIJKLMNOPQRSTUVWXYZ
abcdefghijklmnopqrstuvwxyz

Omnibus Jenson Classico (This typeface was designed by Franko Luin after the original by Nicolas Jenson of the fifteenth century, and is distributed by Linotype Library.)

ABCDEFGHIJKLMNOPQRSTUVWXYZ
abcdefghijklmnopqrstuvwxyz

Monotype Centaur (Designed first as a capital alphabet by Bruce Rogers for the Metropolitan Museum. Later he was commissioned by Monotype to design the lowercase which he based on the work of Nicolas Jenson.)

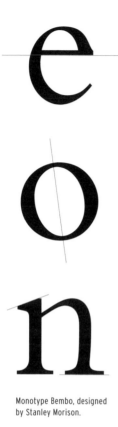

Monotype Bembo, designed by Stanley Morison.

Appeared during the French Renaissance period. The name 'garaldes' is a contraction of the names of the French punchcutter Claude Garamond and of the Venetian printer Aldus Manutius. The first garaldes were based on the humanists, but they are more sophisticated, have narrower proportions and more fluent transitions. This was greatly thanks to the punchcutter Francesco Griffo. Some classification systems are inclined to group the humanists and garaldes together under the heading Renaissance Antiqua. For the humanists, however, the role of the pen in handwriting is more visible while the garaldes are more clearly drawn letters. The latter group contains more typefaces than the humanists. Although most available digital garaldes are based on the Renaissance typefaces, various designs have been drawn again from the ideal that the original designer must have had, but which was not quite attainable with the then available technique. With this thought in mind, Jan Tschichold designed his Sabon. Of course there are typefaces that do not adapt early types, but that are in keeping with the forms and thoughts of the time.
Characteristics: As with the humanists, the axis of the thick-thin contrast slopes somewhat to the left. The contrast is greater. The cross-bar of the lowercase 'e' is horizontal. Top serifs are roof-shaped and, as in the humanistics, have a triangular form. The base serifs have no or hardly any rounding at the bottom. Bold and cursive variants were added later.
Examples: Bembo by Francesco Griffo, Plantin based on a roman by Robert Granjon, Garamond by Claude Garamond, Sabon by Jan Tschichold, Albertina by Chris Brand and the Palatino by Hermann Zapf. In 1969, Dick Dooijes drew the Lectura which has been issued in digital form by Red Rooster as Leighton. It needs to be added that this version is 'American' and therefore has a rather large x-height. The design is nonetheless different in some parts. The Lectura is a fairly narrow letter.

ABCDEFGHIJKLMNOPQRSTUVWXYZ
abcdefghijklmnopqrstuvwxyz

Monotype Bembo (Stanley Morison designed this letter after the typeface that was first used in Cardinal Pietro Bembo's 'De Aetna' of 1495. Pay attention to Bembo's characteristic capital letter 'R'.)

ABCDEFGHIJKLMNOPQRSTUVWXYZ
abcdefghijklmnopqrstuvwxyz

Monotype Plantin (Frank Hinman Pierpont designed this typeface after sixteenth century examples of Robert Granjon in the Plantin-Moretus museum. Later Stanley Morison based his Times New Roman on Plantin and the Granjon type as seen in the 1905 type specimen of the Museum Plantin-Moretus.)

Monotype Baskerville by
John Baskerville.

1.3 Transitionals [FR: Réales, GE: Barock-Antiqua]

The transitionals are the early neoclassical typefaces that appeared in the middle of the eighteenth century and were usually designed for a specific purpose. They are more severe, business-like and sharper drawn than their predecessors. They are seen as the first types that were really designed. The transitionals mark the transition between the Renaissance and neoclassicism. This is why some of these typefaces tend towards the garaldes and others towards the didones. Over the course of time, the thick-thin contrast increases and the serifs become thinner. When a typeface has characteristics of both the garaldes and the didones, it can in principle be grouped with the transitionals. The humanistics were mainly produced in Italy. The garaldes also had a French touch. The transitionals, however, were created all over Europe. There are French, English, Dutch and Italian transitionals. The only country that did not contribute as much to this typographic development was Germany, where the gothic scripts were still widely used. Nevertheless, many German typeface designers did work abroad. Johann Michael Fleischmann for instance was employed by the Dutch company Joh. Enschedé en Zonen.

Characteristics: The axis of the thick-thin contrast is almost vertical or slopes very slightly to the left. The vertical stance is almost always the case for the lowercase 'o', but for the lowercase 'e', the axis can be sloped to the left for the same typeface. The base serifs are only a little or virtually not rounded at the bottom. The lowercase 'e' has a horizontal cross-bar. The top serifs of lowercase letters are roof-shaped. The serifs are sometimes rounded, sometimes sharpened, and in a few cases already strictly horizontal as with the didones. Other typical elements are the bottom part of the descender of the letter 'b' and the 'drop' in the outermost point of the lowercase 'g' and 'r'.

Examples: the Baskerville by John Baskerville, the Concorde by Günter Gerhard Lange, the Fournier by Pierre Simon Fournier, the Perpetua by Eric Gill and – hesitating between a garalde and a transitional – the Caslon Old Face by William Caslon and the Times New Roman by Stanley Morison.

ABCDEFGHIJKLMNOPQRSTUVWXYZ
abcdefghijklmnopqrstuvwxyz

DTL Fleischmann (The German Johann Michael Fleischmann was a letter cutter for Joh. Enschedé from 1743 until his death in 1768. In 1992, the German typeface designer Erhard Kaiser drew the digital version of the Fleischmann for Dutch Type Library.)

ABCDEFGHIJKLMNOPQRSTUVWXYZ
abcdefghijklmnopqrstuvwxyz

Monotype Baskerville (John Baskerville designed this typeface in 1757. Although his books were not a very big commercial success in England, his Baskerville was admired and much imitated.)

bleon

Bauer Bodoni by
Heinrich Jost.

1.4 Didones [FR: Didones, GE: Klassizistische Antiqua]

These are the late neoclassical seriffed types and their name is a combination of the French printing family Didot and the Italian printer Bodoni of Parma. The typeface Bodoni by Giambattista Bodoni, also known as the 'king of the typographers' (principe dei tipografi) or 'printer to the kings', is seen as the highlight of the didones. The monumental symmetrical build and the balanced proportions give the typeface a cool elegance. Legendary is Bodoni's *Manuale Tipografico*, a handbook with 142 typefaces and pages of ornaments which his widow published in 1818 in a limited edition of 250 copies. Bodoni was a perfectionist and he let his feel for proportion and quality come through in the design, the paper quality and even in the composition of special ink in order to print in a deep, glossy black. When designing a letter, Bodoni allowed for the thickening of the thin serifs when printing with metal type on paper, in combination with the spread of ink and the so-called impression in the paper. With the new techniques such as offset, which does not result in an impression, the thin parts of Bodoni often turn out too thin. Also, the contrast was adjusted for different sizes in metal type, which is not the case in most digital versions. Bodoni Classico of 1995 by Franko Luin was adapted to account for these changed conditions, has less contrast and is therefore more suitable for small sizes.

Characteristics: The typefaces show a strong emphasis on the vertical stroke, sharp contrasts, symmetry and sharp transition to the straight serifs, which are as thin as the thin parts of the letter.

The axis of the thick-thin contrast is vertical. Some typefaces have a great many variants, because it was very easy to adjust their thickness and width.

Examples: Didot by Firmin Didot, Bodoni by Giambattista Bodoni, Walbaum by Justus Erich Walbaum and more recently, Linotype Centennial by Adrian Frutiger, which has also been drawn a bit stronger to allow for the contemporary digital technique.

ABCDEFGHIJKLMNOPQRSTUVWXYZ
abcdefghijklmnopqrstuvwxyz

ABCDEFGHIJKLMNOPQRSTUVWXYZ
abcdefghijklmnopqrstuvwxyz

Bauer Bodoni and Omnibus Bodoni Classico (Bauer Bodoni (above) by Heinrich Jost is generally seen as one of the most beautiful revivals of the original Bodoni of the *Manuale Tipografico*. Bodoni Classico shows the version by Franko Luin with the slightly thickened serifs and horizontal parts for smaller texts. However, the example in the margin shows that Bauer Bodoni is very well proportioned for bigger body sizes.)

1.5 Slab-serifs [FR: Mécanes, GE: Serifenbetonte Linear-Antiqua]

The slab-serifs are constructed typefaces and in general have hardly any thick-thin contrast. Some slab-serifs are called egyptians after the popularity of the Napoleonic campaign in Egypt and the resulting interest in Egyptology. The character of these typefaces does however – strangely enough – not fit in with this. The Clarendon typeface is so typical for this group that in some English classifications the term 'slab-serif' is replaced with 'Clarendon'. Some classifications after Vox subdivide this group according to form principles:

a Derived from humanists and garaldes with humanist influences: the dynamic form principle (such as Joanna and PMN Caecilia);

b Derived from the didones with neoclassical influences: the rational form principle (such as the Clarendon and the Glypha); in the subdivision the term 'Clarendon' is also used for the whole;

c Constructed: the geometric form principle (such as the Memphis and the Rockwell), also called Egyptian, derived from the first slab-serifs;

d The decorative form principle (such as the Trixie).

Characteristics: Only a little thick-thin contrast and the heavy rectangular serifs are as thick as the letters themselves. The serifs are the defining characteristic of slab-serifs. The differences in the subdivision are most clearly visible in the lowercase letters. The constructed variant (c) almost seems a sans-serif typeface to which serifs are added.

Examples: Antique by Vincent Figgins, the first Clarendon by Robert Besley, Beton by Heinrich Jost, Memphis by Rudolf Wolf, PMN Caecilia by Peter Matthias Noordzij and Serifa by Adrian Frutiger.

ABCDEFGHIJKLMNOPQRSTUVWXYZ
abcdefghijklmnopqrstuvwxyz

Joanna (a) (A 1937 design by Eric Gill for Monotype.)

ABCDEFGHIJKLMNOPQRSTUVWXYZ
abcdefghijklmnopqrstuvwxyz

Clarendon Light (b) (A 1953 design by Hermann Eidenbenz for Haas, derived from an 1845 version by Robert Besley. The version above is by Bitstream.)

ABCDEFGHIJKLMNOPQRSTUVWXYZ
abcdefghijklmnopqrstuvwxyz

Memphis (c) (A design from 1929-1936 by Rudolf Wolf for Linotype.)

1.6 Humanistic sans-serifs [FR: Linéales Humanes, GE: Serifenlose humanistische Linear-Antiqua]

Humanistic sans-serifs are sans-serif typefaces that seem to have been constructed by ruler and compass. The French word 'Linéal' unsurprisingly means: advancing in a straight line. They first appeared at the beginning of the nineteenth century (Caslon Foundry, 1812/14), but only in capitals. The first sans-serif with lowercase appeared in England in 1834. Towards the end of the nineteenth century, every self-respecting foundry had a number of sans-serif typefaces with several variants. Narrow or wide, bold or thin: the advantage of the fairly technical sans-serif typefaces was that it was easy to create variants that still remained part of the same family. The lineales are subdivided in several varieties:

a The humanistic sans-serifs
b The neoclassical sans-serifs
c The Benton sans-serifs or American gothic
d The geometric sans-serifs.

Especially since the nineties of the previous century, a lot of lineales have been added. This is why in our Vox classification, the different types have been awarded their own group. The humanistic sans-serifs are different because they follow the proportions of the classical Roman capital for the capitals and the humanistic manuscript hand for lowercase letters. Good legibility with clearly recognisable word images.

Characteristics: No serifs, and the line widths are visually equal, though in fact most sans-serifs show some contrast between thick and thin. The extension on the lowercase 'e' points to the right instead of turning toward the cross-bar. The lowercase 'g' often has a classic form with two 'bowls'. The characters have more distinguishing forms than those of the other sans-serifs.

Examples: Gill Sans by Eric Gill, Profile by Martin Wenzel, Frutiger by Adrian Frutiger, Scala Sans by Martin Majoor, Myriad by Carol Twombly and Robert Slimbach, Meta by Erik Spiekermann and Syntax by Hans Eduard Meier.

Gill Sans by Eric Gill commissioned by Stanley Morison for Monotype.

ABCDEFGHIJKLMNOPQRSTUVWXYZ
abcdefghijklmnopqrstuvwxyz

Gill Sans (A 1928 design by Eric Gill for Monotype.)

ABCDEFGHIJKLMNOPQRSTUVWXYZ
abcdefghijklmnopqrstuvwxyz

Profile (A 1999 design by Martin Wenzel for FontFont.)

ABCDEFGHIJKLMNOPQRSTUVWXYZ
abcdefghijklmnopqrstuvwxyz

Syntax (A design [1968–1972] by Hans Eduard Meier for Linotype.)

1.7 Neoclassical sans-serifs [FR: Linéales Classicistes, GE: Serifenlose klassizistische Linear-Antiqua]

The neoclassical sans-serifs mainly appeared at the time of the clinical Swiss Typography after the Second World War. Several sans-serif typefaces (lineales) had been designed before, like Akzidenz Grotesk (1898), Reform-Grotesk (1904–1907), Venus (1907), News Gothic (1908), Erbar (1924), Kabel (1927), Futura (1927), Gill Sans (1927) and Neuzeit-Grotesk (1928). Their use, however, had mostly been confined to headings; they were seldom used for reading texts. Sans-serif started to get used more and more frequently with the advent of the Helvetica in 1957, created by the Swiss Max Miedinger. In 1957, Helvetica was designed as Haas Grotesk for the Haas'sche Schriftgießerei. When the design was converted by D. Stempel AG for Linotype, a new name needed to be chosen. By choosing Helvetica (the Latin name for Switzerland is Confoederatio Helvetica), a link was made with the creator and to the popular Swiss Typography. The Swiss Adrian Frutiger, who at the start of the fifties worked for the Parisian foundry Deberny & Peignot, designed at approximately the same time his Univers typeface. Helvetica is taut and neutral, while Univers is slightly more elegant and richer in form. Univers has an extensive family of variants with a very systematic structure. After the success of the Helvetica and Univers, other type companies naturally also got involved with similar sans-serifs.

Characteristics: No serifs, the line thicknesses seem to be equal but have a slight visual thick-thin contrast, the axis of the rounding is vertical, the ascender height is usually equal to the capital height and the curve of the lowercase 'e' is pointed up towards the cross-bar. The lowercase 'g' has an open curve that ends pointing upwards.

Examples: Akzidenz Grotesk (designed as Royal-Grotesk by Ferdinand Theinhardt in 1880), Helvetica by Max Miedinger, Univers by Adrian Frutiger and Arial by Patricia Saunders and Robin Nicholas.

Helvetica by Max Miedinger.

ABCDEFGHIJKLMNOPQRSTUVWXYZ
abcdefghijklmnopqrstuvwxyz

Akzidenz Grotesk (An 1898 design for Berthold, original design by Ferdinand Theinhardt.)

ABCDEFGHIJKLMNOPQRSTUVWXYZ
abcdefghijklmnopqrstuvwxyz

Neue Helvetica (A reworking of a 1957 design by Max Miedinger for Haas'sche Schriftgießerei.)

ABCDEFGHIJKLMNOPQRSTUVWXYZ
abcdefghijklmnopqrstuvwxyz

Univers (A 1957 design by Adrian Frutiger for Deberny & Peignot.)

Trade Gothic by
Jackson Burke.

1.8 Benton sans-serifs [FR: Benton-Linéales, GE: Serifenlose Benton-Linear-Antiqua]

These lineales are also called American gothics. The prototype of this group is Franklin Gothic by Morris Fuller Benton. These typefaces show a close relationship to the neoclassical sans-serifs. The big differences mainly lie in the counters of the 'B', 'P' and 'R', but also in the fact that the visual impression is fairly narrow and that the x-heights of lowercase letters are large. This makes these typefaces very legible even when the print or the paper is bad. The large x-height is a characteristic of a lot of American type designs. Anyone who has ever been to the US and ordered a 'regular' sized soft drink or seen the bags of crisps in supermarkets may see a parallel. This can leave insufficient room for accents. Because in contrast to French, German and many Slavic languages, English does not contain a lot of accents, this maybe the reason why these are less taken into account in the American type design business. This does not, however, diminish the popularity of these typefaces. Whoever has used the News Gothic for captions or footnotes has seen that even in for instance 4 pt sizes, it remains very legible.

Characteristics: No serifs; the thick-thin contrast is clearly visible; the axis of the rounding is vertical; the counters are large in, among others, the 'B', 'P' and 'R', and the lowercase x-height is often a lot larger than with other sans-serifs. Another characteristic is a narrow, vertical construction of the letters and capitals are often angular.

Examples: Franklin Gothic, News Gothic, Trade Gothic, Bell Gothic, Bell Centennial, Vectora, Antique Olive and Officina Sans.

ABCDEFGHIJKLMNOPQRSTUVWXYZ
abcdefghijklmnopqrstuvwxyz

Franklin Gothic Book (A design [1903-1912] by Morris Fuller Benton for American Type Founders.)

ABCDEFGHIJKLMNOPQRSTUVWXYZ
abcdefghijklmnopqrstuvwxyz

News Gothic (A 1908 design by Morris Fuller Benton for American Type Founders.)

ABCDEFGHIJKLMNOPQRSTUVWXYZ
abcdefghijklmnopqrstuvwxyz

Trade Gothic (A 1948 design by Jackson Burke for Linotype.)

ABCDEFGHIJKLMNOPQRSTUVWXYZ
abcdefghijklmnopqrstuvwxyz

Bell Gothic (A 1937 design by Chauncey H. Griffith for the American Telephone Company.)

1.9 Geometric sans-serifs [FR: Linéales Géométriques, GE: Geometrische serifenlose Linear-Antiqua]

The geometric sans-serifs seem to be drawn with ruler and compass. It takes a lot of skill to produce clearly legible typography with these typefaces. Good microtypography, such as choosing the right letter spacing and line interval, is very important. The idea of constructing a typeface instead of basing it on hand lettering, as Didot and Bodoni had already done, was taken up again during the period of Functionalism and especially by the Bauhaus movement in Weimar (Germany) in the twenties of the last century. The ambition of the Bauhaus and especially László Moholy-Nagy to come to one normalised typeface (Einheitsschrift), never got realised. One of the first typefaces that partly fulfilled this ambition was the Universal Alphabet by Herbert Bayer, a teacher at the Bauhaus. This typeface also influenced the design of the ever popular Futura. Futura's designer, Paul Renner, described designing according to these principles as 'mechanisierte Graphik'. In the forming of words, however, the frequently occurring circular elements seem to repel each other rather than forming an unequivocal word picture. At first the Futura had even more extreme forms, but was eventually executed in more traditional forms. The Avenir by Adrian Frutiger does have a geometrical character, but is in many aspects more useful as a body type than the Futura.

Characteristics: No serifs; line thicknesses are only visually and minimally corrected; the axis of the roundings is vertical, and the letters sometimes seem to have been drawn using ruler and compass.

Examples: Futura by Paul Renner, Avant Garde by Herb Lubalin and Tom Carnase, Eurostile by Aldo Novarese, Erbar by Jakob Erbar and Neuzeit Grotesk by Wilhelm Pischner.

Futura by Paul Renner.

ABCDEFGHIJKLMNOPQRSTUVWXYZ
abcdefghijklmnopqrstuvwxyz

Futura (A 1927 design by Paul Renner for Bauersche Gießerei.)

ABCDEFGHIJKLMNOPQRSTUVWXYZ
abcdefghijklmnopqrstuvwxyz

Avenir (A 1988 design by Adrian Frutiger for Linotype. Avenir is French for future and as such refers to Futura, the typeface the Avenir is based on.)

ABCDEFGHIJKLMNOPQRSTUVWXYZ
abcdefghijklmnopqrstuvwxyz

DTL Nobel (This revival from 1993 is by Fred Smeijers for Dutch Type Library. In 1930, this typeface had already been adapted by Sjoerd Hendrik de Roos for Lettergieterij Amsterdam. The base was the Berthold Grotesk from 1929.)

1.10 Glyphics [FR: Incises, GE: Antiqua-Varianten]

The glyphics show a relationship with stone-cut or metal-cut letters. In Latin they are called 'litterae incisae' and in French, 'lettres incisées'. They are usually monumental, or, in other words, powerful, firm and simple, adapted to the restrictions of the material from which they are cut. They have a slight thickening at the ends, but sometimes also sharp, triangular serifs like the Augustea by Aldo Novarese. A typical representative of this group is the Pascal, drawn by the Spanish-French type designer José Mendoza y Almeida from preliminary sketches his father had made during the Second World War. In 1959, he developed these for Lettergieterij Amsterdam and named the typeface after the French mathematician and philosopher Blaise Pascal. For Mendoza, clarity of spirit went hand in hand with poetical sensitivity. Both characteristics convey the essence of this hybrid in the typeface landscape. It is not a sans-serif, but also not quite a serif. As a result, typefaces in this group bring a bit more liveliness to a text than sans-serifs, but they also make the look-and-feel of the text less classic than a seriffed type. Not all glyphics work well for texts. Albertus by Berthold Wolpe for instance is angular and coarse in form, but still has some elegance when applied. The design was based on a letter that was cut in bronze by Wolpe and so is a true glyphic. Albertus stands out best in headlines and other large texts, and less in reading texts.

Characteristics: Their form alludes to cut letters and they have either a thickening or sharp, triangular serifs at the ends.

Examples: Albertus by Berthold Wolpe, Trajan by Carol Twombly, Pascal by José Mendoza y Almeida, Augustea by Aldo Novarese, Amerigo by Gerard Unger and Friz Quadrata by Ernst Friz. Sometimes Optima by Hermann Zapf is placed in this group because of the characteristic thickenings at the ends of lines. The Optima is, however, unmistakably a humanistic sans-serif.

ABCDEFGHIJKLMNOPQRSTUVWXYZ

Adobe Trajan (In 1989, Carol Twombly designed this typeface following Imperial Roman inscriptional capitals of the first century AD. Trajan's Column in Rome was a particularly big source of inspiration; hence the typeface's name.)

ABCDEFGHIJKLMNOPQRSTUVWXYZ
abcdefghijklmnopqrstuvwxyz

Monotype Albertus (From 1932-1940, Berthold Wolpe designed this typeface for Monotype. The forms clearly show that he based his design on letters that were cut in bronze, a technique in which the material is removed from around the letter. The form, in other words, came about from the outside of the letter and not, as is the case for most type designs, from the shape of the letter itself.

Amerigo by Gerard Unger.

1.11 Scripts [Fr: Scriptes, D: Schreibschriften]

These are designed to look like handwritten letters and usually consist of cursive letter forms. In general, they are not suitable for long texts. Unlike the graphics (see 1.12) these are typefaces that have been drawn digitally, but imitate handwriting. Snell Roundhand is based on the handwriting of the seventeenth century writing master Charles Snell.

Shelley Script has three imaginative variants: Allegro, Andante and Volante, referring to the character of the letter forms. In Zapf Chancery by Hermann Zapf, the calligraphic influences are clearly visible. This type has proven to be useful in body type, too. For Mistral, the starting point was the handwriting of Excoffon, although obviously he did not normally write with a brush. He largely copied the letter forms of his handwriting, adapted to the typeface that he envisaged and fulfilling the technical demands of metal type. The starting point was therefore different from that of the Snell Roundhand, which is a true copy of a handwriting. This is why Mistral is sometimes grouped with the graphics.

Characteristics: These typefaces are usually cursive. The original letters were sometimes firm and calligraphed with a broad pen, and sometimes light and elegantly curly, drawn with a pointed pen.

Examples: Kuenstler Script by Hans Bohn, Berthold Script, Snell Roundhand and Shelley by Matthew Carter, Mistral by Roger Excoffon, Zapf Chancery (see left margin) and Zapfino by Hermann Zapf.

ABCDEFGHIJKLMNOPQRSTUVWXYZ
abcdefghijklmnopqrstuvwxyz

Linotype Kuenstler Script (A 1902 design by Hans Bohn and others for Stempel.)

ABCDEFGHIJKLMNOPQRSTUVWXYZ
abcdefghijklmnopqrstuvwxyz

Linotype Shelley Andante (A 1972 design by Matthew Carter for Mergenthaler Linotype.)

ABCDEFGHIJKLMNOPQRSTUVWXYZ
abcdefghijklmnopqrstuvwxyz

Mistral (A 1953 design by Roger Excoffon for Fonderie Olive.)

ABCDEFGHIJKLMNOPQRSTUVWXYZ
abcdefghijklmnopqrstuvwxyz

ITC Zapf Chancery (A 1979 design by Hermann Zapf for International Type Corporation.)

Zapf Chancery by
Hermann Zapf.

1.12 Graphics [FR: Manuaires, GE: Handschriftliche Antiqua]

Although a lot of confusion surrounds the distinction between scripts and graphics, the German terms clearly show the difference. The term 'Schreib-schriften' for the scripts, freely translated as 'script types', gives the origin but also the transition from an often elegant handwriting to a metal or digital typeface. The German term 'Handschriftliche Antiqua' for the graphics denotes a different origin. The Antiqua are typefaces that originate from the Roman scripts from the 1.1 to 1.10 groups. The so-called gothic scripts of the type that Gutenberg first used for his Bible do not belong to this group and have been separately grouped under 1.13. 'Handschriftliche Antiqua' are therefore typefaces that have characteristics of any of several kinds of hand lettering. The design process of these graphics follows a different route to that of the scripts. As the scripts and graphics are frequently used in France, it is no surprise that in the classification of Maximilien Vox, a Frenchman, these two categories are clearly distinguished. What is more, where the German DIN classification, based on the Vox classification, has an extra subdivision for the fractures or black letter, the original French version (with only six categories) groups these with the graphics. In some, often English versions of the Vox classification, the script, graphics and black letter all appear in a single group.
Characteristics: They are cursive and generally bolder than scripts. The style of drawing is usually a little more informal and less formal.
Examples: Tekton by David Siegel, Pepita by Imre Reiner, Choc by Roger Excoffon (see left-hand side of the margin), Brush by Robert E. Smith and Impuls by P. Zimmermann.

ABCDEFGHIJKLMNOPQRSTUVWXYZ
abcdefghijklmnopqrstuvwxyz

Adobe Tekton (A 1989 design by David Siegel based on the hand lettering of the American architect Frank Ching. Tekton is meant for lettering in architectural drawings and informal designs.)

ABCDEFGHIJKLMNOPQRSTUVWXYZ
abcdefghijklmnopqrstuvwxyz

Choc by Fonderie Olive (A 1954-55 design by Roger Excoffon.)

ABCDEFGHIJKLMNOPQRSTUVWXYZ
abcdefghijklmnopqrstuvwxyz

Monotype Pepita (A 1959 design by Imre Reiner.)

Choc by Roger Excoffon.

1.13 Gothic Types [FR: Caractères Brisés ou à Fractures, GE: Gebrochene Schriften]

'Gothic' types take their name from the era of 'gothic' art and architecture in the Middle Ages, when the minuscule manuscript hands became narrower and more angular with breaks in the curves. Several styles that later developed out of these earliest forms are also called gothic. They display an ornamental aesthetic, but that also makes them difficult to read. In the German version of the Vox classification, recorded in the DIN 16518 norm, a category was even subdivided into Textura, Rotunda, Schwabacher, Fraktur and the gothic script now called Civilité. When, in the fifteenth century, Gutenberg invented mechanical letter pressing with individual metal letters, his examples were the manuscript hands used in scriptoria for biblical and liturgical books. This style is called Textura. Several German printers, like Conrad Sweynheym and Arnold Pannartz, introduced this style to Italy and France. As these countries were heavily influenced by Renaissance humanism, they tended to prefer somewhat wider and rounder gothic hands and the new humanistic hands. Types based on these humanistic hands quickly evolved to form the first of what we now call roman types. In German-speaking areas, however, various gothic styles remained dominant until the 1940's. Although the German national-socialist regime first embraced these typefaces as 'Deutsche Schrift', they banned gothic types and gothic handwriting in 1941, no doubt for pragmatic reasons, though they claimed the Schwabacher had a Jewish origin. It cannot be denied that the Fraktur, with its heavy set and angular forms, was well suited to the Nazi style. That association, combined with their legibility problems, ensures that the Fraktur will not gain in popularity anytime soon.

Characteristics: They are unmistakably angular and calligraphic. This is virtually the only group in the classification where it is crystal clear which typefaces belong and which do not.

Examples: Cloister Black by Morris Fuller Benton, Alte Schwabacher, San Marco, Luthersche Fraktur (see left margin) and Fette Fraktur.

Luthersche Fraktur by Linotype.

ABCDEFGHIJKLMNOPQRSTUVWXYZ
abcdefghijklmnopqrstuvwxyz

Cloister Black by Kingsley/ATF (A 1904 textura by Morris Fuller Benton and John W. Phinney.)

ABCDEFGHIJKLMNOPQRSTUVWXYZ
abcdefghijklmnopqrstuvwxyz

Linotype San Marco (A rotunda [1991-1997] by Karlgeorg Hoefer and based on Italian gothic scripts that were found in the cathedrals of Milan and Florence and on the façade of the San Marco Cathedral in Venice.)

ABCDEFGHIJKLMNOPQRSTUVWXYZ
abcdefghijklmnopqrstuvwxyz

Linotype Fette Fraktur (A nineteenth century design that was from the start intended as a letter for headlines.)

What came after Although the summary on the previous pages is pretty complete, especially when it comes to text typefaces, the introduction of the computer and the resulting demand for and growth in the number of typefaces caused thousands of new typefaces to be designed from about 1985. They are partly revivals or typefaces that are inspired by classic designs, and that as such can be fitted into the classifications described in the previous pages. There are, on the other hand, designs that fall outside those classifications. This had already been the case with other typefaces as, before 1954, so-called 'display' or 'headline' typefaces existed that were used in headlines for adverts or for lettering used for shop windows or vehicles. In general, these typefaces are also not very suitable, or even intended for use as body type. The Vox+1 classification will therefore suffice for the typographer who is mainly concerned with editorial typography. Although it can be debated whether a script like Mistral is a true text typeface, the scripts, graphics and, by now, the gothic types should be seen less as usable text typefaces, and more as a historic completion of the classic Vox classification. Ultimately, handwriting is the origin of our typography. The 'display' or 'headline' typefaces are usually not complete either, as they were designed for a specific purpose. Sometimes they do not come with punctuation marks, and others are only available in capitals. It used to be a small, special group that provided a useful addition to the 'serious' typefaces, a group that was carefully avoided by most typographers. That was something for advertising headlines and other publicity purposes. This has changed nowadays. The choice is vast and usage has expanded enormously. They are not only used as headline letters in magazines, but also in leaders for television shows and in opening and end credits of films. So it is very unsatisfactory if those typefaces would remain unclassified. And after all, one of the main reasons for existence of a classification is to neatly organise supply and make the contents traceable.

The lowercase 'f', above, is part of the nineteenth century Fette Fraktur. The explicit design shines a different light on the question of whether certain recent fonts should be allowed a place amongst the more serious typefaces, especially when one compares it to the lowercase 'f' of the Emigre typeface Dalliance, below right. Which one is 'crazier'?

The dilemma It might seem attractive to start putting together another, new classification, but it is probably smarter to add to the Vox classification as it is still a very good starting point. So, following Lewis Blackwell in his book *20th Century Type*, we are better off adding new categories. His additions 'Decorative, Contemporary and Beyond Classification' do, however, leave us with a considerable amount of unclassifiable typefaces. And the so-called pi fonts are not classified either. We will not discuss the non-Latin typefaces that do fit into Vox+4. This category includes Hebrew, Greek, Arabic, Japanese, Chinese and Cyrillic typefaces. The adapted fonts for diacritic-heavy European languages definitely do belong to our western classification. There are even publishers like Paratype (www.paratype.com) that specialise in these fonts.

Place in the classification As the addition to the Vox classification (see page 58) does not concern typefaces that are suitable as body types in books and magazines, we will number the addition separately. The basic classification starts at 1.1 and ends with 1.13; the addition starts at 2.1 and ends with 2.6. Symbols and figures are numbered 3.1 to 3.3 and the non-Latin typefaces start numbering from 4.1.

By dividing the Vox classification into chapters, we avoid the risk of polluting the basic text typeface division of category 1 with additions of typefaces that are less suitable as body text. These typefaces are discussed in category 2. The symbols in category 3 may not be typefaces as such, but they are accessible via the keyboard and Glyphs frame (readily available in most programmes) and they are a useful addition for recurring symbols in texts or other applications like formulas, maps and drawings. On top of that, many symbols have a universal function which connects them to the early days of writing and of typography. Symbols (like arrows, planes and suitcases) are even applicable worldwide and so make their (typo)graphical contribution to communication between world citizens without belonging to a certain language. The non-Latin typefaces in category 4 are a different story. Both a thorough understanding of the language plus an adjusted keyboard are necessary for delivering texts, and word breaking and corrections. Like category 1 of the Vox classification, categories 2 and 3 are discussed more thoroughly. We leave category 4 aside for reasons mentioned before.

Vox+2 The terminology that is used in the subdivision of the display letters in category 2 is deliberately international in character because the typefaces have no clear European, American or other common signature. The most diversified designers were at the forefront of the type design, among them a Dutchman who settled in the US with a Slovakian, a German who studied in the Netherlands and then worked in Berlin, an Englishman who distributed typefaces with a German, and an Italian designer who ended up in Canada and started designing typefaces with a Canadian ex-ballet dancer. In other words, traditional borders or type designers' training or backgrounds are less important in this category. One result can be that technically speaking, the quality may sometimes not match that of text typefaces because basic knowledge is lacking. Style characteristics, specific typographic features like kerning and spacing and the presence of certain (punctuation) marks are things that many designers in this category have not engaged with. What is nice, though, is that for specific applications they are a lively addition to the existing repertoire.

2.1 Classic-Deco

These typefaces are made to catch the eye in advertisements and lettering to draw attention to merchandise. They therefore need to stand out and fit into the character of an era while remaining fairly legible. The appearance is adjusted to the product that needs to be sold. Well-known typefaces in this group are Art Deco typefaces but for instance Western or 'fifties' typefaces as well. Revivals of these typefaces are usually made to invoke associations with a certain era or setting.

Characteristics: They are usually sturdy and in bold to draw attention, and always quirky. The name and form usually give a clear indication of origin or purpose.

Examples: Broadway Engraved, ITC Caribbean, ArtDeco, Art Nouveau Café, Arnold Böcklin, Figaro, Zambesi, Gillies Gothic, Circus, Metropolis, Juanita, Dubbeldik, Dead Mule Canyon, Empire State, Ponderosa, ITC Surfboard.

JUANITA

Dalliance

Beowolf

Regulator

2.2 Typographic

Typefaces that greatly resemble the classic Vox+1 typefaces. Their use as text letter is limited, however, because their letter image is too detailed for reading texts, because they are incomplete (capitals only) or because they are an intentionally daring interpretation of a classic typeface. An example is the Radiorama of the Spanish Type-Ø-Tones, a Helvetica adaptation that mockingly adds serifs and other forms, and affects letters without adjusting letter width or line thickness. The 2Rebels Un by the Canadian 2Rebels is an amalgamation of a Helvetica and a script.

Characteristics: They are divers but always slightly leaning towards the classic letter forms. In short: traditional typefaces with a tic.

Examples: Radiorama by Enric Jardí (Type-Ø-Tones), 2Rebels Un by Denis Dulude (2Rebels), Regulator by Rian Hughes (Device), Dalliance by Frank Heine (Emigre), Beowolf by Just van Rossum and Erik van Blokland (FontFont).

2Rebels Un

Radiorama

abcdefghijklmnopqrstuvwxyz – Radiorama
abcdefghijklmnopqrstuvwxyz – HelveticaNeue

AchillesBlur

GLUE

Sabotage

2.3 Disorder

These typefaces arose at the start of the nineties of the twentieth century and partly got their inspiration from non-mainstream movements like punk (music). Designers like David Carson, who was responsible for the styling of the Ray Gun magazine, made use of this. He had fellow designers create typefaces that were often different for each issue. They are generally hastily made designs that are based on existing typefaces. Using manual or digital techniques, those typefaces are affected, eroded or deformed.

Characteristics: They consist of eroded, deformed characters, often with crumbly contours. An existing typeface that was used as starting point is almost always recognisable.

Example: AchillesBlur by Rodney Shelden Fehsenfeld, Angst by Jürgen Huber (FontFont), Airflo and Glue by Jim Marcus (T-26), Sabotage by Adam Roe (Lunchbox), President Nixon by Pete McCracken (Plazm Fonts).

PRESIDENT NIXON

bubble

Magneto

R A M I Z

kosmos

REACTIVATOR

2.4 Techno

These are typefaces that are tight and sometimes look like they have been cut from or cast in metal. It is as if they are modularly constructed. When looking closer, this is not really the case, but a great number of basic forms are repeated. A lot of these typefaces are used in games, animations, 3D artwork and posters for the dance and techno scene. Andreas Lindholm's Brainreactor from Sweden has almost exclusively produced these kinds of typefaces. René Knip from The Netherlands actually casts and cuts a number of his superbly designed letters in metal.

Characteristics: They are simple, technical in form and heavily built. It looks like they have been cast in or cut from metal.

Examples: Bubble and Kosmos by Mads Rydahl (Planet), Crystopia and Reactivator by Andreas Lindholm (Brainreactor), FutureKill by Todd Munn (T-26), Ramiz by Greg Samata (T-26), Magneto by Leslie Cabarga (Font Bureau), Panic by Adam Hayes (T-26).

Emperor

Stadia

readout

Zero

Gridder

Stardust

2.5 Modular

These typefaces are designed with the same modular form as their basis. At the start of the digital era, this was actually a requirement because printers in those days – either dot matrix or laser – printed according to a matrix and, as it were, filled in the described pixels from computer to printer. Emigre was one of the agencies that pioneered this technique and experimented with it in the first editions of Emigre magazine. Examples are Modula and Emperor (both 1985). The examples show that this modular construction often results in irregular letter spacing. The result is big gaps between letters ('r' and 'i' in Gridder, 'r' and 'o' in Zero) and letters that seem to stick together.

Characteristics: The basic module is always visible and they are very basic in form.

Examples: Lo-Res is an amalgamation of all of Zuzana Licko's pixel designs from the early Emigre period, Stadia by Rian Hughes (Device), Stardust by Alejandro Paul (T-26), Zero (Identikal), Readout by Steffen Sauerteig (FontFont), Gridder by Simon Schmidt (Closefonts).

Dot Matrix

Adelita

Cappuccino

Ridicule

VARIATOR

2.6 Fantasy

This group brings together typefaces that look festive, are lavishly decorated or express exuberance in any other way.

Characteristics: They are extremely varied and free in form with often profuse decorations. They usually do not take anything from traditional typefaces.

Examples: Adelita by Adela de Bara & Laura Meseguer (Type-Ø-Tones), Cappuccino by Jonathan Edwards (Garagefonts), Jigsaw from the Apollo Font Set by Elliot Peter Earls (Emigre), Motion by Frank Heine (Emigre), Ridicule by Don Synstalien (Synfont), Variator by Jim Marcus (T-26), Wet'N Wilde by Marty Bee (Plazm Fonts).

Wet 'N Wilde

Jigsaw

Motion

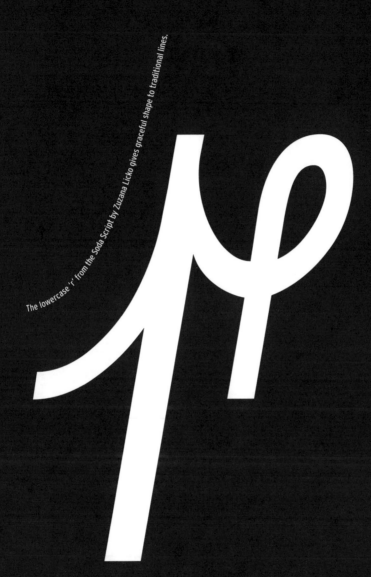

The lowercase 'r' from the Soda Script by Zuzana Licko gives graceful shape to traditional lines.

Vox+3 The word 'pi' in pi fonts derives from the metal era. Pi was an English printing term and meant metal type from set pages that had accidentally come apart and fallen into disarray. Characters that had no designated place in the type case were put in a compartment called the 'pi box', because it too contained a jumble of characters. Unsurprisingly, most pi fonts are a real mess. Although they are usually thematic, they do not have an easily traceable place on the keyboard. Trying every key or using a Glyphs frame is inevitable in this case.

Hypnopaedia One, a 1997 design by Zuzana Licko for Emigre. She is fascinated by patterns. A more recent creation is Puzzler. These are patterns that consist of grid points, geometrical forms and floral shapes.

Ornaments, symbols and pictograms have always been part of typography. The first chapter of thIS book talked about how it all started with the sign, and that actually, signs were there before any writing system. It is convenient if these signs can be entered via a keyboard. Over the past years, a flood of so-called pi fonts have been designed so it is high time to give them a place in the Vox classification. They are, after all, used together with typefaces and often fit in with them. We will discuss them in their three manifestations.

3.1 Ornaments

Ornaments have been around for a long time and were used before the advent of the printing press to 'illuminate' handwritten books. The initials in medieval manuscripts are ornaments also. The most famous example is without a doubt the *Très Riches Heures du Duc de Berry* (1410–1489). Although the *Book of Kells*, which dates from the seventh to the ninth century AD, also contains wonderful ornaments. There are a number of other sources that can inspire designers: from Mexican ornaments in the *Codex Borgia*, art deco decorations and Cambodian murals to Keith Haring's graffiti.

Characteristics: They are border and corner decorations that come in various shapes and styles. Compilations of these ornaments can also cover entire pages or can even be used as decorations for clothes, like a pair of pajamas designed by Zuzana Licko for Emigre. Sometimes capitals are decorated to such a degree they become (corner) ornaments.

Examples: Whirligig by Zuzana Licko, Roarshock One to Six by Bob Aufuldish, Victorian Ornaments One by Richard Kegler, Christina Torre and Amy Greenan, Arts and Crafts Ornaments by Richard Kegler and Dard Hunter, Sagember by Marcus Burlile, Hypnopaedia by Zuzana Licko, Linotype's Border Pi and Caravan Borders and the beautiful, classic Caslon Ornaments by Carol Twombly.

Sagember (A 1994 design by Marcus Burlile for T-26.)

Adobe Caslon Ornaments.

3.2 Symbols

Symbols are undoubtedly the most frequently used pi typefaces. Symbols for formulas, signposting, for cartography and for purposes that need to clarify something in a layout using general symbols. Some symbols still have the same functions as the signs prehistoric humans used, simple and language independent. Examples are arrows, warning signs and – for contemporary prehistoric humans – tourist symbols and 'no smoking' signs.

Characteristics: They are signs that are virtually always language independent.
Examples: ITC Zapf Dingbats by Hermann Zapf, Symbol and Carta by Adobe, Rian's Dingbats by Rian Hughes, FF Dingbats by Johannes Erler and Pi Warning by Linotype.

Arrows from FF Dingbats Arrows One. Although the design for an arrow may seem easy, a lot of designers have a specific preference for a certain form: whether it needs a tail, whether it should be a perfect triangle or an elongated one, how weighted the arrow should be and if the lines should be rounded. The typeface as shown opposite fulfils many of these wishes.

FF Dingbats Arrows One (A 1994 design by Johannes Erler for FontShop.)

Pi Warning (A design for Linotype.)

3.3 Pictograms

These are signs that ask a bit more of an audience's imagination than symbols. Pictograms, a combination of the Latin *pictum* (painted) and the Greek *graphein* (to write), are stylised pictures that can give an indication or information. They are almost always decorative and show their maker's style. They are also called clip art fonts.

Characteristics: They are drawings with a direct or indirect meaning.
Examples: Rayguns by Jeff Gillen, Mambo by Val Fullard, Widows and Phantomekanics by Marcus Burlile, Zeitguys by Eric Donelan.

Two illustrations from Son of Starman; a 1994 design by Marty Bee for T-26.

Zeitguys One (A 1994 design by Eric Donelan and Bob Aufuldish for Emigre.)

Classification and ease of handling On the previous page the amended Vox classification ends. It is far from complete, but a larger extension would make it too complex. Another attempt at a manageable classification was made by the German book typographer and teacher Hans Peter Willberg, who died in 2003. He felt the enormous growth of typefaces after 1954 demanded a different approach and introduced the German term *Sippe*.

The meaning is comparable to that of the word 'clan'. This is a group of people that are related to each other, in other words, the extended family. Willberg transferred this term to the family relationships between typefaces. He proposed a matrix system for style and form characteristics while leaving the historical characteristics aside.

The ideal typeface classification system should, however, also take into account the visual, functional, technical, historical, geographical and cultural characteristics. In order to make the right choice, a user will also often want to know how many variants a typeface has, whether it contains small capitals, non-lining numerals, fraction numerals and whether it has any other characteristics that make it particularly suitable for a certain purpose.

A classification that also meets these criteria has not yet been invented. The need for manageable classifications will always remain because designers want to be able to choose in the right way from the thousands of available typefaces. And suppliers and producers want to offer their clients a convenient way to navigate through their stock of typefaces and make their search as easy as possible.

The examples below show two typefaces that are supposedly hard to fit into the Vox classification and that would fit better in the Willberg matrix.

The Angie Sans by Jean François Porchez would in this matrix fall under the 'Dynamic' style and the 'Antiqua' form. Or maybe it falls under the 'Antiqua' because of its serifs? The Alega by Siegfried Rückel would have to be placed under 'Decorative' and 'Grotesque'. In a bigger point size, the Alega does indeed look like a headline or display typeface. In reading texts, however, this typeface turns out to be very clearly legible. The total structure of the typeface, with dozens of variants, small capitals and Expert fonts, also implies that the designer was looking to design a text typeface instead of a decorative typeface.

Not to be mixed Hans Peter Willberg's matrix on the following pages is interesting because it takes such a different point of view to that of the Vox classification. Willberg poses that typefaces that are next to each other in the matrix should certainly not be mixed because they are alike in form, but too divergent in style. Groups that are placed underneath each other, however, can

Aqua Aqua

Arocdnicg to rsceearch at Cmabrigde Uinervtisy*, it deosn't mttaer in waht oredr the ltteers in a wrod are, the olny iprmoatnt tihng is taht the frist and lsat ltteer are in the rghit pcale. – Angie Sans Regular

Arocdnicg to rsceearch at Cmabrigde Uinervtisy*, it deosn't mttaer in waht oredr the ltteers in a wrod are, the olny iprmoatnt tihng is taht the frist and lsat ltteer are in the rghit pcale. – Alega Normal

Form ▼	Style ▶				
	Dynamic Humanistic form principle (walker)	Static Neoclassical form principle (soldier)	Geometrical Constructed forms (robot)	Decorative Display (dandy)	Provocative Display (freak)
Traditional roman Thick-thin contrast, with serifs	Agaok Monotype Bembo	Agaok Bauer Bodoni	-	AGAOK Linotype Saphir	Agaok FontFont Beowolf
Variations on traditional romans Thick-thin contrast, without serifs	Agaok Agfa Rotis Semi Serif	Agaok URW++ Britannic	-	Agaok Bitstream Broadway	AGAOK Linotype Peignot
Sans-serifs Monoline, without serifs	Agaok Monotype Gill Sans	Agaok Linotype Helvetica	Agaok Bauer Futura	AVANTGA ITC Avant Garde	AΩʌOk Linotype Renee Display
Egyptian/Slab-serif Monoline, with heavy serifs	Agaok Linotype PMN Caecilia	Agaok Linotype Glypha	Agaok Monotype Rockwell	AGAOK Adobe Rosewood	Agaok FontFont Matto
Scripts Written	Agaok Linotype Zapf Chancery	Agaok Linotype Kuenstler Script	-	Agaok Fonderie Olive Choc	agaok Linotype Agrafie

In the above matrix by Hans Peter Willberg, form and style are the most important criteria for classification. Source: *Wegweiser Schrift*, Verlag Hermann Schmidt, Mainz 2001.

be used together. Willberg does expressly state that it is not his intention to create a new classification, but that this matrix is merely a 'typeface signpost'. In the original matrix, the non-Latin typefaces were placed in the bottom row. As we did not include them in this book, they have been omitted from this example as well. We also think a second, separate matrix, using the same structure as the one shown, would do them more justice. After all, the Latin typefaces would be as strange to the people who use the non-Latin typefaces as those non-Latin typefaces are to us.

Advocates of Willberg's matrix state that typefaces that are difficult to classify, such as Palatino (in between Vox 1.1 and 1.2), Alega (in between Vox 1.6 and 2.2) and Melior (in between Vox 1.2 and 1.5) fit more easily into this matrix than the Vox classification. But when things are divided there will always be transitional forms and dubious cases. While some will state that a certain typeface definitely belongs to one group, others will defend another group with equal zeal. The thing that counts, however, is that the classification works for most typefaces. A classification should therefore always be seen as a guiding principle, and never as a strict instruction.

3 seriffed types and 3 sans-serifs

Anyone who can recognise a typeface on the face of it is already a bit of an expert in the field of type design. This knowledge, however, is more than just a gimmick. It enables the designer to both make an intuitively accurate and analytically sound choice from the overwhelming supply of typefaces and variants. By studying the details, a more refined insight and an extended creative versatility is attained. This way, the choice of a typeface for a certain project or application will be a well-considered one.

One is truly bad at observing if one cannot distinguish between seriffed types and sans-serifs. And having read the previous chapter (about type classifications), the main distinctions must be a lot easier to identify. It gets more complex, however, if certain seriffed faces are very much alike, such as Bembo, Garamond and Times. Or – more difficult still – sans-serifs like Akzidenz Grotesk, Helvetica and Univers.
The next pages include the characters which, for each of these six typefaces, show the most striking differences in the 'regular' variant.

Attention can be paid to the height proportions between capitals and lower-case letters, descenders and ascenders, the thick-thin contrast and the slope of the upstrokes and downstrokes. Furthermore, the position and size of the inner forms of the letters, the visual corrections in the transition from straight and curved forms and serifs, and the remarkable differences with regard to some characters and punctuation marks can be taken into account.
Whoever wants to become a connoisseur could, by way of practice, make their own comparative study of italics and other weights, or of some of the almost innumerable variants of the Garamond typeface that have been produced by type founders and in digital designs over the years. Each of these Garamonds has slightly different letter forms. By studying the differences on the following pages, it becomes clear which details to pay attention to.
On the page to the right of each typeface, a text block is reproduced in the same 8 pt size and with a line interval of 10 pt. Although the differences between letters appear to be small at first glance, they cause big differences in a block of text. So the Times may seem less 'economical' than the Garamond, but it looks bigger in the same point size. This way, the Times can be used in a smaller point size while remaining legible, thus being more 'economical' than the Garamond. First impressions can also be confusing!

This text shows how individual letters function in the whole and also how small differences can have big consequences. There are other factors besides the form of a letter that play a part in this, such as the spacing between letters and words, x-height and the width of a letter. The text block also shows how 'economical' a letter is in terms of space, but also how legible it is in this size.

This text shows how individual letters function in the whole and also how small differences can have big consequences. There are other factors besides the form of a letter that play a part in this, such as the spacing between letters and words, x-height and the width of a letter. The text block also shows how 'economical' a letter is in terms of space, but also how legible it is in this size.

This text shows how individual letters function in the whole and also how small differences can have big consequences. There are other factors besides the form of a letter that play a part in this, such as the spacing between letters and words, x-height and the width of a letter. The text block also shows how 'economical' a letter is in terms of space, but also how legible it is in this size.

This text shows how individual letters function in the whole and also how small differences can have big con-sequences. There are other factors besides the form of a letter that play a part in this, such as the spacing be-tween letters and words, x-height and the width of a let-ter. The text block also shows how 'economical' a letter is in terms of space, but also how legible it is in this size.

This text shows how individual letters function in the whole and also how small differences can have big consequences. There are other factors besides the form of a letter that play a part in this, such as the spacing between letters and words, x-height and the width of a letter. The text block also shows how 'eco-nomical' a letter is in terms of space, but also how legible it is in this size.

This text shows how individual letters function in the whole and also how small differences can have big consequences. There are other factors besides the form of a letter that play a part in this, such as the spacing between letters and words, x-height and the width of a letter. The text block also shows how 'economical' a letter is in terms of space, but also how legible it is in this size.

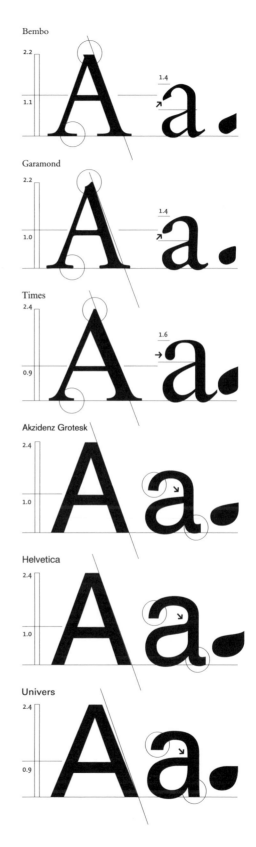

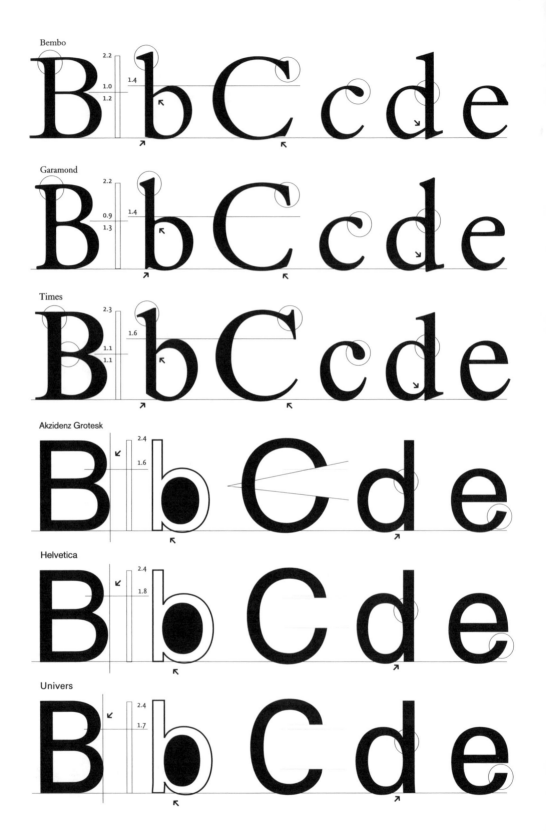

Bembo

2.2
1.0
1.2
1.4

Garamond

2.2
0.9
1.3
1.4

Times

2.3
1.1
1.1
1.6

Akzidenz Grotesk

2.4
1.6

Helvetica

2.4
1.8

Univers

2.4
1.7

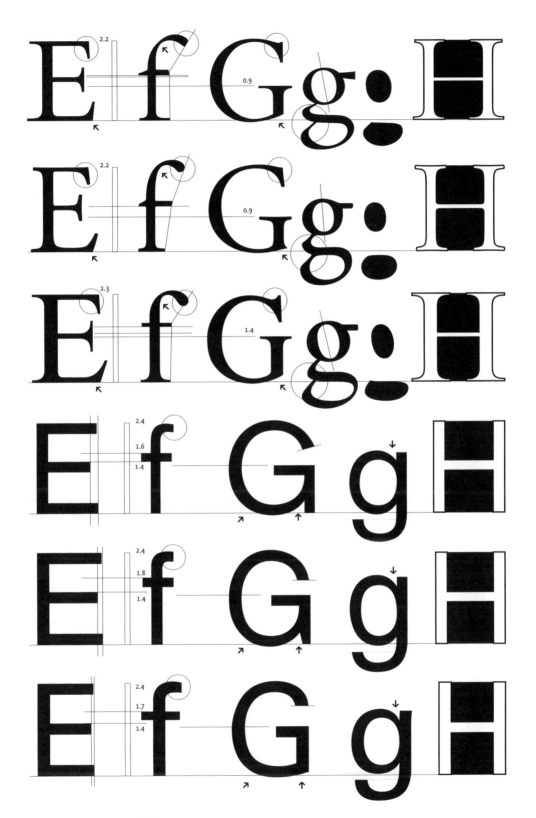

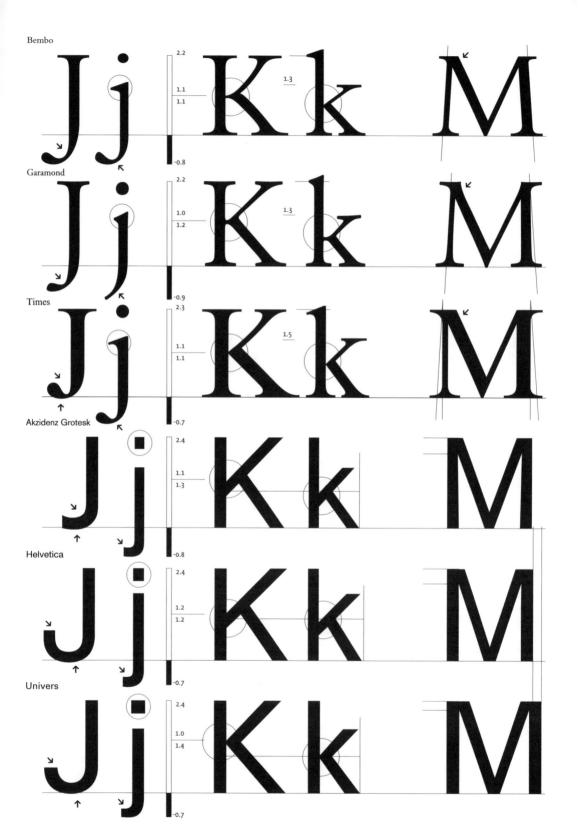

Bembo

Garamond

Times

Akzidenz Grotesk

Helvetica

Univers

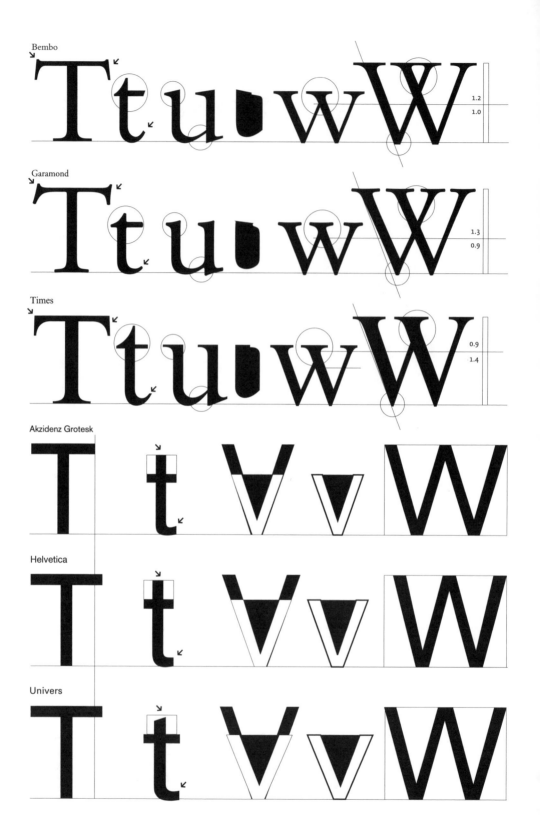

Bembo

Garamond

Times

Akzidenz Grotesk

Helvetica

Univers

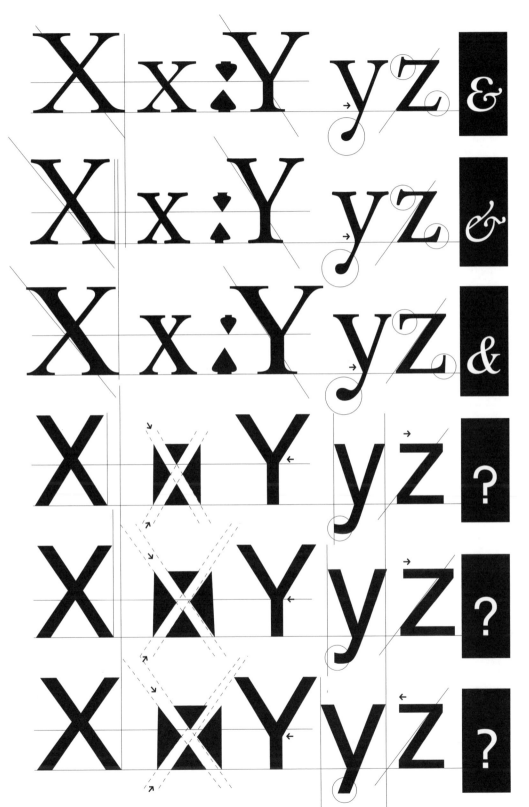

The anatomy of the letter

The skill of a type designer lies in the art of subtlety. A smidgen extra stroke thickness can result in a completely different impression of the heaviness of a body of text. Poorly designed letters can appear as blemishes in the text. Letter shapes that have been used for centuries cannot simply be altered without it having a result on the complete picture. And we have not yet mentioned the habituation – or actually the conditioning – of the letter. In the past, radical changes in typography (in newspapers, for example) provoked some very serious reactions from the readers. The designer of typefaces intended for use as body types should be aware of this and should design right down to the finest details in form and counter form, in the black letter and the white space around it.

The design process In this chapter we will investigate the margins available to the designer and study the form of the letter in detail. The number of different typefaces currently available is thought to be around 50,000 to 60,000. Is it then really necessary to design even more new types? Well, the same question could also be asked about the design of a new chair or a new musical composition. The times in which we live will always play a part in this process by applying different demands and awakening new expectations. The desire for innovation and change is always present.

The first steps towards creating a new typeface are the first characters to be designed. Testing these letters in the form of a word can be done using a word such as 'Hamburgefonstiv' which includes several crucial characters, or by using the sentence 'The quick brown fox jumps over the lazy dog' which contains all 26 characters of the alphabet. When the first word has been formed, the mutual relationships have been assessed and the characters altered where necessary, all the characters of the alphabet can then be made. This includes not only the alphabetic letters but also the figures, punctuation marks, symbols, ligatures and, if required, small capitals.

The text below is a standard sentence which includes all the characters of the alphabet. The type manufacturer Berthold had its own version beginning with its name. The text here is set at 16 pt in ATF Copperplate Gothic, Adobe Garamond and Berthold Akzidenz Grotesk.

THE QUICK BROWN FOX JUMPS OVER THE LAZY DOG

The quick brown fox jumps over the lazy dog

Berthold's quick brown fox jumps over the lazy dog

abc abc abc abc

Example of the grey tone of a body of text. The font size in this case is 5 pt and the line spacing is 7 pt. It is, of course, not meant as a reading text but the grey tone of the text can be easily compared to the other examples. The typeface used is the TheSans, and in this case the 2-ExtraLight style.

Example of the grey tone of a body of text. The font size in this case is 5 pt and the line spacing is 7 pt. It is, of course, not meant as a reading text but the grey tone of the text can be easily compared to the other examples. The typeface used is the TheSans, and in this case the 3-Light style.

Example of the grey tone of a body of text. The font size in this case is 5 pt and the line spacing is 7 pt. It is, of course, not meant as a reading text but the grey tone of the text can be easily compared to the other examples. The typeface used is the TheSans, and in this case the 4-SemiLight style.

Example of the grey tone of a body of text. The font size in this case is 5 pt and the line spacing is 7 pt. It is, of course, not meant as a reading text but the grey tone of the text can be easily compared to the other examples. The typeface used is the TheSans, and in this case the 5-Regular style.

The first capitals The Roman inscriptional capitals, the mother of all western capital or majuscule scripts (see also the chapter 'The Roman and the Roman Empire'), have a geometric construction with a square base. This is logical as these characters were originally carved in stone. The shapes were first painted on the stone. Compasses, triangle and ruler were probably the tools used. This can clearly be seen in the construction of the letters on Trajan's Column in Rome.

The examples shown above illustrate that a slight variation in the thickness of the line can have a great impact on the grey tone of a body of text. These examples also show that the TheSans has the same width in all styles.

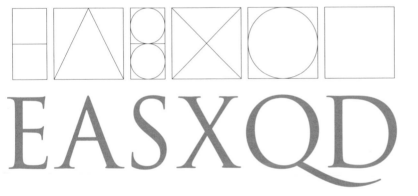

The Adobe Trajan shown above, which was designed by Carol Twombly and is based on the inscriptions on Trajan's Column, shows the geometrical construction method used to draw on the stone before the cutting began.

This simple geometric grid used by the stonemasons formed the basis for fourteen square-shaped characters: A, C, D, G, H, K, N, O, Q, T, V, X, Y and Z. Seven characters were based on the width of half a square: B, E, F, L, P, R and S. The letters 'I' and 'M' fall outside this system, but the 'M' is actually formed from a 'V' with added stems and the 'I' is a stem with serifs. The letters 'J', 'U' and 'W' were added to our alphabet later and as such there are no Roman examples of these. When used in text, the narrower letters appear heavier than the wider ones. The wider characters require more letter spacing. There are therefore a number of practical drawbacks to using the Roman inscriptional capitals as body text letters. Its square-based construction makes it impossible to create a narrower or wider version of the letters. These limited possibilities for extending the typeface were the reason that other typefaces were gradually designed in which the width of different characters became more uniform.

ESM
ESM
ESM

Three letters are shown to the left. This illustration functions as a quick reference from the beginnings of western type design, with Imperial Roman capitals (Trajan), via Bodoni (here the Classico by Franko Luin) and then to Linotype Compatil Exquisit; a journey spanning almost 2000 years of (seriffed) type design.

L'histoire se répète With the invention of printing presses and the subsequent growth in the production of printed material, a uniform grey tone within a body of text and optimal legibility became more and more important. Type designers as well as printers – who certainly in the early days were responsible for good typography – became more aware of the details of type. There followed a centuries-long continual stream of new typefaces onto the market. The turning point in this development came in the 1950's with the arrival of the sans-serif Helvetica, stamped as cold and business-like, in which the width of the characters is relatively uniform. The text is greyer than grey and designers, with a common feeling of uneasiness, began searching for more expression in form and counter form between the white of the page and the black of the letter. The more specific uses of type also became more important, such as signposting for which Helvetica with its uniform characters was less suited. Frutiger, designed by Adrian Frutiger as signposting letter for Roissy airport (later Charles de Gaulle) near Paris, as well as Syntax and Gill Sans are considered textbook examples for young designers. As such, a great many humanistic sans-serifs have been made that contain many similarities in form with the Imperial Roman capitals.

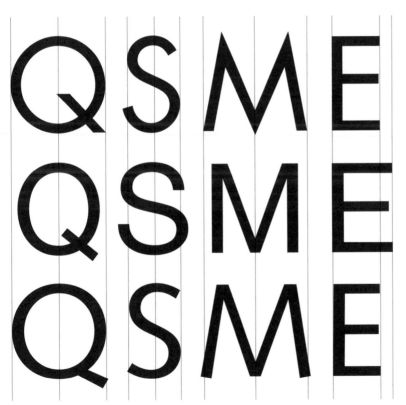

The three sans-serif typefaces shown here represent different design styles. Seriffed types have undergone a clear process of evolution over time. Sans-serif typefaces have developed at a quicker rate. In less than fifty years, the designers have followed the style periods of the serif-fed types. From the Bauhaus period comes the Futura that, just like the Capitalis Monumentalis, is constructed with a square basis. The curves seem more closely related to a circle. The middle example, the famous Helvetica, represents modernism, the corporate world and the search for perfection, the attempt to achieve the ultimate legibility and an even grey tone in a body of text. And finally the Syntax by Hans Eduard Meier, as a reaction to this corporate look. Almost at the same time, Adrian Frutiger designed the Frutiger. As a humanistic sans-serif, the Syntax has been used as a model for many subsequent designs such as the Meta by Erik Spiekermann.

The lowercase letter Lowercase letters did not exist in Roman times. There is therefore no historical reference for these small letters such as there is for the capitals. The handwritten, vertical square capitals and the rustic capitals written with a slanting quill were the starting points for the development of the uncial, the half uncial and the Carolingian minuscule.

The uncial has strong resemblances to handwritten capitals but the Carolingian minuscule contains many similarities to our lowercase letters. From this humanistic sans-serif came the first Venetian printing types. Digital typefaces made from these examples are the Jenson Classico and the Monotype Centaur.

Lasciate Ogni Speranza
Monotype Centaur 34 pt (Humanistic)

Lasciate Ogni Speranza
Monotype Baskerville 34 pt (Transitional)

Lasciate Ogni Speranza
LF TheSerif 34 pt (Slab-serif)

Lasciate Ogni Speranza
Linotype Trade Gothic 34 pt (Benton sans-serif)

Lasciate Ogni Speranza
Linotype Univers 55 34 pt (Neoclassical sans-serif)

Lasciate Ogni Speranza
LF TheSans 34 pt (Humanistic sans-serif)

The examples shown above illustrate that capitals are mostly heavier than lowercase letters. They also show that the x-height of sans-serifs is usually larger than in serif letters. Of course there is an exception to every rule. The weight of the capitals and lowercase letters in TheSerif and the TheSans is as good as equal.

Lowercase letters are generally drawn slightly thinner than capitals. The most likely reason for this is that it results in the initial capital of a sentence being more distinct. Some are of the opinion that it is a visual correction for the slightly heavier result of metal typesetting. Lowercase letters are therefore made slightly wider by the rounder and more closed forms. The difference in boldness is greater with the Monotype Baskerville than with many other typefaces. This difference in boldness can also often be seen in sans-serif typefaces. The examples above clearly show the differences in size of the same body size of different typefaces. Univers has a much larger appearance than Trade Gothic. The Regular style of each typeface has been used. The standard boldness within this style also differs greatly.

Classification according to form and construction Depending on their form and construction, the 26 characters of the alphabet can be arranged into groups, whereby a distinction is made between a group for the capitals and a group for lowercase letters.

Capitals

Construction	Shape Round	Rectangular	Round-rectang.	Diagonal	Diag.-rectang.
Two-storied	G S	E F H	B P R	X	K Y
Open sides	C	L T		X	K Z Y
Wide				W	M
Medium	O Q G S	E F L H T	B P R D U	V A X	N K Z Y
Narrow		I	J		

Lowercase

Construction	Shape Round	Round-vertical	Round-diag.	Diagonal	Vertical
With ascenders		b d f t		k	h l
With descenders	g	j p q		y	
Wide				w	m
Medium	c e o g	b d p q	a s	v y x k z	n h u
Narrow		j f t			i l r

The word most often used to test new typeface designs is Hamburgefonstiv. A number of basic shapes and constructions used for the 26 letters of the alphabet appear in this word. Other words used are Hamburgefons, Hamburgevios, Hamburgefonstives, Handgloves and the favourite of Frenchman Jean François Porchez: Hampurgefonstiv (because he prefers an extra letter with a descender).

Hamburgefonstiv
Monotype Gill Sans (Eric Gill)

Hampurgefonstiv
FontFont Angie (J.F. Porchez)

Handgloves
Dolly (Underware)

HHH

The left hand 'H' has the cross-bar placed under the mid-line, with the middle 'H' it is placed exactly in the middle and on the right it is placed slightly above the middle. The right hand version is visually correct.

What you measure is not what you see As can be seen on the previous page, many different forms and constructions must be taken into account when designing a new type. As a result of the great many different characters that should work in harmony together on a text page, several rules have been developed over hundreds of years, which can be seen back in almost every typeface. An important visual correction is the extrusion of curved (and protruding) forms past the baseline and top line. This also applies to vertical alignment between curved and straight forms.

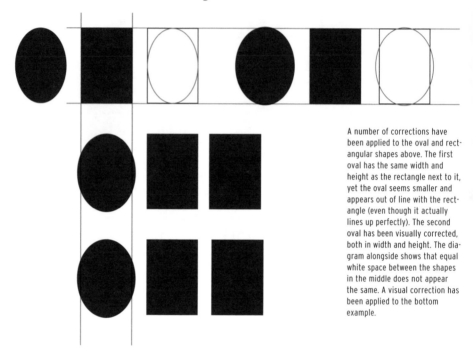

A number of corrections have been applied to the oval and rectangular shapes above. The first oval has the same width and height as the rectangle next to it, yet the oval seems smaller and appears out of line with the rectangle (even though it actually lines up perfectly). The second oval has been visually corrected, both in width and height. The diagram alongside shows that equal white space between the shapes in the middle does not appear the same. A visual correction has been applied to the bottom example.

A visual correction is also needed for the distance between letters. It is not possible to simply place letters next to each other with equal spacing between them. The letters must be altered to a uniform 'visual' white space. This means that the white space between the letters should appear the same. The form of the letter plays a role here. The test word 'minimum', which contains only straight elements, is a good starting point. Words should have a fluid formation and not look like a collection of separate letters. The letters must also not be placed too close together. On the next pages it will become clear that the white space in and around the letter is just as important as the letter itself. Or, as Dutch type designer Fred Smeijers wrote in his book *Counterpunch*: 'The white shapes form the background, the black the foreground. The background determines the foreground and vice versa. Change one and the other also changes. It is a balance between black and white.'

Both lines are of equal thickness and length, yet the horizontal bar appears thicker. A 'visual' correction is also required here in type design. A good example is the letter 'H'.

The 'H' and the 'G' of Monotype Baskerville. The stems of the 'H' are lighter than the curve of the 'G'. A visual correction has also been applied here.

minimum
minimum
minimum
minimum
minimum

The word 'minimum' appears above in Avenir by Adrian Frutiger. The letter spacing is uniform because all the letters are vertically defined. It is a good way to determine an acceptable amount of letter spacing in the early stages of a new design, which can subsequently be applied to the less clearly defined letters. In the trade this is called 'fitting' the type.

Important in the design of (body) type is to introduce a level of order to bring the apparent chaos of form and counter form into balance, so that the reader can focus undisturbed on the content of the text. In practice, a whole arsenal of visual corrections is applied to a typeface in order to avoid unwanted visual phenomenon.

As can be seen with Antique Olive by Roger Excoffon below, breaking the rules can also create a useable typeface. Antique Olive is a letter that is extremely legible and which in its time was very popular. It is a letter that provokes passionate reactions. You either love it or you hate it. That it has an extremely large x-height can be seen here when we set the text using the same point size but switch to Antique Olive: **Antique Olive**.

The capital 'S' has an upside-down appearance, the large x-height results in a squashed cross stroke of the 'f' and the curves of the 'o' and 'e' are somewhat top-heavy. This design challenges almost all the rules of visual correction.

The Nord style was first designed around 1956 for a poster and the Air France logo. Antique Olive was subsequently extended by a commission from the typefoundry Fonderie Olive to compete with Helvetica and Univers.

Antique Olive

This illustration shows how top heavy some of the letters of Antique Olive are. The cross bar of the 'T' is exactly as thick as the stem. The extremely large x-height results in short ascenders and descenders. The cross bar of the 'f' has been moved down due to lack of space.

ABCDEFGHIJKLMNOPQRSTUVWXYZ1234567890
abcdefghijklmnopqrstuvwxyz
Antique Olive Nord – AIR FRANCE

The first letters As well as the H, O, n, l, o and p, Dutch type designer Gerard Unger also likes to include the R, a and g in his first design sketches. As such, each type designer has their own way of working toward the creation of a new typeface.

Alongside this unique working method, there are also a number of facts to take into account during the design process. A square appears to be square only if it is drawn 1% wider and the same is true for circular forms. To make a circular form appear the same size as a square, it should extend an extra 2% to 3% on each side. The point of a triangle appears to line up with a square only if it extends 3% further. These are of course just indications. The definite measurements are completely dependant on the design and the designer's eye. The left-slanting axis and the thick-thin contrast originate from the days of handwriting. The so-called scribes used quills with a broad nib. Holding this at an angle of 30–45 degrees created a slanting axis and the differences in contrast within the letter. When the printed letter replaced handwriting, this axis became more vertical. On the following pages, characters from different typefaces are compared to illustrate the differences and to show how letters are constructed.

The Monotype Perpetua shown below is a Transitional in Vox+. It has an almost vertical to vertical axis. The lowercase letters are slightly thinner than the capitals and the capitals have a greater thick-thin contrast.

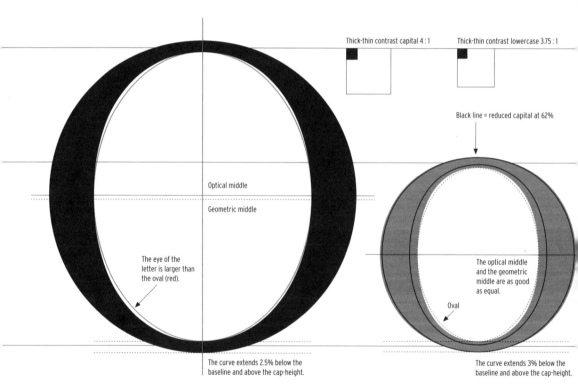

Thick-thin contrast capital 4 : 1

Thick-thin contrast lowercase 3.75 : 1

Black line = reduced capital at 62%

Optical middle

Geometric middle

The eye of the letter is larger than the oval (red).

The optical middle and the geometric middle are as good as equal.

Oval

The curve extends 2.5% below the baseline and above the cap-height.

The curve extends 3% below the baseline and above the cap-height.

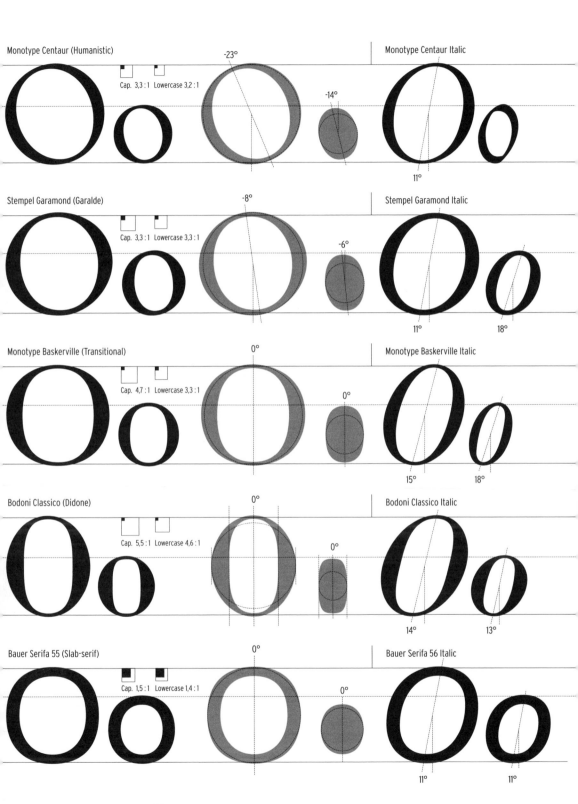

Monotype Centaur (Humanistic)

Cap. 3,3 : 1 Lowercase 3,2 : 1

-23°

-14°

Monotype Centaur Italic

11°

Stempel Garamond (Garalde)

Cap. 3,3 : 1 Lowercase 3,3 : 1

-8°

-6°

Stempel Garamond Italic

11° 18°

Monotype Baskerville (Transitional)

Cap. 4,7 : 1 Lowercase 3,3 : 1

0°

0°

Monotype Baskerville Italic

15° 18°

Bodoni Classico (Didone)

Cap. 5,5 : 1 Lowercase 4,6 : 1

0°

0°

Bodoni Classico Italic

14° 13°

Bauer Serifa 55 (Slab-serif)

Cap. 1,5 : 1 Lowercase 1,4 : 1

0°

0°

Bauer Serifa 56 Italic

11° 11°

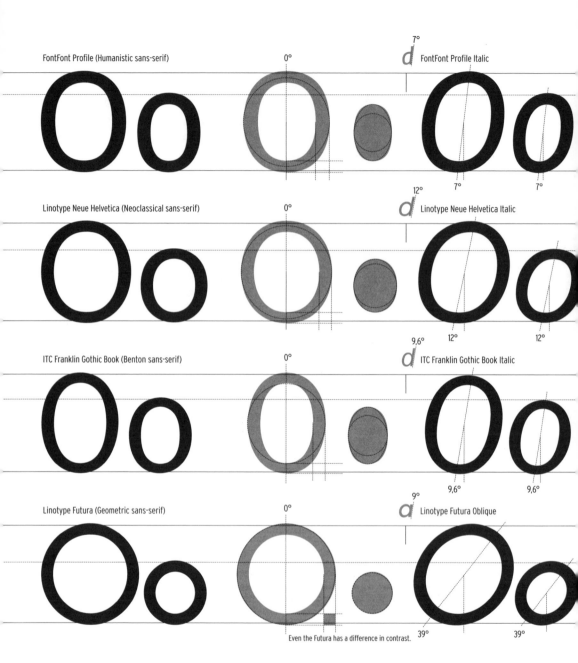

FontFont Profile (Humanistic sans-serif) 0° *d* FontFont Profile Italic

7° 7° 7°

Linotype Neue Helvetica (Neoclassical sans-serif) 0° *d* Linotype Neue Helvetica Italic

12° 12° 12°

ITC Franklin Gothic Book (Benton sans-serif) 0° *d* ITC Franklin Gothic Book Italic

9,6° 9,6° 9,6°

Linotype Futura (Geometric sans-serif) 0° *a* Linotype Futura Oblique

Even the Futura has a difference in contrast. 39° 39°

The letter 'O' This letter appears simple in construction. Looking at Futura, this could quite easily be true, but even the construction of this version is not exactly geometric. The circles and ovals have been visually corrected in the 'corners' and curves.

An enormous number of subtle variations can be made to the form of the 'O'. The construction of the curves should be completed very carefully. A number of visual corrections must be taken into account with the curves. If the form is constructed from a rectangle and semi-circles, such as is more or less the case with the counter of this Bodini, a so-called bone effect can occur. This gives the impression that the left and right sides of the rectangle curve to the inside and that the middle is slightly hollow, just like a bone that is thinner in the middle. This same form of visual illusion is generally also applicable to similar forms in type design.

Bauer Bodoni (Didone) URW Firmin (Didone)

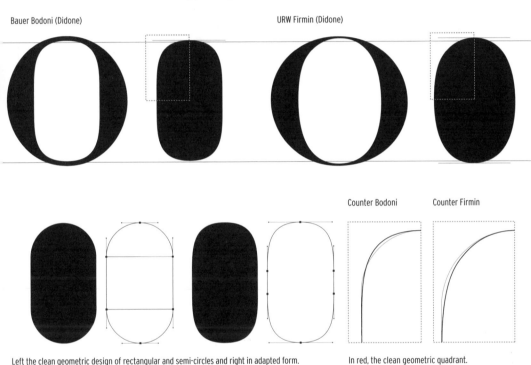

Counter Bodoni Counter Firmin

Left the clean geometric design of rectangular and semi-circles and right in adapted form. In red, the clean geometric quadrant.

Rounded left and right sides of the counter of a letter minimise the bone effect. As is shown above, it remains visible in this Bodoni, but the rounded outer form of the letter provides visual compensation. Firmin (an allusion to the punchcutter Firmin Didot) is actually more balanced in form but is also much wider. A visual correction can be quite extreme without being conspicuous, as is the case here with the counter of the Firmin 'O', which extends below the baseline and above the x-height. The design of the lowercase 'o', more specifically the thickness of the curve, defines the maximal thickness of the curved parts of the other characters in the typeface. It is defining for curves, arches and bowls.

ElE ElE

It seems like the letter 'l' is formed from the stem of the 'E'. This is not usually the case. Above left is the Rockwell and right is the Perpetua.

The letter 'l' Just as the letter 'o' is defining in the form of the curves in a type design, so is the lowercase 'l' defining in the thickness of the stem. Just as with the curves, it does not follow that everything with a similar form is equal in thickness, but it is a starting point for similar forms.

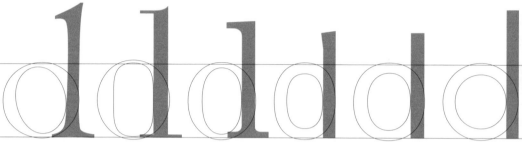

Monotype Centaur
(Humanistic)

Bauer Bodoni
(Didone)

LT Century Schoolbook
(Slab-serif)

FontFont Profile
(Humanistic sans-serif)

Linotype Univers
(Neoclassical sans-serif)

Linotype Futura
(Geometric sans-serif)

The examples above show that there are numerous options for the design of the top serif of the ascender and the proportions of the x-height. The letter 'l' forms the basis for many letters, making the design of this letter very important for the overall look of a typeface.

The letters 'c' and 'e' When the proportions, contrast, maximal curve thickness and thickness of the stem have been defined, the related forms can then be designed. The logical steps from the 'o' are the 'c' and 'e'. These letters, because of the openings at the side, should be drawn narrower. The heavy upper half of the 'e' is in some typefaces, such as Centaur, Baskerville and Garamond, counterbalanced by applying a stronger emphasis to the bottom of the curve. The straight, classical character of Bodoni also serves as an example here. The upper counter, the closed space within the 'e', can be drawn almost symmetrically, but this is not normally the case. The overlapping illustrations below show that each shape has its own elements used to bring the individual letter into balance while ensuring the form of the letter is in keeping with the whole typeface.

Monotype Centaur
(Humanistic)

Bauer Bodoni
(Didone)

Linotype Century Schoolbook
(Slab-serif)

FontFont Profile
(Humanistic sans-serif)

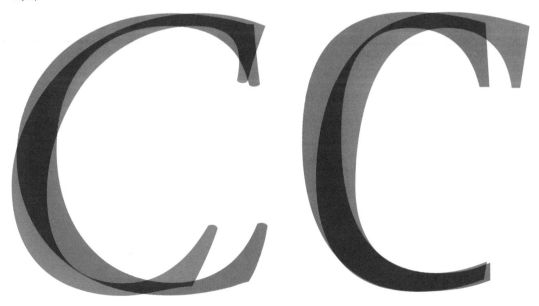

The terminals of the 'c' are the most varied in shape, ranging from the clearly visible form of an old-fashioned pen stroke to the clean lines of a teardrop shape. From left to right: Centaur, Garamond, Baskerville, Bodoni, Glypha, Angie and Lucida Sans.

ee
ee

Above the lowercase 'e' of Stempel Garamond and of Gill Sans in regular and italic. Below: the capital 'C' in italic and regular superimposed. Left: Stempel Garamond with an italic that is visibly different from the roman, and right: Rotis whereby the roman is similar in appearance to an italic as it leans forwards slightly.

The lower terminal of the 'c' is different in almost every typeface. As a guide-line for the maximum thickness of the terminal, it should never be larger than the maximum thickness of the curve in the letter, whether it has a square or droplet form. The heavy tip of the curve has the function of reducing the appearance of the large inner space of the 'c' so that it better fits in with the other letters and gives a more neutral grey tone. The capital 'C' is similar to the lowercase version but is drawn slightly slimmer.

The lowercase 'e' does not have serifs and its basic form is in principle the same for seriffed and sans-serif types. The variations can be found in the thick-thin contrast, in the form of the counter and the cross bar. The position of the cross bar can vary from approximately the middle to very high, which in turn results in a smaller upper counter. As shown here to the left, the italic version, especially with serif typefaces, often stems from the origins of this style, namely handwriting. Of course characteristics are included to create clear similarities in form between roman and italic. Just as in the early days when italics were designed and used as efficient types, the cursive is usually narrower than the roman.

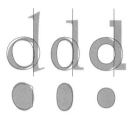

In Centaur (left), the counter of the letter 'd' is flattened against the stem. With Century Schoolbook (middle) the counter seems almost the same as the 'o' (grey shape below). In Memphis Bold (right) they are the same. In the latter, the counter cuts into the stem.

In the overview below, the characters appear to be mirror images of each other. Wrong! With Bodoni it seems as if two letters have been merged into one, while with the Joanna each letter has its own characteristic shape.

Rounded letters with a stem Four letters of the alphabet – the 'd', 'p', 'b' and 'q' – appear quite simply to be a blend of the 'o' with a vertical stem. The 'p' looks looks like a rotated version of the 'd' and likewise the 'q' a rotated 'b'. But this could not be more wrong. Even the most geometric typefaces contain subtle differences. The greatest differences can be seen in the seriffed types. The design challenge with these letters is in the connection between the curve and the stem. Depending on the typeface, triangular notches may appear in the letter, which must not fill with ink when printed at very small sizes. This is why notches are sometimes made deeper than is aesthetically desirable. Alternatively, attempts can be made to avoid these notches during the design phase by creating a right-angled connection between the curve and the stem, as can be seen in a number of typefaces. Similarly, a counter may have a flat side where it meets the stem yet still remain curved in shape. In this case the straight line of the stem must remain visible and the curve should not visually intrude too far into the stem. In heavier styles, the more generous forms make visible compromises necessary.

Bone effect

Centaur 100 pt Baskerville 90 pt Bodoni 91 pt Joanna 88 pt Rockwell 76 pt News Gothic 65 pt Univers 72 pt Futura 77 pt

Middle

ABCDEFGHIJKLMNOPQRSTUVWXYZ
abcdefghijklmnopqrstuvwxyz
ABCDEFGHIJKLMNOPQRSTUVWXYZ
abcdefghijklmnopqrstuvwxyz

ITC Galliard Roman and Italic

Galliard has a very pronounced italic. This typeface is an adaptation of designs by Robert Granjon from the sixteenth century. At that time it was normal that the roman and the italic were two completely different typefaces and not made from the same basic design. The italics of Baskerville, Bodoni and Joanna are shown below.

dpdq

dpdq

dpdq

The capital 'D' can roughly be seen as a combination of the forms of the capital 'E' and 'O'. In order to visually bring the letter 'D' in balance with the 'O', it is drawn slightly narrower so that the counter of the letter appears of equal size. Although relatively simple shapes, different typefaces show the great many ways in which the curve can be joined with the stem. The capital 'B' also shares little in common with its lowercase letter but just as the 'D' is formed from a combination of the 'E' and the 'O'. The slant of the axis in the curves follows the 'O', just like the 'D'. The letters 'P' and 'R' follow the shape of the 'B' whereby, as is so often the case, visual corrections are applied. It is clear that the letter 'Q' is an 'O' with a tail, yet here too we often see surprising differences in shape. As shown in the diagram above, slight differences can be made to the shape of the curve. In general terms, the same characteristics apply to sans-serif types, although the low contrast often requires alterations to the point of intersection of curve and stem. Italic letters are sometimes narrower than the romans they accompany and here too the possibilities are endless.

- 105

Letters with 'legs' There are four letters which are directly related to each other because they all stem from one letter: the 'n'. These are the letters 'n', 'h', 'm' and 'u'. The letter 'r' can also be included in this group because it, perhaps a little generalised, can be seen as a cut-off 'n', in the case of the sans-serifs at least. In seriffed types a so-called 'spur' is added. The terminal may have various forms, as in the 'c'. The reason for this is that the 'r' has an uneven distribution of white space, which can disrupt the flow of a body of text, so the terminal has to be designed to avoid a gap. As already mentioned, the type designer attempts to give each letter an equal grey tone. In the bottom right diagram the 'r' has a large white space. In order to limit this effect the letter is designed as narrow as possible and, in the case of the sans-serif letter, the shape of the curve is made heavier and with the seriffed letter the curve is given a characteristically heavy terminal which is also applied to other letters such as the 'j', 'a', 'c', 'f', 'g' and 'y'. In this way there is uniformity in the typeface as a whole.

In Centennial shown below, the counter space of the 'n' and 'h' have the same shape. This is also true for the width and the curve of the 'u', but then rotated. Those of the 'm' are narrower.

jacfgry

Emigre Filosofia

nhmur

Just like the letters shown on the previous pages with a stem and curve, the 'd', 'p', 'b' and 'q', the letters with 'legs' discussed here also contain a notch at the point where the curve meets the stem. The notch can be made more pronounced in order to limit the effects of ink spread during the printing process. As mentioned earlier, the 'n' is the starting point in the design of these letters. Firstly the optical grey tone and the white space within the curve of the 'n' are usually fine-tuned to fit in with the 'o'. Then the letter 'h' is sometimes made slightly wider and is given an extended stem with an upper serif that is similar to that of the 'b' and 'l'. Conversely, the legs of the letter 'm' may be drawn closer together than with the 'n' so that the final width of the letter remains in balance and to ensure that it fits well into a body of text. The letter 'u' could be seen as a rotated version of the 'n' whereby the serifs are similar in character to the serif on the ascender of the 'h'. The similarities between the 'n' and 'u' are more apparent with sans-serif typefaces, whereby the 'u' is often literally a rotated 'n', as is shown in the Adobe Myriad at the top of the right-hand page.

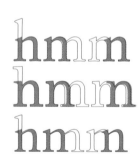

This diagram, showing respectively Stempel Garamond, Linotype New Century Schoolbook and Monotype Bembo, illustrates the significantly different visual choices made.

nubmmmp

The Myriad (above) is a clear example of how the uniformity of sans-serif type-faces is greater than seriffed types. As such, the width of the 'n' is equal to the width of the 'h' and the 'u' is slightly narrower. There are also minimal differences in the notches. The terminal of the 'r' is heavier. The sans-serif letter 'r' is generally also slightly narrower than with seriffed types. The second notch of the 'm' is set deeper than the first. The capitals 'N', 'U', 'H' and 'M' contain fewer similarities in shape than the lowercase letters. The capital 'R' is discussed on page 105 as it contains more similarities with the 'B' and the 'P'.

nhmur

NUHM nuhmr

NUHM nuhmr

NUHM nuhmr

NUHM nuhmr

Linotype Compatil is a perfect typeface for annual reports and fits into the relatively new trend of using a single basic shape to design typefaces that fit into different classification groups. Compatil is one of the most extended examples with four variants. As shown here, they are designed with the same width and one can replace the other without disrupting the length of the text. From top to bottom: Compatil Fact, Letter, Text and Exquisit.

The capitals of the lowercase letters shown on the previous two pages are very angular. The influences of Roman inscriptions are clearly visible here. The letter 'N' combines two vertical stems with a diagonal. The most significant difference to other two-stemmed letters is that the stems are both thinner, while in most other cases a thick and a thin stem are combined. Sometimes the two triangular shapes of the 'N' are of equal size and sometimes the lower of the two is larger than the upper.

Characteristic features are two thin stems and the diagonal. In more classical typefaces, the 'N' and the 'O' are drawn inside the square, just as with Roman inscriptions.

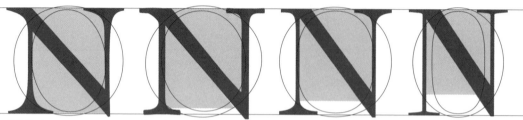

ITC Galliard Stempel Garamond Monotype Baskerville Bodoni Classico

A number of letter shapes have similarities with the letter 'V', which has been rotated and placed over the 'A' shown below. The 'V' should theoretically be drawn slightly narrower than the 'A' because the bar makes the counter smaller, but this is not always the case as can be seen in the diagram.

The letter 'U' did not exist in Roman times and was later added to our alphabet. Its rounded shape is influenced by the handwritten uncial and half uncial. The 'U' stems from the Roman 'V' which represented the u-sound. As such the 'V' changed from vowel to consonant and the 'U' took on the role of a vowel. In contrast to the 'N', the stems of the 'U' are of differing thickness. The 'U' is usually equal in width to the 'V'. The 'W', as its English name 'double-u' and French name 'double-v' suggest, is actually a ligature of a double 'V'.

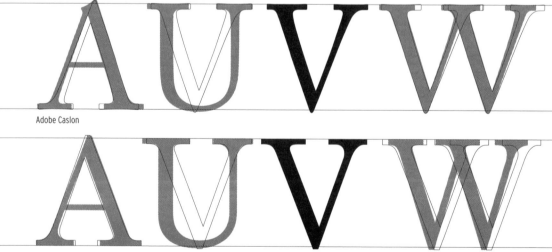

Adobe Caslon

Linotype Century Schoolbook

Although it appears as if an 'M' can be constructed with a little cut-and-paste work, subtle corrections are also required here. The apex of the 'V' often extends below the baseline and this is not necessary for the 'M'. The upper serifs of the 'M' are also different.

The 'M' is in principle a combination of a 'V' with a stem added on either side. The left stem is more slender than the right-hand one. They can be drawn vertical or with a slight slant. Slanting stems give the most classical form, stemming directly from ancient Greek inscriptions. A disadvantage is that the letter becomes wider. The 'M' is often just as wide as a particular font size (this is why a square of white that is as wide as the font size is also called em-quad). The 'Y' can be seen as a squashed 'V' placed on top of a stem (see pages 116/117).

Monotype Plantin Linotype Century Schoolbook Monotype Rockwell

With sans-serif types, the central bar of the 'E', 'F' and 'H' is often placed at the same height and is the same thickness, but a closer look shows that this is not always the case. With Quadraat Sans by designer Fred Smeijers, both the position and the thickness of the bar have been carefully designed. The slanting terminal of the lowercase 'I' extends above the capital height.

The 'H' has a number of soul mates, including the 'E' and the 'F', which also include a central cross bar. The 'I', 'L' and the 'T' can also be included here. As a design element, the 'H' is not a complicated letter: two stems of equal thickness with a cross bar. The bar is placed slightly higher than the centre in order to bring balance to the letter. The last letter shown below is the often-confused lowercase 'l', but slightly altered in form. The figure '1' can also be a source of confusion, especially with Gill Sans for which Monotype released 'Gill Alternative One' variant as a solution.

FF Quadraat Sans

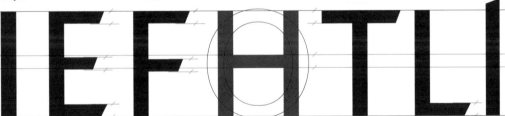

ITC News Gothic MT Gill Sans (the regular 'I' followed by the alternative version) Linotype Syntax

Linotype Bell Centennial Linotype Clarendon EF Swift

Three outsiders The 'a', 's' and 'g' are letters requiring a depth of knowledge and skill from the type designer. Not only to design them in line with the rest of the typeface but also because the curves must be balanced and fluent. While geometrically rounded shapes form a good basis for the design of the letters 'o', 'e' and 'c', these letters are more complicated than a simple circle. Designs elements similar to the other letters must be incorporated into these letters. The shoulders of the 'c' and 'a' can, for example, have essentially the same outer form and the terminal of the 'r' can provide reference points for the ear of the 'g'. The thick-thin contrast must also be in line with the rest of the typeface. These letters do not contain any elements that can be directly copied from other letters yet they must still fit in with the rest of the typeface and flow within a body of text. Useful sources of inspiration are the similar 'old' typefaces. This is also true for the 'g' which can be drawn using two different constructions: the two-storey version with a rounded base form with a loop underneath and the simplified form with a tail curving to the left underneath such as used in most italic types.

gg

The 'g' of the two typefaces used in this book to set the body text and captions respectively. The first is Profile and the second InterstatePlus. The first has the two-storey shape and the second is a simpler shape which stems from handwriting. The second is less likely to result in ink spread at (very) small font sizes.

Note also the similarities in the 'Hague' typefaces, TheSerif (Lucas de Groot) and Caecilia (Peter Matthias Noordzij).

a a
Monotype Centaur

a a
Stempel Garamond

a a
LF TheSerif

a a
Linotype PMN Caecilia

a a
FF Avance

a a
EF Swift

a a
Linotype Melior

a a
Monotype Rockwell

a a
Linotype Futura

The 'a' consists of a bowl and curves. The closed bowl is slightly higher than the middle of the letter. The connection of the bowl with the stem can be formed in many ways. The classic form, such as with the Centaur and the Garamond, is that the tear-shaped bowl joins the stem in a diagonal line. Other typefaces such as TheSans and Swift, consist of a bowl which joins the stem almost at a right angle. The tear-form is still visible in TheSans but gradually disappears with Swift. The bowl can in some cases, such as with Melior, appear almost rectangular. A third variety are the typefaces that have a kind of loop joined to the stem whereby notches are formed above and below the loop (Rockwell). The open curve of the 'a' is generally narrower than the closed bowl. The end point of the open curve can be a serif but can also be a sharp terminal such as is the case with many sans-serif types. An occasional typeface, such as Futura, uses an unusual 'a' in the roman style which is more commonly used in italics and extra bold styles. The capital 'A' is simply an inverted 'v' with a cross bar. The previous pages show how closely these shapes are related.

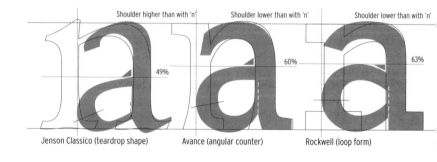

Shoulder higher than with 'n' Shoulder lower than with 'n' Shoulder lower than with 'n'

49% 60% 63%

Jenson Classico (teardrop shape) Avance (angular counter) Rockwell (loop form)

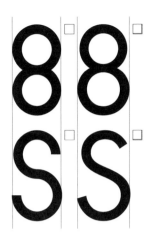

The 's' contains no straight lines. The roman can be drawn by starting with two circles, one above the other, the lower slightly larger than the upper. The letter therefore has a foundation and as such has better visual proportions. This can be compared to the crossbar of the 'H' and the 'E' which are placed slightly above the centre of the letter. Removing the lower right-hand quarter of the upper circle, and the upper left-hand quarter of the lower circle, creates a very simple 's' shape. Dragging the ends of the lines to the outside and creating a more fluent line in the centre creates the beginnings of a real 'S'. From this basic form, thick-thin contrast can be added and the serifs designed if required. Even Futura shows some contrast between thick and thin, shown in the contrast squares in the illustration to the right. The end points should not curl too far back towards the curves because this will have the effect of the 'S' visually resembling the figure 8, especially from a distance. The 's' has a tendency to lean forwards or backwards (see the illustration to the right). The form of the capital 'S' is an enlarged version of the lowercase letter. The capital is usually relatively lighter.

Above left are two identical circles, below left the lower circle is larger than the upper and a quarter of each circle removed. To the right the '8' and the 'S' of Futura. The squares show the difference between the thickest and the thinnest parts of the strokes.

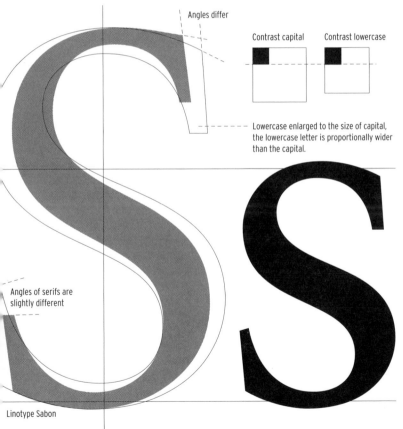

Angles differ

Contrast capital Contrast lowercase

Lowercase enlarged to the size of capital, the lowercase letter is proportionally wider than the capital.

Angles of serifs are slightly different

Linotype Sabon

Above is the 's' of Centaur (left) and Fournier (right). The Centaur 's' seems to slant to the right while the Fournier 's' tends to the left. In Centaur, the stroke of the pen is visible while Fournier is clearly more constructed. Left is the 'S' of Sabon, with narrower proportions than the lowercase version. This is not always the case. The lowercase 's' sometimes has the same proportions as the capital and is sometimes relatively wider. It is usually inherent to the design of the typeface and the designer's philosophy. The 's' of Didot, designed according to classical principles, is proportionally of equal width as the capital 'S' (not illustrated).

S S
Stempel Garamond

S S
Linotype PMN Caecilia

S S
EF Swift

S S
Linotype Melior

S S
Monotype Rockwell

Although the regular 's' is relatively easily constructed, the italic version requires rather more finesse to achieve balance in the curves and the blend of contrast. In Griffo (bottom left) the contrast of the italic is less, giving it a lighter appearance. Designer Peter Verheul calls the cursive version of his typeface Sheriff (bottom right) an italian because even he is of the opinion that the cursive version is not a true italic but also not an oblique. A real italic, in his opinion, is drawn with upstrokes as if it were written with a pen. An oblique on the other hand is always a slanted version of the roman. In general, the term 'italic' has a much wider interpretation. These differences can be seen in the examples shown to the left. The italic 's' of the Garamond has similarities in form to the roman but clearly has different serifs and was, like italics accompanying Venetian romans, actually added later to the regular version. Other italics, such as that of the Rockwell, are clearly slanting versions of the roman.

Sss Sss Sss

Omnibus Griffo Classico · Berthold Bodoni Antiqua · FontFont Sheriff

In contrast to the 's', the capital version of the 'G' and the lowercase version are constructed in completely different ways. The two-storey version of the 'g' is a beautiful and complicated construction. It consists of a small 'o' with an 'ear', and below this a loop which can be drawn either open or closed. The 'o' is a smaller version of the lowercase letter (approximately 60–70%).
The loop can vary widely in nature between different typefaces. As such, the relative proportions of the small 'o' and the loop can be large or small, the loop can be open or closed and it can be rounded or flat. The ear brings balance to the letter and is an essential design element. It compensates the hanging of the loop on the 'o' as a kind of balance organ. The simplified version of the 'g'

The capital 'G' appears to be family of the 'C' and the lowercase 'g', due to its wealth of shapes, is often called the most beautiful letter of the alphabet. Centaur contains traces of handwriting in the 'g', certainly in the italic. Baskerville has a more similar roman and italic but the italic is clearly narrower. Quay has a business-like 'g' and the width of the italic is similar to the roman.

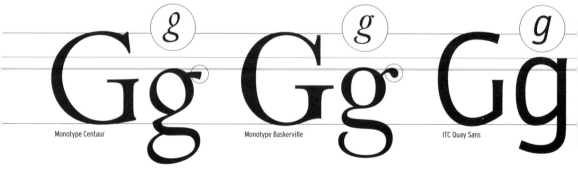

Gg Gg Gg

Monotype Centaur · Monotype Baskerville · ITC Quay Sans

The lowercase 'g' has many forms, but even more numerous are the differences in the italics. With Centaur and in general with the Venetian types, it is well known that the italic is a separate typeface which was later added to the roman. Joanna Italic looks like a completely different type when used in text and is extremely narrow. The italic Bodini is hard and classical and follows the roman as closely as possible. Eureka is a different case. Here the italic seems to revert back to the character of a Venetian type but actually remains quite true to the roman.

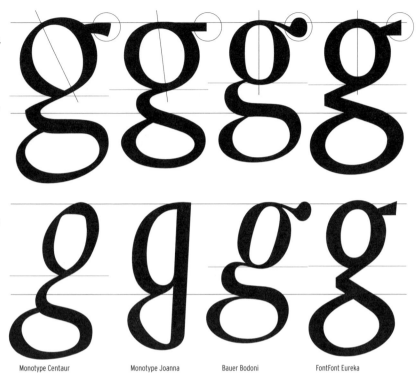

Monotype Centaur Monotype Joanna Bauer Bodoni FontFont Eureka

The 'C' fits closely with the 'G', although the widths and curves are fractionally different. The design of the vertical stroke and its spur can vary greatly between typefaces. The sans-serif types are the most simple. A slant has been used in Quadraat Sans.

which resembles a 'q' with a curved tail instead of a straight one, is closer in form to the group containing the 'd', 'p', 'b' and 'q'. This version of the 'g' is often used for the 'corporate' sans-serif typefaces (Helvetica, Univers), while the American grotesques (Franklin Gothic, News Gothic) and newer humanistic sans-serifs (Scala, Profile) mostly use the two-storey version. The simplest version of the 'g' stems from handwriting and is therefore mainly seen in italic styles, even when the roman style uses the two-storey version of the 'g'. The capital 'G' is closely related to the 'C'. The short vertical stroke of the 'G' usually has the same line thickness as the stem of the 'I'.

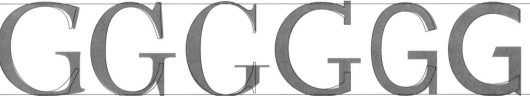

Monotype Guardi URW Century Schoolbook Bauer Bodoni FontFont Scala Linotype Trade Gothic FontFont Quadraat Sans

lijft

ITC New Baskerville shows that the top of the x-height is not always defining for the position of the cross strokes of the 'f' and 't'. It also shows that part of one letter may be repeated in another. The upper serifs of the first three letters, for example, as well as the descender of the 'j' which can be seen rotated 180 degrees as the curve of the 'f'. The ascender of the 't' is usually narrower, and therefore different, but contains similarities in form.

One-legged letters The 'l', 'i', 'j', 'f' and 't' are letters with a single stem. In terms of construction they are not generally very problematic. The 'i' is a shortened 'l' with a dot, the 'j' is an 'i' with a tail. The dots usually line up with the cap height, except when the typeface has a much smaller x-height in relation to the capital, in which case the dots are positioned lower. The dots are visually equal in width to the stem, which means that the total width of a circular, diamond-shaped or even square dot is actually larger. This helps with the positioning and size of the letter, especially if the letter has an upper serif. The descender of the 'j' can be simple and short or it can contain a flourish similar in form to the ear of the 'g' and the terminal of the 'r'. The 'f' could be a 'j' rotated 180 degrees with a cross bar, and this is actually the case with some typefaces. Other types use a clearly different curve and extension. The 'f' and the 't' also contain similarities. Both have a cross stroke which is usually placed at the x-height. Yet there are exceptions. The cross strokes of the 't' and the 'f' in New Baskerville (not Monotype Baskerville!) sink slightly lower than the x-height.

Different dots on the 'i'. From left to right: Akzidenz Grotesk, Futura, Priori Sans, Sauna, Quadraat Italic. All typefaces are set at 56 pt.

f ſ fl ſl ffl ſſl ff ſſ fi ſi ffi ſſi ft ſt fft tt

Ligatures of the DTL Fleischmann whereby more ligatures are available in the alternate style than simply the 'fi' and the 'fl'.
The red versions show the ligatures with a 'long-s', a classic representation of the lowercase 's'. The 'fü', 'fä' and 'fö' ligatures of the Fleischmann (not shown) are also especially clever.

Although so-called ligatures exist for numerous letter combinations, a few commonly used combinations such as the 'fi' and the 'fl' have been included in the standard keyboard of the Mac. These combinations of characters do not present a conflict with the sans-serif typeface used to set this text, but it is a different case with seriffed types. Here, the terminal of the 'f' can touch the dot of the 'i' causing an unattractive overlap. More ligatures are often included in alternate styles.

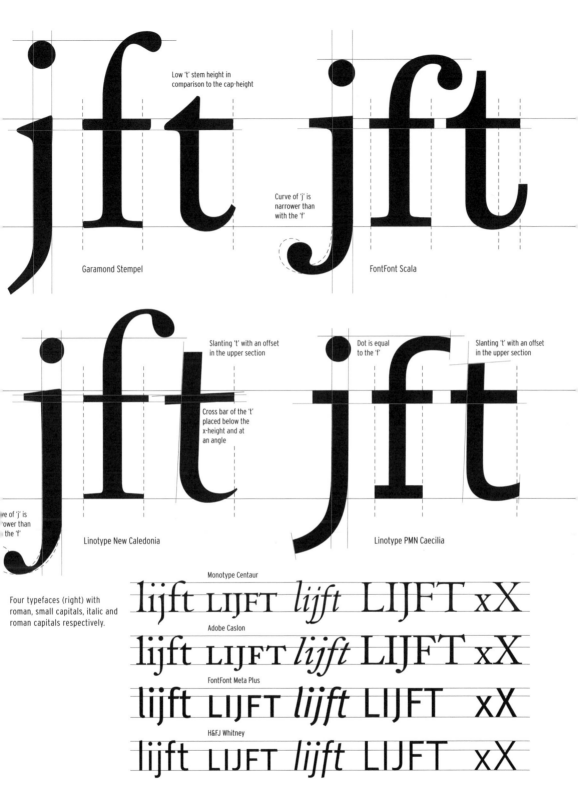

Low 't' stem height in comparison to the cap-height

Curve of 'j' is narrower than with the 'f'

Garamond Stempel

FontFont Scala

Slanting 't' with an offset in the upper section

Cross bar of the 't' placed below the x-height and at an angle

Dot is equal to the 'f'

Slanting 't' with an offset in the upper section

...ve of 'j' is ...ower than ...the 'f'

Linotype New Caledonia

Linotype PMN Caecilia

Four typefaces (right) with roman, small capitals, italic and roman capitals respectively.

Monotype Centaur

lijft LIJFT *lijft* LIJFT xX

Adobe Caslon

lijft LIJFT *lijft* LIJFT xX

FontFont Meta Plus

lijft LIJFT *lijft* LIJFT xX

H&FJ Whitney

lijft LIJFT *lijft* LIJFT xX

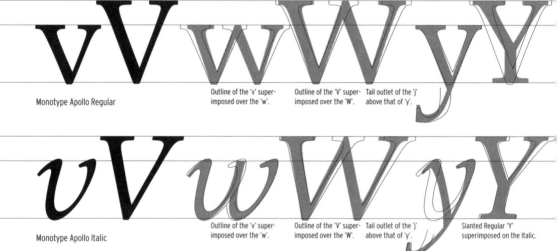

V-shaped letters It is clear to see that the forms of the 'w' and the 'y' share constructive similarities with the 'v'. The construction of the capitals in this group is also the same. Only the lowercase version of the 'y' includes a tail and the uppercase requires a few adjustments to integrate the stem into the design. The tail of the lowercase 'y' is often a lengthening of the right-hand diagonal and the stem of the capital 'Y' is usually vertical. The 'w' is actually a ligature of a double 'v', as its English name 'double-u' and French name 'double-v' would suggest. The 'v' forms of the 'w' are made narrower in order to avoid the letter being far too wide in comparison to the other letters in the typeface. The capital 'V' is an 'A' rotated 180 degrees and without the bar. Visual adjustments are also required here as the counter space is given form by the cross bar. These letters are generally also not problematic and can contain similarities in shape to the 'A' and the 'U'. These have been discussed earlier with the letter 'U'.

The lowercase 'w' and the capital 'W' do not always have the same shape and construction. Stempel Garamond (below) even has linked serifs and no overlapping 'v' shapes. With DTL Fleischmann (above), both have serifs in the middle, while the Apollo shown below does not.

Monotype Apollo Regular

Outline of the 'v' superimposed over the 'w'.

Outline of the 'V' superimposed over the 'W'.

Tail outlet of the 'j' above that of 'y'.

Monotype Apollo Italic

Outline of the 'v' superimposed over the 'w'.

Outline of the 'V' superimposed over the 'W'.

Tail outlet of the 'j' above that of 'y'.

Slanted Regular 'Y' superimposed on the Italic.

Although the letter 'v' has a simple construction, the resulting shape can have a great influence on a number of related letters. In many typefaces, the capital 'V' is of equal width to the 'U' and in almost all renaissance, baroque and neoclassical typefaces, the 'V' is drawn asymmetrically with a thicker stem on the left and a thinner to the right. Its construction originates from handwriting whereby all downstrokes are thicker and upstrokes thinner. The position of the pen used for the handwriting also plays a role. The general opinion is that while reading, the eye is better guided from left to right by the rhythm of thick to thin. Only the slab-serifs such as Rockwell or Serifa use two symmetrically thick stems. Sans-serif typefaces generally use less thick-thin contrast, even the humanistic sans-serifs.

Although the so-called slanting of a roman typeface is not normally considered standard practice in the design of typefaces, the similarities between a slanted version of a regular 'Y' and the italic 'Y' are great. To prevent a letter 'falling over' the right-hand diagonal of the italic is set more vertical. The letter 'w' is generally clearly visually narrower than the 'v'.

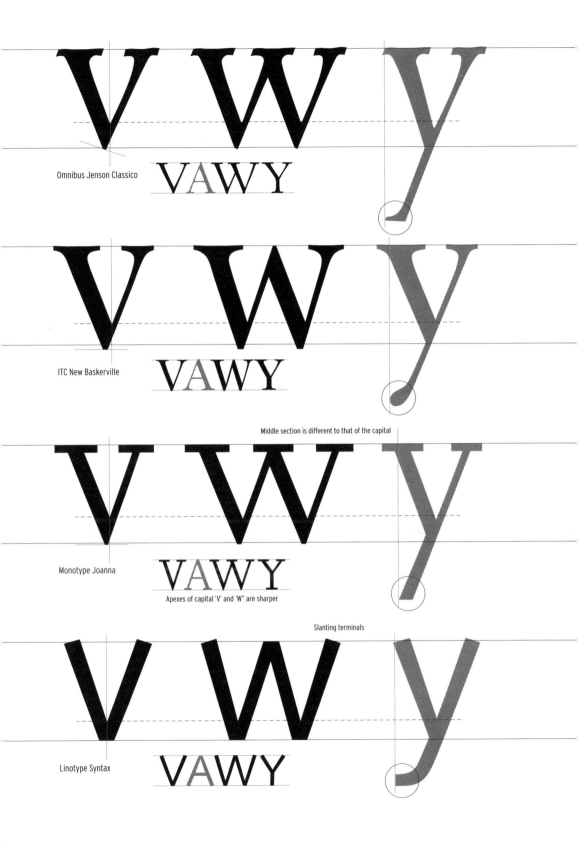

Omnibus Jenson Classico

VAWY

ITC New Baskerville

VAWY

Middle section is different to that of the capital

Monotype Joanna

VAWY

Apexes of capital 'V' and 'W' are sharper

Slanting terminals

Linotype Syntax

VAWY

KZXkzx

The Bell Centennial was constructed specifically for use in telephone books with highly absorbent paper. The clearly visible ink traps ensure that the characters do not become distorted by ink spread. Useful is that the left-hand style is called 'Listing' and extends below the baseline as standard. As such, a fixed positioning and size difference has been programmed into the typeface itself and does not have to be manually altered when setting the text. The style to the right is called 'Address'. The construction of the 'X' is also designed with the avoidance of ink spread in mind, hence the extreme staggering of the diagonals.

Diagonal in lowercase and capital This group includes the letters 'k', 'z' and 'x'. The letter 'k' is a complex combination of inner and outer forms. It begins with a vertical stem against which two diagonals come together. The visual midpoint of the capital 'K' is almost always where the diagonals meet. With the lowercase 'k' it is the visual midpoint of the x-height. How the diagonals come together is extremely varied. It can be a point, sometimes a horizontal line, sometimes with displacement of the lower diagonal. Most designers prefer this join to be the same for both the lowercase and capital letter. The lower diagonal is usually heavier than the upper and so forms a strong leg upon which the construction stands. With sans-serif typefaces the two diagonals tend to be of equal visual thickness. The diagonals can also be arched. A characteristic feature of the 'k' is the visually 'busy' central area, which can lead to ink spread in smaller font sizes, especially when printed on newspaper or other uncoated kinds of paper. Some typefaces designed especially for use in newspapers or telephone books have letters which are designed with extra deep incisions, especially in the condensed and bold styles, which function as so-called ink traps or ink wells.

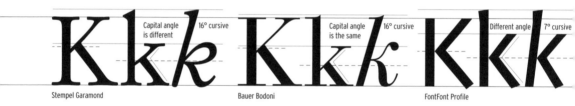

Capital angle is different | 16° cursive
Stempel Garamond

Capital angle is the same | 16° cursive
Bauer Bodoni

Different angle | 7° cursive
FontFont Profile

The letter 'z' has a simpler construction than the 'k'. Two horizontal lines linked by a diagonal. The lowercase version is almost always a smaller representation of the uppercase, but several visual corrections are needed in the boldness and proportions. The corner of the diagonal is often different in the lowercase than with the capital. The lowercase 'z' of humanistic typefaces has somewhat calligraphic properties, visible in a decorative terminal to the strokes or in a curve of the line resembling the stroke of a pencil. From a calligraphic angle, the diagonal connecting line between the two horizontals should be thinner.

The design of the italic versions of both the 'k' and the 'z' can be very different, sometimes because the letter spacing of a basic serif would be too large and sometimes because the italic was traditionally a completely different typeface. The diagonals of the capitals and lowercase letters are usually not placed at the same angle.

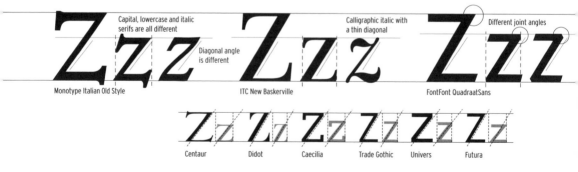

Capital, lowercase and italic serifs are all different
Diagonal angle is different
Monotype Italian Old Style

Calligraphic italic with a thin diagonal
ITC New Baskerville

Different joint angles
FontFont QuadraatSans

Centaur Didot Caecilia Trade Gothic Univers Futura

In general, type designers actually sooner prefer to use a thicker diagonal as this brings the grey tone of the letter more in balance. The lower horizontal line of the 'z' is a little wider than the upper line so that the letter 'stands' steady. In most designs the 'z' leans slightly to the right because the upper horizontal stroke is positioned a little to the right of the centre of the lower horizontal. The corners where the diagonals meet the horizontal lines can be sharp, rounded or angular. In seriffed typefaces, the serifs used here are similar to those of the 'L', 'E' and 'T'. Just as is the case with the 'E', the upper serif is smaller. There are also similarities in form between the diagonals of the capitals and the 'V', 'W', 'M' and 'N'. This is particularly visible with the sans-serifs. This is not the case with the lowercase letters because the 'l', 'e', 't', 'm' and 'n' differ in form to the capitals.

Although the 'X' of the sans-serif Frutiger at first glance appears to consist of two diagonal strokes of equal thickness, the strokes actually become narrower towards the middle and the construction consists of four separate strokes, different in weight and placed irregularly in relation to each other.

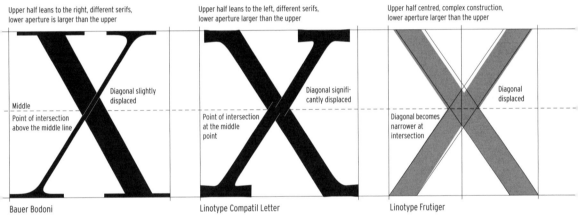

Upper half leans to the right, different serifs, lower aperture is larger than the upper

Diagonal slightly displaced

Middle

Point of intersection above the middle line

Bauer Bodoni

Upper half leans to the left, different serifs, lower aperture larger than the upper

Diagonal significantly displaced

Point of intersection at the middle point

Linotype Compatil Letter

Upper half centred, complex construction, lower aperture larger than the upper

Diagonal displaced

Diagonal becomes narrower at intersection

Linotype Frutiger

The 'x' is a separate case because it consists only of diagonals. In principle there are two diagonals, but these are often staggered, as with Frutiger, Avenir and Univers – not coincidentally all by the hand of Adrian Frutiger. Although the 'x' appears quite simple in construction, it is surprisingly difficult to design, both seriffed and sans-serif versions. If a thin and a thick line cross, a visual illusion is created whereby the lines appear staggered. To avoid this effect, the thinner diagonals of seriffed types are shifted slightly. To avoid the 'x' appearing top heavy, the point at which the diagonals meet is positioned slightly above the vertical middle point of the letter and/or the upper part of the letter is drawn a little narrower than the lower section whereby the white space of the upper part is smaller than the lower. There are two variations for the vertical placement of the upper and lower sections of the letter. With the version deriving from calligraphy, the letter leans a little to the left and the upper and lower sections line up on the left side. The second version is more symmetrical in construction, with the upper section placed centrally in relation to the lower section. The 'x' also often includes a narrowing of the line at the point of intersection of the diagonals.

The italic style often contains surprising differences in form, especially with seriffed types. Below are the lowercase versions of Adobe Garamond and Bauer Bodoni.

The upper 'at sign' is from Adobe Garamond, left the roman and right the identical italic. Second is Proforma, which does have a different italic version. At the bottom is Alega, again with an identical italic version.

The other characters The letters of the alphabet have been globally discussed on the previous pages. It will have become clear that only the regular style has been examined, and where necessary the italic style. The most important message is the understanding of the construction of the different characters and their mutual relationships. It would be too much to strive to complete the picture by also discussing the problems relating to the bold, condensed, extended and light styles. Since the introduction of the computer, numerous existing typefaces have been extended to include additional styles for swash letters, small capitals, various series of figures and even pictograms that are made in the specific style of a typeface. Apart from these separate styles, a font includes a number of ligatures, fractions, symbols, punctuation marks and diacritics as standard. A few examples are shown on these pages. Most of them are designed based on the existing letterforms in the typeface. With the arrival of the digital era, there are many more choices, particularly with figures, which is particularly useful in the typography of annual reports and other financial publications, where old style figures can be used in the body text and tabular figures in the tables and lists. The extra symbols are often a source of enjoyment for the type designer. Jan Tschichold – graphic designer, teacher and publicist – wrote a book, for example, about the variations in form of the & symbol, but the @ symbol also receives a lot of attention, for obvious reasons.

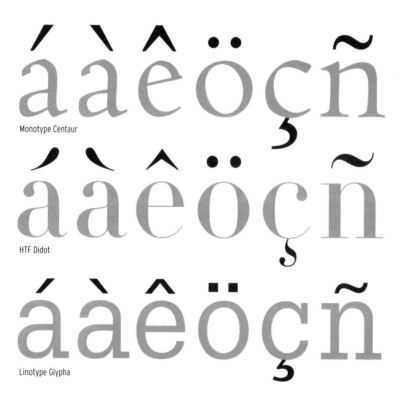

Monotype Centaur

HTF Didot

Linotype Glypha

Diacritics are marks placed below or above a letter that indicate how a word should be pronounced. Left are the most commonly used symbols. The acute accent (right) and the grave accent (to its left) are used to apply emphasis or as pronunciation indicators. The circumflex is generally used in borrowed French words (such as crêpe). The dieresis is used to indicate two successive vowels that should be spoken as two separate syllables. In German the same glyph is called an umlaut, which indicates a change in vowel sound. The cedilla is again used mainly in words borrowed from French (such as façade) and the tilde (as in El Niño) is not used in English.

aA 1234567890

aA 1234567890

AA 1234567890

Scala by Martin Majoor was in 1988 one of the first digital typefaces that, for reasons of practicality, included old style figures as the default. The tabular figures (lower line of the upper diagram) can be found in the small capitals style (Scala-Caps).

Figures as components of a typeface Figures are important components of a typeface. If numbers are used often in a body of text, they can have a significant influence on its legibility. This is why several variations are included in more recent typefaces, especially typefaces designed specifically for annual reports. As such, the graphic designer can be in possession of tabular figures, proportional old style figures and 'monospaced' old style figures as well as fractions and specially designed small figures for use in footnotes, superscripts and subscripts. These are otherwise often simply regular figures made smaller, whereby the strokes are also made thinner and thinner until a more or less scant figure remains. The specially designed additions to the figures can be accessed in an OpenType typeface in one style, but are delivered as separate styles in the Postscript Type 1 and TrueType formats. A certain level of experience with the Glyphs menu, which is now available in many programmes, is often required to find the key needed to select the required symbol.

123.45
234.56
345.67
———
123.45
234.56
345.67
———
123.45
234.56
345.67

1234567890/1/1234567890/1

1234567890

1234567890

1234567890

Left is the extended figure set of Profile with above the specially designed small figures for use in notes, fractions, superscript and subscript figures (note the number '1' without serifs useful for fractions). As well as the proportional old style figures for the text, there are also monospaced old style figures available which can also be used as tabular figures. The number '1' has an altered design to avoid undue white space around the letter. To the left is an example of how these figures align. In the centre are the non-proportional and below are the proportional old style figures.

Xx1234567890

The previous paragraph discusses the different kinds of figures from the viewpoint of the user. It goes without saying that the so-called Arabic figures have been discussed, not Roman numerals. In general, the latter are considered useless for calculations. Their use is therefore limited to more stand-alone applications such as classically designed clock faces, in books as page numbering in the foreword, chapter numbering and the year of publication and in names such as Louis XIV. Roman numerals are made up of regular capitals or, often considered more aesthetically pleasing in a body of text, small capitals. In the chapter 'The Letter Family', the origins of Arabic figures are described at length and the construction of Roman numerals is analysed.

The Adobe Caslon (above) shows that the lining figures are designed slightly smaller than capital letters. The old style figures have the same x-height as the lowercase letters in this typeface.

In the mid sixteenth century, the use of Arabic figures began to spread through Europe, partly due to the introduction of the printing press. The figures were used universally for a long time and did not belong to a particular typeface, similar to the difference between the roman and italic styles at the beginning of the era of printing with cast metal type. Gradually, typefaces were extended with matching italics and figures designed specifically for the typeface. The first figures to be specifically designed as an integral part of a typeface were made around 1522, according to type historian Hendrik D.L. Vervliet. Some sources say that it was Claude Garamond who used them for the first time. They were intended for the body text and had ascenders and descenders, the so-called old style figures. In general these are drawn slightly larger than the x-height of the lowercase letters. Only the figures 0, 1 and 2 are small characters, and the rest of the figures have ascenders or descenders.

The old style figures of the Quadraat (below) include the classically designed Roman '1'.

0123

1234567890

1234567890
1234567890
1234567890

Figures are an important component of signposting. Many countries, including The Netherlands, use the (former) American typeface (FHWA-series) from which both the regular and condensed versions of Interstate are derived (top two). In Germany DIN 1451 is used, upon which FF DIN by Font-Shop is based (below).
Frutiger is also used in several countries. In 1997 Gerard Unger designed a new typeface for the ANWB signposting in the Netherlands.

The diagram below shows Miller Text (top) with capital figures drawn smaller than the capital letters and larger than the lowercase, whereby the '6', '7' and '9' extend above and below. Solex (bottom) has a more hybrid character whereby only the '0', '1' and '2' are of equal size, just as with normal old style figures.

Lining figures only exist since the eighteenth century as a result of the Industrial Revolution. They are generally designed a little lighter and smaller than the capital letters so that they are less obvious in a text. The initial opinion was that capital figures were better legible because they were more obvious within a text, but research later proved that this is not the case and that old style figures are more legible. This is one of the reasons that old style figures are included more often in new typefaces, especially in the regular style. Some typefaces have four different series of figures, split into figures for within a text and the monospaced or non-proportional tabular figures. For both versions there are old style figures and lining figures available. The lining figures are identical to each other, with the exception of the '1' in sans-serif types. This is often given serifs to limit the amount of optical white in the monospaced version. The same is true for the old style figures (which are of course different than lining figures), again with the exception of the '1' which sometimes has serifs like those of a Roman numeral 'I'. A different form is in the making with hybrid figures which have shorter ascenders and descenders and are shorter than normal lining figures but taller than the x-height. Examples are Miller by Matthew Carter for Font Bureau, Solex by Zuzana Licko for Emigre and ITC Biblon by František Storm. Georgia, designed by Matthew Carter for Microsoft, included hybrid figures in its first version, but they were replaced by old style figures in the final version. Bell Gothic has so-called three-quarter figures, which are smaller than the capitals but which are all of equal height.

Xx1234567890

Xx1234567890

The Bell Centennial is a typeface designed specifically for the telephone book. Its name, the sizes and alignment of the basic fonts are based on this.

1234567890	**1234567890**	1234567890	**1234567890**
Adress	Name & Number	Sub-Caption	Bold Listing

01OI
0IOI
01OI
01OI

Everyone is familiar with the confusion that arises when the figure zero appears in a serial number or licence code consisting of figures and capitals. The difference is usually quite clear with seriffed type, as the capital 'O' is wider than the figure 'o' and often has a different angle in the thick-thin axis. This contrast is less with sans-serif typefaces, which means the only difference is the width of the character. Solutions incorporating a slash into the design or a different form do exist but give rise to other associations (such as with the 'Ø'). The figure '1' is a separate case because it is so narrow. Here, the confusion usually occurs with sans-serif typefaces because the '1', 'l' and 'I' are all very similar. Gill Sans by Monotype and Strada by FontFont are perhaps the best examples of this. The figure '1' has two more variations with old style figures. The version most closely resembling a Roman numeral is usually seen in the garaldes such as the Garamond, for example.

The number '2' of the small version and the capital are equal in size to the zero of each version. The construction of the old style figures is closely related to the lowercase letters. The '2' shares similarities with the 's', 'c' and 'a'. The '3' and the '5' contain open bowls which are very similar. The '3' usually has two open bowls but it is also sometimes drawn with the upper bowl replaced by a 'z'-shaped upper section. Although the terminals of the curved strokes and straight lines can have the same serif or teardrop shape, the central elements are seldom decorated.

35

The Formata (above) shows an example of the typical z-shaped '3'. The curved bowl is similar to that of the '5'. A disadvantage of this '3' could be that these two figures are easily visually confused, especially from a distance. Below is the Quadraat by Fred Smeijers.

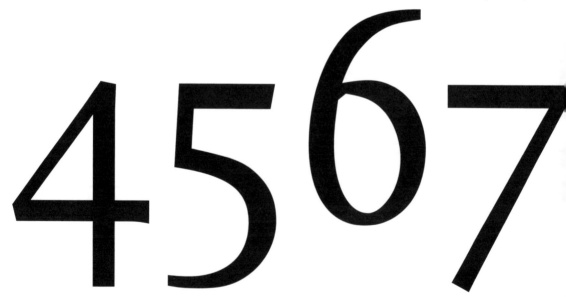

X01 235 47 6 9 8

X01 235 47 69 8

The tabular figures and the old style figures of Meta show that differences in form can be very subtle. In the top line the '6' (red line) has been rotated 180 degrees and superimposed with the '9'. This is the same '6' shown next to it. In the line below the tabular figures in red have been superimposed with the old style figures. The '1' has been moved to highlight the differences. Only the lower and upper sections of the tabular figure '2' have been used to show similarities in the curve and the base.

There are many variations of the '4'. It can have an open or closed form, but the lining and old style '4' usually have the same shape. In general the descender of the old style '4' is shorter than the lining version. The basic form is a triangle, which makes it a rather difficult figure to bring into balance, especially in relation to the other figures. The same is true for the '7' which is also open in shape and contains a diagonal. With its open shape there is a large amount of space around the letter. The '6' and the '9' are sometimes the same character rotated 180 degrees in relation to each other. The counter of the '6' is usually larger than that of the '9', especially with old style figures. The combination of counter and curve should be visually well balanced. The ascender of the 6 and descender of the 9 in a seriffed face often curve back and end in the form of a teardrop. One of the most unusual shapes is the '8' which, in geometric typefaces such as Futura, appears to be constructed of two equal, round shapes. The top one is in fact always smaller. The second variant is a version stemming from calligraphy. Sometimes the lines of the '8' become narrower at the point of intersection.

This chapter only highlights the very tip of the work of the type designer. It is therefore intended only to amuse and as a taste of the complexity and the countless possibilities available.

8 9 = 6

From type to font

The previous chapter detailed the first stage of a type design in which each character is carefully studied and adjusted until unity of form and 'colour' of all characters is achieved. Although the designer has already put letters together to test how they combine in a word or block of text, creating a font for a computer is a labour-intensive task. The individual characters are merely the start of the process.

These pieces of cast metal type, although supplied as a gadget with the Verlag Hermann Schmidt DTP-Typometer, clearly show that the width of the metal shank determines the spacing. Space can obviously be added by means of thin spaces between the letters. So making the spacing wider was not a problem at the time. Photo: Joep Pohlen.

The characters of a typeface obviously all have different shapes. It is important to find a certain harmony in this complexity of form and white space, if only to keep a text as legible as possible. All the various letter forms are put together in different combinations. This can vary greatly per language. The 'ij', for instance, is almost exclusively used in The Netherlands, and the 'ß', you will only find in German-speaking regions. In the metal type era the physical restrictions of the cast type determined the minimum distance between two letters, but the digital age has erased most of these limitations. Nowadays, letters can even overlap and the potential for refinement has enormously increased. In general, one calls a typeface well spaced when a block of text looks uniformly grey through slightly closed eyes, without dark or light patches. On the other hand, increasingly more so-called monospaced typefaces are being developed as an extra addition to text typefaces. An example of these is the TheSans Mono as pictured on the following page, top right. Each letter has an equal set width and there is no real need to space them. Although more and more text typefaces have this as an added option, they are virtually unusable in longer texts. From a practical point of view, these texts need to be as economical as possible, so type designers are constantly looking for the ideal solution, and labour-intensive spacing that meets that requirement. In the case of a five hundred page book, a wide spacing can result in dozens of extra pages. Naturally, this element is less important for an advertising brochure that comprises a small amount of text. Obviously the economy of a letter is also dependent on the width of the letters themselves.

The optimal way to set type also depends on its size. The smaller the type, the more white it needs between letters. The golden rule of typography is that the visual is more important than the geometrical, and this also applies in this case. This is why some typefaces are designed for body text, some for captions,

im

im

im

im

The so-called monospaced type-face is a special variant that does not suffer from traditional spacing problems. Some form adjustments are necessary to fit letters such as the 'm' and 'i' into the same drawing space without creating white gaps or black lumps.

abcdefghijklmnopqrstuvwxyz

Lorem ipsum dolor sit amet, consectetuer adipiscing elit. Pellentesque in metus in purus vulputate porta. Mauris orci. Curabitur non velit quis massa vehicula tincidunt. Donec in arcu sed massa viverra tristique. Nulla pellentesque ipsum bibendum mi. Quisque elit. Vivamus massa turpis, nonummy quis, pharetra a, molestie consectetuer, urna. Praesent euismod. Nunc interdum bibendum turpis. Sed eget turpis. Aliquam erat volutpat. Nullam tempor, dui vel placerat ornare, justo nisi fringilla sapien, in ultrices mi nisl et est. Quisque odio urna, porttitor a, suscipit laoreet, consequat tincidunt, nisi. Vestibulum ac ante eget orci suscipit vehicula.

Lorem ipsum dolor sit amet, consectetuer adipiscing elit. Pellentesque in metus in purus vulputate porta. Mauris orci. Curabitur non velit quis massa vehicula tincidunt. Donec in arcu sed massa viverra tristique. Nulla pellentesque ipsum bibendum mi. Quisque elit. Vivamus massa turpis, nonummy quis, pharetra a, molestie consectetuer, urna. Praesent euismod. Nunc interdum bibendum turpis. Sed eget turpis. Aliquam erat volutpat. Nullam tempor, dui vel placerat ornare, justo nisi fringilla sapien, in ultrices mi nisl et est. Quisque odio urna, porttitor a, suscipit laoreet, consequat tincidunt, nisi. Vestibulum ac ante eget orci suscipit vehicula.

For the TheSans typeface shown here, the type designer Lucas de Groot adjusted the form of almost every letter for the Mono version. In the alphabet above, an outline of the Mono version has been superimposed over the normal version. Virtually every letter, except the 'h', 'n' and 'u', has been adjusted, whether slightly or extensively, to uniformly fill the fixed drawing space (the 'bounding box') of the Mono version. How that works in a block of text is shown on the left: the two versions are of equal size and have the same line interval. It shows how much the white space around the letter influences the legibility and presentation of the text.

Space
Space

Space

Space

Space

Space

The largest word shown above seems to be set more loosely than the smaller ones. This is why the spacing of words set in larger sizes should be slightly reduced. Smaller sizes sometimes need their spacing increased. 'Tracking' is increasing or reducing the white space between letters for an entire passage of text, rather than for individual pairs.

some for headings and some for display. The last two are less widely spaced and therefore optimised for use in bigger sizes. In the metal era the spacing was adjusted for several body sizes. Also, for smaller x-heights, the font was enlarged and the letters cut slightly wider. The 'colouring' of the smaller fonts used, for example, for footnotes or captions for example, better matched the bigger text sizes. Furthermore, the characters were slightly widened to increase the size of the inner spaces. This also prevented ink clogging when printing. When the faster process of phototypesetting was introduced, the number of master fonts for a typeface was reduced for practical reasons (one film for most fonts). With the rise of digitisation, designers began to turn again to detail in typography. Most typefaces however are still set from a single 12 pt master font. There have been attempts to use different master fonts for different sizes. Both Apple's QuickDraw GX technology and Adobe's Multiple Master font format made it possible to generate different fonts for different sizes by

means of different sets of 'master character outlines'. Both formats disappeared because of a lack of interest. They are no longer supported by Apple and Adobe. The OpenType format that was then successfully introduced by Adobe and Microsoft copied a few features of those formats and gives the designer the option to incorporate multiple master fonts for different body sizes. As the master font is automatically assigned to a range of sizes, it is more user-friendly than the GX and Multiple Master fonts. The problem with all these formats, however, is that the designer needs to add more characters to a typeface to make use of all the possibilities. In practice a designer will make a choice based on the purpose and volume of the work, which ultimately means that not all possibilities are utilised.

In 1994, QuickDraw GX provided an enormous step forward in font technology. The character set with more than 1000 glyphs was much larger than the usual 256 positions of PostScript Type 1. Below, two screen images showing alternative numerals, from the now outdated Linotype/Hell presentation.

The road to a font Logistically, the production of digital type can be divided into three stages. Step 1 is the design phase; step 2 is the editing phase for digitising the design, composing the glyph databases, adding letter spacing and producing a kerning table; and step 3 is for hinting bitmaps and creating font formats. In theory, each stage should be completed before starting the next. The designer can also choose to execute the design – step 1 – personally but leave the subsequent, more technical steps to an operator or font producer, as was common in the metal era. Ultimately, the design of the typeface is the most distinctive part of the whole process. The original design is the one element that will survive all techniques in the long term. The technical procedures for making typefaces visible on paper, in digital medium, etc., will constantly change with changing techniques. This even applies to fifteenth century typefaces that over the course of time have constantly been subjected to prevalent technical possibilities.

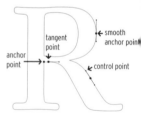

A PostScript drawing with an anchor point, smooth anchor point, tangent point and control point in the DTL Fleischmann 'R'. An anchor point is where two lines join at an angle. A tangent point has a handle, which is an extension of the straight line to enable smooth transitions between line and curve. A smooth anchor point is where two curved lines join to make a continuous curve.

Step 1: the design phase The first sketches of a new type design are still frequently made manually on paper. In some cases each letter is fully drawn by hand. In that case, they can be digitised using a digitiser, a kind of mouse with a magnifier that can very exactly transfer points in the drawing to a computer. Another possibility is to use the auto-trace function to have the software trace the outline from a scan. A letter can also be directly drawn on the computer, often with the help of a scan of the sketch (a template). Recurring shapes are then copied and adjusted. The choice of software programme is personal. Some designers for example use a different programme for each step in the design process; Fontographer for letter forms and spacing, RoboFog and Python scripting for the interpolation of the variants, and FontLab for generating the fonts and the 'cross-platform' terminology. Dutch Type Library and URW++'s DTL FontMaster programme has separate modules for each of these functions. Ultimately, software is a constantly changing means to achieve an end while designing has fundamentally stayed the same; it is something conceptual, with as starting point the function of a typeface. Technical possibilities play a supporting role and will change with progressing techniques. In the design phase, thinking up the typeface and perfecting the shape remain the most important elements.

Below, a screen dump from the FontLab programme. The letter 'G' is shown with selected letters on either side to help the designer compare mutual proportions. The typeface is the Le Monde by Jean François Porchez. Although the x/y coordinates are given for the anchor point in the 'G', these drawings are often printed out and adjusted manually, after which corrections are executed with the font software. It remains a heavily visual process in which a brush, India ink and correction fluid still play an important role. Scissors to shorten or lengthen ascenders and descenders are a much used and handy tool as well, as are tape and glue...

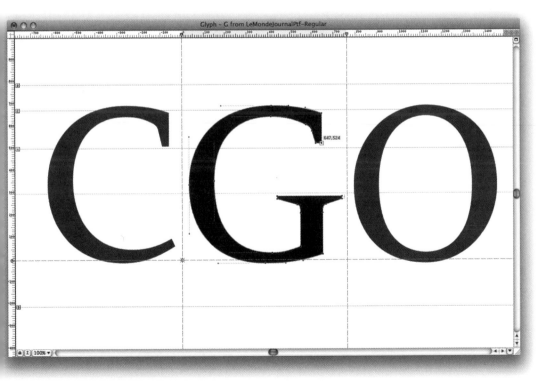

Step 2: the editing phase

In this phase, the characters are aesthetically and technically optimised. Curves can be subtly changed and anchor points can be moved by means of coordinates so they exactly match comparable positions of other characters. Subsequently, a glyph database is generated with all the characters that the designer wants to use. The maximum number of characters depends on the size the font is produced in. Spacing is also defined during this step, as well as constructing a kerning table.

Spacing and kerning specific letter combinations will be further discussed in the following pages, as it is an important stylistic element in microtypography. It sometimes even requires making adjustments to the shape of letters. Then the correlation between different characters is checked again, and the spacing and kerning are tested. This concerns both the white space between the letters and the space between words and punctuation marks. With punctuation marks especially, they often prove to be too close or too far from the preceding character.

In The Netherlands, the 'ij' is a regular topic of discussion, not only for designers but also among compilers of dictionaries. If it is entered as a separate character, do you alphabetise it with the 'y' (historically the two were often interchangable) or after the 'i'? With the new OpenType possibilities, this letter combination could be added as a ligature by the designer. Drawing by author.

Step 3: hinting and producing fonts

To use the font, one must format it for various platforms like PC and Mac. In this phase, any hinting that is needed is also included. Hinting is defining bitmaps for low resolution rendering, usually on monitors and displays. This was very important at the beginning of the digital era because a lot of monitors and printers had a very low resolution, in the case of printers sometimes as little as 144 dpi (so-called dot matrix printers). But even now it is still needed from time to time, for the reproduction of small types on screens or mobile telephone displays. In PostScript Type 1, hinting is limited to the horizontal and vertical axis, while in TrueType, on which OpenType is based, there are far more hinting options, for instance in diagonal lines and curves. This kind of more advanced hinting is also called delta hinting. Finally, edges of letters can be 'blurred' to give them a less ragged appearance on monitors. Whether a pixel is blurred or not depends on the percentage that falls within the outline. This so-called anti-aliasing technique is normally used for larger typefaces from about 16 pt. Anti-aliasing does not improve legibility for smaller sizes, which is why it is important to hint them well for display on monitors.

Above, a Demos glyph database in Mac Os Roman. The names are indicated above the glyphs. The letter 'n' is selected for editing.

Hinting means that the outline in a given resolution is adjusted to the raster. On the left, the automatic font software solution and on the right the hinted bitmap. The outline lies underneath the Adobe Caslon 'g' bitmap in a 12 pt size.

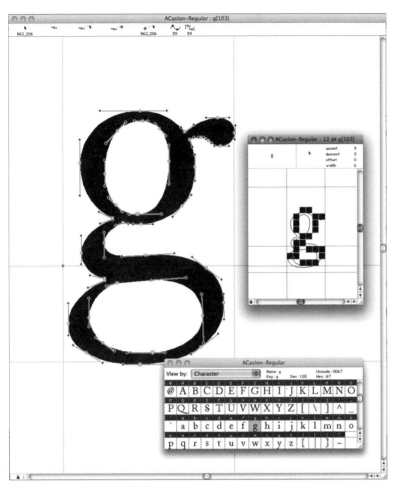

ACaslon-Regular : 12 pt g[103]

g ascent 9
 descent 3
 offset 0
 width 6

ACaslon-Regular

View by: Character Name : g Unicode : 0067
 Key : g Dec : 103 Hex : 67

@ A B C D E F G H I J K L M N O
P Q R S T U V W X Y Z [\] ^ _
` a b c d e f g h i j k l m n o
p q r s t u v w x y z { | } ~

On the left, typical font software windows. The largest character is that being edited, with anchor points, positions of the logo, the character or glyph database with the selected letter and the 12 pt bitmap letter in the hinting palette.

The anti-aliasing technique is intended to make texts of 16 pt and larger more legible on a screen. The outlines are less sharp, which gives the text a less ragged appearance.

Interpolation is a way to make intermediate versions. By using for example a roman and an extra bold variant, a bold can be created.

Interpolation of other variations Interpolation is often used to create the big type families that are becoming more and more common. Interpolation is a method of generating intermediate forms between two existing masters, for instance a regular and a bold or extra bold. Since a light version has less thick-thin contrast, it is usually not suitable as a starting point. The font software generates intermediate versions in the desired steps. Obviously a type designer can and should also be able to intervene in the process at this micro level. The italic naturally takes different masters as its starting point. Interpolation from the normal version can also be used for creating narrow (condensed) and wide (extended) versions. In this case, extra correction will be needed before any further interpolation to make other versions within this group.

minimum

In addition to the Tracy system described on these pages, the word 'minimum' is also a good starting point for determining letter spacing. Every letter has the same white space on either side while at the same time creating a well-structured word. The red lines indicate the 'bounding box'. The typeface is Fred Smeijers' Quadraat Sans. For the size shown, the letter spacing is fairly wide. Quadraat was designed as a text type, so the letter spacing is slightly wider spacing than desirable for a display type.

onz

From left to right: a closed counter, an almost closer counter and an open counter in the Proforma by Petr van Blokland. The counters play a big part in determining the letter spacing.

Letter spacing The space between letters can be called functional white. This means that it partly influences the overall image of the typeface and the way it behaves in a printed text. As the picture below shows, this white is essential for legibility and the desired visual impression of the text. More white makes the type look bigger. Even the line interval seems bigger. In font software, letter spacing is determined by establishing the white space (spacing) on either side of the letter. The body size of a type was once a physical measure of the shank of a piece of cast metal type, but is now defined by the vertical dimension of the 'bounding box' or design space of the letter. Although this height is fixed, the width of the bounding box varies from letter to letter. It is related to the width of the character itself and the protruding forms like serifs and curves, and includes the desired amount of space on either side, which is chosen to give the visual impression of the same amount of space on either side. This does not mean that the physical measurement is the same. It is like the type designer Fred Smeijers describes it in his book *Counterpunch*: 'Type: a game of black and white', in which the same amount of white liquid is, as it were, poured in between the letters, and in which the white spaces within the letters (called 'counters') also play a crucial role. It is often a matter of feeling, as Chauncy H. Griffith, general manager of the New York branch of Linotype, described letter spacing: 'It is a job for the eye alone'. Type designer Walter Tracy, who ran the design department of Linotype England, did not contest Griffith's statement, but he was convinced he could come up with a way to determine letter spacing. Tracy thought up a system that seemed reliable, but at the same time said that it was ultimately the eye that gives the final judgement. He grouped letters as follows:
letters with a vertical line: BDEFHIJKLMNPRU bdhijklmnpqru;
letters with a round curve: CDGOPQ bcdeopq;
triangular letters: AVWXY vwxy;
and finally the outsiders: STZ afgstz.

At vero eos et accusamus et iusto odio saepe eveniet ut et voluptates repudiandae sint neque porro quisquam est. Praesentium voluptatum deleniti qui ratione voluptatem sequi nesciunt. Id quod maxime placeat facere possimus, similique sunt in culpa qui officia deserunt mollitia animi, vel illum qui dolorem eum fugiat.

At vero eos et accusamus et iusto odio saepe eveniet ut et voluptates repudiandae sint neque porro quisquam est. Praesentium voluptatum deleniti qui ratione voluptatem sequi nesciunt. Id quod maxime placeat facere possimus, similique sunt in culpa qui officia deserunt mollitia animi, vel illum qui dolorem eum fugiat.

On the left a single text is shown twice: both in 9 pt New Century Schoolbook with a 9 pt line interval. The upper sample is set with standard spacing, the lower with wider spacing. The type in the lower sample seems bigger and the lines, strangely enough, seem to have a bigger interval. Legibility, however, has decreased. This example shows the importance of good letter spacing.

Typeface used: Monotype Baskerville

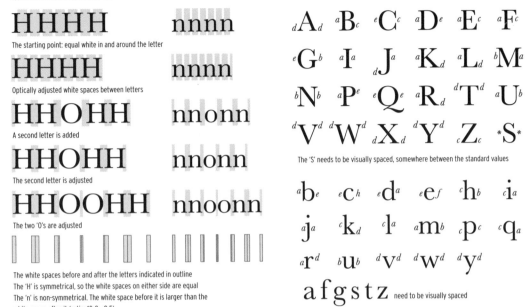

HHHH
The starting point: equal white in and around the letter

nnnn

HHHH
Optically adjusted white spaces between letters

nnnn

HHOHH
A second letter is added

nnonn

HHOHH
The second letter is adjusted

nnonn

HHOOHH
The two 'O's are adjusted

nnoonn

The white spaces before and after the letters indicated in outline
The 'H' is symmetrical, so the white spaces on either side are equal
The 'n' is non-symmetrical. The white space before it is larger than the
white space after it (ratio: 10:9 - 9.5)

$_d$A$_d$ aB$_c$ $_e$Cc $_d$Dc $_a$Ec aFc

$_e$Gb $_d$I$_a$ $_d$Ja $_a$K$_d$ aL$_d$ bMa

bNb aPe $_e$Q$_e$ aR$_d$ dTd aUb

dVd dWd $_d$X$_d$ dYd Z $_c$Z$_c$ *S*

The 'S' needs to be visually spaced, somewhere between the standard values

ab$_e$ $_e$c$_h$ $_e$da $_e$e$_f$ $_c$hb $_c$i$_a$

$_a$ja $_c$k$_d$ $_c$la $_a$mb $_c$pc $_c$q$_a$

$_a$rd bub dvd dwd dyd

a f g s t z need to be visually spaced

As it might be necessary to adjust the shape of letters during spacing, Tracy says letter spacing should be introduced once the letters have been sketched, before they are given their definitive form.

He takes the 'H' as the basis, placing four next to each other. For the spacing on either side of the letter, he begins with half the white space between the vertical stems, making all eight vertical stems equidistant. The horizontal cross bar of the letter pulls its vertical stems together, however, so the white space between the letters needs to be reduced. The optical division of the vertical is important and has to be done carefully. As serifs form a connection between letters, the letter spacing is tighter for sans-serifs than for seriffed typefaces. Once the four letters form a harmonious whole and the white space is not too wide or too narrow, this space is measured. Half of this space then forms the established white to the left and right of the letter 'H', and therefore the white for all capitals with vertical lines. The next letter is the 'O'. An 'O' is placed between two correctly spaced 'H' pairs. Then the white space is balanced by sight and measured. The space already determined for the 'H' subtracted to give the space allocated to the 'O'. Then another 'O' is set next to the first one to determine the white space between them. The process is then repeated and other white spaces are checked to see whether they need adjusting. The values found are the 'standards' between the two outermost characters. For lower-case letters, the 'n' and the 'o' are used to determine the stan-

dard values. Fournier used the 'm', but Tracy prefers the 'n' because the 'm' is usually designed after the 'n' – see the Tracy system on the previous page. As a rule, the white space between letters can never be bigger than the width of the white space in an 'n' or 'm'. The spacing of italics follows the same procedure. The capital italics are the easiest as they are often slanted versions of normal capitals. The italic lower-case diverges more because the letters are usually drawn a lot narrower than the roman. The two white spaces on either side of an italic 'n' can be as wide as the white space within the letter. Walter Tracy's book only briefly mentions the spacing of numerals, in part because the non-proportional lining figures then commonly used were simply centred in an en square. Now that most fonts include proportional non-lining figures in addition to non-proportional lining ones, the white space before and after each numeral needs to be optimised, both for text figures and for non-lining or proportional capital figures. Using the diagram on the previous page, the resemblance between letters is used to define the white space. The same applies to numerals. Wherever no similar form exists, spacing should be done visually. Tracy's system is a set of guidelines and can be supplemented with so-called triplets and test words, as described in Emile Ruder's book *Typography* and elsewhere. Some examples of these letter combinations are pictured on this page. In the triplets, each letter of the alphabet can be placed between two others, resulting in a much longer sequence than the one pictured here.

Bottom left: a selection of so-called triplets to test the letter spacing. The three columns on the left are set in New Century Schoolbook and the columns on the right in Akzidenz Grotesk. The red lines indicate the 'bounding boxes'. Bottom right: a selection of words in Akzidenz Grotesk, used to test problems in spacing. Words are selected from various languages because each language has letter combinations that do not occur in others. Source: *Typographie*, Emil Ruder.

lal	aaa	vav	lal	aaa	vav
lfl	afa	vfv	lfl	afa	vfv
lll	ala	vlv	lll	ala	vlv
lgl	aga	vgv	lgl	aga	vgv
lal	*aaa*	*vav*	*lal*	*aaa*	*vav*
lfl	*afa*	*vfv*	*lfl*	*afa*	*vfv*
lll	*ala*	*vlv*	*lll*	*ala*	*vlv*
lgl	*aga*	*vgv*	*lgl*	*aga*	*vgv*

crainte
trotzkopf
science
damals
prévoyant
wayward
efficiency
possibile
allégir
quälen
vivacity
huldigen
macchina

Kerning In the metal era letters in combinations like We, LT and Ty could be moved closer together to close the gap in their spacing only by physically shaving or cutting away part of the metal shank of the piece of type (a process called 'kerning'). Now the software can easily move them as close as we wish. To adjust the spacing of these specific combinations, kerning values are generated for each problematic pair. These are the exceptions to the standard letter spacing. It is a very precise and time-consuming job. The construction of a good kerning table takes a lot of testing and adjusting. More data means more calculations, so the number of kerning pairs also influences the amount of time software takes to process them. It is furthermore a golden rule that kerning can only be started once the type designer is completely happy with the fitting of the type as a whole. Moreover, there is debate among type designers whether kerning is in fact necessary for text typefaces. Walter Tracy for one stated that it was not demonstrated that kerning enhanced legibility. For typefaces larger than 18 pt, the opinions are not divided and kerning is customary. The letter spacing for typefaces specifically designed for larger sizes is generally smaller than that for text typefaces. So a type designer could in theory choose a text variant with little or no kerning and a display variant with an adjusted spacing and more kerning. Typefaces like the Adobe's fonts average about 100-150 kerning pairs; for Bitstream the figure lies between 200 and 500 pairs. There are, however, also exceptions with 1000 and 2000 kerning pairs. Examples of important kerning pairs are:

Av Aw Ay Ta Te To Tr Tu Tw Ty Ya Yo

Wa We Wo we yo AC AT AV AW AY FA LT LV LW LY OA OV OW OY

PA TA TO VA VO WA WO

YA YA YO

Examples of combinations with punctuation marks are:

A' L' P, P: D, W, V. V, f. r, 't 's '"

A text set in metal type and printed letterpress, from *Typefoundries in The Netherlands* (1978) set in Jan van Krimpen's Romanée. Although the typography and typesetting are sublime, there is a clearly visible wide space in the 'We' letter combination. This problem can be solved by kerning, easier in digital type than in metal type.

Wetstein Typografie

Above: spacing in the digital Garamond Premier Pro. The letters merge as it were into one another. Ligatures like the 'fi' are made to suit the standard letter spacing, but with wider or narrower spacing their use is not recommended.

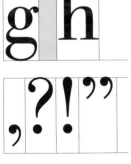

Word space for Bodoni Classico and the white spaces of a few punctuation marks.

Word space and other spaces For most typefaces, the word space is slightly smaller than the 'bounding box' of an 'i', or a fourth of the font size (also called a fourth em space). As italics are often narrower, their 'bounding box' is a fifth of an em space. The width of an em has the same value as the body size. For a 12 pt letter, the em space is 12 pt. However, these values for the word space are only guidelines; wide typefaces need a larger word space than narrow typefaces and bold variants. As previously mentioned, counters are of influence as well. The smaller a counter, the smaller the word space can be. An altogether different story are the punctuation marks; marks like the full stop, comma and colon are placed in or slightly to the right of the middle of a half em space. Question marks and double quotation marks are usually in the centre of a white space measuring 40% of an em space.

Digital formats

Type designers and typographers from the letterpress era had only just begun, reluctantly and full of apprehension, to get used to designing for phototypesetting equipment when the next technological revolution revealed itself: setting type using a computer. And all that in only one lifetime! For most of the somewhat older tradesmen from the metal type era, this revolution proved just too much: They didn't learn how to design for and using computers. After all, the five-century-long evolution to the ultimate, triumphant stage in the mastery of this technology had won great respect and admiration. They had conquered an extremely difficult technique and the resulting aesthetics largely rested on an illusion of effortlessness. These aesthetics were laid down in special formulas, rules and manifestoes, in which 'readability' and 'optimum legibility' were key concepts. Designing a bookface reflecting these concepts had become the consecration of a type designer's profession.

With the introduction of photo-typesetting and the offset print ing, the three-dimensional im-pression of metal type into paper slowly became a thing of the past. The photo above was taken from the book *Typefoundries in The Netherlands* (1978). The de-sign is by Bram de Does. The book was completely composed by hand and letterpress printed to celebrate the 275th anniver-sary of Joh. Enschedé en Zonen. Photo: Joep Pohlen.

Each technological revolution goes through its own Stone Age, and it takes quite a while before a new technological mastery and new aesthetics come in sight.

It was in the mid-1960s that people with vision already recognised that computers as information processors and monitors as medium were predestined to be the major operators in visual communication, even though the computer was still a room-filling monstrosity and the monitor a flickering dwarf.

Together they formed a fascinating and amusing duo that would soon turn the established graphic industry completely upside down.

The status of letterpress printing with its primacy of 'optimum legibility' still compared extremely favourably with the earliest attempts to make type legible by means of computers and the first dot matrix printers.

Even around 1985, most designers were convinced that the professionalisation of computers would take some time yet and that they were never going to see the day that computer typesetting would live up to their standards. Designers and book typographers heavily disputed the quality of the typesetting. In this chapter, we closely follow the most important technical developments that were introduced as letterpress died out. In the space of only a few years, these developments caused a fundamental change in the design world and the whole prepress business at printing offices.

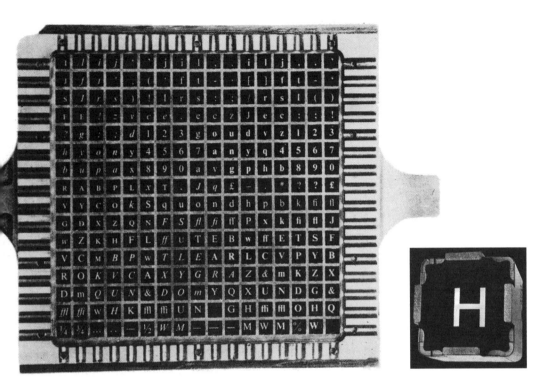

The phototypesetter The first step after the metal type era was photographic typesetting. As the photo above shows it still all looked mechanical. In order to speed up certain actions in phototypesetting – like aesthetic spacing, the very fast retrieval of character images from memory, and the enlarging and reducing of type – the first appeal to computers was made in the late 1960s. And actually, we should not forget that the introduction of the computer also happened very gradually. It had already been a long road from the mechanical punch-cutting machines to the first programme-driven Z3 by Konrad Zuse in 1941. This Z3 device had a storage capacity of one kilobyte (1kb), so it is clear that the gradual growth in storage capacity only made applications such as typesetting and even editing possible at a much later stage. The application of computers in typesetting came about after the time, following the metal type era, in which characters were projected onto photosensitive film or paper via a xenon flash tube, like slides to a screen. This form of type production was a very slow process, for it was still a mechanical composition system and the characters had to be projected one by one. As a result, production left much to be desired, even though the flash tube itself was much faster than lead composition. The letters of the negative film could only be enlarged to a certain, limited degree before they became blurry. Headings were set on machines that contained the larger film masters.

This beautiful metal machine part is a 'Monophoto matrix case' for the Monophoto photosetting machine (1957) by Monotype. In execution, it looks a lot like the Monotype matrix case for casting metal type. The transparent letters on film are in modular compartments each 0.2 inches square. A separate module is shown enlarged above right. The advantages in the transition from metal to film could not be seen in the robustness of the machines.

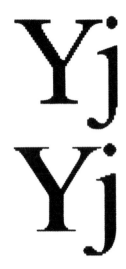

Enlargement of a letter scanned and then reconstructed by means of a cathode ray tube. Depending on the system, this could be done either point for point or line by line (horizontally or vertically). The first example is constructed from vertical and the second from horizontal lines. The limited resolution noticably degrades the letterforms when enlarged to this degree.

From analogue to digital The breakthrough came with the use of the cathode ray tube. The cathode ray tube is incidentally also used for projecting an image on the inside of the screen of a conventional television and the now old-fashioned CRT computer screens.

The first cathode ray tube machines scanned analogue images of the letters and converted them to an electrical charge on the tube surface, which then functioned as an electronic memory. The storage was limited but the letter images could be enlarged or reduced by using lenses, and they were then transmitted to photosensitive material. The advantage of this technique was its speed. The second generation of cathode ray tube machines already stored the letterforms only as digital data in memory that was used to construct the letters rendered visibly on the cathode ray tube. One of the pioneers was Rudolf Hell who in 1956 invented the fax machine. Expanding on this technique he introduced the Chromatograph, the first scanner that was able to scan and rasterise visual material. Before then, images like photographs were rasterised by means of a halftone screen on a light box. In other words, manually! Hell's invention revolutionised the electronic processing of visual material. A letter was, in effect, an image, so Hell's next step was to introduce the Digiset, an electronic typesetting machine that used a cathode ray tube whereby every letter was digitally stored in a size of 2000 pixels. According to today's standards, this is a very limited number of pixels. The Digiset could set one million glyphs per hour and especially for newspapers, this meant an enormous time gain. The first proper digital typeface for typesetting machines, the Marconi, was designed by Hermann Zapf in 1972 for the Digiset of the Dr Engineer Rudolf Hell company. In 1976, Gerard Unger designed the serif typeface Demos for the same machine, and the sans-serif Praxis in 1977.

This digital process was the beginning of a revolutionary chain reaction. The turn from analogue to digital was made. The letter image as the tangible and visible base in the form of metal type or a photographic negative became a thing of the past. From now on, the form of a letter was represented as digital data that could also be represented as zeros and ones. For digital typesetting, the digital data indicates whether a pixel is on or off. The black and white image on film or photopaper was therefore constructed from a grid of pixels, usually round, fuzzy and overlapping each other, but still fixed to their positions in the grid and either black or white. White pixels, however, have to be stored as well and require as much memory as black ones.

At the start, as for instance with the Digiset, not many pixels were available because a computer's calculation speed and memory were limited. For each letter and its surrounding white, 2000 pixels were available. As the images on pages 140 and 141 show, this was not a big problem for smaller sizes. In case of enlargements, however, the visible pixels spoiled the form.

0001100111110

Apollo

Apollo was designed by Adrian Frutiger in 1962 for the Monotype phototype machine and has now been expanded (in digital form) to include SMALL CAPITALS and non-lining figures.

Laser exposure At the end of the 1970s, the first laser exposure machines appeared on the scene. The laser was much more refined, faster, and produced more light than the cathode ray tube which made it possible to switch from halftone paper to light-sensitive paper with a larger contrast. Hell, too, started using laser technology instead of a cathode ray tube for his Digiset.
The Hollander typeface that Gerard Unger made for the Digiset was digitised with the Ikarus programme, not in a pixel format, but in an outline format, which meant that it could be reproduced in much more detail than the earlier Demos and Praxis. These first generation machines were only used to expose plain texts that then had to be physically assembled into a page. The next step involved the introduction of machines that were able to expose the whole page. In order to render a page with a laser, the data representing the image needed to be built up completely beforehand. This was done by means of the Raster Image Processor (RIP). In this case, raster means the pattern or grid and not the raster dots used to build up a screened image for printing. Laser imaging devices were available in various resolutions from about 300 to 2540 dots per inch (dpi). The RIP converts the software's typesetting instructions and fonts into vast sequences of bits that indicate when the laser or other imaging device should be on or off to make the entire page. The data representing that page is called the bitmap and is sent to the exposure device via so-called bitstreams. A page of 21 x 29.7 cm at a resolution of 1000 pixels per cm (2540 dpi), makes 21,000 x 29,700 pixels requiring 29,700 bitstreams, each with a length of 21,000 bits. Each bitstream then forms a line with a width of 21,000 pixels, each of which can be exposed or not. The whole parts of the image are also represented by pixels, but with instructions that they should not be exposed.

Th

Hollander, a 1983 typeface by Gerard Unger, is inspired by seventeenth-century Dutch types such as those of Christoffel van Dijck. This is mainly visible in the generous proportions, the large x-height and the thick-thin contrast. The Hollander could be drawn in much more detail because of new techniques. Only the italic fell victim to Hell's transition from cathode ray tube to laser because the typeface also needed to be suited to the old technique. The beautiful 'Th' combination, above, however clearly shows the digital advantages of combining letter images.

Hollander

110001**1234567890**

the Italic as a victim of technology

aaaaaaaa

On this page: the Praxis lowercase 'a' by Gerard Unger that was originally designed for the Digiset. The grid restriction of 2000 pixels per letter clearly limits the form. In a smaller text, however, the letter does match the PostScript Type 1 version on the right-hand page.

Many thanks to Gerard Unger for supplying the original.

aaaₐₐₐₐₐ

This 'a' is drawn in outline and then filled in with black and is part of the Praxis typeface in Post-Script Type 1 format. The images clearly show the difference between the limitations of a computer with cathode ray tube (CRT) machines and the improvement in quality that laser technology (with faster computers) brought about.

On the left, a letter in PostScript as it is stored in the font, and on the right, the bitmap letter with anti-aliasing as it appears on the screen. You can see the grey parts that soften the letter's edge.

Font formats In the previous chapter on producing type, the last step was to convert the font to a format that can be used in software and for output devices like laser printers, but also, for instance, on a screen. While every digital typesetter had a font format, each was proprietary and could be used only on that device or at best on devices from that company. What was needed was a standard format that would allow any imaging device to use any font. The grandfather of these is Adobe's PostScript language, now firmly established in the world of desktop publishing. With time, however, other, partly related formats were developed for fonts. Some have been briefly discussed in the previous chapter and will now be described in more detail.

PostScript This language is designed for describing a page in image points. The RIP (Raster Image Processor), that was by this time already commonly used, is, simply put, an image point calculator that belongs to a certain imaging device and is only suitable for its resolution. What was special and innovative about the PostScript language that Adobe developed in 1982 was the platform and resolution independent page description. It is properly called a Page Description Language (PDL). PostScript is one of the important reasons behind the rapid development of desktop publishing.

The Apple Macintosh, Apple's Laserwriter and the layout programme Pagemaker by software developer Aldus together offered an all-in-one solution for page layout. This was a surprising development, as traditional suppliers were not involved in any way. It was the combination that was decisive. In 1976, Mono-type had already introduced its Lasercomp, a device that could also image whole pages including both type and pictorial material. The machine was revolutionary, but there was no equipment or software to make up pages for it! This only became a real possibility in 1984, with the combined efforts of the Macintosh and PostScript. PostScript is an object-oriented language that describes typefaces and pictorial material as objects instead of bitmaps. The printer does need to have a so-called PostScript interpreter at its disposal that can generate bitstreams at the printer's resolution. Within five years, PostScript became the standard for high-end prepress output devices. This development marked the start of the dismantling of mounting departments at printing firms. Dark rooms with repro cameras, composing rooms and halls filled with lighting boxes gradually became redundant. The laser for lighting films and later plates (computer to plate) became the centre of prepress departments. As well as the page description language, PostScript had its own PostScript font technology for western typefaces: PostScript Type 1. The Type 1 fonts are different for Mac and Windows. Type 0 existed as well, but was used almost exclusively for complex Asian languages. When Adobe did not release Type 1 to the market, other type manufacturers started to make use of the license-free PostScript Type 3 format. Manufacturers such as Hell had digitised typefaces before – like the Demos by Gerard Unger – but only for their own equipment. The PostScript format was warmly welcomed by the graphic industry and made a standard in typefaces. Manufacturers industriously started to digitise their

The display of a PostScript Type 1 font in Mac OS9. The suitcase contains the hinted bitmap fonts for a correct display on the screen in a low resolution, in this case the 6, 8, 9, 10 and 12 pt sizes because the Bell Centennial was designed for telephone directories and not for use in headers. For regular typefaces the 10, 12, 14, 18 and 24 sizes are more commonly used. The second file is the outline file used for printing and exposing films or plates, here the Bell Centennial Bold Listing. The third is the Adobe Font Metrics file (.afm). This file, which contains general and metrical information, is normally only used in UNIX environments.

Above, a non-hinted and below, a hinted letter. The squares of the grid represent the pixels available on, for instance, a screen.

collections. Type 1 was reserved for Adobe and contains so-called 'hinting' to make typefaces more legible in low resolutions. During hinting, the programme gives instructions that will enhance the way a type is rendered with the available pixels. Type 3 did not have this option, which is why suppliers like Monotype that had quickly started digitising had to adjust their entire library when Adobe, under market pressure, decided to release Type 1 as well. This is why you can still find Type 3 fonts. When Adobe released the Adobe Type Manager software (ATM) to enable a better rendering of typefaces on the screen – using the vector font instead of the bitmap font in the little suitcase – it did not support Type 3, which meant the end for this format. Type 5 typefaces were only used for printers. They were added to the permanent memory of the printer (ROM) and had already been converted into fixed point size bitmaps to enable faster printing. They are further really just another version of the Type 1 typefaces. The hinting in PostScript typefaces is less advanced than that of TrueType.

In order to define curved lines in PostScript, Bézier curves are used. These Bézier curves make use of anchor points from which the curve can be influenced with handles and control points (BCPs) on the handles that determine the shape of the curve. In PostScript, the handles originate in the anchor points and are as such easy to control. TrueType uses quadratic splines (see drawing below) that contain so-called 'off-curve' control handles. These 'off-curve' control handles often only determine part of the curve, which makes it harder to influence the whole of the curve. You often need more anchor points in TrueType. Some designers solve this problem by drawing in PostScript and then converting the font to TrueType.

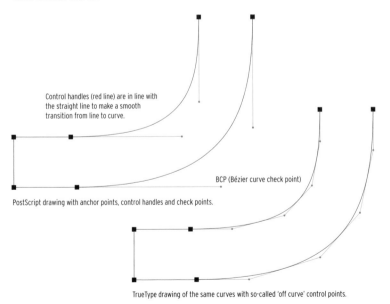

Control handles (red line) are in line with the straight line to make a smooth transition from line to curve.

BCP (Bézier curve check point)

PostScript drawing with anchor points, control handles and check points.

TrueType drawing of the same curves with so-called 'off curve' control points.

Left, a PostScript drawing and a TrueType drawing. They use different formulas to calculate curves. PostScript works with cubic curves whereby the position of the handles and the Bézier control points determine the curve. TrueType uses quadratic splines with control points on the ends of the tangents along the curve, as shown on the left. In principle, there are two kinds of anchor points: with and without handles. Without handles they are always corner points. Corner points can, however, also be two curved lines with handles on both sides. When a straight line passes into a curve, then it is a tangent point for which the handle is in line with the straight line. Curve points have handles on both sides which are in a straight line tangent to the curve.

A B C D E F G H I J K L M N O P Q R
S T U V W X Y Z a b c d e f g h i j
k l m n o p q r s t u v w x y z & 0
1 2 3 4 5 6 7 8 9 Æ Á Â Ä À Å Ã Ç Ð
É Ê Ë È Í Î Ï Ì Ł Ñ Œ Ó Ô Ö Ò Õ Ø Š
Þ Ú Û Ü Ù Ÿ Ý Ž æ á â ä à å ã ç é ê
ë è ð fi fl í î ï ì ı µ ł ñ œ ó ô ö ò
õ ø š þ ß ú û ü ù ÿ ý ž £ ¥ ƒ $ ¢ ¤
™ © ® @ ª º † ‡ § ¶ * ! ¡ ? ¿ · , ;
: ‘ ’ “ ” ‚ „ … ' " ‹ › « » () []
{ } | / \ - – — _ • ´ ^ ¨ ˋ ° ~ ˉ ˘
˙ ˇ ˝ ˛ ¸ # % ‰ ¼ ¾ ½ = − + × ~ < >
± ÷ ¬ ° ∧ / · ¦ 1 2 3

TrueType Apple tried to negotiate with Adobe about releasing the Type 1
font technology so licensing fees could be limited and other parties would also
be able to produce good quality typefaces. Of course this was partly out of
self-interest as Apple was paying licensing fees as well. Apple had already been
working on various vector formats for typefaces in the 1980s because font
technology played, and plays, an important role in the operating system.
As Apple and Microsoft had common interests they decided to work on a new
format together; Microsoft was going to work on a technology for visual mate-
rial that would replace PostScript and Apple on a technology for typefaces.
Microsoft's TrueImage technology turned out to be rather 'buggy' and neither
company ever used it. The TrueType font technology, however, was used in its
totality by Apple for its system 7 while Microsoft introduced it in Windows 3.1.
PostScript fonts use a grid of 1000 x 1000 relative units and TrueType one of
2048 x 2048 units. One of the most important advantages of TrueType is that
a single file contains both the vector data and the hinting information that
keeps texts legible, even at a low resolution. So there are no separate bitmap
fonts like in PostScript Type 1. Adobe reacted by introducing the Adobe Type
Manager (ATM) programme that enhanced the screen image of PostScript Type 1

Standard PostScript Type 1 Adobe
Utopia character set. In this now
old-fashioned Adobe/ ISO version,
the euro sign has not yet been
added. In its place in the font is
the so-called currency sign (or
sputnik). It is used in financial
documents in which currency
values are used that cannot be
specified or for which there is no
specific currency sign. Modern
printer drivers are often no longer
able to use this sign, so the result
is an empty space. A lot of True-
Type typefaces contain the same
character set as the one above,
usually with the euro sign added.

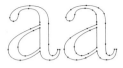

The outlines of Monotype Baskerville in PostScript (left) and TrueType (right). The TrueType version has 34 anchor points, the PostScript one 22. These characters are both well digitised and they have identical outlines.

The possibilities of TrueType and OpenType with the extension of the number of characters in a font are very well utilised in a typeface like the Eureka by Peter Bil'ak. It covers a great number of options within the same font, including a Western, a Central-European (CE) and a separate Eastern-European (EE) version (separate variants in the Post-Script and TrueType fonts). Mathematical signs, phonetic signs, ligatures, arrows and ornaments complete the font. The ratio of cap-height to x-height has been kept fairly large (1.7 : 1) to give accents enough space.

typefaces, and by releasing the Type 1 specifications. Because of these actions by Adobe both formats are in use to this day. In comparison with PostScript Type 1, TrueType has better hinting options – the so-called delta hinting – and because it supports the Unicode standard, TrueType is expandable from 256 characters to 65,536 characters. Delta hinting does not use global hints to reproduce a letter in low resolution but instead gives very detailed instructions for the bitmaps. Delta hinting is only possible for TrueType typefaces. TrueType can furthermore use 'contextual character switching', which means that one character can be switched for another under prescribed conditions. Examples are automatic application of ligatures and correct quotation marks. However, the extensive options are not always fully exploited by font designers because they take a lot of programming. Although calculations for the TrueType quadratic splines are in theory mathematically less complex than the calculations for Bézier curves in PostScript, it is difficult to get parts of lines to fit exactly in TrueType. This is why TrueType generally uses more anchor points than PostScript Type 1, although good TrueType fonts made by well-known type companies have fewer anchor points than those from less experienced users. In short it can be said that a well-made TrueType font can be better than a Post Script Type 1 font, but that this is usually not the case because not all options are utilised or because a typeface is badly digitised. Since the resulting fonts use a lot more anchor points and segments, thus making the calculation of a full page of text very complex, some may prove unprintable. Deals that offer thousands of fonts for a small sum of money can therefore be looked at with suspicion. The following is a way of testing fonts: If they show a lot of anchor points when converted into vector files in a drawing programme, they have most likely been digitised by using an auto-trace function. But there are excellent TrueType fonts available, which make adequate use of this format's options. In other words, there is nothing wrong with the font format and it provides plenty of possibilities for creating good type. For instance, Linotype supplies XSF fonts (eXcellent Screen Fonts), which are optimised for use in small sizes on screens. The print quality on paper is the same as with regular fonts. Now that OpenType seems to own the future it is unclear what part TrueType is going to play in new type design developments.

Eůřękāi

Qfjh'ſtfbffifkffhfflt'tɕtahnzg

QuickDraw GX QuickDraw is the component in the Mac system that is responsible for the graphic representation on a computer screen. It is part of the Macintosh Toolbox that is stored in the computer's permanent memory (ROM). All Mac software uses QuickDraw to not only display interface elements like windows and menus, but also to display images and typefaces. As such is it also a kind of 'page description language' that can be used to print on non-PostScript printers as well; think of cheap inkjet printers and simple laser printers. In 1995, Apple wanted to improve its system's font technology even more and so the QuickDraw GX was introduced. This was, in fact, an application of TrueType that was stored at the computer's system level. The GX font technology was, like the TrueType, 16 bits (65,536 possible characters) and for instance differentiated between characters and 'glyphs'. A character could be a letter, but also a numeral or a punctuation mark. A 'glyph' is an amalgamated mark or an adjusted combination of types within a certain typeface. Quick-Draw GX differentiated between the two and determined by means of a built-in software programme (state machine) that can replace some glyphs with others, following specifications in the GX typeface. If the 'f' and the 'i' were entered, those characters were automatically replaced by a 'glyph', namely the ligature 'fi'. The white space between letters could be set as well, as in TrueType and PostScript Type 1, in so-called kerning tables, but the programme also provided the option of 'class kerning' and 'contextual kerning'. In 'class kerning', the combinations of characters (glyphs) were grouped as well and provided with kerning instructions, and in 'contextual kerning', the white spaces were defined for specific combinations of 'glyphs'. These are only a few of the many advanced possibilities of QuickDraw GX.

First Reactions:
"Wow, automatic
spacing!
Hot news!
Visual sophistication!
Optical correctness!
A timesaving feature!"

First Reactions:
"Wow, automatic
spacing!
Hot news!
Visual sophistication!
Optical correctness!
A timesaving feature!"

Optical margin alignment was one of QuickDraw GX's possibilities. Here shown with Palatino by Hermann Zapf which was later copied by Monotype and subsequently released by Microsoft as Book Antiqua.

N T

The popular Avant Garde Gothic was also released as GX font by Linotype and ITC, and it included some very unusual ligatures.

With this programme, Apple had a technology – with accompanying 'intelligent' typefaces – that was innovative for typographers, but the company refused to make the programme available for Windows. Because of this, software developers paid little attention to the new technology, which marked the end of QuickDraw GX. The programme was however the first real departure from the thoughtless migration of metal era typefaces to computers and it was the first advanced step towards adding more functionality to a typeface. Quick-Draw GX offered the type designer more options to take specific characteristics within letter combinations into account and even to automatically correct common mistakes; think for instance errors with quotation marks or punctuation that could be stored in tables within the typeface. In QuickDraw GX it was also possible to have the so-called aesthetic hanging punctuation defined in tables. Another option was optical margin alignment, whereby curls and other typographic extensions 'hang' outside of the column of text. Apple continued the GX technology in its own system as AAT format. As the options mentioned have been implemented on programme level and built into OpenType, they are now widely available after all.

Min
Min

Above, the Minion Multiple Master that contains, besides master fonts for weight and width (as in Myriad MM), master fonts for visual correction at different point sizes. For this purpose, existing 6 pt and 72 pt primary fonts are used to generate the point sizes in between. The 6 pt primary font (above) has less thick-thin contrast and is wider than the 72 pt version (below).

Below Myriad MM, with the Regular indicated in red. In grey, the Light Regular, SemiBold and Bold. In the corners, the primary fonts that serve as the basis for generating the intermediate variants.

Multiple Master In the meantime, Adobe introduced a new technology that could be used within the existing PostScript Type 1 format. The Multiple Master format made it possible to create one's own variants (which was in fact already possible in the GX fonts), from extremely thin to extra bold and from narrow to wide. The master fonts were drawn as so-called 'primary fonts' and the variants were generated from these master fonts by the FontCreator programme, which was supplied as part of the package. For other typefaces like the Minion MM it was even possible to add a visual correction for different text sizes, comparable to the corrections that were common in the time of metal type. It sounded like every graphic designer's dream. Over the course of time, however, it turned out that users preferred the easier choice of pre-existing variants. Printing these typefaces, moreover, proved to be quite problematic. On top of that, the programme had kerning problems, and some word spaces in the Myriad MM (for instance after a full stop) were rather small, which meant double spaces had to be inserted to achieve a normal word space. And because the number of anchor points needed to be the same in every primary font, type designers were very much constricted. In the end, about fifty Multiple Master typefaces were produced, of which the Myriad MM and the Minion MM by Adobe are the best-known examples. In 1999, Adobe ceased developing this technology and since the introduction of OSX for Mac, it is no longer possible to use Font-Creator. Variants already created can theoretically still be used, but in order to create new variants, a Mac with OS9 and Adobe Type Manager is required.

215WT/300WD	215WT/350WD	215WT/400WD	215WT/450WD	215WT/500WD	215WT/550WD	215WT/600WD	215WT/650WD	215WT/700WD
300WT/300WD	300WT/350WD	300WT/400WD	300WT/450WD	300WT/500WD	300WT/550WD	300WT/600WD	300WT/650WD	300WT/700WD
400WT/300WD	400WT/350WD	400WT/400WD	400WT/450WD	400WT/500WD	400WT/550WD	400WT/600WD	400WT/650WD	400WT/700WD
500WT/300WD	500WT/350WD	500WT/400WD	500WT/450WD	500WT/500WD	500WT/550WD	500WT/600WD	500WT/650WD	500WT/700WD
600WT/300WD	600WT/350WD	600WT/400WD	600WT/450WD	600WT/500WD	600WT/550WD	600WT/600WD	600WT/650WD	600WT/700WD
700WT/300WD	700WT/350WD	700WT/400WD	700WT/450WD	700WT/500WD	700WT/550WD	700WT/600WD	700WT/650WD	700WT/700WD
830WT/300WD	830WT/350WD	830WT/400WD	830WT/450WD	830WT/500WD	830WT/550WD	830WT/600WD	830WT/650WD	830WT/700WD

OpenType After the downfall of QuickDraw GX and the Multiple Master technology, it became clear that connections to existing formats needed to be established. Not only to improve typographic performance, but also for practical reasons. A system typeface that could service all language versions would save producers of operating systems a lot in logistical terms, but it would also make it easier for developers of programme software to create localised versions. Added to this picture is Adobe's desire to maintain the PostScript format, although it had been rendered obsolete by TrueType. Together with Microsoft, Adobe therefore developed the OpenType format. This is effectively an extension of TrueType that also supports the PostScript format. Special about Open-Type is furthermore that it is 'cross-platform'; it can be used on both Apple and Windows computers and consists of one file that stores outline, metric and bitmap data. As mentioned earlier, an OpenType font can be based both on PostScript (.otf) and TrueType (.ttf). Just like the GX technology and TrueType, it is based on the Unicode identification system, a standard division for characters and their combinations (glyphs) in various languages. A large number of positions are defined and they have the same numbering in every OpenType typeface. A type designer need not, as in PostScript Type 1 and TrueType typefaces, assign certain characters a different position to the one prescribed. In PostScript Type 1 and TrueType, the Expert variant or other sub-variants of a typeface use the same sequence of 256 numbers (0–255). With Unicode, this confusion about numbering is a thing of the past. Unicode assigns characters a unique number in an abstract but consequent way for both Windows and Mac. To get the Unicode standard accepted more easily, its developers kept the first

So-called 'opticals' are supplied with Warnock Pro, an OpenType typeface by Adobe. All four variants are depicted below: the Caption for smaller sizes, the Text for normal text sizes, the Subhead for sub-headings and the Display for larger headings. Below, the four variants in a 40 pt size and here, in the sizes for which they were designed.

Dante 6

Dante 9

Dante 16

Dante 24

Warnock Pro *Caption*
Warnock Pro *Text*
Warnock Pro *Subhead*
Warnock Pro *Display*

256 codes as similar as possible to the existing ASCII and extended ASCII standards. This is the number of western characters that is readily available from a keyboard. This is why converting existing texts to the Unicode format usually poses no problems. The OpenType format can contain 65,536 characters and glyphs (0-65,535) because it is a so-called 'double byte coding'. The coding is stored in 2 x 8 bits instead of a 'single byte coding' in PostScript Type 1. True-Type is 'single byte' with the possibility of 'double byte'. Besides the western character set, an OpenType typeface can also contain character sets from Chinese languages, Russian, Greek, Arabic and Indian languages. Chinese characters, for instance, take up most of the allocated numbers in the Unicode system. To make it easy for the user, the software often has an option to choose the language. Special language dependent signs have been preselected for easy access. OpenType typefaces can also contain tables for character and glyph substitution, positioning, position with regard to the baseline and text alignment. These options are all meant to make word processing and language support easier and are less concerned with the visually aesthetic part of typography. For OpenType, the emphasis is on language related options and less on typography related options. This makes it easier for type designers to develop OpenType typefaces because everything is possible, but not necessary. In some OpenType typefaces, for instance, instead of the so-called 'opticals' being continuously variable, as was the case in QuickDraw GX and Multiple Master, a number of variants have been added with names like Caption (optimised for a 6–8pt body size), Text (9–14 pt), Subhead (14–24 pt) and Display (24 pt and larger).

In short, the OpenType typefaces consist of four essential components:
– The outline description; Bézier curves for PostScript outlines (.otf) or quadratic splines for TrueType outlines (.ttf). This includes the optical outline corrections for different point sizes;
– The hinting instructions;
– The tables for character classification;
– The typographic possibilities for substituting characters and glyphs.

An OpenType typeface can, but does not necessarily, include every possibility. The number of characters can be confined to 256 or go up to the theoretical 65,536. Apart from a Latin character set, the font can contain character sets for different languages. In Japanese, for instance, not only Kanji (Chinese characters), Japanese Hiragana and Katakana characters, but also Latin characters (Romaji) for western terms can be used. Theoretically, every language can be supported this way, and it also makes it unnecessary in Europe to make entire separate Central-European and Eastern-European variants with different accents and other characters. They are all in the same file. In practice, however, a lot of OpenType typefaces have the same functionality as TrueType and PostScript Type 1 typefaces.

Japanese is the most complicated writing system in the world because three systems are used alongside one another. The three systems are: the Kanji, derived from the Chinese picto-ideographic script (above left) with about 74,000 characters (including some no longer used), the Hiragana (76 characters) and the Katakana (76 characters), the last two intended as phonetic additions to the Kanji. Our western characters are called Romaji.

Hiragana

Katakana

Adobe Illustrator, InDesign and QuarkXpress have their own Glyphs windows that, using a menu, can call up characters of the typeface. This makes it easy to find characters, even when the typeface is very complex like the MinionPro above. By double clicking the character it can be inserted into the document. The corresponding Unicode numbers are displayed in the window as well, in the example below under the choice palette. Some letter boxes have an arrow in the lower right-hand corner. By clicking on the arrow, a sub-palette is opened from which alternative characters can be inserted.

Although OpenType is theoretically platform independent, not all possibilities are supported by the various operating systems. This is why Adobe, among others, offers support for OpenType features at programme level.

The Dutch Type Library (a Dutch company), together with URW++, has developed the DTL FontMaster programme for the production of OpenType typefaces. The programme automates complex functions using several modules. Other programmes for digitising typefaces are Fontographer and FontLab. Only FontLab has the option to convert typefaces into OpenType format. Fontographer and FontLab are easier to use than DTL FontMaster, which is aimed at the more professional font producers and type designers who are also interested in preparing fonts for distribution. As a standard, Linotype's OpenType typefaces support 48 Latin languages and usually have extensive possibilities including small capitals, ligatures, swashes, etc. A number of OpenType typefaces make use of the 'opticals' mentioned earlier. These are optical variations of the same typeface.

When making metal type for smaller sizes like footnotes and captions, the spreading of ink was taken into account, the thin strokes were made relatively thicker, the letterforms themselves were slightly wider than in normal text sizes and were more widely spaced. It is important to remember that OpenType in its most simple form does not offer a lot more than the older formats. The type designer and type company determine the functionality and choose what characters will be included.

Custom characters Characters outside the Unicode standard are catered for as well. For these characters, 'Private Use' numbers are available that have not been assigned to certain characters. This way a type designer can add characters of his or her own, but it also makes it possible to add a client's logo to a modified typeface that has been created for that client.

The controversy On paper, the possibilities of OpenType typefaces look amazing. The problem is that our American-based keyboards have too few keys to easily and quickly use all the characters at our disposal in OpenType. The layout of the keyboard is adequate for the English language, displaying virtually every character needed. For Dutch, German, French and the Central European languages, it suffices less because of the need for the diaeresis and various accents. In practice, the possibilities of OpenType really do not have a 'keep it simple' nature. The complexity of OpenType is obviously justified in cases of automatic substitution of ligatures and quotation marks, but some characters still need to be selected manually.

Another possibility is to import characters via a glyph palette (Glyphs window) in which the most exotic scripts like Osmanya, Bengali and Tamil can be approximated per character. Apart from the fact that the palette is in the way on a desktop, the input speed is a lot lower than the approximately two hundred characters per minute that can be imported via a keyboard. This is one of the reasons that, relatively speaking, little is published in a country like India. The languages contain so many different characters that it is impossible to give them all a place on a keyboard. The same goes for Japanese and Chinese. Of course new devices are being thought up to combat this problem, like importing screens or palettes that recognise a word after a few characters by means of a built-in dictionary, but it is still not ideal. The source of the problem lies in the fact that these are often oral languages that evolved writing systems much later. In Japan, this did not happen until the fourth century AD. This is why OpenType is to some degree the operating system manufacturers' pet: They do not have to supply each language version with a different character set. Many users, however, are still very happy with their PostScript Type 1 and TrueType typefaces.

Alternative characters under the lowercase 'a' key of the Arno Pro OpenType.

Digital aesthetics

In the modern day world of the media, the book type is no longer the standard. While the illusion of the 'global village' is propagated via the internet, both cultural and ethnic disintegration are taking hold of large supranational and national groups. Smaller social groups, often spread 'at random' throughout the world, affirm themselves with their own way of thinking, their own professional profiles, their own norms, their own language, their own fashion statements and their own design and visual communication codes.

An emoticon or smiley in text language, indicating that the sender is looking for attention. This emoticon is also often seen as a text version of the painting 'The Scream' by the Norwegian artist Edvard Munch. Emoticons are made using punctuation marks placed next to each other, sometimes in combination with letters or numbers, which, when turned 90 degrees, look like a face with a certain expression. Saying a lot with very few characters is a way of fast communication. Over time, this has developed into a new way of communicating, like graffiti did.

The media have followed this diversification by producing numerous magazines for special interest groups. The visually communicative languages of all these groups is constantly being created by designers who can now make use of techniques once used only by experts, and are no longer limited by the old utilitarian and aesthetic norms. In theory, every designer can act as a full-service communicator or even make his own magazine if he wishes. And those who want to create their own visual language will first want to create their own new alphabet, and in doing so will automatically create their own visual vocabulary, their own visual syntax, their own visual poetry and their own visual rhetoric. It now seems as if there was always a carefully thought-out underlying plan to the developments in graphic design and typography. But nothing could be further from the truth. A designer is no 'alien' that communicates with society from afar. The designer reacts, as a part of his social group and peer group, both consciously and subconsciously, to implicit communicative impulses and gives them form and content with their visual creations.

Two movements came into existence around 1975 from the new developments in digital type design. The first has traditional origins, where evolutionary developments, innovations and refinement in type design are visible. The second began around 1990 and saw the introduction of new typefaces drawn freehand and often designed within a day by type designers – sometimes those also active in the first movement – as well as self taught designers.
In this chapter we will try to follow these developments chronologically, predominantly with reference to the creation and the aesthetics of a digital type design.

The influences of punk and graffiti In the seventies, the years of punk, young people began to develop their own code of communication. In the exciting, mildly illegal world of messages sprayed on walls, a strongly coded picture-writing came into existence, which was almost a secret language and in which the shapes, the graffiti, were a source of inspiration for both an artistic movement – with Keith Haring as figurehead – and a new idiom in the world of graphic design. Graphic designers looked with Argus eyes at the freedom of colour, letter and image and began 'sketchy' experiments with the elasticity of the letter as a shape and as a representation of its meaning. The concepts of differentiation and identity became more important and interesting than tradition and functionality. In those days, the first hesitant 'naughty' experiments were carried out, limited to the amputation of the serifs on seriffed typefaces, the addition of serifs to sans-serifs and all kinds of cheerful mutilations and meaningful alterations to existing typefaces. In those days, these experiments used primitive methods such as dry transfer letters, letters copied out of newspapers, magazines and the type companies' speci-mens. The American designer Art Chantry is one of the great names from this movement. Recently graduated as graphic designer, he arrived in Seattle in 1978 and began furiously making posters for theatres, pop groups, political parties and film productions for students. With extremely low budgets, he drew and copied his letters and enlarged the details of existing images and printed publications. In England, the designer Jamie Reid created the album covers for the Sex Pistols and in The Netherlands it was Rob Schröder and Lies Ros's studio Wild Plakken which was involved in design for social, cultural and political organisations in a similar way.
This 'lettering' was not yet digital, but it laid the foundations for what was to be made later in the 1980's and 90's.

Typography on an album of the punk group The Tubes. It clearly shows that the letters have been deliberately distorted. These type-faces are generally traditional in character. Dry transfer letters were often used for this purpose. They were copied many times over and defaced with sand paper until the desired effect had been achieved. Photo: Joep Pohlen.

As can clearly be seen on the cover of the Sex Pistols album from 1977, cut and paste work and the use of felt-tip pens were popular. Many similar design elements can be seen in Neville Brody's work, and later that of David Carson.

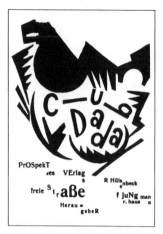

THE FACE

The magazine as catalyst In a number of magazines aimed at a younger audience and in designs for new record companies and for progressive television stations there emerged a new class of designers with an experimental approach to ideas and techniques and who were exploring the monumental, autonomous possibilities of expression with type. From the early eighties, graphic designer Neville Brody found his influences in punk and Dadaism for his work for the English magazine *The Face*. He shared the opinions of designer Wolfgang Weingart from Basel, whose reaction against the hegemony of the 'Swiss' international style is referred to as new wave typography, and who stated that legibility is not the same as 'easy to read'.

Brody experimented with typography and image throughout 1978 while studying at the London College of Printing. He designed his first typeface, Typeface One, in 1979. When he subsequently began working for *The Face* magazine in 1980, all body text for the magazine was set using a phototypesetting machine, but for the headings he used Letraset dry transfer letters in order to retain complete control over the typography. He then began combining different typefaces, and having developed sufficient self-confidence, he began altering letters and adding new elements. The process became steadily more creative. He introduced hand-drawn symbols and replaced letters, removed sections or placed letters overlapping on the page. In 1984 he created Typeface Two, which was used from issue number 50 of *The Face*. In the following years he designed Typeface Four, Five and Six. His typefaces are modular in construction, show similarities in form with Bauhaus designs and yet their roots are in the punk movement. These typefaces were drawn by hand and were reproduced by cutting and pasting.

New forms, old sources. Above, a cover of the magazine *Club DaDa* from 1918. DaDa was one of the sources of inspiration for designers like Neville Brody and Art Chantry.
In the postage stamp design shown below, by Max Kisman from 1987, the edges of the pixels used in the first computers are clearly visible. In this case the computer was an Amiga. In the early eighties, Kisman was the designer for music magazine *Vinyl*. His greatest source of inspiration was the magazine *The Face* which contained design work by Neville Brody, who designed Typeface Six, shown above, in 1986. Photo: Joep Pohlen.

The type industry ploughed forth Aside from the 'wild' young designers who attempted to force a breakthrough with their designs, the type industry was still shaped by a heavy ballast of hundreds of years of tradition and bulky type-setting machines. When phototypesetting machines slowly began replacing the mechanical typesetting machines during the seventies, designers Herb Lubalin and Aaron Burns set up the International Typeface Corporation (ITC). Their innovation was that ITC designed and introduced typefaces that did not take into account the restrictions of typesetting machines. The design itself was the starting point. Companies such as Linotype, Monotype and Berthold, which more or less considered typefaces as a component of the machine, continued to enjoy a strong market position and refused to grant newcomers licences for their popular typefaces. Sales gradually lessened as more and more suppliers began working with phototypesetting machines, including Compu-graphic, Scitex and Scangraphic. ITC met these newcomers' demands for type by introducing its own collection. The Monotype, Agfa (Compugraphic) and ITC collections have now been combined under the collective new company Monotype Imaging Inc. in America.

⊙TⵌⒶFÅHTⳐNT∞RⱭTU

ctssttﬁeehttTh

Ⳮ Avant Garde

Avant Garde Gothic was one of the first typefaces released by ITC. It is named after the magazine *Avant Garde*, where Herb Lubalin was art director. Avant Garde was designed with extreme spacing and unique ligatures (see above). These were later omitted from the PostScript version but were re-introduced in the OpenType version released by ITC in 2005.

The first digital type company Type designer Matthew Carter and divisional manager of Linotype Mike Parker decided to begin their own company in 1980, with the focus purely on design and distribution. They called it Bitstream. They were supported by young producers of hardware such as Scitex that had deve-loped powerful digital machinery but who did not have time to design their own typefaces. Bitstream filled the gap in the market and set to work with its own collection. In order to offer their clients the modern classics, they asked other publishing companies to grant them licences for popular typefaces. ITC and Neufville/Bauer did so, but Linotype, Monotype and Berthold refused. This led to Bitstream digitising designs such as the Gill Sans, Frutiger and Helvetica themselves. There was an agreement within the international typographer's society ATypI that designs that had been on the market longer than fifteen years could be produced on new machinery, but they could not be released under the same names, which were registered trademarks. This is why there are many typefaces in the Bitstream collection with similar names or names that give the same impression such as Humanist for the Gill Sans and Swiss for the Helvetica. It is a high quality collection that, with the introduction of the Macintosh computer, also became available in PostScript format. It shook up the whole world of type production and distribution and almost all the great names have been taken over by Monotype, while retaining their own distribution.

The limitations of technique Although it may sound strange, all the possibilities of the new digital techniques brought with them a number of limitations. PostScript typefaces have special display fonts that are adjusted to suit the resolution of a display screen (often 72 dpi). If the letters are enlarged on the screen, the pixels become markedly visible. Mac users from the early years will remember how difficult it was to put such a bitmapped letter exactly in register with other design elements within a layout. Adobe quickly introduced the programme Adobe Type Manager (ATM), which ensured a sharp representation of enlarged letters using the printer font instead of the display font. A similar pixel problem existed with other machinery. The first printers often had a low resolution, especially the bulk printers used by large organisations had limited rendering capacities. Also a monitor is a low-resolution device in comparison to traditional printed matter. Designers reacted to this by adapting typefaces in order to achieve an acceptable quality in print and on screen. At Océ, a company that manufactures photocopiers and printers, the Dutch designers Gerard Unger and Fred Smeijers worked on the so-called rasterisation of existing typefaces. This process, whereby instructions are formulated to use the number of pixels available in a particular font size to reproduce as closely as possible the character and legibility of a letter, is called hinting or 'gridfitting'. Digital aesthetics at the pixel level! Unger designed the Oranda typeface in 1987 for Océ, optimising it for use with printers. Because Océ is a prominent supplier in the office market, Unger based his designs on typewriter typefaces. It is an attractive serif letter that was not much used by Océ and was subsequently released by Bitstream.

The typeface CMC-7 shown above is actually more a barcode than a typeface, but its clever design makes it also legible to the human eye. At the bottom of this page are a number of symbols from E13B, which consists solely of figures and a few codes.

Oranda was designed by Gerard Unger for use with low-resolution printers. This typeface is included in the 2002 CCTV font set from Bitstream because of its good legibility as a typeface for subtitling and 'closed captioning', whereby the audio component of a TV programme is represented as text in digital television images.

Oranda – abcdefghijklmnoqrstuvwxyz

Machines for mechanical reading were also developed, and specific typefaces were designed for these machines. Examples are CMC7, and E13B made in 1965 by the American Bankers' Association, which is still used in America today for printing on cheques. Both are MICR (Magnetic Ink Character Recognition) barcode typefaces that are automatically generated by a special programme and not entered via the keyboard. Designers liked the typeface, so Bitstream included E13B in their collection under the name MICR.
For true Optical Character Recognition (OCR), whereby the computer recognises the letters from the scanned image, the typefaces OCR-A and OCR-B were

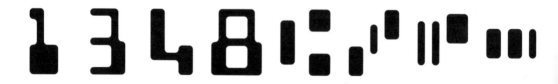

ABCDEFGHIJKLMNOPQRZSTUVWXYZ
abcdefghijklmnopqrstuvwxyz
1234567890/OCR-A

ABCDEFGHIJKLMNOPQRSTUVWXYZ
abcdefghijklmnopqrstuvwxyz
1234567890/OCR-B

Above left is OCR-A and below it OCR-B. The letters are monospaced or non-proportional, just like the old typewriters, as opposed to proportional like most typefaces. Each character in the font has the same set width, which includes both the character and the white space around it. They always line up under each other.

developed. They are based on a grid consisting of a raster with a limited number of pixels. With OCR-A, the letters are formed from 4 × 7 pixels. OCR-B, with Adrian Frutiger as advisor, was designed using a grid of 18 × 25 pixels per letter. A famous and often reproduced typeface from this period is the New Alphabet by Wim Crouwel. When designing his New Alphabet, Crouwel did not use existing letter shapes as a starting point but instead attempted to introduce new letter shapes for use with new techniques.

Below is the New Alphabet by Wim Crouwel from the like-named magazine (1967). It was a proposal for a new typeface that, more than the traditional types, was to be suitable for the cathode ray tube (CRT) typesetting system. In the foreword Crouwel writes: 'The letter has never evolved with the machine'. Capitals are indicated not by a different form, but by a line above the letter. Photo: Joep Pohlen.

In the same period – in keeping with the timeline – designs were also created with a machine-inspired aesthetic such as Eurostile from 1962 by Aldo Novarese. This letter was a development of his 1952 design, Microgramma, and was more useful for reading typography.

Microgramma – abcdefghijklmnopqrstuvwxyz
Eurostile – abcdefghijklmnopqrstuvwxyz

The same 'Zeitgeist' that drove Wim Crouwel to design a typeface that suited the technology of the day also led other designers to be influenced by this technical movement. Microgramma has clear similarities with Crouwel's New Alphabet in its modular construction of the letterforms. Eurostile, which Novarese designed later, has the same style elements but is less extreme and therefore much more suitable for use in body text. Eurostyle was very popular and enjoys a revival from time to time.

Ordinary letter production It seems as if this period was dominated by technique and to a certain degree this was the case. The new photographic and digital techniques required a great deal of adaptation, but at the same time there was also a great deal of aesthetic innovation in the primary typographic process. In 1975, AT&T commissioned Matthew Carter to design Bell Centennial. The letters contain so-called ink traps, which compensate for the effects of ink flow on thin, absorbent paper during the process of printing telephone books. Frutiger, designed in 1968 for the signposting of the Roissy airport near Paris, was released onto the market in 1973 and was considered by many to be the successor of the corporate Helvetica. It was at the time a true innovation, whereas nowadays there are of course many more humanistic sans-serifs available. It is a typeface that visually lies somewhere between the more pronounced thick-thin contrast of the Gill Sans and the taut Univers and Helvetica. A number of revivals also appeared on the market, such as the Galliard by Matthew Carter, based on a design by Granjon from the sixteenth century. This actually added a Garamond-like type to the list. Bram de Does created the Trinité in 1982 especially for the Bobst phototypesetting machine at the printing company Joh. Enschedé en Zonen. Unique to this typeface is that it contains styles with different lengths of ascender and descenders.

Bell Centennial by Matthew Carter with its characteristic ink traps.

count down

Countdown by Colin Brignall is now also available as PostScript typeface.

Transfer typefaces Typesetting with phototypesetters, the successors of the extremely labour intensive metal typesetting, was still very expensive and was difficult to control. The Mac became available in 1984 but not everyone could afford one. The so-called dry transfer letters supplied by Letraset and Mecanorma, already available for twenty years, offered a good alternative. They were rather expensive but offered an enormous amount of freedom during the design process in those days. Besides the well-known typefaces, they offered their own typefaces by designers like Milton Glaser (Baby Teeth) and Colin Brignall (Countdown). The choice was huge and as such designers used them for titles, covers and other designs with little text. The letters were manually positioned and spaced, which at the time was a welcome change. After the text had been rubbed onto a sheet of white paper, the printer put it on film that was pasted up in the layout.

Oakland Eight – abcdefghijklmnoqrstuvwxyz

Emperor Eight – abcdefghijklmnoqrstuvwxyz

Emperor Fifteen – abcdefghijklmnoqrstuvwxyz

Emperor Nineteen – abcdefghijklmnoqrstuvwxyz

Emigre Dutch designer Rudy VanderLans graduated in 1980 and then began working at the studios Vorm Vijf and Tel Design in The Hague, but was disappointed that his work was not more creatively challenging. The work of many larger bureaus consists partly of creating corporate identities, where the production process itself actually takes up more time than the creative process. He decided to spend some time travelling through America and enrolled as a student at the University of California at Berkeley where, to his surprise, he was immediately accepted. There he met Zuzana Licko whom he married in 1983. With a few other Dutch designers who had also travelled to the West Coast, VanderLans created the magazine *Emigre*. The first issue was designed completely with typewriter typography and photocopied photos. Licko was very interested in computers and quickly began to experiment and to programme. In 1984 VanderLans and Licko purchased one of the first Macs with 128K of memory.
Licko subsequently began to design low-resolution typefaces with the Font-Editor programme that was available as public domain software.
The first typefaces they designed were Emperor, Emigre and Oakland, made for use on the dot matrix printer. In *Emigre* 2, published in 1985, Emigre and Oakland were used for the first time in sections of the text.

Oakland and Emperor by Zuzana Licko. The numbers Eight, Fifteen and Nineteen refer to the pixel height of the capitals. Below is the lowercase 'g' of Oakland Eight. The number of pixels can easily be counted.

Emigre 3 was the first publication in which all the text was set using the Apple text programme MacWrite or were made in the pixel programme MacPaint. The text was printed using an ImageWriter, a low-resolution printer from Apple. PostScript and the laser printer were just coming into use elsewhere. The text was then photographically reduced in a darkroom so that the low-resolution images were not so noticable in the final printed version. The first digital steps in the world of desktop publishing were therefore not easy ones.

Citizen, Soda Script and Triplex by Zuzana Licko. These are all designs that show her interest in the basics of type design. One thing leads to another and there is always a reason not to repeat oneself. As strange as some of her typefaces seem when enlarged, they can be surprisingly legible when used in body text.

In 1982, VanderLans had made acquaintance with Henk Elenga from the L.A. Desk of the Dutch bureau Hard Werken, publishers of the like-named cultural magazine. The employees of the Hard Werken collective had not followed a formal graphic design education but were schooled in free art. Their non-traditional approach fascinated him and he attempted to apply their ideas in his own work. As such, the first publications of Emigre contain many similarities with the Hard Werken magazines. He also learned from Henk Elenga that it was possible to do more than just design, that one person could design, produce and sell a product. He began applying this principle by including advertisements for Licko's bitmap fonts in Emigre publications. When the PostScript language was introduced in 1985 and it became possible for Zuzana Licko to create high-resolution outline fonts, she designed Modula, Citizen and Triplex. She based her designs on typefaces made earlier. They were so-called smoothed bitmap fonts, which can clearly be seen in the Citizen, shown below. Her unchanged preference for bitmap fonts and the primitive forms of low resolution remain visible in this letter. Zuzana Licko analysed her own work as follows: 'I am interested in the machine. That is where I find my creative energy. I think that other people work differently. A designer such as Gerard Unger, for example,

Triplex
Triplex
Triplex

Citizen
bold or..

AaBbCcDdEeFfGgHhIiJjKkLlMmNnOoPpQqRrSsTtUuVvWwXxYyZz
1234567890

Soda Script
.light

prefers curves. For him it is unimportant whether they are drawn with a pencil or with the computer so long as the form of the curve is as he intended. He has a vision. I do not'.

With the Matrix, the first of Licko's typefaces to be more or less traditionally designed, she began to experiment in the magazine *Shift*, which Emigre Graphics made for Artspace, a gallery and performance space in San Francisco. Many of the type designs that followed, such as the Modula, Senator and Oblong, first appeared in publicity material by Artspace, after which they were corrected and made definitive. In this period, Emigre received significant criticism about the illegibility of the magazine, the typefaces in particular. Licko took no notice of this and was of the opinion that it was all a matter of habituation. Companies such as Adobe contacted her. Adobe wanted to include the Matrix in the Adobe Type Library. Matthew Carter at Bitstream, who was an admirer of Licko's work, wanted to publish the typeface Variex through Bitstream. Eventually, Emigre published the typefaces themselves and they have now built up a large library including works from other designers such as Barry Deck (Template Gothic, Arbitrary), Jefferey Keedy (Keedy Sans), Frank Heine (Remedy, Motion, Dalliance), Jonathan Barnbrook (Mason, Exocet, Priori), P. Scott Makela (Dead History) and Sybille Hagmann (Cholla). Emigre's last magazine appeared in 2005.

At the top of the page is a beautiful ornament from the Dalliance Flourishes style and below a text set using the roman and italic styles. Right is the Variex, designed by Licko and VanderLans and constructed using straight and curved lines. The bolder versions are made simply by thickeniing the lines. Bottom right is the Unicase style of Filosofia.

Unique to Emigre is that Zuzana Licko's development as a type designer stemmed from the techniques available and was particularly linked to the arrival of the computer as replacement of traditional typesetting machinery. Although she received a lot of criticism about the legibility of her texts, this lessened over time. In contrast to designers who experimented with typefaces specifically suited for headings in the *Fuse* series by FontShop, Licko's experimentation was always directed more towards the design of body text types. From this standpoint, her designs are unique in that they are reminiscent of the fanaticism of the type designer she admired the most, Giambattista Bodoni. Licko's palette (and that of Emigre) also comprises very legible and classical typefaces such as Filosofia, Licko's own interpretation of Bodini, yet of course very much her own creation with less contrast and a more geometric construction. The Unicase version of the Filosofia, with capital and lowercase of equal height, is a separate style.

Dalliance was designed for Emigre in 2000 – 2002 by Frank Heine. His inspiration for the design came from the (cursive) *handwriting* of Luitenant Aldegonde on a map dating from 1799, used in a battle in Ostrach, Germany. Heine had come into possession of the map during a project for a museum. The roman of this typeface is unique in that the *Script* was designed first. As shown above, the Flourishes style contains beautiful ornaments.

FILOSOFIA unicase

ƏZR

The Decoder typeface by Gerard Unger for the Runes edition of *Fuse* 2. The intention was that those who received this *Fuse* would play with the forms, which were based on Unger's typeface Amerigo. This process could then result in a completely new typeface.

FontShop In his first book *The Graphic Language of Neville Brody*, released in 1988, Neville Brody states that he had nothing to do with what he considered the too easy computer, but he subsequently set up the type foundry FontShop in 1990 together with Erik and Joan Spiekermann. The combination of Erik Spiekermann – who designed sound, trim typefaces – and a punk designer like Neville Brody resulted in a pleasingly schizophrenic collection, which on one hand included well designed text typefaces and on the other challenged legibility with strange yet beautiful letter forms. This mixture resulted in these often maligned and less legible typefaces being made 'acceptable', even though many traditional type designers did not approve. Many type foundries were founded around 1990 but FontShop, like Emigre, spent the following years building a consequently sound collection, which now includes several thousand typefaces.

Between 1991 and 2000, Neville Brody and Jon Wozencroft together published the *Fuse* series under the flag of FontShop. Four designers per publication were asked to submit an experimental typeface that had been designed especially for *Fuse*. The publication was presented in a cardboard box and included a floppy with the typefaces in PostScript format and four posters, one by each designer. A number of the typefaces were later completed and included in FontShop's FontFont collection. Dozens of famous type and graphic designers took part in this exercise.

Fuse 1 from the summer of 1991. The box contains four folded posters, one for each of the four typefaces included. From left to right: F State by Neville Brody, F Stealth by Malcolm Garrett, F Can You ...? by Phil Baines and F Maze by Ian Swift. Photo: Joep Pohlen.

Below: a selection of characters from FF Meta. A typical characteristic of Meta is the 'l' which is rounded at the bottom, making it easily distinguishable from a capital 'i', which in many sans-serif typefaces has a similar appearance.

ghijklmno

Deutsche Bundespost
Deutsche Bundespost

FF Meta is named after the design bureau MetaDesign, where Erik Spieker- mann used to be co-owner. In 1984 MetaDesign was given the task of design- ing a typeface for Deutsche Bundespost. When it was completed, the client decided, at the very last moment, not to use this new design and instead to continue using the Helvetica. In those days it was not easy to distribute a typeface because each typesetting machine had its own proprietary format and the fonts had to be produced specifically for it. It would therefore have been a huge task to bring this new typeface onto the market, even though the Deutsche Bundespost was of course a large client for printing companies. Helvetica was used throughout Germany in almost every printing office, either in its original form or as a clone. Hence the client's pragmatic choice. Spieker- mann was understandably unhappy with this decision but took the oppor- tunity to set up his own type publishing company, and a few years later he did so. One of the first typefaces was the 'Deutsche Bundespost' type, which he renamed FF Meta. A gifted speaker, he was and is often asked to speak at seminars and symposiums and has a multitude of contacts, also with Dutch designers. These contacts of course helped him to build up a type collection. In this active period of type design, many young type and graphic designers worked at MetaDesign, for Berlin was the place to be in the days of the newly re-united Germany. This included Dutch designers Lucas de Groot (FF Thesis), Just van Rossum (FF Beowolf), Erik van Blokland (FF Beowolf, FF Trixie), German designers Ole Schäfer (FF Fago, FF Info), Henning Krause (FF Magda Clean) and Jürgen Huber (FF Plus), Austrian Albert Pinggera (FF Strada) and the Swiss Eva Walter (FF Dotty).

Above Helvetica and below it the intended replacement for the Deutsche Bundespost which as 'Meta' later became a strong starting point for founding FontShop.

aa
Scala
ScalaSans

Scala by Martin Majoor was originally designed in the mid- eighties for the Vredenburg music hall in Utrecht. FontShop released FF Scala in 1991. As a result of its enormous success, Scala Sans was added in 1993 (shown in black).

FF Angst is by the German desig- ner Jürgen Huber. As well as these and a number of other splurges into the world of typo- graphy, which can be purchased in the FF DirtyFaces 6 package together with designs by Eva Walter, he also designed the sans- serif FF Plus with an extended type family.

Designers from all over the world reacted to the FontShop initiative, submit- ting designs or replying to Neville Brody's call to join Fuse. This is why the work of more than fifty designers is included in the FontFont label collection. Although the list includes designers who started out with traditional compa- nies such as David Berlow, Christopher Burke, Albert Boton, Evert Bloemsma and of course Erik Spiekermann, it was the younger designers who enthusias- tically expanded the collection with more or less traditionally designed type- faces as well as the most diversely different typefaces which function as headline types but can also be used for film posters, advertising for dance parties, etc. An education in type design was not a prerequisite to join the FontFont team.

FontShop published the diverse *FontBook*, of biblical proportions, which con- tains all the available typefaces. Above all, it remains a work in progress with publications showing possible uses for specific typefaces and giving back- ground information. FontShop distributes collections by other publishers alongside its own, with a total of forty thousand fonts or styles.

Helvetica
Univers
Frutiger
Avenir
Syntax
Memphis
Palatino
PMN Caecilia

A selection from the famous Linotype collection. Optima designed in 1958 by Hermann Zapf is included in the typeface section of this book. This classic typeface remains one of the top five best selling typefaces at Linotype.

Linotype This type company, which is home to a great tradition in the world of type design, almost missed the boat in the early days of digital type. After Bitstream had tried in vain to acquire licences, Adobe's request in the mid-eighties was granted and URW in Hamburg began digitising famous Linotype typefaces such as Helvetica, Univers, Optima and the Frutiger. This was followed in 1990 by the fusion with the firm Dr. Ing. Rudolf Hell GmbH, a pioneer in the area of digital typesetting. The type collection at Hell consisted almost exclusively of relatively new designs by Dutch designer Gerard Unger and German designer Hermann Zapf. This collaboration once again saw the light of day in 1997 in Heidelberg Druckmaschinen AG. Heidelberg named the type library Linotype Library and in 2005 this was shortened to Linotype, which is now a component of Monotype Imaging. As the twentieth century progressed, the collections of Haas'sche Schriftengiesserei (Helvetica, Clarendon), Klingspor (Koch Antiqua, Wilhelm Klingspor Gotisch), Deberny & Peignot (including Univers), D. Stempel AG (Neuzeit Grotesk, Palatino, Optima, Sabon), Fonderie Olive (including Antique Olive) and a number of other smaller foundries were brought together under this name. Due to the large number of famous typefaces included, Linotype refers to this as 'The Source of the Originals'.

During the rougher period in which all the company's hardware disappeared, Linotype continued to focus more and more on their typeface collection. As such, typeface licences were given to Microsoft, Apple and Adobe, and Linotype began the digitisation of its own collection. Above all, Linotype has always focussed on keeping its collection up to date. Its typefaces have been extended to include the euro symbol, small capitals and ligatures were added and Linotype played a pioneering role on many levels in the typographic world, such as the release of OpenType fonts and the organisation of type design competitions to discover new talent. Linotype has shown its innovative character with its Platinum series, which includes brand new typefaces designed specifically for certain media – such as the Compatil, specially designed for use in annual reports – and extensively revised and expanded versions of Syntax, Optima, Palatino, Sabon, Univers and Frutiger, with many extra styles. This company has thus played a significantly active role in developments within the industry and has also become a part of Monotype Imaging. Only the future will tell if Linotype will once again play an independent role in the whole story.

Two calligraphic typefaces from the Linotype collection. Wilhelm Klingspor Gotisch was designed in 1925 by Rudolf Koch. Zapfino by Hermann Zapf dates from 1998 and is a true digital typeface that was never made for metal typesetting. In fact it could not have been, due to the fine overlapping lines and the intersecting ascenders and descenders.

Linotype Aroma – abcdefghijklmnopqrstuvwxyz

Linotype Aroma – abcdefghijklmnopqrstuvwxyz

Linotype Aroma – abcdefghijklmnopqrstuvwxyz

Linotype Aroma – abcdefghijklmnopqrstuvwxyz

Linotype Aroma was designed in 1999 by Tim Ahrens for the *Take-Type* collection. The family has now been extended to include ExtraLight, Light and SemiBold styles and small capitals for most styles.

The International Digital Type Design competitions that took place in 1994, 1997 and 2003 gave rise to the *TakeType* CD series with new typefaces, which were sold for attractive prices. The top *TakeType* CD is a compilation of the best 130 typefaces from the series. The aim of these competitions is the discovery and development of new bestsellers which can be added to the list and that are not only designed by young, up and coming type designers but also by the top-class established designers such as Hermann Zapf, Adrian Frutiger, Gerard Unger and Jean François Porchez.

Compatil|Exquisit
Compatil|Fact
Compatil|Letter
Compatil|Text

In 1996 Linotype also launched a significant project under the direction of Olaf Leu to develop a typeface specifically for annual reports. Such a financial publication is in essence a medium whereby many different characters are used; product names, company names and different kinds of figures appear both throughout the body text and in tabular form. Typefaces are often mixed in annual reports. The headings are then set using a different typeface than the body text. The x-height and ascender and descender length of these typefaces often differ. Olaf Leu and his team came to the conclusion that it should initially be a typeface with four styles and four versions. After a thorough comparison of existing typefaces, a list of advantages and disadvantages was formulated and the Compactil was made in four versions: Compatil Exquisit (a humanistic), Compatil Fact (a sans-serif), Compatil Letter (a slab-serif) and Compatil Text (more transitional than didone). In total it comprises sixteen styles with small capitals and Central European character sets. A unique feature is that the four different typefaces can be interchanged because the overall text width is the same in each version. The line weight is also visually equal so that a body of text has the same grey tone in all four versions. Although the designs are not spectacularly different from existing designs, its completion as a whole system in digital form is unique. In this respect it is a very special project.

KLEINKAPITALEN
KLEINKAPITALEN
KLEINKAPITALEN
KLEINKAPITALEN

1234567890
1234567890

The examples above clearly show how systematically the Compatil is constructed and how the width of all four styles is consistently equal without the whole appearing forced or out of balance. The small capital figures below also have the same width as the regular figures as well as the same characteristics.

Berthold The story of Berthold is very different. Even though designer Günter Gerhard Lange returned in 2000 in his senior years as artistic director, the company never regained its leading role in the industry. Having worked since 1951 with almost painful precision on Berthold's typefaces, Lange retired in 1991. He was succeeded by Bernd Möllenstädt, who had worked at Berthold since 1967. In 1984, Möllenstädt designed the much-used Formata, which was later released under license by Adobe. He began digitising of the Berthold library in 1991. Since 1998, he has worked as independent designer on Berthold's collection (including euro signs and Expert fonts).

At Berthold, Lange designed typefaces such as Concorde, AG Book, Arena and Imago and above all he designed various revivals of typefaces like Baskerville, Bodoni, Akzidenz Grotesk and Garamond.

In 1987, the project group Zettechniek of the GVN (Grafisch Vormgevers Nederland – Dutch Graphic Designers) released a publication about the Berthold typesetting system, which at the time was considered aesthetically superior to the other phototypesetting systems and the Mac. Time has proved otherwise. The digital aesthetic and modernization of the famous Berthold type collection has remained limited to the digitisation of the existing collection.

Also noteworthy in the Berthold system is that the cap height is given in millimetres and serves as a measurable font size. Berthold adopted the metric system. This is in contrast to other type foundries that have always stuck to the nominal body size designated in points.

Left: is the lowercase 'a' from Formata. Right: some designs from Berthold and below them a series of typefaces from Berthold with a font capital size of 18 mm. Below that a series of typefaces from other foundries that each have a different capital height at a font body size of 54 pt.

Berthold Akzidenz Grotesk

Berthold Concorde

Berthold Formata

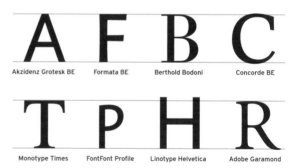

A	F	B	C
Akzidenz Grotesk BE	Formata BE	Berthold Bodoni	Concorde BE

T	P	H	R
Monotype Times	FontFont Profile	Linotype Helvetica	Adobe Garamond

Times

Plantin

Bembo

Gill

Joanna

Rockwell

Baskerville

Centaur

Arial

As with Linotype, here a selection of the top classics from Monotype.

Monotype Monotype is one of the most prominent suppliers of typesetting machinery and typefaces. Just like Linotype and Berthold, Monotype landed in a crisis when the arrival of the Mac made its hardware obsolete. A wave of new owners came and went. In the early nineties, its collection was digitised and Monotype was the first to begin adding so-called Expert fonts, including small capitals, ligatures and old style figures. In 1990, Monotype's entire library was available in PostScript Type 1 format. In 1991, licences were granted to Adobe for the distribution of Monotype typefaces. In 1998, Agfa (with the former Compugraphic library) took over Monotype and combined their typefaces under the collective name Agfa Monotype. In 2000, the International Typeface Corporation collection (ITC) was added, which had previously taken over the Letraset library, and under direction of a new owner the company name was changed to Monotype Imaging. The Arial, an altered version of the Helvetica, is Monotype's most popular typeface. Monotype has since also taken over Linotype.

Legacy

ITC Legacy is a design by Ronald Arnholm from 1992 with a Serif and a Sans. The Serif Bold is shown here.

Even though Monotype has not published a great many new typefaces itself during recent years, the additions of the Agfa, ITC, Letraset and Linotype collections have ensured that the Monotype library is extensive, containing a number of the most popular typefaces on the market. Toppers are of course Times New Roman, Arial and Gill Sans. ITC also had several popular typefaces such as Avant Garde, Galliard, Franklin Gothic, Stone, Quay and Officina. More recent additions are Legacy and Conduit. A beautiful typeface that came from Agfa is Rotis by Otl Aicher from 1988. Many typographers consider the Semi-Serif version controversial due to its ambiguity between serif and sans-serif. Others consider it more beautiful than the Serif and a perfect type for body text.

ITC Officina Sans

ITC Officina Serif

ITC Stone Sans

ITC Stone Serif

ITC Stone Informal

ITC Conduit

ITC Officina is a design by Erik Spiekermann and Ole Schäfer dating from 1990–1998. ITC Stone was designed by Sumner Stone in 1988 and ITC Conduit in 1997 by the American Mark van Bronkhorst. Agfa released Rotis by Otl Aicher in 1988.

Rotis Semiserif
Rotis Serif

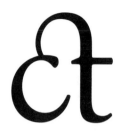

A splendid ligature from Adobe Garamond by the designer Robert Slimbach.

Adobe Type Library This collection was started in 1984 to help boost Adobe's sales of software products and desktop publishing as a whole. It is a credit to Adobe that the quality of its typefaces for use in its own software was taken seriously right from the start. The Adobe Type Library is a purely digital collection and brings with it no excess baggage from the traditions of the industry. In order to make a quick start, licences were purchased for the best-sellers from other suppliers. Adobe has also always respected artist's rights and requested licences right from the beginning. Partly by striving for the highest possible quality typography, and by the high quality of both its purchased typefaces and own designs, Adobe aided a huge and rapid advance in desktop publishing.

Sumner Stone, type designer and former director of typography at Adobe, began selecting the typefaces he had in mind for the library back in 1984. He chose from well-known collections such as those of Linotype, Berthold and ITC as well as commissioning designers like Robert Slimbach and Carol Twombly to design new typefaces. The results were classic designs such as the exquisite Adobe Garamond and Adobe Caslon, as well as completely new designs such as Myriad. For the Garamond it was logical to use the existing Garamond series as starting point, but Slimbach went to Antwerp to study original sixteenth-century type specimens and recent proofs of type made from the surviving original punches and matrices in the Plantin-Moretus museum in order to remain as true as possible to the original. The Adobe Garamond was pretty much the first typeface available with small capitals, ligatures, swash capitals and old style figures. Slimbach based the italic on some by Robert Granjon from the sixteenth century. Adobe Garamond and Stempel Garamond are considered the most beautiful digital designs ever made. For the Trajan, which comprised only capitals, Carol Twombly referred back to the Imperial Roman capitals carved on Trajan's Column. Adobe also introduced the Multiple Master-fonts in 1991 as ultimate digital format, whereby an almost unending number of styles could be generated from a number of basic forms. This project was frozen in 1999 (see also page 147). From 1997, Adobe began working with Microsoft on the OpenType format, which was to replace PostScript and TrueType as a cross-platform type format. Part of the library is now available in OpenType, with the addition of Pro after the name of the typeface.

The section sign from Minion by the designer Robert Slimbach. On the right-hand page is a pattern made from a leaf ornament from Minion with below it a line set in Adobe Garamond. At the bottom of this page is Myriad from 1992, Nueva from 1994 and Chaparral from 1997 by designer Carol Twombly. All are OpenType versions.

Myriad Pro – abcdefghijklmnopqrstuvwxyz

Nueva Pro – abcdefghijklmnopqrstuvwxyz

Chaparral Pro Adob

Garamond ߃ſßℨ£‡fiﬂ‡&

Angie
Quay Sans
Interstate
Fedra Sans
Dolly
Sauna
Imperial

Industrious type designers If you can do it yourself, then why not do just that? More and more type designers came to the realisation that they could promote and sell their own work on the internet. The whole process ultimately begins with the designer. The smaller font suppliers should certainly be and now often are taken seriously and some offer typefaces that equal those of the most famous firms in quality. Jean François Porchez began his own type publishing company after having his FF Angie published by FontShop. Lucas de Groot released the successful FF Thesis through his own company LucasFonts and David Quay began The Foundry after having designed various typefaces for Letraset and Quay Sans for ITC. The American company Font Bureau was also started in this way in 1989 by founders David Berlow and Roger Black. They designed mainly custom (body text) typefaces for publications like the *New York Times* and *Newsweek*. Tobias-Frere Jones designed the popular Interstate for Font Bureau and later began his own company with Jonathan Hoefler. In 1991, Matthew Carter left Bitstream, which he had co-founded, and started a new company Carter & Cone together with Cherie Cone. He also designed the famous Verdana. In 2002, Dutch type designer Fred Smeijers, together with Rudi Geeraerts from FontShop's Belgian office, began the label Ourtype to produce his own designs. Peter Bil'ak released his Fedra Sans through his own company Typotheque. Underware combined type design with graphic design in unique printed publications for each new typeface. The fonts were supplied on CD-ROM and users were requested to pay licence fees only when they actually used a font.

In Germany there are a few bureaus that are not predominantly active in designing but that provide services between the producer and the user. Elsner + Flake is the design studio of Veronika Elsner and Günther Flake from Hamburg, founded in 1986. They have digitised typefaces for authoritative producers such as ITC, and expanded them with euro symbols and Central European symbols. Turkish, Greek, Arabic and Hebrew typefaces are also available in the ever-growing Elsner + Flake library. Over time they have made their own designs and added revivals and display fonts to their collection. The second Hamburg-based studio to be involved in the digitisation of typefaces from the beginning of the digital era is URW++. Directed by Peter Karow, URW (without plusses in the beginning) developed the programme Ikarus which was used in the early days of the digital era by large foundries such as Linotype, Monotype and Berthold for the digitisation of typefaces. Dutch designer Albert-Jan Pool went to work at URW and made Imperial, a sans-serif typeface with the contrast of a serif letter. Some called it a Bodoni Sans. After a bankruptcy, the new URW++ (without Peter Karow) developed the programme FontMaster together with the Dutch Type Library, which used various modules to produce a typeface.

TheMix 5
ABCDEFGHIJ
KLMNOPQRS
TUVWXYZ
abcdefghij
klmnopqrs
tuvwxyz
ABCDEFGHIJ
KLMNOPQRS
TUVWXYZ
1234567890
1234567890
1234567890

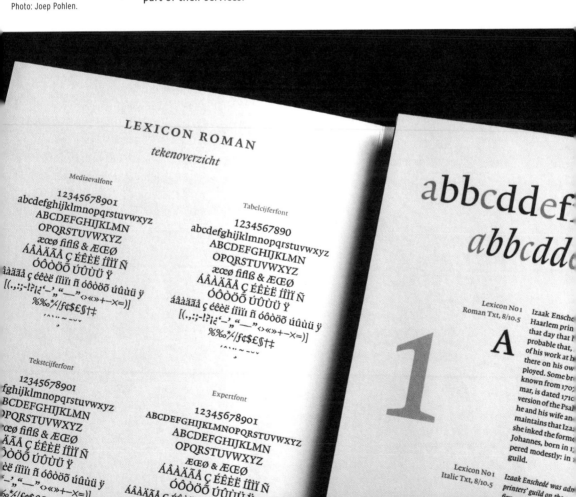

In The Netherlands there are still a few type companies that work in a typo-
graphic tradition to supply typefaces mainly for use in books. The first is The
Enschedé Font Foundry (TEFF). The printing company Joh. Enschedé en Zonen
was founded in 1703 and is renowned for its high quality printing of bank
notes, postage stamps and other unique works.

The company purchased the type foundry of Hendrik Floris Wetstein in 1743 and
began producing its own typefaces. Famous names have since worked for or at
Enschedé, including Joan Michael Fleischmann, Jan van Krimpen and Bram de
Does. In 1978 Enschedé commissioned De Does to design a new typeface for
the phototypesetting system at Enschedé to commemorate its 275th anniver-
sary. This typeface became Trinité. The demand for Trinité was what led Peter
Mathias Noordzij to begin TEFF in 1991, thereby continuing Enschedé's tradition
of craftsmanship into the digital era. In 1992 Lexicon was introduced, originally
designed specifically for the dictionary publisher Van Dale. Fred Smeijers de-
signed the Renard, Gerrit Noordzij the Ruse and Christoph Noordzij the Collis.
It is a small company with beautiful, classical typefaces for the discerning user.
The prices for licences are relatively high and therefore the distribution is
relatively limited. Part of the work of TEFF is the supply of special symbol sets
such as phonetic symbols for dictionaries. Custom made typefaces are also
part of their services.

A second producer is Dutch Type Library (DTL) that, like TEFF, specialises in typefaces for books. Founded in 1990 by Frank Blokland, it aims at supplying high quality typefaces of Dutch and Flemish origin. Their production levels are higher than at TEFF with half the typefaces new designs and the rest re-releases and revivals. Type designers are asked by Blokland to create a design, and then the subsequent technical processes are carried out by DTL. Re-releases are Albertina from 1960 by Chris Brand and Haarlemmer, designed in 1938 by Jan van Krimpen but never previously put on the market. Both were originally made for Monotype. Albertina is also available through Monotype. Revivals are VandenKeere, Elzevir and Fleischmann. Prokyon and Antares are by Erhard Kaiser, Argo by Gerard Unger and Dorian by Elmo van Slingerland. Exclusiveness is more or less guaranteed due to the high prices, although DTL enjoys better international distribution because URW++ acts as its distributor in Germany. DTL Documenta was the result of a collaboration in 1988 between Petr van Blokland and Frank Blokland for the Purup laser printer system. When the collaboration ended, Frank Blokland made Documenta for his own DTL and Petr van Blokland made Proforma for Purup. When Purup was sold in 1992 the rights returned to him and he subsequently released Proforma through Font Bureau in Boston after having added a number of styles and small capitals.

FiSH-

In an edition of the magazine
Ray Gun, David Carson replaced a
number of characters in a par-
ticular typeface with different
characters from the same type-
face. This was no problem in a
programme such as Fontographer.
A strange looking, almost phone-
tic text is the result. Surprisingly
enough it remains legible. And
the typeface in question is the
good old Times New Roman.

Magazines as driving force in type design Earlier in this chapter we exam-
ined the role of the magazine as catalyst for the experimental type design of
the 1980's. We have discussed the progress of the immensely popular designer
Neville Brody, who after his magazine phase with Erik Spiekermann went to
work at FontShop. Alongside and after *The Face*, a new star emerged in the
world of magazine design. Sociology teacher David Carson decided to take a
new direction in his life and became a graphic designer. As a keen surfer, the
first magazine he designed was *Beach Culture*. It won one award after another
but was financially unsuccessful. About three years after it went under, Carson
became art director of the magazine *Ray Gun* in 1992. In the nineties, the intro-
duction of the Mac greatly increased the possibilities of playing with the body
text of a production. Neville Brody had been forced to limit his design input
to the layout and typography of titles and headings. In this respect, a whole
world lay open for Carson. He viewed the design from a conceptual and emo-
tional point of view and tried to use the text and images to make contact with
the reader. It was not his intention to make illegible texts. He wanted to achieve
communication on an emotional level. A result of this method of working
was that the text was less legible, and some sections were even completely
illegible. Initially, the authors found this disturbing, but later they complained
if their article looked more 'normal' than another. Carson's popularity took
on pop-star proportions and his work was imitated by many designers and
students the world over. The most significant difference with Neville Brody's
work remained that Carson had not been educated as a designer. He was a
composer. It is with good reason that designer Edward Fella called him 'The
Paganini of typographers' as he succeeded in placing all components in the

Achilles Blur

right place without being aware of the dogmas or pre-conceived ideas that
always limit the creativity of an educated graphic designer. David Carson did
not design typefaces, but commissioned others to design them. Preferably new
ones for each new publication. When the number of typefaces had significantly
increased, Ray Gun Publishing established the type company Garagefonts.
Garagefonts now has a diverse library and currently operates independently
of *Ray Gun*. Although the *Ray Gun* collection is almost entirely comprised of
extreme and poorly legible typefaces, it also includes some more legible,
recently designed typefaces.

Achilles Blur by Rodney Shelden
Fehsenfeld for *Ray Gun* was in
1994 one of the very first blur
typefaces. It seems as if the lens
of a camera has purposely been
set out of focus. Fehsenfeld has
recalled all his typefaces from
Garagefonts and is reportedly
making music again instead of
typefaces.

so-called women's

MAGAZINE A WHILE AGO

SEEN A REVIEW OF BUST IN SOME

DEAR BUST GALS,
I LOVELOVELOVE your MAGA-
ZINE! I picked up the "MEN WE
LOVE" ISSUE ON A WHIM - I'D

MARCY B.

Anyway, I just wanted to let you know
LE THAT THE GIRLS OF AMERICA ARE BEHIND YOU
100% AND I CAN'T WAIT FOR THE NEXT ISSUE
OUR THEY ARE MISSING.
BAD THESE GUYS DON'T KNOW WHAT
OF BUST.

SE IN HEAVY. SHE'S MY LOVER'.
OPESMEN SHOULD SHARE ANDREW'S
ATTRACTION TO LARGER WOMEN;
NISH'LARGER WOMEN
'SHE AIN'T
MORE

PHILADELPHIA, PA.

Hi CELINA AND BETTY
I LOVE BUST. IT'S AT T
ZINES. I READ THE "MEN
I REALLY ENJOYED TH
WHERE HE MENTIONED TH
THEM WHEN I WAS YOUNG
ONE THING ABOUT THE LAT
IT, I WAS THINKING IT WA
A-PHONE-CALL-THING WA
IT'S MORE OF AN AMERICA
AL DIFFERENCE. IT DIDN'
OR MY GIRLFRIENDS. TH
THAT SITUATION. CALL I
GUY WHO'D NOT PHONED (
THIS AND HE SAID "YEAH
SHOULD PROBABLY READ
WAYS BEFORE I COULD LEN

GLAD I GOT IT. I SPENT THE WHOLE REST OF THE
EVENING READING IT, THEN CALLED A FRIEND IN DALLAS
AND READ MOST OF IT ALOUD TO HER. DON'T YOU DARE
STOP PUBLISHING. LOVE FOREVER,

MONICA
Sydney, Australia.

ANNE
New York, NY

INA AND BETTY:

e pass on to whoever Jane Air
I read her cunt article in my
O COOL. I, TOO, WAS A FAITHFUL Sassu READER
MINIST ENCOUR

JESSICA V

DEAR BUST,
YA KNOW, IT'S NOT THAT '
LY CONFUSED ABOUT WOME
THAT'S PUBLICLY IDENTIFIE

St. Paul Minnesota

DEAR BUST,

Above is a typical page from the spring 1996 edition of *Speak*. Below a section of the cover of the 1996 issue number 1 of the magazine *Blah Blah Blah* from MTV, published by Ray Gun Publishing. Photo: Joep Pohlen.

In the wake of *Ray Gun*'s success, two new magazines appeared in which the layers of text and image strengthened each other, and surprisingly the readers actually read the text. This was in contrast to all the concepts of good typography. Magazines like *Plazm* and *Speak* introduced a similar formula. The starting points were always their own typefaces. Type designers were asked to design these and were even mentioned in the colophon of *Speak*.
In 1996, MTV commissioned the magazine *Blah Blah Blah*, published by Ray Gun Publishing. Its readers soon realised that it was more or less a clone of *Ray Gun* and stopped buying it. Production dried up after just a few numbers. Under the title *The End of Print*, David Carson released two books and most publishers subsequently reverted back to the use of good old legible text. A controversial period was over. What remained was the concept adopted by Emigre's Zuzana Licko, which was that legibility has everything to do with habituation. Above all the reader must want to read. Countless beautiful typefaces were produced as a result of this movement, often distributed by smaller companies. A co-operative supplying these typefaces is Phil's Fonts.

PRESIDENT NIXON

The 1994 President Nixon typeface from Plazm Fonts by Pete McCracken.

Autonomous type design As well as the two extremes of the spectrum, the legible and the illegible typography and all the in-between forms with their corresponding typefaces, there are also designers who take experimentation as their starting point. They explore the boundaries of typography and type design. The Frenchman Pierre di Sciullo is one such designer. He received the Charles Nypels Prize in 1995 for his typographic experiments. He has produced the magazine *Qui? Résiste* (www.quiresiste.com) since 1983, in which he experiments with quotes, collages and transformations. As a sideline to this he also began drawing letters. As such he explored form, content, letter, word, sentence and text, and tried to add an invisible dimension.

For Di Sciullo, the content is inextricably linked to the form. And so he tries, by playing with legibility and illegibility, to lead his readers to the essence of text and image. The letter should become living material. In this way, Di Sciullo can be seen as a successor of the Dadaists, who regarded the writing and the setting of text as a double entity. Di Sciullo's type design Sintetik reduced the French language to the extreme. The words 'fond(s)' and 'font' were, for example, written as 'fon'. Only within context could the reader establish the meaning of the word within the text. At FontShop he created the FF Minimum, whose different styles make the experimental character of the typeface evident. Some styles are reduced to just horizontal and vertical lines. Di Sciullo's Gararond, a parody of Garamond, is available at Agfa Typographic Systems, now Monotype Imaging.

Below left is Sintetik by Pierre di Sciullo, with the word 'photography' clearly visible, spelled phonetically.
Bottom right is his FF Minimum, which was released by FontShop. Below the Clair, Medium and Noir styles in the first column are the Horizontal and Vertical styles that comprise only the horizontal and vertical lines of the text. In principle, exactly the same letters are shown as above. The typeface has no direct influence on the text, it is simply a coded translation in a particular system. Placing these typefaces over each other or mixing them together was Di Sciullo's way of exploring the results of these interventions with the terms subversion and support. Photo: Joep Pohlen.

Minimum clair	Minimum Bong Clair
‾·‾_‾ _‾ ‾≡‾·	Minimum Bong Medium
Plımıꞁıꞁı l hıu	Minimum Bong Noir
Minimum Medium	minimum noir plafond
‾·‾_‾ _‾ ‾≡‾_·	minimum Noir Sol
Plımıꞁıꞁı Plhıu	Minimum Ivre
Minimum noir	Minimum Éclair
‾·‾_‾ _‾ ‾≡‾·	Minimum Crible
Plımıꞁıꞁı lhıu	Minimum Toc

The Dutch designer Max Kisman, many of whose designs can be found in the Fuse series, was experimenting with computers to make new designs even before the introduction of the Mac. In 1986 he and some friends began the magazine *TYP/Typografisch papier* which has since then been sporadically produced. The Dutchmen Erik van Blokland and Just van Rossum joined forces to create the studio LettError, winning the Charles Nypels Prize in 2000 for their typographic innovations. They treated the letter as an actor who received instructions via the computer about how he should appear. Each letter can act differently, as in the typeface Beowolf from 1990 where the contour is defined at random, within certain limits. FF Beowolf was also one of the first typefaces of the then young FontShop. Since then Van Blokland and Van Rossum have designed many famous typefaces such as Trixie, StampGothic, Karton, Advert-Rough and the quasi-random typeface Kosmik. Some of these typefaces are by their standards rather ordinary. Although LettError is currently not actively developing new typefaces, they still play with type, colour and form which are randomly defined through their own parameters and programmes. Commissioned by MTV, they developed a typeface specifically for video. LTR Critter has a small difference between the x-height and the cap-height and has a sturdy and compact design so that it remains legible when used for subtitles with minimal line spacing in videos.

Below is Network by Max Kisman, a typeface similar in form to the letters he drew in the *Tegentonen* posters for Paradiso in Amsterdam. Beneath this is Kosmik by LettError. Both the Plain and the Bold have three styles with alternative characters so that the illusion can be created that the text has been handwritten. In handwriting, after all, it is impossible to write each letter exactly the same every time. With normal fonts one would have to manually switch between the styles, but the Flipper styles make these alterations automatically when the text is printed, though not on the screen. Kosmik also includes a number of special symbols, including a publish symbol, arrows in all directions, an alternative ampersand and a cloud with lightning, shown centre right below. The Kosmik Glyphs are symbols. At the bottom of the page is Trixie by Erik van Blokland.

THE DIFFERENCES BETWEEN THE THREE TYPES OF THE FAMILY

The construction develops from roman to italic; different lengths of stems, different widths and varying contrasts between thick and thin.

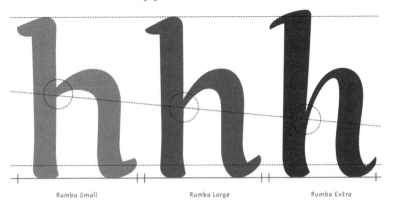

Rumba Small	Rumba Large	Rumba Extra

Left are the three different forms of Rumba by Laura Meseguer. Below left: the complete character set of the Rumba Small. With thanks to Laura Meseguer for the PDF of the typeface.

Below in red DesignOrDie by Luis Mendo, Despaxtada and Frankie-Dos by Jaume Ros and Poca by Pere Torrent and Enric Jardí, all from the Type-Ø-Tones collection.

COMPLETE CHARACTER SET IN RUMBA SMALL

ABCDEFGHIJKLMNOPQRSTUVWXYZabcdefgh
ijklmnopqrstuvwxyz0123456789€1234567890
€ÁÀÄÂÃÅĂĄÇČĆĊĐĎÉÈÊËĚĘĖĒĞĜĢĤHÍÎÌÏĮİĨ
ĨĴĶĹĽĻĿĽÑÑŅŃŊÓÒÔÖÕŐŌØŘŖŔŠ§ŞŚŜŤŢŦÚÙ
ÛÜŬŰŪŮŴŸÝŽŻŻÆŒáàäâãåăąçčćĉđďéèêëěę
ėēğĝģĥħıïíìįİĩĵĺłļŀñňņńŋóòôöõőōøřŗřšşśŝßť
ţťųúùûüŭűūŵÿýžżźæœ¡!¿?&...,·:;"'""''"[]{}()
/\«»‹›+=-–—_*ûü®©™¶@°¥$ƒ£¢†‡#<>≤≥±∓÷=+×∞~
≈%‰§||/½¼¾¹²³⁰ª fi fi fi fi ff ffi fb ffb fj ffj fk ffk fh ffh tx l·k r
ÁÀÉÈÎÌÓÒÚÙÝ

DesignOrDie

Despatxada

FrankieDos

Poca

This Type-Ø-Tones brochure from the nineties shows that some designs were extreme while others were very staid, but always with a touch of humour. FrankieDos is an altered version of the Franklin Gothic as can be seen above right. Photo: Joep Pohlen

In 1992 in Spain, Type-Ø-Tones was founded by four designers: Joan Barjau, Enric Jardí, Laura Meseguer and José Manuel Urós. Production halted in 1999 and their typefaces became available for purchase through FontShop. The collection consists solely of display typefaces. Laura Meseguer, who had previously designed several typefaces for Type-Ø-Tones, decided to follow the 'Type and Media' course at the KABK in The Hague, where she then designed Rumba, a typeface comprising the three styles Small, Large and Extra. Rumba was awarded a TDC Certificate of Excellence in 2005. In her own description of the typeface, the influences of the Hague academy and Gerrit Noordzij can clearly be heard: 'Rumba is a new typeface family consisting of three fonts based on the same model, but with varying contrast, construction and degrees of expressiveness. The family consists of Rumba Small for texts, Rumba Large for headlines and Rumba Extra, when a flavour of hand-lettering is called for. Complete character set in Rumba Small. The differences between the three types of the family: The construction develops from roman to italic; different lengths of stems, different widths and varying contrasts between thick and thin'.

Eduald Pradell was born in 1721 in Ripoll (*Catalonia*, Spain), a small village at the foot of the Pyrenees. ¶ He was born into a family of gunsmiths and learned the trade from his father. Pradell eventually opened his own workshop in Barcelona. In spite of the fact that he was illiterate, he succeeded in engraving one of the most treasured types ever to have been made in Spain. *His fame as punchcutter increased and King Carlos III granted him an allowance to cut types for the* **Imprenta Real** *in Madrid*, where he eventually set up home and began his own type foundry. ¶ Although he has been forgotten as punchcutter, Andreu Balius considers him to be one of the best of eighteenth-century Europe. Balius was inspired by Eudald Pradell's work when designing this typeface (2000–2003).

garcia fonts + co.

¶ſ sh ſt

abcdefghijklmnopqrstuvwxyz

ABCDEFGHIJKLMNOPQRSTUVWXYZ

1234567890 – ®©¶ß§@&€{}¿""‹›,«»

Pradell (above) and Trochut (below) are designs by Andreu Balius, who was inspired by old Catalan typefaces. Trochut is a revival of a design by Joan Trochut from the 1940's. Pradell is the result of two years of research whereby Balius tried to retain the details in his design that were characteristic to the work of Eudald Pradell. Above right is the homepage of garcia fonts & co. Right, below Garcia's homepage, the paragraph mark and a few ligatures from Pradell.

Two other Spanish designers, Andreu Balius and Joan Carles Perez Casasín, founded the Typerware bureau in 1993. The project in which they made their experimental type designs public, through a website and through printed publications, was called garcia fonts & co. These typefaces were not for sale; they could only be swapped for typefaces by guest designers who would then be included in the garcia fonts & co. project. Type designs by FF FontSoup, ITC Belter and ITC Temble are for sale at Typerware. Balius now has his own type foundry called Type Republic, offering several renowned typefaces such as the classical Pradell (2000–2003), inspired by designs of the Catalan punchcutter Eudald Pradell (1721–1788). The typeface contains some magnificent ligatures. The Pradell was recognised by the type design competition Bukva:Raz! from ATypI in 2001 and by the Type Directors Club in 2002.

Priori

Priori

PRIORI

Priori

Príorí

PRIORI

Priori

Priori

The Englishman Jonathan Barnbrook from the Virus type company began designing typefaces because he believed that designers had significant influence on elements such as image and layout in a design, but not on the typeface. When he got hold of the FontStudio programme in 1989, he finally had the feeling that he had complete control. At Emigre, Barnbrook published the typefaces Exocet and Mason. His hero and inspiration is the type designer Eric Gill, not only because he was socially aware, but also because he dared to suggest replacing the Roman alphabet. The question 'why' is very important to Barnbrook in his work. The fact that some critics classify his work as severe and charged just spurs him on. The names of Barnbrooks' designs are quite telling: False Idol, Patriot, Prozac, Drone and NixonScript. His motto 'Love first, money last' is equally so. In 2003 he designed Priori for Emigre. This was actually a logical step forward from Mason, which was only intended as a display type. Priori is a complete family that is also suitable as body text letter.

There are a great many examples of designers that began in the 'rough' years of digital type design whereby there was a certain amount of competition to design the most extreme type, and who then returned to the more classical traditions of the industry. These are not only Laura Meseguer, Andreu Balius and Jonathan Barnbrook with their recent designs, but also the designs of Zuzana Licko show the same tendencies. After her tantalizing Type-Ø-Tones adventure, Laura Meseguer sought the classical traditions of type design at the KABK in The Hague. Although Rumba cannot be called Dutch, the initial principles and starting points of the typical Noordzij references to handwriting are clearly visible in her design. Balius studied ancient Spanish type designers and created designs that were almost the complete opposite of his earlier works. The same is true for Barnbrook with his fascination for Eric Gill. In publications by Emigre in the early nineties, Zuzana Licko indicated that she wanted to use technique as her starting point and from there wanted to develop her signature pixel designs. From Citizen (1986) she designed the austere Triplex (1989) and continued with the classical-looking revival Journal (1990) whereby the curves are constructed of short, straight lines like Citizen, and then back to basics with Filosofia (1996), a revival of Bodoni. It is, of course, her own interpretation, more regularized and with less contrast for the text variant and more for the Grand style for headings. She subsequently made Mrs Eaves in 1996 as a revival of Baskerville. Sarah Eaves was John Baskerville's wife who, just as Bodoni's wife, continued his work after his death. Licko's inspiration for Solex (2000) came from various sans-serif typefaces like Bell Centennial, Alternate Gothic, Bauer Topic and even Meta and Officina by Erik Spiekermann. The same is true for Peter Bil'ak who started with typefaces such as Orbital and Masterpiece and then designed Eureka, Fedra and Greta.

Above is the 'M' of Mason Regular by Jonathan Barnbrook, centre Orbital by Peter Bil'ak and below the capital 'C' of Journal Ultra by Zuzana Licko.

Bukva:Raz! Organizations founded specifically to serve typography and type design, such as the Association Typographique Internationale (ATypI) and the Type Directors Club (TDC), like to keep a finger on the pulse of developments within the industry. But type companies such as Linotype are also interested in market developments. This is why competitions are held. The TDC does this every year and publishes a book containing the winners. This book includes a selection of new type designs as well as the typographic designs. It is a wonderful, annual sample of new typefaces. Another nice touch from TDC is that it lists all the typefaces used in the award-winning graphic designs throughout the book. This gives a good indication of which typefaces are being used each year by the renowned graphic designers. In 2000 the ATypI organized a competition for the first time since its establishment in 1957 and called it 'Bukva:Raz!'.

From the six hundred submissions, they chose one hundred type designs, including not only Latin typefaces but also Arabic, Hebrew, Cyrillic and Greek designs. They are all illustrated in the book *Language Culture Type*, published by Graphis and ATypI. As previously mentioned in this book, Linotype also organises competitions, from which the *TakeType* CD collections are compiled.

The hundred typefaces from the Bukva:Raz! selection show how much has changed over the last two decades and that the worldwide select group of designers has expanded to include a selection of hundreds of designers who are fascinated with both past and present. The select group of designers who began before ca. 1980, such as Gerard Unger, Hermann Zapf, Matthew Carter and Adrian Frutiger is certainly now in the minority. Type design is dominated in numbers by a younger generation of designers such as Jean François Porchez, Lucas de Groot, Ole Schäfer, Jeremy Tankard, Fred Smeijers, Martin Wenzel and Joachim Müller-Lancé. But most noteworthy is that many of the designs recognised by Bukva:Raz! also come from countries like Russia, Portugal, Mexico, Armenia and Argentina and even more surprising is that many of these are actually designs that cannot be categorised according to their geographical origins. They could quite easily have originated in the countries associated with traditional type design, where the major type companies were also situated. The disadvantage is that these new typefaces are often issued by small companies, making it more difficult for the regular user to find them, let alone purchase them.

Cholla, also selected by Bukva:Raz!, appeared in 1999 at Emigre and was designed by Sibylle Hagmann. After studying in Switzerland she went to America where she continued her studies at the California Institute of the Arts in Valencia. Cholla is named after a variety of cactus that grows in the Mojave Desert. The Unicase style includes splendid ligatures that are sometimes conspicuous such as the combination 'LA' and sometimes very subtle.

Latina by the Spanish designer Iñigo Jerez Quintana, with a Sans and a Serif. The designer himself says this greatly extended type family may never be finished. The Latina is not yet available but did appear in the book *Language Culture Type*. Photo: Joep Pohlen.

Conclusion This chapter has given an overview of the progress of type design after the introduction of the computer. It is of course not exhaustive and could never be so. Activity in the industry is simply too abundant for this, with so many new productions. We want to illustrate the general trends and show the path that has been trodden by both the traditional companies and the individual type designers. It is of course interesting to note that the industry is expanding worldwide and that there are no real country-related styles or even styles that are common to the European or American continents.

The new wave or grunge typefaces to have found a place in the Vox+2 are a refreshing addition and it has become clear that many of these typefaces form a welcome lucky-dip for setting the opening and closing titles of films, for use as attention-grabbing titles in printed publications or on the internet and more specific uses, but they will never see more extensive or more structured use as text faces. The shapes are often too extreme for this and the typefaces contain too little structure. These experiments have undoubtedly sparked a period of cross-pollination in type design. The refinement of the more traditional typefaces, with their different styles, small capitals, various figures and symbols, together with the goal of optimal legibility, seem to contradict the search for a primative stunning form for the individual letters. An education as type designer, which teaches about the norms of legibility, spacing, harmony in text and opportunity for research into the balance between letter and white space, allows the designer to gradually develop into a craftsman. Although this can also be achieved autodidactically, the trial and error phase can better take place during education than in practice. The experiments of designers such as Elliot Peter Earls, Pierre di Scuillo, Max Kisman, Jonathan Barnbrook and many others remain essential in an industry that is constantly developing and where art and applied art exist in close quarters.

Typographic recommendations

Typography has a threefold purpose. First of all it is about rousing people's interest *to read a text. The second purpose is to enhance* legibility, *and finally, typography determines the* direction and speed *of reading. These general typographic purposes are furthermore influenced by two other factors: the client's intentions and the graphic designer's or typographer's personality. The intentions of a client are expressed in the 'feel' of a text: Is it long or short, informative or attractive, narrative or demonstrative? The choice of medium is also important: Is it a reading or study book, a magazine or a company brochure, a poster or a business card? Whereas, in order to limit the size, a book will require a type that is more economical, this may be less imperative in case of a brochure. A designer's or typographer's personality on the other hand can express itself in either a certain sobriety or a more elaborate use of form and colour.*

The general purpose, mainly aimed at serving the reader, is obviously governed by certain rules. It needs to be explicitly stated, however, that every conceivable rule only becomes truly interesting by the grace of its possible exceptions. Or, as a famous designer answered when asked why he had suddenly turned his back on his own strict pattern typography after forty years: 'I invented the system, so I can fuck the system'.

Still, some recommendations for making texts optimally legible have arisen by experience. These recommendations are partly based on the tradition of setting metal type but have also resulted from computer typesetting and editing. Trying out different versions and changing details is done much quicker on a computer. In this respect, today's typographers are in much closer contact with the end product than during the long period of metal type and the ensuing typographic interbellum, when hot metal typesetting and phototypesetting were used together, and digital typesetting started its advance in printing offices. During that time, copy still needed to be counted off manually and typefaces chosen beforehand, after which proofs were supplied by a typesetter: a time-consuming and very costly affair. Once the compositor was taken out as intermediary, the designer, besides having unlimited freedom, had to start paying attention to a few technical conditions that the composition needed to meet. And of course, he or she had to perform the same tasks as before: interpreting the materials supplied for the purpose they needed to serve. In this

chapter, we will discuss reading and microtypography, and specifically their application in books and other products that profit from typographic detailing. Reading typography applies to setting texts for continuous reading with all the formal preconditions that apply. Microtypography concerns the applying of details that enhance the legibility and understanding of the text.

Although this chapter primarily deals with printed matter, a large part of it is also applicable to the screen. Screen resolution is steadily increasingly and the quality will undoubtedly approach that of printed matter. One thing that for the moment will not change is that printed matter is static and that the on-screen text is a translation of data that, depending on the software and hardware, can be rendered differently in the various operating systems and software programmes. These include, apart from the computer operating systems, those on mobile phones and so-called e-papers. Printed matter therefore remains the norm, for it remains the same for every user. A book from the 1980s still looks the same, whereas current systems might not be able to read a digital document from that era. As soon as reproduction and recording become more lasting elements in the digital world, it will be possible to discuss typographic preconditions. A good step in that direction is Adobe's Portable Document Format (pdf). As this is, broadly speaking, a digital, 'frozen' version of printed matter, the contents of this chapter apply to this form as well.

Dadaism or dada began in Zürich, Switzerland, but was soon adopted by artists in various other countries. Dadaism played with form and content. This illustration, designed by El Lissitzky, is an example of the style. El Lissitzky designed it for one of the Merz meetings, which Kurt Schwitters organised around 1920. There is no real formal legibility. The influence of this dada typography on designs by Neville Brody, David Carson and their successors in the 1990s is clearly visible. Although this image at first glance seems like the wrong illustration for the spot, at the same time it shows the flexibility of legibility and how much typography is always part of the message.

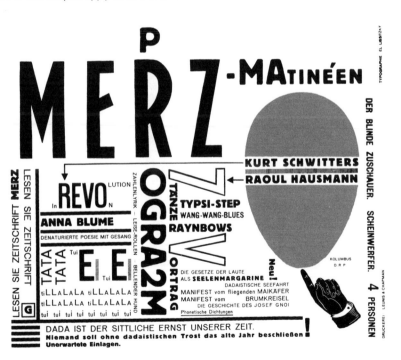

For many people the first typo-graphic object they encounter each day is the newspaper. In this form of typography, the 'searching eye' is struck first by the size of the headings and the eye catching (news) photos. Design and content play a duet in which seduction plays the main part. Not reading it now probably means never reading it. Here a random spread of the *NRC next* of 21 July 2008 in which image, form and content vie for first place. Photo: Joep Pohlen.

The first step As indicated before, typography has a threefold purpose that, from a user's point of view, can be divided into three steps. The first step is the first impression a page makes. This impression often determines whether or not a reader is interested enough to begin reading. Whether the text may be read or must be read is, of course, an important difference. The first example could be a newsletter or magazine where the choice to read or not lies with the reader. The second text could be the theory needed for a driving test or perhaps an instruction manual on how to fill out your tax returns. In the first example, an attractive layout is obviously more logical because the reader needs to be persuaded. In the second example, the informative character is more important because the reader needs to be able to clearly and easily take in the informa-tion. For this first step it is, in general terms, important to catch and guide the 'searching eye'. Where does the reader look first? In what way is he drawn into the text and how does he read the information to be conveyed? Even in medie-val manuscripts, decorated initials were used to mark the beginning of a text and to 'illuminate' the page. Even then, the reason for this was to make the page more easily accessible to the reader.

VOORREDEN.

Een Logogriphe heeft eenige overeen-komst met het geen wy Letterkeerdicht noe-men, en is doorgaans moejelyker, dan een ander Raadzel, optelosfen. In het zelve worden, niet zo zeer de eigenfchappen en hoedanigheden van een wel inzonderheid be-fchreeven, maar een zeker onderwerp be-men het voorgeftelde woord, door het ver-plaatzen of uitwitfchen van eenige letters, kan opleeveren. By voorbeeld: op durdunige wys kan men van het woord Kaart, maken, kaar, kat, kar, tak, ark, raa, aart &c. wyl dit woord alle de daar toe benoodigde ters bevat.

Indien ik mag verneemen, dat deeze Raad-aan de jeugd aangenaam zyn, en in ik kunnen toebrengen, zal ik het eeni-, dat ik my, met ze in 't licht te heb voorgefteld, getroffen hebben.

of the earliest types cut by Fleischman de Waal, 1788, printed by P. Muntendam.

iring on 20 May 1732 the said for another cut, strike, justify,

rate of ten florins a week so to, but while I

JOHANN MICHAEL FLEISCHMAN

was acquired by the Brothers Ploos van Amstel, the Small Pica seems to have disap-peared. It is not in the specimens of Ploos van Amstel; and when their material was bought by our firm in 1799, the inventory made at the time does not include the Small Pica by Fleischman.[1] His Pica Italic and Long Primer Roman and Italic were there; and as early work by the great master we show them in figs. 157–162, p. 195, as they were in the specimen by Uytwerf[2] and in the first specimen-book issued by Ploos van Amstel.[3] They are now listed in our inventory as Pica Italic No. 47, Long Primer Roman No. 48, and Long Primer Italic No. 49. In the latter part of the eighteenth cen-tury these types were altered to some extent: some of the Italic letters were recut, *b* as *h*, *v* as *y*, *w* as *w*, *J* as *J*, *Q* as *Q*, *Y* as *IJ*. They are shown in figs. 163, 164, as they were in a book of 1788.[4]

The agreement between Uytwerf and Fleischman was not renewed. The latter set up on his own in Amsterdam as a punchcutter. In 1732 he finished a Roman, now the English-bodied Roman No. 50 of our inventory (figs. 165–169, pp. 198, 199), a type much favoured in its day.[4] Fig. 168, p. 199, shows this face as it was set in the specimens of Wetstein[5] and of Izaak and Johannes Enschedé,[6] and fig. 169, p. 199, as it was in those of our firm early in the nineteenth century.[7] In the next year Fleischman was cutting a Black Letter, now the Pearl black Letter No. 550 of our inven-tory (figs. 170–172, p. 200), the first of his range of Black Letters, which was in great demand throughout the eighteenth century and is still in occasional use for jobbing. With proofs of his recent work he went to call on Rudolph W— who received them enthusiastically and advised Flei— typefounder.

Flei—

Fleischman as punchcutt and typefou on his own

In contrast with the example on the previous page, the text typo-graphy here is largely con-cerned with legibility and micro-typography. Although it is hard to imagine that such sublime detail could be rendered in metal type, in this case almost no stone was left unturned to put every text element in the right proportions. From ligature to non-lining figure and from italic to small capital – it looks like a test of skill. And it is. The book shown is *Typefoundries in The Netherlands*, a 1978 edition in honour of the 275th anniversary of the printing house Joh. Enschedé en Zonen. Layout and design is by Bram de Does. The metal type comes from the printer's own museum. Photo: Joep Pohlen.

The second step Enhancing legibility is the second step, which goes deeper than a text's first impression. This stage goes one step beyond asking for at-tention by means of catchy headlines or a provocative picture. In case of qual-ity newspapers, by the way, steps one and two can be rolled into one. This second step however expressly deals not only with first impressions and en-couragement, but also with typographic attention on both word and letter level. This is what we call microtypography, which is all about the detailing of headings, grades, spacing, line interval, line length, ensuring register, indents, tabs, white lines, the alignment of the text, word breaks, the use of punctua-tion marks, the use of numerals and ligatures, the placement of initials, the proportion of captions and footnotes to the body text, the placement of illus-trations in a text, the layout of tables, etc. Although much of the above will not be instantly visible, it will, if done badly, make a text less legible and less attractive. Usually, the basic settings of a layout programme will have preset a number of these elements to prevent frequently occurring mistakes. A number of settings, however, will have to either be set by the typographer or applied manually.

The third step Equally important are the direction and speed of reading. A number of ways of reading can be distinguished, each demanding a different solution. The classification below is mainly applicable to larger quantities of text, but is also convertible to other forms of communication with text. Obviously this classification has its transitional forms and exceptions as well. The zeitgeist plays a part, too, and is visible in the layout of books and other publications throughout history.

- *Linear reading* is applicable to a text that can be read from beginning to end without too many obstacles. An example of such a text is a novel. The layout usually consists of one column, and grades like bold and italic are rarely used. Most important is the undisturbed visual impression. You could call it invisible typography for the 'voluntary' reader.

- *Nuanced reading* is applicable to a publication that contains continuously structured information, but still allows the reader to start at any random point. Examples are scientific and educational works. They are linear, but have accentuated terms, more grades, and they are aimed at the professional reader and student who do not need a great deal of reading comfort but who are looking for terms and know where to find footnotes, references and captions or comments in the margin. The layout usually contains one wide column of text and a narrow column for additional referencing, although a layout of two or more columns is also possible.

This annual report for the Stichting Indonesische Pensioenen has a single column structure. The annual report is bound in the so-called Japanese stab binding style in which each leaf is a double-leaf with the fold on the fore-edge. The column of text is accentuated in the layout by a dark strip that is pressed into the inside of the folded sheet. The layout is aimed at nuanced reading. Design and photo: Joep Pohlen.

This spread from the *Larousse Universel* of 1923 shows an example of a layout that is aimed at a scanning way of reading. The eye is caught by the words in bold in the three columns and of course by the wonderful drawings that have been placed in the text. Photo: Joep Pohlen.

- *Selective reading* is applicable to a publication that contains several inter-connecting layers that can also be read separately. An example is a school-book, since a school child may be less motivated than a college or university student. A lot of reading comfort is therefore important. Finding the right bit of text should also be easy. The layout sometimes consists of one column, but two columns are normal too, plus a lot of space for illustrations. The page contains a lot of white space to allow the eye some rest and in order to isolate the text from its surroundings.
- *Scanning style of reading* is applicable to texts that are aimed at answering questions. Examples are an encyclopaedia, a bibliography, a dictionary and large parts of the internet. Think, for instance, of quick and effective googling to find information. The layout usually consists of two or three columns in a dictionary or encyclopaedia.
- *Comprehensive reading* is applicable to a text for which an understanding of each sentence is important. Examples are children's books and an antho-logy of poetry. Speed is of lesser importance. One column often suffices.
- *Informative reading* is applicable when reading a newspaper. We pick and choose what we find important and let our eye wander the page to find what interests us. We seldom read a paper from A to Z. A newspaper has many columns. The supplements usually have fewer columns to enable a story-like structure.

Typography and layout often need to be adapted in order to satisfy the needs of different forms of reading. In general these adjustments affect the structure of the page, but they can also affect the size of the type and other means to accentuate a text.

The graphic designer/typographer has several possibilities to choose from:
- *Reserved typography* is very suitable for a novel, but also for anthologies of poetry and prose, books for toddlers and good user manuals.
 The reader does not actively perceive the typographer's efforts but profits from expert page layout and text typography.
- *Economical typography* works well for dictionaries, telephone directories, bibles and really every publication in which texts need to be spaced economically. Type designers have designed typefaces specifically for this purpose; these types have a relatively large x-height, small ascenders and descenders and are quite narrow (an example is Lexicon by Bram de Does). For telephone directories, the lower paper quality is taken into account and the letters are fitted with so-called ink traps that make sure they remain legible in case of ink spread (an example is Bell Centennial by Matthew Carter).
- *Differentiated typography* is used in scientific publications, annual reports and policy documents. The typographer has a large variety of typographic resources at his disposal; from non-lining figures in the text and lining figures for additions in tables to various grades and text sizes to differentiate different parts of a text.
- *Didactic typography* is used to support the reader, for example in schoolbooks for young children or cookbooks and travel guides. In this case, the less motivated reader is partly borne in mind. The main aim is finding information, not reading. In the case of travel guides this applies to some guides, but not to others: A travel guide may well turn into a travel journal that can be read as a novel.
- *Activating typography* is necessary to seduce the reader. Think, for example of newspapers, magazines, advertising brochures and adverts. The reader is triggered by a striking head or a different layout. The layout needs to be done separately for nearly every page, making every page different from the other. In general, lots of photographic images and illustrations are used to make the text more attractive.
- *Staged typography* is the kind of typography that demands the most from the reader. Form and content stumble over each other, each vying for the reader's attention. Movements that have influenced this kind of typography are the 1920s dada, the punk typography and experiments by designers like David Carson, approximately sixty years later. In the case of poetry as well, typography is sometimes used to visually strengthen text and content.

In his work, the poet and writer Guillaume Apollinaire (1880-1918) often made use of 'mobile typography'. One of the most well-known examples of this is his poem 'Il Pleut', from the *Calligrammes* anthology, pictured above. A slightly less mobile example is his anthology *Alcool* in which he uses not a single punctuation mark. The French poet and essayist André Breton called him the first Dadaist in 1940; a posthumous compliment. This form of typography is also called calligramme, after Apollinaire's collection of poetry. The works of El Lissitzky, Kurt Schwitters, Piet Zwart and Hendrik Werkman use typography in the same way.

TAIL-PIECES, COLOPHONS, &c.

Fig. 96 represents a coloured Tail-piece or decorative finish at the end of a book (or chapter).

The *Colophon* (see p. 128 & figs. 13, 191), generally distinguished from the text by a smaller or different hand, and—especially in early printed books—by *colour* or other decorative treatment, occurs at the end of a book, where it is the traditional right of the penman and the printer to add a statement or a symbolical device. The *Name* (of craftsman and assistants), *Time*, and *Place* are commonly stated—preferably quite simply — *e.g.* "*This book, written out by me, A.B., in LONDON, was finished on the 31st day of DECEMBER* 1900." Any reasonable matter of interest concerning the *text*, the *materials*, *methods*, *lettering*, or *ornament*, and an account of the *number of leaves and their size, &c.*, may be added. But the craftsman, properly and modestly keeping his name off the title-page, is at liberty to exercise his right, marking the end of, and *signing* his work in any way he chooses—even in a speech or a sentiment—provided the form of the colophon be unobtrusive and its language natural. *Printer's devices* or *book-marks*, consisting of symbols, monograms, &c. (p. 362), were likewise used.

The opportunity generally provided by the final margin, and the natural wish to close the book with a fitting ornament, also led to the use of colour or capitals in the concluding lines ; and sometimes the "tail" of the text was given a triangular form, the lines becoming shorter and shorter till they ended in a single word, or even one letter.

142

But I have not finished the five acts, but only three of them"—Thou sayest well, but in life the three acts are the whole drama; for what shall be a complete drama is determined by him who was once the cause of its composition, and now of its dissolution: but thou art the cause of neither

Depart then satisfied, for he also who releases thee is satisfied.

FIG. 96.

143

Edward Johnston's *Writing and Illuminating and Lettering* of 1917 (ninth edition) gives examples of setting a text and accentuating parts of it. On the left-hand page above, the last paragraph of the column ends in a tail, making the text itself an ornament. The typesetting is obviously executed in metal. Photo: Joep Pohlen.

Although the above seems quite complex, the nature of the assignment and the text usually eliminates certain options pretty quickly, thus limiting the final choice. The emphasis is mainly on book typography and the choice of typeface is not very important yet. That will be discussed later. Making choices is incidentally one of the most important tasks in the process that leads to a text that is clearly legible.

The character of the text Even without knowing the assignment or the target audience, a text without layout can already show what it is meant to do. Even in a neutral typeface in a word processing programme, a poem will be immediately distinguishable from a novel and a dictionary from a newspaper article. Beyond this difference in content, however, every writer gives a text its own specific character. A lot of or a few lines of white, long or short sentences,

many paragraphs or an uninterrupted text, a lot of or a few punctuation marks, short sub-headings or long ones. The typographer has to take these character traits into account because they all influence the layout and typography. The following paragraphs offer an overview of the available typographic means plus an indication of the kinds of problems they can help to solve. Eventually it will become clear that a typographer's job consists mostly of making the right choices and having a feeling for form. Compare it to an architect who constructs a building from small elements. Each element influences the final, entire building. It is not for nothing that Piet Zwart, mostly known as a graphic designer, called himself a *form engineer* or *typotect*. The proportions of a page form the foundation of each piece of printed matter. It starts with the page size and the choice of paper.

Paper and page size Because of a thorough standardisation, normalised DIN A sizes are usually the starting point for paper sizes for printed matter. The sizes of the sheets of paper that are supplied by paper manufacturers are based on these DIN A sizes, with a bit added for trimming, the gripper margin of the printing press and the finish. In the case of books and magazines, how-ever, other sizes that correspond to the subject and structure of the product are used as well. Besides saleability, a publisher will look at the most economic use of the printing press, especially when considerable amounts of paper are involved. As the production planning of books or magazines, as opposed to regular commercial printing, is usually known long beforehand, it is possible to order bespoke paper instead of using paper from a manufacturer's warehouse. This has several advantages: It keeps paper waste to a minimum, the grain direction can be specified and the overall process can be kept economical, even when using non-standard sizes. The production planning will obviously account for the longer paper delivery period. With a big enough paper order it is also possible to deviate from standard paper thicknesses so it can be adjusted to the book or magazine production at hand.

Every bookcase contains books of different sizes, with different kinds of paper and with a diffe-rent finish.

DIN sizes use a $1 : \sqrt{2}$ ratio. Besides the well-know A sizes, B and C sizes are also used. The B sizes are so-called uncut sizes so the page can be printed with bleed after which the sheet can be cut to A size. The C sizes are mostly used for envelopes, which can then hold an A size. The American version of the A4 size (21 : 29.7 cm) is 8.5 : 11 inches (21.57 : 27.94 cm) and is therefore considerably shorter than an A4.

Regular paper sizes are a definite option when choosing a book or magazine format, but divergent sizes are used as well if they can be economically printed on the printing press. Apart from the practical aspects of the printing press, there are a few other aspects that are important when printing a book. The finish of a book might influence the choice for a certain paper size. In case of a hardcover book, the book block can start to 'hang from the spine' because the hard cover is larger than the book block. When the book is frequently used, the binding of the book block can be torn 'from the spine'. Traditionally, reading

Books have been produced industrially since Gutenberg, long before DIN sizes were around. The sizes were based on prevalent printer's sheet sizes and over time, each got its own name:
Royal: 50.8 x 63.5 cm
Demy: 44.5 x 57.1 cm
Double demy: 88.9 x 57.2 cm
Crown: 38.1 x 50.8 cm
Double crown: 76.2 x 50.8 cm
Foolscap: 34.3 x 43.2 cm
Medium: 45.7 x 58.4 cm
Imperial: 55.9 x 76.2 cm

Books usually contain sheets of paper that have been folded into quires of eight, sixteen or other numbers of pages, so book formats were defined by the number of times the original sheets were folded, such as quarto (folded twice to make four leaves = eight pages) and octavo (folded three times to make eight leaves = sixteen pages). The still current sheet size of 70 x 100 cm gives a quarto format of 24 x 34 cm and an octavo format of 17 x 24 cm. *Letter Fountain* has an octavo format of 16.8 x 24 cm (the amount of trim can vary slightly).

DIN-sizes:
A0 = 841 x 1189 mm (= 1 m²)
A1 = 594 x 841 mm
A2 = 420 x 594 mm
A3 = 297 x 420 mm
A4 = 210 x 297 mm
A5 = 148 x 210 mm
A6 = 105 x 148 mm
A7 = 74 x 105 mm
A8 = 52 x 74 mm
A9 = 37 x 52 mm
A10 = 26 x 37 mm

B0 = 1000 x 1414 mm
C0 = 917 x 1297 mm

On the right, a well-known size chart of the DIN A sizes that shows that each size is half the size of the previous one.

books are therefore relatively narrow and tall, which coincidentally is often perceived as a comfortable 'hand-held' reading size. This naturally does not apply to adhesive-bound books as the cover has the same proportions as the book block. A reading book moreover has a one column layout which makes for a comfortable read. Illustrations, which usually benefit from a slightly wider paper size, do not need to be taken into account. In case a book is used as a reference publication or study book (as opposed to a reading book) on a table or other surface, the choice of the size is less important.

Paper sizes used to have their own names, derived from the then current printing paper size. Since the transition from letterpress printing to offset and the standardisation to A sizes, this has changed. It is not for nothing that we refer to a 50/70 or a 70/100 sheet-fed printing press. Although rotary printing presses are used for magazines because of the size of their runs, books are still mainly printed on sheet-fed printing presses. In case of a 50/70 sheet-fed printing press, standard warehouse sizes of 45 × 64, 50 × 70 and 52 × 72 cm are available. For a 70/100 sheet-fed printing press, the 64 × 90, 70 × 100 and the 72 × 102 cm are the most common sizes. The paper is usually long grain, but for the most frequently used paper sizes a short grain version is in stock as well. For long grain paper, the paper fibre is parallel to the long side of the paper. The fibres are structured this way because the paper mass in the paper machine is poured out onto a conveyor belt. The conveyor belt itself is a screen. Because the belt moves in the lengthwise direction of the paper, the fibres are ordered in that direction. Because of this, the paper is less likely bend easily lengthwise. For books and other folded printed matter, the grain direction

A0
A2
A1
A3
A5
A7
A9
A8
A6
A4

should preferably be parallel to the spine. It makes the paper 'lie' neatly when a book is opened. The choice of paper obviously matters as well, but it is beyond the scope of this typography book to discuss it in detail. It can be briefly said that for reading books and other texts publications without illustrations, a light coloured, uncoated paper works best because it makes the contrast between letter and paper less harsh and is less tiresome on the eye. Uncoated paper has two different sides. The wire side is generally a bit more structured. For colourful illustrations with less text, a so-called machinecoated (MC) paper is used that has a layer of china clay for quick drying and a crisp image. Alternatively, there are the more or less hybrid versions like extra smooth uncoated paper, or a slightly thicker and lightly coated MC, which is a little less smooth than regular MC. From a typographic point of view, the choice of paper has to be taken into account as well. MC paper can make the type look slightly overexposed and thin, as not all type designs take the sharpness of printing into account, thus influencing its contrast. Uncoated paper thickens the letter slightly because of ink squash, which makes the letter slightly heavier. The choice of paper influences the typography, like the transparency or opacity of paper mentioned earlier.

The grid as base A useful grid simplifies the systematic and logical rendering of text and images, adds rhythm to the text and image structure and ensures that the visual information is conveyed in a structured and transparent way. A good grid moreover offers economic advantages as well. Because design solutions have been set, an assignment can be completed in less time and with less cost. A grid is usually part of an organisation's visual identity and can add to a structured and controlled flow of its publications. It allows for multiple designers to work together in the same way, which results in an unambiguous image for the organisation to send out. Many designers however fear the boring uniformity it might cause. A grid's logical structure and its corresponding elements need not apply to printed matter alone, but can be expanded to include the fleet of vehicles, signposting in and around buildings, sponsors' messages and the positioning of the logo on buildings. In this book we stick to printed materials and the design of larger amounts of text.

The first choice when determining a grid is that of a measurement system. In the US, the inch is standard. With the introduction of the computer, whose operating systems were mainly developed by American companies like Apple and Microsoft, the traditional Anglo-American point system for metal type was adjusted to the inch. The point was defined to give 72 points to the inch (see the chapter on measurement systems). Paper formats and image sizes are also based on the inch. This means the American system works well with formats measured in inches. Outside the UK, it is slightly more complex for Europe because the metric system is used. In continental European metal type, moreover, the Didot point was used for measurements. The Didot system, like the

The baseline grid of this book. Top left, a small left-hand page with grid and on the right, the structure of the baseline grid of a right-hand page. The grid starts 32 mm from the top and has a line interval of 4 mm. A second grid for captions has a variable start point that can start at any grid line and has a line interval of 3 mm. This way, the two grids coincide after every three lines. This is indicated by the black dotted line to the right of this caption. In theory, illustrations start at the top of the x-height of the main text and end at the grid line of the main text, unless they are wholly or in part bleed illustrations. But in that case, too, the grid is taken into account as much as possible. As this is a hardcover book, the space in the spine can be smaller than a glued book because the book stays open better and the page is visible up to the spine.

xxxXXX

Over time, a lot of systems have been developed for the proportions of a book. Below left, the 'secret canon' of late medieval handwritings as used by Jan Tschichold. The page proportion is 2 : 3 and the proportions of the margins are 2 : 3 : 4 : 6. The height of the text area is equal to the width of the page. The text area/text covers 44% of the surface of a page.

Below right, a system of wider size, proportioned 1 : √2 (DIN size). According to Villard's Canon, the width and height are divided in nine parts. The proportions of the margins are 4 : 6 : 8 : 11. The text area is again 44% of the page's surface.

Many systems were developed, some based on the golden ratio, the divine proportion or 'Divina Proportione' (also used by the French architect Le Corbusier for his 'Modulor'). The Fibonacci sequence 0, 1, 1, 2, 3, 5, 8, 13, 21, 34, 55, 89 ... etc. also played a part in determining number ratios. Each element in the sequence is the sum of the two previous elements. Jan Tschichold added his voice as well, developing a system of *Klare Verhältnisse* (pure ratio) and *Unklare Verhältnisse* (impure ratio).

Anglo-American, is duodecimal, but the units are slightly larger. The Didot point has by now all but disappeared and the adjusted Anglo-American point (sometimes called a DTP point) is used alongside the metric system (1 point = 0.352777 mm; 1 pica = 12 points). The result is that in Europe the decimal system and the duodecimal system are used simultaneously. Most software programs convert values to the measurement system of the user's choice.

An important aid to text layout is the baseline grid. In the vertical direction this is the main structure of the text. It indicates the position of the baseline for each line of type (see page 193) and at the same time ensures that texts on the two sides of the paper are in register. That means a line of text on one side coincides with one on the other side. Since all paper is transparent to some degree, lines out of register can irritate the reader especially when very thin paper is required, as in most bibles. The baseline grid is generally the same throughout a publication. A second baseline grid is used only when large parts of a book are reserved for an index, notes, a bibliography and/or glossary, etc.

Because some designers find the duodecimal system more flexible, the line intervals in the baseline grid are sometimes built up in points rather than millimetres. European paper sizes are metric, however, so residual spaces at the head and foot of the page are indicated in metric units. This is also the case with illustrations in a text that are lined up with the baseline grid. Many designers therefore use the metric system for all measurements. Designers who choose the point system are, however, not wrong in saying that it has geometrical advantages in structuring a grid. In such a duodecimal system, elements can be divided by three and four, simplifying calculations and notation in the design of much more flexible systems where the various grids for main texts, captions and footers can be combined. The same grid can ob-

12 pt 9 pt 6 pt 4 pt

5 mm ———— ———— ————
4 mm 3 mm 2 mm

Anglo-American points are conside-
rably smaller than millimetres. As
the above examples show, more
values coincide in the duodecimal
system than in the metric system,
especially for whole numbers. The
differences between the steps are
also smaller which makes it possi-
ble to be more subtle with the line
interval for various elements in
the layout.

viously be specified in the metric system as well, but it is less varied because the smallest unit is a millimetre that is about three times bigger than a point and therefore, when it gets complex, requires more digits after the decimal points. The metric system is nonetheless gaining popularity as a universal tool because it is easier to link to paper sizes, photo sizes and the use of page margins. The accuracy of conversions on a computer whose system still takes the inch as starting point is not problematic either. As far back as the 1970s, grid systems were seen as indispensable and were studied a lot because they offer a lot of support when doing the layout for large numbers of pages and they also visualise a book's structure and rhythm. As current design program-mes usually ask only for the margins when making a new document, the type area is more and more a residual value with an accidental width. In order to design a really good system, some calculations must be made in advance so that measurements are unambiguous and clear without three or more digits after the decimal point. Often, each designer has his or her own method of working. Documents will have a certain logic to their structure, which means they are easily adjustable in case of re-use, layout, corrections or amendments by third parties without losing their cohesion.

The margins Superficially, the white in a page could be seen as space that has been paid for and needs to be filled. In some cases the margins can be relatively small, for instance when a book is meant to be read selectively and needs to contain a lot of information, as in dictionaries and other reference books. Here too, the design is subordinate to the purpose and content. How-ever, the layout of a page has to take into account the manner of reading as discussed before. The margins on a page are connected to this as well. The white space on a page is therefore functional. It offers moments of rest, isolates the content from its surroundings and guides reading behaviour. It also makes

The grid below can make use of a two-column layout with a narrow information column, a three-column, or a one-column layout within the same type area. It is an application for a magazine. The grid is mirrored for the left- and right-hand pages. The illustration on the right is a right-hand page.

for a clear separation between the various elements on a page, which often results in greater legibility. The white spaces on a page are therefore functional styling elements. The margins are the first step and determine to a large degree the first impression of a page. The left- and right-hand page can have the same margins or they can be mirrored. When they are mirrored, the columns on the back of a page coincide with those on the front. This is recommended when paper is highly transparent. The adjustment of the margins depends on the subject and the design. In a book on photography, for instance, the grid and margins will be structured so that the images are presented in the best possible way. In between the extremes of a dense dictionary and a book on photography there is a vast array of possibilities for creating a grid. Sometimes there is no need for margins at all. Full bleeding images then make for an overall picture that has a less framed feel to it. An added bonus of a bleed image is that it makes the page look bigger and gives the optical illusion that the illustration continues. This way a designer can on the one hand play with margins and rhythm and on the other hand be more restrained and let the visual material speak for itself. In a book or magazine, designers can react to the images and text in the layout, which ideally should support rather than constrict that reaction.

The spread below is taken from the photo book *Z* ('t Veld Self Portrait) by photographer Peter Wijnands. The photo on the left-hand page bleeds and the right-hand page is black. The power of the image and the covering of the face with a headscarf is enhanced by the placement on the page and the fact that the image bleeds. The use of white margins would have affected the photo differently. Design: Joep Pohlen and Dennis Schmitz.

Lorem ipsum dolor sit amet, consectetuer adipiscing elit. Duis sit amet nulla. Phasellus vulputate, orci pretium commodo gravida, tortor pede blan-

Lorem ipsum dolor sit amet, consectetuer adipiscing elit. Duis sit amet nulla. Phasellus vulputate, orci pretium commodo gravida, tortor pede blandit lacus, ut ornare lectus nibh vel tellus. Duis vestibulum rhoncus sapien. Phasellus iaculis ornare velit. Sed tincidunt, diam eu pretium auctor, ligula nisl vehicula nisl, ultricies egestas dolor sapien ac ligula. Phasellus aliquet risus in eros. Vestibulum ante ipsum primis in faucibus orci luctus et

Lorem ipsum dolor sit amet, consectetuer adipiscing elit. Duis sit amet nulla. Phasellus vulputate, orci pretium commodo gravida, tortor pede blandit lacus, ut ornare lectus nibh vel tellus. Duis vestibulum rhoncus sapien. Phasellus iaculis ornare velit. Sed tincidunt, diam eu pretium auctor, ligula nisl vehicula nisl, ultricies egestas dolor sapien ac ligula. Phasellus aliquet risus in eros. Vestibulum ante ipsum primis in faucibus orci luctus et ultrices posuere cubilia Curae; Nam viverra. Donec at ante nec magna ornare malesuada. Duis auctor metus. Mauris dignissim molestie est. Fusce interdum. Morbi risus. Nam et

Lorem ipsum dolor sit amet, consectetuer adipiscing elit. Duis sit amet nulla. Phasellus vulputate, orci pretium commodo gravida, tortor pede blandit lacus, ut ornare lectus nibh vel tellus. Duis vestibulum rhoncus sapien. Phasellus iaculis ornare velit. Sed tincidunt, diam eu pretium auctor, ligula nisl vehicula nisl, ultricies egestas dolor sapien ac ligula. Phasellus aliquet risus in eros. Vestibulum ante ipsum primis in faucibus orci luctus et ultrices posuere cubilia Curae; Nam viverra. Donec at ante nec magna ornare malesuada. Duis auctor metus. Mauris dignissim

Lorem ipsum dolor sit amet, consectetuer adipiscing elit. Duis sit amet nulla. Phasellus vulputate, orci pretium commodo gravida, tortor pede blandit lacus, ut ornare lectus nibh vel tellus. Duis vestibulum rhoncus sapien. Phasellus iaculis ornare velit. Sed tincidunt, diam eu pretium auctor, ligula nisl vehicula nisl, ultricies egestas dolor sapien ac ligula. Phasellus aliquet risus in eros. Vestibulum ante ipsum primis in faucibus orci luctus et ultrices

Lorem ipsum dolor sit amet, consectetuer adipiscing elit. Duis sit amet nulla. Phasellus vulputate, orci pretium commodo gravida, tortor pede blandit lacus, ut ornare lectus nibh vel tellus. Duis vestibulum rhoncus sapien. Phasellus iaculis ornare velit. Sed tinci- dunt, diam eu pretium auctor, ligula nisl vehicula nisl, ultricies egestas dolor sapien ac ligula.

Lorem ipsum dolor sit amet, consectetuer adipiscing elit. Duis sit amet nulla. Phasellus vulputate, orci pretium com- modo gravida, tortor pede blandit lacus, ut ornare lectus nibh vel tellus. Duis vestibulum rhoncus sapien. Phasellus iaculis ornare velit. Sed tinci- dunt, diam eu pretium auctor, ligula nisl vehicula nisl, ultricies egestas dolor sapien ac ligula.

Lorem ipsum dolor sit amet, con- sectetuer adipiscing elit. Duis sit amet nulla. Phasellus vulputate, orci pretium commodo gravida, tortor pede blandit lacus, ut ornare lectus nibh vel tellus. Duis vestibulum rhoncus sapien. Phasellus iaculis ornare velit. Sed tinci- dunt, diam eu pretium auctor, ligula nisl vehicula nisl, ultricies egestas dolor sapien ac ligula. Phasellus aliquet risus in eros. Vestibulum ante ipsum primis in

Lorem Ipsum is a dummy text that has been in use for hundreds of years to make proofs before the actual text is available. On the web, these texts can be generated in any desired amount. The texts above are set in a 'classic' way in points on a grid in the 'Swiss typography' style. Everything fits the grid perfectly because both the frames and placement of the texts are based on one measure- ment system (pica). The line inter- val is also in classic solid setting (without any extra white between the lines: 6/6 pt) and with extra white (line spacing) in points (7/8 pt, 10/12 pt, 20/24 pt).

Column layout, set width and line interval The length of a line relative to the point size and line interval plays an important role in making a text legible. When lines are too long, the reader will have difficulty finding the start of the next line. Lines that are too short make for a restless read because the reader needs to jump to the next line too often. Word breaks will moreover be inevi- table when a text is set to a narrow measure, as will big white spaces between words when a narrow block of text is justified. The latter phenomenon often occurs in newspapers. For lines that are too wide, legibility is enhanced by en- larging the line interval. A suitable guideline is a line length of ten to twelve words or of sixty to seventy characters. But here too, the designer will have to experiment to arrive at the ideal relations between typeface, point size, line interval and set width. Text set solid (without extra white between lines) should result in a legible text when using a standard letter of 8 to 12 pt because most

text typefaces are designed for that size. As typography is not immune to trends either, there will be some periods when everything is set solid and others where as much white as possible is used. A lot of extra white in between lines can reduce legibility because it makes a text seem restless and it disturbs the coherence between lines. When there is too little white between lines the reader will partly read the following line, and when there is too much white it is difficult for the eye to find the next line. When the line interval is just right it guides the eye visually, resulting in a better reading rhythm. These remarks should be taken only as guidelines, because the length of a text, the set width and the structure of a text also influence the line interval. In the era of costly metal typesetting, the typographer had to trust his experience and expertise. In comparison, it is now much easier to make several printouts of the actual text and make a well-founded choice based on experiment.

Suspendisse consectetuer ante vel arcu. Curabitur vehicula lectus et enim. Nam quis tellus a enim pellentesque eleifend. Sed fringilla, urna ut semper.

Suspendisse consectetuer ante vel arcu. Curabitur vehicula lectus et enim. Nam quis tellus a enim pellentesque eleifend. Sed fringilla, urna ut semper mollis, libero risus lobortis est, sed varius enim felis ac ante. Quisque varius enim nibh eget magna. Nullam eu pede vitae risus facilisis vestibulum. Suspendisse sit amet tortor nec enim tempor tristique. Vestibulum elit. Nullam dapibus condimentum odio. Aliquam sit amet augue rhoncus nibh sollicitudin sodales. Proin rutrum est quis sem. Pellentesque metus.

Suspendisse consectetuer ante vel arcu. Curabitur vehicula lectus et enim. Nam quis tellus a enim pellentesque eleifend. Sed fringilla, urna ut semper.

Suspendisse consectetuer ante vel arcu. Curabitur vehicula lectus et enim. Nam quis tellus a enim pellentesque eleifend. Sed fringilla, urna ut semper mollis, libero risus lobortis est, sed varius enim felis ac ante. Quisque varius nibh eget magna. Nullam eu pede vitae risus facilisis vestibulum. Suspendisse sit amet tortor nec enim tempor tristique. Vestibulum elit. Nullam dapibus condimentum odio. Aliquam sit amet augue rhoncus nibh sollicitudin sodales. Proin rutrum est quis sem. Pellentesque metus.

Variation in size and grades Once the choice of typeface and size has been made for the running text, attention has to be given to the layout of elements that do not belong to the running text, but that function as aids to navigation. Examples are chapter titles, introductions, tables of content, headings, sub-headings, quotes in the text, paragraph headings, section dividers, annotations, names of authors, footnotes, postscripts, captions, page numbers, references, bibliography, index, glossary, etc. Sometimes a document contains even more elements, but they should always serve a purpose and help the reader find what he or she is looking for. The designer therefore needs to determine which elements deserve the most attention and which ones are less important. Experience shows that the easiest way to organise a page is to first set all text in the same type and size as the main text and then determine which text elements deserve extra attention. It is therefore important, for example, to consider how a heading fits into a text, the consequences of re-ducing or enlarging it and how it should be positioned on the grid in relation to the preceding and following lines. This is why it is again advisable to start off simple, and not to make too many variations in point size and grades. Can different elements share size and grade, differentiated simply by their position,

Legibility is dependent on the choice of typeface, body size, line length and line interval. Although the type designer takes the line interval into account when designing a text typeface, he has only the average set width to work from. The examples above with the same text show that text set solid (8/8 pt) suffices for a narrow column in Times New Roman – it was designed for narrow columns – but that for wider texts the lines are too close together. In the following paragraph, the line interval has 2 pt of extra white (8/10 pt) which makes it easier for the eye to be led to the next line.

The magazine spread, above, shows a three column layout on the left-hand page and a two column layout on the right-hand page with an equal type area. The main text is the same size on both pages, but seems smaller on the left. This is a result of variations in width and boldness in the Multiple Master typeface. Spacing is also determined, and determined, for each grade and size. The use of colour and grey tones in the text also makes a difference (not visible here as this book is printed in two colours). The pages have been reduced to about 30%. The baseline grid has a line interval of 4 mm. The red sub-headings on the right-hand page have been moved 1.5 mm from the baseline so they are visually neatly spaced in between the two blocks of text. Design: Joep Pohlen.

set width or colour? Newspapers sometimes use different typefaces to differentiate between heading and text, for example a bold sans-serif for headings and a seriffed typeface for the text. As a general rule, typefaces should differ clearly in shape and preferably belong to a different group in the Vox classification. See also the matrix by Hans Peter Willberg on page 81.

Many typefaces already cater to this need, like Scala and Syntax, which have both a sans-serif and a seriffed version. Some have different versions that are based on the same master font. An example is the Linotype Compatil. Its variant versions work very well together because their structure is the same. For documents that are divided into sections and sub-sections, it is also important to have sufficient typographic resources to indicate a descending order of importance so the reader can easily spot where a section starts and how it is subdivided. The designer may need to further consult the author in order to make choices that will enhance legibility.

When producing magazines or a series of books it is not unusual to set certain rules beforehand; these can be rules on the extent of the text, length and subdivision of headings and the way in which certain elements in the text are emphasised (italic, bold, small capitals, etc.). This means some important

choices are already made in the writing process. Clarity and simplicity remain paramount, at least if legibility is the most important criterion. As Dadaism and the typography in some 1990's magazines like *Ray Gun* and *Speak* demonstrate, a text can also demand the reader's active participation. Form then becomes part of the message.

The illustration on the previous page is an example of how different elements in a magazine can be designed. The original design is in colour and although the Myriad Multiple Master font is no longer supported by Adobe, this design makes elaborate use of its possibilities. The grades that have been created can still be used, but it is no longer possible to create new ones (except in the Mac OS9) because FontCreator, the programme supplied with the font, does not work in more recent versions of the Apple system. And that, once more, means the end of a typeface experiment from which many expected a lot.

I quattro libri dell'architettura
I quattro libri dell'architettura

Spacing a heading by feel is a matter of assessing the white space with one's eyes slightly narrowed and then inserting or deleting some white. Since this is a partly subjective matter, no two designers will reach the same result. The lower line is visually corrected. The arrows indicate where the spacing needed to be reduced.

In the example below, the upper passage is normally spaced, while the passage below has wider spacing for better legibility. They are set in Times New Roman at 4.8 pt.

Suspendisse consectetuer ante vel arcu. Curabitur vehicula lectus et enim. Nam quis tellus a enim pellentesque eleifend. Sed fringilla, urna ut semper.

Suspendisse consectetuer ante vel arcu. Curabitur vehicula lectus et enim. Nam quis tellus a enim pellentesque eleifend. Sed fringilla, urna ut semper.

Spacing The use of white space between characters and words depends on the designer's personal view and on the influence of the prevailing style of the period. A lot of white between characters and words has sometimes been all the rage, while the following year characters were squeezed nearly against each other.

However, we must not overlook the fact that the type's designer has looked at letter combinations and indicated their ideal spacing in a so-called kerning table. He or she has also drawn the letterforms so that the designated spacing results in a balanced block of text.

Too little space makes the separate letters difficult to distinguish; too much space makes it more difficult to recognise a certain word image. For most reading texts, the standard spacing is a good choice. Manual spacing is, obviously, out of the question in this case. Different point sizes do however demand different spacing. Smaller sizes for footnotes and captions, for example, need wider spacing to reach the same clear legibility as larger sizes. This need arises partly from visual effects (the eye's resolving power remains the same whether the type is large of small) and partly from ink squash which obviously influences the shape and spacing of smaller types more than large ones. Large types in titles and headings can reveal the typesetter's skill or weakness from a distance. Their spacing needs to be slightly tighter than in smaller sizes to correct for visual effect of the type size. It might even be necessary to manually adjust the space between letters.

Fleischmann D

Fleischmann D (Display) for headlines

Fleischmann T

Fleischmann T (Text) for text

Partly to meet this need, some type manufacturers have issued special fonts that include separate versions for headings or display type. Such versions usually have a somewhat different spacing so the white is better distributed, and they are based on a larger master. As indicated in the chapter 'The digital formats', the master font for smaller text types is often drawn somewhat heavier.

Programmes for graphics and design provide the option to space texts or pairs of letters manually by means of key combinations or by entering special values. From a purely typographic point of view, such options should not be used thoughtlessly to make a text fit. Since the spacing units of different design programmes rarely match, we discuss them here in further detail. Most programmes use so-called em values. These values are based on the body size of current typeface. An em in a 5 point type measures 5 points and an em in 10 point type measures 10 points. The unit used is 1/1000 em. So a spacing value of 100 gives .5 point for a 5 point type and 1 point for a 10 point type. Some design programmes also use the en space, which is half the width of an em. Although the manual of the QuarkXPress design programme also defines an em in this way, the programme itself strangely uses a different value, namely the width of two noughts in the given font. More recent versions do allow the normal em as an option, however.

The designer of a typeface specifies not only the spacing of the letters but also the width of the default word space. In traditional metal typesetting, the prevailing view recommended setting word spaces of 1/3 of an em in a non-justified text (ranged left with a ragged right margin). For digital fonts, the word space takes up the 'bounding-box' of the 'i'. This usually equals approximately 25% of an em space in normal text types. Narrow faces need a narrower word space, wider faces a wider. With types of 16 pt or larger, the word space can be decreased.

A swift-footed dog
A swift-footed dog
00A swift-footed dog
A swift-footed dog

When text is justified, it is better to adjust only the word spacing and not the letter spacing. The default settings of design programmes often include some letter spacing, but this setting is manually adjustable. With justified text in very narrow columns, as in newspapers, one can hardly avoid this variable letter spacing without very wide word spacing. A choice between two evils is inevitable in this case (see also the section on methods of typesetting

pt	+/−pt	QXP	ID
4	0,270	13,5	68
6	0,229	7,6	38
7	0,208	6,0	30
8	0,188	4,7	23
9	0,167	3,7	19
10	0,146	2,9	15
11	0,125	2,3	11
12	0,104	1,7	9
14	0,063	0,9	4
16	0,021	0,3	1
20	−0,063	−0,6	−3
24	−0,146	−1,2	−6
28	−0,229	−1,6	−8
32	−0,313	−2,0	−10
36	−0,396	−2,2	−11
48	−0,646	−2,7	−13
60	−0,896	−3,0	−15
72	−1,146	−3,2	−16

6 pt FontFont Profile Regular

8 pt FontFont Profile Regular

10 pt FontFont Profile Regular

12 pt FontFont Profile Regular

16 pt FontFont Profile Regular

24 pt FontFont Profile Regular

36 pt FontFont Profile Regular

further on in this chapter). Headings or other short texts are sometimes spaced very widely for aesthetical reasons. There are several reasons for caution, however. Eyes do not move evenly over a text when reading. Eye movements (also called saccades) and fixations alternate. During a fixation, the eye can see about 8 to 12 letters clearly. It recognizes the word instead of deciphering individual letters. A fixation is followed by an eye movement. During this movement, the eye does not see clearly. It needs an orientation point to focus. These orientation points are mainly word spaces. 93−95% of reading time is spent on pauses to fixate. It will be clear that, when the spacing between letters is too wide, the eye has more trouble orienting, and thus finds the word space less quickly. This means that fewer fixations can be used for recognising words, which in turn means that the reader will read less quickly. Moreover, the appearance of a text is messier and texts take up more space, thus potentially using more pages.

This is not a plea to never use this method, but we do want to show the effect it has on legibility.

In QuarkXPress, it is possible to use the so-called flexible space width. On a Mac, this space is accessible through the Alt-Shift-spacebar combination and is a default space that does not change with justification. The setting can be changed in preferences and is normally set to 50%. Experience shows that 25% is enough for the setting that is based on the em space and 20% for the standard em space in QuarkXPress. It is slightly confusing that this space, which is supposed to be the standard em space, is not the normal em space (equal to the body size) but the width of two noughts in Quark. This flexible space is used when the normal space is considered too wide: 6 − 8 pm becomes 6−8 pm and A. Einstein becomes A. Einstein. In the design programme InDesign, various em value based spaces can be inserted via the menu.

'A paragraph is a part of a text that is smaller than a chapter and that shows some coherence. Writers divide texts into paragraphs in order to indicate sudden turns in a story or to insert breaks in the reading of a text, and to give the whole a more ordered appearance by means of these visual guides. The way a paragraph is indicated often depends on whether it is short or long. A number of successive paragraphs can also form a whole that is nonetheless not a chapter yet, and that is a problem that needs a solution as well.'

'A paragraph is a part of a text that is smaller than a chapter and that shows some coherence. Writers divide texts into paragraphs in order to indicate sudden turns in a story or to insert breaks in the reading of a text, and to give the whole a more ordered appearance by means of these visual guides. The way a paragraph is indicated often depends on whether it is short or long. A number of successive paragraphs can also form a whole that is nonetheless not a chapter yet, and that is a problem that needs a solution as well.'

'Optical'
Text
Alignment.

'Optical'
Text
Alignment.

'Optical'
Text
Alignment.

'Optical'
Text
Alignment.

Above left: normal justified text, and right: with aesthetically aligned margins. Below: manual spacing of characters and alignment of the margin. Typeface: Proforma.

Aesthetic text alignment The digital typesetting systems of Linotype, Berthold and others in the late 1980s gave the option of separately purchasing an aesthetic programme. This programme automatically decreased the white in critical letter combinations like 'Ty' and 'Ve' by using kerning tables.

Optically aligning the left- and right-hand margin was another function of the aesthetic programme that took a long time to become available on computers. For a long time it was impossible to let punctuation marks like hyphens, full stops and quotation marks extend beyond the text frame, though it was possible to manually indent with a space and then to space negatively by hand. One could also place each line of text in a separate frame and shift, narrow or widen them individually, but this was not a very fast or economical way of working. Adobe InDesign was the first consumer programme to automate this function, albeit with limited setting options, allowing characters to extend beyond the text frame. QuarkXpress went one step further by making it possible to set hanging punctuation marks. Both programmes will no doubt offer further possibilities to enhance the visual or aesthetic alignment.

The aesthetic alignment of margins is mainly used for larger type sizes, quotations, short texts and headings and lists that extend over several lines. In multiple narrow columns with little white between them, overhanging punctuation marks can also be disruptive. Since even margins are usually not important in terms of legibility, optical text alignment is not usually applied to long passages of text. As with spacing and manual adjustment of font metrics, it is better to do nothing than do too much. Justified text with many breaks and punctuation marks is less suitable. For large type sizes it is better to avoid correcting the alignment.

There is still no solution to the problem of widely differing type sizes that are set close together in the same text frame. Since the white space before and after a large letter is larger than that in a smaller letter, the two will not align. A work-around solution is to put the larger text in a separate frame, which is then shifted. The most important 'gap makers' on the edges of a text are the

Headline
Bodytext

Headline
Bodytext

When larger fonts are combined with smaller fonts in the same text frame, alignment is a problem because there will always be a white space around the text, independent of the space settings within the frame. To achieve a good alignment, the headings can be put in the second frame as shown in the example below.

dash and the hyphen. In aesthetic text alignment, the hyphen is placed on the right outside of the block of text and the dash is placed halfway over the edge so it does not hang too much. Capital letters like the 'W', 'V', 'A', 'J' and 'T' are notorious troublemakers on the left-hand side of the block of text. These are placed so they overhang slightly on the left. On the right-hand margin, the seriffed 'f' can also be aesthetically aligned. Lowercase letters are less noticeable and in small sizes do not need their alignment adjusted. Lowercase letters of larger sizes can benefit from adjustment. These adjustments, however, will be different for every typeface.

This obviously does not apply to the full stop or the comma, which can always be placed outside the margin on the right-hand side. The same goes for quotation marks on the left-hand side in case of a left-ranging text. Quotation marks rarely appear on the right-hand side in justified text. The alignment of the right margin obviously applies only to right-ranging and justified text. Hyphens and punctuation marks can also bring the centring visually off balance in centred texts. The same applies: The larger the text, the more visible this will be.

Paragraphs A paragraph is a part of a text that is smaller than a chapter and that shows some coherence. Writers divide texts into paragraphs in order to indicate sudden turns in a story or to insert breaks in the reading of a text, and to give the whole a more ordered appearance by means of these visual guides. The way a paragraph is indicated often depends on whether it is short or long. A number of successive paragraphs can also form a whole that is nonetheless not a chapter yet, and that is a problem that needs a solution as well. All in all, designers have to study the structure, pace and dynamics of a text thoroughly to find the best possible graphic translation for the writer's intentions.

The most frequently used, classical way of indicating paragraphs is to indent the first line of writing. Designers used to use a square of white for this, which comes down to a whole em-space. So, in case of a 9 pt this is 9 points of white (or approximately 3 mm).

Another way to indent text is by the so-called hanging or reverse indent, which means indenting all lines except the first. So, one could speak of a ragged first line or of an indented piece of text.

One can, of course, indent more than an em: a quarter or a third of the set

The paragraph mark and section mark of Adobe Garamond.

Below: indenting of the first line of each paragraph and a hanging indent, each indented by 1 em. The third example shows indenting by a quarter of the column width, which results in an ugly gap. The example on the far right, where indenting only occurs after a white line, gives a more even image.

'A paragraph is a part of a text that is smaller than a chapter and that shows some coherence.

Writers divide texts into paragraphs in order to indicate sudden turns in a story or to insert breaks in the reading of a text, and to give the whole a more ordered appearance by means of these visual guides. The way a paragraph is indicated often depends on whether it is short or long. A number of successive paragraphs can also form a whole that is nonetheless not a chapter yet, and that is a problem that needs a solution as well.'

'A paragraph is a part of a text that is smaller than a chapter and that shows some coherence.

Writers divide texts into paragraphs in order to indicate sudden turns in a story or to insert breaks in the reading of a text, and to give the whole a more ordered appearance by means of these visual guides. The way a paragraph is indicated often depends on whether it is short or long. A number of successive paragraphs can also form a whole that is nonetheless not a chapter yet, and that is a problem that needs a solution as well.'

'A paragraph is a part of a text that is smaller than a chapter and that shows some coherence.

Writers divide texts into paragraphs in order to indicate sudden turns in a story or to insert breaks in the reading of a text, and to give the whole a more ordered appearance by means of these visual guides. The way a paragraph is indicated often depends on whether it is short or long. A number of successive paragraphs can also form a whole that is nonetheless not a chapter yet, and that is a problem that needs a solution as well.'

'A paragraph is a part of a text that is smaller than a chapter and that shows some coherence.

Writers divide texts into paragraphs in order to indicate sudden turns in a story or to insert breaks in the reading of a text, and to give the whole a more ordered appearance by means of these visual guides. The way a paragraph is indicated often depends on whether it is short or long. A number of successive paragraphs can also form a whole that is nonetheless not a chapter yet, and that is a problem that needs a solution as well.'

width for example. But one must be careful: If the last line of the previous paragraph consists of only one word or, after word breaking, of a few characters, some ugly holes may occur in the text.

In order to separate two paragraphs, a full line of white may also be used. However, this may result in a very unsteady text image, particularly in case of short paragraphs. There are, of course, far more ways to indicate paragraphs. Depending on the overall design, any of many special signs, followed by a normal word space, can indicate the beginning of a paragraph. It is also possible to indicate the beginning of a new paragraph within a line of text by inserting an extra space or a paragraph mark. In classical typography, it is common not to indent the first line after a line of white, and the same goes for the very first line of a text.

In general, a typographer has enough means at his or her disposal to offer the reader more reading ease and pleasure. These should all be combined together with headings and subheadings, italic texts, words set in capitals, numerical material and the amount of punctuation, typesetting methods, widths of columns and other text details.

'A paragraph is a part of a text that is smaller than a chapter and that shows some coherence. ¶ Writers divide texts into paragraphs in order to indicate sudden turns in a story or to insert breaks in the reading of a text, and to give the whole a more ordered appearance by means of these visual guides.'

'The way a paragraph is indicated often depends on whether it is short or long.
A number of successive paragraphs can also form a whole that is nonetheless not a chapter yet, and that is a problem that needs a solution as well.'

In the first example, a paragraph mark is used to indicate a new paragraph. In the second example, the first line after a white line is not indented, whereas the first line of the following paragraph in the same block of text is.

Different ways of setting type Lines of type may be set in various ways. The western eye, used to reading from left to right, is most conditioned to text set ranged left. Left-ranged texts can be justified on the right – i.e. right-ranging – or not. Justified lines of type are seen in newspapers and magazines, where the blocks of text, sometimes separated by a vertical line, result in an orderly and steady image in combination with the headlines, other pieces of text, illustrations and adverts. Because the page is completely filled, the text image has an even grey appearance. Justified lines of type are also used in books like novels where linear reading is needed with a undisturbed visual impression.

Left-ranging text, justified text, right-ranging and centred text.

'A paragraph is a part of a text that is smaller than a chapter and that shows some coherence. Writers divide texts into paragraphs in order to indicate sudden turns in a story or to insert breaks in the reading of a text, and to give the whole a more ordered appearance by means of these visual guides. The way a paragraph is indicated often depends on whether it is short or long. A number of successive paragraphs can also form a whole that is nonetheless not a chapter yet, and that is a problem that needs a solution as well.'

'A paragraph is a part of a text that is smaller than a chapter and that shows some coherence. Writers divide texts into paragraphs in order to indicate sudden turns in a story or to insert breaks in the reading of a text, and to give the whole a more ordered appearance by means of these visual guides. The way a paragraph is indicated often depends on whether it is short or long. A number of successive paragraphs can also form a whole that is nonetheless not a chapter yet, and that is a problem that needs a solution as well.'

'A paragraph is a part of a text that is smaller than a chapter and that shows some coherence. Writers divide texts into paragraphs in order to indicate sudden turns in a story or to insert breaks in the reading of a text, and to give the whole a more ordered appearance by means of these visual guides. The way a paragraph is indicated often depends on whether it is short or long. A number of successive paragraphs can also form a whole that is nonetheless not a chapter yet, and that is a problem that needs a solution as well.'

'A paragraph is a part of a text that is smaller than a chapter and that shows some coherence. Writers divide texts into paragraphs in order to indicate sudden turns in a story or to insert breaks in the reading of a text, and to give the whole a more ordered appearance by means of these visual guides. The way a paragraph is indicated often depends on whether it is short or long. A number of successive paragraphs can also form a whole that is nonetheless not a chapter yet, and that is a problem that needs a solution as well.'

In typographic terms, left-ranged text is the clearest way of typesetting: The word spacing is nice and regular and no so-called undesirable 'rivers' occur. Right-ranged texts turn out to be more difficult to read for westerners and are only used because of their special graphic effect or to give an emphasis that contrasts with the main text. They are often used for captions, colophons or in special printed matter such as letterheads and other expressions of house style. Centred texts range neither left nor right. They form the lines arranged symmetrically on a vertical axis. This way of typesetting derives from classic typography, where it was used for, for example, title pages of books, pamphlets and occasional printed matter like menus, business cards and invitations.

Just one thought further and I am sixteen, and the trees are in bloom underneath wildly billowing curtains of rain. I stand in a meandering line of people with my father and mother, getting closer to the Grand Palais step by step, where a Picasso exhibition is being shown. We are like beads on a rosary. We have the arthropodal tread of slaves, who, by sheer numbers alone, will manage to drag the enormous stone of expectation to the gate. The exhibition only confirms the greatness of my father, who painted the two pastiches that hang above the couch in our living room, signed Pissacco. When we are looking for our car afterwards – none of us paid attention to the street name when we parked it – Paris seizes me. Eventually, we find the car, which has changed into a 'bagnole'. [From the short story PAR(AD)IS REVISITÉ]

Just one thought further and I am sixteen, and the trees are in bloom underneath wildly billowing curtains of rain. I stand in a meandering line of people with my father and mother, getting closer to the Grand Palais step by step, where a Picasso exhibition is being shown. We are like beads on a rosary. We have the arthropodal tread of slaves, who, by sheer numbers alone, will manage to drag the enormous stone of expectation to the gate. The exhibition only confirms the greatness of my father, who painted the two pastiches that hang above the couch in our living room, signed Pissacco. When we are looking for our car afterwards – none of us paid attention to the street name when we parked it – Paris seizes me. Eventually, we find the car, which has changed into a 'bagnole'. [From the short story PAR(AD)IS REVISITÉ]

FiSH-

The first line of the wide column shows a widow in its most conspicuous form, just before an indented paragraph. The last line of the column is an orphan, the first line of a new paragraph.

Widows and orphans Now that document layout is no longer the domain of professionals such as typesetters and typographers and virtually everyone can try their hand at typography and layout, widows and orphans are a regular occurrence in printed matter. A widow is the last line of a paragraph (a word or group of words) that appears on its own at the beginning of the next column or page. This is less objectionable when the line is filled or almost filled and is not followed by a blank line. An orphan is the first line of a paragraph that appears as the last line of a page. This is especially unattractive when the paragraph's opening line is indented. The person who executed the layout is not always to blame, for in some documents widows and orphans can be caused by font changes. If a document from a word processing or layout programme is opened on a computer that does not have that font required, a different typeface is automatically substituted, which can create widows or orphans due to text overflow. Professional layout programmes have an optional setting that prevents a paragraph from overflowing, but this too causes problems in the correction phase. But a solution to the problem of widows and orphans is to be expected, in the same way that incorrect quotation marks can automatically be replaced with correct ones and that software comes with an extensive automated spell checker. It does however show that, in an aesthetic sense, a fully automated layout process will not be possible. Unattractive breaks, annoying short sentences in the wrong places and wide gaps that occur in a text because some words are not hyphenated because they do not feature in the hyphenation table are only a few of the examples that the corrector on a cleaning mission can encounter.

Word breaks Splitting words or compound words at the end of a line in ragged right setting is not generally conducive to comfortable reading, but neither are white gaps at the ends of lines.

It is best not to break words or to sparingly break them manually, and in case of long compound words, to break them after a whole word. In justified text, word breaks are almost inevitable if you wish to avoid word spaces that are too big. In unjustified text with a normal line length they can be avoided. The image of an unjustified block of text is, however, strongly determined by the ends of the successive lines. Large white gaps are generally considered annoying and the same goes for successive lines of nearly the same length.

An unjustified text block with successive lines that clearly but not excessively differ in length, and which do not have a strikingly ragged right, is considered to be harmonious. This applies even more to centred texts, as there are two ragged sides. Virtually all graphic computer programmes offer the option to split words automatically. For this purpose, one specifies the minimum number of characters required before the break. The word breaks should be checked, however, because some words may be break incorrectly. With manual word breaks during a spelling check one should also watch for text overflown.

Good hyphenation, word spaces that are used in a balanced way, a good margin alignment, punctuation and ligatures; typography that was already understood in 1559, when the *Chroniques de Tournes* by Froissart was compiled, set in a Garamond Roman.

f‑ f‑

f‑ f‑

This example shows that hyphens are not just straight lines. Above, Calisto and Angie and below, Warnock Pro and Candara.

The hidden symbols can be a guide to spot errors in a text. A discretionary hyphen is indicated by small dashes above and below the hyphen. A paragraph mark indicates a hard return. A double space is indicated by two dots and the shifting of text to the next column with an arrow that points down. It is best to work in a typographically clean way from the start to keep the document as 'unpolluted' as possible.

If a hyphen has been used instead of a discretionary hyphen, this can lead to a word break in the middle of a line. A discretionary hyphen automatically disappears if the text overflows. The same goes for a discretionary and manual line break. Here too, a wrong choice will haunt the typographer until the document is finished. Each correction can in that case lead to text overflow and the appearance of holes in the text or hyphens in the middle of a line. In case of doubt, the document can be checked by turning on the so-called 'hidden symbols'. A paragraph return is made visible by the paragraph mark, double spaces can be seen and discretionary hyphens are marked.

If·a·hyphen·has·been·used·instead·of·a·discretionary·hyphen,·this·can·lead·to·¶
a·word·break·in·the·middle·of·a·line.·A·discretionary·hyphen·automatically·dis‑
appears·if·the·text·overflows.·The·same·goes·for·a·discretionary·and·manual·
line·break.·Here·too,·a·wrong·choice·will·haunt·the·typographer·until·the·docu‑
ment·is·finished.·Each·correction·can·in·that·case·lead·to·text·overflow·and·the·
appearance·of·holes·in·the·text·or·hyphens·in·the·middle·of·a·line.·In·case·of·
doubt,·the·document·can·be·checked·by·turning·on·the·so-called·'hidden·¶
symbols'.·A·paragraph·return·is·made·visible·by·the·paragraph·mark,·double·
spaces·can·be·seen·and·discretionary·hyphens·are·marked.·

Line interval A 9 pt character has, without extra line spacing, a normal line interval of 9 points. It is specified as point size 9/9 and is said to be 'set solid'. In general, such solid setting is legible because ascenders and descenders should not touch. But for better legible text it is with almost every typeface better to use some line spacing. This mainly depends on the x-height, the length of the ascenders and descenders of the typeface and the length of the lines. The actual image of the characters may be larger in one typeface than another when they are set with the same body size, so that the larger will require more white space. Other things being equal, however, a larger type needs relatively less white space between the lines. Furthermore, a bolder typeface usually requires a somewhat larger line interval. Wide typefaces will ask for somewhat more white to guide the reader to the start of the next line. It is therefore wise to first make a proof and to read it or have it read by someone else to judge its legibility. The possibilities are virtually endless. Also note that a text with more white looks bigger. The visual perception also has some influence on the text, and each typeface will respond differently. Carelessly increasing or reducing white space certainly doesn't aid the typographer's search for the most legible or the most aesthetically balanced image of a page.

In theory, ascenders and descenders should not touch in text set solid, here 64/64 pt. Those of Palatino, often supplied as a system typeface, do and it needs four points of line space extra to rectify this.

The exhibition only confirms the greatness of my father, who painted the two pastiches that hang above the couch in our living room, signed Pissacco. When we are looking for our car afterwards – none of us paid attention to the street name when we parked it – Paris seizes me. Eventually, we find the car, which has changed into a 'bagnole'.
[From the short story PAR(AD)IS REVISITÉ]

The exhibition only confirms the greatness of my father, who painted the two pastiches that hang above the couch in our living room, signed Pissacco. When we are looking for our car afterwards – none of us paid attention to the street name when we parked it – Paris seizes me. Eventually, we find the car, which has changed into a 'bagnole'.
[From the short story PAR(AD)IS REVISITÉ]

The exhibition only confirms the greatness of my father, who painted the two pastiches that hang above the couch in our living room, signed Pissacco. When we are looking for our car afterwards – none of us paid attention to the street name when we parked it – Paris seizes me. Eventually, we find the car, which has changed into a 'bagnole'.
[From the short story PAR(AD)IS REVISITÉ]

The same text, set set to three different measures, each with three different line spacings: set solid in a type size 8.5/8.5, with an extra 1 pt line space in type size 8.5/9.5 and an extra 2 pt line space in type size 8.5/10.5. The typeface used is Quadraat by Fred Smeijers. The general rule is: The longer the lines, the larger the line interval needed. Visually, the type in the left-hand box seems bigger than the other examples. It is not. This should also be taken into account.

The exhibition only confirms the greatness of my father, who painted the two pastiches that hang above the couch in our living room, signed Pissacco. When we are looking for our car afterwards – none of us paid attention to the street name when we parked it – Paris seizes me. Eventually, we find the car, which has changed into a 'bagnole'.
[From the short story PAR(AD)IS REVISITÉ]

The exhibition only confirms the greatness of my father, who painted the two pastiches that hang above the couch in our living room, signed Pissacco. When we are looking for our car afterwards – none of us paid attention to the street name when we parked it – Paris seizes me. Eventually, we find the car, which has changed into a 'bagnole'.
[From the short story PAR(AD)IS REVISITÉ]

The exhibition only confirms the greatness of my father, who painted the two pastiches that hang above the couch in our living room, signed Pissacco. When we are looking for our car afterwards – none of us paid attention to the street name when we parked it – Paris seizes me. Eventually, we find the car, which has changed into a 'bagnole'.
[From the short story PAR(AD)IS REVISITÉ]

The exhibition only confirms the greatness of my father, who painted the two pastiches that hang above the couch in our living room, signed Pissacco. When we are looking for our car afterwards – none of us paid attention to the street name when we parked it – Paris seizes me. Eventually, we find the car, which has changed into a 'bagnole'.
[From the short story PAR(AD)IS REVISITÉ]

The exhibition only confirms the greatness of my father, who painted the two pastiches that hang above the couch in our living room, signed Pissacco. When we are looking for our car afterwards – none of us paid attention to the street name when we parked it – Paris seizes me. Eventually, we find the car, which has changed into a 'bagnole'.
[From the short story PAR(AD)IS REVISITÉ]

The exhibition only confirms the greatness of my father, who painted the two pastiches that hang above the couch in our living room, signed Pissacco. When we are looking for our car afterwards – none of us paid attention to the street name when we parked it – Paris seizes me. Eventually, we find the car, which has changed into a 'bagnole'.
[From the short story PAR(AD)IS REVISITÉ]

Choosing a typeface

Although many designers prefer to work with a limited number of favourite type-faces, it is also important to constantly assess whether a particular typeface is suited to the project in question. Does it include the required styles and symbols? How efficient is the letter? Does it support other languages? Are ligatures or small capitals required? Are old style figures available for use in text containing lots of numbers? Are lining figures available for setting tables and lists? These are the technical conditions that a typeface must meet. If the project is limited and will not be repeated, a typeface without too many trimmings can be chosen, one with a limited number of styles and without old style figures and small capitals, for example. This requires a good relationship with the text writer as the choice of typeface can potentially limit their freedom of expression in particular words or terms.

Children and the visually impaired In general, it is true to say that some typefaces are less suited for particular uses while others are specially designed for them. Gill Sans, for example, is very popular for children's books because it is a humanistic lineal. Distinct shapes with sufficient differences between the individual letters that, especially in the larger font sizes used in books for small children, are more similar to teaching material than seriffed types. In recent years, many new designs have been made, particularly in this category, so the automatic choice of the Gill Sans is no longer necessary. At the other end of

The greatest problems for the visually impaired and dyslexic are the similarly formed characters such as those shown here with Myriad.

To the right: a few typefaces used for children's books and texts for the visually impaired and dyslexic. Gill Sans is often used for children's books because of its mild character. APHont was specifically designed for the visually impaired. Tahoma and Comic Sans are considered easily accessible alternatives by interest groups for the visually impaired. The latter is not the first choice for body text type by the most typographers as it is too similar to a script letter.

A great blue elephant

Gill Sans 24 pt

A great blue elephant

APHont 24 pt

A great blue elephant

Tahoma 24 pt

A great blue elephant

Comic Sans 24 pt

the spectrum, typefaces are also made specifically for those with a visual impediment. Dyslexia also brings with it special conditions for a typeface. Designed specifically for schoolbooks for children are Sassoon Primary and an adapted version of the Gill Sans, Gill Sans Schoolbook or Gill Sans Infant. In Germany AG Schulbuch and FF Schulbuch Nord are lord and master of the classroom. FontSmith offers the specially designed FS Me with the subtle 'accessible type'. The typeface Fiendstar by Nicolas Garner was designed as a more modern alternative to Gill Sans Schoolbook. In general it can be acknowledged that for those learning to read, the visually impaired and people with dyslexia, each letter must be sufficiently different from the others and the shapes should be kept simple and clear. Counters are made large and ascenders and descenders are rather long than short, resulting in an optimal legibility. The Gill Sans was not specifically made for this user group and a number of details do not meet the aforementioned requirements. This is why the two-storey 'g' and 'a' characters were re-designed and restyled for the Gill Sans Infant typeface. The characters 'l', '1' and '4' were also made more distinct.

fiendstar Regular
fiendstar Italic
fiendstar Semibold
fiendstar Semibold Italic
fiendstar Bold
fiendstar Bold Italic

Fiendstar is a typeface designed specifically as successor to Gill Sans in schoolbooks.

a b d g l y l 4
a b d g l y 1 4

The differences between the regular (above) and 'Schoolbook' or 'Infant' versions of Gill Sans can clearly be seen here in several characters. In contrast with many sans-serifs, the 'b' and 'd' already differed significantly from each other in the original version. They are illustrated here to show that they did not need to be altered.

Below is an image taken from the folder for Greta by Typotheque. Greta is one of the most extended typefaces for newspapers with three 'grades' (as with the Miller), narrow and display versions and ornaments. Photo: Joep Pohlen.

Newspapers Since the introduction of Times New Roman and Excelsior in the 1930's there have of course been numerous developments with typefaces designed specifically for use in newspapers. The emphasis with these typefaces lies, not surprisingly, in legibility on paper of lesser quality as well as in efficiency. Dutch type designer Gerard Unger is particularly interested in this area. The typefaces Swift, Gulliver and Coranto are three of his designs with large x-heights and large counters. Swift can be seen in many newspapers, both in The Netherlands and further afield. Gulliver is the most extreme newspaper type for saving space. The American paper *USA Today* was able to reduce the size of its newspaper by 3 cm simply by using this typeface. The Gulliver appears even larger than the previously used Bedford. The Frenchman Jean François Porchez also designed 'custom' typefaces for large clients. The typeface Le Monde was, as its name suggests, designed for the quality French paper *Le Monde*. Around 1986 the Dutch newspaper *Trouw* introduced a

new design and layout exclusively set in the sans-serif typeface Frutiger. This sparked many reactions from readers and even reached the international press. Not long after, Frutiger was replaced as body text letter but is still used for headings and secondary texts. It is a well-known fact that newspaper readers in particular find continuity in their paper very important. An extreme reaction to a drastic change often has more to do with the conditioning of the reader than with actual legibility. The designer Lucas de Groot designed the sans-serif Taz for the German paper *Tageszeitung* (*TAZ*) and SpiegelSans as heading typeface for the magazine *Der Spiegel*. For the Brazilian newspaper *Folha de S. Paulo* he designed the heading letter FolhaSerif.

The top ten most popular typefaces on the front page of the hundred greatest American newspapers are: Poynter, Franklin Gothic, Helvetica, Utopia, Times, Nimrod, Century Oldstyle, Interstate, Bureau Grotesque and Miller. This list refers to embedded typefaces in the PDF of the front page; it is not likely that the body text is set in the sans-serif typefaces Helvetica, Franklin Gothic and Interstate. The American company Font Bureau, which has designed many typefaces for newspapers, has created an adaptation of Miller: Miller Daily. This is sold in four different 'grades' (not to be confused with 'normal' styles) of which each version is slightly heavier than the previous one. As such every newspaper can choose the grade that gives the desired end result, no matter what paper or press is used. In fact, the grade chosen corrects the technical conditions under which the newspaper is made. Each grade also includes the normal styles bold and regular with their respective italics.

Just one thought further and I am sixteen, and the trees are in bloom underneath wildly billowing curtains of rain. I stand in a meandering line of people with my father and mother, getting closer to the Grand Palais step by step, where a Picasso exhibition is being shown.
[Times New Roman 9/9 pt]

Just one thought further and I am sixteen, and the trees are in bloom underneath wildly billowing curtains of rain. I stand in a meandering line of people with my father and mother, getting closer to the Grand Palais step by step, where a Picasso exhibition is being shown.
[Swift Regular 8/8 pt]

Just one thought further and I am sixteen, and the trees are in bloom underneath wildly billowing curtains of rain. I stand in a meandering line of people with my father and mother, getting closer to the Grand Palais step by step, where a Picasso exhibition is being shown.
[Century Old Style 7,7/7,7 pt]

Just one thought further and I am sixteen, and the trees are in bloom underneath wildly billowing curtains of rain. I stand in a meandering line of people with my father and mother, getting closer to the Grand Palais step by step, where a Picasso exhibition is being shown.
[Miller Text Roman 8,1/8,1 pt]

Just one thought further and I am sixteen, and the trees are in bloom underneath wildly billowing curtains of rain. I stand in a meandering line of people with my father and mother, getting closer to the Grand Palais step by step, where a Picasso exhibition is being shown.
[Concorde Regular 7,8/7,8 pt]

Just one thought further and I am sixteen, and the trees are in bloom underneath wildly billowing curtains of rain. I stand in a meandering line of people with my father and mother, getting closer to the Grand Palais step by step, where a Picasso exhibition is being shown.
[Excelsior 7,5/7,5 pt]

Times New Roman – 18 pt	abcdefghijklmnopqrstuvwxyz
Swift Regular – 18 pt	abcdefghijklmnopqrstuvwxyz
Century Oldstyle – 18 pt	abcdefghijklmnopqrstuvwxyz
Miller Text Roman – 18 pt	abcdefghijklmnopqrstuvwxyz
Concorde Regular – 18 pt	abcdefghijklmnopqrstuvwxyz
Excelsior Regular – 18 pt	abcdefghijklmnopqrstuvwxyz
Franklin Gothic Book – 18 pt	abcdefghijklmnopqrstuvwxyz
Neue Helvetica – 18 pt	abcdefghijklmnopqrstuvwxyz
Interstate Plus Regular – 18 pt	abcdefghijklmnopqrstuvwxyz
TheSans 5 – 18 pt	abcdefghijklmnopqrstuvwxyz
Meta Plus Normal – 18 pt	abcdefghijklmnopqrstuvwxyz
Frutiger 55 Roman – 18 pt	abcdefghijklmnopqrstuvwxyz

Just one thought further and I am sixteen, and the trees are in bloom underneath wildly billowing curtains of rain. I stand in a meandering line of people with my father and mother, getting closer to the Grand Palais step by step, where a Picasso exhibition is being shown.
[Franklin Gothic Book 8,5/8,5 pt]

Just one thought further and I am sixteen, and the trees are in bloom underneath wildly billowing curtains of rain. I stand in a meandering line of people with my father and mother, getting closer to the Grand Palais step by step, where a Picasso exhibition is being shown.
[Neue Helvetica Regular 8/8 pt]

Just one thought further and I am sixteen, and the trees are in bloom underneath wildly billowing curtains of rain. I stand in a meandering line of people with my father and mother, getting closer to the Grand Palais step by step, where a Picasso exhibition is being shown.
[Interstate Regular 7,7/7,7 pt]

Just one thought further and I am sixteen, and the trees are in bloom underneath wildly billowing curtains of rain. I stand in a meandering line of people with my father and mother, getting closer to the Grand Palais step by step, where a Picasso exhibition is being shown.
[TheSans 5 8,2/8,2 pt]

Just one thought further and I am sixteen, and the trees are in bloom underneath wildly billowing curtains of rain. I stand in a meandering line of people with my father and mother, getting closer to the Grand Palais step by step, where a Picasso exhibition is being shown.
[Meta Plus Normal 8,4/8,4 pt]

Just one thought further and I am sixteen, and the trees are in bloom underneath wildly billowing curtains of rain. I stand in a meandering line of people with my father and mother, getting closer to the Grand Palais step by step, where a Picasso exhibition is being shown.
[Frutiger Roman 7,5/7,5 pt]

Typefaces made especially for signposting often include relevant pictograms, which can be accessed via the keyboard, such as one shown here for the German Autobahn.

Signposting Signposting requires a different set of initial criteria than newspapers. It is noteworthy that many typefaces designed specifically for signposting have also become the most popular sans-serifs for newspapers. This is the case with the American roadways typeface Interstate and with Frutiger. The most famous typefaces for signposting are undoubtedly the Johnston sans-serif by Edward Johnston, drawn in 1916 for the London Underground, and Frutiger made in 1968 which was designed by Adrian Frutiger as 'Roissy' for the signposting of the new Roissy (later Charles de Gaulle) airport, near Paris. Eric Gill also worked on the design of the Johnston and later incorporated his experiences into Gill Sans. Futura by Paul Renner contains many influences from the Johnston. Many designers have worked in this field. Jean François Porchez designed Parisine for the Paris Metro. Gerard Unger designed a new, distinct sans-serif for the signposting of the Dutch organization ANWB.

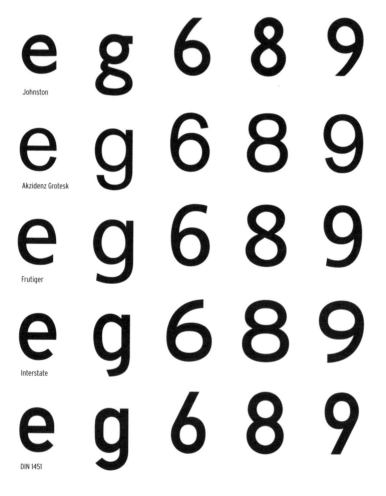

Johnston

Akzidenz Grotesk

Frutiger

Interstate

DIN 1451

Left are shown the differences in typefaces for signposting. At the top is the Johnston sans-serif drawn for the London Underground in 1916. Akzidenz Grotesk from 1896 was used for the signposting at Schiphol Airport and was later replaced by Frutiger. Interstate is used for road signposting in many countries including the USA, Spain, the Netherlands, Australia, New Zealand and several Central American and South American countries. The DIN 1451 is used in Germany, Czech Republic and elsewhere. For this illustration we have chosen some so-called critical characters, often difficult to distinguish from one another, especially at greater distances. These typefaces should be as narrow as possible so that longer names can fit onto signboards. Some typefaces therefore also include a condensed version.

abcdefghijklmnopqrstuvwxyz1234567890
abcdefghijklmnopqrstuvwxyz1234567890

The typeface SNV (above) is used for signposting in Belgium, Switzerland, Slovenia, Croatia and elsewhere. Parisine (below) for the Paris Metro by Jean François Porchez shows that a modern typeface with the same width can appear larger and distinguishes more clearly between the characters. Its figures are even slightly narrower than SNV's.

ANWB-Uu was intended to replace the ANWB-Ee and the condensed ANWB-Cc, both derived from the American Interstate. The client wanted an efficient typeface that was more legible than the old one, which was based on the American signposting system. The existing typeface was used as a starting point so that the resulting differences with the existing signposts could be kept to a minimum. Font Bureau released the American typeface onto the market as a commercial typeface in 1993 under the appropriate name Interstate and since then it has been extended by type designer Tobias Frere-Jones into a complete typeface family. Unger also designed the Capitolium typeface for the signposting of the anniversary of the Catholic Church in 2000, for which he found inspiration in the work of sixteenth century Italian calligrapher Cresci, who was familiar with Imperial Roman inscriptional lettering. It is unusual that this typeface includes serifs and as such differs from the majority of types used for signposting. The Metadesign bureau, birthplace of many type designers due to its past links with type producer and distributor FontShop, designed the typeface Transit for the Berliner Verkehrsbetriebe (BVG), which included a large number of symbols and pictograms. The signposting at the Dutch airport Schiphol has generated a great deal of imitation and was designed with the Akzidenz Grotesk typeface around 1960 by Benno Wissing at the Total Design bureau. During a re-design Paul Mijksenaar replaced the Akzidenz Grotesk with Frutiger as it was deemed more legible.

Corporate fonts the so-called corporate fonts are another important area for type designers. These fonts are often greatly extended and focus on expressing the image of a company or institution and making the typeface fit in with its specific demands. One of the first was the VAG by Adrian Williams from 1979 for Volkswagen AG. Each stroke in this typeface has a rounded terminal. It is not a particularly extensive typeface and its use was limited to advertisements and user manuals. As such it was not really a true corporate typeface such as we know today. The successors Volkswagen Headline and Volkswagen Copy were derived from Futura and restyled by Lucas de Groot. Eastern European, Greek, Hebrew and Cyrillic typefaces and punctuation marks were added to make it possible to use the typeface worldwide. Other designs such as the AgroSans (renamed Corpid), designed by Lucas de Groot for the Dutch Ministry of Agriculture, contain a great diversity in the styles, with added small capitals and figures. The extended typeface family Sun, both the seriffed version and the sans-serif, was designed by Lucas de Groot for Sun Microsystems. Mercedes Benz has its own typeface designed by Kurt Weidemann. Nivea uses Metro by W.A. Dwiggins from 1929/30 for its logo and publications, a typeface that was initially designed out of dissatisfaction with Futura, but it remains very similar. This kind of similar typeface is often released onto the market by competing type companies after the resulting popularity of the original; Futura was

Two extremely well-known typefaces that were among the first corporate typefaces.

RENAULT
RENAULT
RENAULT
RENAULT
RENAULT
RENAULT
RENAULT

produced by Bauersche Gießerei and Metro by Mergentaler Linotype. Specially designed corporate fonts are not often available for general use or licensing, but are restricted to publications of the company or institution itself. An example is the new design Renault by Jean François Porchez from 2004. The old Renault typeface (shown left), which was designed in 1979 by the bureau Wolff Olins, is now freely available. Special versions of this typeface were made for texts set in white on a dark background. This is the case with the Bold Negative and the Bold Italic Negative. The shapes of the letters are drawn slightly thinner as a visual correction for use in this way. Almost every type supplier now offers the possibility to have corporate fonts designed, be it exclusive or not.

Dictionaries and bibles Very specific typefaces have been developed for space-saving typography such as is required in dictionaries, bibles and encyclopaedias, as well as the Yellow Pages and other telephone books. A version of Lexicon including phonetic symbols was made for Van Dale Lexicografie, publisher of the most renowned Dutch dictionary. Bram de Does designed Lexicon with special styles including shortened descenders and ascenders. It is a good example of a typeface that is at its best when set with a smaller line spacing and in full pages of text. A number of the typefaces discussed under the heading 'Newspapers' also fall into this category, whereby the most important factors are optimal use of space and good legibility. As well as being efficient, the letter should also survive on inferior paper types such as is often used for telephone books. With this in mind, Matthew Carter from Font Bureau adapted Bell Gothic by Chauncy H. Griffith and made it into Bell Centennial. This typeface was made for the American telephone books and has so-called ink traps, which ensure that the counters do not fill with ink during the printing process. Even with considerable ink squash, the typeface therefore remains legible. Due to its efficiency, Gulliver by Gerard Unger is also suitable for use in dictionaries and other reference works, just like Fedra by Peter Bil'ak, which is used by Harper Collins in dictionaries. In contrast to Gulliver, Fedra and Lexicon include phonetic characters. The construction of these typefaces is based on a large x-height and an open structure with a reasonable ascender length so that accents remain visible. The descender lengths, in contrast, are shorter. The lowercase letters without ascenders and descenders are therefore lower on the body (in most types they are approximately centred).

ABCDEFGHIJ
KLMNOPQRS
TUVWXYZ&
abcdefghijkl
mnopqrstuv
wxyzæœß/@
Ø(–).:;!?€¥£§
1234567890

Gulliver by Gerard Unger is considered the most efficient typeface in the world, but has (as yet) no phonetic symbols for use in dictionaries.

Syntax (left) and Fedra, showing the difference in the x-height.

akgfpx 54 pt akgfhpx

Mixed typeface families Mixing typefaces is becoming more and more common due to the use of both seriffed and sans-serif typefaces within corporate identities, with one publication requiring perhaps a less business-like feel than another. As such, extended typeface families have been created, particularly for corporate typefaces, which include both sans-serifs and types from other categories in the classification. The simplest form is to remove the serifs from a serif letter. The result is a sans-serif. According to some theories, this is how the very first sans-serifs were actually made.

Rotis Serif
Rotis SemiSerif
Rotis SemiSans
Rotis SansSerif

One of the first to combine a related seriffed type and sans-serif was Jan van Krimpen with the Romulus typeface. If one version is placed on top of the other, it becomes clear that the skeletal forms are roughly the same. The typeface Rotis by Otl Aicher comprises sans-serif (SansSerif) and seriffed (Serif) versions as well as a SemiSans and SemiSerif.

This expansion of functionality has increased dramatically and nowadays a new type design including only the traditional three or four styles (regular, italic, bold and sometimes bold italic) is considered impoverished. One of the early examples is the seriffed type Scala (1990) to which Martin Majoor subsequently added the Scala Sans (1993). Lucas de Groot has also extended his Thesis (1989) over time with a whole repertory of possibilities. From the three basic forms TheSans, TheSerif, TheMix and TheSansMono, there are now more than 140 styles available. His aim was to design a typeface family as total solution to the needs of a company, from façade lettering to business cards and from signposting to microtypography for an annual report. Publishers such as Linotype noticed the success of these typefaces and also began extending their existing typefaces; at first with small capitals and extra figures and then with other variations. An example of this is the Syntax (1970) by Hans Eduard Meier. This typeface has now been extended with a seriffed version. Under the direction of Olaf Leu, Linotype designed a completely new typeface specifically for use in annual reports. This typeface, the Compatil, was designed as a complete system from the beginning. The Compatil Exquisit has decorative, classical forms, the Compatil Fact is a sans-serif, the Compatil Letter has sturdy serifs, and the Compatil Text is good for body text. These typefaces can be interchanged without resulting in displacement of the text. Each typeface includes small capitals and various styles of figures, which is very important for financial publications such as annual reports. The grey tone of the text remains the same when one of the other styles is chosen and the kerning and width of the different styles are identical. As such negative spacing, when applied to all styles, does not alter the placement of the text. The italic versions are all designed at an angle of 11 degrees. The complexity and the coupling of the four different grades of this typeface cost the design team a

Compatil
Compatil
Compatil
Compatil

Compatil Exquisit, Fact, Letter and Text versions by Linotype.

large amount of time. The four Compatil fonts are available in regular, italic, bold and bold italic. The Open Type Pro XSF version also includes 387 different symbols for 48 western languages.

The XSF version (eXcellent Screen Fonts) is available in OpenType and TrueType and is made with delta hinting for the better reproduction of typefaces in smaller sizes and on low-resolution computer screens. This delta hinting is the manual optimization of each character for screen reproduction in order to increase its legibility. In general this technique is used in so-called corporate fonts because they are used for both printed publications and intranet and internet applications. But the mixing goes further. The Filosofia by Zuzana Licko includes the normal styles regular, italic and bold as well as the special style Unicase, which is a mixture of capital and lowercase letters. Only the unique character 'j' and the tail of the letter 'Q' extend below the baseline. Besides language versions with complete symbol sets for Greek, Russian and other languages, specific styles are also often added for the application in question; phonetic symbols for dictionaries, pictograms for signposting and swash letters and other decorative elements from the style period of the typeface.

Filosofia at first appears to be a serious body text typeface based on Bodoni, with an extensive variety of style variants. The Unicase variant is especially surprising.

GHIJKLMNOPQrs

Body text typefaces A great many of the available and most widely used typefaces were designed primarily for use as body text. It should be clear, even to the layman, that a typeface such as the Wet'N'Wilde (see page 76) was not designed primarily for body text and that carefully adjusted letter spacing was not a high piority in its production. Due to the fact that most type designers earn their money with designs that have wide reaching application possibilities, it is no surprise that Frutiger by Adrian Frutiger, for example, was designed for signposting but is used more for printed publications. Early in his career, Adrian Frutiger worked at the Deberny & Peignot type foundry, where he designed Univers. Gerard Unger made a name for himself at the company Hell, which later merged with Linotype. Although he occasionally designed for signposting and other applications, his primary work area is body text typefaces. It remains true that a typeface for body text should be technically correct. It should be designed so as to avoid output problems, should be well spaced and the characters available should be useable and numerous. There are many type designers offering their wares via internet and making made-to-measure typefaces for newspapers and the corporate world. In the knowledge that it can never be complete, we have compiled a list at the back of this book containing

a number of type companies, some of which were active in the days of cast metal typesetting. A number of mergers have taken place since, but the collections are usually still referred to with their original name. The chapter 'Digital aesthetics' discusses a number of type companies in detail. Most typefaces still in use today are revivals of designs hundreds of years old, even from the very beginning of type design. One much used source is the work of Claude Garamond. Below is a small selection of the almost endless series of Garamonds available. The power of a sixteenth century typeface. We often think we live in a fast world, but sometimes our current role in history is perhaps less important than we think.

A selection of six Garamonds, each with its own character, yet all stemming from the same origins. Outside this selection there are countless versions with the same name and still more with other names, all stemming from the Garamond in form and feel.

abcdefghijklmnopqrstuvwxyz – Simoncini Garamond

abcdefghijklmnopqrstuvwxyz – ITC Garamond

abcdefghijklmnopqrstuvwxyz – Garamond Classico

abcdefghijklmnopqrstuvwxyz – Garamond 3

abcdefghijklmnopqrstuvwxyz – Adobe Garamond

abcdefghijklmnopqrstuvwxyz – Stempel Garamond

The typeface overview The second section of this book is an overview of typefaces, giving more visual information about the uses of particular typefaces. As such, the typefaces are shown in a number of ways so that the right choice can easily be made. It is a classical choice of typefaces and almost every member of the Vox+1 classification is represented. Various versions of each typeface have been included so that comparisons and choices can be made. Furthermore, the choice of typeface is the individual selection of the designer, whereby a personal feeling plays an important role. It is therefore wise to carry out a number of tests with the desired text in order to see if the text is well presented. Serif or sans-serif is probably the first choice. The nuances should then be studied, as well as the selection of characters available. With all this in mind, the novice typographer will perhaps view the mountain of available typefaces with trepidation, but 'learning by doing' is the advice here. To keep track of all the new releases requires regular visits to the websites of various distributors in order to keep on top of all the newest developments. The possibilities of faster production bring with them increased production and in this case more interesting typefaces. This book can therefore only represent a snapshot of a dynamic field of work.

The typefaces

2

Serif

Sans-serif

Miscellaneous

These lines, drawn across the width of the page, indicate the x-height and the cap-height of the typeface shown on that page. The number indicates the font size.

The black column containing white text in different sizes illustrates whether a particular font size is suitable for use in this way.
If ink spread is a potential problem, it is not advisable to place this font size as white text on a black or other dark coloured background.

This text is printed on each style page and shows how a particular style appears as a body of text. It is set as a 9 pt letter, a font size often used for setting large amounts of body text.
Repeating this text on every example page gives a good impression of how practical the letter is in comparison to other typefaces.

Linotype Centennial 55 Roman & SC · Font size 28/13 mm

A B C D E F G H I J K
L M N O P Q R S T U V
W X Y Z a b c d e f g
h i j k l m n o p q r
s t u v w x y z 1 2 3
4 5 6 7 8 9 0 ? ! () []
& " " « » ; : / - – à ç é î

A B C D E F G H I J K
L M N O P Q R S T U V
W X Y Z I 2 3 4 5 6 7
8 9 0 fi fl À ?

HxqkmHxqkmHxqkmHxqkmHxqkm · 20, 16, 12, 10, 8, 6, 4 pt

Font size 9/11 pt

Just one thought further and I am sixteen, and the trees are in bloom underneath wildly billowing curtains of rain. I stand in a meandering line of people with my father and mother, getting closer to the Grand Palais step by step, where a Picasso exhibition is being shown. We are like beads on a rosary. We have the arthropodal tread of slaves, who, by sheer numbers alone, will manage to drag the enormous stone of expectation to the gate. The exhibition only confirms the greatness of my father, who painted the two pastiches that hang above the couch in our living room, signed Pissacco. When we are looking for our car afterwards – none of us paid attention to the street name when we parked it – Paris seizes me. Eventually, we find the car,

– 276

Linotype Centennial

Font size 5/6.5 pt

In Paris, new buildings thrive like ivy, she says, staring out the window as the sun's rays glide past. They colour with the seasons and quickly obtain the status of immortality. In front of the Louvre, for example, a glass pyramid has arisen from the surface to memory of a president. The Gare d'Orsay's overcoat received a lining: a design train à grande vitesse stands in its final depot. And because of all this, Café Costes has already become the oldest watering place in Paris. All those 'immobile' creatures are, after a short period of discomfort, welcomed into the city's bosom as in-laws.

6/7.5 pt

In Paris, new buildings thrive like ivy, she says, staring out the window as the sun's rays glide past. They colour with the seasons and quickly obtain the status of immortality. In front of the Louvre, for example, a glass pyramid has arisen from the surface to memory of a president. The Gare d'Orsay's overcoat received a lining: a design train à grande vitesse stands in its final depot. And because of all this, Café Costes has already become the oldest watering place in Paris. All those 'immobile' creatures are, after a short period of discomfort, welcomed into the city's bosom as in-laws.

7/8.5 pt

In Paris, new buildings thrive like ivy, she says, staring out the window as the sun's rays glide past. They colour with the seasons and quickly obtain the status of immortality. In front of the Louvre, for example, a glass pyramid has arisen from the surface in memory of a president. The Gare d'Orsay's overcoat received a lining: a design train à grande vitesse stands in its final depot. And because of all this, Café Costes has already become the oldest

8/10 pt

In Paris, new buildings thrive like ivy, she says, staring out the window as the sun's rays glide past. They colour with the seasons and quickly obtain the status of immortality. In front of the Louvre, for example, a glass pyramid has arisen from the surface in memory of a president. The Gare d'Orsay's overcoat received a lining: a design train à grande vitesse stands in its final depot. And because of all this, Café Costes has already become the oldest watering place in Paris. All those 'im-

10/12 pt

In Paris, new buildings thrive like ivy, she says, staring out the window as the sun's rays glide past. They colour with the seasons and quickly obtain the status of immortality. In front of the Louvre, for example, a glass pyramid has arisen from the surface in memory of a president. The Gare d'Orsay's overcoat received a lining: a design train à grande vitesse stands in its final depot.

– 282

Light & Light Italic 24, 32, 40, 48 pt

Corps
Corps
Corps
Corps

Roman & Italic 24, 32, 40, 48 pt

Corps
Corps
Corps
Corps

Bold & B. Italic, Black & Bl. It. 24, 32, 40, 48 pt

Corps
Corps
Corps
Corps

Seriffed typefaces

Monotype Baskerville

Monotype Bembo

Berthold Bodoni Antiqua

Adobe Caslon

Monotype Centaur

Linotype Centennial

Bitstream Clarendon

Linotype Cochin

Monotype Ehrhardt

Adobe Garamond

Monotype Joanna

Monotype Rockwell

Monotype Times New Roman

It all starts with the Romans Seriffed typefaces have a long prehistory, but we confine our story to a few turning points. The mother of all western types, especially the capitals, are the *Imperial Roman inscriptional capitals* cut in stone around 100 AD. They provided good models for what we still call 'roman' capitals.

The *Carolingian minuscule* manuscript hand, associated with Charles the Great around 800 AD, became the indirect model for what we now call 'lowercase'. Seriffed roman types gradually united these forms. Around 1465 the German printers Sweynheym & Pannartz in Rome introduced a semi-roman with lower-case and capitals. Nicolas Jenson's fine 1470 roman established a model for the so-called Venetian romans and Bruce Rogers based his *Monotype Centaur* (1929) on it. Francesco Griffo cut a new roman for Bembo's book *De Aetna*, printed by Aldus Manutius (1495), which provided the model for *Monotype Bembo* (1929). In 1500/01 Aldus introduced the first italic type, also cut by Griffo, but *Centaur* and *Bembo*'s italics followed those introduced about 1524 by the scribes Arrighi and Tagliente respectively. Roman and italic were then still independent types, rather than parts of a family.

The leading role then shifted to France. Claude Garamond set up as an inde-pendent punchcutter supplying many printers around 1535 following roman types cut in Paris around 1530. These took inspiration from Griffo's roman, but were more delicate and well balanced, and further unified the capitals and lowercase. Garamond's types spread throughout Europe, and some of his sur-viving punches and matrices that had been acquired by Plantin in Antwerp provided the models for Robert Slimbach's *Adobe Garamond* (1989).

Plantin and other Low Countries printers used many types by Garamond, Robert Granjon and the Ghent punchcutter Hendrik van den Keere, which served as a basis for the practical and robust *Dutch Old Face*, whose revivals include *Monotype Van Dijck* (1937) and *Stempel Janson* (1921-26).

Around 1670 John Fell set up the Oxford University Press with matrices from Amsterdam. Many British printers used Dutch types, which served as models for the first great English punchcutter, William Caslon. *Adobe Caslon* by Carol Twombly is a modern interpretation. John Baskerville in Birmingham, England, a former writing master, introduced new romans and italics influenced by the pointed pen and engraving.

Inspired by Baskerville's books and types, the Italian Giambattista Bodoni and the French Didot family vied with each other to increase contrast between thick and thin, refine serifs to hairlines and produce austere, elegant types around 1800: the epitome of neoclassicism. *Berthold Bodoni* and *HTF Didot* are modern interpretations.

Slab-serif types (ca. 1818) and their Clarendon variants (ca. 1850) complete the list of historical seriffed types. Most seriffed typefaces used today follow the historical models, whether closely or distantly.

Monotype Baskerville

Ba

John Baskerville (1706–1775) was a printer of extreme perfectionism. He improved just about everything that could be improved upon as well as everything that did not meet his high standards. He had typefaces cut with a clearer and sharper image, developed the first wove paper, made printing inks blacker, improved printing presses and pressed his paper between hot rollers. His publications met with acclaim in England and abroad and his types were copied. Although English tastes turned back to Caslon around the end of Baskerville's life, his work greatly influenced Didot, Bodoni and later English punchcutters, and his contributions to typography and printing remain significant to this day.
Monotype Baskerville (1924) follows Baskerville's *Great Primer type* in his 1772 edition of Terence.

Baskerville, with its high contrast, is a perfect book letter and extremely well suited to calendared paper. It requires a generous line spacing.
The italic contains a number of pronounced, elegant characters. The striking capitals, which appear slightly bolder, have the effect of leading the eye to the beginning of the sentence.

A B C D E F G H I J K
L M N O P Q R S T U V
W X Y Z a b c d e f g
h i j k l m n o p q r
s t u v w x y z 1 2 3
4 5 6 7 8 9 0 ? ! () []
& " " ' ' « » ; : / - — à ç é î

A B C D E F G H I J K
L M N O P Q R S T U V
W X Y Z I 2 3 4 5 6 7
8 9 0 ½ ff fi fl ffi ffl À ?

HxqkmHxqkmHxqkmHxqkmHxqkmHxqkmHxqkm

20, 16, 12, 10, 8, 6, 4 pt

Just one thought further and I am sixteen, and the trees are in bloom underneath wildly billowing curtains of rain. I stand in a meandering line of people with my father and mother, getting closer to the Grand Palais step by step, where a Picasso exhibition is being shown. We are like beads on a rosary. We have the arthropodal tread of slaves, who, by sheer numbers alone, will manage to drag the enormous stone of expectation to the gate. The exhibition only confirms the greatness of my father, who painted the two pastiches that hang above the couch in our living room, signed Pissacco. When we are looking for our car afterwards – none of us paid attention to the street name when we parked it – Paris seizes me. Eventually, we find the car, which has changed into a 'bagnole'. [*From the short story* PAR(AD)IS REVISITÉ]

Font size: 9/11 pt

A B C D E F G H I J K
L M N O P Q R S T U V
W X Y Z a b c d e f g
h i j k l m n o p q r
s t u v w x y z 1 2 3
4 5 6 7 8 9 0 ? ! () []
& """ ‹‹›› ;: / - — à ç é î
1 2 3 4 5 6 7 8 9 0 ½
ff fi fl ffi ffl

HxqkmHxqkmHxqkmHxqkmHxqkmHxqkmHxqkm 20, 16, 12, 10, 8, 6, 4 pt

Font size: 9/11 pt

Just one thought further and I am sixteen, and the trees are in bloom underneath wildly billowing curtains of rain. I stand in a meandering line of people with my father and mother, getting closer to the Grand Palais step by step, where a Picasso exhibition is being shown. We are like beads on a rosary. We have the arthropodal tread of slaves, who, by sheer numbers alone, will manage to drag the enormous stone of expectation to the gate. The exhibition only confirms the greatness of my father, who painted the two pastiches that hang above the couch in our living room, signed Pissacco. When we are looking for our car afterwards – none of us paid attention to the street name when we parked it – Paris seizes me. Eventually, we find the car, which has changed into a 'bagnole'. [From the short story PAR(AD)IS REVISITÉ]

A B C D E F G H I J K
L M N O P Q R S T U V
W X Y Z a b c d e f g
h i j k l m n o p q r
s t u v w x y z 1 2 3
4 5 6 7 8 9 0 ? ! () []
& "" ‹‹›› ;: / - – à ç é î
1 2 3 4 5 6 7 8 9 0 ½
ff fi fl ffi ffl

HxqkmHxqkmHxqkmHxqkmHxqkmHxqkmHxqkm 20, 16, 12, 10, 8, 6, 4 pt

Just one thought further and I am sixteen, and the trees are in Font size: 9/11 pt
bloom underneath wildly billowing curtains of rain. I stand in a
meandering line of people with my father and mother, getting
closer to the Grand Palais step by step, where a Picasso exhibi-
tion is being shown. We are like beads on a rosary. We have the
arthropodal tread of slaves, who, by sheer numbers alone, will
manage to drag the enormous stone of expectation to the gate.
The exhibition only confirms the greatness of my father, who
painted the two pastiches that hang above the couch in our living
room, signed Pissacco. When we are looking for our car after-
wards – none of us paid attention to the street name when we
parked it – Paris seizes me. Eventually, we find the car, which

Font size: 28/13 mm

A B C D E F G H I J K
L M N O P Q R S T U V
W X Y Z a b c d e f g
h i j k l m n o p q r
s t u v w x y z 1 2 3
4 5 6 7 8 9 0 ? ! () []
& "" «» ;: / - – à ç é î
1 2 3 4 5 6 7 8 9 0 ½
ff fi fl ffi ffl

6
7
8
9
10
11
12
14
16
18
20
22
24
28
32
36
42
48
60
72

HxqkmHxqkmHxqkmHxqkmHxqkmHxqkmHxqkm

20, 16, 12, 10, 8, 6, 4 pt

Font size: 9/11 pt

Just one thought further and I am sixteen, and the trees are in bloom underneath wildly billowing curtains of rain. I stand in a meandering line of people with my father and mother, getting closer to the Grand Palais step by step, where a Picasso exhibition is being shown. We are like beads on a rosary. We have the arthropodal tread of slaves, who, by sheer numbers alone, will manage to drag the enormous stone of expectation to the gate. The exhibition only confirms the greatness of my father, who painted the two pastiches that hang above the couch in our living room, signed Pissacco. When we are looking for our car afterwards – none of us paid attention to the street name when we parked it – Paris seizes me. Eventually, we find the car, which has changed into a 'bagno-

A B C D E F G H I J K
L M N O P Q R S T U V
W X Y Z a b c d e f g
h i j k l m n o p q r
s t u v w x y z 1 2 3
4 5 6 7 8 9 0 ? ! () []
& "" «‹›» ;: / - – à ç é î
ɪ 2 3 4 5 6 7 8 9 0 ½
ff fi fl ffi ffl

HxqkmHxqkmHxqkmHxqkmHxqkmHxqkmHxqkm

20, 16, 12, 10, 8, 6, 4 pt

Just one thought further and I am sixteen, and the trees are in bloom underneath wildly billowing curtains of rain. I stand in a meandering line of people with my father and mother, getting closer to the Grand Palais step by step, where a Picasso exhibition is being shown. We are like beads on a rosary. We have the arthropodal tread of slaves, who, by sheer numbers alone, will manage to drag the enormous stone of expectation to the gate. The exhibition only confirms the greatness of my father, who painted the two pastiches that hang above the couch in our living room, signed Pissacco. When we are looking for our car afterwards – none of us paid attention to the street name when we parked it – Paris seizes me. Eventually,

Font size: 9/11 pt

A B C D E F G H I J K
L M N O P Q R S T U V
W X Y Z a b c d e f g
h i j k l m n o p q r
s t u v w x y z 1 2 3
4 5 6 7 8 9 0 ? ! () []
& "" «» ;: / - – à ç é î
1 2 3 4 5 6 7 8 9 0 ½
ff fi fl ffi ffl

HxqkmHxqkmHxqkmHxqkmHxqkmHxqkmHxqkm

20, 16, 12, 10, 8, 6, 4 pt

Font size: 9/11 pt

Just one thought further and I am sixteen, and the trees are in bloom underneath wildly billowing curtains of rain. I stand in a meandering line of people with my father and mother, getting closer to the Grand Palais step by step, where a Picasso exhibition is being shown. We are like beads on a rosary. We have the arthropodal tread of slaves, who, by sheer numbers alone, will manage to drag the enormous stone of expectation to the gate. The exhibition only confirms the greatness of my father, who painted the two pastiches that hang above the couch in our living room, signed Pissacco. When we are looking for our car afterwards – none of us paid attention to the street name when we parked it – Paris seizes me. Eventually, we find the car,

Monotype Fournier
Fournier, like Baskerville, falls into the transitional category. This version by Monotype from 1925 was drawn from an example in Fournier's *Manuel Typographique* 1764–1766. Note the characteristic, extreme slant of the italic.

Just one thought further and I am sixteen, and the trees are in bloom underneath wildly billowing curtains of rain. I stand in a meandering line of people with my father and mother, getting closer to the Grand Palais step by step, where a Picasso exhibition is being shown. We are like beads on a rosary. We have the arthropodal tread of slaves, who, by sheer numbers alone, will manage to drag the enormous stone of expectation to the gate. The exhibition only confirms the greatness of my father, who painted the two pastiches that hang above the couch in our living room, signed Pissacco. [*From the short story* PAR(AD)IS REVISITÉ]

RQEN baegn *baegn*

ABCDEFGHIJKLMNOPQRSTUVWXYZ
abcdefghijklmnopqrstuvwxyz 0123456789

Monotype Bell
A 1931 revival of a typeface originally created in 1788 by Richard Austin for John Bell's British Letter Foundry. Due to its fine hairlines, Bell is also considered to be a forerunner of the didones. Bell was used regularly by Jan Tschichold in his book typography.

Just one thought further and I am sixteen, and the trees are in bloom underneath wildly billowing curtains of rain. I stand in a meandering line of people with my father and mother, getting closer to the Grand Palais step by step, where a Picasso exhibition is being shown. We are like beads on a rosary. We have the arthropodal tread of slaves, who, by sheer numbers alone, will manage to drag the enormous stone of expectation to the gate. The exhibition only confirms the greatness of my father, who painted the two pastiches that hang above the couch in our living room, signed Pissacco. [*From the short story* PAR(AD)IS REVISITÉ]

RQEN baegn *baegn*

ABCDEFGHIJKLMNOPQRSTUVWXYZ
abcdefghijklmnopqrstuvwxyz 0123456789

Monotype Bulmer
Morris Fuller Benton designed this version in 1928 based on a design dating from 1790 by William Martin for William Bulmer at the Shakespeare Press. Martin's uncle worked for Baskerville, whose influence is clearly visible. Bulmer is narrower and has a more vertical stress than Baskerville.

Just one thought further and I am sixteen, and the trees are in bloom underneath wildly billowing curtains of rain. I stand in a meandering line of people with my father and mother, getting closer to the Grand Palais step by step, where a Picasso exhibition is being shown. We are like beads on a rosary. We have the arthropodal tread of slaves, who, by sheer numbers alone, will manage to drag the enormous stone of expectation to the gate. The exhibition only confirms the greatness of my father, who painted the two pastiches that hang above the couch in our living room, signed Pissacco. [*From the short story* PAR(AD)IS REVISITÉ]

RQEN baegn *baegn*

ABCDEFGHIJKLMNOPQRSTUVWXYZ
abcdefghijklmnopqrstuvwxyz 0123456789

ITC New Baskerville
Matthew Carter and John Quaranda designed this version of Linotype Baskerville between 1978 and 1982. The grey tone value of this typeface lies between Monotype Baskerville and Baskerville Classico.

Just one thought further and I am sixteen, and the trees are in bloom underneath wildly billowing curtains of rain. I stand in a meandering line of people with my father and mother, getting closer to the Grand Palais step by step, where a Picasso exhibition is being shown. We are like beads on a rosary. We have the arthropodal tread of slaves, who, by sheer numbers alone, will manage to drag the enormous stone of expectation to the gate. The exhibition only confirms the greatness of my father, who painted the two pastiches that hang above the couch in our living room, signed Pissacco. [*From the short story* Par(ad)is Revisité]

RQEN baegn *baegn*

ABCDEFGHIJKLMNOPQRSTUVWXYZ
abcdefghijklmnopqrstuvwxyz 0123456789

Monotype Perpetua
This design by Eric Gill in 1928 was first published in 1935. It does not exclusively show a vertical stress and displays influences of both Baskerville and Caslon. It also shows strong influences from Gill's stone-cut lettering. The x-height is extremely small and the text here has therefore been set 1.5 pt larger (10.5/11 pt). The alphabet and the red text show how small it is in comparison to the other examples.

Just one thought further and I am sixteen, and the trees are in bloom underneath wildly billowing curtains of rain. I stand in a meandering line of people with my father and mother, getting closer to the Grand Palais step by step, where a Picasso exhibition is being shown. We are like beads on a rosary. We have the arthropodal tread of slaves, who, by sheer numbers alone, will manage to drag the enormous stone of expectation to the gate. The exhibition only confirms the greatness of my father, who painted the two pastiches that hang above the couch in our living room, signed Pissacco. [*From the short story* Par(ad)is Revisité]

RQEN baegn *baegn*

ABCDEFGHIJKLMNOPQRSTUVWXYZ
abcdefghijklmnopqrstuvwxyz 0123456789

Emigre Mrs Eaves
This typeface dating from 1996, created by Zuzana Licko at Emigre, is named after Sarah Eaves, John Baskerville's wife. This unique Baskerville has a small x-height, large capitals and long ascenders and descenders. The roman includes old style figures.

Just one thought further and I am sixteen, and the trees are in bloom underneath wildly billowing curtains of rain. I stand in a meandering line of people with my father and mother, getting closer to the Grand Palais step by step, where a Picasso exhibition is being shown. We are like beads on a rosary. We have the arthropodal tread of slaves, who, by sheer numbers alone, will manage to drag the enormous stone of expectation to the gate. The exhibition only confirms the greatness of my father, who painted the two pastiches that hang above the couch in our living room, signed Pissacco. [*From the short story* Par(ad)is Revisité]

RQEN baegn *baegn*

ABCDEFGHIJKLMNOPQRSTUVWXYZ
abcdefghijklmnopqrstuvwxyz 0123456789

Monotype Baskerville

Font size: 5 pt/6,5 pt

In Paris, new buildings thrive like ivy, she says, staring out the window as the sun's rays glide past. They colour with the seasons and quickly obtain the status of immortality. In front of the *Louvre*, for example, a glass pyramid has arisen from the surface in memory of a president. The *Gare d'Orsay*'s overcoat received a lining: a design train à grande vitesse stands in its final depot. And because of all this, *Café Costes* has already become the oldest watering place in Paris. All those 'immobile' creatures are, after a short period of discomfort, welcomed into the city's bosom as in-laws. [*From the short story* Par(ad)is Revisité]

6 /7,5 pt

In Paris, new buildings thrive like ivy, she says, staring out the window as the sun's rays glide past. They colour with the seasons and quickly obtain the status of immortality. In front of the *Louvre*, for example, a glass pyramid has arisen from the surface in memory of a president. The *Gare d'Orsay*'s overcoat received a lining: a design train à grande vitesse stands in its final depot. And because of all this, *Café Costes* has already become the oldest watering place in Paris. All those 'immobile' creatures are, after a short period of discomfort, welcomed into the city's bosom as in-laws. [*From the short story* Par(ad)is Revisité]

7 /8,5 pt

In Paris, new buildings thrive like ivy, she says, staring out the window as the sun's rays glide past. They colour with the seasons and quickly obtain the status of immortality. In front of the *Louvre*, for example, a glass pyramid has arisen from the surface in memory of a president. The *Gare d'Orsay*'s overcoat received a lining: a design train à grande vitesse stands in its final depot. And because of all this, *Café Costes* has already become the oldest watering place in Paris. All those 'immobile' creatures are, after a short period of discomfort, welcomed

8 / 10 pt

In Paris, new buildings thrive like ivy, she says, staring out the window as the sun's rays glide past. They colour with the seasons and quickly obtain the status of immortality. In front of the *Louvre*, for example, a glass pyramid has arisen from the surface in memory of a president. The *Gare d'Orsay*'s overcoat received a lining: a design train à grande vitesse stands in its final depot. And because of all this, *Café Costes* has already become the oldest watering place in Paris. All those 'immobile' creatures are, after a short period of discomfort, welcomed into the city's bosom as in-laws.

10 / 12 pt

In Paris, new buildings thrive like ivy, she says, staring out the window as the sun's rays glide past. They colour with the seasons and quickly obtain the status of immortality. In front of the *Louvre*, for example, a glass pyramid has arisen from the surface in memory of a president. The *Gare d'Orsay*'s overcoat received a lining: a design train à grande vitesse stands in its final depot. And because of all this, *Café Costes* has already become the oldest watering

Regular & Italic 24, 32, 40, 48 pt

Corps

Corps

Corps

Corps

Semibold & Semibold Italic 24, 32, 40, 48 pt

Corps

Corps

Corps

Corps

Bold & Bold Italic 24, 32, 40, 48 pt

Corps

Corps

Corps

Corps

Monotype Bembo

Be

The famous book publisher of the Renaissance, Aldus Manutius, published the book *De Aetna* in 1495. It was written by Cardinal Pietro Bembo. Francesco Griffo cut a roman especially for this publication, and Monotype revived it in the 1920's under the direction of Stanley Morison. The Monotype Corporation was then producing new punches and matrices based on many historical typefaces. In 1929, *Monotype Bembo* was produced, containing an altered version of an italic from 1524 by Giovantonio Tagliente. A beautiful italic, created by Alfred Fairbank, was found to be too narrow and anomalous and so was published separately as *Monotype Fairbank*.

Bembo has a relatively large x-height and therefore requires very little line spacing to remain legible as a body text type.

A B C D E F G H I J K
L M N O P Q R S T U V
W X Y Z a b c d e f g
h i j k l m n o p q r
s t u v w x y z 1 2 3
4 5 6 7 8 9 0 ? ! () []
& "" «» ;: / – — à ç é î

A B C D E F G H I J K
L M N O P Q R S T U V
W X Y Z I 2 3 4 5 6 7
8 9 0 ½ ff fi fl ffi ffl À ?

HxqkmHxqkmHxqkmHxqkmHxqkmHxqkmHxqkm

20, 16, 12, 10, 8, 6, 4 pt

Just one thought further and I am sixteen, and the trees are in bloom underneath wildly billowing curtains of rain. I stand in a meandering line of people with my father and mother, getting closer to the Grand Palais step by step, where a Picasso exhibition is being shown. We are like beads on a rosary. We have the arthropodal tread of slaves, who, by sheer numbers alone, will manage to drag the enormous stone of expectation to the gate. The exhibition only confirms the greatness of my father, who painted the two pastiches that hang above the couch in our living room, signed Pissacco. When we are looking for our car afterwards – none of us paid attention to the street name when we parked it – Paris seizes me. Eventually, we find the car, which has changed into a 'bagnole'. [*From the short story* PAR(AD)IS REVISITÉ]

Font size: 9/11 pt

A B C D E F G H I J K

L M N O P Q R S T U V

W X Y Z a b c d e f g

h i j k l m n o p q r

s t u v w x y z 1 2 3

4 5 6 7 8 9 0 ? ! () []

& "" «» ;: / - — à ç é î

1 2 3 4 5 6 7 8 9 0 ½

ff fi fl ffi ffl

HxqkmHxqkmHxqkmHxqkmHxqkmHxqkmHxqkm

20, 16, 12, 10, 8, 6, 4 pt

Font size: 9/11 pt

Just one thought further and I am sixteen, and the trees are in bloom underneath wildly billowing curtains of rain. I stand in a meandering line of people with my father and mother, getting closer to the Grand Palais step by step, where a Picasso exhibition is being shown. We are like beads on a rosary. We have the arthropodal tread of slaves, who, by sheer numbers alone, will manage to drag the enormous stone of expectation to the gate. The exhibition only confirms the greatness of my father, who painted the two pastiches that hang above the couch in our living room, signed Pissacco. When we are looking for our car afterwards – none of us paid attention to the street name when we parked it – Paris seizes me. Eventually, we find the car, which has changed into a 'bagnole'. [From the short story PAR(AD)IS REVISITÉ]

Font size: 28/13 mm

A B C D E F G H I J K
L M N O P Q R S T U V
W X Y Z a b c d e f g
h i j k l m n o p q r
s t u v w x y z 1 2 3
4 5 6 7 8 9 0 ? ! () []
& " " ' ' « » ; : / – — à ç é î
1 2 3 4 5 6 7 8 9 0 ½
ff fi fl ffi ffl

HxqkmHxqkmHxqkmHxqkmHxqkmHxqkmHxqkm

20, 16, 12, 10, 8, 6, 4 pt

Just one thought further and I am sixteen, and the trees are in bloom underneath wildly billowing curtains of rain. I stand in a meandering line of people with my father and mother, getting closer to the Grand Palais step by step, where a Picasso exhibition is being shown. We are like beads on a rosary. We have the arthropodal tread of slaves, who, by sheer numbers alone, will manage to drag the enormous stone of expectation to the gate. The exhibition only confirms the greatness of my father, who painted the two pastiches that hang above the couch in our living room, signed Pissacco. When we are looking for our car afterwards – none of us paid attention to the street name when we parked it – Paris seizes me. Eventually, we find the car, which has changed into a 'bagnole'. [*From the short story*

Font size: 9/11 pt

Font size: 28/13 mm

A B C D E F G H I J K
L M N O P Q R S T U V
W X Y Z a b c d e f g
h i j k l m n o p q r
s t u v w x y z 1 2 3
4 5 6 7 8 9 0 ? ! () []
& "" «» ;: / - – à ç é î
1 2 3 4 5 6 7 8 9 0 ½
ff fi fl ffi ffl

6
7
8
9
10
11
12
14
16
18
20
22
24
28
32
36
42

HxqkmHxqkmHxqkmHxqkmHxqkmHxqkmHxqkm

20, 16, 12, 10, 8, 6, 4 pt

Font size: 9/11 pt

48

*Just one thought further and I am sixteen, and the trees are in bloom under-
neath wildly billowing curtains of rain. I stand in a meandering line of people
with my father and mother, getting closer to the Grand Palais step by step,
where a Picasso exhibition is being shown. We are like beads on a rosary.
We have the arthropodal tread of slaves, who, by sheer numbers alone, will
manage to drag the enormous stone of expectation to the gate. The exhibition
only confirms the greatness of my father, who painted the two pastiches that
hang above the couch in our living room, signed Pissacco. When we are
looking for our car afterwards – none of us paid attention to the street name
when we parked it – Paris seizes me. Eventually, we find the car, which has
changed into a 'bagnole'. [From the short story* Par(ad)is Revisité*]*

60

72

A B C D E F G H I J K
L M N O P Q R S T U V
W X Y Z a b c d e f g
h i j k l m n o p q r
s t u v w x y z 1 2 3
4 5 6 7 8 9 0 ? ! () []
& " " « » ;: / – — à ç é î
I 2 3 4 5 6 7 8 9 0 ½
ff fi fl ffi ffl

HxqkmHxqkmHxqkmHxqkmHxqkmHxqkmHxqkm

20, 16, 12, 10, 8, 6, 4 pt

Font size: 9/11 pt

Just one thought further and I am sixteen, and the trees are in bloom underneath wildly billowing curtains of rain. I stand in a meandering line of people with my father and mother, getting closer to the Grand Palais step by step, where a Picasso exhibition is being shown. We are like beads on a rosary. We have the arthropodal tread of slaves, who, by sheer numbers alone, will manage to drag the enormous stone of expectation to the gate. The exhibition only confirms the greatness of my father, who painted the two pastiches that hang above the couch in our living room, signed Pissacco. When we are looking for our car afterwards – none of us paid attention to the street name when we parked it – Paris seizes me. Eventually, we find the car, which has

A B C D E F G H I J K

L M N O P Q R S T U V

W X Y Z a b c d e f g

h i j k l m n o p q r

s t u v w x y z 1 2 3

4 5 6 7 8 9 0 ? ! () []

& "" «» ;: / – — à ç é î

1 2 3 4 5 6 7 8 9 0 ½

ff fi fl ffi ffl

HxqkmHxqkmHxqkmHxqkmHxqkmHxqkmHxqkm

20, 16, 12, 10, 8, 6, 4 pt

Just one thought further and I am sixteen, and the trees are in bloom under-neath wildly billowing curtains of rain. I stand in a meandering line of people with my father and mother, getting closer to the Grand Palais step by step, where a Picasso exhibition is being shown. We are like beads on a rosary. We have the arthropodal tread of slaves, who, by sheer numbers alone, will manage to drag the enormous stone of expectation to the gate. The exhibition only confirms the greatness of my father, who painted the two pastiches that hang above the couch in our living room, signed Pissacco. When we are looking for our car afterwards – none of us paid attention to the street name when we parked it – Paris seizes me. Eventually, we find the car, which has changed into a 'bagnole'. [From the short story **Par(ad)is Revisité**]

Font size: 9/11 pt

Monotype Bembo Book
Bembo Book was designed by Robin Nicholas. The digital version of the normal Bembo is based on cast metal type with a size of 9 pt, whereas that of Bembo Book is based on cast metal type between 10 and 24 pt. The Book is slightly narrower and is therefore a more practical type. It is a good alternative for readers.

Just one thought further and I am sixteen, and the trees are in bloom underneath wildly billowing curtains of rain. I stand in a meandering line of people with my father and mother, getting closer to the Grand Palais step by step, where a Picasso exhibition is being shown. We are like beads on a rosary. We have the arthropodal tread of slaves, who, by sheer numbers alone, will manage to drag the enormous stone of expectation to the gate. The exhibition only confirms the greatness of my father, who painted the two pastiches that hang above the couch in our living room, signed Pissacco. [*From the short story* Par(ad)is Revisité]

RQEN baegn *baegn*

ABCDEFGHIJKLMNOPQRSTUVWXYZ
abcdefghijklmnopqrstuvwxyz 0123456789

Monotype Poliphilus/Blado
Poliphilus is an exact reproduction of a roman by Francesco Griffo dating from 1499. As accompanying italic, Blado was copied from a cursive by Ludovico degli Arrighi from 1526. They are exact digital reproductions of the original printed text on handmade paper so that even the ink squash on the paper is visible in the end result. These typefaces are still surprisingly applicable today.

Just one thought further and I am sixteen, and the trees are in bloom underneath wildly billowing curtains of rain. I stand in a meandering line of people with my father and mother, getting closer to the Grand Palais step by step, where a Picasso exhibition is being shown. We are like beads on a rosary. We have the arthropodal tread of slaves, who, by sheer numbers alone, will manage to drag the enormous stone of expectation to the gate. The exhibition only confirms the greatness of my father, who painted the two pastiches that h ang above the couch in our living room, signed Pissacco. [*From the short story* Par(ad)is Revisité]

RQEN baegn *baegn*

ABCDEFGHIJKLMNOPQRSTUVWXYZ
abcdefghijklmnopqrstuvwxyz 0123456789

Bitstream Goudy Old Style
Designed in 1916 by Frederic W. Goudy for American Type Founders, this typeface is gracious and well balanced with a few eccentric details. Note the 'ear' of the lowercase 'g' and the dots of the 'i' and the 'j'. Although it obviously falls into the garalde category, there are also Venetian influences. The design of the capitals could easily stem from the 'illuminated' capitals taken from a bible dating back to 1491 by the printer Johann Froben in Basel.

Just one thought further and I am sixteen, and the trees are in bloom underneath wildly billowing curtains of rain. I stand in a meandering line of people with my father and mother, getting closer to the Grand Palais step by step, where a Picasso exhibition is being shown. We are like beads on a rosary. We have the arthropodal tread of slaves, who, by sheer numbers alone, will manage to drag the enormous stone of expectation to the gate. The exhibition only confirms the greatness of my father, who painted the two pastiches that hang above the couch in our living room, signed Pissacco. [*From the short story* Par(ad)is Revisité]

RQEN baegn *baegn*

ABCDEFGHIJKLMNOPQRSTUVWXYZ
abcdefghijklmnopqrstuvwxyz 0123456789

Linotype Palatino
Palatino is one of the most frequently used typefaces because it is often delivered as standard with system software. Hermann Zapf began work on the design in 1948 but also based it partly on drawings of Italian inscriptions that he made later in 1950. It is named after Giambattista Palatino, a sixteenth century Italian master of the art of calligraphy.

Just one thought further and I am sixteen, and the trees are in in bloom underneath wildly billowing curtains of rain. I stand in a meandering line of people with my father and mother, getting closer to the Grand Palais step by step, where a Picasso exhibition is being shown. We are like beads on a rosary. We have the arthropodal tread of slaves, who, by sheer numbers alone, will manage to drag the enormous stone of expectation to the gate. The exhibition only confirms the greatness of my father, who painted the two pastiches that hang above the couch in our living room, signed Pissacco. [*From the short story* PAR(AD)IS REVISITÉ]

RQEN baegn *baegn*

ABCDEFGHIJKLMNOPQRSTUVWXYZ
abcdefghijklmnopqrstuvwxyz 0123456789

Linotype Aldus
Designed by Hermann Zapf in 1954 for D. Stempel AG, Aldus takes its name from the fifteenth century Venetian printer Aldus Manutius. It is a slightly lighter version of Zapf's Palatino. The clear calligraphic base is typical of Zapf's designs.

Just one thought further and I am sixteen, and the trees are in bloom underneath wildly billowing curtains of rain. I stand in a meandering line of people with my father and mother, getting closer to the Grand Palais step by step, where a Picasso exhibition is being shown. We are like beads on a rosary. We have the arthropodal tread of slaves, who, by sheer numbers alone, will manage to drag the enormous stone of expectation to the gate. The exhibition only confirms the greatness of my father, who painted the two pastiches that hang above the couch in our living room, signed Pissacco. [*From the short story* PAR(AD)IS REVISITÉ]

RQEN baegn *baegn*

ABCDEFGHIJKLMNOPQRSTUVWXYZ
abcdefghijklmnopqrstuvwxyz 0123456789

Adobe Minion Pro
In creating Minion, Robert Slimbach had made a well thought-out and extensive design that, just as Bembo, uses the Aldine style that Griffo created for Aldus Manutius. Although it is not strictly a revival, there are distinct influences visible. The typeface is greatly extended with many styles, various series of figures, small caps, swashes (more elaborate italic capitals) and ornaments.

Just one thought further and I am sixteen, and the trees are in bloom underneath wildly billowing curtains of rain. I stand in a meandering line of people with my father and mother, getting closer to the Grand Palais step by step, where a Picasso exhibition is being shown. We are like beads on a rosary. We have the arthropodal tread of slaves, who, by sheer numbers alone, will manage to drag the enormous stone of expectation to the gate. The exhibition only confirms the greatness of my father, who painted the two pastiches that hang above the couch in our living room, signed Pissacco. [*From the short story* PAR(AD)IS REVISITÉ]

RQEN baegn *baegn*

ABCDEFGHIJKLMNOPQRSTUVWXYZ
abcdefghijklmnopqrstuvwxyz 0123456789

Monotype Bembo

Font size: 5/6,5 pt

In Paris, new buildings thrive like ivy, she says, staring out the window as the sun's rays glide past. They colour with the seasons and quickly obtain the status of immortality. In front of the *Louvre*, for example, a glass pyramid has arisen from the surface in memory of a president. The *Gare d'Orsay*'s overcoat received a lining: a design train à grande vitesse stands in its final depot. And because of all this, *Café Costes* has already become the oldest watering place in Paris. All those 'immobile' creatures are, after a short period of discomfort, welcomed into the city's bosom as in-laws. [*From the short story* PAR(AD)IS REVISITÉ]

6/7,5 pt

In Paris, new buildings thrive like ivy, she says, staring out the window as the sun's rays glide past. They colour with the seasons and quickly obtain the status of immortality. In front of the *Louvre*, for example, a glass pyramid has arisen from the surface in memory of a president. The *Gare d'Orsay*'s overcoat received a lining: a design train à grande vitesse stands in its final depot. And because of all this, *Café Costes* has already become the oldest watering place in Paris. All those 'immobile' creatures are, after a short period of discomfort, welcomed into the city's bosom as in-laws. [*From the short story* PAR(AD)IS REVISITÉ]

7/8,5 pt

In Paris, new buildings thrive like ivy, she says, staring out the window as the sun's rays glide past. They colour with the seasons and quickly obtain the status of immortality. In front of the *Louvre*, for example, a glass pyramid has arisen from the surface in memory of a president. The *Gare d'Orsay*'s overcoat received a lining: a design train à grande vitesse stands in its final depot. And because of all this, *Café Costes* has already become the oldest watering place in Paris. All those 'immobile' creatures are, after a short period of discomfort, welcomed into

8/10 pt

In Paris, new buildings thrive like ivy, she says, staring out the window as the sun's rays glide past. They colour with the seasons and quickly obtain the status of immortality. In front of the *Louvre*, for example, a glass pyramid has arisen from the surface in memory of a president. The *Gare d'Orsay*'s overcoat received a lining: a design train à grande vitesse stands in its final depot. And because of all this, *Café Costes* has already become the oldest watering place in Paris. All those 'immobile' creatures are, after a short period of dis-comfort, welcomed into the city's bosom as in-laws.

10/12 pt

In Paris, new buildings thrive like ivy, she says, staring out the window as the sun's rays glide past. They colour with the seasons and quickly obtain the status of immortality. In front of the *Louvre*, for example, a glass pyramid has arisen from the surface in memory of a president. The *Gare d'Orsay*'s overcoat received a lining: a design train à grande vitesse stands in its final depot. And because of all this, *Café Costes* has already become the oldest watering place in Paris.

Regular & Italic 24, 32, 40, 48 pt

Corps

Corps

Corps

Corps

Semibold & Semibold Italic 24, 32, 40, 48 pt

Corps

Corps

Corps

Corps

Bold & B. Italic, Extra B. & Ex. B. Italic 24, 32, 40

Corps

Corps

Corps

Corps

Berthold Bodoni Antiqua

Bo

Light
Light Italic
Regular
Italic
Medium
Medium Italic
Bold
Bold Italic
(+ Small Caps)

Giambattista Bodoni (1740–1813) applied his fantastic skills to create the types in his 1788 type specimen. His early types were influenced by Pierre Simon Fournier (1712–1768) and later ones by Baskerville and the Didot family (which began introducing new types in the 1780's). In his time he was so famous that his portrait, like that of a saint, hung on the walls of numerous printing firms. His typefaces were the first in typographic history to have no links or similarities to handwriting. As a purely graphic symbol, *Bodoni* transcends the mere industrial functionality of the letter and adds to it an intelligent, autonomous and poetic aesthetic. Countless variations of it were made, of which those made by Berthold are some of the most delicate. The collection of his life's work, the *Manuale Tipografico*, comprises 650 pages and was published by his widow in 1818, five years after his death. His influences dominated the world of typography until the end of the nineteenth century.

Bodoni has an extremely large thick-thin contrast and as such has a tendency to sparkle on smooth, white paper. The use of a larger font size and plenty of white space is advisable.

A B C D E F G H I J K
L M N O P Q R S T U V
W X Y Z a b c d e f g
h i j k l m n o p q r
s t u v w x y z 1 2 3
4 5 6 7 8 9 0 ? ! () []
& ""„ «» ;: / - – à ç é î

A B C D E F G H I J K
L M N O P Q R S T U V
W X Y Z 1 2 3 4 5 6 7
8 9 0 ½ ff fi fl ffi ffl À ?

HxqkmHxqkmHxqkmHxqkmHxqkmHxqkmHxqkm 20, 16, 12, 10, 8, 6, 4 pt

Just one thought further and I am sixteen, and the trees are in bloom Font size 9/11 pt
underneath wildly billowing curtains of rain. I stand in a meandering line
of people with my father and mother, getting closer to the Grand Palais
step by step, where a Picasso exhibition is being shown. We are like
beads on a rosary. We have the arthropodal tread of slaves, who, by sheer
numbers alone, will manage to drag the enormous stone of expectation
to the gate. The exhibition only confirms the greatness of my father, who
painted the two pastiches that hang above the couch in our living room,
signed Pissacco. When we are looking for our car afterwards – none of
us paid attention to the street name when we parked it – Paris seizes
me. Eventually, we find the car, which has changed into a 'bagnole'.
[*From the short story* Par(ad)is Revisité]

A B C D E F G H I J K
L M N O P Q R S T U V
W X Y Z a b c d e f g
h i j k l m n o p q r
s t u v w x y z 1 2 3
4 5 6 7 8 9 0 ? ! () []
& "" «» ;: / - – à ç é î
1 2 3 4 5 6 7 8 9 0 ½
ff fi fl ffi ffl

HxqkmHxqkmHxqkmHxqkmHxqkmHxqkmHxqkm

20, 16, 12, 10, 8, 6, 4 pt

Font size 9/11 pt

Just one thought further and I am sixteen, and the trees are in bloom underneath wildly billowing curtains of rain. I stand in a meandering line of people with my father and mother, getting closer to the Grand Palais step by step, where a Picasso exhibition is being shown. We are like beads on a rosary. We have the arthropodal tread of slaves, who, by sheer numbers alone, will manage to drag the enormous stone of expectation to the gate. The exhibition only confirms the greatness of my father, who painted the two pastiches that hang above the couch in our living room, signed Pissacco. When we are looking for our car afterwards – none of us paid attention to the street name when we parked it – Paris seizes me. Eventually, we find the car, which has changed into a 'bagnole'.
[From the short story Par(ad)is Revisité*]*

A B C D E F G H I J K
L M N O P Q R S T U V
W X Y Z a b c d e f g
h i j k l m n o p q r
s t u v w x y z 1 2 3
4 5 6 7 8 9 0 ? ! () []
& "" «» ;: / – — à ç é î

A B C D E F G H I J K
L M N O P Q R S T U V
W X Y Z 1 2 3 4 5 6 7
8 9 0 ½ ff fi fl ffi ffl À ?

HxqkmHxqkmHxqkmHxqkmHxqkmHxqkmHxqkm

20, 16, 12, 10, 8, 6, 4 pt

Font size 9/11 pt

Just one thought further and I am sixteen, and the trees are in bloom underneath wildly billowing curtains of rain. I stand in a meandering line of people with my father and mother, getting closer to the Grand Palais step by step, where a Picasso exhibition is being shown. We are like beads on a rosary. We have the arthropodal tread of slaves, who, by sheer numbers alone, will manage to drag the enormous stone of expectation to the gate. The exhibition only confirms the greatness of my father, who painted the two pastiches that hang above the couch in our living room, signed Pissacco. When we are looking for our car afterwards – none of us paid attention to the street name when we parked it – Paris seizes me. Eventually, we find the car, which has changed into a 'bagnole'. [*From the short story* PAR(AD)IS REVISITÉ]

A B C D E F G H I J K
L M N O P Q R S T U V
W X Y Z a b c d e f g
h i j k l m n o p q r
s t u v w x y z 1 2 3
4 5 6 7 8 9 0 ? ! () []
& "" «» ;: / - – à ç é î
1 2 3 4 5 6 7 8 9 0 ½
ff fi fl ffi ffl

HxqkmHxqkmHxqkmHxqkmHxqkmHxqkmHxqkm

20, 16, 12, 10, 8, 6, 4 pt

Font size 9/11 pt

Just one thought further and I am sixteen, and the trees are in bloom underneath wildly billowing curtains of rain. I stand in a meandering line of people with my father and mother, getting closer to the Grand Palais step by step, where a Picasso exhibition is being shown. We are like beads on a rosary. We have the arthropodal tread of slaves, who, by sheer numbers alone, will manage to drag the enormous stone of expectation to the gate. The exhibition only confirms the greatness of my father, who painted the two pastiches that hang above the couch in our living room, signed Pissacco. When we are looking for our car afterwards – none of us paid attention to the street name when we parked it – Paris seizes me. Eventually, we find the car, which has changed into a 'bagnole'. [From the short story PAR(AD)IS REVISITÉ]

A B C D E F G H I J K
L M N O P Q R S T U V
W X Y Z a b c d e f g
h i j k l m n o p q r
s t u v w x y z 1 2 3
4 5 6 7 8 9 0 ? ! () []
& ""'' «» ;: / - – à ç é î

A B C D E F G H I J K
L M N O P Q R S T U V
W X Y Z 1 2 3 4 5 6 7
8 9 0 ½ ff fi fl ffi ffl À ?

HxqkmHxqkmHxqkmHxqkmHxqkmHxqkmHxqkm

20, 16, 12, 10, 8, 6, 4 pt

Font size 9/11 pt

Just one thought further and I am sixteen, and the trees are in bloom underneath wildly billowing curtains of rain. I stand in a meandering line of people with my father and mother, getting closer to the Grand Palais step by step, where a Picasso exhibition is being shown. We are like beads on a rosary. We have the arthropodal tread of slaves, who, by sheer numbers alone, will manage to drag the enormous stone of expectation to the gate. The exhibition only confirms the greatness of my father, who painted the two pastiches that hang above the couch in our living room, signed Pissacco. When we are looking for our car afterwards – none of us paid attention to the street name when we parked it – Paris seizes me. Eventually, we find the car, which has changed into a 'bagnole'.

A B C D E F G H I J K
L M N O P Q R S T U V
W X Y Z a b c d e f g
h i j k l m n o p q r
s t u v w x y z 1 2 3
4 5 6 7 8 9 0 ? ! () []
& "" «» ;: / - - à ç é î
1 2 3 4 5 6 7 8 9 0 ½
ff fi fl ffi ffl

HxqkmHxqkmHxqkmHxqkmHxqkmHxqkmHxqkm 20, 16, 12, 10, 8, 6, 4 pt

Font size 9/11 pt

Just one thought further and I am sixteen, and the trees are in bloom underneath wildly billowing curtains of rain. I stand in a meandering line of people with my father and mother, getting closer to the Grand Palais step by step, where a Picasso exhibition is being shown. We are like beads on a rosary. We have the arthropodal tread of slaves, who, by sheer numbers alone, will manage to drag the enormous stone of expectation to the gate. The exhibition only confirms the greatness of my father, who painted the two pastiches that hang above the couch in our living room, signed Pissacco. When we are looking for our car afterwards – none of us paid attention to the street name when we parked it – Paris seizes me. Eventually, we find the car, which has changed into a 'bagnole'.

H&FJ Didot (HTF Didot)
HTF Didot, designed by Jonathan Hoefler in 1991, has seven optical master designs so that the hairlines can be optimally reproduced in every format. They are thicker at 6 pt and thinner in the 96 pt master. The text shown here is 11 pt and the red text uses the 42 pt master. This typeface is named after Firmin Didot, the Parisian counterpart of Giambattista Bodoni. They fall into the didone classification.

Just one thought further and I am sixteen, and the trees are in bloom underneath wildly billowing curtains of rain. I stand in a meandering line of people with my father and mother, getting closer to the Grand Palais step by step, where a Picasso exhibition is being shown. We are like beads on a rosary. We have the arthropodal tread of slaves, who, by sheer numbers alone, will manage to drag the enormous stone of expectation to the gate. The exhibition only confirms the greatness of my father, who painted the two pastiches that hang above the couch in our living room, signed Pissacco. [*From the short story* Par(ad)is Revisité]

RQEN baegn *baegn*

ABCDEFGHIJKLMNOPQRSTUVWXYZ
abcdefghijklmnopqrstuvwxyz 0123456789

Bauer Bodoni
Designed in 1926 by Heinrich Jost and cut by Louis Höll, this variant has remained the closest to Bodoni's original and is a favourite of many designers. Some of the detail of the smaller font sizes can be lost when modern day printing techniques are used. In the days of cast metal typesetting, the pressure applied during the printing process always ensured that the hairlines remained visible. Cast metal type also used what we now call non-linear scaling for the various sizes, similar to Hoefler's Didot described above.

Just one thought further and I am sixteen, and the trees are in bloom underneath wildly billowing curtains of rain. I stand in a meandering line of people with my father and mother, getting closer to the Grand Palais step by step, where a Picasso exhibition is being shown. We are like beads on a rosary. We have the arthropodal tread of slaves, who, by sheer numbers alone, will manage to drag the enormous stone of expectation to the gate. The exhibition only confirms the greatness of my father, who painted the two pastiches that hang above the couch in our living room, signed Pissacco. [*From the short story* Par(ad)is Revisité]

RQEN baegn *baegn*

ABCDEFGHIJKLMNOPQRSTUVWXYZ
abcdefghijklmnopqrstuvwxyz 0123456789

ITC Bodoni Twelve
ITC also published three versions of the Bodoni: Bodoni Six, Bodoni Twelve and Bodoni Seventy-Two. The names refer to the design height in points. The larger the final text, the leaner the thin lines can be without disappearing. Bodoni Six hairlines are therefore the thickest. The Twelve (on the right in the block of text) is a sturdy and relatively economical text letter. The red text is set in Seventy-Two.

Just one thought further and I am sixteen, and the trees are in bloom underneath wildly billowing curtains of rain. I stand in a meandering line of people with my father and mother, getting closer to the Grand Palais step by step, where a Picasso exhibition is being shown. We are like beads on a rosary. We have the arthropodal tread of slaves, who, by sheer numbers alone, will manage to drag the enormous stone of expectation to the gate. The exhibition only confirms the greatness of my father, who painted the two pastiches that hang above the couch in our living room, signed Pissacco. [*From the short story* PAR(AD)IS REVISITÉ]

RQEN baegn *baegn*

ABCDEFGHIJKLMNOPQRSTUVWXYZ
abcdefghijklmnopqrstuvwxyz 0123456789

Berthold Walbaum Book
This sturdy Walbaum was designed by Günter Gerhard Lange in 1975 and is a revival of the 16 pt hand-cut version by Justus Erich Walbaum dating from 1804. The design is influenced by the works of both Didot and Bodoni. The lowercase 'b' has no basic serif and the basic forms of the lowercase letters in particular are slightly square. This makes Walbaum a typical German neoclassical variation of the didones from the time of the French Revolution.

Just one thought further and I am sixteen, and the trees are in bloom underneath wildly billowing curtains of rain. I stand in a meandering line of people with my father and mother, getting closer to the Grand Palais step by step, where a Picasso exhibition is being shown. We are like beads on a rosary. We have the arthropodal tread of slaves, who, by sheer numbers alone, will manage to drag the enormous stone of expectation to the gate. The exhibition only confirms the greatness of my father, who painted the two pastiches that hang above the couch in our living room, signed Pissacco. [*From the short story* Par(ad)is Revisité]

RQEN baegn *baegn*

ABCDEFGHIJKLMNOPQRSTUVWXYZ
abcdefghijklmnopqrstuvwxyz 0123456789

Bitstream Bodoni
This version was first drawn by Morris Fuller Benton for American Type Founders in 1907. The hairlines are slightly thicker so that they remain visible in smaller font sizes. The Book style is shown here on the right.

Just one thought further and I am sixteen, and the trees are in bloom underneath wildly billowing curtains of rain. I stand in a meandering line of people with my father and mother, getting closer to the Grand Palais step by step, where a Picasso exhibition is being shown. We are like beads on a rosary. We have the arthropodal tread of slaves, who, by sheer numbers alone, will manage to drag the enormous stone of expectation to the gate. The exhibition only confirms the greatness of my father, who painted the two pastiches that hang above the couch in our living room, signed Pissacco. [*From the short story* Par(ad)is Revisité]

RQEN baegn *baegn*

ABCDEFGHIJKLMNOPQRSTUVWXYZ
abcdefghijklmnopqrstuvwxyz 0123456789

Emigre Filosofia
Zuzana Licko also made a beautiful and unique variant of Bodoni. Throughout his lifetime, Bodoni made around four hundred variations of his roman and italic. Licko therefore sees each revival as an interpretation. Hers is a more geometric version with rounded serifs such as used for the smaller text sizes in the days of cast metal type. Filosofia Grand is available for larger texts. The Unicase style has been discussed earlier in this book (see general index).

Just one thought further and I am sixteen, and the trees are in bloom underneath wildly billowing curtains of rain. I stand in a meandering line of people with my father and mother, getting closer to the Grand Palais step by step, where a Picasso exhibition is being shown. We are like beads on a rosary. We have the arthropodal tread of slaves, who, by sheer numbers alone, will manage to drag the enormous stone of expectation to the gate. The exhibition only confirms the greatness of my father, who painted the two pastiches that hang above the couch in our living room, signed Pissacco. [*From the short story* Par(ad)is Revisité]

RQEN baegn *baegn*

ABCDEFGHIJKLMNOPQRSTUVWXYZ
abcdefghijklmnopqrstuvwxyz 0123456789

Berthold Bodoni Antiqua

Font size 5/6,5 pt

In Paris, new buildings thrive like ivy, she says, staring out the window as the sun's rays glide past. They colour with the seasons and quickly obtain the status of immortality. In front of the *Louvre*, for example, a glass pyramid has arisen from the surface in memory of a president. The *Gare d'Orsay*'s overcoat received a lining: a design train à grande vitesse stands in its final depot. And because of all this, *Café Costes* has already become the oldest watering place in Paris. All those 'immobile' creatures are, after a short period of discomfort, welcomed into the city's bosom as in-laws. [*From the short story* PARIS REVISITÉ]

6/7,5 pt

In Paris, new buildings thrive like ivy, she says, staring out the window as the sun's rays glide past. They colour with the seasons and quickly obtain the status of immortality. In front of the *Louvre*, for example, a glass pyramid has arisen from the surface in memory of a president. The *Gare d'Orsay*'s overcoat received a lining: a design train à grande vitesse stands in its final depot. And because of all this, *Café Costes* has already become the oldest watering place in Paris. All those 'immobile' creatures are, after a short period of discomfort, welcomed into the city's bosom as in-laws. [*From the short story* PAR(AD)IS REVISITÉ]

7/8,5 pt

In Paris, new buildings thrive like ivy, she says, staring out the window as the sun's rays glide past. They colour with the seasons and quickly obtain the status of immortality. In front of the *Louvre*, for example, a glass pyramid has arisen from the surface in memory of a president. The *Gare d'Orsay*'s overcoat received a lining: a design train à grande vitesse stands in its final depot. And because of all this, *Café Costes* has already become the oldest watering place in Paris. All those 'immobile' creatures are, after a short period of dis-

8/10 pt

In Paris, new buildings thrive like ivy, she says, staring out the window as the sun's rays glide past. They colour with the seasons and quickly obtain the status of immortality. In front of the *Louvre*, for example, a glass pyramid has arisen from the surface in memory of a president. The *Gare d'Orsay*'s overcoat received a lining: a design train à grande vitesse stands in its final depot. And because of all this, *Café Costes* has already become the oldest watering place in Paris. All those 'immobile' creatures are, after a short period of discomfort, welcomed into the city's

10/12 pt

In Paris, new buildings thrive like ivy, she says, staring out the window as the sun's rays glide past. They colour with the seasons and quickly obtain the status of immortality. In front of the *Louvre*, for example, a glass pyramid has arisen from the surface in memory of a president. The *Gare d'Orsay*'s overcoat received a lining: a design train à grande vitesse stands in its final depot. And because of all this, *Café Costes* has already become the oldest

Light & Light Italic 24, 32, 40, 48 pt

Corps

Corps

Corps

Corps

Regular & Italic 24, 32, 40, 48 pt

Corps

Corps

Corps

Corps

Medium, M. Italic, Bold & B. Italic 24, 32, 40, 48

Corps

Corps

Corps

Corps

Adobe Caslon

Ca

The original Caslon was cut mostly in the years 1728–1734 by the Englishman William Caslon (1692–1766), who was better known as a virtuoso punchcutter than an innovator. His inspiration came from typefaces originating in The Netherlands by Nicolaes Briot and Christoffel van Dijck, and marked the end of the era of so-called 'Old Face' types. Caslon's types were distributed worldwide throughout the British Empire. In America they became famous as the types used in the U.S. Declaration of Independence. Adobe Caslon was designed in 1990 by Carol Twombly and is an extended family that comprises small capitals, ligatures, decorative letters (swashes) and beautiful ornaments.

William Caslon left behind him a liberally extended letter family, both literally and figuratively. Three more William Caslons after him (II, III, IV) developed his family into a true 'typefounding dynasty'.

A B C D E F G H I J K
L M N O P Q R S T U V
W X Y Z a b c d e f g
h i j k l m n o p q r
s t u v w x y z 1 2 3
4 5 6 7 8 9 0 ? ! () []
& "" «» ;: / – — à ç é î

A B C D E F G H I J K
L M N O P Q R S T U V
W X Y Z I 2 3 4 5 6 7
8 9 0 ½ ff fi fl ffi ffl À ?

HxqkmHxqkmHxqkmHxqkmHxqkmHxqkmHxqkm 20, 16, 12, 10, 8, 6, 4 pt

Just one thought further and I am sixteen, and the trees are in bloom underneath wildly billowing curtains of rain. I stand in a meandering line of people with my father and mother, getting closer to the Grand Palais step by step, where a Picasso exhibition is being shown. We are like beads on a rosary. We have the arthropodal tread of slaves, who, by sheer numbers alone, will manage to drag the enormous stone of expectation to the gate. The exhibition only confirms the greatness of my father, who painted the two pastiches that hang above the couch in our living room, signed Pissacco. When we are looking for our car afterwards – none of us paid attention to the street name when we parked it – Paris seizes me. Eventually, we find the car, which has changed into a 'bagnole'. [*From the short story* PAR(AD)IS REVISITÉ]

Font size 9/11 pt

A B C D E F G H I J K
L M N O P Q R S T U V
W X Y Z a b c d e f g
h i j k l m n o p q r
s t u v w x y z 1 2 3
4 5 6 7 8 9 0 ? ! () []
& "" «» ;: / – — à ç é î
1 2 3 4 5 6 7 8 9 0 ½
ff fi fl ffi ffl

HxqkmHxqkmHxqkmHxqkmHxqkmHxqkmHxqkm

20, 16, 12, 10, 8, 6, 4 pt

Just one thought further and I am sixteen, and the trees are in bloom underneath wildly billowing curtains of rain. I stand in a meandering line of people with my father and mother, getting closer to the Grand Palais step by step, where a Picasso exhibition is being shown. We are like beads on a rosary. We have the arthropodal tread of slaves, who, by sheer numbers alone, will manage to drag the enormous stone of expectation to the gate. The exhibition only confirms the greatness of my father, who painted the two pastiches that hang above the couch in our living room, signed Pissacco. When we are looking for our car afterwards – none of us paid attention to the street name when we parked it – Paris seizes me. Eventually, we find the car, which has changed into a 'bagnole'. [From the short story PAR(AD)IS REVISITÉ]

Font size 9/11 pt

A B C D E F G H I J K
L M N O P Q R S T U V
W X Y Z a b c d e f g
h i j k l m n o p q r
s t u v w x y z 1 2 3
4 5 6 7 8 9 0 ? ! () []
& "" «» ;: / – — à ç é î

A B C D E F G H I J K
L M N O P Q R S T U V
W X Y Z I 2 3 4 5 6 7
8 9 0 ½ ff fi fl ffi ffl À ?

HxqkmHxqkmHxqkmHxqkmHxqkmHxqkmHxqkm

Just one thought further and I am sixteen, and the trees are in bloom underneath wildly billowing curtains of rain. I stand in a meandering line of people with my father and mother, getting closer to the Grand Palais step by step, where a Picasso exhibition is being shown. We are like beads on a rosary. We have the arthropodal tread of slaves, who, by sheer numbers alone, will manage to drag the enormous stone of expectation to the gate. The exhibition only confirms the greatness of my father, who painted the two pastiches that hang above the couch in our living room, signed Pissacco. When we are looking for our car afterwards – none of us paid attention to the street name when we parked it – Paris seizes me. Eventually, we find the car, which has changed into a 'bagnole'. [*From the short story* Par(ad)is Revisité]

A B C D E F G H I J K
L M N O P Q R S T U V
W X Y Z a b c d e f g
h i j k l m n o p q r
s t u v w x y z 1 2 3
4 5 6 7 8 9 0 ? ! () []
& "" «» ;: / – — à ç é î
1 2 3 4 5 6 7 8 9 0 ½
ff fi fl ffi ffl

HxqkmHxqkmHxqkmHxqkmHxqkmHxqkmHxqkm 20, 16, 12, 10, 8, 6, 4 pt

Font size 9/11 pt

Just one thought further and I am sixteen, and the trees are in bloom underneath wildly billowing curtains of rain. I stand in a meandering line of people with my father and mother, getting closer to the Grand Palais step by step, where a Picasso exhibition is being shown. We are like beads on a rosary. We have the arthropodal tread of slaves, who, by sheer numbers alone, will manage to drag the enormous stone of expectation to the gate. The exhibition only confirms the greatness of my father, who painted the two pastiches that hang above the couch in our living room, signed Pissacco. When we are looking for our car afterwards – none of us paid attention to the street name when we parked it – Paris seizes me. Eventually, we find the car, which has changed into a 'bagnole'. [From the short story Par(ad)is Revisité]

A B C D E F G H I J K
L M N O P Q R S T U V
W X Y Z a b c d e f g
h i j k l m n o p q r
s t u v w x y z 1 2 3
4 5 6 7 8 9 0 ? ! () []
& "" «» ;: / – – à ç é î
1 2 3 4 5 6 7 8 9 0 ½
ff fi fl ffi ffl

HxqkmHxqkmHxqkmHxqkmHxqkmHxqkmHxqkm

20, 16, 12, 10, 8, 6, 4 pt

Just one thought further and I am sixteen, and the trees are in bloom underneath wildly billowing curtains of rain. I stand in a meandering line of people with my father and mother, getting closer to the Grand Palais step by step, where a Picasso exhibition is being shown. We are like beads on a rosary. We have the arthropodal tread of slaves, who, by sheer numbers alone, will manage to drag the enormous stone of expectation to the gate. The exhibition only confirms the greatness of my father, who painted the two pastiches that hang above the couch in our living room, signed Pissacco. When we are looking for our car afterwards – none of us paid attention to the street name when we parked it – Paris seizes me. Eventually, we find the car, which has changed into a 'bagnole'. [*From the short story* Par(ad)is Revisité]

Font size 9/11 pt

*A B C D E F G H I J K
L M N O P Q R S T U V
W X Y Z a b c d e f g
h i j k l m n o p q r
s t u v w x y z 1 2 3
4 5 6 7 8 9 0 ? ! () []
& "" «» ;: / – — à ç é î
1 2 3 4 5 6 7 8 9 0 ½
ff fi fl ffi ffl*

HxqkmHxqkmHxqkmHxqkmHxqkmHxqkmHxqkm

20, 16, 12, 10, 8, 6, 4 pt

Font size 9/11 pt

Just one thought further and I am sixteen, and the trees are in bloom under-neath wildly billowing curtains of rain. I stand in a meandering line of people with my father and mother, getting closer to the Grand Palais step by step, where a Picasso exhibition is being shown. We are like beads on a rosary. We have the arthropodal tread of slaves, who, by sheer numbers alone, will manage to drag the enormous stone of expectation to the gate. The exhibition only confirms the greatness of my father, who painted the two pastiches that hang above the couch in our living room, signed Pissacco. When we are looking for our car afterwards – none of us paid attention to the street name when we parked it – Paris seizes me. Eventually, we find the car, which has changed into a 'bagnole'. [From the short story **Par(ad)is Revisité**]

Linotype Caslon 540
American Type Founders issued this type in 1902 in response to the continued popularity of Caslon and the desire of every typefoundry to profit from its success. Characteristics of this version are the shorter descenders and slightly greater contrast.

Just one thought further and I am sixteen, and the trees are in bloom underneath wildly billowing curtains of rain. I stand in a meandering line of people with my father and mother, getting closer to the Grand Palais step by step, where a Picasso exhibition is being shown. We are like beads on a rosary. We have the arthropodal tread of slaves, who, by sheer numbers alone, will manage to drag the enormous stone of expectation to the gate. The exhibition only confirms the greatness of my father, who painted the two pastiches that hang above the couch in our living room, signed Pissacco. [*From the short story* PAR(AD)IS REVISITÉ]

RQEN baegn *baegn*

ABCDEFGHIJKLMNOPQRSTUVWXYZ
abcdefghijklmnopqrstuvwxyz 0123456789

ITC Founders Caslon Twelve
This recent Caslon revival was made in 1998 by Justin Howes. He reproduced each font size of the original Caslon and conserved the irregularities of the printed letter. He made a total of four variations: 12, 30, 42 and 96 pt, naming the latter 'Poster'. Particularly the 'Twelve', shown here, has the warmth and character of eighteenth century printed text.

Just one thought further and I am sixteen, and the trees are in bloom underneath wildly billowing curtains of rain. I stand in a meandering line of people with my father and mother, getting closer to the Grand Palais step by step, where a Picasso exhibition is being shown. We are like beads on a rosary. We have the arthropodal tread of slaves, who, by sheer numbers alone, will manage to drag the enormous stone of expectation to the gate. The exhibition only confirms the greatness of my father, who painted the two pastiches that hang above the couch in our living room, signed Pissacco. [*From the short story* PAR(AD)IS REVISITÉ]

RQEN baegn *baegn*

ABCDEFGHIJKLMNOPQRSTUVWXYZ
abcdefghijklmnopqrstuvwxyz 0123456789

ITC Caslon 224 (Bitstream)
Edward Benguiat drew this version of Caslon with a complete family of styles. The number 224 was the designer's house number, to distinguish it from the other Caslons. The descenders are short and the width of the italics in the Book style are altered.

Just one thought further and I am sixteen, and the trees are in bloom underneath wildly billowing curtains of rain. I stand in a meandering line of people with my father and mother, getting closer to the Grand Palais step by step, where a Picasso exhibition is being shown. We are like beads on a rosary. We have the arthropodal tread of slaves, who, by sheer numbers alone, will manage to drag the enormous stone of expectation to the gate. The exhibition only confirms the greatness of my father, who painted the two pastiches that hang above the couch in our living room, signed Pissacco. [*From the short story* Par(ad)is Revisité]

RQEN baegn *baegn*

ABCDEFGHIJKLMNOPQRSTUVWXYZ
abcdefghijklmnopqrstuvwxyz 0123456789

Berthold Caslon 471

In 1858 the Laurence Johnson Foundry in Philadelphia copied the original Caslon Old Face (perhaps by electro-typing) and called the resulting type Old Style. When American Type Founders came into possession of the matrices, ATF considered it the only existing original Caslon and named it Caslon 471. The Haas'sche Schrift-gießerei used this typeface in 1940 as a basis for what would become the definitive version, later distributed by Berthold.

Just one thought further and I am sixteen, and the trees are in bloom underneath wildly billowing curtains of rain. I stand in a meandering line of people with my father and mother, getting closer to the Grand Palais step by step, where a Picasso exhibition is being shown. We are like beads on a rosary. We have the arthropodal tread of slaves, who, by sheer numbers alone, will manage to drag the enormous stone of expectation to the gate. The exhibition only confirms the greatness of my father, who painted the two pastiches that hang above the couch in our living room, signed Pissacco. [*From the short story* Par(ad)is Revisité]

RQEN baegn *baegn*

ABCDEFGHIJKLMNOPQRSTUVWXYZ
abcdefghijklmnopqrstuvwxyz 0123456789

URW Imprint

In 1912, Monotype issued a new type influenced by Caslon for the printing and typography magazine 'The Imprint'. Edward Johnston was one of the designers. Geoffrey Lee drew this version for URW.

Just one thought further and I am sixteen, and the trees are in bloom underneath wildly billowing curtains of rain. I stand in a meandering line of people with my father and mother, getting closer to the Grand Palais step by step, where a Picasso exhibition is being shown. We are like beads on a rosary. We have the arthropodal tread of slaves, who, by sheer numbers alone, will manage to drag the enormous stone of expectation to the gate. The exhibition only confirms the greatness of my father, who painted the two pastiches that hang above the couch in our living room, signed Pissacco. [*From the short story* Par(ad)is Revisité]

RQEN baegn *baegn*

ABCDEFGHIJKLMNOPQRSTUVWXYZ
abcdefghijklmnopqrstuvwxyz 0123456789

Type Republic Pradell

Eudald Pradell (1721–1788) was a Catalan punchcutter and the most prominent type designer of eighteenth century Spain. His types follow Enschedé's, cut by Fleisch-man and Rosart. Although the designer Andreu Balius de-scribes Pradell (2003) as transitional, its slightly leftward slanting axis is more reminiscent of a garald. Like Caslon, it therefore falls more or less at the end of the garald era. The italic is noticeably lighter.

Just one thought further and I am sixteen, and the trees are in bloom underneath wildly billowing curtains of rain. I stand in a meandering line of people with my father and mother, getting closer to the Grand Palais step by step, where a Picasso exhibition is being shown. We are like beads on a rosary. We have the arthropodal tread of slaves, who, by sheer numbers alone, will manage to drag the enormous stone of expectation to the gate. The exhibition only confirms the greatness of my father, who painted the two pastiches that hang above the couch in our living room, signed Pissacco. [*From the short story* Par(ad)is Revisité]

RQEN baegn *baegn*

ABCDEFGHIJKLMNOPQRSTUVWXYZ
abcdefghijklmnopqrstuvwxyz 0123456789

Adobe Caslon

Font size 5/6,5 pt

In Paris, new buildings thrive like ivy, she says, staring out the window as the sun's rays glide past. They colour with the seasons and quickly obtain the status of immortality. In front of the *Louvre*, for example, a glass pyramid has arisen from the surface in memory of a president. The *Gare d'Orsay*'s overcoat received a lining: a design train à grande vitesse stands in its final depot. And because of all this, *Café Costes* has already become the oldest watering place in Paris. All those 'immobile' creatures are, after a short period of discomfort, welcomed into the city's bosom as in-laws. [*From the short story* PAR(AD)IS REVISITÉ]

6/7,5 pt

In Paris, new buildings thrive like ivy, she says, staring out the window as the sun's rays glide past. They colour with the seasons and quickly obtain the status of immortality. In front of the *Louvre*, for example, a glass pyramid has arisen from the surface in memory of a president. The *Gare d'Orsay*'s overcoat received a lining: a design train à grande vitesse stands in its final depot. And because of all this, *Café Costes* has already become the oldest watering place in Paris. All those 'immobile' creatures are, after a short period of discomfort, welcomed into the city's bosom as in-laws. [*Aus der Novelle* PAR(AD)IS REVISITÉ]

7/8,5 pt

In Paris, new buildings thrive like ivy, she says, staring out the window as the sun's rays glide past. They colour with the seasons and quickly obtain the status of immortality. In front of the *Louvre*, for example, a glass pyramid has arisen from the surface in memory of a president. The *Gare d'Orsay*'s overcoat received a lining: a design train à grande vitesse stands in its final depot. And because of all this, *Café Costes* has already become the oldest watering place in Paris. All those 'immobile' creatures are, after a short period of discomfort, wel-

8/10 pt

In Paris, new buildings thrive like ivy, she says, staring out the window as the sun's rays glide past. They colour with the seasons and quickly obtain the status of immortality. In front of the *Louvre*, for example, a glass pyramid has arisen from the surface in memory of a president. The *Gare d'Orsay*'s overcoat received a lining: a design train à grande vitesse stands in its final depot. And because of all this, *Café Costes* has already become the oldest watering place in Paris. All those 'immobile' creatures are, after a short period of discomfort, welcomed into the city's bosom as in-laws.

10/12 pt

In Paris, new buildings thrive like ivy, she says, staring out the window as the sun's rays glide past. They colour with the seasons and quickly obtain the status of immortality. In front of the *Louvre*, for example, a glass pyramid has arisen from the surface in memory of a president. The *Gare d'Orsay*'s overcoat received a lining: a design train à grande vitesse stands in its final depot. And because of all this, *Café Costes* has already become the oldest

Regular & Italic 24, 32, 40, 48 pt

Corps

Corps

Corps

Corps

Semibold & Semibold Italic 24, 32, 40, 48 pt

Corps

Corps

Corps

Corps

Bold & Bold Italic 24, 32, 40, 48 pt

Corps

Corps

Corps

Corps

Monotype Centaur

Ce

Regular
Italic
Bold
Bold Italic
(+ Expert)

Bruce Rogers (1870–1957), schooled as painter and illustrator, became one of America's most brilliant designers of bibliophile books. His typeface *Centaur* from 1914 is based on the type from a treatise by Eusebius: *De Praeparatione Evangelica* (1470), cut by the French Venetian Nicolas Jenson (ca. 1420–1480). Rogers considered the work of the Venetian printers to be the perfect examples of form and had sufficient talent and vision to add new, elegant elements to the original. He first drew *Centaur* by hand in ink; Frederic Warde (1894–1939) drew the italic, taking inspiration from a 1524 italic type by the scribe Ludovico degli Arrighi and named after him. *Centaur* takes its name from the first book to be printed in 1915: the English translation of *Le Centaure, poème en prose* by Maurice de Guérin. In 1935 Rogers used this typeface for his masterwork as designer, the *Oxford Lectern Bible*.

The calligraphic influence is visible in the ascenders and descenders of the roman and the capital 'N'. The x-height is extremely small and needs therefore little or no extra line spacing. The italic includes a series of beautiful swashes including the 'C', 'E', 'G', 'I' and 'S'.

Font size 28/13 mm

A B C D E F G H I J K
L M N O P Q R S T U V
W X Y Z a b c d e f g
h i j k l m n o p q r
s t u v w x y z I 2 3
4 5 6 7 8 9 0 ? ! () []
& " " «‹›» ;: / - — à ç é î

A B C D E F G H I J K
L M N O P Q R S T U V
W X Y Z I 2 3 4 5 6 7
8 9 0 ½ ff fi fl ffi ffl À ?

HxqkmHxqkmHxqkmHxqkmHxqkmHxqkmHxqkm

20, 16, 12, 10, 8, 6, 4 pt

Just one thought further and I am sixteen, and the trees are in bloom underneath wildly billowing curtains of rain. I stand in a meandering line of people with my father and mother, getting closer to the Grand Palais step by step, where a Picasso exhibition is being shown. We are like beads on a rosary. We have the arthropodal tread of slaves, who, by sheer numbers alone, will manage to drag the enormous stone of expectation to the gate. The exhibition only confirms the greatness of my father, who painted the two pastiches that hang above the couch in our living room, signed Pissacco. When we are looking for our car afterwards — none of us paid attention to the street name when we parked it — Paris seizes me. Eventually, we find the car, which has changed into a 'bagnole'. [*From the short story* PAR(AD)IS REVISITÉ]

Font size 9/11 pt

A B C D E F G H I J K

L M N O P Q R S T U V

W X Y Z a b c d e f g

h i j k l m n o p q r

s t u v w x y z 1 2 3

4 5 6 7 8 9 0 ? ! () []

& "" «» ;: / ~ — à ç é î

1 2 3 4 5 6 7 8 9 0 ½

ff fi fl ffi ffl

HxqkmHxqkmHxqkmHxqkmHxqkmHxqkmHxqkm

20, 16, 12, 10, 8, 6, 4 pt

Font size 9/11 pt

Just one thought further and I am sixteen, and the trees are in bloom underneath wildly billowing curtains of rain. I stand in a meandering line of people with my father and mother, getting closer to the Grand Palais step by step, where a Picasso exhibition is being shown. We are like beads on a rosary. We have the arthropodal tread of slaves, who, by sheer numbers alone, will manage to drag the enormous stone of expectation to the gate. The exhibition only confirms the greatness of my father, who painted the two pastiches that hang above the couch in our living room, signed Pissacco. When we are looking for our car afterwards — none of us paid attention to the street name when we parked it — Paris seizes me. Eventually, we find the car, which has changed into a 'bagnole'. [From the short story PAR(AD)IS REVISITÉ]

A B C D E F G H I J K
L M N O P Q R S T U V
W X Y Z a b c d e f g
h i j k l m n o p q r
s t u v w x y z I 2 3
4 5 6 7 8 9 0 ? ! () []
& "" ‹‹›› :; / - – à ç é î
1 2 3 4 5 6 7 8 9 0 ½
ff fi fl ffi ffl

HxqkmHxqkmHxqkmHxqkmHxqkmHxqkmHxqkm

20, 16, 12, 10, 8, 6, 4 pt

Just one thought further and I am sixteen, and the trees are in bloom under-
neath wildly billowing curtains of rain. I stand in a meandering line of people
with my father and mother, getting closer to the Grand Palais step by step,
where a Picasso exhibition is being shown. We are like beads on a rosary. We
have the arthropodal tread of slaves, who, by sheer numbers alone, will manage
to drag the enormous stone of expectation to the gate. The exhibition only
confirms the greatness of my father, who painted the two pastiches that hang
above the couch in our living room, signed Pissacco. When we are looking for
our car afterwards – none of us paid attention to the street name when we
parked it – Paris seizes me. Eventually, we find the car, which has changed into
a 'bagnole'. [*From the short story* Par(ad)is Revisité]

Font size 9/11 pt

A B C D E F G H I J K
L M N O P Q R S T U V
W X Y Z a b c d e f g
h i j k l m n o p q r
s t u v w x y z 1 2 3
4 5 6 7 8 9 0 ? ! () []
& "" «» ;: / - — à ç é î
1 2 3 4 5 6 7 8 9 0 ½
ff fi fl ffi ffl

HxqkmHxqkmHxqkmHxqkmHxqkmHxqkmHxqkm 20, 16, 12, 10, 8, 6, 4 pt

Just one thought further and I am sixteen, and the trees are in bloom underneath wildly billowing curtains of rain. I stand in a meandering line of people with my father and mother, getting closer to the Grand Palais step by step, where a Picasso exhibition is being shown. We are like beads on a rosary. We have the arthropodal tread of slaves, who, by sheer numbers alone, will manage to drag the enormous stone of expectation to the gate. The exhibition only confirms the greatness of my father, who painted the two pastiches that hang above the couch in our living room, signed Pissacco. When we are looking for our car afterwards – none of us paid attention to the street name when we parked it – Paris seizes me. Eventually, we find the car, which has changed into a 'bagnole'. [From the short story Par(ad)is Revisité]

Font size 9/11 pt

Omnibus Jenson Classico

Using the classical forms of Nicolas Jenson's roman from 1470 as a starting point, Franko Luin (Omnibus) designed this Jenson Classico in 1993. Like Centaur, it has a small x-height and the lowercase 'e' has an upward slanting cross bar. They are both classified as humanistic.

Just one thought further and I am sixteen, and the trees are in bloom underneath wildly billowing curtains of rain. I stand in a meandering line of people with my father and mother, getting closer to the Grand Palais step by step, where a Picasso exhibition is being shown. We are like beads on a rosary. We have the arthropodal tread of slaves, who, by sheer numbers alone, will manage to drag the enormous stone of expectation to the gate. The exhibition only confirms the greatness of my father, who painted the two pastiches that hang above the couch in our living room, signed Pissacco. [*From the short story* Par(ad)is Revisité]

RQEN baegn *baegn*

ABCDEFGHIJKLMNOPQRSTUVWXYZ
abcdefghijklmnopqrstuvwxyz 0123456789

Adobe Jenson Pro

More modern and with a larger x-height, this Jenson is a creation of designer Robert Slimbach, who has reinterpreted several classic typefaces for Adobe. In 1470 italic types did not yet exist, so Slimbach sought his inspiration in Arrighi's italics from around 1525. Jenson Pro offers an enormous choice of styles.

Just one thought further and I am sixteen, and the trees are in bloom underneath wildly billowing curtains of rain. I stand in a meandering line of people with my father and mother, getting closer to the Grand Palais step by step, where a Picasso exhibition is being shown. We are like beads on a rosary. We have the arthropodal tread of slaves, who, by sheer numbers alone, will manage to drag the enormous stone of expectation to the gate. The exhibition only confirms the greatness of my father, who painted the two pastiches that hang above the couch in our living room, signed Pissacco. [*From the short story* Par(ad)is Revisité]

RQEN baegn *baegn*

ABCDEFGHIJKLMNOPQRSTUVWXYZ
abcdefghijklmnopqrstuvwxyz 0123456789

Monotype Italian Old Style

Although this typeface from 1911 seems a little rough at first glance when compared to Jenson and Centaur, it is still a humanist. It has a clearly larger x-height and can be used when an elegant result is desired without a small body size. The form of the italic more closely resembles a roman. Monotype based this typeface on the Golden Type by William Morris, who was also inspired by Nicolas Jenson.

Just one thought further and I am sixteen, and the trees are in bloom underneath wildly billowing curtains of rain. I stand in a meandering line of people with my father and mother, getting closer to the Grand Palais step by step, where a Picasso exhibition is being shown. We are like beads on a rosary. We have the arthropodal tread of slaves, who, by sheer numbers alone, will manage to drag the enormous stone of expectation to the gate. The exhibition only confirms the greatness of my father, who painted the two pastiches that hang above the couch in our living room, signed Pissacco. [*From the short story* Par(ad)is Revisité]

RQEN baegn *baegn*

ABCDEFGHIJKLMNOPQRSTUVWXYZ
abcdefghijklmnopqrstuvwxyz 0123456789

Stempel Schneidler
F.H. Ernst Schneidler design-
ed this humanist in 1936 for
D. Stempel AG after first
having designed Schneidler
Old Style for Bauersche
Gießerei. Based on Venetian
typefaces from the Renais-
sance, it is a light and legible
typeface. The question mark
is especially unusual (see
right next to the 9).

Just one thought further and I am sixteen, and the trees are in
bloom underneath wildly billowing curtains of rain. I stand in a
meandering line of people with my father and mother, getting closer
to the Grand Palais step by step, where a Picasso exhibition is being
shown. We are like beads on a rosary. We have the arthropodal
tread of slaves, who, by sheer numbers alone, will manage to drag
the enormous stone of expectation to the gate. The exhibition only
confirms the greatness of my father, who painted the two pastiches
that hang above the couch in our living room, signed Pissacco. [*From
the short story* Par(ad)is Revisité]

RQEN baegn *baegn*

ABCDEFGHIJKLMNOPQRSTUVWXYZ
abcdefghijklmnopqrstuvwxyz 0123456789¿

Adobe Arno Pro
This typeface by Robert
Slimbach from 2007 is named
after the river that flows
through Florence. In 2007 the
Arno typeface was distingui-
shed by the Type Directors
Club New York. As well as a
great number of styles, there
are also separate versions
for body text, captions, sub-
headings and even larger
displays. The red text is set
in the slightly narrower
subhead style.

Just one thought further and I am sixteen, and the trees are in bloom under-
neath wildly billowing curtains of rain. I stand in a meandering line of people
with my father and mother, getting closer to the Grand Palais step by step,
where a Picasso exhibition is being shown. We are like beads on a rosary. We
have the arthropodal tread of slaves, who, by sheer numbers alone, will manage
to drag the enormous stone of expectation to the gate. The exhibition only
confirms the greatness of my father, who painted the two pastiches that hang
above the couch in our living room, signed Pissacco. [*From the short story*
Par(ad)is Revisité]

RQEN baegn *baegn*

ABCDEFGHIJKLMNOPQRSTUVWXYZ
abcdefghijklmnopqrstuvwxyz 0123456789

ITC Berkeley Oldstyle
Frederic W. Goudy first de-
signed this typeface as
Californian in 1938 for the
University of California Press
in Berkeley. Tony Stan crea-
ted this version in 1983 for
ITC. It is a legible typeface
suitable for longer passages
of text.

Just one thought further and I am sixteen, and the trees are in
bloom underneath wildly billowing curtains of rain. I stand in a mean-
dering line of people with my father and mother, getting closer to the
Grand Palais step by step, where a Picasso exhibition is being shown.
We are like beads on a rosary. We have the arthropodal tread of slaves,
who, by sheer numbers alone, will manage to drag the enormous stone
of expectation to the gate. The exhibition only confirms the greatness
of my father, who painted the two pastiches that hang above the couch
in our living room, signed Pissacco. [*From the short story* Par(ad)is
Revisité]

RQEN baegn *baegn*

ABCDEFGHIJKLMNOPQRSTUVWXYZ
abcdefghijklmnopqrstuvwxyz 0123456789

Monotype Centaur

Font size 5/6,5 pt

In Paris, new buildings thrive like ivy, she says, staring out the window as the sun's rays glide past. They colour with the seasons and quickly obtain the status of immortality. In front of the *Louvre*, for example, a glass pyramid has arisen from the surface in memory of a president. The *Gare d'Orsay*'s overcoat received a lining: a design train à grande vitesse stands in its final depot. And because of all this, *Café Costes* has already become the oldest watering place in Paris. All those 'immobile' creatures are, after a short period of discomfort, welcomed into the city's bosom as in-laws. [*From the short story* Par(ad)is Revisité]

6/7,5 pt

In Paris, new buildings thrive like ivy, she says, staring out the window as the sun's rays glide past. They colour with the seasons and quickly obtain the status of immortality. In front of the *Louvre*, for example, a glass pyramid has arisen from the surface in memory of a president. The *Gare d'Orsay*'s overcoat received a lining: a design train à grande vitesse stands in its final depot. And because of all this, *Café Costes* has already become the oldest watering place in Paris. All those 'immobile' creatures are, after a short period of discomfort, welcomed into the city's bosom as in-laws. [*From the short story* Par(ad)is Revisité]

7/8,5 pt

In Paris, new buildings thrive like ivy, she says, staring out the window as the sun's rays glide past. They colour with the seasons and quickly obtain the status of immortality. In front of the *Louvre*, for example, a glass pyramid has arisen from the surface in memory of a president. The *Gare d'Orsay*'s overcoat received a lining: a design train à grande vitesse stands in its final depot. And because of all this, *Café Costes* has already become the oldest watering place in Paris. All those 'immobile' creatures are, after a short period of discomfort, welcomed into the city's bosom as in-laws. [*From the short story*

8/10 pt

In Paris, new buildings thrive like ivy, she says, staring out the window as the sun's rays glide past. They colour with the seasons and quickly obtain the status of immortality. In front of the *Louvre*, for example, a glass pyramid has arisen from the surface in memory of a president. The *Gare d'Orsay*'s overcoat received a lining: a design train à grande vitesse stands in its final depot. And because of all this, *Café Costes* has already become the oldest watering place in Paris. All those 'immobile' creatures are, after a short period of discomfort, welcomed into the city's bosom as in-laws. [*From the short story* Par(ad)is Revisité]

10/12 pt

In Paris, new buildings thrive like ivy, she says, staring out the window as the sun's rays glide past. They colour with the seasons and quickly obtain the status of immortality. In front of the *Louvre*, for example, a glass pyramid has arisen from the surface in memory of a president. The *Gare d'Orsay*'s overcoat received a lining: a design train à grande vitesse stands in its final depot. And because of all this, *Café Costes* has already become the oldest watering place in Paris. All those 'immobile' creatures are, after a short

Regular & Italic 24, 32, 40, 48 pt

Corps

Corps

Corps

Corps

Bold & Bold Italic 24, 32, 40, 48, 60, 72 pt

Corps

Corps

Corps

Corps

Corps

Corps

Linotype Centennial

Ce

Light
Light Italic
Roman
Italic
Bold
Bold Italic
Black
Black Italic
(+ Small Caps & OsF)

The Swiss type designer Adrian Frutiger, whose most famous typefaces, *Univers* and *Frutiger*, began their glorious careers in 1957 and 1976 respectively, was always keen to embrace new technology and apply it as best he could during the design process. Such was the case with his typeface *OCR-B*, which he designed in 1968 especially for optical reading equipment and the *Centennial*, shown here in honour of the hundredth anniversary of Linotype.

Centennial roman and italic (1986) is a typical 'modern' type or didone and Frutiger found his inspiration quite easily in *Century*, designed at the end of the nineteenth century for American Type Founders by Linn Boyd Benton and then expanded into a family by his son Morris Fuller Benton. *Centennial* has a more elegant and modern appearance due to the typical Frutiger influence. The vertical stress, the slightly narrower forms, the large x-height and the high thick-thin contrast are also evidence of influences from *Bodoni* yet without the disadvantage of the extremely thin lines that tend to sparkle on coated paper.

A B C D E F G H I J K
L M N O P Q R S T U V
W X Y Z a b c d e f g
h i j k l m n o p q r
s t u v w x y z 1 2 3
4 5 6 7 8 9 0 ? ! () []
& "" «» ;: / - – à ç é î

A B C D E F G H I J K
L M N O P Q R S T U V
W X Y Z I 2 3 4 5 6 7
8 9 0 fi fl À ?

HxqkmHxqkmHxqkmHxqkmHxqkmHxqkmHxqkm 20, 16, 12, 10, 8, 6, 4 p

Font size 9/11 pt

Just one thought further and I am sixteen, and the trees are in
bloom underneath wildly billowing curtains of rain. I stand in a
meandering line of people with my father and mother, getting
closer to the Grand Palais step by step, where a Picasso exhibi-
tion is being shown. We are like beads on a rosary. We have the
arthropodal tread of slaves, who, by sheer numbers alone, will
manage to drag the enormous stone of expectation to the gate.
The exhibition only confirms the greatness of my father, who
painted the two pastiches that hang above the couch in our
living room, signed Pissacco. When we are looking for our car
afterwards – none of us paid attention to the street name when
we parked it – Paris seizes me. Eventually, we find the car,

A B C D E F G H I J K
L M N O P Q R S T U V
W X Y Z a b c d e f g
h i j k l m n o p q r
s t u v w x y z 1 2 3
4 5 6 7 8 9 0 ? ! () []
& "" «» ;: / - – à ç é î
1 2 3 4 5 6 7 8 9 0 fi
fl

HxqkmHxqkmHxqkmHxqkmHxqkmHxqkmHxqkm 20, 16, 12, 10, 8, 6, 4 pt

Font size 9/11 pt

Just one thought further and I am sixteen, and the trees are in bloom underneath wildly billowing curtains of rain. I stand in a meandering line of people with my father and mother, getting closer to the Grand Palais step by step, where a Picasso exhibition is being shown. We are like beads on a rosary. We have the arthropodal tread of slaves, who, by sheer numbers alone, will manage to drag the enormous stone of expectation to the gate. The exhibition only confirms the greatness of my father, who painted the two pastiches that hang above the couch in our living room, signed Pissacco. When we are looking for our car afterwards – none of us paid attention to the street name when we parked it – Paris seizes me. Eventually, we find the car,

A B C D E F G H I J K
L M N O P Q R S T U V
W X Y Z a b c d e f g
h i j k l m n o p q r
s t u v w x y z 1 2 3
4 5 6 7 8 9 0 ? ! () []
& "" «» ;: / - – à ç é î

A B C D E F G H I J K
L M N O P Q R S T U V
W X Y Z I 2 3 4 5 6 7
8 9 0 fi fl À ?

HxqkmHxqkmHxqkmHxqkmHxqkmHxqkmHxqkm

Just one thought further and I am sixteen, and the trees are in bloom underneath wildly billowing curtains of rain. I stand in a meandering line of people with my father and mother, getting closer to the Grand Palais step by step, where a Picasso exhibition is being shown. We are like beads on a rosary. We have the arthropodal tread of slaves, who, by sheer numbers alone, will manage to drag the enormous stone of expectation to the gate. The exhibition only confirms the greatness of my father, who painted the two pastiches that hang above the couch in our living room, signed Pissacco. When we are looking for our car afterwards – none of us paid attention to the street name when we parked it – Paris seizes me. Eventually, we find the car,

A B C D E F G H I J K
L M N O P Q R S T U V
W X Y Z a b c d e f g
h i j k l m n o p q r
s t u v w x y z 1 2 3
4 5 6 7 8 9 0 ? ! () []
& " " « » ; : / - – à ç é î
1 2 3 4 5 6 7 8 9 0 fi
fl

HxqkmHxqkmHxqkmHxqkmHxqkmHxqkmHxqkm

20, 16, 12, 10, 8, 6, 4 pt

Font size 9/11 pt

Just one thought further and I am sixteen, and the trees are in bloom underneath wildly billowing curtains of rain. I stand in a meandering line of people with my father and mother, getting closer to the Grand Palais step by step, where a Picasso exhibition is being shown. We are like beads on a rosary. We have the arthropodal tread of slaves, who, by sheer numbers alone, will manage to drag the enormous stone of expectation to the gate. The exhibition only confirms the greatness of my father, who painted the two pastiches that hang above the couch in our living room, signed Pissacco. When we are looking for our car afterwards – none of us paid attention to the street name when we parked it – Paris seizes me. Eventually, we find the car,

A B C D E F G H I J K
L M N O P Q R S T U V
W X Y Z a b c d e f g
h i j k l m n o p q r
s t u v w x y z 1 2 3
4 5 6 7 8 9 0 ? ! () []
& "" «» ;: / - – à ç é î
1 2 3 4 5 6 7 8 9 0 fi
fl

HxqkmHxqkmHxqkmHxqkmHxqkmHxqkmHxqkm

20, 16, 12, 10, 8, 6, 4 pt

**Just one thought further and I am sixteen, and the trees are
in bloom underneath wildly billowing curtains of rain. I stand
in a meandering line of people with my father and mother,
getting closer to the Grand Palais step by step, where a
Picasso exhibition is being shown. We are like beads on a
rosary. We have the arthropodal tread of slaves, who, by
sheer numbers alone, will manage to drag the enormous
stone of expectation to the gate. The exhibition only con-
firms the greatness of my father, who painted the two pas-
tiches that hang above the couch in our living room, signed
Pissacco. When we are looking for our car afterwards – none
of us paid attention to the street name when we parked it –**

Font size 9/11 pt

A B C D E F G H I J K
L M N O P Q R S T U V
W X Y Z a b c d e f g
h i j k l m n o p q r
s t u v w x y z 1 2 3
4 5 6 7 8 9 0 ? ! () []
& "" «»;: / - – à ç é î
1 2 3 4 5 6 7 8 9 0 fi
fl

6
7
8
9
10
11
12
14
16
18
20
22
24
28
32
36
42
48
60
72

HxqkmHxqkmHxqkmHxqkmHxqkmHxqkmHxqkm 20, 16, 12, 10, 8, 6, 4 pt

Font size 9/11 pt

Just one thought further and I am sixteen, and the trees are in bloom underneath wildly billowing curtains of rain. I stand in a meandering line of people with my father and mother, getting closer to the Grand Palais step by step, where a Picasso exhibition is being shown. We are like beads on a rosary. We have the arthropodal tread of slaves, who, by sheer numbers alone, will manage to drag the enormous stone of expectation to the gate. The exhibition only confirms the greatness of my father, who painted the two pastiches that hang above the couch in our living room, signed Pissacco. When we are looking for our car afterwards – none of us paid attention to the street name when we parked it –

Monotype Scotch Roman
Scotch Roman is one of the first examples from which the popular Century Old Style emerged, the model originating in the Miller foundry in Edinburgh ca. 1813, supposedly cut by Richard Austin. Although the Scotch tends to have a patchy effect in text, it was extremely popular in the nineteenth century, especially in America. This page shows the development of Scotch Roman via the Old Style to Century Old Style. Century is as text the most balanced and the word forming is significantly better than with Scotch Roman.

Just one thought further and I am sixteen, and the trees are in bloom underneath wildly billowing curtains of rain. I stand in a meandering line of people with my father and mother, getting closer to the Grand Palais step by step, where a Picasso exhibition is being shown. We are like beads on a rosary. We have the arthropodal tread of slaves, who, by sheer numbers alone, will manage to drag the enormous stone of expectation to the gate. The exhibition only confirms the greatness of my father, who painted the two pastiches that hang above the couch in our living room, signed Pissacco. [*From the short story* Par(ad)is Revisité]

RQEN baegn *baegn*

ABCDEFGHIJKLMNOPQRSTUVWXYZ
abcdefghijklmnopqrstuvwxyz 0123456789

Linotype Old Style Seven
This Old Style Seven by Linotype from 1902 is a revival of the Old Style from the Scottish Miller & Richard foundry, cut by Alexander Phemister shortly before 1860. It was a direct reaction to the revival of the Caslon's eighteenth century types, put on the market around 1854 after a decade of private use, but brought it into accord with nineteenth century norms.

Just one thought further and I am sixteen, and the trees are in bloom underneath wildly billowing curtains of rain. I stand in a meandering line of people with my father and mother, getting closer to the Grand Palais step by step, where a Picasso exhibition is being shown. We are like beads on a rosary. We have the arthropodal tread of slaves, who, by sheer numbers alone, will manage to drag the enormous stone of expectation to the gate. The exhibition only confirms the greatness of my father, who painted the two pastiches that hang above the couch in our living room, signed Pissacco. [*From the short story* PAR(AD)IS REVISITÉ]

RQEN baegn *baegn*

ABCDEFGHIJKLMNOPQRSTUVWXYZ
abcdefghijklmnopqrstuvwxyz 0123456789

Linotype Century Old Style
Century, cut by Linn Boyd Benton for T.L. De Vinne, first appeared in the Century Magazine in 1895 and Benton's son Morris Fuller Benton expanded it into a family in 1908–1909 for American Type Founders. It remains popular for newspapers and magazines. Centennial is based on Century Old Style but has a larger x-height and greater thick-thin contrast.

Just one thought further and I am sixteen, and the trees are in bloom underneath wildly billowing curtains of rain. I stand in a meandering line of people with my father and mother, getting closer to the Grand Palais step by step, where a Picasso exhibition is being shown. We are like beads on a rosary. We have the arthropodal tread of slaves, who, by sheer numbers alone, will manage to drag the enormous stone of expectation to the gate. The exhibition only confirms the greatness of my father, who painted the two pastiches that hang above the couch in our living room, signed Pissacco. [*From the short story* PAR(AD)IS REVISITÉ]

RQEN baegn *baegn*

ABCDEFGHIJKLMNOPQRSTUVWXYZ
abcdefghijklmnopqrstuvwxyz 0123456789

Font Bureau Miller Text
Matthew Carter's 1997 Miller Text, as its name suggests, is based on the early nineteenth century types of the Miller foundry that became known as Scotch Roman.

Just one thought further and I am sixteen, and the trees are in bloom underneath wildly billowing curtains of rain. I stand in a meandering line of people with my father and mother, getting closer to the Grand Palais step by step, where a Picasso exhibition is being shown. We are like beads on a rosary. We have the arthropodal tread of slaves, who, by sheer numbers alone, will manage to drag the enormous stone of expectation to the gate. The exhibition only confirms the greatness of my father, who painted the two pastiches that hang above the couch in our living room, signed Pissaco. [*From the short story* Par(ad)is Revisité]

RQEN baegn *baegn*

ABCDEFGHIJKLMNOPQRSTUVWXYZ
abcdefghijklmnopqrstuvwxyz 0123456789

FF Celeste
Although Christopher Burke had the intention in 1994 of designing a new and original typeface, he later considered Celeste to fall somewhere between a transitional and a didone, like Centennial. The vertical stress and the relatively high thick-thin contrast are contributing elements. Celeste's serifs are much more angular and the italic contrasts more with the roman than in the other typefaces on these pages.

Just one thought further and I am sixteen, and the trees are in bloom underneath wildly billowing curtains of rain. I stand in a meandering line of people with my father and mother, getting closer to the Grand Palais step by step, where a Picasso exhibition is being shown. We are like beads on a rosary. We have the arthropodal tread of slaves, who, by sheer numbers alone, will manage to drag the enormous stone of expectation to the gate. The exhibition only confirms the greatness of my father, who painted the two pastiches that hang above the couch in our living room, signed Pissaco. [*From the short story* Par(ad)is Revisité]

RQEN baegn *baegn*

ABCDEFGHIJKLMNOPQRSTUVWXYZ
abcdefghijklmnopqrstuvwxyz 0123456789

Adobe Kepler
This typeface was initially designed by Robert Slimbach as a Multiple Master typeface and was only later issued as a so-called 'opticals' family with variations for different sizes: caption (6–8 pt), regular (9–13 pt), subhead (14–24 pt) and display (25–72 pt). Like Centennial, Kepler has a more vertical and narrower character than Century.

Just one thought further and I am sixteen, and the trees are in bloom underneath wildly billowing curtains of rain. I stand in a meandering line of people with my father and mother, getting closer to the Grand Palais step by step, where a Picasso exhibition is being shown. We are like beads on a rosary. We have the arthropodal tread of slaves, who, by sheer numbers alone, will manage to drag the enormous stone of expectation to the gate. The exhibition only confirms the greatness of my father, who painted the two pastiches that hang above the couch in our living room, signed Pissaco. [*From the short story* Par(ad)is Revisité]

RQEN baegn *baegn*

ABCDEFGHIJKLMNOPQRSTUVWXYZ
abcdefghijklmnopqrstuvwxyz 0123456789

Linotype Centennial

Font size 5/6,5 pt

In Paris, new buildings thrive like ivy, she says, staring out the window as the sun's rays glide past. They colour with the seasons and quickly obtain the status of immortality. In front of the *Louvre*, for example, a glass pyramid has arisen from the surface in memory of a president. The *Gare d'Orsay*'s overcoat received a lining: a design train à grande vitesse stands in its final depot. And because of all this, *Café Costes* has already become the oldest watering place in Paris. All those 'immobile' creatures are, after a short period of discomfort, welcomed into the city's bosom as

6/7,5 pt

In Paris, new buildings thrive like ivy, she says, staring out the window as the sun's rays glide past. They colour with the seasons and quickly obtain the status of immortality. In front of the *Louvre*, for example, a glass pyramid has arisen from the surface in memory of a president. The *Gare d'Orsay*'s overcoat received a lining: a design train à grande vitesse stands in its final depot. And because of all this, *Café Costes* has already become the oldest watering place in Paris. All those 'immobile' creatures are, after a short period of discomfort, welcomed into the city's bosom as in-laws.

7/8,5 pt

In Paris, new buildings thrive like ivy, she says, staring out the window as the sun's rays glide past. They colour with the seasons and quickly obtain the status of immortality. In front of the *Louvre*, for example, a glass pyramid has arisen from the surface in memory of a president. The *Gare d'Orsay*'s overcoat received a lining: a design train à grande vitesse stands in its final depot. And because of all this, *Café Costes* has already become the oldest

8/10 pt

In Paris, new buildings thrive like ivy, she says, staring out the window as the sun's rays glide past. They colour with the seasons and quickly obtain the status of immortality. In front of the *Louvre*, for example, a glass pyramid has arisen from the surface in memory of a president. The *Gare d'Orsay*'s overcoat received a lining: a design train à grande vitesse stands in its final depot. And because of all this, *Café Costes* has already become the oldest watering place in Paris. All those 'im-

10/12 pt

In Paris, new buildings thrive like ivy, she says, staring out the window as the sun's rays glide past. They colour with the seasons and quickly obtain the status of immortality. In front of the *Louvre*, for example, a glass pyramid has arisen from the surface in memory of a president. The *Gare d'Orsay*'s overcoat received a lining: a design train à grande vitesse stands in its final

Light & Light Italic 24, 32, 40, 48 pt

Corps

Corps

Corps

Corps

Roman & Italic 24, 32, 40, 48 pt

Corps

Corps

Corps

Corps

Bold & B. Italic, Black & Bl. It. 24, 32, 40,

Corps

Corps

Corps

Corps

Bitstream Clarendon

C1

Light
Roman
Heavy
Bold
Black
Condensed
Bold Condensed

Clarendon is a so-called slab-serif, also known as *Egyptian*, but with bracketed serifs. Vincent Figgins (1766–1844) in London issued the first slab-serif ca. 1818. The name *Egyptian* had first been used for sans-serif, but continental type-founders followed the London typefounder Thorowgood in using it for slab-serif, which later became a common practice in England as well.

In 1845, Benjamin Fox cut the original *Clarendon* for Robert Besley & Co.'s London typefoundry and named it after the university publishing house, the Clarendon Press in Oxford. It was immensely popular and widely imitated. *Clarendon*'s heavy serifs and low thick-thin contrast make it the best typo-graphic representative of the machine era and the industrial revolution. It was originally made for use on posters, adverts and encyclopaedic works. *Bitstream Clarendon* is one of the more elegant English variations.

A B C D E F G H I J K
L M N O P Q R S T U V
W X Y Z a b c d e f g
h i j k l m n o p q r
s t u v w x y z 1 2 3
4 5 6 7 8 9 0 ? ! () []
& " " « » ; : / - – à ç é î

HxqkmHxqkmHxqkmHxqkmHxqkmHxqkmHxqkm

20, 16, 12, 10, 8, 6, 4

Just one thought further and I am sixteen, and the trees are in bloom underneath wildly billowing curtains of rain. I stand in a meandering line of people with my father and mother, getting closer to the Grand Palais step by step, where a Picasso exhibition is being shown. We are like beads on a rosary. We have the arthropodal tread of slaves, who, by sheer numbers alone, will manage to drag the enormous stone of expectation to the gate. The exhibition only confirms the greatness of my father, who painted the two pastiches that hang above the couch in our living room, signed Pissacco. When we are looking for our car afterwards – none of us paid attention to the street name when

Font size 9/11 pt

A B C D E F G H I J K
L M N O P Q R S T U V
W X Y Z a b c d e f g
h i j k l m n o p q r
s t u v w x y z 1 2 3
4 5 6 7 8 9 0 ? ! () []
& "" «» ;: / - – à ç é î

6
7
8
9
10
11
12
14
16
18
20
22
24
28
32
36
42

HxqkmHxqkmHxqkmHxqkmHxqkmHxqkmHxqkm

20, 16, 12, 10, 8, 6, 4 pt

Just one thought further and I am sixteen, and the trees
are in bloom underneath wildly billowing curtains of rain.
I stand in a meandering line of people with my father and
mother, getting closer to the Grand Palais step by step,
where a Picasso exhibition is being shown. We are like
beads on a rosary. We have the arthropodal tread of slaves,
who, by sheer numbers alone, will manage to drag the
enormous stone of expectation to the gate. The exhibition
only confirms the greatness of my father, who painted the
two pastiches that hang above the couch in our living
room, signed Pissacco. When we are looking for our car
afterwards – none of us paid attention to the street name

Font size 9/11 pt

48

60

72

A B C D E F G H I J K
L M N O P Q R S T U V
W X Y Z a b c d e f g
h i j k l m n o p q r
s t u v w x y z 1 2 3
4 5 6 7 8 9 0 ? ! ()[]
& "" «» ;: / - – à ç é î

HxqkmHxqkmHxqkmHxqkmHxqkmHxqkmHxqkm

20, 16, 12, 10, 8, 6, 4

Just one thought further and I am sixteen, and the trees
are in bloom underneath wildly billowing curtains of rain.
I stand in a meandering line of people with my father and
mother, getting closer to the Grand Palais step by step,
where a Picasso exhibition is being shown. We are like
beads on a rosary. We have the arthropodal tread of slaves,
who, by sheer numbers alone, will manage to drag the
enormous stone of expectation to the gate. The exhibition
only confirms the greatness of my father, who painted the
two pastiches that hang above the couch in our living
room, signed Pissacco. When we are looking for our car
afterwards – none of us paid attention to the street name

Font size 9/11 pt

A B C D E F G H I J K
L M N O P Q R S T U V
W X Y Z a b c d e f g
h i j k l m n o p q r
s t u v w x y z 1 2 3
4 5 6 7 8 9 0 ? ! () []
& " " « » ; : / - – à ç é î

HxqkmHxqkmHxqkmHxqkmHxqkmHxqkmHxqkm

20, 16, 12, 10, 8, 6, 4 pt

Font size 9/11 pt

Just one thought further and I am sixteen, and the trees
are in bloom underneath wildly billowing curtains of
rain. I stand in a meandering line of people with my
father and mother, getting closer to the Grand Palais
step by step, where a Picasso exhibition is being shown.
We are like beads on a rosary. We have the arthropodal
tread of slaves, who, by sheer numbers alone, will ma-
nage to drag the enormous stone of expectation to the
gate. The exhibition only confirms the greatness of my
father, who painted the two pastiches that hang above
the couch in our living room, signed Pissacco. When we
are looking for our car afterwards – none of us paid

Bitstream News 701
News 701 is a slab-serif that falls under the Clarendon types in the Vox Classification system but that also has similarities with the didones. It is based on Ionic No. 5 by Chauncey H. Griffith, designed in 1925 for Mergenthaler Linotype. Griffith also based his design on Ionic 156J by Monotype.
Font size: 7.3/11 pt.

Just one thought further and I am sixteen, and the trees are in bloom underneath wildly billowing curtains of rain. I stand in a meandering line of people with my father and mother, getting closer to the Grand Palais step by step, where a Picasso exhibition is being shown. We are like beads on a rosary. We have the arthropodal tread of slaves, who, by sheer numbers alone, will manage to drag the enormous stone of expectation to the gate. The exhibition only confirms the greatness of my father, who painted the two pastiches that hang above the couch in our living room, signed Pissacco. [*From the short story* Par(ad)is Revisité]

RQEN baegn *baegn*

ABCDEFGHIJKLMNOPQRSTUVWXYZ
abcdefghijklmnopqrstuvwxyz 0123456789

Linotype Excelsior
Excelsior, introduced six years after Ionic No. 5, is slightly lighter. The thick-thin contrast is also greater and the white spaces within the letters are more open, to compensate for ink squash in the printing of newspapers. These typefaces were most popular with newspapers and magazines. Excelsior dates from 1931 and was also designed by Griffith.
Font size: 7.8/11 pt. `

Just one thought further and I am sixteen, and the trees are in bloom underneath wildly billowing curtains of rain. I stand in a meandering line of people with my father and mother, getting closer to the Grand Palais step by step, where a Picasso exhibition is being shown. We are like beads on a rosary. We have the arthropodal tread of slaves, who, by sheer numbers alone, will manage to drag the enormous stone of expectation to the gate. The exhibition only confirms the greatness of my father, who painted the two pastiches that hang above the couch in our living room, signed Pissacco. [*From the short story* Par(ad)is Revisité]

RQEN baegn *baegn*

ABCDEFGHIJKLMNOPQRSTUVWXYZ
abcdefghijklmnopqrstuvwxyz 0123456789

Linotype Corona
Corona, which combines a number of style elements from Ionic No. 5 and Excelsior, was one of the later typefaces to be included in the so-called 'Legibility Group' by Linotype. Corona is more often listed as a didone than as a slab-serif, like the similar Opticon and Paragon by Linotype, which are also included in the 'Legibility Group'. Corona was designed by Griffith in 1941.
Font size: 7.1/11 pt.

Just one thought further and I am sixteen, and the trees are in bloom underneath wildly billowing curtains of rain. I stand in a meandering line of people with my father and mother, getting closer to the Grand Palais step by step, where a Picasso exhibition is being shown. We are like beads on a rosary. We have the arthropodal tread of slaves, who, by sheer numbers alone, will manage to drag the enormous stone of expectation to the gate. The exhibition only confirms the greatness of my father, who painted the two pastiches that hang above the couch in our living room, signed Pissacco. [*From the short story* Par(ad)is Revisité]

RQEN baegn *baegn*

ABCDEFGHIJKLMNOPQRSTUVWXYZ
abcdefghijklmnopqrstuvwxyz 0123456789

Bitstream Clarendon *alternatives*

URW Egizio
Aldo Novarese designed Egizio in 1955 for Nebiolo in Turin. It is used significantly more for headings than for body text. According to Novarese, his inspiration came more from Bodoni than Clarendon, but he was certainly heavily influenced by the popularity of the Clarendon with other typefoundries. Font Bureau also issued this type as Belizio.
Font size: 8.4/11 pt.

Just one thought further and I am sixteen, and the trees are in bloom underneath wildly billowing curtains of rain. I stand in a meandering line of people with my father and mother, getting closer to the Grand Palais step by step, where a Picasso exhibition is being shown. We are like beads on a rosary. We have the arthropodal tread of slaves, who, by sheer numbers alone, will manage to drag the enormous stone of expectation to the gate. The exhibition only confirms the greatness of my father, who painted the two pastiches that hang above the couch in our living room, signed Pissacco. [*From the short story* Par(ad)is Revisité]

RQEN baegn *baegn*

ABCDEFGHIJKLMNOPQRSTUVWXYZ
abcdefghijklmnopqrstuvwxyz 0123456789

Linotype Impressum
Designed by Konrad F. Bauer and Walter Baum in 1963 for the Bauersche Schriftgieβerei. Bauer's typefaces are now in possession of Neufville. Impressum was designed as an alternative for Excelsior by Linotype. Its open structure and large x-height ensure that Impressum remains legible in smaller font sizes.
Font size: 7.2/11 pt.

Just one thought further and I am sixteen, and the trees are in bloom underneath wildly billowing curtains of rain. I stand in a meandering line of people with my father and mother, getting closer to the Grand Palais step by step, where a Picasso exhibition is being shown. We are like beads on a rosary. We have the arthropodal tread of slaves, who, by sheer numbers alone, will manage to drag the enormous stone of expectation to the gate. The exhibition only confirms the greatness of my father, who painted the two pastiches that hang above the couch in our living room, signed Pissacco. [*From the short story* Par(ad)is Revisité]

RQEN baegn *baegn*

ABCDEFGHIJKLMNOPQRSTUVWXYZ
abcdefghijklmnopqrstuvwxyz 0123456789

Linotype Olympian
Big, bigger, biggest. Space is particularly holy in the design of typefaces for newspapers. Efficiency was therefore the focus for Matthew Carter when he designed this typeface specifically as a newspaper type in 1970. The larger the face of the letter, the smaller the font size and the line spacing need to be. The alphabet under the red text clearly shows this size in comparison to the other typefaces on this page.
Font size: 7.5/11 pt.

Just one thought further and I am sixteen, and the trees are in bloom underneath wildly billowing curtains of rain. I stand in a meandering line of people with my father and mother, getting closer to the Grand Palais step by step, where a Picasso exhibition is being shown. We are like beads on a rosary. We have the arthropodal tread of slaves, who, by sheer numbers alone, will manage to drag the enormous stone of expectation to the gate. The exhibition only confirms the greatness of my father, who painted the two pastiches that hang above the couch in our living room, signed Pissacco. [*From the short story* Par(ad)is Revisité]

RQEN baegn *baegn*

ABCDEFGHIJKLMNOPQRSTUVWXYZ
abcdefghijklmnopqrstuvwxyz 0123456789

Bitstream Clarendon

Font size 5/6,5 pt

In Paris, new buildings thrive like ivy, she says, staring out the window as the sun's rays glide past. They colour with the seasons and quickly obtain the status of immortality. In front of the **Louvre**, for example, a glass pyramid has arisen from the surface in memory of a president. The **Gare d'Orsay**'s overcoat received a lining: a design train à grande vitesse stands in its final depot. And because of all this, **Café Costes** has already become the oldest watering place in Paris. All those 'immobile' creatures are, after a short period of

6/7,5 pt

In Paris, new buildings thrive like ivy, she says, staring out the window as the sun's rays glide past. They colour with the seasons and quickly obtain the status of immortality. In front of the **Louvre**, for example, a glass pyramid has arisen from the surface in memory of a president. The **Gare d'Orsay**'s overcoat received a lining: a design train à grande vitesse stands in its final depot. And because of all this, **Café Costes** has already become the oldest watering place in Paris. All those 'immobile' creatures are, after a short period of discomfort, welcomed

7/8,5 pt

In Paris, new buildings thrive like ivy, she says, staring out the window as the sun's rays glide past. They colour with the seasons and quickly obtain the status of immortality. In front of the **Louvre**, for example, a glass pyramid has arisen from the surface in memory of a president. The **Gare d'Orsay**'s overcoat received a lining: a design train à grande vitesse stands in its final depot. And because of all this, **Café Costes** has

8/10 pt

In Paris, new buildings thrive like ivy, she says, staring out the window as the sun's rays glide past. They colour with the seasons and quickly obtain the status of immortality. In front of the **Louvre**, for example, a glass pyramid has arisen from the surface in memory of a president. The **Gare d'Orsay**'s overcoat received a lining: a design train à grande vitesse stands in its final depot. And because of all this, **Café Costes** has already become the oldest

10/12 pt

In Paris, new buildings thrive like ivy, she says, staring out the window as the sun's rays glide past. They colour with the seasons and quickly obtain the status of immortality. In front of the **Louvre**, for example, a glass pyramid has arisen from the surface in memory of a president. The **Gare d'Orsay**'s overcoat received a lining: a design train à grande vitesse stands in its

Light & Roman 24, 32, 40, 48 pt

Corps
Corps
Corps
Corps

Heavy, Bold & Black 24, 32, 40, 48 pt

Corps
Corps
Corps
Corps

Roman Cond. & Bold Cond. 24, 32, 40, 4

Corps
Corps
Corps
Corps

Linotype Cochin

Regular
Italic
Bold
Bold Italic

Charles Nicolas Cochin (1715–1790) was one of the best engravers of his time. As a distinguished illustrator in the court of Louis XV, his engravings showed graceful lettering, sharp and elegant in nature and the perfect and unparalleled accompaniment to his illustrations. It may have inspired Baskerville, Didot and Bodoni. The Peignot (later Deberny & Peignot) typefoundry in Paris first rendered Cochin's lettering as a typeface in 1912, cut by Henri Parmentier and Charles Malin. The version of *Cochin* shown here was re-designed in 1977 by Matthew Carter.

Cochin may not be a conventional type for body text but its long ascenders and wide form, with little line spacing, offer decorative perspectives. The thin lines of the italic have a tendency to fade away in smaller sizes.

A B C D E F G H I J K
L M N O P Q R S T U V
W X Y Z a b c d e f g
h i j k l m n o p q r
s t u v w x y z 1 2 3
4 5 6 7 8 9 0 ? ! () []
& "" « » ; : / - – à ç é î

HxqkmHxqkmHxqkmHxqkmHxqkmHxqkmHxqkm

20, 16, 12, 10, 8, 6, 4 pt

Just one thought further and I am sixteen, and the trees are in bloom underneath wildly billowing curtains of rain. I stand in a meandering line of people with my father and mother, getting closer to the Grand Palais step by step, where a Picasso exhibition is being shown. We are like beads on a rosary. We have the arthropodal tread of slaves, who, by sheer numbers alone, will manage to drag the enormous stone of expectation to the gate. The exhibition only confirms the greatness of my father, who painted the two pastiches that hang above the couch in our living room, signed Pissacco. When we are looking for our car afterwards – none of us paid attention to the street name when we parked it – Paris seizes me. Eventually, we find the car, which has changed into a 'bagnole'. [*From the short story* Par(ad)is Revisité]

Font size 9/11 pt

A B C D E F G H I J K

L M N O P Q R S T U V

W X Y Z a b c d e f g

h i j k l m n o p q r

s t u v w x y z 1 2 3

4 5 6 7 8 9 0 ? ! () []

& "" «» ;: / - — à ç é î

HxqkmHxqkmHxqkmHxqkmHxqkmHxqkmHxqkm

20, 16, 12, 10, 8, 6, 4 pt

Just one thought further and I am sixteen, and the trees are in bloom underneath wildly billowing curtains of rain. I stand in a meandering line of people with my father and mother, getting closer to the Grand Palais step by step, where a Picasso exhibition is being shown. We are like beads on a rosary. We have the arthropodal tread of slaves, who, by sheer numbers alone, will manage to drag the enormous stone of expectation to the gate. The exhibition only confirms the greatness of my father, who painted the two pastiches that hang above the couch in our living room, signed Pissacco. When we are looking for our car afterwards – none of us paid attention to the street name when we parked it – Paris seizes me. Eventually, we find the car, which has changed into a 'bagnole'. [From the short story Par(ad)is Revisité]

Font size 9/11 pt

A B C D E F G H I J K
L M N O P Q R S T U V
W X Y Z a b c d e f g
h i j k l m n o p q r
s t u v w x y z 1 2 3
4 5 6 7 8 9 0 ? ! () []
& "" «» ;: / - — à ç é î

HxqkmHxqkmHxqkmHxqkmHxqkmHxqkmHxqkm

20, 16, 12, 10, 8, 6, 4 pt

Font size 9/11 pt

Just one thought further and I am sixteen, and the trees are in bloom underneath wildly billowing curtains of rain. I stand in a meandering line of people with my father and mother, getting closer to the Grand Palais step by step, where a Picasso exhibition is being shown. We are like beads on a rosary. We have the arthropodal tread of slaves, who, by sheer numbers alone, will manage to drag the enormous stone of expectation to the gate. The exhibition only confirms the greatness of my father, who painted the two pastiches that hang above the couch in our living room, signed Pissacco. When we are looking for our car afterwards – none of us paid attention to the street name when we parked it – Paris seizes me. Eventually, we find the car, which has changed into a 'bagnole'. [*From the short story*

A B C D E F G H I J K
L M N O P Q R S T U V
W X Y Z a b c d e f g
h i j k l m n o p q r
s t u v w x y z 1 2 3
4 5 6 7 8 9 0 ? ! () []
& *"" «» ;: / - — à ç é î*

HxqkmHxqkmHxqkmHxqkmHxqkmHxqkmHxqkm

20, 16, 12, 10, 8, 6, 4 pt

Font size 9/11 pt

Just one thought further and I am sixteen, and the trees are in bloom underneath wildly billowing curtains of rain. I stand in a meandering line of people with my father and mother, getting closer to the Grand Palais step by step, where a Picasso exhibition is being shown. We are like beads on a rosary. We have the arthropodal tread of slaves, who, by sheer numbers alone, will manage to drag the enormous stone of expectation to the gate. The exhibition only confirms the greatness of my father, who painted the two pastiches that hang above the couch in our living room, signed Pissacco. When we are looking for our car afterwards – none of us paid attention to the street name when we parked it – Paris seizes me. Eventually, we find the car, which has changed into a 'bagnole'. [From the short story Par(ad)is Revisité]

URW Cochin
This is an almost exact and well-made copy of Linotype Cochin. The advantage of this version is the addition of two extra styles, the black and the black italic. There are a few differences, such as altered acute and grave accents.

Just one thought further and I am sixteen, and the trees are in bloom underneath wildly billowing curtains of rain. I stand in a meandering line of people with my father and mother, getting closer to the Grand Palais step by step, where a Picasso exhibition is being shown. We are like beads on a rosary. We have the arthropodal tread of slaves, who, by sheer numbers alone, will manage to drag the enormous stone of expectation to the gate. The exhibition only confirms the greatness of my father, who painted the two pastiches that hang above the couch in our living room, signed Pissacco. [*From the short story* Par(ad)is Revisité]

RQEN baegn *baegn*

ABCDEFGHIJKLMNOPQRSTUVWXYZ
abcdefghijklmnopqrstuvwxyz 0123456789

Linotype Miramar
Franko Luin designed this typeface in 1993. It is slightly less pronounced than Cochin but nevertheless shares several features with it. In contrast to Cochin, Miramar does include small capitals and old style figures.

Just one thought further and I am sixteen, and the trees are in bloom underneath wildly billowing curtains of rain. I stand in a meandering line of people with my father and mother, getting closer to the Grand Palais step by step, where a Picasso exhibition is being shown. We are like beads on a rosary. We have the arthropodal tread of slaves, who, by sheer numbers alone, will manage to drag the enormous stone of expectation to the gate. The exhibition only confirms the greatness of my father, who painted the two pastiches that hang above the couch in our living room, signed Pissacco. [*From the short story* Par(ad)is Revisité]

RQEN baegn *baegn*

ABCDEFGHIJKLMNOPQRSTUVWXYZ
abcdefghijklmnopqrstuvwxyz 0123456789

Monotype Dante
Another type based on Griffo's 1495 roman for Aldus, this time designed by Giovanni Mardersteig, cut by Charles Malin and first used by Mardersteig's private press, the Officina Bodoni, in 1955. Many consider it the best Aldine revival, but by the time the Monotype version began to appear in 1957 the metal type era was drawing to a close. Dante includes a large number of styles with small capitals and old style figures. Note the characteristic form of the serif on the upper crossbar of the 'E' and 'F'.

Just one thought further and I am sixteen, and the trees are in bloom underneath wildly billowing curtains of rain. I stand in a meandering line of people with my father and mother, getting closer to the Grand Palais step by step, where a Picasso exhibition is being shown. We are like beads on a rosary. We have the arthropodal tread of slaves, who, by sheer numbers alone, will manage to drag the enormous stone of expectation to the gate. The exhibition only confirms the greatness of my father, who painted the two pastiches that hang above the couch in our living room, signed Pissacco. [*From the short story* Par(ad)is Revisité]

RQEN baegn *baegn*

ABCDEFGHIJKLMNOPQRSTUVWXYZ
abcdefghijklmnopqrstuvwxyz 0123456789

Emigre Dalliance

This characteristic typeface by Frank Heine for Émigré combines a constructed roman with an italic that stems from handwriting, like Cochin. The styles with floral elements are based on a type specimen from the Wagnerische Buchdruckerei in the German city of Ulm. As well as a roman, script and flourishes, Dalliance also includes another style of script, a display version, small caps, fractions and numerals.

Just one thought further and I am sixteen, and the trees are in bloom underneath wildly billowing curtains of rain. I stand in a meandering line of people with my father and mother, getting closer to the Grand Palais step by step, where a Picasso exhibition is being shown. We are like beads on a rosary. We have the arthropodal tread of slaves, who, by sheer numbers alone, will manage to drag the enormous stone of expectation to the gate. The exhibition only confirms the greatness of my father, who painted the two pastiches that hang above the couch in our living room, signed Pissacco. [*From the short story* PAR(AD)IS REVISITÉ]

RQEN baegn *baegn*

ABCDEFGHIJKLMNOPQRSTUVWXYZ
abcdefghijklmnopqrstuvwxyz 0123456789

Bitstream ITC Zapf Chancery

Many of Hermann Zapf's typefaces have origins in calligraphy. One of the classics is Zapf Chancery, based on handwriting from the Italian Renaissance, as is Poetica, although the forms of this type are much more angular than Poetica.

Just one thought further and I am sixteen, and the trees are in bloom underneath wildly billowing curtains of rain. I stand in a meandering line of people with my father and mother, getting closer to the Grand Palais step by step, where a Picasso exhibition is being shown. We are like beads on a rosary. We have the arthropodal tread of slaves, who, by sheer numbers alone, will manage to drag the enormous stone of expectation to the gate. The exhibition only confirms the greatness of my father, who painted the two pastiches that hang above the couch in our living room, signed Pissacco. [*From the short story* Par(ad)is Revisité]

RQEN baegn *baegn*

ABCDEFGHIJKLMNOPQRSTUVWXYZ
abcdefghijklmnopqrstuvwxyz 0123456789

Adobe Poetica

Robert Slimbach designed this typeface, based on handwriting from the Italian Renaissance. In contrast to Cochin, Poetica has no roman style for lowercase letters but does include four different styles of capitals that are more or less italic and are decorated. Poetica 4 has been used here, whereby the capitals are the most vertical. The capital 'R' in the red text has been set in Poetica 1, 2, 3 and 4. As well as ornaments, swashes, ligatures and various decorated characters are also available.

Just one thought further and I am sixteen, and the trees are in bloom underneath wildly billowing curtains of rain. I stand in a meandering line of people with my father and mother, getting closer to the Grand Palais step by step, where a Picasso exhibition is being shown. We are like beads on a rosary. We have the arthropodal tread of slaves, who, by sheer numbers alone, will manage to drag the enormous stone of expectation to the gate. The exhibition only confirms the greatness of my father, who painted the two pastiches that hang above the couch in our living room, signed Pissacco. [From the short story PAR(AD)IS REVISITÉ]

RRRRQEN *baegn ckchctffft*

ABCDEFGHIJKLMNOPQRSTUVWXYZ
abcdefghijklmnopqrstuvwxyz 0123456789

Linotype Cochin

Font size 5/6,5 pt

In Paris, new buildings thrive like ivy, she says, staring out the window as the sun's rays glide past. They colour with the seasons and quickly obtain the status of immortality. In front of the *Louvre*, for example, a glass pyramid has arisen from the surface in memory of a president. The *Gare d'Orsay*'s overcoat received a lining: a design train à grande vitesse stands in its final depot. And because of all this, *Café Costes* has already become the oldest watering place in Paris. All those 'immobile' creatures are, after a short period of discomfort, welcomed into the city's bosom as in-laws. [*From the short story* Par(ad)is Revisité]

6/7,5 pt

In Paris, new buildings thrive like ivy, she says, staring out the window as the sun's rays glide past. They colour with the seasons and quickly obtain the status of immortality. In front of the *Louvre*, for example, a glass pyramid has arisen from the surface in memory of a president. The *Gare d'Orsay*'s overcoat received a lining: a design train à grande vitesse stands in its final depot. And because of all this, *Café Costes* has already become the oldest watering place in Paris. All those 'immobile' creatures are, after a short period of discomfort, welcomed into the city's bosom as in-laws. [*From the short story* Par(ad)is Revisité]

7/8,5 pt

In Paris, new buildings thrive like ivy, she says, staring out the window as the sun's rays glide past. They colour with the seasons and quickly obtain the status of immortality. In front of the *Louvre*, for example, a glass pyramid has arisen from the surface in memory of a president. The *Gare d'Orsay*'s overcoat received a lining: a design train à grande vitesse stands in its final depot. And because of all this, Café Costes has already become the oldest watering place in Paris. All those 'immobile' creatures are, after a short period

8/10 pt

In Paris, new buildings thrive like ivy, she says, staring out the window as the sun's rays glide past. They colour with the seasons and quickly obtain the status of immortality. In front of the *Louvre*, for example, a glass pyramid has arisen from the surface in memory of a president. The *Gare d'Orsay*'s overcoat received a lining: a design train à grande vitesse stands in its final depot. And because of all this, *Café Costes* has already become the oldest watering place in Paris. All those 'immobile' creatures are, after a short period of discomfort, welcomed into the city's

10/12 pt

In Paris, new buildings thrive like ivy, she says, staring out the window as the sun's rays glide past. They colour with the seasons and quickly obtain the status of immortality. In front of the *Louvre*, for example, a glass pyramid has arisen from the surface in memory of a president. The *Gare d'Orsay*'s overcoat received a lining: a design train à grande vitesse stands in its final depot. And because of all this, *Café Costes* has already become the oldest

Regular & Italic 24, 32, 40, 48 pt

Corps

Corps

Corps

Corps

Bold & Bold Italic 24, 32, 40, 48, 60, 72 pt

Corps

Corps

Corps

Corps

Corp

Corp

Monotype Ehrhardt

Eh

Ehrhardt is based on types from the Ehrhardt foundry in Leipzig. Some survived in the Stempel typefoundry, which named their revival after the Dutchman Anton Janson (1620–1687), whose Leipzig typefoundry descended to Ehrhardt and who was formerly thought to have cut the types. In 1953, Harry Carter showed they were cut in Amsterdam, where the Transylvanian punchcutter Miklós (Nicholas) Kis, (1650–1702), offered them in his ca. 1689 type specimen. He learned punchcutting and typefounding from Dirck Voskens in Amsterdam, where he also published a *Hungarian Bible* in 1685. His types are among the most important textbook examples of the *Dutch Old Face*.

The type displays similarities with *Caslon* but is somewhat more elegant. These similarities are understandable since William Caslon was inspired by Dutch types used in England.
Ehrhardt's large x-height requires generous line spacing.

A B C D E F G H I J K
L M N O P Q R S T U V
W X Y Z a b c d e f g
h i j k l m n o p q r
s t u v w x y z 1 2 3
4 5 6 7 8 9 0 ? ! () []
& "" «» ;: / – — à ç é î

A B C D E F G H I J K
L M N O P Q R S T U V
W X Y Z I 2 3 4 5 6 7
8 9 0 ½ ff fi fl ffi ffl À ?

HxqkmHxqkmHxqkmHxqkmHxqkmHxqkmHxqkm

Just one thought further and I am sixteen, and the trees are in bloom under-neath wildly billowing curtains of rain. I stand in a meandering line of people with my father and mother, getting closer to the Grand Palais step by step, where a Picasso exhibition is being shown. We are like beads on a rosary. We have the arthropodal tread of slaves, who, by sheer numbers alone, will manage to drag the enormous stone of expectation to the gate. The exhibition only confirms the greatness of my father, who painted the two pastiches that hang above the couch in our living room, signed Pissacco. When we are looking for our car afterwards – none of us paid attention to the street name when we parked it – Paris seizes me. Eventually, we find the car, which has changed into a 'bagnole'. [*From the short story* PAR(AD)IS REVISITÉ]

A B C D E F G H I J K
L M N O P Q R S T U V
W X Y Z a b c d e f g
h i j k l m n o p q r
s t u v w x y z 1 2 3
4 5 6 7 8 9 0 ? ! () []
& "" «» ;: / – — à ç é î
1 2 3 4 5 6 7 8 9 0 ½
ff fi fl ffi ffl

HxqkmHxqkmHxqkmHxqkmHxqkmHxqkmHxqkm

20, 16, 12, 10, 8, 6, 4 pt

Font size 9/11 pt

Just one thought further and I am sixteen, and the trees are in bloom underneath wildly billowing curtains of rain. I stand in a meandering line of people with my father and mother, getting closer to the Grand Palais step by step, where a Picasso exhibition is being shown. We are like beads on a rosary. We have the arthropodal tread of slaves, who, by sheer numbers alone, will manage to drag the enormous stone of expectation to the gate. The exhibition only confirms the greatness of my father, who painted the two pastiches that hang above the couch in our living room, signed Pissacco. When we are looking for our car afterwards – none of us paid attention to the street name when we parked it – Paris seizes me. Eventually, we find the car, which has changed into a 'bagnole'. [From the short story PAR(AD)IS REVISITÉ]

A B C D E F G H I J K
L M N O P Q R S T U V
W X Y Z a b c d e f g
h i j k l m n o p q r
s t u v w x y z 1 2 3
4 5 6 7 8 9 0 ? ! () []
& "" «» ;: / - – à ç é î
1 2 3 4 5 6 7 8 9 0 ½
ff fi fl ffi ffl

HxqkmHxqkmHxqkmHxqkmHxqkmHxqkmHxqkm

20, 16, 12, 10, 8, 6, 4 pt

Just one thought further and I am sixteen, and the trees are in bloom underneath wildly billowing curtains of rain. I stand in a meandering line of people with my father and mother, getting closer to the Grand Palais step by step, where a Picasso exhibition is being shown. We are like beads on a rosary. We have the arthropodal tread of slaves, who, by sheer numbers alone, will manage to drag the enormous stone of expectation to the gate. The exhibition only confirms the greatness of my father, who painted the two pastiches that hang above the couch in our living room, signed Pissacco. When we are looking for our car afterwards – none of us paid attention to the street name when we parked it – Paris seizes me. Eventually, we find the car, which has changed into a 'bagnole'.

Font size 9/11 pt

Font size 28/13 mm

A B C D E F G H I J K
L M N O P Q R S T U V
W X Y Z a b c d e f g
h i j k l m n o p q r
s t u v w x y z 1 2 3
4 5 6 7 8 9 0 ? ! () []
& "" «» ;: / - – à ç é î
1 2 3 4 5 6 7 8 9 0 ½
ff fi fl ffi ffl

HxqkmHxqkmHxqkmHxqkmHxqkmHxqkmHxqkm

20, 16, 12, 10, 8, 6, 4 pt

Font size 9/11 pt

Just one thought further and I am sixteen, and the trees are in bloom underneath wildly billowing curtains of rain. I stand in a meandering line of people with my father and mother, getting closer to the Grand Palais step by step, where a Picasso exhibition is being shown. We are like beads on a rosary. We have the arthropodal tread of slaves, who, by sheer numbers alone, will manage to drag the enormous stone of expectation to the gate. The exhibition only confirms the greatness of my father, who painted the two pastiches that hang above the couch in our living room, signed Pissacco. When we are looking for our car afterwards – none of us paid attention to the street name when we parked it – Paris seizes me. Eventually, we find the car, which has changed into a 'bagnole'. [From the short story Par(ad)is Revisité*]*

Linotype Janson Text

Because matrices made by Kis came into possession of D. Stempel AG, Stempel Janson is considered the most authentic version, though Stempel revised it for its revival in the 1920's. Linotype acquired the materials when it took over Stempel and in 1985, under the guidance of Adrian Frutiger and Hermann Zapf, a version was made under the name Janson for digital use. For the italic they followed the one size of the Stempel version that was cut by Christian Zinck in the eighteenth century. Just as with Monotype it has small capitals and old style figures.

Just one thought further and I am sixteen, and the trees are in bloom underneath wildly billowing curtains of rain. I stand in a meandering line of people with my father and mother, getting closer to the Grand Palais step by step, where a Picasso exhibition is being shown. We are like beads on a rosary. We have the arthropodal tread of slaves, who, by sheer numbers alone, will manage to drag the enormous stone of expectation to the gate. The exhibition only confirms the greatness of my father, who painted the two pastiches that hang above the couch in our living room, signed Pissacco. [*From the short story* PAR(AD)IS REVISITÉ]

RQEN baegn *baegn*

ABCDEFGHIJKLMNOPQRSTUVWXYZ
abcdefghijklmnopqrstuvwxyz 0123456789

Omnibus Kis Classico

Designer Franko Luin has digitalized a large number of classic types including this Kis Classico. He attempted to remain true to the originals when making his revivals.

Just one thought further and I am sixteen, and the trees are in bloom underneath wildly billowing curtains of rain. I stand in a meandering line of people with my father and mother, getting closer to the Grand Palais step by step, where a Picasso exhibition is being shown. We are like beads on a rosary. We have the arthropodal tread of slaves, who, by sheer numbers alone, will manage to drag the enormous stone of expectation to the gate. The exhibition only confirms the greatness of my father, who painted the two pastiches that hang above the couch in our living room, signed Pissacco. [*From the short story* PAR(AD)IS REVISITÉ]

RQEN baegn *baegn*

ABCDEFGHIJKLMNOPQRSTUVWXYZ
abcdefghijklmnopqrstuvwxyz 0123456789

H&FJ Hoefler Text

Jonathan Hoefler designed this typeface in 1991, at the beginning of the digital era. It was one of the first typefaces with special styles such as swash capitals, small capitals and old style figures. Commissioned by Apple, it was introduced as one of the first GX-fonts in system 7. Although it has original touches here and there, the Kis influences remain clearly visible.

Just one thought further and I am sixteen, and the trees are in bloom underneath wildly billowing curtains of rain. I stand in a meandering line of people with my father and mother, getting closer to the Grand Palais step by step, where a Picasso exhibition is being shown. We are like beads on a rosary. We have the arthropodal tread of slaves, who, by sheer numbers alone, will manage to drag the enormous stone of expectation to the gate. The exhibition only confirms the greatness of my father, who painted the two pastiches that hang above the couch in our living room, signed Pissacco. [*From the short story* Par(ad)is Revisité]

RQEN baegn *baegn*

ABCDEFGHIJKLMNOPQRSTUVWXYZ
abcdefghijklmnopqrstuvwxyz 0123456789

Linotype Hollander
Gerard Unger designed
Hollander for Hell in 1985.
His primary sources of inspira-
tion were seventeenth century
Dutch types. Since Hollander
is much larger on the body
than Monotype Van Dijck
(which is also thinly digitised),
it has been set 1 pt smaller in
the text shown here (8/11 pt).

Just one thought further and I am sixteen, and the trees are in
bloom underneath wildly billowing curtains of rain. I stand in a
meandering line of people with my father and mother, getting closer
to the Grand Palais step by step, where a Picasso exhibition is being
shown. We are like beads on a rosary. We have the arthropodal tread
of slaves, who, by sheer numbers alone, will manage to drag the enor-
mous stone of expectation to the gate. The exhibition only confirms
the greatness of my father, who painted the two pastiches that hang
above the couch in our living room, signed Pissacco. [*From the short
story* Par(ad)is Revisité]

RQEN baegn *baegn*

ABCDEFGHIJKLMNOPQRSTUVWXYZ
abcdefghijklmnopqrstuvwxyz 0123456789

FF Quadraat
This typeface designed by
Fred Smeijers for Fontshop
in 1992 refers back to letter
forms from the sixteenth
century yet also has similari-
ties with the designs made by
Kis that can also be seen
in Janson Text and Ehrhardt.
The capital 'S' slants slightly
to the right just as with
Janson and Garamond.
The italic is angular and has a
smaller slant than the other
types on this page.

Just one thought further and I am sixteen, and the trees are in bloom
underneath wildly billowing curtains of rain. I stand in a meandering
line of people with my father and mother, getting closer to the Grand
Palais step by step, where a Picasso exhibition is being shown. We are
like beads on a rosary. We have the arthropodal tread of slaves, who, by
sheer numbers alone, will manage to drag the enormous stone of
expectation to the gate. The exhibition only confirms the greatness of
my father, who painted the two pastiches that hang above the couch in
our living room, signed Pissacco. [*From the short story* Par(ad)is
Revisité]

RQEN baegn *baegn*

ABCDEFGHIJKLMNOPQRSTUVWXYZ
abcdefghijklmnopqrstuvwxyz 0123456789

DTL Fleischmann
The German Paul Renner (1878 –
1956) was one of the many ad-
mirers of Joan Michael Fleisch-
mann (1707 – 1768). After 1728
Fleischmann worked in The
Netherlands for various type-
foundries, including Joh. Ensche-
dé in Haarlem. DTL Fleischmann
was designed in 1993 by Erhard
Kaiser. Special to Fleischmann
are its text (T) and display (D)
styles and the numerous liga-
tures, as well as the three kinds
of figures: standard tabular
figures, old style figures and
special tabular figures for the
small capitals. It is a heavy text
letter (and is therefore set
slightly smaller here: 8.5/11 pt).

Just one thought further and I am sixteen, and the trees are in
bloom underneath wildly billowing curtains of rain. I stand in a
meandering line of people with my father and mother, getting closer
to the Grand Palais step by step, where a Picasso exhibition is being
shown. We are like beads on a rosary. We have the arthropodal tread
of slaves, who, by sheer numbers alone, will manage to drag the enor-
mous stone of expectation to the gate. The exhibition only confirms
the greatness of my father, who painted the two pastiches that hang
above the couch in our living room, signed Pissacco. [*From the short
story* Par(ad)is Revisité]

RQEN baegn *baegn*

ABCDEFGHIJKLMNOPQRSTUVWXYZ
abcdefghijklmnopqrstuvwxyz 0123456789

Monotype Ehrhardt

Font size 5/6,5 pt

In Paris, new buildings thrive like ivy, she says, staring out the window as the sun's rays glide past. They colour with the seasons and quickly obtain the status of immortality. In front of the Louvre, for example, a glass pyramid has arisen from the surface in memory of a president. The *Gare d'Orsay*'s overcoat received a lining: a design train à grande vitesse stands in its final depot. And because of all this, *Café Costes* has already become the oldest watering place in Paris. All those 'immobile' creatures are, after a short period of discomfort, welcomed into the city's bosom as in-laws. [*From the short story* Par(ad)is Revisité]

6/7,5 pt

In Paris, new buildings thrive like ivy, she says, staring out the window as the sun's rays glide past. They colour with the seasons and quickly obtain the status of immortality. In front of the *Louvre*, for example, a glass pyramid has arisen from the surface in memory of a president. The *Gare d'Orsay*'s overcoat received a lining: a design train à grande vitesse stands in its final depot. And because of all this, *Café Costes* has already become the oldest watering place in Paris. All those 'immobile' creatures are, after a short period of discomfort, welcomed into the city's bosom as in-laws. [*From the short story* Par(ad)is Revisité]

7/8,5 pt

In Paris, new buildings thrive like ivy, she says, staring out the window as the sun's rays glide past. They colour with the seasons and quickly obtain the status of immortality. In front of the *Louvre*, for example, a glass pyramid has arisen from the surface in memory of a president. The *Gare d'Orsay*'s overcoat received a lining: a design train à grande vitesse stands in its final depot. And because of all this, *Café Costes* has already become the oldest watering place in Paris. All those 'immobile' creatures are, after a short period of discomfort, welcomed into

8/10 pt

In Paris, new buildings thrive like ivy, she says, staring out the window as the sun's rays glide past. They colour with the seasons and quickly obtain the status of immortality. In front of the *Louvre*, for example, a glass pyramid has arisen from the surface in memory of a president. The *Gare d'Orsay*'s overcoat received a lining: a design train à grande vitesse stands in its final depot. And because of all this, *Café Costes* has already become the oldest watering place in Paris. All those 'immobile' creatures are, after a short period of discomfort, welcomed into the city's bosom as in-laws.

10/12 pt

In Paris, new buildings thrive like ivy, she says, staring out the window as the sun's rays glide past. They colour with the seasons and quickly obtain the status of immortality. In front of the *Louvre*, for example, a glass pyramid has arisen from the surface in memory of a president. The *Gare d'Orsay*'s overcoat received a lining: a design train à grande vitesse stands in its final depot. And because of all this, *Café Costes* has already become the oldest watering

Regular & Italic 24, 32, 40, 48 pt

Corps

Corps

Corps

Corps

Semibold & Semibold Italic 24, 32, 40, 48, 60, 72

Corps

Corps

Corps

Corps

Corp

Corp

Adobe Garamond

Ga

Claude Garamond (ca. 1510–1561), famed in his own day and ours, was long known to have cut Greek types for Robert Estienne in Paris, printer to the King of France. From 1530 to 1534 Estienne's anonymous punchcutter (the mysterious 'Constantin'?) and Augereau introduced stunning new romans based on that in Aldus Manutius's 1495 *De Aetna*. Garamond followed and refined these types from ca. 1535 to his death, producing some of the finest types ever known, and printers used them throughout Europe. Some of his punches and matrices went to the Le Bé foundry in Paris, the Berner foundry (Egenolff-Berner type specimen from 1592) in Frankfurt and Plantin's printing office in Antwerp, these last still surviving today. In the nineteenth century, types cut by Jean Jannon (1580–1658) more than fifty years after Garamond's death were incorrectly attributed to him and served as the model for many 'Garamond' revivals. When that attribution was corrected, Estienne's types of 1530 that Garamond had copied were incorrectly attributed to him! Robert Slimbach based the roman of his 1989 *Adobe Garamond* on some of Garamond's surviving materials at the Plantin-Moretus Museum. Its italic is based on those of Garamond's contemporary Robert Granjon. *Garamond* was, together with *Bembo*, one of the most commonly used seriffed types in the world of classic book typography.

Adobe Garamond has a somewhat rustic character and a small x-height, is light in colour and wider than it at first appears.

A B C D E F G H I J K
L M N O P Q R S T U V
W X Y Z a b c d e f g
h i j k l m n o p q r
s t u v w x y z 1 2 3
4 5 6 7 8 9 0 ? ! () []
& "" «» ;: / - — à ç é î

A B C D E F G H I J K
L M N O P Q R S T U V
W X Y Z I 2 3 4 5 6 7
8 9 0 ½ ff fi fl ffi ffl À ?

HxqkmHxqkmHxqkmHxqkmHxqkmHxqkmHxqkm

20, 16, 12, 10, 8, 6, 4 pt

Just one thought further and I am sixteen, and the trees are in bloom underneath wildly billowing curtains of rain. I stand in a meandering line of people with my father and mother, getting closer to the Grand Palais step by step, where a Picasso exhibition is being shown. We are like beads on a rosary. We have the arthropodal tread of slaves, who, by sheer numbers alone, will manage to drag the enormous stone of expectation to the gate. The exhibition only confirms the greatness of my father, who painted the two pastiches that hang above the couch in our living room, signed Pissacco. When we are looking for our car afterwards – none of us paid attention to the street name when we parked it – Paris seizes me. Eventually, we find the car, which has changed into a 'bagnole'. [*From the short story* PAR(AD)IS REVISITÉ]

Font size 9/11 pt

Font size 28/13 mm

A B C D E F G H I J K
L M N O P Q R S T U V
W X Y Z a b c d e f g
h i j k l m n o p q r
s t u v w x y z 1 2 3
4 5 6 7 8 9 0 ? ! () []
& "" «» ;: / - – à ç é î
1 2 3 4 5 6 7 8 9 0 ½
ff fi fl ffi ffl

6
7
8
9
10
11
12
14
16
18
20
22
24
28
32
36
42

HxqkmHxqkmHxqkmHxqkmHxqkmHxqkmHxqkm

20, 16, 12, 10, 8, 6, 4 pt

Just one thought further and I am sixteen, and the trees are in bloom underneath wildly billowing curtains of rain. I stand in a meandering line of people with my father and mother, getting closer to the Grand Palais step by step, where a Picasso exhibition is being shown. We are like beads on a rosary. We have the arthropodal tread of slaves, who, by sheer numbers alone, will manage to drag the enormous stone of expectation to the gate. The exhibition only confirms the greatness of my father, who painted the two pastiches that hang above the couch in our living room, signed Pissacco. When we are looking for our car afterwards – none of us paid attention to the street name when we parked it – Paris seizes me. Eventually, we find the car, which has changed into a 'bagnole'. [From the short story Par(ad)is Revisité]

Font size 9/11 pt

48
60
72

A B C D E F G H I J K
L M N O P Q R S T U V
W X Y Z a b c d e f g
h i j k l m n o p q r
s t u v w x y z 1 2 3
4 5 6 7 8 9 0 ? ! () []
& "" «» ;: / - — à ç é î
1 2 3 4 5 6 7 8 9 0 ½
ff fi fl ffi ffl

HxqkmHxqkmHxqkmHxqkmHxqkmHxqkmHxqkm

20, 16, 12, 10, 8, 6, 4 pt

Just one thought further and I am sixteen, and the trees are in bloom underneath wildly billowing curtains of rain. I stand in a meandering line of people with my father and mother, getting closer to the Grand Palais step by step, where a Picasso exhibition is being shown. We are like beads on a rosary. We have the arthropodal tread of slaves, who, by sheer numbers alone, will manage to drag the enormous stone of expectation to the gate. The exhibition only confirms the greatness of my father, who painted the two pastiches that hang above the couch in our living room, signed Pissacco. When we are looking for our car afterwards – none of us paid attention to the street name when we parked it – Paris seizes me. Eventually, we find the car, which has changed into a 'bagnole'. [*From the short story* Par(ad)is Revisité]

Font size 9/11 pt

A B C D E F G H I J K
L M N O P Q R S T U V
W X Y Z a b c d e f g
h i j k l m n o p q r
s t u v w x y z 1 2 3
4 5 6 7 8 9 0 ? ! () []
& "" «» ;: / - – à ç é î
I 2 3 4 5 6 7 8 9 0 ½
ff fi fl ffi ffl

HxqkmHxqkmHxqkmHxqkmHxqkmHxqkmHxqkm

20, 16, 12, 10, 8, 6, 4 pt

Font size 9/11 pt

Just one thought further and I am sixteen, and the trees are in bloom underneath wildly billowing curtains of rain. I stand in a meandering line of people with my father and mother, getting closer to the Grand Palais step by step, where a Picasso exhibition is being shown. We are like beads on a rosary. We have the arthropodal tread of slaves, who, by sheer numbers alone, will manage to drag the enormous stone of expectation to the gate. The exhibition only confirms the greatness of my father, who painted the two pastiches that hang above the couch in our living room, signed Pissacco. When we are looking for our car afterwards – none of us paid attention to the street name when we parked it – Paris seizes me. Eventually, we find the car, which has changed into a 'bagnole'. [From the short story Par(ad)is *Revisité]*

A B C D E F G H I J K
L M N O P Q R S T U V
W X Y Z a b c d e f g
h i j k l m n o p q r
s t u v w x y z 1 2 3
4 5 6 7 8 9 0 ? ! () []
& "" «» ;: / - – à ç é î
ı 2 3 4 5 6 7 8 9 0 ½
ff fi fl ffi ffl

HxqkmHxqkmHxqkmHxqkmHxqkmHxqkmHxqkm

20, 16, 12, 10, 8, 6, 4 pt

Just one thought further and I am sixteen, and the trees are in bloom underneath wildly billowing curtains of rain. I stand in a meandering line of people with my father and mother, getting closer to the Grand Palais step by step, where a Picasso exhibition is being shown. We are like beads on a rosary. We have the arthropodal tread of slaves, who, by sheer numbers alone, will manage to drag the enormous stone of expectation to the gate. The exhibition only confirms the greatness of my father, who painted the two pastiches that hang above the couch in our living room, signed Pissacco. When we are looking for our car afterwards – none of us paid attention to the street name when we parked it – Paris seizes me. Eventually, we find the car, which has changed into a 'bagnole'. [*From the short story* Par(ad)is Revisité]

Font size 9/11 pt

A B C D E F G H I J K

L M N O P Q R S T U V

W X Y Z a b c d e f g

h i j k l m n o p q r

s t u v w x y z 1 2 3

4 5 6 7 8 9 0 ? ! () []

& "" «» ;: / - – à ç é î

1 2 3 4 5 6 7 8 9 0 ½

ff fi fl ffi ffl

HxqkmHxqkmHxqkmHxqkmHxqkmHxqkmHxqkm

20, 16, 12, 10, 8, 6, 4 pt

Font size 9/11 pt

Just one thought further and I am sixteen, and the trees are in bloom underneath wildly billowing curtains of rain. I stand in a meandering line of people with my father and mother, getting closer to the Grand Palais step by step, where a Picasso exhibition is being shown. We are like beads on a rosary. We have the arthropodal tread of slaves, who, by sheer numbers alone, will manage to drag the enormous stone of expectation to the gate. The exhibition only confirms the greatness of my father, who painted the two pastiches that hang above the couch in our living room, signed Pissacco. When we are looking for our car afterwards – none of us paid attention to the street name when we parked it – Paris seizes me. Eventually, we find the car, which has changed into a 'bagnole'. [From the short story **Par(ad)is Revisité**]

Stempel Garamond
This Garamond from 1924 is based on Garamond's roman in a 1592 type specimen of the Egenolff-Berner type-foundry in Frankfurt and on italics by Robert Granjon (1512/13–1590) in the same specimen. This Garamond, with its embellished small capitals and old style figures, is considered one of the finest revivals.

Just one thought further and I am sixteen, and the trees are in bloom underneath wildly billowing curtains of rain. I stand in a meandering line of people with my father and mother, getting closer to the Grand Palais step by step, where a Picasso exhibition is being shown. We are like beads on a rosary. We have the arthropodal tread of slaves, who, by sheer numbers alone, will manage to drag the enormous stone of expectation to the gate. The exhibition only confirms the greatness of my father, who painted the two pastiches that hang above the couch in our living room, signed Pissacco. [*From the short story* PAR(AD)IS REVISITÉ]

RQEN baegn *baegn*

ABCDEFGHIJKLMNOPQRSTUVWXYZ
abcdefghijklmnopqrstuvwxyz 0123456789

Linotype Garamond 3 (ATF)
In contrast to Stempel Gara-mond and Adobe Garamond, which are based on Gara-mond's original punches and matrices, Morris Fuller Benton's 1917 Garamond for American Type Founders is based on the Jannon punches and matrices housed in the French 'Imprimerie Natio-nale', which are Jannon's interpretations of Claude Garamond's work, cut more than fifty years after Gara-mond's death.

Just one thought further and I am sixteen, and the trees are in bloom underneath wildly billowing curtains of rain. I stand in a meandering line of people with my father and mother, getting closer to the Grand Palais step by step, where a Picasso exhibition is being shown. We are like beads on a rosary. We have the arthropodal tread of slaves, who, by sheer numbers alone, will manage to drag the enormous stone of expectation to the gate. The exhibition only confirms the greatness of my father, who painted the two pastiches that hang above the couch in our living room, signed Pissacco. [*From the short story* PAR(AD)IS REVISITÉ]

RQEN baegn *baegn*

ABCDEFGHIJKLMNOPQRSTUVWXYZ
abcdefghijklmnopqrstuvwxyz 0123456789

Simoncini Garamond
This Garamond was designed in 1961 by Francesco Simon-cini and W. Bilz and later distributed by Bauer-Neuf-ville. Just as with Linotype Garamond 3, it is based on Jannon's work. This Gara-mond has no small capitals and no old style figures. The x-height of Simoncini Gara-mond is larger and the italic is comparatively thinner.

Just one thought further and I am sixteen, and the trees are in bloom underneath wildly billowing curtains of rain. I stand in a meandering line of people with my father and mother, getting closer to the Grand Palais step by step, where a Picasso exhibition is being shown. We are like beads on a rosary. We have the arthropodal tread of slaves, who, by sheer numbers alone, will manage to drag the enormous stone of expectation to the gate. The exhibition only confirms the greatness of my father, who painted the two pastiches that hang above the couch in our living room, signed Pissacco. [*From the short story* Par(ad)is Revisité]

RQEN baegn *baegn*

ABCDEFGHIJKLMNOPQRSTUVWXYZ
abcdefghijklmnopqrstuvwxyz 0123456789

Linotype Granjon
This typeface was not named after Garamond in order to avoid confusion with the other Garamond typefaces. The confusion, however, remains in that it is named after the original designer of the accompanying italic, Robert Granjon. It was actually designed by George William Jones and Chauncy H. Griffith and dates from 1928.

Just one thought further and I am sixteen, and the trees are in bloom underneath wildly billowing curtains of rain. I stand in a meandering line of people with my father and mother, getting closer to the Grand Palais step by step, where a Picasso exhibition is being shown. We are like beads on a rosary. We have the arthropodal tread of slaves, who, by sheer numbers alone, will manage to drag the enormous stone of expectation to the gate. The exhibition only confirms the greatness of my father, who painted the two pastiches that hang above the couch in our living room, signed Pissacco. [*From the short story* Par(ad)is Revisité]

RQEN baegn *baegn*

ABCDEFGHIJKLMNOPQRSTUVWXYZ
abcdefghijklmnopqrstuvwxyz 0123456789

Linotype Sabon Next
Jan Tschichold designed Sabon in 1967, based in part on Garamond types in the 1592 specimen of the Egenolff-Berner typefoundry in Frankfurt, and in part on a large roman by Guillaume Le Bé I, said to date from 1588. Tschichold designed it for three typesetting systems simultaneously, namely for Stempel, Linotype and Monotype. Jean François Porchez redesigned Sabon in 2002 and used the Egenolff-Berner specimen as inspiration.

Just one thought further and I am sixteen, and the trees are in bloom underneath wildly billowing curtains of rain. I stand in a meandering line of people with my father and mother, getting closer to the Grand Palais step by step, where a Picasso exhibition is being shown. We are like beads on a rosary. We have the arthropodal tread of slaves, who, by sheer numbers alone, will manage to drag the enormous stone of expectation to the gate. The exhibition only confirms the greatness of my father, who painted the two pastiches that hang above the couch in our living room, signed Pissacco. [*From the short story* Par(ad)is Revisité]

RQEN baegn *baegn*

ABCDEFGHIJKLMNOPQRSTUVWXYZ
abcdefghijklmnopqrstuvwxyz 0123456789

DTL Albertina
This was designed in 1965 by Chris Brand for Monotype and first used in the catalogue of Stanley Morison's exhibition at the Royal Albert I Library in Brussels. Hence the name Albertina. It is an efficient letter. Albertina was originally made for metal typesetting but it became entangled in the transition from metal to phototypesetting. The DTL version is based on the designer's original drawings. It is the official type of the European Union.

Just one thought further and I am sixteen, and the trees are in bloom underneath wildly billowing curtains of rain. I stand in a meandering line of people with my father and mother, getting closer to the Grand Palais step by step, where a Picasso exhibition is being shown. We are like beads on a rosary. We have the arthropodal tread of slaves, who, by sheer numbers alone, will manage to drag the enormous stone of expectation to the gate. The exhibition only confirms the greatness of my father, who painted the two pastiches that hang above the couch in our living room, signed Pissacco. [*From the short story* Par(ad)is Revisité]

RQEN baegn *baegn*

ABCDEFGHIJKLMNOPQRSTUVWXYZ
abcdefghijklmnopqrstuvwxyz 0123456789

Adobe Garamond

Font size 5/6,5 pt

In Paris, new buildings thrive like ivy, she says, staring out the window as the sun's rays glide past. They colour with the seasons and quickly obtain the status of immortality. In front of the *Louvre*, for example, a glass pyramid has arisen from the surface in memory of a president. The *Gare d'Orsay*'s overcoat received a lining: a design train à grande vitesse stands in its final depot. And because of all this, *Café Costes* has already become the oldest watering place in Paris. All those 'immobile' creatures are, after a short period of discomfort, welcomed into the city's bosom as in-laws. [*From the short story* PAR(AD)IS REVISITÉ]

6/7,5 pt

In Paris, new buildings thrive like ivy, she says, staring out the window as the sun's rays glide past. They colour with the seasons and quickly obtain the status of immortality. In front of the *Louvre*, for example, a glass pyramid has arisen from the surface in memory of a president. The *Gare d'Orsay*'s overcoat received a lining: a design train à grande vitesse stands in its final depot. And because of all this, *Café Costes* has already become the oldest watering place in Paris. All those 'immobile' creatures are, after a short period of discomfort, welcomed into the city's bosom as in-laws. [*From the short story* PAR(AD)IS REVISITÉ]

7/8,5 pt

In Paris, new buildings thrive like ivy, she says, staring out the window as the sun's rays glide past. They colour with the seasons and quickly obtain the status of immortality. In front of the *Louvre*, for example, a glass pyramid has arisen from the surface in memory of a president. The *Gare d'Orsay*'s overcoat received a lining: a design train à grande vitesse stands in its final depot. And because of all this, *Café Costes* has already become the oldest watering place in Paris. All those 'immobile' creatures are, after a short period of discomfort, welcomed into the city's

8/10 pt

In Paris, new buildings thrive like ivy, she says, staring out the window as the sun's rays glide past. They colour with the seasons and quickly obtain the status of immortality. In front of the *Louvre*, for example, a glass pyramid has arisen from the surface in memory of a president. The *Gare d'Orsay*'s overcoat received a lining: a design train à grande vitesse stands in its final depot. And because of all this, *Café Costes* has already become the oldest watering place in Paris. All those 'immobile' creatures are, after a short period of discomfort, welcomed into the city's bosom as in-laws. [*From the short*

10/12 pt

In Paris, new buildings thrive like ivy, she says, staring out the window as the sun's rays glide past. They colour with the seasons and quickly obtain the status of immortality. In front of the *Louvre*, for example, a glass pyramid has arisen from the surface in memory of a president. The *Gare d'Orsay*'s overcoat received a lining: a design train à grande vitesse stands in its final depot. And because of all this, *Café Costes* has already become the oldest watering place in Paris.

Regular & Italic 24, 32, 40, 48 pt

Corps

Corps

Corps

Corps

Semibold & Semibold Italic 24, 32, 40, 48 pt

Corps

Corps

Corps

Corps

Bold & Bold Italic 24, 32, 40, 48 pt

Corps

Corps

Corps

Corps

Monotype Joanna

Jo

Eric Gill (1882–1940) was a multifaceted and controversial figure: Catholic and socialist, pacifist, social critic, stone letter cutter, sculptor, engraver, type designer and extremely promiscuous father of Joan Gill, after whom he named this typeface, designed in 1931. *Joanna* was cast for hand-setting by the Caslon foundry for Hague & Gill, the printing firm owned by Gill and his brother-in-law. In 1937 he released the rights for production by Monotype.

Joanna has unique and hybrid characteristics, just like its maker. The italic is extremely narrow and without adjusted spacing can be illegible in large passages of text. The serifs are angular and the slant is minimal (3 degrees), but it still retains some typical italic elements as can be seen in the letters 'a' and 'g'.

A B C D E F G H I J K
L M N O P Q R S T U V
W X Y Z a b c d e f g
h i j k l m n o p q r
s t u v w x y z 1 2 3
4 5 6 7 8 9 0 ? ! () []
& "" «» ;: / – — à ç é î

A B C D E F G H I J K
L M N O P Q R S T U V
W X Y Z I 2 3 4 5 6 7
8 9 0 ½ ff fi fl ffi ffl À ?

HxqkmHxqkmHxqkmHxqkmHxqkmHxqkmHxqkm

20, 16, 12, 10, 8, 6, 4 pt

Just one thought further and I am sixteen, and the trees are in bloom
underneath wildly billowing curtains of rain. I stand in a meandering line
of people with my father and mother, getting closer to the Grand Palais
step by step, where a Picasso exhibition is being shown. We are like beads
on a rosary. We have the arthropodal tread of slaves, who, by sheer num-
bers alone, will manage to drag the enormous stone of expectation to the
gate. The exhibition only confirms the greatness of my father, who painted
the two pastiches that hang above the couch in our living room, signed
Pissacco. When we are looking for our car afterwards – none of us paid
attention to the street name when we parked it – Paris seizes me. Even-
tually, we find the car, which has changed into a 'bagnole'. [*From the short
story* PAR(AD)IS REVISITÉ]

Font size 9 / 11 pt

A B C D E F G H I J K
L M N O P Q R S T U V
W X Y Z a b c d e f g
h i j k l m n o p q r
s t u v w x y z 1 2 3
4 5 6 7 8 9 0 ? ! () []
& " " « » ; : / – — à ç é î
1 2 3 4 5 6 7 8 9 0 ½
ff fi fl ffi ffl

HxqkmHxqkmHxqkmHxqkmHxqkmHxqkmHxqkm

Just one thought further and I am sixteen, and the trees are in bloom underneath wildly billowing curtains of rain. I stand in a meandering line of people with my father and mother, getting closer to the Grand Palais step by step, where a Picasso exhibition is being shown. We are like beads on a rosary. We have the arthropodal tread of slaves, who, by sheer numbers alone, will manage to drag the enormous stone of expectation to the gate. The exhibition only confirms the greatness of my father, who painted the two pastiches that hang above the couch in our living room, signed Pissacco. When we are looking for our car afterwards – none of us paid attention to the street name when we parked it – Paris seizes me. Eventually, we find the car, which has changed into a 'bagnole'. [From the short story Par(ad)is Revisité]

A B C D E F G H I J K
L M N O P Q R S T U V
W X Y Z a b c d e f g
h i j k l m n o p q r
s t u v w x y z 1 2 3
4 5 6 7 8 9 0 ? ! () []
& "" «» ;: / – — à ç é î
A B C D E F G H I J K
L M N O P Q R S T U V
W X Y Z I 2 3 4 5 6 7
8 9 0 ½ ff fi fl ffi ffl À ?

HxqkmHxqkmHxqkmHxqkmHxqkmHxqkmHxqkm

20, 16, 12, 10, 8, 6, 4 pt

Just one thought further and I am sixteen, and the trees are in bloom underneath wildly billowing curtains of rain. I stand in a meandering line of people with my father and mother, getting closer to the Grand Palais step by step, where a Picasso exhibition is being shown. We are like beads on a rosary. We have the arthropodal tread of slaves, who, by sheer numbers alone, will manage to drag the enormous stone of expectation to the gate. The exhibition only confirms the greatness of my father, who painted the two pastiches that hang above the couch in our living room, signed Pissacco. When we are looking for our car afterwards – none of us paid attention to the street name when we parked it – Paris seizes me. Eventually, we find the car, which has changed into a 'bagnole'. [From the short story Par(ad)is Revisité]

Font size 9 / 11 pt

A B C D E F G H I J K
L M N O P Q R S T U V
W X Y Z a b c d e f g
h i j k l m n o p q r
s t u v w x y z 1 2 3
4 5 6 7 8 9 0 ? ! () []
& " " « » ; : / – — à ç é î
I 2 3 4 5 6 7 8 9 0 ½
ff fi fl ffi ffl

HxqkmHxqkmHxqkmHxqkmHxqkmHxqkmHxqkm

20, 16, 12, 10, 8, 6, 4 pt

Just one thought further and I am sixteen, and the trees are in bloom underneath wildly billowing curtains of rain. I stand in a meandering line of people with my father and mother, getting closer to the Grand Palais step by step, where a Picasso exhibition is being shown. We are like beads on a rosary. We have the arthropodal tread of slaves, who, by sheer numbers alone, will manage to drag the enormous stone of expectation to the gate. The exhibition only confirms the greatness of my father, who painted the two pastiches that hang above the couch in our living room, signed Pissacco. When we are looking for our car afterwards – none of us paid attention to the street name when we parked it – Paris seizes me. Eventually, we find the car, which has changed into a 'bagnole'. [From the short story Par(ad)is Revisité]

Font size 9 / 11 pt

A B C D E F G H I J K
L M N O P Q R S T U V
W X Y Z a b c d e f g
h i j k l m n o p q r
s t u v w x y z 1 2 3
4 5 6 7 8 9 0 ? ! () []
& "" «» ;: / – — à ç é î
1 2 3 4 5 6 7 8 9 0 ½
ff fi fl ffi ffl

HxqkmHxqkmHxqkmHxqkmHxqkmHxqkmHxqkm

Just one thought further and I am sixteen, and the trees are in bloom underneath wildly billowing curtains of rain. I stand in a meandering line of people with my father and mother, getting closer to the Grand Palais step by step, where a Picasso exhibition is being shown. We are like beads on a rosary. We have the arthropodal tread of slaves, who, by sheer numbers alone, will manage to drag the enormous stone of expectation to the gate. The exhibition only confirms the greatness of my father, who painted the two pastiches that hang above the couch in our living room, signed Pissacco. When we are looking for our car afterwards – none of us paid attention to the street name when we parked it – Paris seizes me. Eventually, we find the car, which has changed into a 'bagnole'. [From the short story Par(ad)is Revisité]

A B C D E F G H I J K
L M N O P Q R S T U V
W X Y Z a b c d e f g
h i j k l m n o p q r
s t u v w x y z 1 2 3
4 5 6 7 8 9 0 ? ! () []
& "" «» ;: / - — à ç é î
I 2 3 4 5 6 7 8 9 0 ½
ff fi fl ffi ffl

HxqkmHxqkmHxqkmHxqkmHxqkmHxqkmHxqkm

Just one thought further and I am sixteen, and the trees are in bloom underneath wildly billowing curtains of rain. I stand in a meandering line of people with my father and mother, getting closer to the Grand Palais step by step, where a Picasso exhibition is being shown. We are like beads on a rosary. We have the arthropodal tread of slaves, who, by sheer numbers alone, will manage to drag the enormous stone of expectation to the gate. The exhibition only confirms the greatness of my father, who painted the two pastiches that hang above the couch in our living room, signed Pissacco. When we are looking for our car afterwards – none of us paid attention to the street name when we parked it – Paris seizes me. Eventually, we find the car, which has changed into a 'bagnole'. [From the short story Par(ad)is Revisité]

Font Bureau Whitman
Designer Kent Law was in-
spired by Gill's Joanna and
Dwiggins' Electra. The end
product was good enough
for an award from the Type
Directors Club in 2002.
The italic more closely
resembles the roman than
with Joanna.

Just one thought further and I am sixteen, and the trees are in bloom
underneath wildly billowing curtains of rain. I stand in a meandering line of
people with my father and mother, getting closer to the Grand Palais step by
step, where a Picasso exhibition is being shown. We are like beads on a
rosary. We have the arthropodal tread of slaves, who, by sheer numbers
alone, will manage to drag the enormous stone of expectation to the gate.
The exhibition only confirms the greatness of my father, who painted the
two pastiches that hang above the couch in our living room, signed Pissacco
[*From the short story* Par(ad)is Revisité]

RQEN baegn *baegn*

ABCDEFGHIJKLMNOPQRSTUVWXYZ
abcdefghijklmnopqrstuvwxyz 0123456789

Linotype Electra
William A. Dwiggins designed
this typeface for Linotype in
1935. His influences were the
English types of the time and
especially Joanna. The capi-
tal 'Q' has a unique charac-
ter. The x-height of Electra is
clearly larger than that of
Joanna.

Just one thought further and I am sixteen, and the trees are in bloom
underneath wildly billowing curtains of rain. I stand in a meandering
line of people with my father and mother, getting closer to the Grand
Palais step by step, where a Picasso exhibition is being shown. We are
like beads on a rosary. We have the arthropodal tread of slaves, who,
by sheer numbers alone, will manage to drag the enormous stone of
expectation to the gate. The exhibition only confirms the greatness
of my father, who painted the two pastiches that hang above the couch
in our living room, signed Pissacco [*From the short story* Par(ad)is
Revisité]

RQEN baegn *baegn*

ABCDEFGHIJKLMNOPQRSTUVWXYZ
abcdefghijklmnopqrstuvwxyz 0123456789

FF Scala
Martin Majoor designed this
typeface in 1989 for the Vre-
denburg Music Hall in Utrecht
as a signposting typeface.
It was one of the first Post-
Script fonts that included old
style figures in the roman.
The combination of classic
and modern influences made
Scala suitable for a wide
variety of uses. ScalaHands,
with images of pointing
hands, is an amusing addi-
tion. Scala Sans was a later
addition.

Just one thought further and I am sixteen, and the trees are in
bloom underneath wildly billowing curtains of rain. I stand in a mean-
dering line of people with my father and mother, getting closer to the
Grand Palais step by step, where a Picasso exhibition is being shown.
We are like beads on a rosary. We have the arthropodal tread of slaves,
who, by sheer numbers alone, will manage to drag the enormous stone
of expectation to the gate. The exhibition only confirms the greatness of
my father, who painted the two pastiches that hang above the couch in
our living room, signed Pissacco [*From the short story* Par(ad)is
Revisité]

RQEN baegn *baegn*

ABCDEFGHIJKLMNOPQRSTUVWXYZ
abcdefghijklmnopqrstuvwxyz 0123456789

FF Nexus Serif
This recent typeface designed by Martin Majoor in 2004 has many similarities with Scala and Joanna. Scala's lowercase 'g' uses a two-storey construction whereas Nexus's uses a variation more like handwriting, a feature also found in Joanna. Nexus also includes variants with small capitals and old style figures for optimal use as a body-text typeface. There is also a Nexus Mix and a Nexus Sans.

Just one thought further and I am sixteen, and the trees are in bloom underneath wildly billowing curtains of rain. I stand in a meandering line of people with my father and mother, getting closer to the Grand Palais step by step, where a Picasso exhibition is being shown. We are like beads on a rosary. We have the arthropodal tread of slaves, who, by sheer numbers alone, will manage to drag the enormous stone of expectation to the gate. The exhibition only confirms the greatness of my father, who painted the two pastiches that hang above the couch in our living room, signed Pissacco. [*From the short story* PAR(AD)IS REVISITÉ]

RQEN baegn *baegn*

ABCDEFGHIJKLMNOPQRSTUVWXYZ
abcdefghijklmnopqrstuvwxyz 0123456789

Font Bureau Proforma
Petr van Blokland was awarded the Prix Charles Peignot in 1988 for his design of Proforma. This was first designed for the Danish company Purup, which made machines for form printing. A light, clear typeface that remains legible at smaller font sizes.

Just one thought further and I am sixteen, and the trees are in bloom underneath wildly billowing curtains of rain. I stand in a meandering line of people with my father and mother, getting closer to the Grand Palais step by step, where a Picasso exhibition is being shown. We are like beads on a rosary. We have the arthropodal tread of slaves, who, by sheer numbers alone, will manage to drag the enormous stone of expectation to the gate. The exhibition only confirms the greatness of my father, who painted the two pastiches that hang above the couch in our living room, signed Pissacco. [*From the short story* Par(ad)is Revisité]

RQEN baegn *baegn*

ABCDEFGHIJKLMNOPQRSTUVWXYZ
abcdefghijklmnopqrstuvwxyz 0123456789

Monotype Lucida Fax
Lucida, the first typeface explicitly designed for use with laser printers, was designed by Charles Bigelow and Kris Holmes and produced by Imagen, was released in 1985. The present version, from 1992, is delivered as standard with the Microsoft Office package and has therefore been distributed worldwide. It has an enormous x-height and has as such been set 1.5 pt smaller here (7.5/11 pt). The line in red has also been set slightly smaller. The alphabet is equal in size to the other examples on this page. The large x-height is compensated by the short ascenders and descenders.

Just one thought further and I am sixteen, and the trees are in bloom underneath wildly billowing curtains of rain. I stand in a meandering line of people with my father and mother, getting closer to the Grand Palais step by step, where a Picasso exhibition is being shown. We are like beads on a rosary. We have the arthropodal tread of slaves, who, by sheer numbers alone, will manage to drag the enormous stone of expectation to the gate. The exhibition only confirms the greatness of my father, who painted the two pastiches that hang above the couch in our living room, signed Pissacco. [*From the short story* Par(ad)is Revisité]

RQEN baegn *baegn*

ABCDEFGHIJKLMNOPQRSTUVWXYZ
abcdefghijklmnopqrstuvwxyz 0123456789

Monotype Joanna

Font size 5 / 6,5 pt

In Paris, new buildings thrive like ivy, she says, staring out the window as the sun's rays
glide past. They colour with the seasons and quickly obtain the status of immortality. In
front of the Louvre, for example, a glass pyramid has arisen from the surface in memory of
a president. The Gare d'Orsay's overcoat received a lining: a design train à grande vitesse
stands in its final depot. And because of all this, Café Costes has already become the oldest
watering place in Paris. All those 'immobile' creatures are, after a short period of discom-
fort, welcomed into the city's bosom as in-laws. [From the short story PAR(AD)IS REVISITÉ]

6 / 7,5 pt

In Paris, new buildings thrive like ivy, she says, staring out the window
as the sun's rays glide past. They colour with the seasons and quickly
obtain the status of immortality. In front of the Louvre, for example, a glass
pyramid has arisen from the surface in memory of a president. The Gare
d'Orsay's overcoat received a lining: a design train à grande vitesse stands
in its final depot. And because of all this, Café Costes has already become
the oldest watering place in Paris. All those 'immobile' creatures are, after
a short period of discomfort, welcomed into the city's bosom as in-laws.
[From the short story PAR(AD)IS REVISITÉ]

7 / 8,5 pt

In Paris, new buildings thrive like ivy, she says, staring out the
window as the sun's rays glide past. They colour with the
seasons and quickly obtain the status of immortality. In front
of the Louvre, for example, a glass pyramid has arisen from the
surface in memory of a president. The Gare d'Orsay's overcoat
received a lining: a design train à grande vitesse stands in its
final depot. And because of all this, Café Costes has already be-
come the oldest watering place in Paris. All those 'immobile'
creatures are, after a short period of discomfort, welcomed

8 / 10 pt

In Paris, new buildings thrive like ivy, she says, staring
out the window as the sun's rays glide past. They
colour with the seasons and quickly obtain the status of
immortality. In front of the Louvre, for example, a glass
pyramid has arisen from the surface in memory of a
president. The Gare d'Orsay's overcoat received a lining:
a design train à grande vitesse stands in its final depot.
And because of all this, Café Costes has already become
the oldest watering place in Paris. All those 'immobile'
creatures are, after a short period of discomfort, wel-
comed into the city's bosom as in-laws. [From the short

10 / 12 pt

In Paris, new buildings thrive like ivy, she
says, staring out the window as the sun's
rays glide past. They colour with the sea-
sons and quickly obtain the status of im-
mortality. In front of the Louvre, for exam-
ple, a glass pyramid has arisen from the
surface in memory of a president. The Gare
d'Orsay's overcoat received a lining: a design
train à grande vitesse stands in its final
depot. And because of all this, Café Costes has
already become the oldest watering place

Regular & Italic 24, 32, 40, 48 pt

Corps

Corps

Corps

Corps

Semibold & Semibold Italic 24, 32, 40, 48 pt

Corps

Corps

Corps

Corps

Bold, Bold Italic & Extra Bold 24, 32, 40, 48 pt

Corps

Corps

Corps

Corps

Monotype Rockwell

Ro

Light
Light Italic
Regular
Italic
Bold
Bold Italic
Extra Bold
Condensed
Bold Condensed

Frank Hinman Pierpont (1860–1937), together with his design team at Monotype, designed *Rockwell* in 1933 as a slab-serif, in the wake of the successful *Clarendon*. He is also known for his many technical inventions and improvements in the Monotype machine park and for his contribution to the development of the revival typeface *Plantin*.

Rockwell has a geometric construction whereby both the capital 'O' and the lowercase 'o' are almost circular. Another characteristic feature is the upper serif of the capital 'A'. The serifs have the same thickness as the other lines and there is almost no thick-thin contrast. In general, the bold styles are most often used for headings and larger display texts.

A B C D E F G H I J K
L M N O P Q R S T U V
W X Y Z a b c d e f g
h i j k l m n o p q r
s t u v w x y z 1 2 3
4 5 6 7 8 9 0 ? ! () []
& ' ' " " ‹ › › ; : / – — à ç é î

HxqkmHxqkmHxqkmHxqkmHxqkmHxqkmHxqkm

20, 16, 12, 10, 8, 6, 4 pt

Just one thought further and I am sixteen, and the trees are in bloom underneath wildly billowing curtains of rain. I stand in a meandering line of people with my father and mother, getting closer to the Grand Palais step by step, where a Picasso exhibition is being shown. We are like beads on a rosary. We have the arthropodal tread of slaves, who, by sheer numbers alone, will manage to drag the enormous stone of expectation to the gate. The exhibition only confirms the greatness of my father, who painted the two pastiches that hang above the couch in our living room, signed Pissacco. When we are looking for our car afterwards – none of us paid attention to the street name when we parked it – Paris seizes me. Eventually, we find the car, which has changed into a 'bagnole'. [*From the short story*

Font size 9 / 11 pt

Monotype Rockwell *Light Italic*

Font size 28 / 13 mm

A B C D E F G H I J K
L M N O P Q R S T U V
W X Y Z a b c d e f g
h i j k l m n o p q r
s t u v w x y z 1 2 3
4 5 6 7 8 9 0 ? ! () []
& ' ' ' ' ⟨⟩ ;: / - — à ç é î

HxqkmHxqkmHxqkmHxqkmHxqkmHxqkmHxqkm

20, 16, 12, 10, 8, 6, 4 pt

Just one thought further and I am sixteen, and the trees are in bloom underneath wildly billowing curtains of rain. I stand in a meandering line of people with my father and mother, getting closer to the Grand Palais step by step, where a Picasso exhibition is being shown. We are like beads on a rosary. We have the arthropodal tread of slaves, who, by sheer numbers alone, will manage to drag the enormous stone of expectation to the gate. The exhibition only confirms the greatness of my father, who painted the two pastiches that hang above the couch in our living room, signed Pissacco. When we are looking for our car afterwards – none of us paid attention to the street name when we parked it – Paris seizes me. Eventually, we find the car, which has changed into a 'bagnole'. [From the short story Par(ad)is Revisité]

Font size 9 / 11 pt

A B C D E F G H I J K
L M N O P Q R S T U V
W X Y Z a b c d e f g
h i j k l m n o p q r
s t u v w x y z 1 2 3
4 5 6 7 8 9 0 ? ! () []
& "" «» ;: / – — à ç é î

HxqkmHxqkmHxqkmHxqkmHxqkmHxqkmHxqkm

20, 16, 12, 10, 8, 6, 4 pt

Just one thought further and I am sixteen, and the trees are in bloom underneath wildly billowing curtains of rain. I stand in a meandering line of people with my father and mother, getting closer to the Grand Palais step by step, where a Picasso exhibition is being shown. We are like beads on a rosary. We have the arthropodal tread of slaves, who, by sheer numbers alone, will manage to drag the enormous stone of expectation to the gate. The exhibition only confirms the greatness of my father, who painted the two pastiches that hang above the couch in our living room, signed Pissacco. When we are looking for our car afterwards – none of us paid attention to the street name when we parked it – Paris seizes me. Eventually, we find the car, which has

Font size 9 / 11 pt

A B C D E F G H I J K
L M N O P Q R S T U V
W X Y Z a b c d e f g
h i j k l m n o p q r
s t u v w x y z 1 2 3
4 5 6 7 8 9 0 ? ! () []
& "" «» ;: / - – à ç é î

HxqkmHxqkmHxqkmHxqkmHxqkmHxqkmHxqkm

Just one thought further and I am sixteen, and the trees are in bloom underneath wildly billowing curtains of rain. I stand in a meandering line of people with my father and mother, getting closer to the Grand Palais step by step, where a Picasso exhibition is being shown. We are like beads on a rosary. We have the arthropodal tread of slaves, who, by sheer numbers alone, will manage to drag the enormous stone of expectation to the gate. The exhibition only confirms the greatness of my father, who painted the two pastiches that hang above the couch in our living room, signed Pissacco. When we are looking for our car afterwards – none of us paid attention to the street name when we parked it – Paris seizes me. Eventually, we find the car, which has changed into a 'bag-

A B C D E F G H I J K
L M N O P Q R S T U V
W X Y Z a b c d e f g
h i j k l m n o p q r
s t u v w x y z 1 2 3
4 5 6 7 8 9 0 ? ! () []
& " " ‹ › ; : / - – à ç é î

HxqkmHxqkmHxqkmHxqkmHxqkmHxqkmHxqkm

20, 16, 12, 10, 8, 6, 4 pt

Just one thought further and I am sixteen, and the trees are in
bloom underneath wildly billowing curtains of rain. I stand in
a meandering line of people with my father and mother, get-
ting closer to the Grand Palais step by step, where a Picasso
exhibition is being shown. We are like beads on a rosary. We
have the arthropodal tread of slaves, who, by sheer numbers
alone, will manage to drag the enormous stone of expectation
to the gate. The exhibition only confirms the greatness of my
father, who painted the two pastiches that hang above the
couch in our living room, signed Pissacco. When we are look-
ing for our car afterwards – none of us paid attention to the
street name when we parked it – Paris seizes me. Eventually,

Font size 9 / 11 pt

A B C D E F G H I J K
L M N O P Q R S T U V
W X Y Z a b c d e f g
h i j k l m n o p q r
s t u v w x y z 1 2 3
4 5 6 7 8 9 0 ? ! () []
& " " «» ; : / - – à ç é î

HxqkmHxqkmHxqkmHxqkmHxqkmHxqkmHxqkm

20, 16, 12, 10, 8, 6, 4 pt

Font size 9/11 pt

Just one thought further and I am sixteen, and the trees are in bloom underneath wildly billowing curtains of rain. I stand in a meandering line of people with my father and mother, getting closer to the Grand Palais step by step, where a Picasso exhibition is being shown. We are like beads on a rosary. We have the arthropodal tread of slaves, who, by sheer numbers alone, will manage to drag the enormous stone of expectation to the gate. The exhibition only confirms the greatness of my father, who painted the two pastiches that hang above the couch in our living room, signed Pissacco. When we are looking for our car afterwards – none of us paid attention to the street name when we parked it – Paris seizes me. Eventually, we find the car,

Linotype Memphis

Rudolf Wolf designed this typeface in 1929 for D. Stempel AG and was inspired by the geometric forms of Paul Renner's Futura and the Bauhaus.

Just one thought further and I am sixteen, and the trees are in bloom underneath wildly billowing curtains of rain. I stand in a meandering line of people with my father and mother, getting closer to the Grand Palais step by step, where a Picasso exhibition is being shown. We are like beads on a rosary. We have the arthropodal tread of slaves, who, by sheer numbers alone, will manage to drag the enormous stone of expectation to the gate. The exhibition only confirms the greatness of my father, who painted the two pastiches that hang above the couch in our living room, signed Pissacco. [*From the short story* Par(ad)is Revisité]

RQEN baegn *baegn*

ABCDEFGHIJKLMNOPQRSTUVWXYZ
abcdefghijklmnopqrstuvwxyz 0123456789

Bitstream Stymie

Morris Fuller Benton designed Stymie in 1931 for American Type Founders. It was based on Memphis but showed also some other choices as for example can be seen in the 'a', 'E' and 'F'.

Just one thought further and I am sixteen, and the trees are in bloom underneath wildly billowing curtains of rain. I stand in a meandering line of people with my father and mother, getting closer to the Grand Palais step by step, where a Picasso exhibition is being shown. We are like beads on a rosary. We have the arthropodal tread of slaves, who, by sheer numbers alone, will manage to drag the enormous stone of expectation to the gate. The exhibition only confirms the greatness of my father, who painted the two pastiches that hang above the couch in our living room, signed Pissacco. [*From the short story* Par(ad)is Revisité]

RQEN baegn *baegn*

ABCDEFGHIJKLMNOPQRSTUVWXYZ
abcdefghijklmnopqrstuvwxyz 0123456789

Linotype Serifa

Adrian Frutiger designed Serifa for Bauer in 1966. It is less geometric in form and is also slightly more efficient in width.

Just one thought further and I am sixteen, and the trees are in bloom underneath wildly billowing curtains of rain. I stand in a meandering line of people with my father and mother, getting closer to the Grand Palais step by step, where a Picasso exhibition is being shown. We are like beads on a rosary. We have the arthropodal tread of slaves, who, by sheer numbers alone, will manage to drag the enormous stone of expectation to the gate. The exhibition only confirms the greatness of my father, who painted the two pastiches that hang above the couch in our living room, signed Pissacco. [*From the short story* Par(ad)is Revisité]

RQEN baegn *baegn*

ABCDEFGHIJKLMNOPQRSTUVWXYZ
abcdefghijklmnopqrstuvwxyz 0123456789

Linotype Glypha
Glyphia from 1977 by Adrian Frutiger moves another step closer to a narrower and more useful body-text typeface. The x-height is slightly larger than in Serifa, which gives it a less efficient appearance. Using smaller font sizes helps overcome this effect. Glypha even remains legible when set in very small font sizes.

Just one thought further and I am sixteen, and the trees are in bloom underneath wildly billowing curtains of rain. I stand in a meandering line of people with my father and mother, getting closer to the Grand Palais step by step, where a Picasso exhibition is being shown. We are like beads on a rosary. We have the arthropodal tread of slaves, who, by sheer numbers alone, will manage to drag the enormous stone of expectation to the gate. The exhibition only confirms the greatness of my father, who painted the two pastiches that hang above the couch in our living room, signed Pissacco. [*From the short story* Par(ad)is Revisité]

RQEN baegn *baegn*

ABCDEFGHIJKLMNOPQRSTUVWXYZ
abcdefghijklmnopqrstuvwxyz 0123456789

Linotype PMN Caecilia
PMN Caecilia by Peter Matthias Noordzij in 1990 was a further refined version of the slab-serif whereby small capitals and old style figures have been added to make the typeface more suitable as a body-text typeface. Even though it remains a relatively heavy type, the ascenders and descenders have more standard proportions and ensure the balanced appearance of a body of text. It is also attractive as a heading and display type.

Just one thought further and I am sixteen, and the trees are in bloom underneath wildly billowing curtains of rain. I stand in a meandering line of people with my father and mother, getting closer to the Grand Palais step by step, where a Picasso exhibition is being shown. We are like beads on a rosary. We have the arthropodal tread of slaves, who, by sheer numbers alone, will manage to drag the enormous stone of expectation to the gate. The exhibition only confirms the greatness of my father, who painted the two pastiches that hang above the couch in our living room, signed Pissacco. [*From the short story* PAR(AD)IS REVISITÉ]

RQEN baegn *baegn*

ABCDEFGHIJKLMNOPQRSTUVWXYZ
abcdefghijklmnopqrstuvwxyz 0123456789

ITC Officina Serif
Officina Serif by Erik Spiekermann from 1990 is a more vertical typeface. It was designed with both a serif and a sans-serif version and was originally intended for corporate communication uses, as the name implies. When the typeface became popular for other uses, a number of new styles were designed to increase its versatility.

Just one thought further and I am sixteen, and the trees are in bloom underneath wildly billowing curtains of rain. I stand in a meandering line of people with my father and mother, getting closer to the Grand Palais step by step, where a Picasso exhibition is being shown. We are like beads on a rosary. We have the arthropodal tread of slaves, who, by sheer numbers alone, will manage to drag the enormous stone of expectation to the gate. The exhibition only confirms the greatness of my father, who painted the two pastiches that hang above the couch in our living room, signed Pissacco. [*From the short story* Par(ad)is Revisité]

RQEN baegn *baegn*

ABCDEFGHIJKLMNOPQRSTUVWXYZ
abcdefghijklmnopqrstuvwxyz 0123456789

Monotype Rockwell

Font size 5/6,5 pt

In Paris, new buildings thrive like ivy, she says, staring out the window as
the sun's rays glide past. They colour with the seasons and quickly obtain
the status of immortality. In front of the *Louvre*, for example, a glass pyramid
has arisen from the surface in memory of a president. The *Gare d'Orsay*'s
overcoat received a lining: a design train à grande vitesse stands in its final
depot. And because of all this, *Café Costes* has already become the oldest
watering place in Paris. All those 'immobile' creatures are, after a short
period of discomfort, welcomed into the city's bosom as in-laws. [*From the*

6/7,5 pt

In Paris, new buildings thrive like ivy, she says, staring out the
window as the sun's rays glide past. They colour with the
seasons and quickly obtain the status of immortality. In front of
the *Louvre*, for example, a glass pyramid has arisen from the
surface in memory of a president. The *Gare d'Orsay*'s overcoat
received a lining: a design train à grande vitesse stands in its
final depot. And because of all this, *Café Costes* has already
become the oldest watering place in Paris. All those 'immobile'
creatures are, after a short period of discomfort, welcomed into
the city's bosom as in-laws. [*From the short story* Par(ad)is

7/8,5 pt

In Paris, new buildings thrive like ivy, she says, sta-
ring out the window as the sun's rays glide past. They
colour with the seasons and quickly obtain the status
of immortality. In front of the *Louvre*, for example, a
glass pyramid has arisen from the surface in memory
of a president. The *Gare d'Orsay*'s overcoat received
a lining: a design train à grande vitesse stands in its
final depot. And because of all this, *Café Costes* has
already become the oldest watering place in Paris.

8/10 pt

In Paris, new buildings thrive like ivy, she says,
staring out the window as the sun's rays glide
past. They colour with the seasons and quickly
obtain the status of immortality. In front of the
Louvre, for example, a glass pyramid has arisen
from the surface in memory of a president. The
Gare d'Orsay's overcoat received a lining: a
design train à grande vitesse stands in its final
depot. And because of all this, *Café Costes* has
already become the oldest watering place in
Paris. All those 'immobile' creatures are, after

10/12 pt

In Paris, new buildings thrive like ivy,
she says, staring out the window as
the sun's rays glide past. They colour
with the seasons and quickly obtain
the status of immortality. In front of
the *Louvre*, for example, a glass pyra-
mid has arisen from the surface in
memory of a president. The *Gare
d'Orsay*'s overcoat received a lining:
a design train à grande vitesse stands
in its final depot. And because of all

Light, Light It., Regular & Reg. It. 24, 32, 40

Corps

Corps

Corps

Corps

Bold, Bold Italic & Extra Bold 24, 32, 40, 48

Corps

Corps

Corps

Corp

Condensed & Bold Condensed 24, 32, 40, 4

Corps

Corps

Corps

Corps

Monotype Times New Roman

Ti

Stanley Morison was one of the most influential figures of English typography. He designed only one new typeface, *Times New Roman*, commissioned by English newspaper *The Times*, but it may have been the most frequently used roman type of the century. It was drawn for Morison by Victor Lardent, a draftsman at *The Times*, who said Morison gave him a type specimen by 'Plantin' as model, but it is fairly clear it was actually the 1905 specimen of the Plantin-Moretus Museum. Both *Times New Roman* and Pierpont's earlier *Monotype Plantin* follow a 1569 roman by Robert Granjon (1512/13–1590) that came to the Plantin-Moretus printing office long after Plantin's death, and they even copy a wrong font 'a' used there from the eighteenth to the twentieth century. The final type differs significantly from Lardent's drawings, and it is clear that Morison, Lardent and *Monotype Plantin* all had an influence on the final form. Granjon's 1569 roman was the first with such a large x-height. *Times New Roman* was first used in *The Times* on Monday 3 October 1932. Morison gave further design commissions to Eric Gill (*Perpetua*) and Jan van Krimpen (*Van Dijck*). Above all, he made several revivals of popular classic typefaces.

Times New Roman's larger x-height and narrow, efficient setting make it a better newspaper type than *Plantin*. For other forms of printed text, the typographic designer and general computer user considered it a rather uninspiring option: never actually wrong, yet never a distinctive choice. Perhaps it is a victim of its own success. A 'rediscovery' is perhaps in the making, with an increase in the use of types for rougher paper ...

A B C D E F G H I J K
L M N O P Q R S T U V
W X Y Z a b c d e f g
h i j k l m n o p q r
s t u v w x y z 1 2 3
4 5 6 7 8 9 0 ? ! () []
& " " « » ; : / - — à ç é î

A B C D E F G H I J K
L M N O P Q R S T U V
W X Y Z I 2 3 4 5 6 7
8 9 0 ½ ff fi fl ffi ffl À ?

HxqkmHxqkmHxqkmHxqkmHxqkmHxqkmHxqkm 20, 16, 12, 10, 8, 6, 4 pt

Font size 9/11 pt

Just one thought further and I am sixteen, and the trees are in bloom underneath wildly billowing curtains of rain. I stand in a meandering line of people with my father and mother, getting closer to the Grand Palais step by step, where a Picasso exhibition is being shown. We are like beads on a rosary. We have the arthropodal tread of slaves, who, by sheer numbers alone, will manage to drag the enormous stone of expectation to the gate. The exhibition only confirms the greatness of my father, who painted the two pastiches that hang above the couch in our living room, signed Pissacco. When we are looking for our car afterwards – none of us paid attention to the street name when we parked it – Paris seizes me. Eventually, we find the car, which has changed into a 'bagnole'. [*From the short story* Par(ad)is Revisité]

A B C D E F G H I J K
L M N O P Q R S T U V
W X Y Z a b c d e f g
h i j k l m n o p q r
s t u v w x y z 1 2 3
4 5 6 7 8 9 0 ? ! () []
& "" «» ;: / - – à ç é î
1 2 3 4 5 6 7 8 9 0 ½
fi fl

HxqkmHxqkmHxqkmHxqkmHxqkmHxqkmHxqkm

20, 16, 12, 10, 8, 6, 4 pt

Font size 9/11 pt

Just one thought further and I am sixteen, and the trees are in bloom underneath wildly billowing curtains of rain. I stand in a meandering line of people with my father and mother, getting closer to the Grand Palais step by step, where a Picasso exhibition is being shown. We are like beads on a rosary. We have the arthropodal tread of slaves, who, by sheer numbers alone, will manage to drag the enormous stone of expectation to the gate. The exhibition only confirms the greatness of my father, who painted the two pastiches that hang above the couch in our living room, signed Pissacco. When we are looking for our car afterwards – none of us paid attention to the street name when we parked it – Paris seizes me. Eventually, we find the car, which has changed into a 'bagnole'. [From the short story PAR(AD)IS REVISITÉ]

A B C D E F G H I J K
L M N O P Q R S T U V
W X Y Z a b c d e f g
h i j k l m n o p q r
s t u v w x y z 1 2 3
4 5 6 7 8 9 0 ? ! () []
& ""‚' «‹›» ;: / - – à ç é î
1 2 3 4 5 6 7 8 9 0 ½
fi fl

HxqkmHxqkmHxqkmHxqkmHxqkmHxqkmHxqkm

20, 16, 12, 10, 8, 6, 4 pt

Just one thought further and I am sixteen, and the trees are in bloom underneath wildly billowing curtains of rain. I stand in a meandering line of people with my father and mother, getting closer to the Grand Palais step by step, where a Picasso exhibition is being shown. We are like beads on a rosary. We have the arthropodal tread of slaves, who, by sheer numbers alone, will manage to drag the enormous stone of expectation to the gate. The exhibition only confirms the greatness of my father, who painted the two pastiches that hang above the couch in our living room, signed Pissacco. When we are looking for our car afterwards – none of us paid attention to the street name when we parked it – Paris seizes me. Eventually, we find the car, which has changed into a 'bagnole'. [*From the short story* Par(ad)is Revisité]

Font size 9/11 pt

A B C D E F G H I J K
L M N O P Q R S T U V
W X Y Z a b c d e f g
h i j k l m n o p q r
s t u v w x y z 1 2 3
4 5 6 7 8 9 0 ? ! () []
& "" «» ;: / - – à ç é î
1 2 3 4 5 6 7 8 9 0 ½
fi fl

HxqkmHxqkmHxqkmHxqkmHxqkmHxqkmHxqkm

20, 16, 12, 10, 8, 6, 4 pt

Just one thought further and I am sixteen, and the trees are in bloom underneath wildly billowing curtains of rain. I stand in a meandering line of people with my father and mother, getting closer to the Grand Palais step by step, where a Picasso exhibition is being shown. We are like beads on a rosary. We have the arthropodal tread of slaves, who, by sheer numbers alone, will manage to drag the enormous stone of expectation to the gate. The exhibition only confirms the greatness of my father, who painted the two pastiches that hang above the couch in our living room, signed Pissacco. When we are looking for our car afterwards – none of us paid attention to the street name when we parked it – Paris seizes me. Eventually, we find the car, which has changed into a 'bagnole'. [From the short story **Par(ad)is Revisité**]

Font size 9/11 pt

Monotype Plantin

Plantin was designed by Frank Hinham Pierpont in 1913, based on a 1569 typeface by Robert Granjon from the 1905 type specimen of the Plantin-Moretus Museum. Ironically Plantin never used it himself. In 1932 it was the most significant model used for the design of Times New Roman. Plantin is a sturdy letter, somewhat wider than Times and more open. In many ways it has a more modern appearance than Times.

Just one thought further and I am sixteen, and the trees are in bloom underneath wildly billowing curtains of rain. I stand in a meandering line of people with my father and mother, getting closer to the Grand Palais step by step, where a Picasso exhibition is being shown. We are like beads on a rosary. We have the arthropodal tread of slaves, who, by sheer numbers alone, will manage to drag the enormous stone of expectation to the gate. The exhibition only confirms the greatness of my father, who painted the two pastiches that hang above the couch in our living room, signed Pissacco. [*From the short story* PAR(AD)IS REVISITÉ]

RQEN baegn *baegn*

ABCDEFGHIJKLMNOPQRSTUVWXYZ
abcdefghijklmnopqrstuvwxyz 0123456789

Linotype ITC Galliard

Galliard is based on a design by Robert Granjon dating back to the sixteenth century and was drawn in 1978 by Matthew Carter. Carter remained true to Granjon's original. The italic is particularly rich in form and includes a lowercase 'g' that can more or less be seen in Joanna and Perpetua by Gill. Plantin commissioned Granjon to cut the italic, which clearly shows influences from handwriting.

Just one thought further and I am sixteen, and the trees are in bloom underneath wildly billowing curtains of rain. I stand in a meandering line of people with my father and mother, getting closer to the Grand Palais step by step, where a Picasso exhibition is being shown. We are like beads on a rosary. We have the arthropodal tread of slaves, who, by sheer numbers alone, will manage to drag the enormous stone of expectation to the gate. The exhibition only confirms the greatness of my father, who painted the two pastiches that hang above the couch in our living room, signed Pissacco. [*From the short story* Par(ad)is Revisité]

RQEN baegn *baegn*

ABCDEFGHIJKLMNOPQRSTUVWXYZ
abcdefghijklmnopqrstuvwxyz 0123456789

Berthold Concorde

Concorde was designed in 1969 by Günter Gerhard Lange as a Berthold alternative to Times New Roman.

Just one thought further and I am sixteen, and the trees are in bloom underneath wildly billowing curtains of rain. I stand in a meandering line of people with my father and mother, getting closer to the Grand Palais step by step, where a Picasso exhibition is being shown. We are like beads on a rosary. We have the arthropodal tread of slaves, who, by sheer numbers alone, will manage to drag the enormous stone of expectation to the gate. The exhibition only confirms the greatness of my father, who painted the two pastiches that hang above the couch in our living room, signed Pissacco. [*From the short story* Par(ad)is Revisité]

RQEN baegn *baegn*

ABCDEFGHIJKLMNOPQRSTUVWXYZ
abcdefghijklmnopqrstuvwxyz 0123456789

EF Swift
This typeface from 1985 is one of Gerard Unger's most famous designs. Although the serifs have sharper corners, this is not visible in the punctuation marks, making Swift an excellent replacement for Times in newspapers. The large x-height means that Swift can be set in smaller sizes, resulting in a legible text requiring less space. Gerard Unger has since made an improved version called Swift 2.0.

Just one thought further and I am sixteen, and the trees are in bloom underneath wildly billowing curtains of rain. I stand in a meandering line of people with my father and mother, getting closer to the Grand Palais step by step, where a Picasso exhibition is being shown. We are like beads on a rosary. We have the arthropodal tread of slaves, who, by sheer numbers alone, will manage to drag the enormous stone of expectation to the gate. The exhibition only confirms the greatness of my father, who painted the two pastiches that hang above the couch in our living room, signed Pissacco. [*From the short story* Par(ad)is Revisité]

RQEN baegn *baegn*

ABCDEFGHIJKLMNOPQRSTUVWXYZ
abcdefghijklmnopqrstuvwxyz 0123456789

Linotype Life
Francesco Simoncini and W. Bilz drew this typeface dating from 1965, which has many similarities with Times New Roman but also significant differences. The curious tail of the capital 'Q' is one such difference.

Just one thought further and I am sixteen, and the trees are in bloom underneath wildly billowing curtains of rain. I stand in a meandering line of people with my father and mother, getting closer to the Grand Palais step by step, where a Picasso exhibition is being shown. We are like beads on a rosary. We have the arthropodal tread of slaves, who, by sheer numbers alone, will manage to drag the enormous stone of expectation to the gate. The exhibition only confirms the greatness of my father, who painted the two pastiches that hang above the couch in our living room, signed Pissacco. [*From the short story* Par(ad)is Revisité]

RQEN baegn *baegn*

ABCDEFGHIJKLMNOPQRSTUVWXYZ
abcdefghijklmnopqrstuvwxyz 0123456789

Le Monde Journal Ptf
Jean François Porchez designed this newspaper typeface in 1994 for the French A-class paper *Le Monde*. It was meant as an alternative for Times and has a similar grey tone but is more open. The forms are also somewhat sharper. As a result of its success, a whole family was created. Other variations in this family are Le Monde Livre, Le Monde Courrier and Le Monde Sans.

Just one thought further and I am sixteen, and the trees are in bloom underneath wildly billowing curtains of rain. I stand in a meandering line of people with my father and mother, getting closer to the Grand Palais step by step, where a Picasso exhibition is being shown. We are like beads on a rosary. We have the arthropodal tread of slaves, who, by sheer numbers alone, will manage to drag the enormous stone of expectation to the gate. The exhibition only confirms the greatness of my father, who painted the two pastiches that hang above the couch in our living room, signed Pissacco. [*From the short story* Par(ad)is Revisité]

RQEN baegn *baegn*

ABCDEFGHIJKLMNOPQRSTUVWXYZ
abcdefghijklmnopqrstuvwxyz 0123456789

Monotype Times New Roman

Font size 5/6,5 pt

In Paris, new buildings thrive like ivy, she says, staring out the window as the sun's rays glide past. They colour with the seasons and quickly obtain the status of immortality. In front of the *Louvre*, for example, a glass pyramid has arisen from the surface in memory of a president. The *Gare d'Orsay*'s overcoat received a lining: a design train à grande vitesse stands in its final depot. And because of all this, *Café Costes* has already become the oldest watering place in Paris. All those 'immobile' creatures are, after a short period of discomfort, welcomed into the city's bosom as in-laws. [*From the short story* PARIS REVISITÉ]

6/7,5 pt

In Paris, new buildings thrive like ivy, she says, staring out the window as the sun's rays glide past. They colour with the seasons and quickly obtain the status of immortality. In front of the *Louvre*, for example, a glass pyramid has arisen from the surface in memory of a president. The *Gare d'Orsay*'s overcoat received a lining: a design train à grande vitesse stands in its final depot. And because of all this, *Café Costes* has already become the oldest watering place in Paris. All those 'immobile' creatures are, after a short period of discomfort, welcomed into the city's bosom as in-laws. [*From the short story* PARIS REVISITÉ]

7/8,5 pt

In Paris, new buildings thrive like ivy, she says, staring out the window as the sun's rays glide past. They colour with the seasons and quickly obtain the status of immortality. In front of the *Louvre*, for example, a glass pyramid has arisen from the surface in memory of a president. The *Gare d'Orsay*'s overcoat received a lining: a design train à grande vitesse stands in its final depot. And because of all this, *Café Costes* has already become the oldest watering place in Paris. All those 'immobile' creatures are, after a

8/10 pt

In Paris, new buildings thrive like ivy, she says, staring out the window as the sun's rays glide past. They colour with the seasons and quickly obtain the status of immortality. In front of the *Louvre*, for example, a glass pyramid has arisen from the surface in memory of a president. The *Gare d'Orsay*'s overcoat received a lining: a design train à grande vitesse stands in its final depot. And because of all this, *Café Costes* has already become the oldest watering place in Paris. All those 'immobile' creatures are, after a short period of discomfort, wel-

10/12 pt

In Paris, new buildings thrive like ivy, she says, staring out the window as the sun's rays glide past. They colour with the seasons and quickly obtain the status of immortality. In front of the *Louvre*, for example, a glass pyramid has arisen from the surface in memory of a president. The *Gare d'Orsay*'s overcoat received a lining: a design train à grande vitesse stands in its final depot. And because of all this, *Café Costes* has al-

Regular & Italic 24, 32, 40, 48 pt

Corps

Corps

Corps

Corps

Bold 24, 32, 40, 48 pt

Corps

Corps

Corps

Corps

Bold Italic 24, 32, 40, 48 pt

Corps

Corps

Corps

Corps

Sans-serif

Berthold Akzidenz Grotesk

ITC Franklin Gothic

Linotype Frutiger Next

Linotype Futura

Monotype Gill Sans

Linotype Neue Helvetica

FontFont Meta Plus

Linotype Optima

Linotype Syntax

The creation of the sans-serif type Other sections of this book discuss sans-serif typefaces, but here we give a brief historical overview leading to their current form and use.

Sans-serif capitals can be found in Latin, Etruscan and Greek inscriptions dating back to 500 BC. British architects borrowed them around 1780 and under the influence of archaeological discoveries from Napoleon's 1799 Egyptian campaign they became fashionable for London shop signs in 1805 under the name 'Egyptian'. William Caslon IV introduced the first sans-serif typeface ca. 1812/14 in a single size: *Two-Line English* (that is, 28 point) *Egyptian*, a monoline sans-serif clearly reflecting the proportions and structure of ancient inscriptional letters. At first failed to catch on, but a seriffed variant, sometimes also called *Egyptian* (the twentieth century term 'slab-serif' is less ambiguous) spread quickly through the English foundries from ca. 1818 and the continental ones from 1826. With the second sans-serif (now under that name), introduced by the Figgins foundry in 1828, the inscriptional proportions gave way to those of contemporary roman capitals (sometimes with some contrast between thick and thin). In this form sans-serifs spread through English and from 1836 continental foundries, acqui-ring a lowercase in 1834. The German Berthold foundry began to introduce its *Akzidenz Grotesk* family of sans-serifs in various weights and widths in 1898, creating the first sans-serif type family that could compete with serif typefaces. Other foundries quickly followed, including ATF, where Morris Fuller Benton created his first sans-serif family, *Franklin Gothic*, in 1903.

The calligrapher Edward Johnston designed his sans-serif in 1916 especially for the signposting of the London Underground. It has a geometric basis, but its proportions followed Florentine inscriptional capitals and as such it became the textbook example of a humanistic sans-serif. Eric Gill, student and friend of Johnston, designed *Gill Sans* in 1928, using Johnston's as starting point. Influenced by the Bauhaus movement, Paul Renner's *Futura* appeared on the market in 1927. In Holland, *Nobel* by Sjoerd Hendrik de Roos and Dick Dooijes appeared in reaction to *Futura*. The period of so-called Swiss typography began in 1957 with the introduction of *Helvetica* by Max Miedinger and *Univers* by Adrian Frutiger.

The next step was *Syntax* by Hans Eduard Meier, which appeared on the market in 1968 as humanistic sans-serif just before the end of the cast metal typesetting era. When Adrian Frutiger developed new signposting for Paris-Roissy airport, he concluded that neither *Helvetica* nor *Univers* was legible enough from a distance. His alternative, introduced in 1975, met success in other applications as the typeface *Frutiger*. When the digital era erupted around 1985, numerous new sans serifs were introduced, including *Meta* by Erik Spiekermann in 1989 as one of the first digital humanistic sans-serif typefaces. At the beginning of the twenty-first century there are now thousands of sans-serifs available, some with numerous styles and with additions such as small capitals, ligatures, pictograms and various kinds of figures and numerals.

Berthold Akzidenz Grotesk

Light
Light Italic
Roman
Italic
Medium
Medium Italic
Bold
Bold Italic
Super

Akzidenz Grotesk was born around 1898 and the extended family was designed from the various grotesques which were available at the time. A significant example was *Royal Grotesk Mager*, put on the market by Ferdinand Theinhardt in 1880 with his own foundry in Berlin. The typeface was developed in the tradition of a number of sans-serif types which appeared at the beginning of the nineteenth century. It was issued by the Berlin typefoundry Berthold (founded in 1858). The typeface was an instant success in Europe but especially attracted a great many followers in America. This led to it becoming the father of an entire series of sans-serifs.

Akzidenz Grotesk has, compared to the impassive balanced character of its successors *Helvetica* and *Univers*, a unique and somewhat 'scaffolding-like' feel.

A B C D E F G H I J K
L M N O P Q R S T U V
W X Y Z a b c d e f g
h i j k l m n o p q r
s t u v w x y z 1 2 3
4 5 6 7 8 9 0 ? ! () []
& "" «» ;: / - – à ç é î
1 2 3 4 5 6 7 8 9 0

HxqkmHxqkmHxqkmHxqkmHxqkmHxqkmHxqkm

20, 16, 12, 10, 8, 6, 4 pt

Font size 9/11 pt

Just one thought further and I am sixteen, and the trees are in bloom underneath wildly billowing curtains of rain. I stand in a meandering line of people with my father and mother, getting closer to the Grand Palais step by step, where a Picasso exhibition is being shown. We are like beads on a rosary. We have the arthropodal tread of slaves, who, by sheer numbers alone, will manage to drag the enormous stone of expectation to the gate. The exhibition only confirms the greatness of my father, who painted the two pastiches that hang above the couch in our living room, signed Pissacco. When we are looking for our car afterwards – none of us paid attention to the street name when we parked it – Paris seizes me. Eventually, we find the car, which has changed into a 'bagnole'. [*From the short story* Par(ad)is Revisité]

A B C D E F G H I J K

L M N O P Q R S T U V

W X Y Z a b c d e f g

h i j k l m n o p q r

s t u v w x y z 1 2 3

4 5 6 7 8 9 0 ? ! () []

& "" «» ;: / - – à ç é î

1 2 3 4 5 6 7 8 9 0

6
7
8
9
10
11
12
14
16
18
20
22
24
28
32
36
42
48
60
72

HxqkmHxqkmHxqkmHxqkmHxqkmHxqkmHxqkm

20, 16, 12, 10, 8, 6, 4 pt

Font size 9/11 pt

Just one thought further and I am sixteen, and the trees are in bloom underneath wildly billowing curtains of rain. I stand in a meandering line of people with my father and mother, getting closer to the Grand Palais step by step, where a Picasso exhibition is being shown. We are like beads on a rosary. We have the arthropodal tread of slaves, who, by sheer numbers alone, will manage to drag the enormous stone of expectation to the gate. The exhibition only confirms the greatness of my father, who painted the two pastiches that hang above the couch in our living room, signed Pissacco. When we are looking for our car afterwards – none of us paid attention to the street name when we parked it – Paris seizes me. Eventually, we find the car, which has changed into a 'bagnole'. [From the short story Par(ad)is Revisité]

A B C D E F G H I J K
L M N O P Q R S T U V
W X Y Z a b c d e f g
h i j k l m n o p q r
s t u v w x y z 1 2 3
4 5 6 7 8 9 0 ? ! () []
& " " « » ; : / – – à ç é î

HxqkmHxqkmHxqkmHxqkmHxqkmHxqkmHxqkm

20, 16, 12, 10, 8, 6, 4 pt

Just one thought further and I am sixteen, and the trees are in bloom
underneath wildly billowing curtains of rain. I stand in a meandering
line of people with my father and mother, getting closer to the Grand
Palais step by step, where a Picasso exhibition is being shown. We
are like beads on a rosary. We have the arthropodal tread of slaves,
who, by sheer numbers alone, will manage to drag the enormous stone
of expectation to the gate. The exhibition only confirms the greatness
of my father, who painted the two pastiches that hang above the
couch in our living room, signed Pissacco. When we are looking for
our car afterwards – none of us paid attention to the street name when
we parked it – Paris seizes me. Eventually, we find the car, which has
changed into a 'bagnole'. [*From the short story* Par(ad)is Revisité]

Font size 9 / 11 pt

Berthold Akzidenz Grotesk *Italic*

Font size 28 / 13 mm

A B C D E F G H I J K
L M N O P Q R S T U V
W X Y Z a b c d e f g
h i j k l m n o p q r
s t u v w x y z 1 2 3
4 5 6 7 8 9 0 ? ! () []
& " " « » ; : / - – à ç é î

HxqkmHxqkmHxqkmHxqkmHxqkmHxqkmHxqkm

20, 16, 12, 10, 8, 6, 4 pt

Font size 9 / 11 pt

Just one thought further and I am sixteen, and the trees are in bloom underneath wildly billowing curtains of rain. I stand in a meandering line of people with my father and mother, getting closer to the Grand Palais step by step, where a Picasso exhibition is being shown. We are like beads on a rosary. We have the arthropodal tread of slaves, who, by sheer numbers alone, will manage to drag the enormous stone of expectation to the gate. The exhibition only confirms the greatness of my father, who painted the two pastiches that hang above the couch in our living room, signed Pissacco. When we are looking for our car afterwards – none of us paid attention to the street name when we parked it – Paris seizes me. Eventually, we find the car, which has changed into a 'bagnole'. [From the short story Par(ad)is

A B C D E F G H I J K
L M N O P Q R S T U V
W X Y Z a b c d e f g
h i j k l m n o p q r
s t u v w x y z 1 2 3
4 5 6 7 8 9 0 ? ! () []
& " " « › » ; : / - – à ç é î

HxqkmHxqkmHxqkmHxqkmHxqkmHxqkmHxqkm

20, 16, 12, 10, 8, 6, 4 pt

Just one thought further and I am sixteen, and the trees are in bloom underneath wildly billowing curtains of rain. I stand in a meandering line of people with my father and mother, getting closer to the Grand Palais step by step, where a Picasso exhibition is being shown. We are like beads on a rosary. We have the arthropodal tread of slaves, who, by sheer numbers alone, will manage to drag the enormous stone of expectation to the gate. The exhibition only confirms the greatness of my father, who painted the two pastiches that hang above the couch in our living room, signed Pissacco. When we are looking for our car afterwards – none of us paid attention to the street name when we parked it – Paris seizes me. Eventually, we find the car, which

Font size 9 / 11 pt

A B C D E F G H I J K
L M N O P Q R S T U V
W X Y Z a b c d e f g
h i j k l m n o p q r
s t u v w x y z 1 2 3
4 5 6 7 8 9 0 ? ! () []
& "" ‹›› ;: / - – à ç é î

HxqkmHxqkmHxqkmHxqkmHxqkmHxqkmHxqkm

20, 16, 12, 10, 8, 6, 4 pt

Font size 9/11 pt

Just one thought further and I am sixteen, and the trees are in bloom underneath wildly billowing curtains of rain. I stand in a meandering line of people with my father and mother, getting closer to the Grand Palais step by step, where a Picasso exhibition is being shown. We are like beads on a rosary. We have the arthropodal tread of slaves, who, by sheer numbers alone, will manage to drag the enormous stone of expectation to the gate. The exhibition only confirms the greatness of my father, who painted the two pastiches that hang above the couch in our living room, signed Pissacco. When we are looking for our car afterwards – none of us paid attention to the street name when we parked it – Paris seizes me. Eventually, we find the car, which has changed into a 'bag-

A B C D E F G H I J K
L M N O P Q R S T U V
W X Y Z a b c d e f g
h i j k l m n o p q r
s t u v w x y z 1 2 3
4 5 6 7 8 9 0 ? ! () []
& "" «» ;: / - – à ç é î

HxqkmHxqkmHxqkmHxqkmHxqkmHxqkmHxqkm

20, 16, 12, 10, 8, 6, 4 pt

Just one thought further and I am sixteen, and the trees are in
bloom underneath wildly billowing curtains of rain. I stand in a
meandering line of people with my father and mother, getting
closer to the Grand Palais step by step, where a Picasso exhi-
bition is being shown. We are like beads on a rosary. We have
the arthropodal tread of slaves, who, by sheer numbers alone,
will manage to drag the enormous stone of expectation to the
gate. The exhibition only confirms the greatness of my father,
who painted the two pastiches that hang above the couch in
our living room, signed Pissacco. When we are looking for our
car afterwards – none of us paid attention to the street name
when we parked it – Paris seizes me. Eventually, we find the

Font size 9 / 11 pt

A B C D E F G H I J K
L M N O P Q R S T U V
W X Y Z a b c d e f g
h i j k l m n o p q r
s t u v w x y z 1 2 3
4 5 6 7 8 9 0 ? ! () []
& "" «» ;: / - – à ç é î

HxqkmHxqkmHxqkmHxqkmHxqkmHxqkmHxqkm

20, 16, 12, 10, 8, 6, 4 pt

Font size 9 / 11 pt

Just one thought further and I am sixteen, and the trees are in bloom underneath wildly billowing curtains of rain. I stand in a meandering line of people with my father and mother, getting closer to the Grand Palais step by step, where a Picasso exhibition is being shown. We are like beads on a rosary. We have the arthropodal tread of slaves, who, by sheer numbers alone, will manage to drag the enormous stone of expectation to the gate. The exhibition only confirms the greatness of my father, who painted the two pastiches that hang above the couch in our living room, signed Pissacco. When we are looking for our car afterwards – none of us paid attention to the street name when we parked it – Paris seizes me. Eventually, we find the

Linotype Basic Commercial
With Basic Commercial from 1900, Linotype attempted to profit from the success and popularity of Akzidenz Grotesk.
Font size: 9/11 pt.

Just one thought further and I am sixteen, and the trees are in bloom underneath wildly billowing curtains of rain. I stand in a meandering line of people with my father and mother, getting closer to the Grand Palais step by step, where a Picasso exhibition is being shown. We are like beads on a rosary. We have the arthropodal tread of slaves, who, by sheer numbers alone, will manage to drag the enormous stone of expectation to the gate. The exhibition only confirms the greatness of my father, who painted the two pastiches that hang above the couch in our living room, signed Pissacco. [*From the short story* Par(ad)is Revisité]

RQEN baegn *baegn*

ABCDEFGHIJKLMNOPQRSTUVWXYZ
abcdefghijklmnopqrstuvwxyz 0123456789

Linotype Venus Halbfett
This grotesque was added to the type collection by the Bauersche Schriftgießerei in 1907 to fill the ever increasing demand for sans-serifs. The italic has a more pronounced slant than with Monotype Grotesque. Some capitals, such as the 'R' and the 'E', have a very high upper section. The face is relatively small, which can clearly be seen here in the alphabet that is much smaller than Monotype Grotesque.
Font size: 10.2/11 pt.

Just one thought further and I am sixteen, and the trees are in bloom underneath wildly billowing curtains of rain. I stand in a meandering line of people with my father and mother, getting closer to the Grand Palais step by step, where a Picasso exhibition is being shown. We are like beads on a rosary. We have the arthropodal tread of slaves, who, by sheer numbers alone, will manage to drag the enormous stone of expectation to the gate. The exhibition only confirms the greatness of my father, who painted the two pastiches that hang above the couch in our living room, signed Pissacco. [*From the short story* Par(ad)is Revisité]

RQEN baegn *baegn*

ABCDEFGHIJKLMNOPQRSTUVWXYZ
abcdefghijklmnopqrstuvwxyz 0123456789

Monotype Grotesque
Frank Hinman Pierpont based this typeface in 1926 on Ideal by Berthold, which in turn was based on the grotesque by William Thorowgood from 1832, the first sans-serif to include lowercase characters. This Monotype version has never been as popular as Akzidenz Grotesk. The italic is a sloped roman, as is customary with these typefaces.
Font size: 8.5/11 pt.

Just one thought further and I am sixteen, and the trees are in bloom underneath wildly billowing curtains of rain. I stand in a meandering line of people with my father and mother, getting closer to the Grand Palais step by step, where a Picasso exhibition is being shown. We are like beads on a rosary. We have the arthropodal tread of slaves, who, by sheer numbers alone, will manage to drag the enormous stone of expectation to the gate. The exhibition only confirms the greatness of my father, who painted the two pastiches that hang above the couch in our living room, signed Pissacco. [*From the short story* Par(ad)is Revisité]

RQEN baegn *baegn*

ABCDEFGHIJKLMNOPQRSTUVWXYZ
abcdefghijklmnopqrstuvwxyz 0123456789

Bitstream Gothic 720
Like Monotype Grotesque, this version was based on Berthold's Ideal. The body of text has exactly the same length as Monotype Grotesque at the same font size. However, it contains several differences as can be seen in the alphabet text, which is equal in width but where the capitals have a relatively different width than the lowercase of the Monotype version.
Font size: 8.5/11 pt.

Just one thought further and I am sixteen, and the trees are in bloom underneath wildly billowing curtains of rain. I stand in a meandering line of people with my father and mother, getting closer to the Grand Palais step by step, where a Picasso exhibition is being shown. We are like beads on a rosary. We have the arthropodal tread of slaves, who, by sheer numbers alone, will manage to drag the enormous stone of expectation to the gate. The exhibition only confirms the greatness of my father, who painted the two pastiches that hang above the couch in our living room, signed Pissacco. [*From the short story* Par(ad)is Revisité]

RQEN baegn *baegn*

ABCDEFGHIJKLMNOPQRSTUVWXYZ
abcdefghijklmnopqrstuvwxyz 0123456789

Bitstream Folio
Folio was introduced in 1956, at the end of the era of grotesques, and was designed by Konrad F. Bauer and Walter Baum for the Bauersche Gießerei. Folio was Max Miedinger's inspiration for designing the Neue Haas Grotesk in 1957, which was subsequently given the name Helvetica in 1960. The Bitstream version is one of the most extensive. The book version has no italic, but the light version does (shown right).
Font size: 8.6/11 pt.

Just one thought further and I am sixteen, and the trees are in bloom underneath wildly billowing curtains of rain. I stand in a meandering line of people with my father and mother, getting closer to the Grand Palais step by step, where a Picasso exhibition is being shown. We are like beads on a rosary. We have the arthropodal tread of slaves, who, by sheer numbers alone, will manage to drag the enormous stone of expectation to the gate. The exhibition only confirms the greatness of my father, who painted the two pastiches that hang above the couch in our living room, signed Pissacco. [From the short story Par(ad)is Revisité]

RQEN baegn *baegn*

ABCDEFGHIJKLMNOPQRSTUVWXYZ
abcdefghijklmnopqrstuvwxyz 0123456789

FF Bau
Based on a grotesque dating from 1880 by the Schelter & Giesecke typefoundry in Leipzig, Christian Schwartz designed a sizeable family in 2002 that offers endless possibilities with an attractive italic and styles ranging from regular to super.
Font size: 8.7/11 pt.

Just one thought further and I am sixteen, and the trees are in bloom underneath wildly billowing curtains of rain. I stand in a meandering line of people with my father and mother, getting closer to the Grand Palais step by step, where a Picasso exhibition is being shown. We are like beads on a rosary. We have the arthropodal tread of slaves, who, by sheer numbers alone, will manage to drag the enormous stone of expectation to the gate. The exhibition only confirms the greatness of my father, who painted the two pastiches that hang above the couch in our living room, signed Pissacco. [*From the short story* Par(ad)is Revisité]

RQEN baegn *baegn*

ABCDEFGHIJKLMNOPQRSTUVWXYZ
abcdefghijklmnopqrstuvwxyz 0123456789

Berthold Akzidenz Grotesk

Font size 5 / 6,5 pt

In Paris, new buildings thrive like ivy, she says, staring out the window as the sun's rays glide past. They colour with the seasons and quickly obtain the status of immortality. In front of the *Louvre*, for example, a glass pyramid has arisen from the surface in memory of a president. The *Gare d'Orsay*'s overcoat received a lining: a design train à grande vitesse stands in its final depot. And because of all this, *Café Costes* has already become the oldest watering place in Paris. All those 'immobile' creatures are, after a short period of discomfort, welcomed into the city's bosom as in-laws. [*From the short story* Par(ad)is Revisité]

6 / 7,5 pt

In Paris, new buildings thrive like ivy, she says, staring out the window as the sun's rays glide past. They colour with the seasons and quickly obtain the status of immortality. In front of the *Louvre*, for example, a glass pyramid has arisen from the surface in memory of a president. The *Gare d'Orsay*'s overcoat received a lining: a design train à grande vitesse stands in its final depot. And because of all this, *Café Costes* has already become the oldest watering place in Paris. All those 'immobile' creatures are, after a short period of discomfort, welcomed into the city's bosom as in-laws. [*From the short story* Par(ad)is Revisité]

7 / 8,5 pt

In Paris, new buildings thrive like ivy, she says, staring out the window as the sun's rays glide past. They colour with the seasons and quickly obtain the status of immortality. In front of the *Louvre*, for example, a glass pyramid has arisen from the surface in memory of a president. The *Gare d'Orsay*'s overcoat received a lining: a design train à grande vitesse stands in its final depot. And because of all this, *Café Costes* has already become the oldest watering place in Paris. All those 'immobile' creatures are, after a

8 / 10 pt

In Paris, new buildings thrive like ivy, she says, staring out the window as the sun's rays glide past. They colour with the seasons and quickly obtain the status of immortality. In front of the *Louvre*, for example, a glass pyramid has arisen from the surface in memory of a president. The *Gare d'Orsay*'s overcoat received a lining: a design train à grande vitesse stands in its final depot. And because of all this, *Café Costes* has already become the oldest watering place in Paris. All those 'immobile' creatures are, after a short period of discomfort, wel-

10 / 12 pt

In Paris, new buildings thrive like ivy, she says, staring out the window as the sun's rays glide past. They colour with the seasons and quickly obtain the status of immortality. In front of the *Louvre*, for example, a glass pyramid has arisen from the surface in memory of a president. The *Gare d'Orsay*'s overcoat received a lining: a design train à grande vitesse stands in its final depot. And because of all this, *Café Costes* has already become

Light, Roman & Italic 24, 32, 40, 48 pt

Corps
Corps
Corps
Corps

Medium & Medium Italic 24, 32, 40, 48 pt

Corps
Corps
Corps
Corps

Bold, Bold Italic & Super 24, 32, 40, 48 pt

Corps
Corps
Corps
Corps

– 358

ITC Franklin Gothic

FG

Book
Book Oblique
Medium
Medium Italic
Demi
Demi Oblique

Morris Fuller Benton (1872–1948) is one of the most prolific type designers of all time. His father, Linn Boyd Benton (1844–1932), had earned fame as the inventor of the Benton Pantograph and many other technical innovations for Linotype and American Type Founders. The success of the sans-serif typefaces from the late nineteenth century, especially *Akzidenz Grotesk* (1898), was the go-ahead for Morris Benton to design *Franklin Gothic* in 1903 which he enlarged, like many of his typefaces, for commercial reasons, into an extended family, six styles of which are shown here.

Franklin Gothic is lighter, narrower and more efficient than *Akzidenz Grotesk* and has a larger x-height.

A B C D E F G H I J K
L M N O P Q R S T U V
W X Y Z a b c d e f g
h i j k l m n o p q r
s t u v w x y z 1 2 3
4 5 6 7 8 9 0 ? ! () []
& " " « » ;: / - – à ç é î

HxqkmHxqkmHxqkmHxqkmHxqkmHxqkmHxqkm

20, 16, 12, 10, 8, 6, 4 pt

Font size 9 / 11 pt

Just one thought further and I am sixteen, and the trees are in bloom underneath wildly billowing curtains of rain. I stand in a meandering line of people with my father and mother, getting closer to the Grand Palais step by step, where a Picasso exhibition is being shown. We are like beads on a rosary. We have the arthropodal tread of slaves, who, by sheer numbers alone, will manage to drag the enormous stone of expectation to the gate. The exhibition only confirms the greatness of my father, who painted the two pastiches that hang above the couch in our living room, signed Pissacco. When we are looking for our car afterwards – none of us paid attention to the street name when we parked it – Paris seizes me. Eventually, we find the car, which has changed into a 'bagnole'.

A B C D E F G H I J K
L M N O P Q R S T U V
W X Y Z a b c d e f g
h i j k l m n o p q r
s t u v w x y z 1 2 3
4 5 6 7 8 9 0 ? ! () []
& "" «» ;: / - – à ç é î

HxqkmHxqkmHxqkmHxqkmHxqkmHxqkmHxqkm

20, 16, 12, 10, 8, 6, 4 pt

Just one thought further and I am sixteen, and the trees are in bloom underneath wildly billowing curtains of rain. I stand in a meandering line of people with my father and mother, getting closer to the Grand Palais step by step, where a Picasso exhibition is being shown. We are like beads on a rosary. We have the arthropodal tread of slaves, who, by sheer numbers alone, will manage to drag the enormous stone of expectation to the gate. The exhibition only confirms the greatness of my father, who painted the two pastiches that hang above the couch in our living room, signed Pissacco. When we are looking for our car afterwards – none of us paid attention to the street name when we parked it – Paris seizes me. Eventually, we find the car, which has changed into a 'bagnole'. [From

Font size 9 / 11 pt

A B C D E F G H I J K
L M N O P Q R S T U V
W X Y Z a b c d e f g
h i j k l m n o p q r
s t u v w x y z 1 2 3
4 5 6 7 8 9 0 ? ! () []
& " " « » ;: / - – à ç é î

HxqkmHxqkmHxqkmHxqkmHxqkmHxqkmHxqkm

20, 16, 12, 10, 8, 6, 4

Just one thought further and I am sixteen, and the trees are in bloom underneath wildly billowing curtains of rain. I stand in a meandering line of people with my father and mother, getting closer to the Grand Palais step by step, where a Picasso exhibition is being shown. We are like beads on a rosary. We have the arthropodal tread of slaves, who, by sheer numbers alone, will manage to drag the enormous stone of expectation to the gate. The exhibition only confirms the greatness of my father, who painted the two pastiches that hang above the couch in our living room, signed Pissacco. When we are looking for our car afterwards – none of us paid attention to the street name when we parked it – Paris seizes me. Eventually, we find the car, which has changed into a 'bagnole'. [*From the short story*

Font size 9 / 11 pt

ITC Franklin Gothic *Medium Italic*

Font size 28 / 13 mm

A B C D E F G H I J K

L M N O P Q R S T U V

W X Y Z a b c d e f g

h i j k l m n o p q r

s t u v w x y z 1 2 3

4 5 6 7 8 9 0 ? ! () []

& " " « » ; : / − – à ç é î

Hxqkm HxqkmHxqkmHxqkmHxqkmHxqkmHxqkm

20, 16, 12, 10, 8, 6, 4 pt

Font size 9 / 11 pt

Just one thought further and I am sixteen, and the trees are in bloom underneath wildly billowing curtains of rain. I stand in a meandering line of people with my father and mother, getting closer to the Grand Palais step by step, where a Picasso exhibition is being shown. We are like beads on a rosary. We have the arthropodal tread of slaves, who, by sheer numbers alone, will manage to drag the enormous stone of expectation to the gate. The exhibition only confirms the greatness of my father, who painted the two pastiches that hang above the couch in our living room, signed Pissacco. When we are looking for our car afterwards – none of us paid attention to the street name when we parked it – Paris seizes me. Eventually, we find the car, which has changed into a 'bagnole'. [From the short story

A B C D E F G H I J K
L M N O P Q R S T U V
W X Y Z a b c d e f g
h i j k l m n o p q r
s t u v w x y z 1 2 3
4 5 6 7 8 9 0 ? ! () []
& " " « » ; : / - – à ç é î

HxqkmHxqkmHxqkmHxqkmHxqkmHxqkmHxqkm

20, 16, 12, 10, 8, 6, 4 p

Just one thought further and I am sixteen, and the trees are in bloom underneath wildly billowing curtains of rain. I stand in a meandering line of people with my father and mother, getting closer to the Grand Palais step by step, where a Picasso exhibition is being shown. We are like beads on a rosary. We have the arthropodal tread of slaves, who, by sheer numbers alone, will manage to drag the enormous stone of expectation to the gate. The exhibition only confirms the greatness of my father, who painted the two pastiches that hang above the couch in our living room, signed Pissacco. When we are looking for our car afterwards – none of us paid attention to the street name when we parked it – Paris seizes me. Eventually, we find the car, which has changed into a 'bagno-

Font size 9 / 11 pt

ITC Franklin Gothic *Demi Oblique*

Font size 28 / 13 mm

A B C D E F G H I J K
L M N O P Q R S T U V
W X Y Z a b c d e f g
h i j k l m n o p q r
s t u v w x y z 1 2 3
4 5 6 7 8 9 0 ? ! () []
& " " « » ; : / - – à ç é î

HxqkmHxqkmHxqkmHxqkmHxqkmHxqkmHxqkm

20, 16, 12, 10, 8, 6, 4 pt

Just one thought further and I am sixteen, and the trees are in bloom underneath wildly billowing curtains of rain. I stand in a meandering line of people with my father and mother, getting closer to the Grand Palais step by step, where a Picasso exhibition is being shown. We are like beads on a rosary. We have the arthropodal tread of slaves, who, by sheer numbers alone, will manage to drag the enormous stone of expectation to the gate. The exhibition only confirms the greatness of my father, who painted the two pastiches that hang above the couch in our living room, signed Pissacco. When we are looking for our car afterwards – none of us paid attention to the street name when we parked it – Paris seizes me. Eventually, we find the car, which

Font size 9 / 11 pt

ITC Franklin Gothic *alternatives*

Linotype News Gothic
Morris Fuller Benton designed
this narrower gothic in 1908
for American Type Founders.
It has characteristics of a
humanistic sans-serif with its
subtle thick-thin contrast
and the lowercase 's' and
two-storey 'g'. The large
x-height, and short ascend-
ers and descenders are
typical for American gothics
and are inherent components
of newspapers and maga-
zines. The term 'gothic' is
used in America and Canada
to refer to sans-serifs.
Font size: 8.7/11 pt.

Just one thought further and I am sixteen, and the trees are in bloom underneath wildly billowing curtains of rain. I stand in a meandering line of people with my father and mother, getting closer to the Grand Palais step by step, where a Picasso exhibition is being shown. We are like beads on a rosary. We have the arthropodal tread of slaves, who, by sheer numbers alone, will manage to drag the enormous stone of expectation to the gate. The exhibition only confirms the greatness of my father, who painted the two pastiches that hang above the couch in our living room, signed Pissacco. [*From the short story* Par(ad)is Revisité]

RQEN baegn *baegn*

ABCDEFGHIJKLMNOPQRSTUVWXYZ
abcdefghijklmnopqrstuvwxyz 0123456789

Linotype Bell Gothic
Chauncy H. Griffith of Mer-
genthaler Linotype designed
this typeface in 1938 for AT&T
for use in telephone books.
Bell Gothic did not include an
italic because it was not
needed. A typical character-
istic is the larger x-height of
the bold. It remained in use
for forty years and was even-
tually replaced by Bell Cen-
tennial, which was designed
in 1978 by Matthew Carter.
Font size: 9/11 pt.

Just one thought further and I am sixteen, and the trees are in bloom underneath wildly billowing curtains of rain. I stand in a mean-dering line of people with my father and mother, getting closer to the Grand Palais step by step, where a Picasso exhibition is being shown. We are like beads on a rosary. We have the arthropodal tread of slaves, who, by sheer numbers alone, will manage to drag the enormous stone of expectation to the gate. The exhibition only confirms the greatness of my father, who painted the two pastiches that hang above the couch in our living room, signed Pissacco. [From the short story Par(ad)is Revisité]

RQEN baegn baegn

ABCDEFGHIJKLMNOPQRSTUVWXYZ
abcdefghijklmnopqrstuvwxyz 0123456789

Linotype Trade Gothic
Jackson Burke designed this
American gothic in 1948 for
Mergenthaler Linotype. The
roman has a slightly lighter
character than most gothics.
Both condensed and extend-
ed styles have been made.
The bold and condensed
Trade Gothic is often used
for newspaper headings, as
with most other sans-serifs.
Font size: 8.6/11 pt.

Just one thought further and I am sixteen, and the trees are in bloom underneath wildly billowing curtains of rain. I stand in a mean-dering line of people with my father and mother, getting closer to the Grand Palais step by step, where a Picasso exhibition is being shown. We are like beads on a rosary. We have the arthropodal tread of slaves, who, by sheer numbers alone, will manage to drag the enormous stone of expectation to the gate. The exhibition only confirms the greatness of my father, who painted the two pastiches that hang above the couch in our living room, signed Pissacco. [*From the short story* Par(ad)is Revisité]

RQEN baegn *baegn*

ABCDEFGHIJKLMNOPQRSTUVWXYZ
abcdefghijklmnopqrstuvwxyz 0123456789

ITC Franklin Gothic *alternatives*

Font Bureau Interstate Plus
Tobias Frere-Jones designed this typeface based on an example of Highway Gothic, the typeface used for the signposting of roadways in America. Highway Gothic is the informal name for the official typefaces of the Federal Highway Administration (FHWA). Interstate condensed light has been used for the captions in this book due to its legibility in smaller sizes.
Font size: 8.5/11 pt.

Just one thought further and I am sixteen, and the trees are in bloom underneath wildly billowing curtains of rain. I stand in a meandering line of people with my father and mother, getting closer to the Grand Palais step by step, where a Picasso exhibition is being shown. We are like beads on a rosary. We have the arthropodal tread of slaves, who, by sheer numbers alone, will manage to drag the enormous stone of expectation to the gate. The exhibition only confirms the greatness of my father, who painted the two pastiches that hang above the couch in our living room, signed Pissacco. [*From the short story* Par(ad)is Revisité]

RQEN baegn *baegn*

ABCDEFGHIJKLMNOPQRSTUVWXYZ
abcdefghijklmnopqrstuvwxyz 0123456789

Linotype Vectora
Adrian Frutiger designed this sans-serif in 1990 for Linotype in the style of designs by Morris Fuller Benton and especially Franklin Gothic and News Gothic. It is larger on the body and has a larger x-height than Franklin Gothic.
Font size: 8.1/11 pt.

Just one thought further and I am sixteen, and the trees are in bloom underneath wildly billowing curtains of rain. I stand in a meandering line of people with my father and mother, getting closer to the Grand Palais step by step, where a Picasso exhibition is being shown. We are like beads on a rosary. We have the arthropodal tread of slaves, who, by sheer numbers alone, will manage to drag the enormous stone of expectation to the gate. The exhibition only confirms the greatness of my father, who painted the two pastiches that hang above the couch in our living room, signed Pissacco. [*From the short story* Par(ad)is Revisité]

RQEN baegn *baegn*

ABCDEFGHIJKLMNOPQRSTUVWXYZ
abcdefghijklmnopqrstuvwxyz 0123456789

H&FJ Whitney
This typeface from 1996 by Tobias Frere-Jones was designed for the corporate identity of the Whitney Museum in New York. It had to be suitable for both signposting and regular text. Frere-Jones says he found his inspiration in News Gothic and Frutiger. As such he closed the gap between the American gothics and the European humanistic typefaces. The x-height is smaller than usual for a sans-serif.
Font size: 8.7/11 pt.

Just one thought further and I am sixteen, and the trees are in bloom underneath wildly billowing curtains of rain. I stand in a meandering line of people with my father and mother, getting closer to the Grand Palais step by step, where a Picasso exhibition is being shown. We are like beads on a rosary. We have the arthropodal tread of slaves, who, by sheer numbers alone, will manage to drag the enormous stone of expectation to the gate. The exhibition only confirms the greatness of my father, who painted the two pastiches that hang above the couch in our living room, signed Pissacco. [*From the short story* Par(ad)is Revisité]

RQEN baegn *baegn*

ABCDEFGHIJKLMNOPQRSTUVWXYZ
abcdefghijklmnopqrstuvwxyz 0123456789

ITC Franklin Gothic

Font size 5 / 6,5 pt

In Paris, new buildings thrive like ivy, she says, staring out the window as the sun's rays glide past. They colour with the seasons and quickly obtain the status of immortality. In front of the *Louvre*, for example, a glass pyramid has arisen from the surface in memory of a president. The *Gare d'Orsay*'s overcoat received a lining: a design train à grande vitesse stands in its final depot. And because of all this, *Café Costes* has already become the oldest watering place in Paris. All those 'immobile' creatures are, after a short period of discomfort, welcomed into the city's bosom as in-laws. [*From the short story* Par(ad)is

6 / 7,5 pt

In Paris, new buildings thrive like ivy, she says, staring out the window as the sun's rays glide past. They colour with the seasons and quickly obtain the status of immortality. In front of the *Louvre*, for example, a glass pyramid has arisen from the surface in memory of a president. The *Gare d'Orsay*'s overcoat received a lining: a design train à grande vitesse stands in its final depot. And because of all this, *Café Costes* has already become the oldest watering place in Paris. All those 'immobile' creatures are, after a short period of discomfort, welcomed into the city's bosom as in-laws. [*From the short story* Par(ad)is

7 / 8,5 pt

In Paris, new buildings thrive like ivy, she says, staring out the window as the sun's rays glide past. They colour with the seasons and quickly obtain the status of immortality. In front of the *Louvre*, for example, a glass pyramid has arisen from the surface in memory of a president. The *Gare d'Orsay*'s overcoat received a lining: a design train à grande vitesse stands in its final depot. And because of all this, *Café Costes* has already become the oldest watering place in Paris. All those 'immobile'

8 / 10 pt

In Paris, new buildings thrive like ivy, she says, staring out the window as the sun's rays glide past. They colour with the seasons and quickly obtain the status of immortality. In front of the *Louvre*, for example, a glass pyramid has arisen from the surface in memory of a president. The *Gare d'Orsay*'s overcoat received a lining: a design train à grande vitesse stands in its final depot. And because of all this, *Café Costes* has already become the oldest watering place in Paris. All those 'immobile' creatures are, after a

10 / 12 pt

In Paris, new buildings thrive like ivy, she says, staring out the window as the sun's rays glide past. They colour with the seasons and quickly obtain the status of immortality. In front of the *Louvre*, for example, a glass pyramid has arisen from the surface in memory of a president. The *Gare d'Orsay*'s overcoat received a lining: a design train à grande vitesse stands in its final depot. And because of all this, *Café*

Corps

Corps

Corps

Corps

Corps

Corps

Corps

Corps

Corps

Corps

Corps

Corps

Linotype Frutiger Next

Fr

Next LT Light
Next LT Light Italic
Next LT Regular
Next LT Italic
Next LT Medium
Next LT Medium Italic
Next LT Bold
Next LT Bold Italic
Next LT Heavy
Next LT Heavy Italic
Next LT Black
Next LT Black Italic

The Swiss typographer Adrian Frutiger (born 1928) was persuaded by type-founder Charles Peignot to move to Paris in 1952. In 1976, nineteen years after his worldwide success with Univers, he launched *Frutiger*, which was originally designed as *Roissy* for signposting on Charles de Gaulle airport in Paris-Roissy. In 2001 Frutiger revised his *Frutiger* typeface and re-named it *Frutiger Next*. Many graphic designers condensed *Frutiger* slightly for use as a body type. Adrian Frutiger noticed this and made *Frutiger Next* more compact with a slightly smaller face, as well as adding a medium variant and extending the condensed series. It also includes a real italic instead of a sloped roman. These changes were more a result of the demand from the market than the wishes of the designer himself.

Frutiger shares some characteristics with *Gill Sans* and is often compared to it, but it has a more open, regular and lively face with a larger x-height.

A B C D E F G H I J K
L M N O P Q R S T U V
W X Y Z a b c d e f g
h i j k l m n o p q r
s t u v w x y z 1 2 3
4 5 6 7 8 9 0 ? ! () []
& "" «» ;: / - – à ç é î

HxqkmHxqkmHxqkmHxqkmHxqkmHxqkmHxqkm

20, 16, 12, 10, 8, 6, 4 pt

Just one thought further and I am sixteen, and the trees are in bloom underneath wildly billowing curtains of rain. I stand in a meandering line of people with my father and mother, getting closer to the Grand Palais step by step, where a Picasso exhibition is being shown. We are like beads on a rosary. We have the arthropodal tread of slaves, who, by sheer numbers alone, will manage to drag the enormous stone of expectation to the gate. The exhibition only confirms the greatness of my father, who painted the two pastiches that hang above the couch in our living room, signed Pissacco. When we are looking for our car afterwards – none of us paid attention to the street name when we parked it – Paris seizes me. Eventually, we find the car, which has changed into a 'bagnole'. [*From the short story* Par(ad)is Revisité]

Font size 9/11 pt

Linotype Frutiger Next *Light Italic*

Font size 28/13 mm

A B C D E F G H I J K
L M N O P Q R S T U V
W X Y Z a b c d e f g
h i j k l m n o p q r
s t u v w x y z 1 2 3
4 5 6 7 8 9 0 ? ! () []
& "" «» ;: / - – à ç é î

6
7
8
9
10
11
12
14
16
18
20
22
24
28
32
36
42
48
60
72

HxqkmHxqkmHxqkmHxqkmHxqkmHxqkmHxqkm

20, 16, 12, 10, 8, 6, 4 pt

Font size 9/11 pt

Just one thought further and I am sixteen, and the trees are in bloom underneath wildly billowing curtains of rain. I stand in a meandering line of people with my father and mother, getting closer to the Grand Palais step by step, where a Picasso exhibition is being shown. We are like beads on a rosary. We have the arthropodal tread of slaves, who, by sheer numbers alone, will manage to drag the enormous stone of expectation to the gate. The exhibition only confirms the greatness of my father, who painted the two pastiches that hang above the couch in our living room, signed Pissacco. When we are looking for our car afterwards – none of us paid attention to the street name when we parked it – Paris seizes me. Eventually, we find the car, which has changed into a 'bagnole'. [From the short story Par(ad)is Revisité]

A B C D E F G H I J K
L M N O P Q R S T U V
W X Y Z a b c d e f g
h i j k l m n o p q r
s t u v w x y z 1 2 3
4 5 6 7 8 9 0 ? ! () []
& "" «» ;: / - – à ç é î

HxqkmHxqkmHxqkmHxqkmHxqkmHxqkmHxqkm

20, 16, 12, 10, 8, 6, 4 pt

Just one thought further and I am sixteen, and the trees are in bloom underneath wildly billowing curtains of rain. I stand in a meandering line of people with my father and mother, getting closer to the Grand Palais step by step, where a Picasso exhibition is being shown. We are like beads on a rosary. We have the arthropodal tread of slaves, who, by sheer numbers alone, will manage to drag the enormous stone of expectation to the gate. The exhibition only confirms the greatness of my father, who painted the two pastiches that hang above the couch in our living room, signed Pissacco. When we are looking for our car afterwards – none of us paid attention to the street name when we parked it – Paris seizes me. Eventually, we find the car, which has changed into a 'bagnole'. [*From the short story* Par(ad)is Revisité]

Font size 9/11 pt

A B C D E F G H I J K

L M N O P Q R S T U V

W X Y Z a b c d e f g

h i j k l m n o p q r

s t u v w x y z 1 2 3

4 5 6 7 8 9 0 ? ! () []

& "" «» ;: / - – à ç é î

HxqkmHxqkmHxqkmHxqkmHxqkmHxqkmHxqkm

20, 16, 12, 10, 8, 6, 4 pt

Font size 9/11 pt

Just one thought further and I am sixteen, and the trees are in bloom underneath wildly billowing curtains of rain. I stand in a meandering line of people with my father and mother, getting closer to the Grand Palais step by step, where a Picasso exhibition is being shown. We are like beads on a rosary. We have the arthropodal tread of slaves, who, by sheer numbers alone, will manage to drag the enormous stone of expectation to the gate. The exhibition only confirms the greatness of my father, who painted the two pastiches that hang above the couch in our living room, signed Pissacco. When we are looking for our car afterwards – none of us paid attention to the street name when we parked it – Paris seizes me. Eventually, we find the car, which has changed into a 'bagnole'. [From the short story Par(ad)is Revisité]

A B C D E F G H I J K
L M N O P Q R S T U V
W X Y Z a b c d e f g
h i j k l m n o p q r
s t u v w x y z 1 2 3
4 5 6 7 8 9 0 ? ! () []
& "" «» ;: / - – à ç é î

HxqkmHxqkmHxqkmHxqkmHxqkmHxqkmHxqkm

20, 16, 12, 10, 8, 6, 4 pt

Just one thought further and I am sixteen, and the trees are in bloom underneath wildly billowing curtains of rain. I stand in a meandering line of people with my father and mother, getting closer to the Grand Palais step by step, where a Picasso exhibition is being shown. We are like beads on a rosary. We have the arthropodal tread of slaves, who, by sheer numbers alone, will manage to drag the enormous stone of expectation to the gate. The exhibition only confirms the greatness of my father, who painted the two pastiches that hang above the couch in our living room, signed Pissacco. When we are looking for our car afterwards – none of us paid attention to the street name when we parked it – Paris seizes me. Eventually, we find the car, which has changed into a 'bagnole'.

Font size 9/11 pt

A B C D E F G H I J K
L M N O P Q R S T U V
W X Y Z a b c d e f g
h i j k l m n o p q r
s t u v w x y z 1 2 3
4 5 6 7 8 9 0 ? ! () []
& "" «» ;: / - – à ç é î

6
7
8
9
10
11
12
14
16
18
20
22
24
28
32
36
42

HxqkmHxqkmHxqkmHxqkmHxqkmHxqkmHxqkm

20, 16, 12, 10, 8, 6, 4 pt

Font size 9/11 pt

48

Just one thought further and I am sixteen, and the trees are in bloom underneath wildly billowing curtains of rain. I stand in a meandering line of people with my father and mother, getting closer to the Grand Palais step by step, where a Picasso exhibition is being shown. We are like beads on a rosary. We have the arthropodal tread of slaves, who, by sheer numbers alone, will manage to drag the enormous stone of expectation to the gate. The exhibition only confirms the greatness of my father, who painted the two pastiches that hang above the couch in our living room, signed Pissacco. When we are looking for our car afterwards – none of us paid attention to the street name when we parked it – Paris seizes me. Eventually, we find the car, which has changed into a 'bag-

60

72

A B C D E F G H I J K
L M N O P Q R S T U V
W X Y Z a b c d e f g
h i j k l m n o p q r
s t u v w x y z 1 2 3
4 5 6 7 8 9 0 ? ! () []
& "" «» ;: / - – à ç é î

HxqkmHxqkmHxqkmHxqkmHxqkmHxqkmHxqkm

20, 16, 12, 10, 8, 6, 4 pt

Just one thought further and I am sixteen, and the trees are in
bloom underneath wildly billowing curtains of rain. I stand in a
meandering line of people with my father and mother, getting
closer to the Grand Palais step by step, where a Picasso exhibi-
tion is being shown. We are like beads on a rosary. We have the
arthropodal tread of slaves, who, by sheer numbers alone, will
manage to drag the enormous stone of expectation to the gate.
The exhibition only confirms the greatness of my father, who
painted the two pastiches that hang above the couch in our
living room, signed Pissacco. When we are looking for our car
afterwards – none of us paid attention to the street name when
we parked it – Paris seizes me. Eventually, we find the car,

Font size 9/11 pt

Linotype Frutiger Next *Bold Italic*

A B C D E F G H I J K
L M N O P Q R S T U V
W X Y Z a b c d e f g
h i j k l m n o p q r
s t u v w x y z 1 2 3
4 5 6 7 8 9 0 ? ! () []
& "" «» ;: / - – à ç é î

HxqkmHxqkmHxqkmHxqkmHxqkmHxqkmHxqkm

20, 16, 12, 10, 8, 6, 4 pt

Font size 9/11 pt

Just one thought further and I am sixteen, and the trees are in bloom underneath wildly billowing curtains of rain. I stand in a meandering line of people with my father and mother, getting closer to the Grand Palais step by step, where a Picasso exhibition is being shown. We are like beads on a rosary. We have the arthropodal tread of slaves, who, by sheer numbers alone, will manage to drag the enormous stone of expectation to the gate. The exhibition only confirms the greatness of my father, who painted the two pastiches that hang above the couch in our living room, signed Pissacco. When we are looking for our car afterwards – none of us paid attention to the street name when we parked it – Paris seizes me. Eventually, we find the

Adobe Myriad Pro
Myriad by Robert Slimbach and Carol Twombly from 1991 is the most similar in design to Frutiger. It was originally released as a Multiple Master typeface and much later as a version with separate styles. Myriad has a smaller face than Frutiger and the italic has a softer form.
Font size: 9/11 pt.

Just one thought further and I am sixteen, and the trees are in bloom underneath wildly billowing curtains of rain. I stand in a meandering line of people with my father and mother, getting closer to the Grand Palais step by step, where a Picasso exhibition is being shown. We are like beads on a rosary. We have the arthropodal tread of slaves, who, by sheer numbers alone, will manage to drag the enormous stone of expectation to the gate. The exhibition only confirms the greatness of my father, who painted the two pastiches that hang above the couch in our living room, signed Pissacco. [*From the short story* Par(ad)is Revisité]

RQEN baegn *baegn*

ABCDEFGHIJKLMNOPQRSTUVWXYZ
abcdefghijklmnopqrstuvwxyz 0123456789

Microsoft Corbel
Jeremy Tankard designed this typeface in 2005 for the ClearType rendering by Microsoft for an improved representation of text on LCD screens. It is delivered standard with Windows Vista and Office 2007. The size of the face is similar to that of Myriad but the text appears slightly lighter. The italic is rounder in form than Myriad.
Font size: 9/11 pt.

Just one thought further and I am sixteen, and the trees are in bloom underneath wildly billowing curtains of rain. I stand in a meandering line of people with my father and mother, getting closer to the Grand Palais step by step, where a Picasso exhibition is being shown. We are like beads on a rosary. We have the arthropodal tread of slaves, who, by sheer numbers alone, will manage to drag the enormous stone of expectation to the gate. The exhibition only confirms the greatness of my father, who painted the two pastiches that hang above the couch in our living room, signed Pissacco. [*From the short story* PAR(AD)IS REVISITÉ]

RQEN baegn *baegn*

ABCDEFGHIJKLMNOPQRSTUVWXYZ
abcdefghijklmnopqrstuvwxyz 0123456789

Bitstream Vera Sans
Bitstream developed this 'freeware' typeface as a component of the freely available Gnome, a 'graphical user interface'. It is very similar to Frutiger but some capitals are slightly different such as the capital 'E' and 'G' which are a little wider.
The face is also much larger which is why the text in the example to the right has been set a significant 1.5 pt smaller than MyriadPro and Corbel. The alphabet lines show the difference in size of the characters.
Font size: 7.5/11 pt.

Just one thought further and I am sixteen, and the trees are in bloom underneath wildly billowing curtains of rain. I stand in a meandering line of people with my father and mother, getting closer to the Grand Palais step by step, where a Picasso exhibition is being shown. We are like beads on a rosary. We have the arthropodal tread of slaves, who, by sheer numbers alone, will manage to drag the enormous stone of expectation to the gate. The exhibition only confirms the greatness of my father, who painted the two pastiches that hang above the couch in our living room, signed Pissacco. [*From the short story* Par(ad)is Revisité]

RQEN baegn *baegn*

ABCDEFGHIJKLMNOPQRSTUVWXYZ
abcdefghijklmnopqrstuvwxyz 0123456789

Adobe Lucida Sans
Lucida Sans, a complete family with various styles, was designed by Charles Bigelow and Kris Holmes soon after Imagen released the Lucida roman and italic in 1985. It is included standard on most computers and is used in the operating system or other software. The face is large and the thick-thin contrast is slightly greater than in Frutiger. The cursive is not a sloped roman, but a separately designed italic. It is a good alternative to Helvetica or Ariel for correspondence purposes.
Font size: 8/11 pt.

Just one thought further and I am sixteen, and the trees are in bloom underneath wildly billowing curtains of rain. I stand in a meandering line of people with my father and mother, getting closer to the Grand Palais step by step, where a Picasso exhibition is being shown. We are like beads on a rosary. We have the arthropodal tread of slaves, who, by sheer numbers alone, will manage to drag the enormous stone of expectation to the gate. The exhibition only confirms the greatness of my father, who painted the two pastiches that hang above the couch in our living room, signed Pissacco. [*From the short story* Par(ad)is Revisité]

RQEN baegn *baegn*

ABCDEFGHIJKLMNOPQRSTUVWXYZ
abcdefghijklmnopqrstuvwxyz 0123456789

ITC Stone Sans
Sumner Stone designed this typeface in 1987 as component of various styles such as the Serif and the Informal. In 1987 it was one of the very first typefaces to offer such a variety of styles in a single typeface. Stone has more thick-thin contrast than Frutiger and has a separately designed italic which is not simply a sloped roman as with the original Frutiger, even though this appears to be the case with some of the characters.
Font size: 8.4/11 pt.

Just one thought further and I am sixteen, and the trees are in bloom underneath wildly billowing curtains of rain. I stand in a meandering line of people with my father and mother, getting closer to the Grand Palais step by step, where a Picasso exhibition is being shown. We are like beads on a rosary. We have the arthropodal tread of slaves, who, by sheer numbers alone, will manage to drag the enormous stone of expectation to the gate. The exhibition only confirms the greatness of my father, who painted the two pastiches that hang above the couch in our living room, signed Pissacco. [*From the short story* Par(ad)is Revisité]

RQEN baegn *baegn*

ABCDEFGHIJKLMNOPQRSTUVWXYZ
abcdefghijklmnopqrstuvwxyz 0123456789

Typotheque Fedra Sans
Type designer Peter Bil'ak designed Fedra Sans in 2001 to replace the corporate identity type Univers for an insurance company. The aim was to make Univers less formal. As such it is therefore logical that influences can be seen from Frutiger, which Adrian Frutiger made as a successor to Univers. Yet it remains a unique design, somewhat heavier and more angular than Frutiger but with numerous surprises and a real italic.
Font size: 7.7/11 pt.

Just one thought further and I am sixteen, and the trees are in bloom underneath wildly billowing curtains of rain. I stand in a meandering line of people with my father and mother, getting closer to the Grand Palais step by step, where a Picasso exhibition is being shown. We are like beads on a rosary. We have the arthropodal tread of slaves, who, by sheer numbers alone, will manage to drag the enormous stone of expectation to the gate. The exhibition only confirms the greatness of my father, who painted the two pastiches that hang above the couch in our living room, signed Pissacco. [*From the short story* Par(ad)is Revisité]

RQEN baegn *baegn*

ABCDEFGHIJKLMNOPQRSTUVWXYZ
abcdefghijklmnopqrstuvwxyz 0123456789

Linotype Frutiger Next

Font size 5/6,5 pt

In Paris, new buildings thrive like ivy, she says, staring out the window as the sun's rays glide past. They colour with the seasons and quickly obtain the status of immortality. In front of the *Louvre*, for example, a glass pyramid has arisen from the surface in memory of a president. The *Gare d'Orsay*'s overcoat received a lining: a design train à grande vitesse stands in its final depot. And because of all this, *Café Costes* has already become the oldest watering place in Paris. All those 'immobile' creatures are, after a short period of discomfort, welcomed into the city's bosom as in-laws. [*From the short story* Par(ad)is Revisité]

6/7,5 pt

In Paris, new buildings thrive like ivy, she says, staring out the window as the sun's rays glide past. They colour with the seasons and quickly obtain the status of immortality. In front of the *Louvre*, for example, a glass pyramid has arisen from the surface in memory of a president. The *Gare d'Orsay*'s overcoat received a lining: a design train à grande vitesse stands in its final depot. And because of all this, *Café Costes* has already become the oldest watering place in Paris. All those 'immobile' creatures are, after a short period of discomfort, welcomed into the city's bosom as in-laws. [*From the short story* Par(ad)is Revisité]

7/8,5 pt

In Paris, new buildings thrive like ivy, she says, staring out the window as the sun's rays glide past. They colour with the seasons and quickly obtain the status of immortality. In front of the *Louvre*, for example, a glass pyramid has arisen from the surface in memory of a president. The *Gare d'Orsay*'s overcoat received a lining: a design train à grande vitesse stands in its final depot. And because of all this, *Café Costes* has already become the oldest watering place in Paris. All those 'immobile' creatures are, after a

8/10 pt

In Paris, new buildings thrive like ivy, she says, staring out the window as the sun's rays glide past. They colour with the seasons and quickly obtain the status of immortality. In front of the *Louvre*, for example, a glass pyramid has arisen from the surface in memory of a president. The *Gare d'Orsay*'s overcoat received a lining: a design train à grande vitesse stands in its final depot. And because of all this, *Café Costes* has already become the oldest watering place in Paris. All those 'immobile' creatures are, after a short period of discomfort, wel-

10/12 pt

In Paris, new buildings thrive like ivy, she says, staring out the window as the sun's rays glide past. They colour with the seasons and quickly obtain the status of immortality. In front of the *Louvre*, for example, a glass pyramid has arisen from the surface in memory of a president. The *Gare d'Orsay*'s overcoat received a lining: a design train à grande vitesse stands in its final depot. And because of all this, *Café Costes* has already become the

Light, Light It., Regular & Italic 24, 32, 40, 48

Corps

Corps

Corps

Corps

Medium, Med. It., Bold & Bold Italic 24, 32, 4

Corps

Corps

Corps

Corps

Heavy, Heavy It., Black & Black It. 24, 32, 40,

Corps

Corps

Corps

Corps

Linotype Futura

Fu

Light
Light Oblique
Book
Book Oblique
Medium
Medium Oblique
Heavy
Heavy Oblique
Bold
Bold Oblique
Extra Bold
Extra Bold Oblique

Futura by Paul Renner (1878–1956) is the textbook example of a geometrically constructed typeface (though in fact subtle deviations give the illusion of geometrical construction), with a concept fitting into the Bauhaus ideologies and those of the Neue Typography, though probably influenced by Edward Johnston's sans-serif as well. Renner, who both founded and taught at the Meisterschule für Deutschlands Buchdrucker, launched this typeface in 1927 at the Bauersche Gießerei. It was a bestseller.

Futura has extended ascenders and descenders and therefore requires a generous line spacing. As well as *Futura* styles shown here, there is also an extended condensed series.

A B C D E F G H I J K
L M N O P Q R S T U V
W X Y Z a b c d e f g
h i j k l m n o p q r
s t u v w x y z 1 2 3
4 5 6 7 8 9 0 ? ! () []
& " " « » ; : / - — à ç é î

HxqkmHxqkmHxqkmHxqkmHxqkmHxqkmHxqkm

20, 16, 12, 10, 8, 6, 4 p

Font size 9 / 11 pt

Just one thought further and I am sixteen, and the trees are in bloom underneath wildly billowing curtains of rain. I stand in a meandering line of people with my father and mother, getting closer to the Grand Palais step by step, where a Picasso exhibition is being shown. We are like beads on a rosary. We have the arthropodal tread of slaves, who, by sheer numbers alone, will manage to drag the enormous stone of expectation to the gate. The exhibition only confirms the greatness of my father, who painted the two pastiches that hang above the couch in our living room, signed Pissacco. When we are looking for our car afterwards — none of us paid attention to the street name when we parked it — Paris seizes me. Eventually, we find the car, which has changed into a 'bagnole'. [*From the short story* Par(ad)is Revisité]

A B C D E F G H I J K
L M N O P Q R S T U V
W X Y Z a b c d e f g
h i j k l m n o p q r
s t u v w x y z 1 2 3
4 5 6 7 8 9 0 ? ! () []
& "" «» ;: / - – à ç é î

6
7
8
9
10
11
12
14
16
18
20
22
24
28
32
36
42

HxqkmHxqkmHxqkmHxqkmHxqkmHxqkmHxqkm

20, 16, 12, 10, 8, 6, 4 pt

Font size 9 / 11 pt

48

Just one thought further and I am sixteen, and the trees are in bloom underneath wildly billowing curtains of rain. I stand in a meandering line of people with my father and mother, getting closer to the Grand Palais step by step, where a Picasso exhibition is being shown. We are like beads on a rosary. We have the arthropodal tread of slaves, who, by sheer numbers alone, will manage to drag the enormous stone of expectation to the gate. The exhibition only confirms the greatness of my father, who painted the two pastiches that hang above the couch in our living room, signed Pissacco. When we are looking for our car afterwards – none of us paid attention to the street name when we parked it – Paris seizes me. Eventually, we find the car, which has changed into a 'bagnole'. [From the short story Par(ad)is Revisité]

60

72

A B C D E F G H I J K
L M N O P Q R S T U V
W X Y Z a b c d e f g
h i j k l m n o p q r
s t u v w x y z 1 2 3
4 5 6 7 8 9 0 ? ! () []
& "" «» ;: / - – à ç é î

HxqkmHxqkmHxqkmHxqkmHxqkmHxqkmHxqkm

20, 16, 12, 10, 8, 6, 4 pt

Font size 9 / 11 pt

Just one thought further and I am sixteen, and the trees are in bloom underneath wildly billowing curtains of rain. I stand in a meandering line of people with my father and mother, getting closer to the Grand Palais step by step, where a Picasso exhibition is being shown. We are like beads on a rosary. We have the arthropodal tread of slaves, who, by sheer numbers alone, will manage to drag the enormous stone of expectation to the gate. The exhibition only confirms the greatness of my father, who painted the two pastiches that hang above the couch in our living room, signed Pissacco. When we are looking for our car afterwards – none of us paid attention to the street name when we parked it – Paris seizes me. Eventually, we find the car, which has changed into a 'bagnole'. [*From the short story*

Linotype *Futura* Book Oblique

Font size 28 / 13 mm

```
A B C D E F G H I J K
L M N O P Q R S T U V
W X Y Z a b c d e f g
h i j k l m n o p q r
s t u v w x y z 1 2 3
4 5 6 7 8 9 0 ? ! () []
& "" «» ;: / - – à ç é î
```

6
7
8
9
10
11
12
14
16
18
20
22
24
28
32
36
42
48
60
72

HxqkmHxqkmHxqkmHxqkmHxqkmHxqkmHxqkm 20, 16, 12, 10, 8, 6, 4 pt

Font size 9 / 11 pt

Just one thought further and I am sixteen, and the trees are in bloom underneath wildly billowing curtains of rain. I stand in a meandering line of people with my father and mother, getting closer to the Grand Palais step by step, where a Picasso exhibition is being shown. We are like beads on a rosary. We have the arthropodal tread of slaves, who, by sheer numbers alone, will manage to drag the enormous stone of expectation to the gate. The exhibition only confirms the greatness of my father, who painted the two pastiches that hang above the couch in our living room, signed Pissacco. When we are looking for our car afterwards – none of us paid attention to the street name when we parked it – Paris seizes me. Eventually, we find the car, which has changed into a 'bagnole'. [From the short story

A B C D E F G H I J K
L M N O P Q R S T U V
W X Y Z a b c d e f g
h i j k l m n o p q r
s t u v w x y z 1 2 3
4 5 6 7 8 9 0 ? ! () []
& "" «» ;: / - – à ç é î

HxqkmHxqkmHxqkmHxqkmHxqkmHxqkmHxqkm 20, 16, 12, 10, 8, 6, 4 p

Just one thought further and I am sixteen, and the trees are in bloom underneath wildly billowing curtains of rain. I stand in a meandering line of people with my father and mother, getting closer to the Grand Palais step by step, where a Picasso exhibition is being shown. We are like beads on a rosary. We have the arthropodal tread of slaves, who, by sheer numbers alone, will manage to drag the enormous stone of expectation to the gate. The exhibition only confirms the greatness of my father, who painted the two pastiches that hang above the couch in our living room, signed Pissacco. When we are looking for our car afterwards – none of us paid attention to the street name when we parked it – Paris seizes me. Eventually, we find the car, which has changed into a 'bagnole'. [*From the short story* Par(ad)is Revisité]

Font size 9 / 11 pt

A B C D E F G H I J K
L M N O P Q R S T U V
W X Y Z a b c d e f g
h i j k l m n o p q r
s t u v w x y z 1 2 3
4 5 6 7 8 9 0 ? ! () []
& "" «» ;: / - – à ç é î

HxqkmHxqkmHxqkmHxqkmHxqkmHxqkmHxqkm

20, 16, 12, 10, 8, 6, 4 pt

Font size 9 / 11 pt

Just one thought further and I am sixteen, and the trees are in bloom underneath wildly billowing curtains of rain. I stand in a meandering line of people with my father and mother, getting closer to the Grand Palais step by step, where a Picasso exhibition is being shown. We are like beads on a rosary. We have the arthropodal tread of slaves, who, by sheer numbers alone, will manage to drag the enormous stone of expectation to the gate. The exhibition only confirms the greatness of my father, who painted the two pastiches that hang above the couch in our living room, signed Pissacco. When we are looking for our car afterwards – none of us paid attention to the street name when we parked it – Paris seizes me. Eventually, we find the car, which has changed into a 'bagnole'. [From the short story Par(ad)is Revisité]

A B C D E F G H I J K
L M N O P Q R S T U V
W X Y Z a b c d e f g
h i j k l m n o p q r
s t u v w x y z 1 2 3
4 5 6 7 8 9 0 ? ! () []
& "" «» ;: / - – à ç é î

HxqkmHxqkmHxqkmHxqkmHxqkmHxqkmHxqkm

20, 16, 12, 10, 8, 6, 4 p

Just one thought further and I am sixteen, and the trees are in bloom underneath wildly billowing curtains of rain. I stand in a meandering line of people with my father and mother, getting closer to the Grand Palais step by step, where a Picasso exhibition is being shown. We are like beads on a rosary. We have the arthropodal tread of slaves, who, by sheer numbers alone, will manage to drag the enormous stone of expectation to the gate. The exhibition only confirms the greatness of my father, who painted the two pastiches that hang above the couch in our living room, signed Pissacco. When we are looking for our car afterwards – none of us paid attention to the street name when we parked it – Paris seizes me. Eventually, we find the car, which has changed into a 'bagnole'. [*From the short story*

Font size 9 / 11 pt

A B C D E F G H I J K
L M N O P Q R S T U V
W X Y Z a b c d e f g
h i j k l m n o p q r
s t u v w x y z 1 2 3
4 5 6 7 8 9 0 ? ! () []
& "" «» ;: / - – à ç é î

HxqkmHxqkmHxqkmHxqkmHxqkmHxqkmHxqkm

20, 16, 12, 10, 8, 6, 4 pt

Font size 9 / 11 pt

Just one thought further and I am sixteen, and the trees are in bloom underneath wildly billowing curtains of rain. I stand in a meandering line of people with my father and mother, getting closer to the Grand Palais step by step, where a Picasso exhibition is being shown. We are like beads on a rosary. We have the arthropodal tread of slaves, who, by sheer numbers alone, will manage to drag the enormous stone of expectation to the gate. The exhibition only confirms the greatness of my father, who painted the two pastiches that hang above the couch in our living room, signed Pissacco. When we are looking for our car afterwards – none of us paid attention to the street name when we parked it – Paris seizes me. Eventually, we find the car, which has changed into a 'bagnole'. [From the short story

DTL Nobel

Fred Smeijers and Andrea Fuchs created this typeface in 1993 based on a design by Sjoerd Hendrik de Roos. De Roos made this type in 1929 as a result of the success of Futura although he made it more practical for use as a body text type by making it more compact and designing a classic lowercase 'a'. DTL includes seven styles ranging from light to condensed. Font Bureau offers a Nobel made by Tobias Frere-Jones with eighteen styles. Font size: 8.7/11 pt.

Just one thought further and I am sixteen, and the trees are in bloom underneath wildly billowing curtains of rain. I stand in a meandering line of people with my father and mother, getting closer to the Grand Palais step by step, where a Picasso exhibition is being shown. We are like beads on a rosary. We have the arthropodal tread of slaves, who, by sheer numbers alone, will manage to drag the enormous stone of expectation to the gate. The exhibition only confirms the greatness of my father, who painted the two pastiches that hang above the couch in our living room, signed Pissacco. [*From the short story* Par(ad)is Revisité]

RQEN baegn *baegn*

ABCDEFGHIJKLMNOPQRSTUVWXYZ
abcdefghijklmnopqrstuvwxyz 0123456789

Linotype Metro

William Addison Dwiggins designed this typeface in 1929 for Linotype in a limited number of styles just after the release of Futura and Gill Sans. Although geometric like Futura, Metro has an art-deco touch. Widely used in America, its uses range from lettering on shop fronts to comic books. In Europe it is recognisable as the typeface for the company Nivea. Cyrus Highsmith at Font Bureau, comic book lover, made a version with no less than forty styles under the name Relay. Font size: 8.7/11 pt.

Just one thought further and I am sixteen, and the trees are in bloom underneath wildly billowing curtains of rain. I stand in a meandering line of people with my father and mother, getting closer to the Grand Palais step by step, where a Picasso exhibition is being shown. We are like beads on a rosary. We have the arthropodal tread of slaves, who, by sheer numbers alone, will manage to drag the enormous stone of expectation to the gate. The exhibition only confirms the greatness of my father, who painted the two pastiches that hang above the couch in our living room, signed Pissacco. [From the short story Par(ad)is Revisité]

RQEN baegn baegn

ABCDEFGHIJKLMNOPQRSTUVWXYZ
abcdefghijklmnopqrstuvwxyz 0123456789

ITC Kabel

The first version of Kabel appeared in 1927 and was designed by Rudolf Koch for typefoundry Gebr. Klingspor. The ITC version by Victor Caruso has a much larger x-height and differs here and there from the original but is more suitable for body text. For comparison purposes, the last three lines of the text shown here have been set in the same font size as Linotype Kabel which has more similarities to the original. Kabel has no italics. Font size: 8.7/11 pt.

Just one thought further and I am sixteen, and the trees are in bloom underneath wildly billowing curtains of rain. I stand in a meandering line of people with my father and mother, getting closer to the Grand Palais step by step, where a Picasso exhibition is being shown. We are like beads on a rosary. We have the arthropodal tread of slaves, who, by sheer numbers alone, will manage to drag the enormous stone of expectation to the gate. The exhibition only confirms the greatness of my father, who painted the two pastiches that hang above the couch in our living room, signed Pissacco. [From the short story Par(ad)is Revisité]

RQEN baegn baegn

ABCDEFGHIJKLMNOPQRSTUVWXYZ
abcdefghijklmnopqrstuvwxyz 0123456789

ITC Avant Garde
Herb Lubalin and Tom Carnase were inspired for this 1970 design by the Bauhaus period and by a logo that Lubalin had previously designed for *Avant Garde Magazine*. The condensed version was introduced in 1974 and was made by Ed Benguiat. The ligatures are also extremely famous, a few of which are shown here to the right with the alphabet. The italic is a sloped roman.
Font size: 7.7/11 pt.

Just one thought further and I am sixteen, and the trees are in bloom underneath wildly billowing curtains of rain. I stand in a meandering line of people with my father and mother, getting closer to the Grand Palais step by step, where a Picasso exhibition is being shown. We are like beads on a rosary. We have the arthropodal tread of slaves, who, by sheer numbers alone, will manage to drag the enormous stone of expectation to the gate. The exhibition only confirms the greatness of my father, who painted the two pastiches that hang above the couch in our living room, signed Pissacco. (*From the short story* Par(ad)is Revisité)

RQEN baegn *baegn*

ABCDEFGHIJKLMNOPQRSTUVWXYZ CATTURANTGO
abcdefghijklmnopqrstuvwxyz 0123456789

Linotype Avenir
Adrian Frutiger designed this geometric sans-serif in 1988 in the tradition of Futura. Avenir (French for future) has more thick-thin contrast and is a favourite of many designers due to its legibility.
Font size: 8,4/11 pt.

Just one thought further and I am sixteen, and the trees are in bloom underneath wildly billowing curtains of rain. I stand in a meandering line of people with my father and mother, getting closer to the Grand Palais step by step, where a Picasso exhibition is being shown. We are like beads on a rosary. We have the arthropodal tread of slaves, who, by sheer numbers alone, will manage to drag the enormous stone of expectation to the gate. The exhibition only confirms the greatness of my father, who painted the two pastiches that hang above the couch in our living room, signed Pissacco. [*From the short story* Par(ad)is Revisité]

RQEN baegn *baegn*

ABCDEFGHIJKLMNOPQRSTUVWXYZ
abcdefghijklmnopqrstuvwxyz 0123456789

H&FJ Gotham Narrow
In 2000, Tobias Frere-Jones designed Gotham, the regular version of which is often compared to Avenir. His inspiration came from façade lettering that began appearing around 1930 on buildings in New York. Gotham has a more balanced appearance than Avenir when used for headings in capitals. The face is large and the italic is a sloped roman. Gotham Narrow from 2009, shown to the right, was designed for use as body text type and is slightly narrower.
Font size: 8.4/11 pt.

Just one thought further and I am sixteen, and the trees are in bloom underneath wildly billowing curtains of rain. I stand in a meandering line of people with my father and mother, getting closer to the Grand Palais step by step, where a Picasso exhibition is being shown. We are like beads on a rosary. We have the arthropodal tread of slaves, who, by sheer numbers alone, will manage to drag the enormous stone of expectation to the gate. The exhibition only confirms the greatness of my father, who painted the two pastiches that hang above the couch in our living room, signed Pissacco. [*From the short story* Par(ad)is Revisité]

RQEN baegn *baegn*

ABCDEFGHIJKLMNOPQRSTUVWXYZ
abcdefgghijklmnopqrstuvwxyz 0123456789

Linotype Futura

Font size 5 / 6,5 pt

In Paris, new buildings thrive like ivy, she says, staring out the window as the sun's rays glide past. They colour with the seasons and quickly obtain the status of immortality. In front of the *Louvre*, for example, a glass pyramid has arisen from the surface in memory of a president. The *Gare d'Orsay*'s overcoat received a lining: a design train à grande vitesse stands in its final depot. And because of all this, *Café Costes* has already become the oldest watering place in Paris. All those 'immobile' creatures are, after a short period of discomfort, welcomed into the city's bosom as in-laws. [*From the short story* Par(ad)is Revisité]

6 / 7,5 pt

In Paris, new buildings thrive like ivy, she says, staring out the window as the sun's rays glide past. They colour with the seasons and quickly obtain the status of immortality. In front of the *Louvre*, for example, a glass pyramid has arisen from the surface in memory of a president. The *Gare d'Orsay*'s overcoat received a lining: a design train à grande vitesse stands in its final depot. And because of all this, *Café Costes* has already become the oldest watering place in Paris. All those 'immobile' creatures are, after a short period of discomfort, welcomed into the city's bosom as in-laws. [*From the short story* Par(ad)is Revisité]

7 / 8,5 pt

In Paris, new buildings thrive like ivy, she says, staring out the window as the sun's rays glide past. They colour with the seasons and quickly obtain the status of immortality. In front of the *Louvre*, for example, a glass pyramid has arisen from the surface in memory of a president. The *Gare d'Orsay*'s overcoat received a lining: a design train à grande vitesse stands in its final depot. And because of all this, *Café Costes* has already become the oldest watering place in Paris. All those 'immobile' creatures are, after a

8 / 10 pt

In Paris, new buildings thrive like ivy, she says, staring out the window as the sun's rays glide past. They colour with the seasons and quickly obtain the status of immortality. In front of the *Louvre*, for example, a glass pyramid has arisen from the surface in memory of a president. The *Gare d'Orsay*'s overcoat received a lining: a design train à grande vitesse stands in its final depot. And because of all this, *Café Costes* has already become the oldest watering place in Paris. All those 'immobile' creatures are, after a short period of discomfort, wel-

10 / 12 pt

In Paris, new buildings thrive like ivy, she says, staring out the window as the sun's rays glide past. They colour with the seasons and quickly obtain the status of immortality. In front of the *Louvre*, for example, a glass pyramid has arisen from the surface in memory of a presi-dent. The *Gare d'Orsay*'s overcoat re-ceived a lining: a design train à grande vitesse stands in its final depot. And be-cause of all this, *Café Costes* has already

Light, Book, Medium, Heavy,
Bold, Extra Bold 24, 32, 40, 48, 48, 48 pt

Corps

Corps

Corps

Corps

Corps

Corps

Corps

Light Condensed, Regular Condensed, Bold Co
Extra Bold Condensed 24, 32, 40, 48 pt

Corps

Corps

Corps

Corps

Monotype Gill Sans

Gi

Light
Light Italic
Regular
Italic
Bold
Bold Italic
Extra Bold
Ultra Bold
Condensed
Bold Condensed
Ultra Bold Condensed

As designer of the *London Underground Type* and teacher and friend of Eric Gill, Edward Johnston (1872–1944) was of significant importance to the development of sans-serif typefaces in general and for those made by Gill in particular. *Monotype Gill Sans* by Eric Gill (1882–1940) is based on Johnston's *London Underground Type* dating from 1916. *Gill Sans*, commissioned by Stanley Morison, appeared in 1928. Both Johnston's type and *Gill Sans* have more similarities in proportion with the Renaissance Florentine inscriptional capitals than with the other nineteenth century grotesques or other twentieth century sans-serifs. *Monotype Gill Sans* in its current PostScript form is too condensed and as such requires an extra degree of letter spacing. Monotype now offers thirty styles of *Gill Sans* including a condensed series and an outline version. The design studio of Letraset created *Gill Kayo*, an extremely heavy and narrow variant of *Gill Sans* Ultra Bold with a characteristic dot on the 'i'.

Due to the popularity of *Gill Sans* for use in children's books, a special *Gill Sans Infant/Schoolbook* was introduced with several altered characters as well as *Gill Sans Alt One*, which includes a figure 1 with serif. *Gill Sans Pro* appeared in 2005 with 21 styles, including the alternative figure 1 which can be selected in the OpenType alternates.

A B C D E F G H I J K
L M N O P Q R S T U V
W X Y Z a b c d e f g
h i j k l m n o p q r
s t u v w x y z I 2 3
4 5 6 7 8 9 0 ? ! () []
& "" «» ;: / - — à ç é î

HxqkmHxqkmHxqkmHxqkmHxqkmHxqkmHxqkm

20, 16, 12, 10, 8, 6, 4 pt

Just one thought further and I am sixteen, and the trees are in bloom underneath wildly billowing curtains of rain. I stand in a meandering line of people with my father and mother, getting closer to the Grand Palais step by step, where a Picasso exhibition is being shown. We are like beads on a rosary. We have the arthropodal tread of slaves, who, by sheer numbers alone, will manage to drag the enormous stone of expectation to the gate. The exhibition only confirms the greatness of my father, who painted the two pastiches that hang above the couch in our living room, signed Pissacco. When we are looking for our car afterwards – none of us paid attention to the street name when we parked it – Paris seizes me. Eventually, we find the car, which has changed into a 'bagnole'. [*From the short story* Par(ad)is Revisité]

Font size 9/11 pt

Monotype Gill Sans *Light Italic*

Font size 28/13 mm

A B C D E F G H I J K
L M N O P Q R S T U V
W X Y Z a b c d e f g
h i j k l m n o p q r
s t u v w x y z 1 2 3
4 5 6 7 8 9 0 ? ! () []
& "" ‹›› ;: / - — à ç é î

HxqkmHxqkmHxqkmHxqkmHxqkmHxqkmHxqkm

20, 16, 12, 10, 8, 6, 4 pt

Font size 9/11 pt

Just one thought further and I am sixteen, and the trees are in bloom underneath wildly billowing curtains of rain. I stand in a meandering line of people with my father and mother, getting closer to the Grand Palais step by step, where a Picasso exhibition is being shown. We are like beads on a rosary. We have the arthropodal tread of slaves, who, by sheer numbers alone, will manage to drag the enormous stone of expectation to the gate. The exhibition only confirms the greatness of my father, who painted the two pastiches that hang above the couch in our living room, signed Pissacco. When we are looking for our car afterwards – none of us paid attention to the street name when we parked it – Paris seizes me. Eventually, we find the car, which has changed into a 'bagnole'. [From the short story Par(ad)is Revisité]

A B C D E F G H I J K
L M N O P Q R S T U V
W X Y Z a b c d e f g
h i j k l m n o p q r
s t u v w x y z 1 2 3
4 5 6 7 8 9 0 ? ! () []
& "" «» ;: / - – à ç é î

HxqkmHxqkmHxqkmHxqkmHxqkmHxqkmHxqkm 20, 16, 12, 10, 8, 6, 4 pt

Just one thought further and I am sixteen, and the trees are in bloom Font size 9/11 pt
underneath wildly billowing curtains of rain. I stand in a meandering line
of people with my father and mother, getting closer to the Grand Palais
step by step, where a Picasso exhibition is being shown. We are like
beads on a rosary. We have the arthropodal tread of slaves, who, by
sheer numbers alone, will manage to drag the enormous stone of
expectation to the gate. The exhibition only confirms the greatness of my
father, who painted the two pastiches that hang above the couch in our
living room, signed Pissacco. When we are looking for our car afterwards
– none of us paid attention to the street name when we parked it – Paris
seizes me. Eventually, we find the car, which has changed into a 'bagnole'.
[*From the short story* Par(ad)is Revisité]

A B C D E F G H I J K
L M N O P Q R S T U V
W X Y Z a b c d e f g
h i j k l m n o þ q r
s t u v w x y z 1 2 3
4 5 6 7 8 9 0 ? ! () []
& "" «» ;: / - – à ç é î

6
7
8
9
10
11
12
14
16
18
20
22
24
28
32
36
42
48
60
72

HxqkmHxqkmHxqkmHxqkmHxqkmHxqkmHxqkm

20, 16, 12, 10, 8, 6, 4 pt

Font size 9/11 pt

Just one thought further and I am sixteen, and the trees are in bloom underneath wildly billowing curtains of rain. I stand in a meandering line of people with my father and mother, getting closer to the Grand Palais step by step, where a Picasso exhibition is being shown. We are like beads on a rosary. We have the arthropodal tread of slaves, who, by sheer numbers alone, will manage to drag the enormous stone of expectation to the gate. The exhibition only confirms the greatness of my father, who painted the two pastiches that hang above the couch in our living room, signed Pissacco. When we are looking for our car afterwards – none of us paid attention to the street name when we parked it – Paris seizes me. Eventually, we find the car, which has changed into a 'bagnole'. [From the short story Par(ad)is Revisité]

A B C D E F G H I J K
L M N O P Q R S T U V
W X Y Z a b c d e f g
h i j k l m n o p q r
s t u v w x y z 1 2 3
4 5 6 7 8 9 0 ? ! () []
& "" «» ;: / – – à ç é î

HxqkmHxqkmHxqkmHxqkmHxqkmHxqkmHxqkm 20, 16, 12, 10, 8, 6, 4 pt

Just one thought further and I am sixteen, and the trees are in
bloom underneath wildly billowing curtains of rain. I stand in a
meandering line of people with my father and mother, getting
closer to the Grand Palais step by step, where a Picasso exhibi-
tion is being shown. We are like beads on a rosary. We have the
arthropodal tread of slaves, who, by sheer numbers alone, will
manage to drag the enormous stone of expectation to the gate.
The exhibition only confirms the greatness of my father, who
painted the two pastiches that hang above the couch in our
living room, signed Pissacco. When we are looking for our car
afterwards – none of us paid attention to the street name when
we parked it – Paris seizes me. Eventually, we find the car,

Font size 9/11 pt

A B C D E F G H I J K
L M N O P Q R S T U V
W X Y Z a b c d e f g
h i j k l m n o þ q r
s t u v w x y z 1 2 3
4 5 6 7 8 9 0 ? ! () []
& "" ‹‹›› ;: / - – à ç é î

HxqkmHxqkmHxqkmHxqkmHxqkmHxqkmHxqkm

20, 16, 12, 10, 8, 6, 4 pt

Font size 9/11 pt

Just one thought further and I am sixteen, and the trees are in bloom underneath wildly billowing curtains of rain. I stand in a meandering line of people with my father and mother, getting closer to the Grand Palais step by step, where a Picasso exhibition is being shown. We are like beads on a rosary. We have the arthropodal tread of slaves, who, by sheer numbers alone, will manage to drag the enormous stone of expectation to the gate. The exhibition only confirms the greatness of my father, who painted the two pastiches that hang above the couch in our living room, signed Pissacco. When we are looking for our car afterwards – none of us paid attention to the street name when we parked it – Paris seizes me. Eventually, we find the car, which has changed into a 'bagnole'.

P22 Johnston Underground
Edward Johnston designed this typeface in 1916 for use as signposting in the London Underground. P22 collaborated with the London Underground to add digitalized and graphic elements with which route maps could be made. The design of Gill Sans typeface was heavily influenced by this typeface. It was also admired by a delegation of German designers who visited London in 1924 and it probably influenced Erbar (1926), Futura (1927) and Kabel (1927). Johnston has no italic style because this was not required for its original purpose.
Font size: 8.7/11 pt.

Just one thought further and I am sixteen, and the trees are in bloom underneath wildly billowing curtains of rain. I stand in a meandering line of people with my father and mother, getting closer to the Grand Palais step by step, where a Picasso exhibition is being shown. We are like beads on a rosary. We have the arthropodal tread of slaves, who, by sheer numbers alone, will manage to drag the enormous stone of expectation to the gate. The exhibition only confirms the greatness of my father, who painted the two pastiches that hang above the couch in our living room, signed Pissacco. [From the short story Par(ad)is Revisité]

RQEN baegn

ABCDEFGHIJKLMNOPQRSTUVWXYZ
abcdefghijklmnopqrstuvwxyz 0123456789

ITC Johnston
ITC Johnston was designed in 1999 by David Farey and Richard Dawson and later extended with an italic to make it more suited to body text than the original Johnston. Old style figures were also added as well as small capitals. The weight and form of this version are closest to the original (aside from the P22 which does not include an italic).
Font size: 8.7/11 pt.

Just one thought further and I am sixteen, and the trees are in bloom underneath wildly billowing curtains of rain. I stand in a meandering line of people with my father and mother, getting closer to the Grand Palais step by step, where a Picasso exhibition is being shown. We are like beads on a rosary. We have the arthropodal tread of slaves, who, by sheer numbers alone, will manage to drag the enormous stone of expectation to the gate. The exhibition only confirms the greatness of my father, who painted the two pastiches that hang above the couch in our living room, signed Pissacco. [*From the short story* PAR(AD)IS REVISITÉ]

RQEN baegn *baegn*

ABCDEFGHIJKLMNOPQRSTUVWXYZ
abcdefghijklmnopqrstuvwxyz 0123456789

Font Bureau Agenda
Greg Thompson designed this extended typeface in 1993 based on Johnston's Underground type. The italic was also added and there is a series of no less than 54 styles available in various weights from Light to Black.
Font size: 8.7/11 pt.

Just one thought further and I am sixteen, and the trees are in bloom underneath wildly billowing curtains of rain. I stand in a meandering line of people with my father and mother, getting closer to the Grand Palais step by step, where a Picasso exhibition is being shown. We are like beads on a rosary. We have the arthropodal tread of slaves, who, by sheer numbers alone, will manage to drag the enormous stone of expectation to the gate. The exhibition only confirms the greatness of my father, who painted the two pastiches that hang above the couch in our living room, signed Pissacco. [*From the short story* Par(ad)is Revisité]

RQEN baegn *baegn*

ABCDEFGHIJKLMNOPQRSTUVWXYZ
abcdefghijklmnopqrstuvwxyz 0123456789

Linotype Charlotte Sans
Michael Gills designed
Charlotte Sans in 1992 as an
addition to Charlotte Roman.
It is a typeface that shares
many characteristics with Gill
Sans such as the thick-thin
contrast of the 'e' and the
classic form of the 'g'.
A number of characters can
also be compared to Frutiger.
The italic is classical in form
and has more contrast than
Frutiger italic.
Font size: 7.7/11 pt.

Just one thought further and I am sixteen, and the trees are in bloom underneath wildly billowing curtains of rain. I stand in a meandering line of people with my father and mother, getting closer to the Grand Palais step by step, where a Picasso exhibition is being shown. We are like beads on a rosary. We have the arthropodal tread of slaves, who, by sheer numbers alone, will manage to drag the enormous stone of expectation to the gate. The exhibition only confirms the greatness of my father, who painted the two pastiches that hang above the couch in our living room, signed Pissacco. [*From the short story* PAR(AD)IS REVISITÉ]

RQEN baegn *baegn*

ABCDEFGHIJKLMNOPQRSTUVWXYZ
abcdefghijklmnopqrstuvwxyz 0123456789

MT Gill Sans Infant
Because Gill Sans was used
so often for children's books,
a special version was re-
leased under the name Gill
Sans Infant (also called Gill
Sans Schoolbook). The main
differences can be seen in
the lowercase letters 'a', 'g'
and 'l' and the '1'.
Font size: 9/11 pt.

Just one thought further and I am sixteen, and the trees are in bloom underneath wildly billowing curtains of rain. I stand in a meandering line of people with my father and mother, getting closer to the Grand Palais step by step, where a Picasso exhibition is being shown. We are like beads on a rosary. We have the arthropodal tread of slaves, who, by sheer numbers alone, will manage to drag the enormous stone of expectation to the gate. The exhibition only confirms the greatness of my father, who painted the two pastiches that hang above the couch in our living room, signed Pissacco. [*From the short story* Par(ad)is Revisité]

RQEN baegn *baegn*

ABCDEFGHIJKLMNOPQRSTUVWXYZ
abcdefghijklmnopqrstuvwxyz 0123456789

AVP Fiendstar
In 1999, Nicholas Garner
designed this typeface for
his own company Aviation
Partners in London as an
alternative to Gill Sans
Schoolbook. It includes a
large number of styles for
signposting and educational
material. There are many
similarities with Gill Sans but
Fiendstar has a less dated
appearance due to its low
levels of thick-thin contrast
and the lighter lines.
Font size: 9/11 pt.

Just one thought further and I am sixteen, and the trees are in bloom underneath wildly billowing curtains of rain. I stand in a meandering line of people with my father and mother, getting closer to the Grand Palais step by step, where a Picasso exhibition is being shown. We are like beads on a rosary. We have the arthropodal tread of slaves, who, by sheer numbers alone, will manage to drag the enormous stone of expectation to the gate. The exhibition only confirms the greatness of my father, who painted the two pastiches that hang above the couch in our living room, signed Pissacco. [*From the short story* Par(ad)is Revisité]

RQEN baegn *baegn*

ABCDEFGHIJKLMNOPQRSTUVWXYZ
abcdefghijklmnopqrstuvwxyz 0123456789

Monotype Gill Sans

Font size 5/6,5 pt

In Paris, new buildings thrive like ivy, she says, staring out the window as the sun's rays glide past. They colour with the seasons and quickly obtain the status of immortality. In front of the *Louvre*, for example, a glass pyramid has arisen from the surface in memory of a president. The *Gare d'Orsay*'s overcoat received a lining: a design train à grande vitesse stands in its final depot. And because of all this, *Café Costes* has already become the oldest watering place in Paris. All those 'immobile' creatures are, after a short period of discomfort, welcomed into the city's bosom as in-laws. [*From the short story* Par(ad)is Revisité]

6/7,5 pt

In Paris, new buildings thrive like ivy, she says, staring out the window as the sun's rays glide past. They colour with the seasons and quickly obtain the status of immortality. In front of the *Louvre*, for example, a glass pyramid has arisen from the surface in memory of a president. The *Gare d'Orsay*'s overcoat received a lining: a design train à grande vitesse stands in its final depot. And because of all this, *Café Costes* has already become the oldest watering place in Paris. All those 'immobile' creatures are, after a short period of discomfort, welcomed into the city's bosom as in-laws. [*From the short story* Par(ad)is Revisité]

7/8,5 pt

In Paris, new buildings thrive like ivy, she says, staring out the window as the sun's rays glide past. They colour with the seasons and quickly obtain the status of immortality. In front of the *Louvre*, for example, a glass pyramid has arisen from the surface in memory of a president. The *Gare d'Orsay*'s overcoat received a lining: a design train à grande vitesse stands in its final depot. And because of all this, *Café Costes* has already become the oldest watering place in Paris. All those 'immobile' creatures are, after a short period of dis-

8/10 pt

In Paris, new buildings thrive like ivy, she says, staring out the window as the sun's rays glide past. They colour with the seasons and quickly obtain the status of immortality. In front of the *Louvre*, for example, a glass pyramid has arisen from the surface in memory of a president. The *Gare d'Orsay*'s overcoat received a lining: a design train à grande vitesse stands in its final depot. And because of all this, *Café Costes* has already become the oldest watering place in Paris. All those 'immobile' creatures are, after a short period of dis-comfort, welcomed into the city's bosom as in-laws.

10/12 pt

In Paris, new buildings thrive like ivy, she says, staring out the window as the sun's rays glide past. They colour with the sea-sons and quickly obtain the status of im-mortality. In front of the *Louvre*, for ex-ample, a glass pyramid has arisen from the surface in memory of a president. The *Gare d'Orsay*'s overcoat received a lining: a design train à grande vitesse stands in its final depot. And because of all this, *Café Costes* has already become the oldest

Corps

Corps

Corps

Corps

Bold, Bold Italic, Extra Bold &
Ultra Bold 24, 32, 40, 48 pt

Corps

Corps

Corps

Corp

Condensed, Bold Condensed &
Ultra Bold Condensed 24, 32, 40, 48 pt

Corps

Corps

Corps

Corps

Linotype Neue Helvetica

25 Ultra Light
26 Ultra Light Italic
35 Thin
36 Thin Italic
45 Light
46 Light Italic
55 Roman
56 Italic
65 Medium
66 Medium Italic
75 Bold
76 Bold Italic
85 Heavy
86 Heavy Italic
95 Black
96 Black Italic

In 1957, Max Miedinger, in-house designer of the Haas'sche Schriftgießerei AG, made a version of the existing *Haas Grotesk* to suit the tastes of the day: *Neue Haas Grotesk*. The letter was an immediate success and in 1961 the German type foundry D. Stempel AG launched it under the name *Helvetica* (the Latin name for Swiss). This was a clever move, with an eye to the imminent popularity of Swiss typography. *Helvetica* remains to this day the best selling sans-serif typeface.

Its enormous distribution, together with monomaniac use of the type in the sixties and seventies – the period of hegemony for the Swiss International Style – had led to the devaluation of the *Helvetica* in the minds of designers looking for innovation and originality. Yet *Helvetica* continues to be rediscovered from time to time by new generations of designers and now even provokes feelings of nostalgia in older users.

Helvetica has a large x-height and is rather wide-set.

A B C D E F G H I J K
L M N O P Q R S T U V
W X Y Z a b c d e f g
h i j k l m n o p q r
s t u v w x y z 1 2 3
4 5 6 7 8 9 0 ? ! () []
& " " « » ; : / - – à ç é î

HxqkmHxqkmHxqkmHxqkmHxqkmHxqkmHxqkm

20, 16, 12, 10, 8, 6, 4 pt

Just one thought further and I am sixteen, and the trees are in bloom underneath wildly billowing curtains of rain. I stand in a meandering line of people with my father and mother, getting closer to the Grand Palais step by step, where a Picasso exhibition is being shown. We are like beads on a rosary. We have the arthropodal tread of slaves, who, by sheer numbers alone, will manage to drag the enormous stone of expectation to the gate. The exhibition only confirms the greatness of my father, who painted the two pastiches that hang above the couch in our living room, signed Pissacco. When we are looking for our car afterwards – none of us paid attention to the street name when we parked it – Paris seizes me. Eventually, we find the car, which has changed into a 'bagnole'. [*From the short story*

Font size 9 / 11 pt

A B C D E F G H I J K
L M N O P Q R S T U V
W X Y Z a b c d e f g
h i j k l m n o p q r
s t u v w x y z 1 2 3
4 5 6 7 8 9 0 ? ! () []
& "" «» ;: / - – à ç é î

HxqkmHxqkmHxqkmHxqkmHxqkmHxqkmHxqkm

20, 16, 12, 10, 8, 6, 4 pt

Font size 9/11 pt

Just one thought further and I am sixteen, and the trees are in bloom underneath wildly billowing curtains of rain. I stand in a meandering line of people with my father and mother, getting closer to the Grand Palais step by step, where a Picasso exhibition is being shown. We are like beads on a rosary. We have the arthropodal tread of slaves, who, by sheer numbers alone, will manage to drag the enormous stone of expectation to the gate. The exhibition only confirms the greatness of my father, who painted the two pastiches that hang above the couch in our living room, signed Pissacco. When we are looking for our car afterwards – none of us paid attention to the street name when we parked it – Paris seizes me. Eventually, we find the car, which has changed into a 'bagnole'. [From the short story

A B C D E F G H I J K
L M N O P Q R S T U V
W X Y Z a b c d e f g
h i j k l m n o p q r
s t u v w x y z 1 2 3
4 5 6 7 8 9 0 ? ! () []
& "" «» ;: / - – à ç é î

HxqkmHxqkmHxqkmHxqkmHxqkmHxqkmHxqkm

20, 16, 12, 10, 8, 6, 4 pt

Just one thought further and I am sixteen, and the trees are in bloom underneath wildly billowing curtains of rain. I stand in a meandering line of people with my father and mother, getting closer to the Grand Palais step by step, where a Picasso exhibition is being shown. We are like beads on a rosary. We have the arthropodal tread of slaves, who, by sheer numbers alone, will manage to drag the enormous stone of expectation to the gate. The exhibition only confirms the greatness of my father, who painted the two pastiches that hang above the couch in our living room, signed Pissacco. When we are looking for our car afterwards – none of us paid attention to the street name when we parked it – Paris seizes me. Eventually, we find the car, which has changed into a 'bag-

Font size 9/11 pt

A B C D E F G H I J K
L M N O P Q R S T U V
W X Y Z a b c d e f g
h i j k l m n o p q r
s t u v w x y z 1 2 3
4 5 6 7 8 9 0 ? ! () []
& "" ‹› ;: / - – à ç é î

6
7
8
9
10
11
12
14
16
18
20
22
24
28
32
36
42
48
60
72

HxqkmHxqkmHxqkmHxqkmHxqkmHxqkmHxqkm

20, 16, 12, 10, 8, 6, 4 pt

Font size 9/11 pt

Just one thought further and I am sixteen, and the trees are in bloom underneath wildly billowing curtains of rain. I stand in a meandering line of people with my father and mother, getting closer to the Grand Palais step by step, where a Picasso exhibition is being shown. We are like beads on a rosary. We have the arthropodal tread of slaves, who, by sheer numbers alone, will manage to drag the enormous stone of expectation to the gate. The exhibition only confirms the greatness of my father, who painted the two pastiches that hang above the couch in our living room, signed Pissacco. When we are looking for our car afterwards – none of us paid attention to the street name when we parked it – Paris seizes me. Eventually, we find the car, which has changed into a 'bag-

A B C D E F G H I J K
L M N O P Q R S T U V
W X Y Z a b c d e f g
h i j k l m n o p q r
s t u v w x y z 1 2 3
4 5 6 7 8 9 0 ? ! () []
& "" «» ;: / - – à ç é î

HxqkmHxqkmHxqkmHxqkmHxqkmHxqkmHxqkm

20, 16, 12, 10, 8, 6, 4 pt

Font size 9/11 pt

Just one thought further and I am sixteen, and the trees are in bloom underneath wildly billowing curtains of rain. I stand in a meandering line of people with my father and mother, getting closer to the Grand Palais step by step, where a Picasso exhibition is being shown. We are like beads on a rosary. We have the arthropodal tread of slaves, who, by sheer numbers alone, will manage to drag the enormous stone of expectation to the gate. The exhibition only confirms the greatness of my father, who painted the two pastiches that hang above the couch in our living room, signed Pissacco. When we are looking for our car afterwards – none of us paid attention to the street name when we parked it – Paris seizes me. Eventually, we find the car, which

A B C D E F G H I J K
L M N O P Q R S T U V
W X Y Z a b c d e f g
h i j k l m n o p q r
s t u v w x y z 1 2 3
4 5 6 7 8 9 0 ? ! () []
& "" «» ;: / - – à ç é î

HxqkmHxqkmHxqkmHxqkmHxqkmHxqkmHxqkm

Just one thought further and I am sixteen, and the trees are in bloom underneath wildly billowing curtains of rain. I stand in a meandering line of people with my father and mother, getting closer to the Grand Palais step by step, where a Picasso exhibition is being shown. We are like beads on a rosary. We have the arthropodal tread of slaves, who, by sheer numbers alone, will manage to drag the enormous stone of expectation to the gate. The exhibition only confirms the greatness of my father, who painted the two pastiches that hang above the couch in our living room, signed Pissacco. When we are looking for our car afterwards – none of us paid attention to the street name when we parked it – Paris seizes me. Eventually, we find the car, which

A B C D E F G H I J K L M N O P Q R S T U V W X Y Z a b c d e f g h i j k l m n o p q r s t u v w x y z 1 2 3 4 5 6 7 8 9 0 ? ! () [] & "" «» ;: / - – à ç é î

HxqkmHxqkmHxqkmHxqkmHxqkmHxqkmHxqkm

20, 16, 12, 10, 8, 6, 4 pt

Font size 9/11 pt

Just one thought further and I am sixteen, and the trees are in bloom underneath wildly billowing curtains of rain. I stand in a meandering line of people with my father and mother, getting closer to the Grand Palais step by step, where a Picasso exhibition is being shown. We are like beads on a rosary. We have the arthropodal tread of slaves, who, by sheer numbers alone, will manage to drag the enormous stone of expectation to the gate. The exhibition only confirms the greatness of my father, who painted the two pastiches that hang above the couch in our living room, signed Pissacco. When we are looking for our car afterwards – none of us paid attention to the street name when we parked it – Paris seizes me. Eventually, we find the

A B C D E F G H I J K
L M N O P Q R S T U V
W X Y Z a b c d e f g
h i j k l m n o p q r
s t u v w x y z 1 2 3
4 5 6 7 8 9 0 ? ! () []
& "" ‹› ;: / - – à ç é î

HxqkmHxqkmHxqkmHxqkmHxqkmHxqkmHxqkm 20, 16, 12, 10, 8, 6, 4 pt

Just one thought further and I am sixteen, and the trees are in Font size 9/11 pt
bloom underneath wildly billowing curtains of rain. I stand in a
meandering line of people with my father and mother, getting
closer to the Grand Palais step by step, where a Picasso exhi-
bition is being shown. We are like beads on a rosary. We have
the arthropodal tread of slaves, who, by sheer numbers alone,
will manage to drag the enormous stone of expectation to the
gate. The exhibition only confirms the greatness of my father,
who painted the two pastiches that hang above the couch in
our living room, signed Pissacco. When we are looking for our
car afterwards – none of us paid attention to the street name
when we parked it – Paris seizes me. Eventually, we find the

Monotype Arial
Linotype had a bestseller with Helvetica. Robin Nicholas and Patricia Saunders subsequently created Arial for Monotype, which was based on Monotype Grotesque and was made in such a way that it could replace Helvetica exactly without altering the setting. When Microsoft began delivering Arial standard with Windows, distribution rocketed. In the alphabet lines shown here, the Helvetica characters in red highlight the subtle differences.
Font size: 8.6/11 pt.

Just one thought further and I am sixteen, and the trees are in bloom underneath wildly billowing curtains of rain. I stand in a meandering line of people with my father and mother, getting closer to the Grand Palais step by step, where a Picasso exhibition is being shown. We are like beads on a rosary. We have the arthropodal tread of slaves, who, by sheer numbers alone, will manage to drag the enormous stone of expectation to the gate. The exhibition only confirms the greatness of my father, who painted the two pastiches that hang above the couch in our living room, signed Pissacco. [*From the short story* Par(ad)is Revisité]

RQEN baegn *baegn*
ABCDEFGGHIJKLMNOPQRRSTUVWXYZ
aabcdefghijklmnopqrsttuvwxyz 0123456789

URW Maxima
East German Gerd Wunderlich designed Maxima in 1962 for Typoart as counterpart to Helvetica. It is a limited family with four styles and no italic. The red text to the left shows the Medium and to the right is the Light. The Light is lighter than Helvetica Regular and the Medium is heavier. A digital version of Maxima was released by Elsner + Flake and by URW++.
Font size: 8.4/11 pt.

Just one thought further and I am sixteen, and the trees are in bloom underneath wildly billowing curtains of rain. I stand in a meandering line of people with my father and mother, getting closer to the Grand Palais step by step, where a Picasso exhibition is being shown. We are like beads on a rosary. We have the arthropodal tread of slaves, who, by sheer numbers alone, will manage to drag the enormous stone of expectation to the gate. The exhibition only confirms the greatness of my father, who painted the two pastiches that hang above the couch in our living room, signed Pissacco. [From the short story Par(ad)is Revisité]

RQEN baegn baegn
ABCDEFGHIJKLMNOPQRSTUVWXYZ
abcdefghijklmnopqrstuvwxyz 0123456789

Linotype Antique Olive
Roger Excoffon designed this French response to Helvetica and Univers in 1962 for Fonderie Olive. It is a very personal typeface that has little to do with the generally accepted principles of type design. The characters appear to be heavier than the average typeface and its thick-thin contrast is greater than Helvetica's. The x-height is extremely large which makes the Olive especially legible at smaller font sizes.
Font size: 7/11 pt.

Just one thought further and I am sixteen, and the trees are in bloom underneath wildly billowing curtains of rain. I stand in a meandering line of people with my father and mother, getting closer to the Grand Palais step by step, where a Picasso exhibition is being shown. We are like beads on a rosary. We have the arthropodal tread of slaves, who, by sheer numbers alone, will manage to drag the enormous stone of expectation to the gate. The exhibition only confirms the greatness of my father, who painted the two pastiches that hang above the couch in our living room, signed Pissacco. [*From the short story* Par(ad)is Revisité]

RQEN baegn *baegn*
ABCDEFGHIJKLMNOPQRSTUVWXYZ
abcdefghijklmnopqrstuvwxyz 0123456789

Linotype Univers
Adrian Frutiger made a small advance specimen of four weights of Univers in 1954, but released the face only in 1957. It quickly became popular in many countries. Like Helvetica it is based on sans-serif types from ca. 1900, particularly Akzidenz Grotesk, but departed further from their forms than Helvetica did. Univers has always included a numerical element in the naming of the styles. In 1997 the series was revised and extended from 21 to 63 styles. The numbering is now compiled with three figures instead of two.
Font size: 8/11 pt.

Just one thought further and I am sixteen, and the trees are in bloom underneath wildly billowing curtains of rain. I stand in a meandering line of people with my father and mother, getting closer to the Grand Palais step by step, where a Picasso exhibition is being shown. We are like beads on a rosary. We have the arthropodal tread of slaves, who, by sheer numbers alone, will manage to drag the enormous stone of expectation to the gate. The exhibition only confirms the greatness of my father, who painted the two pastiches that hang above the couch in our living room, signed Pissacco. [*From the short story* Par(ad)is Revisité]

RQEN baegn *baegn*

ABCDEFGHIJKLMNOPQRSTUVWXYZ
abcdefghijklmnopqrstuvwxyz 0123456789

140 *monde*	141 *monde*	130 *monde*	131 *monde*	120 *monde*	121 *monde*	110 *monde*
240 *monde*	241 *monde*	230 *monde*	231 *monde*	220 *monde*	221 *monde*	39/210 *monde*
340 *monde*	341 *monde*	45/330 *monde*	46/331 *monde*	47/320 *monde*	48/321 *monde*	49/310 *monde*
53/440 *monde*	441 *monde*	55/430 *monde*	56/431 *monde*	57/420 *monde*	58/421 *monde*	59/410 *monde*
63/540 *monde*	541 *monde*	65/530 *monde*	66/531 *monde*	67/520 *monde*	68/521 *monde*	510 *monde*
73/640 *monde*	641 *monde*	75/630 *monde*	76/631 *monde*	620 *monde*	621 *monde*	
83/740 *monde*	741 *monde*	730 *monde*	731 *monde*	720 *monde*	721 *monde*	
840 *monde*	841 *monde*	830 *monde*	831 *monde*	820 *monde*	821 *monde*	
940 *mond*	941 *mond*	930 *mond*	931 *mond*	920 *mond*	921 *mond*	

The original series is shown in red, with the two-figure numbering system listed first.

With the three-figure numbering system, the first figure represents the boldness, the second stands for width and the third for roman or italic. The four missing styles are versions specifically for the typewriter.

Linotype Neue Helvetica

Font size 5 / 6,5 pt

In Paris, new buildings thrive like ivy, she says, staring out the window as the sun's rays glide past. They colour with the seasons and quickly obtain the status of immortality. In front of the *Louvre*, for example, a glass pyramid has arisen from the surface in memory of a president. The *Gare d'Orsay*'s overcoat received a lining: a design train à grande vitesse stands in its final depot. And because of all this, *Café Costes* has already become the oldest watering place in Paris. All those 'immobile' creatures are, after a short period of discomfort, welcomed into the city's bosom as in-laws. [*From the short story* Par(ad)is

6 / 7,5 pt

In Paris, new buildings thrive like ivy, she says, staring out the window as the sun's rays glide past. They colour with the seasons and quickly obtain the status of immortality. In front of the *Louvre*, for example, a glass pyramid has arisen from the surface in memory of a president. The *Gare d'Orsay*'s overcoat received a lining: a design train à grande vitesse stands in its final depot. And because of all this, *Café Costes* has already become the oldest watering place in Paris. All those 'immobile' creatures are, after a short period of discomfort, welcomed into the city's bosom as in-laws. [*From the short story* Par(ad)is Revisité]

7 / 8,5 pt

In Paris, new buildings thrive like ivy, she says, staring out the window as the sun's rays glide past. They colour with the seasons and quickly obtain the status of immortality. In front of the *Louvre*, for example, a glass pyramid has arisen from the surface in memory of a president. The *Gare d'Orsay*'s overcoat received a lining: a design train à grande vitesse stands in its final depot. And because of all this, *Café Costes* has already become the oldest watering place in Paris. All those

8 / 10 pt

In Paris, new buildings thrive like ivy, she says, staring out the window as the sun's rays glide past. They colour with the seasons and quickly obtain the status of immortality. In front of the *Louvre*, for example, a glass pyramid has arisen from the surface in memory of a president. The *Gare d'Orsay*'s overcoat received a lining: a design train à grande vitesse stands in its final depot. And because of all this, *Café Costes* has already become the oldest watering place in Paris. All those 'immobile' creatures are, after a

10 / 12 pt

In Paris, new buildings thrive like ivy, she says, staring out the window as the sun's rays glide past. They colour with the seasons and quickly obtain the status of immortality. In front of the *Louvre*, for example, a glass pyramid has arisen from the surface in memory of a president. The *Gare d'Orsay*'s overcoat received a lining: a design train à grande vitesse stands in its final depot. And because of all this, *Café*

Ultra Light, Thin, Roman, Medium, Bold, Black 24, 32, 40, 48, 48, 48 pt

Corps
Corps
Corps
Corps
Corps
Corps

Ultra Light Condensed, Light Condensed, Condensed, Bold Condensed, Black Condensed 24, 32, 40, 48, 60 pt

Corps
Corps
Corps
Corps
Corps

FontFont Meta+

Me

The Berlin type and graphic designer Erik Spiekermann (born 1947) is managing director of FontShop as well as a gifted speaker and writer in the world of typography. He originally designed *Meta* for the Deutsche Bundespost, which cancelled the commission at a late stage in its development: Out of pure laziness they continued to use *Helvetica*. His dissatisfaction at this decision spurred Spiekermann to begin his own type company, FontShop, with *Meta* as its first typeface.

Meta has an extremely clear face with a youthful, informal character and is therefore well suited to rough and informal documents. It includes small capitals and old style figures in almost all styles.

A B C D E F G H I J K
L M N O P Q R S T U V
W X Y Z a b c d e f g
h i j k l m n o p q r
s t u v w x y z 1 2 3
4 5 6 7 8 9 0 ? ! () []
& "" «» ;: / - – à ç é î

A B C D E F G H I J K
L M N O P Q R S T U V
W X Y Z 1 2 3 4 5 6 7
8 9 0 fi fl À

HxqkmHxqkmHxqkmHxqkmHxqkmHxqkmHxqkm

20, 16, 12, 10, 8, 6, 4 pt

Just one thought further and I am sixteen, and the trees are in bloom underneath wildly billowing curtains of rain. I stand in a meandering line of people with my father and mother, getting closer to the Grand Palais step by step, where a Picasso exhibition is being shown. We are like beads on a rosary. We have the arthropodal tread of slaves, who, by sheer numbers alone, will manage to drag the enormous stone of expectation to the gate. The exhibition only confirms the greatness of my father, who painted the two pastiches that hang above the couch in our living room, signed Pissacco. When we are looking for our car afterwards – none of us paid attention to the street name when we parked it – Paris seizes me. Eventually, we find the car, which has changed into a 'bagnole'. [*From the short story* PAR(AD)IS REVISITÉ]

Font size 9 / 11 pt

A B C D E F G H I J K
L M N O P Q R S T U V
W X Y Z a b c d e f g
h i j k l m n o p q r
s t u v w x y z 1 2 3
4 5 6 7 8 9 0 ? ! () []
& "" «» ;: / - – à ç é î

A B C D E F G H I J K
L M N O P Q R S T U V
W X Y Z 1 2 3 4 5 6 7
8 9 0 *fi fl* À

HxqkmHxqkmHxqkmHxqkmHxqkmHxqkmHxqkm

20, 16, 12, 10, 8, 6, 4 pt

Font size 9 / 11 pt

Just one thought further and I am sixteen, and the trees are in bloom underneath wildly billowing curtains of rain. I stand in a meandering line of people with my father and mother, getting closer to the Grand Palais step by step, where a Picasso exhibition is being shown. We are like beads on a rosary. We have the arthropodal tread of slaves, who, by sheer numbers alone, will manage to drag the enormous stone of expectation to the gate. The exhibition only confirms the greatness of my father, who painted the two pastiches that hang above the couch in our living room, signed Pissacco. When we are looking for our car afterwards – none of us paid attention to the street name when we parked it – Paris seizes me. Eventually, we find the car, which has changed into a 'bagnole'. [From the short story PAR(AD)IS REVISITÉ]

A B C D E F G H I J K
L M N O P Q R S T U V
W X Y Z a b c d e f g
h i j k l m n o p q r
s t u v w x y z 1 2 3
4 5 6 7 8 9 0 ? ! () []
& "" «» ;: / - – à ç é î

A B C D E F G H I J K
L M N O P Q R S T U V
W X Y Z 1 2 3 4 5 6 7
8 9 0 fi fl À

HxqkmHxqkmHxqkmHxqkmHxqkmHxqkmHxqkm

20, 16, 12, 10, 8, 6, 4 pt

Just one thought further and I am sixteen, and the trees are in bloom underneath wildly billowing curtains of rain. I stand in a meandering line of people with my father and mother, getting closer to the Grand Palais step by step, where a Picasso exhibition is being shown. We are like beads on a rosary. We have the arthropodal tread of slaves, who, by sheer numbers alone, will manage to drag the enormous stone of expectation to the gate. The exhibition only confirms the greatness of my father, who painted the two pastiches that hang above the couch in our living room, signed Pissacco. When we are looking for our car afterwards – none of us paid attention to the street name when we parked it – Paris seizes me. Eventually, we find the car, which has changed into a 'bagnole'. [*From the short story* Par(ad)is Revisité]

Font size 9 / 11 pt

Font size 28/13 mm

A B C D E F G H I J K
L M N O P Q R S T U V
W X Y Z a b c d e f g
h i j k l m n o p q r
s t u v w x y z 1 2 3
4 5 6 7 8 9 0 ? ! () []
& "" «» ;: / - – à ç é î
A B C D E F G H I J K
L M N O P Q R S T U V
W X Y Z 1 2 3 4 5 6 7
8 9 0 fi fl À

HxqkmHxqkmHxqkmHxqkmHxqkmHxqkmHxqkm

20, 16, 12, 10, 8, 6, 4 pt

Font size 9 / 11 pt

Just one thought further and I am sixteen, and the trees are in bloom underneath wildly billowing curtains of rain. I stand in a meandering line of people with my father and mother, getting closer to the Grand Palais step by step, where a Picasso exhibition is being shown. We are like beads on a rosary. We have the arthropodal tread of slaves, who, by sheer numbers alone, will manage to drag the enormous stone of expectation to the gate. The exhibition only confirms the greatness of my father, who painted the two pastiches that hang above the couch in our living room, signed Pissacco. When we are looking for our car afterwards – none of us paid attention to the street name when we parked it – Paris seizes me. Eventually, we find the car, which has changed into a 'bagnole'. [From the short story PAR(AD)IS REVISITÉ]

A B C D E F G H I J K
L M N O P Q R S T U V
W X Y Z a b c d e f g
h i j k l m n o p q r
s t u v w x y z 1 2 3
4 5 6 7 8 9 0 ? ! () []
& "" «» ;: / - – à ç é î

A B C D E F G H I J K
L M N O P Q R S T U V
W X Y Z 1 2 3 4 5 6 7
8 9 0 fi fl À

HxqkmHxqkmHxqkmHxqkmHxqkmHxqkmHxqkm

20, 16, 12, 10, 8, 6, 4 pt

Just one thought further and I am sixteen, and the trees are in bloom underneath wildly billowing curtains of rain. I stand in a meandering line of people with my father and mother, getting closer to the Grand Palais step by step, where a Picasso exhibition is being shown. We are like beads on a rosary. We have the arthropodal tread of slaves, who, by sheer numbers alone, will manage to drag the enormous stone of expectation to the gate. The exhibition only confirms the greatness of my father, who painted the two pastiches that hang above the couch in our living room, signed Pissacco. When we are looking for our car afterwards – none of us paid attention to the street name when we parked it – Paris seizes me. Eventually, we find the car, which has changed into a 'bagnole'. [*From the short story*

Font size 9 / 11 pt

A B C D E F G H I J K
L M N O P Q R S T U V
W X Y Z a b c d e f g
h i j k l m n o p q r
s t u v w x y z 1 2 3
4 5 6 7 8 9 0 ? ! () []
& "" «» ;: / - – à ç é î

A B C D E F G H I J K
L M N O P Q R S T U V
W X Y Z 1 2 3 4 5 6 7
8 9 0 fi fl À

6
7
8
9
10
11
12
14
16
18
20
22
24
28
32
36
42

HxqkmHxqkmHxqkmHxqkmHxqkmHxqkmHxqkm

Just one thought further and I am sixteen, and the trees are in bloom underneath wildly billowing curtains of rain. I stand in a meandering line of people with my father and mother, getting closer to the Grand Palais step by step, where a Picasso exhibition is being shown. We are like beads on a rosary. We have the arthropodal tread of slaves, who, by sheer numbers alone, will manage to drag the enormous stone of expectation to the gate. The exhibition only confirms the greatness of my father, who painted the two pastiches that hang above the couch in our living room, signed Pissacco. When we are looking for our car afterwards – none of us paid attention to the street name when we parked it – Paris seizes me. Eventually, we find the car, which has changed into a 'bagnole'. [From the short story

48
60
72

A B C D E F G H I J K
L M N O P Q R S T U V
W X Y Z a b c d e f g
h i j k l m n o p q r
s t u v w x y z 1 2 3
4 5 6 7 8 9 0 ? ! () []
& "" ‹› ;: / - – à ç é î
fi fl

HxqkmHxqkmHxqkmHxqkmHxqkmHxqkmHxqkm

20, 16, 12, 10, 8, 6, 4 pt

Just one thought further and I am sixteen, and the trees are in bloom underneath wildly billowing curtains of rain. I stand in a meandering line of people with my father and mother, getting closer to the Grand Palais step by step, where a Picasso exhibition is being shown. We are like beads on a rosary. We have the arthropodal tread of slaves, who, by sheer numbers alone, will manage to drag the enormous stone of expectation to the gate. The exhibition only confirms the greatness of my father, who painted the two pastiches that hang above the couch in our living room, signed Pissacco. When we are looking for our car afterwards – none of us paid attention to the street name when we parked it – Paris seizes me. Eventually, we find the car, which has changed into a 'bagnole'.

Font size 9 / 11 pt

A B C D E F G H I J K
L M N O P Q R S T U V
W X Y Z a b c d e f g
h i j k l m n o p q r
s t u v w x y z 1 2 3
4 5 6 7 8 9 0 ? ! () []
& "" ‹› ;: / - – à ç é î
fi fl

Hxqkm Hxqkm Hxqkm Hxqkm Hxqkm Hxqkm Hxqkm

20, 16, 12, 10, 8, 6, 4 pt

Font size 9 / 11 pt

Just one thought further and I am sixteen, and the trees are in bloom underneath wildly billowing curtains of rain. I stand in a meandering line of people with my father and mother, getting closer to the Grand Palais step by step, where a Picasso exhibition is being shown. We are like beads on a rosary. We have the arthropodal tread of slaves, who, by sheer numbers alone, will manage to drag the enormous stone of expectation to the gate. The exhibition only confirms the greatness of my father, who painted the two pastiches that hang above the couch in our living room, signed Pissacco. When we are looking for our car afterwards – none of us paid attention to the street name when we parked it – Paris seizes me. Eventually, we find the car, which has changed into a 'bagnole'.

ITC Officina Sans

Officina Sans from 1990 is type designer Erik Spieker-mann's favourite letter be-cause, according to him, it is a re-design of Letter Gothic by IBM. Meta is also one of his typefaces, which makes his handwriting unmistakable. There is also a Serif version of Officina. Officina is drawn slightly thinner than FF Letter Gothic shown below.
Font size: 9/11 pt.

Just one thought further and I am sixteen, and the trees are in bloom underneath wildly billowing curtains of rain. I stand in a mean-dering line of people with my father and mother, getting closer to the Grand Palais step by step, where a Picasso exhibition is being shown. We are like beads on a rosary. We have the arthropodal tread of slaves, who, by sheer numbers alone, will manage to drag the enormous stone of expectation to the gate. The exhibition only confirms the greatness of my father, who painted the two pastiches that hang above the couch in our living room, signed Pissacco. [*From the short story* Par(ad)is Revisité]

RQEN baegn *baegn*

ABCDEFGHIJKLMNOPQRSTUVWXYZ
abcdefghijklmnopqrstuvwxyz 0123456789

FF Letter Gothic

In 1998, Albert Pinggera made this text version of the fa-mous mono-spaced type-writer letter by IBM, which was designed in 1956 by Roger Roberson. Erik Spieker-mann's design of Meta was inspired by Letter Gothic.
Font size: 9/11 pt.

Just one thought further and I am sixteen, and the trees are in bloom underneath wildly billowing curtains of rain. I stand in a mean-dering line of people with my father and mother, getting closer to the Grand Palais step by step, where a Picasso exhibition is being shown. We are like beads on a rosary. We have the arthropodal tread of slaves, who, by sheer numbers alone, will manage to drag the enormous stone of expectation to the gate. The exhibition only confirms the greatness of my father, who painted the two pastiches that hang above the couch in our living room, signed Pissacco. [*From the short story* Par(ad)is Revisité]

RQEN baegn *baegn*

ABCDEFGHIJKLMNOPQRSTUVWXYZ
abcdefghijklmnopqrstuvwxyz 0123456789

Linotype Textra

Jochen Schuss and Jörg Herz designed this typeface in 2002. It has a slightly irregu-lar character for a sans-serif, which makes it less formal and therefore suitable for use as a body type. The Book version, shown to the right, is quite light in colour and has a reasonably large face. The strong character of the Bold and Heavy make them well suited for use in head-ings and displays. Influences of Meta (with the exception of the 'g') are clearly visible.
Font size: 8.8/11 pt.

Just one thought further and I am sixteen, and the trees are in bloom underneath wildly billowing curtains of rain. I stand in a mean-dering line of people with my father and mother, getting closer to the Grand Palais step by step, where a Picasso exhibition is being shown. We are like beads on a rosary. We have the arthropodal tread of slaves, who, by sheer numbers alone, will manage to drag the enormous stone of expectation to the gate. The exhibition only confirms the great-ness of my father, who painted the two pastiches that hang above the couch in our living room, signed Pissacco. [*From the short story* Par(ad)is Revisité]

RQEN baegn *baegn*

ABCDEFGHIJKLMNOPQRSTUVWXYZ
abcdefghijklmnopqrstuvwxyz 0123456789

Foundry Journal
Foundry Journal by David Quay was designed in 1995 and is actually an improved, new design of ITC Quay Sans that he made before starting his own type company. Journal has a small face, like Profile, and an unusually heavy Bold style.
Font size: 9.2/11 pt.

Just one thought further and I am sixteen, and the trees are in bloom underneath wildly billowing curtains of rain. I stand in a meandering line of people with my father and mother, getting closer to the Grand Palais step by step, where a Picasso exhibition is being shown. We are like beads on a rosary. We have the arthropodal tread of slaves, who, by sheer numbers alone, will manage to drag the enormous stone of expectation to the gate. The exhibition only confirms the greatness of my father, who painted the two pastiches that hang above the couch in our living room, signed Pissacco. [*From the short story* PAR(AD)IS REVISITÉ]

RQEN baegn *baegn*

ABCDEFGHIJKLMNOPQRSTUVWXYZ
abcdefghijklmnopqrstuvwxyz 0123456789

FF Info Text
Originating from the same designer, influences of FF Meta and ITC Officina are clearly present here. Erik Spiekermann designed Info in 1996 as a signposting type. When he realised that the typeface also worked well in body text, Info Text and Info Office were added with the help of Ole Schäfer. Info Text is efficient and has a small face. In Info, all sharp corners have been rounded.
Font size: 9.5/11 pt.

Just one thought further and I am sixteen, and the trees are in bloom underneath wildly billowing curtains of rain. I stand in a meandering line of people with my father and mother, getting closer to the Grand Palais step by step, where a Picasso exhibition is being shown. We are like beads on a rosary. We have the arthropodal tread of slaves, who, by sheer numbers alone, will manage to drag the enormous stone of expectation to the gate. The exhibition only confirms the greatness of my father, who painted the two pastiches that hang above the couch in our living room, signed Pissacco. [*From the short story* PAR(AD)IS REVISITÉ]

RQEN baegn *baegn*

ABCDEFGHIJKLMNOPQRSTUVWXYZ
abcdefghijklmnopqrstuvwxyz 0123456789

Emigre Vista Sans
In 1998, Zuzana Licko's Tarzana proved that the use of style icons and breaking free of formal rules could give the world of type design a new impulse. Xavier Dupré followed this tradition to a slightly lesser degree in 2004 with the design of Vista Sans. It has a narrow appearance, like Meta, but with more extreme details such as the sharp corner in the curve of the 'a'.
Font size: 8.7/11 pt.

Just one thought further and I am sixteen, and the trees are in bloom underneath wildly billowing curtains of rain. I stand in a meandering line of people with my father and mother, getting closer to the Grand Palais step by step, where a Picasso exhibition is being shown. We are like beads on a rosary. We have the arthropodal tread of slaves, who, by sheer numbers alone, will manage to drag the enormous stone of expectation to the gate. The exhibition only confirms the greatness of my father, who painted the two pastiches that hang above the couch in our living room, signed Pissacco. [*From the short story* PAR(AD)IS REVISITÉ]

RQEN baegn *baegn*

ABCDEFGHIJKLMNOPQRSTUVWXYZ
abcdefghijklmnopqrstuvwxyz 0123456789

FontFont Meta+

Font size 5/6,5 pt

In Paris, new buildings thrive like ivy, she says, staring out the window as the sun's rays glide past. They colour with the seasons and quickly obtain the status of immortality. In front of the *Louvre*, for example, a glass pyramid has arisen from the surface in memory of a president. The *Gare d'Orsay*'s overcoat received a lining: a design train à grande vitesse stands in its final depot. And because of all this, *Café Costes* has already become the oldest watering place in Paris. All those 'immobile' creatures are, after a short period of discomfort, welcomed into the city's bosom as in-laws. [*From the short story* Par(ad)is Revisité]

6/7,5 pt

In Paris, new buildings thrive like ivy, she says, staring out the window as the sun's rays glide past. They colour with the seasons and quickly obtain the status of immortality. In front of the *Louvre*, for example, a glass pyramid has arisen from the surface in memory of a president. The *Gare d'Orsay*'s overcoat received a lining: a design train à grande vitesse stands in its final depot. And because of all this, *Café Costes* has already become the oldest watering place in Paris. All those 'immobile' creatures are, after a short period of discomfort, welcomed into the city's bosom as in-laws. [*From the short story* Par(ad)is Revisité]

7/8,5 pt

In Paris, new buildings thrive like ivy, she says, staring out the window as the sun's rays glide past. They colour with the seasons and quickly obtain the status of immortality. In front of the *Louvre*, for example, a glass pyramid has arisen from the surface in memory of a president. The *Gare d'Orsay*'s overcoat received a lining: a design train à grande vitesse stands in its final depot. And because of all this, *Café Costes* has already become the oldest watering place in Paris. All those 'immobile' creatures are, after a short

8/10 pt

In Paris, new buildings thrive like ivy, she says, staring out the window as the sun's rays glide past. They colour with the seasons and quickly obtain the status of immortality. In front of the *Louvre*, for example, a glass pyramid has arisen from the surface in memory of a president. The *Gare d'Orsay*'s overcoat received a lining: a design train à grande vitesse stands in its final depot. And because of all this, *Café Costes* has already become the oldest watering place in Paris. All those 'immobile' creatures are, after a short period of discomfort, wel-

10/12 pt

In Paris, new buildings thrive like ivy, she says, staring out the window as the sun's rays glide past. They colour with the seasons and quickly obtain the status of immortality. In front of the *Louvre*, for example, a glass pyramid has arisen from the surface in memory of a president. The *Gare d'Orsay*'s overcoat received a lining: a design train à grande vitesse stands in its final depot. And because of all this, *Café Costes* has already become the

Normal & Italic, Medium & Italic 24, 32, 40, 4

Corps

Corps

Corps

Corps

Bold & Bold Italic 24, 32, 40, 48 pt

Corps

Corps

Corps

Corps

Black & Black Italic 24, 32, 40, 48 pt

Corps

Corps

Corps

Corps

Linotype Optima

Roman
Italic
Medium
Medium Italic
Demi Bold
Demi Bold Italic
Bold
Bold Italic
Black
Black Italic
Extra Black
Extra Black Italic

Hermann Zapf (born in 1918) has designed a respectable number of typefaces to date. On a different level he has also built a great name for himself as one of the most productive and especially most virtuoso calligraphers. His calligraphic influences originate from Rudolf Koch and from Edward Johnston, and handwriting has remained a visible element in most of his type designs. He is also a gifted publicist with books such as *Feder und Stichel* (1950 – calligraphic samples) and *Manuale Typographicum* (1954) to his name.
He was type director of D. Stempel AG in Frankfurt between 1945 and 1956 where he produced the typefaces *Palatino* (1948), *Melior* (1952) and *Aldus* (1954), among others. He has built himself a successful international career.

Optima, which became available in 1958, was inspired by fifteenth century Florentine inscriptional capitals, cut in stone: sans-serif letters with flared strokes and with a completely vertical axis in the round characters.
It was an experimental moment in typography, a cross between sans-serif and roman types. Zapf's intention with this typeface was to create a letter that combined the advantages of both seriffed and sans-serif typefaces.

A B C D E F G H I J K
L M N O P Q R S T U V
W X Y Z a b c d e f g
h i j k l m n o p q r
s t u v w x y z 1 2 3
4 5 6 7 8 9 0 ? ! () []
& "" «» ;: / - – à ç é î

HxqkmHxqkmHxqkmHxqkmHxqkmHxqkmHxqkm

20, 16, 12, 10, 8, 6, 4 pt

Just one thought further and I am sixteen, and the trees are in bloom underneath wildly billowing curtains of rain. I stand in a meandering line of people with my father and mother, getting closer to the Grand Palais step by step, where a Picasso exhibition is being shown. We are like beads on a rosary. We have the arthropodal tread of slaves, who, by sheer numbers alone, will manage to drag the enormous stone of expectation to the gate. The exhibition only confirms the greatness of my father, who painted the two pastiches that hang above the couch in our living room, signed Pissacco. When we are looking for our car afterwards – none of us paid attention to the street name when we parked it – Paris seizes me. Eventually, we find the car, which has changed into a 'bagnole'. [*From the short story*

Font size 9/11 pt

A B C D E F G H I J K
L M N O P Q R S T U V
W X Y Z a b c d e f g
h i j k l m n o p q r
s t u v w x y z 1 2 3
4 5 6 7 8 9 0 ? ! () []
& "" «» ;: / - – à ç é î

HxqkmHxqkmHxqkmHxqkmHxqkmHxqkmHxqkm

20, 16, 12, 10, 8, 6, 4 pt

Font size 9/11 pt

Just one thought further and I am sixteen, and the trees are in bloom underneath wildly billowing curtains of rain. I stand in a meandering line of people with my father and mother, getting closer to the Grand Palais step by step, where a Picasso exhibition is being shown. We are like beads on a rosary. We have the arthropodal tread of slaves, who, by sheer numbers alone, will manage to drag the enormous stone of expectation to the gate. The exhibition only confirms the greatness of my father, who painted the two pastiches that hang above the couch in our living room, signed Pissacco. When we are looking for our car afterwards – none of us paid attention to the street name when we parked it – Paris seizes me. Eventually, we find the car, which has changed into a 'bagnole'. [From the short story

A B C D E F G H I J K
L M N O P Q R S T U V
W X Y Z a b c d e f g
h i j k l m n o p q r
s t u v w x y z 1 2 3
4 5 6 7 8 9 0 ? ! () []
& "" «» ;: / - – à ç é î

HxqkmHxqkmHxqkmHxqkmHxqkmHxqkmHxqkm

20, 16, 12, 10, 8, 6, 4 pt

Just one thought further and I am sixteen, and the trees are in bloom underneath wildly billowing curtains of rain. I stand in a meandering line of people with my father and mother, getting closer to the Grand Palais step by step, where a Picasso exhibition is being shown. We are like beads on a rosary. We have the arthropodal tread of slaves, who, by sheer numbers alone, will manage to drag the enormous stone of expectation to the gate. The exhibition only confirms the greatness of my father, who painted the two pastiches that hang above the couch in our living room, signed Pissacco. When we are looking for our car afterwards – none of us paid attention to the street name when we parked it – Paris seizes me. Eventually, we find the car, which has

Font size 9/11 pt

A B C D E F G H I J K
L M N O P Q R S T U V
W X Y Z a b c d e f g
h i j k l m n o p q r
s t u v w x y z 1 2 3
4 5 6 7 8 9 0 ? ! () []
& "" «» ;: / - – à ç é î

HxqkmHxqkmHxqkmHxqkmHxqkmHxqkmHxqkm

20, 16, 12, 10, 8, 6, 4 pt

Font size 9/11 pt

Just one thought further and I am sixteen, and the trees are in bloom underneath wildly billowing curtains of rain. I stand in a meandering line of people with my father and mother, getting closer to the Grand Palais step by step, where a Picasso exhibition is being shown. We are like beads on a rosary. We have the arthropodal tread of slaves, who, by sheer numbers alone, will manage to drag the enormous stone of expectation to the gate. The exhibition only confirms the greatness of my father, who painted the two pastiches that hang above the couch in our living room, signed Pissacco. When we are looking for our car afterwards – none of us paid attention to the street name when we parked it – Paris seizes me. Eventually, we find the car, which has

A B C D E F G H I J K
L M N O P Q R S T U V
W X Y Z a b c d e f g
h i j k l m n o p q r
s t u v w x y z 1 2 3
4 5 6 7 8 9 0 ? ! () []
& "" «» ;: / - – à ç é î

HxqkmHxqkmHxqkmHxqkmHxqkmHxqkmHxqkm 20, 16, 12, 10, 8, 6, 4 pt

Just one thought further and I am sixteen, and the trees are in Font size 9/11 pt
bloom underneath wildly billowing curtains of rain. I stand in a
meandering line of people with my father and mother, getting
closer to the Grand Palais step by step, where a Picasso exhibition
is being shown. We are like beads on a rosary. We have the arthro-
podal tread of slaves, who, by sheer numbers alone, will manage to
drag the enormous stone of expectation to the gate. The exhibition
only confirms the greatness of my father, who painted the two
pastiches that hang above the couch in our living room, signed
Pissacco. When we are looking for our car afterwards – none of us
paid attention to the street name when we parked it – Paris seizes
me. Eventually, we find the car, which has changed into a 'bagnole'.

A B C D E F G H I J K
L M N O P Q R S T U V
W X Y Z a b c d e f g
h i j k l m n o p q r
s t u v w x y z 1 2 3
4 5 6 7 8 9 0 ? ! () []
& "" «» ;: / - – à ç é î

HxqkmHxqkmHxqkmHxqkmHxqkmHxqkmHxqkm

20, 16, 12, 10, 8, 6, 4 pt

Just one thought further and I am sixteen, and the trees are in bloom underneath wildly billowing curtains of rain. I stand in a meandering line of people with my father and mother, getting closer to the Grand Palais step by step, where a Picasso exhibition is being shown. We are like beads on a rosary. We have the arthropodal tread of slaves, who, by sheer numbers alone, will manage to drag the enormous stone of expectation to the gate. The exhibition only confirms the greatness of my father, who painted the two pastiches that hang above the couch in our living room, signed Pissacco. When we are looking for our car afterwards – none of us paid attention to the street name when we parked it – Paris seizes me. Eventually, we find the car, which has changed into a 'bagnole'.

Font size 9/11 pt

A B C D E F G H I J K
L M N O P Q R S T U V
W X Y Z a b c d e f g
h i j k l m n o p q r
s t u v w x y z 1 2 3
4 5 6 7 8 9 0 ? ! () []
& *""* «» ;: / - – à ç é î

HxqkmHxqkmHxqkmHxqkmHxqkmHxqkmHxqkm

Just one thought further and I am sixteen, and the trees are in bloom underneath wildly billowing curtains of rain. I stand in a meandering line of people with my father and mother, getting closer to the Grand Palais step by step, where a Picasso exhibition is being shown. We are like beads on a rosary. We have the arthropodal tread of slaves, who, by sheer numbers alone, will manage to drag the enormous stone of expectation to the gate. The exhibition only confirms the greatness of my father, who painted the two pastiches that hang above the couch in our living room, signed Pissacco. When we are looking for our car afterwards – none of us paid attention to the street name when we parked it – Paris seizes me. Eventually, we find the car, which has changed into a 'bagnole'.

A B C D E F G H I J K
L M N O P Q R S T U V
W X Y Z a b c d e f g
h i j k l m n o p q r
s t u v w x y z 1 2 3
4 5 6 7 8 9 0 ? ! () []
& "" «» ;: / - – à ç é î

HxqkmHxqkmHxqkmHxqkmHxqkmHxqkmHxqkm

20, 16, 12, 10, 8, 6, 4 pt

Just one thought further and I am sixteen, and the trees are in bloom underneath wildly billowing curtains of rain. I stand in a meandering line of people with my father and mother, getting closer to the Grand Palais step by step, where a Picasso exhibition is being shown. We are like beads on a rosary. We have the arthropodal tread of slaves, who, by sheer numbers alone, will manage to drag the enormous stone of expectation to the gate. The exhibition only confirms the greatness of my father, who painted the two pastiches that hang above the couch in our living room, signed Pissacco. When we are looking for our car afterwards – none of us paid attention to the street name when we parked it – Paris seizes me. Eventually, we find the car, which has changed into a 'bagnole'.

Font size 9/11 pt

ITC Legacy Sans
Legacy Sans was designed in 1992 by Ronald Arnholm as a sans-serif for use in combination with the serif letter ITC Legacy. Legacy is based on Nicolas Jenson's roman from 1470. The classical background of Legacy is similar to that of Optima.
Font size: 9/11 pt.

Just one thought further and I am sixteen, and the trees are in bloom underneath wildly billowing curtains of rain. I stand in a meandering line of people with my father and mother, getting closer to the Grand Palais step by step, where a Picasso exhibition is being shown. We are like beads on a rosary. We have the arthropodal tread of slaves, who, by sheer numbers alone, will manage to drag the enormous stone of expectation to the gate. The exhibition only confirms the greatness of my father, who painted the two pastiches that hang above the couch in our living room, signed Pissacco. [*From the short story* PAR(AD)IS REVISITÉ]

RQEN baegn *baegn*

ABCDEFGHIJKLMNOPQRSTUVWXYZ
abcdefghijklmnopqrstuvwxyz 0123456789

Linotype (Omnibus) Odense
Franko Luin designed Odense in 1994 and in doing so consciously entered an area in which Optima had been all-powerful for a long time. He considered the differences between them to be as great as the differences between a Garamond and a Baskerville. And this is true. The thick-thin contrast of Odense is more comparable to a seriffed typeface.
Font size: 9/11 pt.

Just one thought further and I am sixteen, and the trees are in bloom underneath wildly billowing curtains of rain. I stand in a meandering line of people with my father and mother, getting closer to the Grand Palais step by step, where a Picasso exhibition is being shown. We are like beads on a rosary. We have the arthropodal tread of slaves, who, by sheer numbers alone, will manage to drag the enormous stone of expectation to the gate. The exhibition only confirms the greatness of my father, who painted the two pastiches that hang above the couch in our living room, signed Pissacco. [*From the short story* PAR(AD)IS REVISITÉ]

RQEN baegn *baegn*

ABCDEFGHIJKLMNOPQRSTUVWXYZ
abcdefghijklmnopqrstuvwxyz 0123456789

FF Bradlo Sans
Bradlo is a unique humanistic sans-serif from 1995 by Slovenian designer Andrej Kràtky, which was originally designed as a corporate typeface for a large Slovenian bank. There is also a slab-serif version of Bradlo available, shown here to the right in red. Bradlo does not include an italic. Unusual characteristics are the notches that serve to compensate for ink squash in smaller sizes but which also have an aesthetic function in the larger sizes.
Font size: 8.3/11 pt.

Just one thought further and I am sixteen, and the trees are in bloom underneath wildly billowing curtains of rain. I stand in a meandering line of people with my father and mother, getting closer to the Grand Palais step by step, where a Picasso exhibition is being shown. We are like beads on a rosary. We have the arthropodal tread of slaves, who, by sheer numbers alone, will manage to drag the enormous stone of expectation to the gate. The exhibition only confirms the greatness of my father, who painted the two pastiches that hang above the couch in our living room, signed Pissacco. [From the short story Par(ad)is Revisité]

RQEN baegn baegn

ABCDEFGHIJKLMNOPQRSTUVWXYZ
abcdefghijklmnopqrstuvwxyz 0123456789

Linotype Optima *alternatives*

AT Rotis Semi Sans
Rotis from 1989 by Otl Aicher was designed to achieve optimal legibility. The Semi Sans is part of a hybrid type family that also includes a Serif, a Semi Serif and a Sans-serif. The Sans-serif had less thick-thin contrast than the Semi Sans. Rotis is frowned upon by a number of typographers yet is admired by just as many. As number 32 of Fontshop's '100 best typefaces of all time' its popularity is certain. Font size: 9.3/11 pt.

Just one thought further and I am sixteen, and the trees are in bloom underneath wildly billowing curtains of rain. I stand in a meandering line of people with my father and mother, getting closer to the Grand Palais step by step, where a Picasso exhibition is being shown. We are like beads on a rosary. We have the arthropodal tread of slaves, who, by sheer numbers alone, will manage to drag the enormous stone of expectation to the gate. The exhibition only confirms the greatness of my father, who painted the two pastiches that hang above the couch in our living room, signed Pissacco. [*From the short story* Par(ad)is Revisité]

RQEN baegn *baegn*

ABCDEFGHIJKLMNOPQRSTUVWXYZ
abcdefghijklmnopqrstuvwxyz 0123456789

Linotype Finnegan
Jürgen Weltin designed this typeface in 1997. Like Optima, Legacy and Odense, it is inspired by humanistic types from the Renaissance period. Although they have a less prominent thick-thin contrast, the joins of the lines are more accentuated. Finnegan has a large extended letter family with small capitals and old style figures in all styles and is therefore particularly suited for use as a body type. Font size: 9/11 pt.

Just one thought further and I am sixteen, and the trees are in bloom underneath wildly billowing curtains of rain. I stand in a meandering line of people with my father and mother, getting closer to the Grand Palais step by step, where a Picasso exhibition is being shown. We are like beads on a rosary. We have the arthropodal tread of slaves, who, by sheer numbers alone, will manage to drag the enormous stone of expectation to the gate. The exhibition only confirms the greatness of my father, who painted the two pastiches that hang above the couch in our living room, signed Pissacco. [*From the short story* PAR(AD)IS REVISITÉ]

RQEN baegn *baegn*

ABCDEFGHIJKLMNOPQRSTUVWXYZ
abcdefghijklmnopqrstuvwxyz 0123456789

FF Legato
Evert Bloemsma was particularly proud of his Legato from 2004. It is an innovative typeface because it is not only designed using the black forms of the characters themselves but also clearly using the white space in and around the the letter. The slight thickening at the ends of the lines highlights a similarity with Optima, but in many ways it remains his personal solution to the quest for optimal legibility. Font size: 8.4/11 pt.

Just one thought further and I am sixteen, and the trees are in bloom underneath wildly billowing curtains of rain. I stand in a meandering line of people with my father and mother, getting closer to the Grand Palais step by step, where a Picasso exhibition is being shown. We are like beads on a rosary. We have the arthropodal tread of slaves, who, by sheer numbers alone, will manage to drag the enormous stone of expectation to the gate. The exhibition only confirms the greatness of my father, who painted the two pastiches that hang above the couch in our living room, signed Pissacco. [*From the short story* PAR(AD)IS REVISITÉ]

RQEN baegn *baegn*

ABCDEFGHIJKLMNOPQRSTUVWXYZ
abcdefghijklmnopqrstuvwxyz 0123456789

Linotype Optima

Font size 5 /6,5 pt

In Paris, new buildings thrive like ivy, she says, staring out the window as the sun's rays glide past. They colour with the seasons and quickly obtain the status of immortality. In front of the *Louvre*, for example, a glass pyramid has arisen from the surface in memory of a president. The *Gare d'Orsay*'s overcoat received a lining: a design train à grande vitesse stands in its final depot. And because of all this, *Café Costes* has already become the oldest watering place in Paris. All those 'immobile' creatures are, after a short period of discomfort, welcomed into the city's bosom as in-laws. [*From the short story* Par(ad)is Revisité]

6 /7,5 pt

In Paris, new buildings thrive like ivy, she says, staring out the window as the sun's rays glide past. They colour with the seasons and quickly obtain the status of immortality. In front of the *Louvre*, for example, a glass pyramid has arisen from the surface in memory of a president. The *Gare d'Orsay*'s overcoat received a lining: a design train à grande vitesse stands in its final depot. And because of all this, *Café Costes* has already become the oldest watering place in Paris. All those 'immobile' creatures are, after a short period of discomfort, welcomed into the city's bosom as in-laws. [*From the short story* Par(ad)is Revisité]

7 / 8,5 pt

In Paris, new buildings thrive like ivy, she says, staring out the window as the sun's rays glide past. They colour with the seasons and quickly obtain the status of immortality. In front of the *Louvre*, for example, a glass pyramid has arisen from the surface in memory of a president. The *Gare d'Orsay*'s overcoat received a lining: a design train à grande vitesse stands in its final depot. And because of all this, *Café Costes* has already become the oldest watering place in Paris. All those 'immobile' creatures are, after

8 / 10 pt

In Paris, new buildings thrive like ivy, she says, staring out the window as the sun's rays glide past. They colour with the seasons and quickly obtain the status of immortality. In front of the *Louvre*, for example, a glass pyramid has arisen from the surface in memory of a president. The *Gare d'Orsay*'s overcoat received a lining: a design train à grande vitesse stands in its final depot. And because of all this, *Café Costes* has already become the oldest watering place in Paris. All those 'immobile' creatures are, after a short period of discomfort,

10 / 12 pt

In Paris, new buildings thrive like ivy, she says, staring out the window as the sun's rays glide past. They colour with the seasons and quickly obtain the status of immortality. In front of the *Louvre*, for example, a glass pyramid has arisen from the surface in memory of a president. The *Gare d'Orsay*'s overcoat received a lining: a design train à grande vitesse stands in its final depot. And because of all this, *Café*

Roman & Italic, Med. & Med It. 24, 32, 40, 4

Corps

Corps

Corps

Corps

Demi B. & D. B. It., Bold & B. It. 24, 32, 40, 4

Corps

Corps

Corps

Corps

Corps

Linotype Syntax

Sy

Light
Light Italic
Regular
Italic
Medium
Medium Italic
Bold
Bold Italic
Heavy
Heavy Italic
Black
Black Italic

Hans Eduard Meier (born 1922) designed this distinctive sans-serif that stems from the Renaissance humanists. As such it does not fall into the category of the 'Swiss' types but distinguishes itself with its dynamic, a more tangible than visible slant and diagonals with characteristic terminals perpendicular to the stroke direction. All this makes it excellent for use as a body type. Although Meier had designed *Syntax* back in 1955, it only appeared on the market in 1968 as one of the very last typefaces made for cast metal typesetting.

Between 1995 and 1999 *Syntax* was entirely re-drawn. In 2001 a 'real' italic was added as well as more styles, small capitals and old style figures. Most importantly, the *Syntax* family was extended with a Letter and a Serif variant.

A B C D E F G H I J K
L M N O P Q R S T U V
W X Y Z a b c d e f g
h i j k l m n o p q r
s t u v w x y z 1 2 3
4 5 6 7 8 9 0 ? ! () []
& " " « » ;: / – – à ç é î
A B C D E F G H I J K
L M N O P Q R S T U V
W X Y Z 1 2 3 4 5 6 7
8 9 0 ½ fi fl À

HxqkmHxqkmHxqkmHxqkmHxqkmHxqkmHxqkm

20, 16, 12, 10, 8, 6, 4 p

Font size 9/11 pt

Just one thought further and I am sixteen, and the trees are in bloom underneath wildly billowing curtains of rain. I stand in a meandering line of people with my father and mother, getting closer to the Grand Palais step by step, where a Picasso exhibition is being shown. We are like beads on a rosary. We have the arthropodal tread of slaves, who, by sheer numbers alone, will manage to drag the enormous stone of expectation to the gate. The exhibition only confirms the greatness of my father, who painted the two pastiches that hang above the couch in our living room, signed Pissacco. When we are looking for our car afterwards – none of us paid attention to the street name when we parked it – Paris seizes me. Eventually, we find the car, which has changed into a 'bag-

A B C D E F G H I J K
L M N O P Q R S T U V
W X Y Z a b c d e f g
h i j k l m n o p q r
s t u v w x y z 1 2 3
4 5 6 7 8 9 0 ? ! () []
& " " « » ; : / - – à ç é î

A B C D E F G H I J K
L M N O P Q R S T U V
W X Y Z 1 2 3 4 5 6 7
8 9 0 ½ fi fl À

HxqkmHxqkmHxqkmHxqkmHxqkmHxqkmHxqkm 20, 16, 12, 10, 8, 6, 4 pt

Font size 9/11 pt

Just one thought further and I am sixteen, and the trees are in bloom underneath wildly billowing curtains of rain. I stand in a meandering line of people with my father and mother, getting closer to the Grand Palais step by step, where a Picasso exhibition is being shown. We are like beads on a rosary. We have the arthropodal tread of slaves, who, by sheer numbers alone, will manage to drag the enormous stone of expectation to the gate. The exhibition only confirms the greatness of my father, who painted the two pastiches that hang above the couch in our living room, signed Pissacco. When we are looking for our car afterwards – none of us paid attention to the street name when we parked it – Paris seizes me. Eventually, we find the car, which has changed into a 'bagnole'. [From the short story PAR(AD)IS REVISITÉ]

A B C D E F G H I J K
L M N O P Q R S T U V
W X Y Z a b c d e f g
h i j k l m n o p q r
s t u v w x y z 1 2 3
4 5 6 7 8 9 0 ? ! () []
& "" «» ;: / – — à ç é î
A B C D E F G H I J K
L M N O P Q R S T U V
W X Y Z 1 2 3 4 5 6 7
8 9 0 ½ fi fl À

HxqkmHxqkmHxqkmHxqkmHxqkmHxqkmHxqkm 20, 16, 12, 10, 8, 6, 4 pt

Just one thought further and I am sixteen, and the trees are in bloom underneath wildly billowing curtains of rain. I stand in a meandering line of people with my father and mother, getting closer to the Grand Palais step by step, where a Picasso exhibition is being shown. We are like beads on a rosary. We have the arthropodal tread of slaves, who, by sheer numbers alone, will manage to drag the enormous stone of expectation to the gate. The exhibition only confirms the greatness of my father, who painted the two pastiches that hang above the couch in our living room, signed Pissacco. When we are looking for our car afterwards – none of us paid attention to the street name when we parked it – Paris seizes me. Eventually, we find the car, which has changed

Font size 9/11 pt

A B C D E F G H I J K

L M N O P Q R S T U V

W X Y Z a b c d e f g

h i j k l m n o p q r

s t u v w x y z 1 2 3

4 5 6 7 8 9 0 ? ! () []

& "" «» ;: / - – à ç é î

A B C D E F G H I J K

L M N O P Q R S T U V

W X Y Z 1 2 3 4 5 6 7

8 9 0 ½ fi fl À

HxqkmHxqkmHxqkmHxqkmHxqkmHxqkmHxqkm

20, 16, 12, 10, 8, 6, 4 pt

Font size 9 / 11 pt

Just one thought further and I am sixteen, and the trees are in bloom underneath wildly billowing curtains of rain. I stand in a meandering line of people with my father and mother, getting closer to the Grand Palais step by step, where a Picasso exhibition is being shown. We are like beads on a rosary. We have the arthropodal tread of slaves, who, by sheer numbers alone, will manage to drag the enormous stone of expectation to the gate. The exhibition only confirms the greatness of my father, who painted the two pastiches that hang above the couch in our living room, signed Pissacco. When we are looking for our car afterwards – none of us paid attention to the street name when we parked it – Paris seizes me. Eventually, we find the car, which has changed into a 'bagnole'. [From the short story

A B C D E F G H I J K
L M N O P Q R S T U V
W X Y Z a b c d e f g
h i j k l m n o p q r
s t u v w x y z 1 2 3
4 5 6 7 8 9 0 ? ! () []
& "" «» ;: / - – à ç é î
A B C D E F G H I J K
L M N O P Q R S T U V
W X Y Z 1 2 3 4 5 6 7
8 9 0 ½ fi fl À

HxqkmHxqkmHxqkmHxqkmHxqkmHxqkmHxqkm

20, 16, 12, 10, 8, 6, 4 pt

Just one thought further and I am sixteen, and the trees are in bloom underneath wildly billowing curtains of rain. I stand in a meandering line of people with my father and mother, getting closer to the Grand Palais step by step, where a Picasso exhibition is being shown. We are like beads on a rosary. We have the arthropodal tread of slaves, who, by sheer numbers alone, will manage to drag the enormous stone of expectation to the gate. The exhibition only confirms the greatness of my father, who painted the two pastiches that hang above the couch in our living room, signed Pissacco. When we are looking for our car afterwards – none of us paid attention to the street name when we parked it – Paris seizes me. Eventually, we find the car, which

Font size 9/11 pt

Font size 28/13 mm

A B C D E F G H I J K
L M N O P Q R S T U V
W X Y Z a b c d e f g
h i j k l m n o p q r
s t u v w x y z 1 2 3
4 5 6 7 8 9 0 ? ! () []
& "" «» ;: / - – à ç é î
A B C D E F G H I J K
L M N O P Q R S T U V
W X Y Z 1 2 3 4 5 6 7
8 9 0 ½ fi fl À

Hxqkm HxqkmHxqkmHxqkmHxqkmHxqkmHxqkm

20, 16, 12, 10, 8, 6, 4 pt

Just one thought further and I am sixteen, and the trees are in bloom underneath wildly billowing curtains of rain. I stand in a meandering line of people with my father and mother, getting closer to the Grand Palais step by step, where a Picasso exhibition is being shown. We are like beads on a rosary. We have the arthropodal tread of slaves, who, by sheer numbers alone, will manage to drag the enormous stone of expectation to the gate. The exhibition only confirms the greatness of my father, who painted the two pastiches that hang above the couch in our living room, signed Pissacco. When we are looking for our car afterwards – none of us paid attention to the street name when we parked it – Paris seizes me. Eventually, we find the car, which has changed into a 'bagnole'.

Font size 9/11 pt

6
7
8
9
10
11
12
14
16
18
20
22
24
28
32
36
42
48
60
72

A B C D E F G H I J K
L M N O P Q R S T U V
W X Y Z a b c d e f g
h i j k l m n o p q r
s t u v w x y z 1 2 3
4 5 6 7 8 9 0 ? ! () []
& "" «» ;: / - – à ç é î

HxqkmHxqkmHxqkmHxqkmHxqkmHxqkmHxqkm

20, 16, 12, 10, 8, 6, 4 p

Just one thought further and I am sixteen, and the trees are in bloom underneath wildly billowing curtains of rain. I stand in a meandering line of people with my father and mother, getting closer to the Grand Palais step by step, where a Picasso exhibition is being shown. We are like beads on a rosary. We have the arthropodal tread of slaves, who, by sheer numbers alone, will manage to drag the enormous stone of expectation to the gate. The exhibition only confirms the greatness of my father, who painted the two pastiches that hang above the couch in our living room, signed Pissacco. When we are looking for our car afterwards – none of us paid attention to the street name when we parked it – Paris seizes me. Eventually, we find the

Font size 9/11 pt

A B C D E F G H I J K
L M N O P Q R S T U V
W X Y Z a b c d e f g
h i j k l m n o p q r
s t u v w x y z 1 2 3
4 5 6 7 8 9 0 ? ! () []
& " " « » ; : / - – à ç é î

HxqkmHxqkmHxqkmHxqkmHxqkmHxqkmHxqkm

20, 16, 12, 10, 8, 6, 4 pt

Font size 9/11 pt

Just one thought further and I am sixteen, and the trees are in bloom underneath wildly billowing curtains of rain. I stand in a meandering line of people with my father and mother, getting closer to the Grand Palais step by step, where a Picasso exhibition is being shown. We are like beads on a rosary. We have the arthropodal tread of slaves, who, by sheer numbers alone, will manage to drag the enormous stone of expectation to the gate. The exhibition only confirms the greatness of my father, who painted the two pastiches that hang above the couch in our living room, signed Pissacco. When we are looking for our car afterwards – none of us paid attention to the street name when we parked it – Paris seizes me. Eventually, we find the car, which has

FF Quadraat Sans
One of the most classic-looking humanistic sans-serifs is Quadraat Sans from 1997, designed to be used alongside the seriffed Quadraat by Fred Smeijers from 1992. It is a complete typeface for body text with small capitals and old style figures.
Font size: 9/11 pt.

Just one thought further and I am sixteen, and the trees are in bloom underneath wildly billowing curtains of rain. I stand in a meandering line of people with my father and mother, getting closer to the Grand Palais step by step, where a Picasso exhibition is being shown. We are like beads on a rosary. We have the arthropodal tread of slaves, who, by sheer numbers alone, will manage to drag the enormous stone of expectation to the gate. The exhibition only confirms the greatness of my father, who painted the two pastiches that hang above the couch in our living room, signed Pissacco. [*From the short story* PAR(AD)IS REVISITÉ]

RQEN baegn *baegn*

ABCDEFGHIJKLMNOPQRSTUVWXYZ
abcdefghijklmnopqrstuvwxyz 0123456789

Berthold Formata
Bernd Möllenstädt designed Formata in 1984. In the tradition of Frutiger it includes an italic which is a sloped roman. The characters have more classical forms than Frutiger and the details are therefore more reminiscent of Syntax. It is a somewhat heavy type with a large face.
Font size: 8.2/11 pt.

Just one thought further and I am sixteen, and the trees are in bloom underneath wildly billowing curtains of rain. I stand in a meandering line of people with my father and mother, getting closer to the Grand Palais step by step, where a Picasso exhibition is being shown. We are like beads on a rosary. We have the arthropodal tread of slaves, who, by sheer numbers alone, will manage to drag the enormous stone of expectation to the gate. The exhibition only confirms the greatness of my father, who painted the two pastiches that hang above the couch in our living room, signed Pissacco. [*From the short story* Par(ad)is Revisité]

RQEN baegn *baegn*

ABCDEFGHIJKLMNOPQRSTUVWXYZ
abcdefghijklmnopqrstuvwxyz 0123456789

Lucasfonts TheSans
One of the most successful humanistic sans-serifs is without doubt the Thesis family, designed in 1994 by Lucas de Groot while working at Metadesign in Berlin, which was at the time the bureau of Fontshop founder Erik Spiekermann. With more than 140 styles, it was at the time one of the largest type families ever made. To date the family has increased in number to around three hundred with variants such as TheSerif, TheMix, TheSans and TheAntiqua.
Font size: 8.5/11 pt.

Just one thought further and I am sixteen, and the trees are in bloom underneath wildly billowing curtains of rain. I stand in a meandering line of people with my father and mother, getting closer to the Grand Palais step by step, where a Picasso exhibition is being shown. We are like beads on a rosary. We have the arthropodal tread of slaves, who, by sheer numbers alone, will manage to drag the enormous stone of expectation to the gate. The exhibition only confirms the greatness of my father, who painted the two pastiches that hang above the couch in our living room, signed Pissacco. [*From the short story* PAR(AD)IS REVISITÉ]

RQEN baegn *baegn*

ABCDEFGHIJKLMNOPQRSTUVWXYZ
abcdefghijklmnopqrstuvwxyz 0123456789

FF Scala Sans
In 1999 Martin Majoor added this sans-serif variant to his successful seriffed typeface Scala. Scala is more rigid than Quadraat Sans, which was designed by his fellow student Fred Smeijers. Nevertheless, the classic elements are unmistakable and these type designers are well-known for being adept in the traditions of the Arnhem school.
Font size: 8.8/11 pt.

Just one thought further and I am sixteen, and the trees are in bloom underneath wildly billowing curtains of rain. I stand in a meandering line of people with my father and mother, getting closer to the Grand Palais step by step, where a Picasso exhibition is being shown. We are like beads on a rosary. We have the arthropodal tread of slaves, who, by sheer numbers alone, will manage to drag the enormous stone of expectation to the gate. The exhibition only confirms the greatness of my father, who painted the two pastiches that hang above the couch in our living room, signed Pissacco. [*From the short story* PAR(AD)IS REVISITÉ]

RQEN baegn *baegn*

ABCDEFGHIJKLMNOPQRSTUVWXYZ
abcdefghijklmnopqrstuvwxyz 0123456789

Linotype Aroma
Tim Ahrens designed this typeface in 1999. He wanted to create a typeface with more character than Frutiger. The thick-thin contrast shows more similarities to Syntax than Frutiger. It has a large face. The small capitals are rather small and the italic has pronounced forms.
Font size: 8.3/11 pt.

Just one thought further and I am sixteen, and the trees are in bloom underneath wildly billowing curtains of rain. I stand in a meandering line of people with my father and mother, getting closer to the Grand Palais step by step, where a Picasso exhibition is being shown. We are like beads on a rosary. We have the arthropodal tread of slaves, who, by sheer numbers alone, will manage to drag the enormous stone of expectation to the gate. The exhibition only confirms the greatness of my father, who painted the two pastiches that hang above the couch in our living room, signed Pissacco. [*From the short story* PAR(AD)IS REVISITÉ]

RQEN baegn *baegn*

ABCDEFGHIJKLMNOPQRSTUVWXYZ
abcdefghijklmnopqrstuvwxyz 0123456789

FF Profile
Martin Wenzel designed Profile in 1999 as an everyday body type. It has classic proportions with a contemporary clarity and remains legible at smaller sizes. It is available in five weights with various sets of figures and small capitals. Wenzel studied in The Hague and this can be seen in the typeface. The body text of this book has been set using Profile.
Font size: 9/11 pt.

Just one thought further and I am sixteen, and the trees are in bloom underneath wildly billowing curtains of rain. I stand in a meandering line of people with my father and mother, getting closer to the Grand Palais step by step, where a Picasso exhibition is being shown. We are like beads on a rosary. We have the arthropodal tread of slaves, who, by sheer numbers alone, will manage to drag the enormous stone of expectation to the gate. The exhibition only confirms the greatness of my father, who painted the two pastiches that hang above the couch in our living room, signed Pissacco. [*From the short story* PAR(AD)IS REVISITÉ]

RQEN baegn *baegn*

ABCDEFGHIJKLMNOPQRSTUVWXYZ
abcdefghijklmnopqrstuvwxyz 0123456789

Linotype Syntax

Font size 5/6,5 pt

In Paris, new buildings thrive like ivy, she says, staring out the window as the sun's rays glide past. They colour with the seasons and quickly obtain the status of immortality. In front of the *Louvre*, for example, a glass pyramid has arisen from the surface in memory of a president. The *Gare d'Orsay*'s overcoat received a lining: a design train à grande vitesse stands in its final depot. And because of all this, *Café Costes* has already become the oldest watering place in Paris. All those 'immobile' creatures are, after a short period of discomfort, welcomed into the city's bosom as in-laws. [*From the short story* PAR(AD)IS

6/7,5 pt

In Paris, new buildings thrive like ivy, she says, staring out the window as the sun's rays glide past. They colour with the seasons and quickly obtain the status of immortality. In front of the *Louvre*, for example, a glass pyramid has arisen from the surface in memory of a president. The *Gare d'Orsay*'s overcoat received a lining: a design train à grande vitesse stands in its final depot. And because of all this, *Café Costes* has already become the oldest watering place in Paris. All those 'immobile' creatures are, after a short period of discomfort, welcomed into the city's bosom as in-laws. [*From the short story* PAR(AD)IS REVISITÉ]

7/8,5 pt

In Paris, new buildings thrive like ivy, she says, staring out the window as the sun's rays glide past. They colour with the seasons and quickly obtain the status of immortality. In front of the *Louvre*, for example, a glass pyramid has arisen from the surface in memory of a president. The *Gare d'Orsay*'s overcoat received a lining: a design train à grande vitesse stands in its final depot. And because of all this, *Café Costes* has already become the oldest watering place in Paris. All those

8/10 pt

In Paris, new buildings thrive like ivy, she says, staring out the window as the sun's rays glide past. They colour with the seasons and quickly obtain the status of immortality. In front of the *Louvre*, for example, a glass pyramid has arisen from the surface in memory of a president. The *Gare d'Orsay*'s overcoat received a lining: a design train à grande vitesse stands in its final depot. And because of all this, *Café Costes* has already become the oldest watering place in Paris. All those 'immobile' creatures are, after a

10/12 pt

In Paris, new buildings thrive like ivy, she says, staring out the window as the sun's rays glide past. They colour with the seasons and quickly obtain the status of immortality. In front of the *Louvre*, for example, a glass pyra-mid has arisen from the surface in memory of a president. The *Gare d'Orsay*'s overcoat received a lining: a design train à grande vitesse stands in its final depot. And because of all

Reg. & Italic, Med. & Med. It. 24, 32, 40,

Corps

Corps

Corps

Corps

Bold & It., Heavy & It., Bl. & It. 24, 32, 40,

Corps

Corps

Corps

Corps

Corp

Corp

Miscella-
neous

Berthold Script

Adobe Carta

P22 Cézanne Pro

Adobe Courier

FontFont Dingbats

FontFont ErikRightHand
& JustLeftHand

FontFont Isonorm 3098

Linotype Kuenstler Script

Adobe OCR-A/OCR-B

Adobe Prestige Elite

Adobe Trajan

Adobe Symbol

ITC Zapf Dingbats

Berthold Script

Regular *Berthold Script* is a design by Günter Gerhard Lange from 1977. Working for
Typefoundry Berthold, Lange has been one of Germany's most productive type
designers. It is fascinating to note that graphic designers and even type
designers almost always include a script when listing their top five favourite
typefaces. It is usually one of the classics such as *Bickham Script* by Richard
Lipton (based on engravings by George Bickham), *Mistral* by Roger Excoffon or
this *Berthold Script* by Günter Gerhard Lange, yet more recent designs such as
Cézanne by P22, *Dalliance* by Frank Heine and of course *Zapfino* by calligraphy
master Hermann Zapf are also among the best sold typefaces. Almost every
type publisher has at least one script to its name. An attractive pencil typeface
is *Bello* by Underware. The '100 Best typefaces of all time' by Fontshop includes
eight script typefaces.

Berthold Script

Font size 28/13 mm

A B C D E F G H I J K
L M N O P Q R S T U V
W X Y Z a b c d e f g
h i j k l m n o p q r
s t u v w x y z 1 2 3
4 5 6 7 8 9 0 ? ! () []
& " " « » ; : / - - à ç é î

Hxqkm Hxqkm Hxqkm Hxqkm Hxqkm Hxqkm Hxqkm

20, 16, 12, 10, 8, 6, 4 pt

Font size 9/11 pt

Just one thought further and I am sixteen, and the trees are in bloom underneath wildly billowing curtains of rain. I stand in a meandering line of people with my father and mother, getting closer to the 'Grand Palais' step by step, where a Picasso exhibition is being shown. We are like beads on a rosary. We have the arthropodal tread of slaves, who, by sheer numbers alone, will manage to drag the enormous stone of expectation to the gate. The exhibition only confirms the greatness of my father, who painted the two pastiches that hang above the couch in our living room, signed Pissacco. When we are looking for our car afterwards - none of us paid attention to the street name when we parked it - Paris seizes me. Eventually, we find the car, which has changed into a 'bagnole'. [From the short story Par (ad)is Revisité]

Adobe Carta

Regular *Adobe Carta* was designed by Lynne Garell in 1986 in the studios at Adobe. After studying a great number of maps of the U.S. Geological Survey and *National Geographic* maps, an extremely diverse set of symbols was created for use in maps for city planning, tourism, nature and environment and other applications. *Carta* has just one style.

Adobe Carta (English Mac-keyboard)

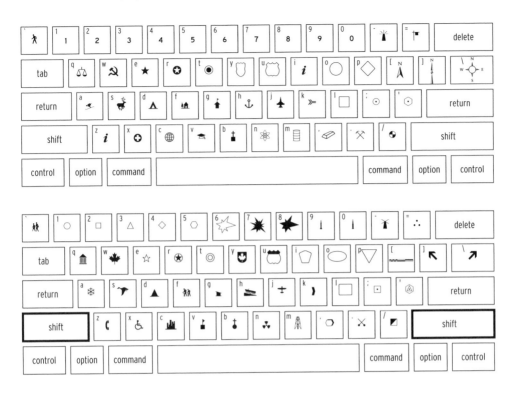

Adobe Carta (complete set of symbols from the 'Glyphs' menu)

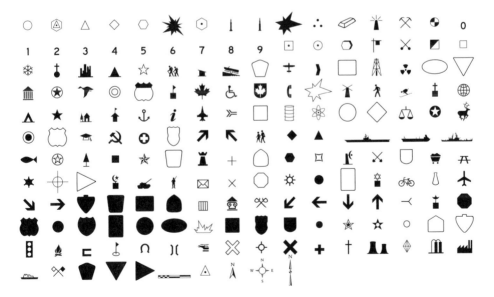

P22 Cézanne Pro

Cézanne

Regular — *P22 Cézanne* was designed in 1996 for an exhibition in the Philadelphia Museum of Art and is inspired by the handwriting of French painter Paul Cézanne. *Cézanne Pro* includes so-called alternates, which means that three alternative characters are included for every character of the Latin set. When the Contextual Alternates are selected in the OpenType menu, overlapping letters are avoided and the different letter alternatives are used together within a body of text. The word 'Cézanne' shown above uses two different versions of the letters 'e' and 'n'. When Swash is also selected, a decorative Swash letter is set as the last letter of each line. Characters can be manually replaced by using the Glyphs menu. As well as table figures, old style figures, proportional figures, fraction figures and superior and inferior figures are available. The handwritten character of the typeface is emphasised by the specific OpenType properties. Due to its widespread use in America, by Starbucks for example, it is now known as the new *Comic Sans*, after a script delivered as standard with Microsoft Windows. Because of the excessive use of *Comic Sans* in America, some designers have even started an anti *Comic Sans* movement.

20, 16, 12, 10, 8, 6, 4 pt

Font size 9/11 pt

Just one thought further and I am sixteen, and the trees are in bloom underneath wildly billowing curtains of rain. I stand in a meandering line of people with my father and mother, getting closer to the Grand Palais step by step, where a Picasso exhibition is being shown. We are like beads on a rosary. We have the arthropodal head of slaves, who, by sheer numbers alone, will manage to drag the enormous stone of expectation to the gate. The exhibition only confirms the greatness of my father, who painted the two pastiches that hang above the couch in our living room, signed Pissacco. When we are looking for our car afterwards – none of us paid attention to the street name when we parked it – Paris seizes me. Eventually, we find the car, which has changed into a 'bagnole'. [From the short story Par(ad)is Revisite]

Adobe Courier

Co

Regular
Oblique
Bold
Bold Oblique

Regular
Oblique
Bold
Bold Oblique

The appearance of *Courier* was in the past for many designers a warning of a possible typeface conflict. Through so-called font substitution, *Courier* would automatically appear on a printed document instead of the desired typeface. *Courier* was designed in 1955 by Howard Kettler. He based his design on a typewriter letter made by IBM in the fifties. Because IBM had not correctly registered the rights, it quickly became the standard letter used by competitor typewriter companies. It is a monospaced or non-proportional slab-serif, which also became extremely popular in the computer era. Adrian Frutiger re-designed *Courier* for the IBM Selectric Composers. By installation of Acrobat Reader on a computer, the *Adobe Courier* series shown here replaces the PostScript *Courier* that is installed as standard on all computers.

A B C D E F G H I J K
L M N O P Q R S T U V
W X Y Z a b c d e f g
h i j k l m n o p q r
s t u v w x y z 1 2 3
4 5 6 7 8 9 0 ? ! () []
& " " « » ; : / – — à ç é î

HxqkmHxqkmHxqkmHxqkmHxqkmHxqkmHxqkm

Just one thought further and I am sixteen, and the
trees are in bloom underneath wildly billowing
curtains of rain. I stand in a meandering line of
people with my father and mother, getting closer
to the Grand Palais step by step, where a Picasso
exhibition is being shown. We are like beads on a
rosary. We have the arthropodal tread of slaves,
who, by sheer numbers alone, will manage to drag
the enormous stone of expectation to the gate.
The exhibition only confirms the greatness of my
father, who painted the two pastiches that hang
above the couch in our living room, signed

A B C D E F G H I J K
L M N O P Q R S T U V
W X Y Z a b c d e f g
h i j k l m n o p q r
s t u v w x y z 1 2 3
4 5 6 7 8 9 0 ? ! () []
& " " « » ; : / – – à ç é î

HxqkmHxqkmHxqkmHxqkmHxqkmHxqkmHxqkm

20, 16, 12, 10, 8, 6, 4 pt

Just one thought further and I am sixteen, and the
trees are in bloom underneath wildly billowing
curtains of rain. I stand in a meandering line of
people with my father and mother, getting closer
to the Grand Palais step by step, where a Picasso
exhibition is being shown. We are like beads on a
rosary. We have the arthropodal tread of slaves,
who, by sheer numbers alone, will manage to drag
the enormous stone of expectation to the gate.
The exhibition only confirms the greatness of my
father, who painted the two pastiches that hang
above the couch in our living room, signed

Font size 9/11 pt

A B C D E F G H I J K
L M N O P Q R S T U V
W X Y Z a b c d e f g
h i j k l m n o p q r
s t u v w x y z 1 2 3
4 5 6 7 8 9 0 ? ! () []
& " " « » ; : / – – à ç é î

HxqkmHxqkmHxqkmHxqkmHxqkmHxqkmHxqkm

20, 16, 12, 10, 8, 6, 4 pt

Just one thought further and I am sixteen, and the
trees are in bloom underneath wildly billowing
curtains of rain. I stand in a meandering line of
people with my father and mother, getting closer
to the Grand Palais step by step, where a Picasso
exhibition is being shown. We are like beads on a
rosary. We have the arthropodal tread of slaves,
who, by sheer numbers alone, will manage to drag
the enormous stone of expectation to the gate.
The exhibition only confirms the greatness of my
father, who painted the two pastiches that hang
above the couch in our living room, signed

Font size 9/11 pt

A B C D E F G H I J K

L M N O P Q R S T U V

W X Y Z a b c d e f g

h i j k l m n o p q r

s t u v w x y z 1 2 3

4 5 6 7 8 9 0 ? ! () []

& " " « » ; : / – – à ç é î

HxqkmHxqkmHxqkmHxqkmHxqkmHxqkmHxqkm 20, 16, 12, 10, 8, 6, 4 pt

Just one thought further and I am sixteen, and the Font size 9/11 pt
trees are in bloom underneath wildly billowing
curtains of rain. I stand in a meandering line of
people with my father and mother, getting closer
to the Grand Palais step by step, where a Picasso
exhibition is being shown. We are like beads on a
rosary. We have the arthropodal tread of slaves,
who, by sheer numbers alone, will manage to drag
the enormous stone of expectation to the gate.
The exhibition only confirms the greatness of my
father, who painted the two pastiches that hang
above the couch in our living room, signed

FontFont Dingbats

There are hundreds of typefaces available which include symbols, signs and ornaments. With the success of *Zapf Dingbats* and *Symbol* it became clear how useful it was to be able to access these characters via the keyboard. However these typefaces did not include symbols such as an open square character or different versions of arrows, which prompted the most determined designers to illustrate these themselves and enter them manually. FontShop capitalized on these shortcomings with this series. It comprises arrows with rounded ends, arrows with various line weights and straight lines or slanted ones as well as much used symbols such as telephones, scissors, stars and symbols for cartography. As such it includes something to suit the different tastes of every designer. The symbols were designed by Johannes Erler and Olaf Stein from the Hamburg design studio Factor Design.

FontFont Dingbats *Arrows One*

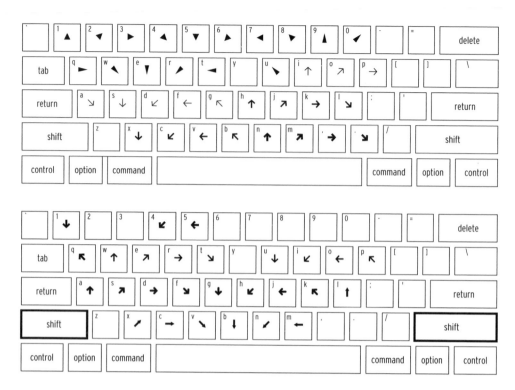

FontFont Dingbats *Arrows One* (complete set of symbols from the 'Glyphs' menu)

FontFont Dingbats *Arrows Two* (English Mac-keyboard)

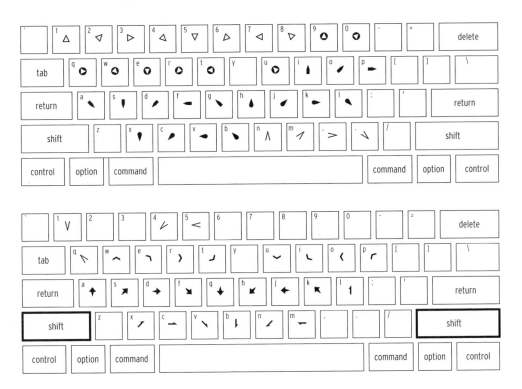

FontFont Dingbats *Arrows Two* (complete set of symbols from the 'Glyphs' menu)

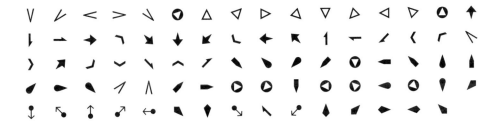

FontFont Dingbats *Basic Forms* (English Mac-keyboard)

FontFont Dingbats *Basic Forms* (complete set of symbols from the 'Glyphs' menu

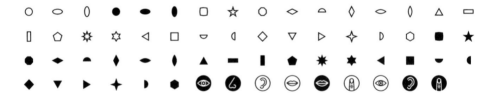

FontFont Dingbats *Number*

FontFont Dingbats *Number* (complete set of symbols from the 'Glyphs' menu)

FontFont Dingbats *Signs One* (English Mac-keyboard)

FontFont Dingbats *Signs One* (complete set of symbols from the 'Glyphs' menu)

FontFont Dingbats *Signs Two* (English Mac-keyboard)

FontFont Dingbats *Signs Two* (complete set of symbols from the 'Glyphs' menu)

FontFont Dingbats *Symbols One* (English Mac-keyboard)

FontFont Dingbats *Symbols One* (complete set of symbols from the 'Glyphs' me

FontFont Dingbats *Symbols Two* (English Mac-keyboard)

FontFont Dingbats *Symbols Two* (complete set of symbols from the 'Glyphs' menu)

FontFont ErikRightHand & JustLeftHand

ErikRightHand
JustLeftHand
(+ Caps)

Erik van Blokland and Just van Rossum have an on-off working relationship with their company LettError and after the randomfont Beowolf (1990) they designed both of these typefaces based on their own handwriting in 1991. As well as these scripts, they designed a number of 'readymades' such as *Trixie*, based on a typewriter letter, the stamp letter StampGothic and the tape embossing letter *Dynamoe*. It was actually the first counter-reaction to the digital rigidity which governed after the days of metal typesetting. Everything had to be perfect down to the thousandth of a millimetre. The LettError typefaces were a success and were used from MTV to the *Rolling Stone* magazine.

A B C D E F G H I J K
L M N O P Q R S T U V
W X Y Z a b c d e f g
h i j k l m n o p q r
s t u v w x y z 1 2 3
4 5 6 7 8 9 0 ? ! () []
&c ;: / – — A B C D E F
G H I J K L M N O P Q
R S T U V W X Y Z

HxqkmHxqkmHxqkmHxqkmHxqkmHxqkm

20, 16, 12, 10, 8, 6, 4 pt

Font size 9/11 pt

Just one thought further and I am sixteen, and the trees are in bloom underneath wildly billowing curtains of rain. I stand in a meandering line of people with my father and mother, getting closer to the Grand Palais step by step, where a Picasso exhibition is being shown. We are like beads on a rosary. We have the arthropodal tread of slaves, who, by sheer numbers alone, will manage to drag the enormous stone of expectation to the gate. The exhibition only confirms the greatness of my father, who painted the two pastiches that hang above the couch in our living room, signed Pissacco. When we are looking for our car afterwards – none of us paid attention to the street name when we parked it – Paris seizes me. Eventually, we find the car, which has changed into a 'bagnole'. [From the short story Par(ad)is Revisité]

20, 16, 12, 10, 8, 6, 4 pt

Font size 5 / 11 pt

Just one thought further and I am sixteen, and the trees are in bloom underneath wildly billowing curtains of rain. I stand in a meandering line of people with my father and mother, getting closer to the Grand Palais step by step, where a Picasso exhibition is being shown. We are like beads on a rosary. We have the arthropodal tread of slaves, who, by sheer numbers alone, will manage to drag the enormous stone of expectation to the gate. The exhibition only confirms the greatness of my father, who painted the two pastiches that hang above the couch in our living room, signed Pissacco. When we are looking for our car afterwards – none of us paid attention to the street name when we parked it – Paris seizes me. Eventually, we find the car, which has changed into a 'bagnole'. [From the short story PAR(AD)IS REVISITÉ]

FontFont Isonorm 3098

Is

3098 Regular
3098 Italic
(Monospaced Regular)
(Monospaced Italic)

Isonorm was introduced in 1980 by the ISO (International Standards Organisation). It is a simple typeface and has a geometric construction with lines of equal thickness and rounded ends. It can be easily read by both man and machine. Its construction makes it suitable for use with pen plotters in architectural illustrations and other technical drawings. There are proportional and monospaced or non-proportional versions. Robert Kirchner designed this version in 1993 for FontFont and unusually he also made expert versions for all four styles, with special accents, euro symbols and ligatures.

A B C D E F G H I J K
L M N O P Q R S T U V
W X Y Z a b c d e f g
h i j k l m n o p q r
s t u v w x y z 1 2 3
4 5 6 7 8 9 0 ? ! () []
& "" «» ;: / – – à ç é î

HxqkmHxqkmHxqkmHxqkmHxqkmHxqkmHxqkm

20, 16, 12, 10, 8, 6, 4 pt

Just one thought further and I am sixteen, and the trees are in bloom underneath wildly billowing curtains of rain. I stand in a meandering line of people with my father and mother, getting closer to the Grand Palais step by step, where a Picasso exhibition is being shown. We are like beads on a rosary. We have the arthropodal tread of slaves, who, by sheer numbers alone, will manage to drag the enormous stone of expectation to the gate. The exhibition only confirms the greatness of my father, who painted the two pastiches that hang above the couch in our living room, signed Pissacco. When we are looking for our car afterwards – none of us paid attention to the street name when we parked it – Paris seizes me. Eventually, we find the car, which has changed into a 'bagnole'. [*From the short story* Par(ad)is Revisité]

Font size 9/11 pt

A B C D E F G H I J K
L M N O P Q R S T U V
W X Y Z a b c d e f g
h i j k l m n o p q r
s t u v w x y z 1 2 3
4 5 6 7 8 9 0 ? ! () []
& "" «» ;: / - – à ç é î

HxqkmHxqkmHxqkmHxqkmHxqkmHxqkmHxqkm

20, 16, 12, 10, 8, 6, 4 pt

Font size 9/11 pt

Just one thought further and I am sixteen, and the trees are in bloom underneath wildly billowing curtains of rain. I stand in a meandering line of people with my father and mother, getting closer to the Grand Palais step by step, where a Picasso exhibition is being shown. We are like beads on a rosary. We have the arthropodal tread of slaves, who, by sheer numbers alone, will manage to drag the enormous stone of expectation to the gate. The exhibition only confirms the greatness of my father, who painted the two pastiches that hang above the couch in our living room, signed Pissacco. When we are looking for our car afterwards – none of us paid attention to the street name when we parked it – Paris seizes me. Eventually, we find the car, which has changed into a 'bagnole'. [From the short story Par(ad)is Revisité]

Linotype Kuenstler Script

Medium
Nr. 2 Bold
Black

Kuenstler Script is a classic in the handwriting category. The basic style was designed by the in-house studio of D. Stempel AG in 1902 and was given the name *Künstlerschreibschrift*. In 1957 Hans Bohn added a medium and a black style to *Kuenstler Script*. The typeface is based on nineteenth century copper engravings, which themselves were inspired by scripts from George Bickham, Charles Snell and George Shelley dating from the early eighteenth century. These were reproductions of a calligraphic writing style called 'Round hand', which originated from around 1660 in England. Similar typefaces are *Snell Roundhand* and *Bickham Script*.

A B C D E F G H I J K
L M N O P Q R S T U V
W X Y Z a b c d e f g
h i j k l m n o p q r
s t u v w x y z 1 2 3
4 5 6 7 8 9 0 ? ! () []
& " " « » ; : / | – — à ç é i

Hxgkm Hxgkm Hxgkm Hxgkm Hxgkm Hxgkm Hxgkm

20. 16. 12. 10. 8. 6. 4 pt

Font size 9/11 pt

Just one thought further and I am sixteen, and the trees are in bloom underneath wildly billowing curtains of rain. I stand in a meandering line of people with my father and mother, getting closer to the Grand Palais step by step, where a Picasso exhibition is being shown. We are like beads on a rosary. We have the arthropodal tread of slaves, who, by sheer numbers alone, will manage to drag the enormous stone of expectation to the gate. The exhibition only confirms the greatness of my father, who painted the two pastiches that hang above the couch in our living room, signed Pissacco. When we are looking for our car afterwards – none of us paid attention to the street name when we parked it – Paris seizes me. Eventually, we find the car, which has changed into a 'bagnole'. [From the short story Par(ad)is Revisité]

Font size 28/13 mm

A B C D E F G H I J K
L M N O P Q R S T U V
W X Y Z a b c d e f g
h i j k l m n o p q r
s t u v w x y z 1 2 3
4 5 6 7 8 9 0 ? ! () []
& " " « » ; : / - — à ç é i

HxgkmHxgkmHxgkmHxgkmHxgkmHxgkmHxgkm

20. 16. 12. 10. 8. 6. 4 pt

Font size 9/11 pt

Just one thought further and I am sixteen, and the trees are in bloom underneath wildly billowing curtains of rain.
I stand in a meandering line of people with my father and mother, getting closer to the Grand Palais step by step,
where a Picasso exhibition is being shown. We are like beads on a rosary. We have the arthropodal tread of slaves,
who, by sheer numbers alone, will manage to drag the enormous stone of expectation to the gate. The exhibition only
confirms the greatness of my father, who painted the two pastiches that hang above the couch in our living room,
signed Pissacco. When we are looking for our car afterwards — none of us paid attention to the street name when we
parked it — Paris seizes me. Eventually, we find the car, which has changed into a 'bagnole'. (From the short story
Par(ad)is Revisité.)

Linotype Kuenstler Script *Black*

Font size 28/13 mm

\mathcal{A} \mathcal{B} \mathcal{C} \mathcal{D} \mathcal{E} \mathcal{F} \mathcal{G} \mathcal{H} \mathcal{I} \mathcal{J} \mathcal{K}

\mathcal{L} \mathcal{M} \mathcal{N} \mathcal{O} \mathcal{P} \mathcal{Q} \mathcal{R} \mathcal{S} \mathcal{T} \mathcal{U} \mathcal{V}

\mathcal{W} \mathcal{X} \mathcal{Y} \mathcal{Z} a b c d e f g

h i j k l m n o p q r

s t u v w x y z 1 2 3

4 5 6 7 8 9 0 ? ! () []

& " " « » ; : / - – à ç é î

Hxgkm. Hxgkm. Hxgkm. Hxgkm. Hxgkm. Hxgkm. Hxgkm.

20. 16. 12. 10. 8. 6. 4 pt

Font size 9/11 pt

Just one thought further and I am sixteen, and the trees are in bloom underneath wildly billowing curtains of rain. I stand in a meandering line of people with my father and mother, getting closer to the Grand Palais step by step, where a Picasso exhibition is being shown. We are like beads on a rosary. We have the arthropodal tread of slaves, who, by sheer numbers alone, will manage to drag the enormous stone of expectation to the gate. The exhibition only confirms the greatness of my father, who painted the two pastiches that hang above the couch in our living room, signed Pissacco. When we are looking for our car afterwards – none of us paid attention to the street name when we parked it – Paris seizes me. Eventually, we find the car, which has changed into a 'bagnole'. [From the short story Par(ad)is Revisité]

Adobe OCR-A/OCR-B

OCR-A
OCR-B
(+ Alternate)
In 1951 David Shepard used a simple machine, which he called the Gismo, to experiment with the optical recognition of Morse codes, music notes and type-writer text. He registered this so-called Optical Character Recognition (OCR) under U.S. Patent number 2.663.758. He subsequently set up the company Intelligent Machines Research Corp. His first client was *Reader's Digest*, who were keen to use mechanical methods to read and register the data of millions of subscribers. This process required a typeface that could be easily recognised by a scanning machine with OCR software as well as easily read by people. The result was *OCR-A*, a non-proportional typeface that was produced as cast metal type by American Type Founders based on the criteria of the U.S. Bureau of Standards. *OCR-B* was designed in 1968 by Adrian Frutiger for competitor company Monotype, commissioned by European Computer Manufacturers Association (ECMA), and is more legible for people due to a newer generation of reading devices which are more tolerant with letter recognition. Both typefaces had a limited number of OCR characters but Adobe has added an alternate style to the digital version in which the complete ISO Adobe character set is available including accents and additional characters.

A B C D E F G H I J K
L M N O P Q R S T U V
W X Y Z a b c d e f g
h i j k l m n o p q r
s t u v w x y z 1 2 3
4 5 6 7 8 9 0 ? ! () []
& ; : / - —

H x q k m H x q k m H x q k m H x q k m H x q k m H x q k m H x q k m 20, 16, 12, 10, 8, 6, 4 pt

Just one thought further and I am sixteen, Font size 9/11 pt
and the trees are in bloom underneath
wildly billowing curtains of rain. I stand
in a meandering line of people with my
father and mother, getting closer to the
Grand Palais step by step, where a Picasso
exhibition is being shown. We are like
beads on a rosary. We have the arthropodal
tread of slaves, who, by sheer numbers
alone, will manage to drag the enormous
stone of expectation to the gate. The ex-
hibition only confirms the greatness of my

A B C D E F G H I J K
L M N O P Q R S T U V
W X Y Z a b c d e f g
h i j k l m n o p q r
s t u v w x y z 1 2 3
4 5 6 7 8 9 0 ? ! ()[]
& ;: / -

H x q k m H x q k m H x q k m H x q k m H x q k m H x q k m H x q k m 20, 16, 12, 10, 8, 6, 4 pt

Just one thought further and I am sixteen, Font size 9/11 pt
and the trees are in bloom underneath
wildly billowing curtains of rain. I stand
in a meandering line of people with my
father and mother, getting closer to the
Grand Palais step by step, where a Picasso
exhibition is being shown. We are like
beads on a rosary. We have the arthropodal
tread of slaves, who, by sheer numbers
alone, will manage to drag the enormous
stone of expectation to the gate. The ex-
hibition only confirms the greatness of my

Adobe Prestige Elite

Pr

Regular
Slanted
Bold
Bold Slanted

Prestige Elite was designed in 1954 by Howard Kettler for IBM and was originally intended for typewriters. It falls under the slab-serif group within the Vox+ Classification System. Although it no longer meets the current standards with regard to legibility, it still has an aesthetic value. *Prestige Elite* is a so-called monospaced or non-proportional typeface whereby each letter takes up the same amount of white space. This can clearly be seen with characters such as the 'i', 'f' and 'r' which would normally be drawn much narrower and with characters such as the 'w' and the 'm' which are much wider in proportional types and are extremely narrow in *Prestige Elite*.

Font size 28/13 mm

A B C D E F G H I J K
L M N O P Q R S T U V
W X Y Z a b c d e f g
h i j k l m n o p q r
s t u v w x y z 1 2 3
4 5 6 7 8 9 0 ? ! () []
& " " « » ; : / – – à ç é î

HxqkmHxqkmHxqkmHxqkmHxqkmHxqkmHxqkm

20, 16, 12, 10, 8, 6, 4 pt

Just one thought further and I am sixteen, and the
trees are in bloom underneath wildly billowing
curtains of rain. I stand in a meandering line of
people with my father and mother, getting closer
to the Grand Palais step by step, where a Picasso
exhibition is being shown. We are like beads on a
rosary. We have the arthropodal tread of slaves,
who, by sheer numbers alone, will manage to drag
the enormous stone of expectation to the gate.
The exhibition only confirms the greatness of
my father, who painted the two pastiches that
hang above the couch in our living room, signed

Font size 9/11 pt

Adobe Prestige Elite *Slanted*

Font size 28/13 mm

A B C D E F G H I J K
L M N O P Q R S T U V
W X Y Z a b c d e f g
h i j k l m n o p q r
s t u v w x y z 1 2 3
4 5 6 7 8 9 0 ? ! () []
& " " «» ; : / – – à ç é î

HxqkmHxqkmHxqkmHxqkmHxqkmHxqkmHxqkm

20, 16, 12, 10, 8, 6, 4 pt

Just one thought further and I am sixteen, and the trees are in bloom underneath wildly billowing curtains of rain. I stand in a meandering line of people with my father and mother, getting closer to the Grand Palais step by step, where a Picasso exhibition is being shown. We are like beads on a rosary. We have the arthropodal tread of slaves, who, by sheer numbers alone, will manage to drag the enormous stone of expectation to the gate. The exhibition only confirms the greatness of my father, who painted the two pastiches that hang above the couch in our living room, signed

Font size 9/11 pt

A B C D E F G H I J K
L M N O P Q R S T U V
W X Y Z a b c d e f g
h i j k l m n o p q r
s t u v w x y z 1 2 3
4 5 6 7 8 9 0 ? ! () []
& " " « » ; : / – – à ç é î

HxqkmHxqkmHxqkmHxqkmHxqkmHxqkmHxqkm 20, 16, 12, 10, 8, 6, 4 pt

Just one thought further and I am sixteen, and the Font size 9/11 pt
trees are in bloom underneath wildly billowing
curtains of rain. I stand in a meandering line of
people with my father and mother, getting closer
to the Grand Palais step by step, where a Picasso
exhibition is being shown. We are like beads on a
rosary. We have the arthropodal tread of slaves,
who, by sheer numbers alone, will manage to drag
the enormous stone of expectation to the gate.
The exhibition only confirms the greatness of
my father, who painted the two pastiches that
hang above the couch in our living room, signed

Adobe Prestige Elite *Bold Slanted*

Font size 28/13 mm

A B C D E F G H I J K
L M N O P Q R S T U V
W X Y Z a b c d e f g
h i j k l m n o p q r
s t u v w x y z 1 2 3
4 5 6 7 8 9 0 ? ! () []
& " " « » ; : / – - à ç é î

HxqkmHxqkmHxqkmHxqkmHxqkmHxqkmHxqkm

20, 16, 12, 10, 8, 6, 4 pt

Just one thought further and I am sixteen, and the
trees are in bloom underneath wildly billowing
curtains of rain. I stand in a meandering line of
people with my father and mother, getting closer
to the Grand Palais step by step, where a Picasso
exhibition is being shown. We are like beads on a
rosary. We have the arthropodal tread of slaves,
who, by sheer numbers alone, will manage to drag
the enormous stone of expectation to the gate.
The exhibition only confirms the greatness of
my father, who painted the two pastiches that
hang above the couch in our living room, signed

Font size 9/11 pt

Adobe Trajan

TR

Adobe Trajan from 1989 is based on Imperial Roman inscriptional letters cut in stone, in particular on the most famous example, on the column of emperor Trajanus, built in 113 AD in Rome. Designer Carol Twombly studied the inscriptions on the pillar and discovered that the letters could not be easily digitalised. The 'N' was too heavy, the 'S' too light and the serifs were very thin. Twombly corrected the serifs and the line thicknesses but in doing so tried to remain as close as possible to the originals. She added characters that do not appear in the inscription, such as punctuation marks and Arabic figures. *Adobe Trajan* is available only as capitals in Regular and Bold.

A B C D E F G H I J K
L M N O P Q R S T U V
W X Y Z 1 2 3 4 5 6 7
8 9 0 ? ! () [] & "" « » :;
/ - – À Ç É Î

A B C D E F G H I J K
L M N O P Q R S T U V
W X Y Z 1 2 3 4 5 6 7
8 9 0 ? ! () [] & "" « » :;
/ - – À Ç É Î

HXQKHXQKHXQKHXQKHXQKHXQKHXQK

20, 16, 12, 10, 8, 6, 4 PT

JUST ONE THOUGHT FURTHER AND I AM SIXTEEN,
AND THE TREES ARE IN BLOOM UNDERNEATH WILD-
LY BILLOWING CURTAINS OF RAIN. I STAND IN A
MEANDERING LINE OF PEOPLE WITH MY FATHER AND
MOTHER, GETTING CLOSER TO THE GRAND PALAIS
STEP BY STEP, WHERE A PICASSO EXHIBITION IS BEING
SHOWN. WE ARE LIKE BEADS ON A ROSARY. WE HAVE
THE ARTHROPODAL TREAD OF SLAVES, WHO, BY
SHEER NUMBERS ALONE, WILL MANAGE TO DRAG THE
ENORMOUS STONE OF EXPECTATION TO THE GATE.
THE EXHIBITION ONLY CONFIRMS THE GREATNESS
OF MY FATHER, WHO PAINTED THE TWO PASTICHES

FONT SIZE 9/11 PT

Adobe Symbol

Regular

Adobe Symbol is a so-called pi font and was delivered as a standard ROM font with the very first Apple LaserWriters, like *Zapf Dingbats* on the following pages. The design comes from the Adobe Type Staff and is based on *Times Roman*, which was also delivered as a standard ROM font. It includes a complete Greek alphabet, mathematical signs and various symbols. *Symbol* is included standard with various software programmes and is therefore installed on pretty much every computer. Bitstream also supplies a sans-serif version which gives a more formal result.

Adobe Symbol (English Mac-keyboard)

Adobe Symbol (complete set of symbols from the 'Glyphs' menu)

$$! \quad \# \quad \% \quad \& \quad (\quad) \quad + \quad , \quad . \quad / \quad 0 \quad 1 \quad 2 \quad 3 \quad 4 \quad 5$$

$$6 \quad 7 \quad 8 \quad 9 \quad : \quad ; \quad < \quad = \quad > \quad ? \quad [\quad] \quad _ \quad \{ \quad | \quad \}$$

$$\circ \quad \bullet \quad \neq \quad \infty \quad \pm \quad \leq \quad \geq \quad \mu \quad \partial \quad \sum \quad \prod \quad \pi \quad \int \quad \Omega \quad \neg \quad \sqrt{}$$

$$f \quad \approx \quad \Delta \quad \ldots \quad \div \quad \lozenge \quad / \quad \text{\Large\char"F8FF} \quad - \quad \times \quad \equiv \quad \downarrow \quad \leftarrow \quad \rightarrow \quad \uparrow \quad \leftrightarrow$$

$$\in \quad \cap \quad \cup \quad \lceil \quad \rfloor \quad A \quad B \quad \Gamma \quad E \quad Z \quad H \quad \Theta \quad I \quad K \quad \Lambda \quad M$$

$$N \quad \Xi \quad O \quad \Pi \quad P \quad \Sigma \quad T \quad Y \quad \Phi \quad X \quad \Psi \quad \alpha \quad \beta \quad \gamma \quad \delta \quad \zeta$$

$$\eta \quad \theta \quad \iota \quad \kappa \quad \lambda \quad \nu \quad \xi \quad o \quad \rho \quad \sigma \quad \underline{\varsigma} \quad \tau \quad \upsilon \quad \phi \quad \chi \quad \psi$$

$$\omega \quad \cdot \quad \prime \quad '' \quad \heartsuit \quad \clubsuit \quad \blacklozenge \quad \spadesuit \quad \propto \quad \quad \ni \quad \oplus \quad \otimes \quad \cong \quad \supset \quad \supseteq$$

$$\subset \quad \subseteq \quad \not\subset \quad \Downarrow \quad \Leftarrow \quad \Rightarrow \quad \Uparrow \quad \Leftrightarrow \quad \perp \quad \notin \quad \wedge \quad \vee \quad \angle \quad \therefore \quad \varnothing \quad |$$

$$\aleph \quad \lceil \quad \lfloor \quad \rceil \quad \rfloor \quad \forall \quad \exists \quad * \quad \rangle \quad \langle \quad \vartheta \quad \varpi \quad \varphi \quad \varepsilon \quad \nabla \quad ($$

$$\backslash \quad \rangle \quad / \quad \wp \quad \lceil \quad \{ \quad \lfloor \quad | \quad \rceil \quad \} \quad \rfloor \quad \Upsilon \quad | \quad — \quad | \quad |$$

$$| \quad | \quad © \quad ® \quad {}^{\text{TM}} \quad © \quad ® \quad {}^{\text{TM}} \quad \Im \quad \Re \quad \sim \quad \lrcorner \quad € \quad /$$

$- \ 493$

ITC Zapf Dingbats

Regular The symbols of *ITC Zapf Dingbats* are creations of Hermann Zapf who designed between 1000 and 1200 signs and symbols of which ITC eventually chose 360. Massive distribution was possible because it was, together with *Helvetica* and *Times*, one of the 35 typefaces delivered standard with the very first laser printers made by Apple and later other companies. With the so-called *Zapf Essentials*, a new version has been released but this does not include all the characters of the original *ITC Zapf Dingbats*.

ITC Zapf Dingbats (English Mac-keyboard)

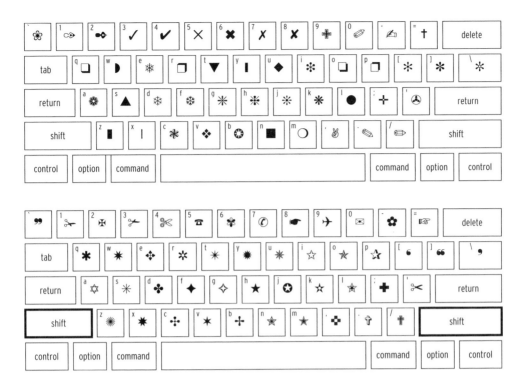

ITC Zapf Dingbats (complete set of symbols from the 'Glyphs' menu)

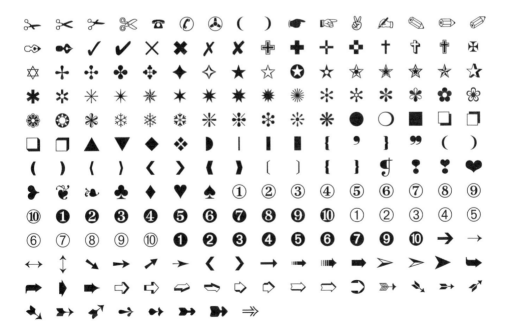

Appendix

3

General Index

This index lists reference terms and names to provide quick and easy access to the contents of this book. Names of (type) designers and names of typefaces are listed in separate indexes. The page numbers printed in red refer to a term that is accompanied by an image or illustration. Terms such as 'font', 'italic', 'regular' and 'typeface' and a large number of standard terms are used so often that we have indexed only their primary basic descriptions. Names of artists and art institutes in the time-line on pages 30–36 have not been included here as this index is limited to typographic related terms. Many of the terms are also described in more detail in the glossary.

Index of typefaces

This index lists all the typefaces named, illustrated or discussed in this book. The relevant page numbers of the typefaces illustrated in the book are shown in red. In some cases there is no type company listed because the reference applies to multiple typefaces from different companies that are all named after the same example. References are often made to the original design. Square brackets are used to refer to the type designer in question, as listed in the Index of type designers starting on page 511.

Index of type designers

This index lists the names of (type) designers and their respective typefaces that are mentioned in the main body of this book or whose typeface is named or illustrated. If the typeface of a particular designer is named in the book, the page references are printed in black, and the page references of typefaces illustrated in the book are printed in red. Type foundries are listed in the General Index. The current supplier of each typeface is listed, not the company for which it was originally designed. These are often no longer in existence, have been taken over by the current supplier, have issued a licence for the typeface in question to the current supplier or the authors' rights of the design are no longer valid.

Index of type companies

Since the art of printing began, with the 1455 Gutenberg Bible as starting point, both small and large type foundries have constantly appeared – sometimes as part of a printing company but also as specialised companies supplying type and/or punches and matrices to printing firms. At the end of the nineteenth century some companies also started supplying typesetting machines, first for cast metal typesetting and later for phototypesetting and digital setting. The availability of digital typefaces has now almost completely eliminated the need for these machines. This index is limited to the foundries and other suppliers that are mentioned in this book. There have been hundreds of such companies and it would be impracticable to discuss them all. The aim of this index is to provide a concise insight into history and to show how fusions between prominent foundries have led to the creation of today's type collections.

The photos in this index were made by Joep Pohlen, mostly from items in his own collection of books and type specimens.

Illustration from the 1990 Adobe Originals brochure, featuring Adobe Garamond, drawn by Robert Slimbach on the basis of Claude Garamond's original matrices and punches in the Plantin Moretus Museum. In 1990, it was innovative to add ligatures and old style figures in separate variants. Adobe called this the Expert Collection.

Adobe Type Library Adobe was founded in 1982 by John Warnock (1940 –) and Charles Geschke (1939 –). Warnock began developing the concept of language for describing documents in 1976 while working at Evans & Sutherland. From 1978 to 1982 he worked on the Interpress Graphics Language for Geschke at Xerox's Palo Alto Research Center (PARC). When Xerox failed to show any interest in further developing this language, Warnock and Geschke left and set up Adobe in 1982, using their experience to write what became the PostScript language. In 1984 they released it for Apple's very first LaserWriter.

Already in these early days of the desktop publishing revolution, they recognised the indispensable role of type design, so Adobe entered into an alliance with Linotype. They began enthusiastically digitising popular typefaces such as the well-known Helvetica. The company URW in Hamburg took care of the digitisation process using the Ikarus programme. This is why typefaces by Adobe and Linotype with the same name are identical. Adobe also added licensed typefaces to its collection from Monotype, Berthold and ITC. Their own Adobe Type Staff, including extremely productive designers such as Robert Slimbach and Carol Twombly, also begin creating their own collection, called Adobe Originals. Once Adobe established PostScript as industry standard, they stepped back from creating typefaces and concentrated once again on the production of software for desktop publishing and web design. Adobe developed the Multiple Master technology in the mid-nineties, allowing the user to interpolate between a limited number of basic fonts to create intermediate grades. When they abandoned this technology due to lack of interest, Adobe and Microsoft joined forces to develop the cross-platform OpenType technology, which the market embraced as a standard.

Although Adobe focussed only briefly on the production of their own new typefaces they have also created a number of attractive interpretations and added new designs.

Example typefaces: Adobe Garamond, Adobe Caslon, Trajan, Minion, Myriad, Utopia.

Situated in: San José, USA.

Website: www.adobe.com

Agfa/Compugraphic Compugraphic was founded in 1960 by William Garth Jr. In 1963 the company introduced the Linasec I and II, the first typesetting computers that made coded tape to control Linotype hot metal typesetting machines, then still normal for the production of newspapers and magazines. They increased the production rate from 600 to 3600 lines per hour, allowing newspapers to include much more recent news. In 1966 Compugraphic introduced the AP Offsetter for Associated Press, which uses a cable connection to prepare camera-ready copy. In 1967 they began to build their own type collection, beginning with Bodoni, and they put their first phototypesetting machines on the market in 1968. These were controlled by perforated coded tape made on a separate machine. In 1969 they released their first direct-entry typesetting machine for headings, and in 1971 their first direct-entry phototypesetter for body text, the CompuWriter, with four typefaces. These machines eliminated the punched paper tape. Compugraphic first released a new typeface of its own in 1973, Holland Seminar by designer Hollis Holland. Compugraphic continued to introduce steadily smaller, less expensive and more advanced typesetting machines. In 1981 they released the MCS (Modular Composition System) phototypesetting machine, with software and hardware modules that could be assembled to meet the requirements of the user. In the same year Agfa Gevaert Graphics Inc. purchased 51% of the shares. In 1982 they released their thousandth typeface, Shannon by Kris Holmes and Janice Prescott. Shannon is an interpretation of Zapf's Optima By 1984 the company could offer fifteen hundred typefaces. The type collection consists

Part of the title page of the *Compugraphic* type specimen (1985).

mainly of licensed typefaces. In 1987 Compugraphic also developed Intellifont, a technology used to enlarge and reduce typefaces while applying hinting. This patented technology was later added to the control software (from PCL-5) of Hewlett-Packard printers and became an industry standard. Agfa later used it in its Universal Font Scaling Technology (UFST). Agfa took over Compugraphic completely in 1988 and took over Monotype in 1999, continuing under the name Agfa Monotype. They sold the entire typeface division in 2004 and now operate under the name Monotype Imaging.

Example typefaces: Shannon, Garth Graphic, Holland Seminar, Triumvirate, Feinen.

Established in: Brookline, USA.

Website: www.fonts.com

Aldus Manutius In 1495 Aldus (ca. 1449–1515) set up a printing and publishing office in Venice and soon became one of the most significant sources of inspiration of the Italian Renaissance. He first concentrated on scholarly editions of Greek classics in the original Greek, beginning with a five volume Aristotle (1495–1498). It's even been claimed the workmen conversed in Greek in the printing office. His most important publication in Latin is *De Aetna* from 1495 by Pietro Bembo (1470–1547) who also edited texts for Manutius. It was to be thirty-five years before the roman type of this modest little book was to prove a turning point in typographic history. Aldus' publications also include *La Divina Commedia* by Dante and poems by Francesco Petrarca. The *Hypnerotomachia Poliphili* by Francesco Colonna from 1499 is Aldus Manutius' masterwork. The punchcutter Francesco Griffo (1450–1518) cut all Aldus's types, including the world's first italic type, cut in 1500 for his 1501 edition of Virgil. After Aldus Manutius' death, his brothers-in-law operated the printing office until his son Paulus Manutius, only three at his fathers death, took over in the 1530's. He passed it on to his son Aldus Manutius the younger in the 1560's. In 1595 the Aldine printers ceases to exist. The press issued about a thousand publications between 1495 and 1595. With the famous

The title page of the book *Della vera tranquillità dell'animo* (1544), written by Isabella Sforza. The title page also contains Aldus Manutius's publisher's device: the anchor and dolphin.

Hypnerotomachia Poliphili as his example, Stanley Morison designed the Monotype Poliphilus. The Monotype Bembo is designed using the typeface from *De Aetna* as starting point. A number of typefaces, such as the ITC Legacy and the LTC Cloister, are made using examples of Jenson's work for the roman, but the italics are always based on Aldus' publications. Claude Garamond also based his romans (indirectly) on Francesco Griffo's roman for Aldus's *De Aetna*.

Example typefaces: Monotype Poliphilus, Monotype Bembo, Bitstream Aldine 401.

Situated in: Venice, Italy.

Website: n.a.

American Type Founders In 1892, 23 American typefoundries merged to American Type Founders (ATF) to better compete with the Linotype hot-metal typesetting machines and later with Mono-type. American typefoundries had depended heavily on purchases by local newspapers, which began to introduce the Linotype in 1886. The only way the foundries could survive was to eliminate competion between foundries and to turn to the larger display types. The merged partners re-tained their separate identies for a few years and a small numer of independent typefoundries held out for a few years, but by 1919 ATF was the only United States typefoundry. Robert Nelson (1851–1926) became general manager in 1894 and presi-dent in 1901. This merger also brought together the materials of the most historically significant type foundries, such as Binny & Ronaldson, Boston Type Foundry, Central Type Foundry, Cincinnati Type Foundry, Dickinson Type Foundry, Farmer, Little & Co, Bruce Type Foundry, Barnhart Brothers & Spindler and Inland Type Foundry. The new company had its head office in Jersey City. Marketing manager Henry Lewis Bullen (1857–1938) had a great deal of influence at ATF and played an important role in building its type collection. In the early days the partners remai-ned in their old locations and retained a degree of independence. Joseph W. Phinney of the Dickinson Type Foundry asked William Morris for permission to produce his Golden Type. When

Morris refused Phinney published his own version in 1893, Jenson Old Style. Phinney, keen to release more new typefaces, purchased the first type designed by the young Frederic W. Goudy (1865–1947) sent to him unsolicited and released in 1896 as Camelot. Goudy was to become one of America's most productive type designers. He claimed not to know exactly how many typefaces he designed but in Goudy's *Type Designs* he lists 123 for various type foundries. Some were more successful than others (some were made only for handsetting). He designed the ever-popular Copperplate Gothic for ATF in 1901 and in 1916 the classic Goudy Old Style. ATF's in-house designer Morris Fuller Benton (1872–1948) would later add several extra grades to this typeface. He was the son of Linn Boyd Benton, inventor of the panto-graph, which stimulated a great development in the production of punches and matrices. Linn Boyd Benton and his company Benton, Waldo & Company was one of the original 23 companies to form ATF. His colleague Waldo was in charge of sales. Linn Boyd ran the type foundry and con-stantly improved production techniques. In 1885 his company delivered the first pantograph to Monotype. It was the pantograph that made type-setting machines practical. Morris Fuller followed in his father's footsteps at ATF, working there from 1900 to 1937. M.D. Hitchcock, *Benton Types*, lists more than 200 typefaces he designed during this period. He worked closely with Henry Lewis Bullen, who also began setting up the ATF mu-seum and library in 1908. Most of this incredible library went to Columbia University. The thick ATF type specimens dating from 1912 and 1923 are absolute gems. Morris Fuller Benton made various successful versions of classic typefaces such as Cloister and Garamond. He also designed an altered version of Goudy Old Style, called Goudy Catalogue and considered by many to be more attractive than the original. In 1903 he designed the sans-serif Alternate Gothic and in 1906 Cen-tury Old Style, based on the 1894 Century, which his father had designed together with the pub-lisher Theodore Low De Vinne for the like-named periodical. Bertram Grosvenor Goodhue (1869–

1924), architect by trade, designed Cheltenham in 1896 for the Cheltenham Press in New York. Cheltenham was an enormous success and Morris Fuller Benton added almost thirty grades to it for ATF from 1904 to 1915, the first extensive seriffed typeface family. He designed Franklin Gothic (1903), News Gothic (1908), Clearface (1907), Souvenir (1914), Bulmer (a 1928 revival of a typeface by William Martin from 1791) and Stymie (1931). Other designers who worked for ATF were W.A. Parker (Bookman, 1903), Hermann Ihlenburg (Bradley, 1895, Roundhand, 1900), Max R. Kaufmann (Kaufmann Script, 1936), Oswald Bruce Cooper (Cooper Black, 1922), Warren Chappell (Lydian, 1938), Will Bradley (Wayside, 1900), Freeman Craw (Ad Lib, 1961), Lucien Bernhard (Bernhard Gothic, 1929) and William Martin Johnson (Bulfinch Oldstyle, 1903). Hit hard by the 1929 stock market crash, ATF sold some of its

collection in the 1930's and 1940's but remained an important player in the market after the War. Its turnover dropped until it was taken over by the Kingsley Holding Company in 1986. In 1993 the company closed its doors and the matrices and punches were sold. An unsuccessful attempt was made to sell digital typefaces under the name Kingsley/ATF, which continues to licence typefaces to various type companies.
Example typefaces: Goudy Old Style, Franklin Gothic, Bank Gothic, Alternate Gothic, Copperplate Gothic, Americana.
Situated in: Jersey City, USA.
Website: n.a.

Aviation Partners Founded in 1987 by Nicholas Garner and Jacqueline Millar. The design of typefaces began as a service for clients and grew to become one of the company's main products. The

The American Specimen Book of Type Styles by the American Type Founders Company (1912) has 1304 pages. Here a sample setting of the successful Cheltenham.

most famous typeface is Fiendstar, designed as an alternative to Gill Sans Schoolbook and intended mainly for use in schoolbooks for the visually impaired.

Example typefaces: Fiendstar, Sky Sans, Sky Serif, Kensington
Situated in: London, Great Britain.
Website: www.codesign.co.uk

John Baskerville Baskerville (1706–1775) began his career as writing-master around 1733 and also cut gravestones. Around 1750 he began setting up a printing office and in 1754 published a type specimen containing new types cut under his guidance by John Handy. His stunningly beautiful 1757 edition of *Virgil* instantly established his reputation. He reformed not only typography but also the printing press (building his own), paper (Whatman making the first wove paper for him, which he hot-pressed after printing) and ink (prepared himself) to achieve the desired result. His books gained fame and his types were widely copied, but his venture into printing was a disappointment financially and his interest in it flagged in the 1760's. Failing to sell his materials, he resumed printing. In 1762 he published a type specimen that is printed on coated paper and is unprecedented in its quality and richness of contrast. When his widow sold his type, matrices and punches in 1779, the older Caslon types were returning to fashion and finding no English purchaser she sold the entire collection to Beaumarchais of the French 'Société Littéraire-Typographique'. In 1953 Charles Peignot, who came into possession of them after taking over another type foundry, donated the original punches and matrices to the University of Cambridge, thereby returning this historic material to England.

Example typefaces: Baskerville
Situated in: Birmingham, Great Britain.
Website: n.a.

Bauersche Gießerei Founded in 1837 in Frankfurt am Main by the punchcutter Johann Christian Bauer (1802–1867). He learned the trade from the punchcutter Andreas Schneider and worked for several foundries and in partnership before setting up on his own. At the time, England was the place to be in the world of punchcutting and typefounding. In 1839 he therefore moved to England and then Edinburgh, supplying typefoundries and in 1845 setting up his own typefoundry in partnership, Bauer, Ferguson & Huie. Returning to Frankfurt in 1847 he continued his foundry with his English punches and matrices, meeting great success. At his death in 1867 he left a company that supplied typographic material around the world. His wife and two of his sons sold the company in 1873 to share holder August Schorr and salesman Eduard Kramer. The oldest son, Friedrich Eduard Bauer had already set up his own business elsewhere as letter

A life-size specimen of the Diamant-Antiqua (1858), cut by Johann Christian Bauer, *before* the arrival of the pantograph! Taken from the publication *Werden und Wachsen einer Deutschen Schriftgießerei*, Bauersche Gießerei, 1937.

Folio in a Bauer type specimen (1960).

began working for Bauer. In 1909 he designed Weiss-Fraktur. With the 1912 acquisition of the A. Numrich & Co. foundry, Bauer took over famous typefaces such as Leipziger Fraktur and high quality music types. By 1914 Bauer employed four hundred people with around a hundred casting machines. The upheaval of the First World War ruined the export market and the company's turnover plummeted to a fraction of what it was, but in 1916 Bauer boldly took over Schriftgiesserei Flinsch (successor to Dresler & Rost-Fingerlin, established 1827, where Christian Bauer had learned the trade). Flinsch continued briefly under its old name. This takeover added 145,000 punches to Bauer's collection, further expanded when they took over Schriftgießerei Wilhelm von Maur and a part of Schriftgießerei Brötz & Glock in 1918, partly to acquire their metal for casting, which was scarce during the war. The acquisition of Flinsch also brought the excellent punchcutter Louis Höll to work at Bauer, where he later cut Bauer Bodoni under the direction of Heinrich Jost. The owner's son Carl Hartmann joined the management of the company in 1919 and his son-in-law Ernst Vischer in 1920. After the war the company met success again with types like Paul Renner's famous Futura (influenced by Bauhaus ideas) in 1924, Weiss-Antiqua by Emil Rudolf Weiss in 1925 and Corvinus by Imre Reiner in 1934. Heinrich Jost became artistic director in 1923 and designed the extremely successful Bauer Bodoni in 1926 and the Beton Halbfett in 1929. Other designers to have worked for Bauer, including some with wilder designs, are Lucian Bernhard (Bernhard, 1912), Jakob Erbar (Candida, 1930), Friedrich Hermann Ernst Schneidler (Schneidler Old Style, 1936), Francesco Simoncini (Simoncini Garamond, 1961), Adrian Frutiger (Serifa, 1966) and Karlgeorg Hoefer (Big Band, 1974). Konrad Friedrich Bauer and Walter Baum, designers employed by Bauersche Gießerei, designed Folio in 1957, similar to Berthold's Akzidenz Grotesk but issued as Helvetica and Univers began to appear. They also design Impressum in 1962 and Volta in 1956, a slab-serif in the tradition of Clarendon. In 1972 all activities in Frankfurt ceased and were turned

cutter but returned to work at the Bauersche Gießerei. His designs such as the Akzidenz-Gotisch and the Breite Gotisch, both from 1876, proved enormously successful. In 1880 Schorr sold his shares to Gustav Fuchs, who deserves some credit for the enormous growth of the company. In 1881 the Bauersche Gießerei also began producing typecasting machines, having acquired the German patent rights to the Universal-, Typengieß- und Fertigmach-Maschine. In 1885 Bauer acquired the typefoundry of the letterpress printing office N. Ramirez y Rialp in Barcelona, where they set up a branch office under the Frankfurt-born Jacob de Neufville. In 1895 Fuchs left the company and in 1798 Kramer sold it to Georg Hartmann, son of an influencial Frankfurt family, who became the new company director.

He enlisted famous designers to create new typefaces. The artist Heinrich Wieynck designed several, including the extremely successful Trianon in 1905. The advertising artist August Haiduk designed Haiduk-Antiqua in 1909 and Friedrich Wilhelm Kleuskens designs Kleuskens-Antiqua in 1910. In 1913 followed the display types Femina and Majestic by Julius Gipkens. At the same time the young Emil Rudolf Weiss also

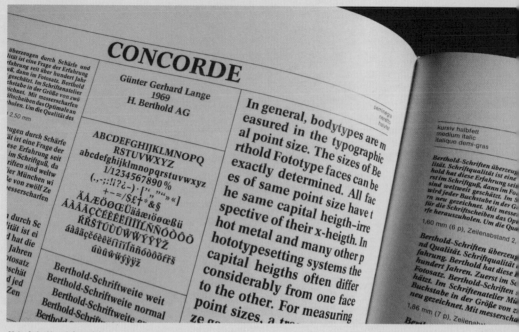

Günter Gerhard Lange's Concorde in a
Berthold type specimen (1985).

over to Fundición Tipográfica Neufville in Barcelona, a daughter enterprise of Bauersche Gießerei. Neufville Digital still sells digital type and licences of the affiliated companies such as Fundición Tipográfica Neufville, Bauersche Giesserei, Ludwig & Mayer, Fonderie Typographique Française and Fundición Tipográfica Nacional.

Example typefaces: Bernhard Antiqua, Bauer Bodoni, Beton, Candida, Folio, Volta, Futura, Weiss, Schneidler, Serifa, Life.

Situated in: Barcelona, Spain.

Website: www.neufville.com

H. Berthold AG Founded in 1858 by Hermann Berthold (1831–1904) as 'Institut für Galvanotypie', shareholder G. Zechendorf adding a type foundry and a workshop for making stereotype plates in 1861. In 1864 Berthold continued alone as H. Berthold Schriftgießerei und Messinglinienfabrik. He adopted the Didot point (2660 points/meter) encouraging many other typefoundries to accept this standard. The directorship passed to Alfred Selberg in 1888 and Balthasar Kohler in 1891 and under him the firm became a limited company in 1896. H. Berthold AG continued to expand and

acquire other companies, including Schriftgießerei Gustav Reinhold in 1893, Schriftgießerei Bauer & Co. in Stuttgart in 1897, Gießerei Georg Russ & Co. in St. Petersburg in 1900 and Gießerei Rust & Co. in Vienna in 1905. In 1908 Berthold purchased the Theinhardtsche Schriftgiesserei from Ferdinand Theinhardt including the matrices and punches of the ca. 1880 sans-serif Royal-Grotesk. All these acquisitions greatly extended Berthold's type collection and in 1911 they published a voluminous type specimen comprising no less than 850 pages. After the dissolution of the monarchy in Germany in 1918, Berthold added the 'majestic' Royal-Grotesk to the Akzidenz Grotesk family, which was designed in 1898 with the Royal-Grotesk as its inspiration. A new acquisition in 1912 was the St. Petersburg office of Flinsch typefoundry, with around 145,000 punches and 420,000 matrices. Erwin Graumann, from the acquired company Gießerei Gursch, became the new company director in 1917. By 1918 H. Berthold AG was the world's largest typefoundry. In 1926 Berthold collaborated with D. Stempel AG to take over the Poppelbaum typefoundry in Vienna. In spite of the damage from bombing during the Second World War, production

resumed soon after and Curt Thier became managing director in 1956. The firm introduced its first phototypesetting machine, the Diatype, in 1958 and switched its focus more to the production of machines than of typefaces. In 1967 they released the Diatronic, the first direct-entry phototypesetting machine. Designer Günter Gerhard Lange joined Berthold in 1950 and as artistic director from 1961 to 1990 was responsible for the expansion of the extensive type collection of around 1800 typefaces. In the 1980's, Berthold began to digitise typefaces using URW's Ikarus system, and in 1991 they collaborated with Adobe, which began selling 365 Berthold BE (Berthold Exclusives) typefaces. The drastically reduced market for typesetting machines caused Berthold to go bankrupt in 1993. H. Berthold-Systeme was created from the remnants of the company but once again ceased business in 1996, selling its typeface rights to Berthold Types in Chicago. In 2000 they brought the 80-year-old Günter Gerhard Lange back to breathe new life into the collection. He designed Whittingham, not a version of Caslon, as the name might suggest, but a revival of a didone that Charles Whittingham and his English Chiswick Press used at the time they also began reviving Caslon's types. In 2001 he added various grades to Akzidenz Grotesk. His rhetorical qualities and provocative speaking earned him the nickname 'Gutenberg's machine gun'. Lange died in 2008.
Example typefaces: Akzidenz Grotesk, Concorde Nova, City, Berthold Bodoni, Berthold Baskerville, Berthold Garamond, Arena, Imago.
Situated in: Berlin, Germany.
Website: www.bertholdtypes.com

Bitstream Matthew Carter and Mike Parker, both initially employed at Linotype, set up Bitstream in 1981 as the first independent company (not affiliated with one particular manufacturer of typesetting machines) to supply digital type. At that time each manufacturer of typesetting machines had their own font format, so they had to supply their data to the manufacturers for conversion, but as PostScript became accepted as an industry standard from ca. 1990, they could supply fonts to

A Bitstream type specimen (1989).

end users as well. They offered a collection of classic typefaces as well as their own new designs. When unable to reach an agreement to license a classic face, they copied them without license and issued them under new names, as many manufacturers of phototypesetting machines had done before them (Helvetica was called Swiss, for example). In some cases they nevertheless made an agreement with the original designer, which won them support from, for example, Hermann Zapf. Gerard Unger designed Amerigo in 1986 and Oranda in 1987 and Jil Lyles and Sue Safarana designed Prima in 1998. Co-founder Matthew Carter designed Charter in 1987. It is a high quality collection, undoubtedly partly thanks to Matthew Carter. The price of the total collection was initially very low but is now more in line of other suppliers. In 1991 Carter left the company to begin the design studio Carter & Cone together with Cherie Cone, who had gone with him from Linotype to Bitstream. In 1999, when Bitstream was well established in the market, they began the website myfonts.com as a sales channel for their own typefaces and those of other companies. The site is full of information and has become an encyclopaedia of typography. Bitstream Vera Sans is a recent freeware typeface (free of licence costs) with extended hinting information for applications on low-resolution display screens. Bitstream has also developed a great deal of typeface-related technology, including Font Fusion for the rendering of typefaces on small display screens such as mobile telephones.
Example typefaces: Amerigo, Chianti, Charter, Cataneo, Carmina, Iowen Old Style, Vera Sans.
Situated in: Cambridge, USA.
Website: www.myfonts.com

Bodoni, Giambattista (1740–1813) son of a Saluzzo printer, left home at age eighteen to become a typesetter at the Propaganda Fide printing office of the Vatican in Rome, which was also taking charge of materials from the old Vatican press. There he worked with almost all languages in the world, used in publications to promote the Catholic faith. He sorted and catalogued these exotic

A page from Bodoni's foreword to the *Manuale Tipografico* (Parma, 1818). It was published by his widow in a run of 290 copies after Bodoni's death in 1813. Picture from *Printing Types* by D.B. Updike (1937).

typefaces. He admired the beautiful typefaces by famous type cutters of earlier ages and the spectacular new books and types of John Baskerville in England. He had already dabbled in punch-cutting, and took a growing interest in it. When Ruggeri, director of the Propaganda Fide, committed suicide in 1766, Bodoni set out for England (no doubt planning to meet Baskerville in Birmingham). Passing through Saluzzo to visit his parents, a serious illness forced him to postpone his journey. In 1768, however, the Duke of Parma, a lover of the arts, invited him to set up and run the ducal press there, the Stamperia Reale in the traditions of the Imprimerie Royale in Paris. He was to work there for forty-five years, though from 1791 as an independent printing office on his own acount. In his early years at Parma he imported types and rococo fleurons by Pierre Simon Fournier and cut some new materials to match them, issuing a specimen in 1771. By 1788 he had developed a style of his own, influenced by the work of John Baskerville and by the new types that were beginning to appear at the press of François Ambroise Didot in Paris. Bodoni and the Didots were to vie with each other for thirty years, refining their letterforms and increasing the contrast between thick and thin strokes, creating the epitome of the neoclassical type. Bodoni's beautiful books include the famous 1806 *Oratio dominica* presenting the Lord's Prayer in no less than 155 different languages. His constant search for perfection is a source of inspiration for typographers and printers throughout Europe and he is therefore respectfully known as the king of printers (Principe dei tipografi). His commercial independence gave him the freedom to experiment to his heart's content. He sometimes designed letters especially for the title page of a book with the size, width and contrast altered to achieve the exact aesthetic balance he sought. An inventory of his materials at the Stamperia Reale lists 25,735 punches and 50,994 matrices. He would have needed an average of four hours to cut a punch. He undoubtedly had help but it is noted that he cut the majority himself. He published the first edition of his *Manuale Tipografico* in 1788. His widow published the second and last edition in 1818: two large volumes in an edition of 290 copies. It displays 142 original typefaces with their italics, as well as a collection of ornamental fleurons with floral and geometric motifs. Bodoni was fanatical in his involvement with every aspect of his book production. The choice of a layout, the typography of every element on the page, the paper itself and even the printing ink that should give the deepest black. He even adjusted the composition of his ink in order to achieve the specific gloss he wanted. He shared this fanaticism with John

Baskerville, who also searched for perfection (neither, alas, editorially). Bodoni created his types to give the best results when used with his own ink on his specially selected paper. He therefore altered the typefaces to fit the printing circumstances. The thin lines of his designs are printed slightly thicker by the metal letters under high pressure, whereby they are perfectly in balance. During the transition from letterpress to offset printing this characteristic is often not taken into account, with the result that the thin lines are often printed far too thin in offset printing. This can be explained partly by the fact that people wanted to produce the classic typefaces for phototypesetting and subsequently for digital typesetting as quickly as possible. Once the market calmed down, various newly adapted designs appeared, altered to correct this effect. There are therefore typefaces available with different versions for various body sizes such as the ITC Bodoni Six, Twelve and Seventy Two. The numbers refer to the approximate body size for which they are intended. The thin lines of these typefaces are slightly thicker in the smaller sizes so that they do not disappear or appear weak in offset. Since Bodoni's death there have been regular revivals of his typefaces and countless type designers have their own Bodoni-like design based on examples of his work. Besides the interplay of influences between Bodoni and Didot, other punchcutters carried on under their influence, an important early example being Justus Erich Walbaum in 1800 who, particularly in Germany, enriched the typographic world in the nineteenth century. The Englishman William Martin's types cut in 1791 for Bulmer's Shakespeare Press, also show influences from Bodoni's and Didot's work. Morris Fuller Benton's 1911 Bodoni for American Type Founders may also owe as much to Didot as to Bodoni and greatly influenced other typefoundries. In 1923 Giovanni Mardersteig was granted permission by the Italian government to use the original matrices to cast several of Bodoni's typefaces for his Officina Bodoni in Switzerland. In 1927 he moved his printing office to Verona where he tried to match the high quality of Bodini's printing work. Mardersteig's activities sparked renewed interest in the creation of Bodini-like typefaces. One of the most admired of the period is the Bauer Bodoni designed by Heinrich Jost in 1927.

Example typefaces: the Bodoni in 142 variants in the *Manuale Tipografico*.
Born in: Saluzzo, Italy.
Website: n.a.

British Letter Foundry The publisher, bookseller and printer John Bell (1746–1831) set up this typefoundry in 1787, employing the punchcutter Richard Austin (1756–1832), named as cutter of the punches in type specimens published in 1788 and 1796, but the foundry was sold and its materials dispersed in 1797. The Besley foundry in London revived the 1788 face by 1861 and the Riverside Press in American purchased a font in 1864 and named it Copperface. The American book designer Bruce Rogers named it Brimmer while the printer and type historian Daniel Berkeley Updike, who had used the letter at the Riverside Press, named it Mountjoye. The 1788 specimen turned up in Paris in 1926 allowing Stanley Morison to give a proper account of the face's origins in a 1930 book set in type cast from the original matrices. He oversaw a revival for Monotype, issued in 1931 under the name Bell. It is one of the first typefaces to include figures at two-thirds the cap-height instead of old style figures, which were commonly used at the time. Richard Austin worked for many foundries as a freelance punchcutter and set up his own typefoundry in 1815, the Imperial Letter Foundry.

Example typefaces: Monotype Bell.
Situated in: London, Great Britain.
Website: n.a

Bruce Type Foundry Founded in 1813 in New York by David and George Bruce (1781–1866). The brothers came from Scotland and emigrated to America around 1793. American printers of that day imported most of their cast metal type, paper and ink from England and Scotland. In 1806 the brothers started a printing company and in 1813 a

Title page of John Bell's first type specimen in 1788. The italic 'A' in front of the name Richard Austin looks like it is more on a slant than the other italic capitals: this is one of the characteristics of this typeface. For the 'V' and 'W', the slant seems to diverge as well. In this case, the design choice turns out to again be very conscious. The downstroke of the 'A' beautifully aligns with the slant of the lower-case letters.

typefoundry, where they also made stereotypes. Using this technique (introduced by William Ged in 1725) the set page is pressed into papier-mâché, which serves as a mould to make a metal casting of the whole page. The cast type can then be re-used for other work. In 1822 the brothers separated, George concentrating on the typefoundry business, together with David's son, David Wolfe Bruce (1802–1892). After George's death in 1866, David Jr. ran the foundry. David Jr. and George invent a typesetting machine in 1838 (the Pivotal Typecaster) that could cast 6,000 sorts per hour. It was awarded a patent in 1848. The machine mechanically mimics the manual operations carried out by typefounders. Type casters employed at the foundries saw it as a potential threat, so that some schemed to push the casting machine from a ferry after a demonstration. The Pivotal Typecaster quickly spread to other foundries, including Miller & Richard. David Bruce Jr. retired in 1890 and sold the company to three employees. The business declined, partly due to the introduction of the Monotype and Linotype, and in 1901 they became part of American Type Founders. The machines were moved to the new ATF factory in Jersey City in 1906. Some of the Bruce typefaces are available in digital format.
Example typefaces: Linotype Old style 7, Bitstream Bruce Old Style, Précense Typo Madisonian.
Situated in: New York, USA.
Website: n.a.

Carter & Cone Having already built a whole career as a type designer, Matthew Carter left the digital type company Bitstream, which he had co-founded, in 1991 and started a new company together with Cherie Cone, who had worked with him at Linotype and Bitstream. Carter & Cone make custom typefaces for various customers, including Apple and Microsoft as well as large newspapers and magazines such as *Time*, *The Washington Post* and *The New York Times*. In 1955 Matthew Carter's father, Harry Carter, sent his son to his friend Jan van Krimpen in The Netherlands to complete a year's internship at Joh. Enschedé en Zonen. There he learned the trade from an expert punchcutter, Paul Rädisch. After completing his internship he returned to London to work as freelancer for various customers and then in 1965 joined Mergenthaler Linotype. He worked there until 1981, designing a new telephone book typeface for the hundredth anniversary of the Bell Telephone Company, appropriately called the Bell Centennial, and many other faces. In 1981 he co-founded the first independent digital type company Bitstream where he created many new designs.
Example typefaces: Bell Centennial, Bitstream Charter, ITC Galliard, Georgia, FB Miller, Tahoma, Verdana, Shelley Script, Big Caslon.
Situated in: Cambridge, USA.
Website: www.carterandcone.com and www.myfonts.com

Caslon Foundry William Caslon (1693–1766) began his career in 1706 as an apprentice to a metal worker who specialized in engraving gun locks, and specifically decorating them with ornaments. He set up on his own in 1716, also cutting book binders' finishing tools. Around 1720 his decorations on a bookbinding attracted the attention of the printer William Bowyer, and with support from several printers he began cutting type. In 1722 he began cutting a new Arabic type for an Arabic *Psalter* and *New Testament*, cast by the foundry of Thomas James, for which he received high praise. He then cut a pica roman and italic based on Dutch models, and quickly established his reputation, and issued a type specimen sheet

uïque

tere Ca

uſque ta

re, Cati

Two Lines E

uſque tan

Catilina,

a? quamo

que tande

na, patien

Two Lines P

que tande

a, patientia

ue tandem

showing a range of romans and italics ca. 1730. His
1734 specimen shows about 50 types, nearly all
cut by him and including several non-Latin types.
In 1737 he moved the foundry to Chiswell Street
where it remained for two hundred years. The
quality of Caslon's work was so good that the type
community in Great Britain breathed a sigh of
relief: finally, an Englishman who is capable of
equalling the quality of the letter cutters on the
continent. The British typefoundries in those days
offered a mixture of native types, most rather
poor, and continental types, some cast in matrices
that had been in England for more than a century.
Many of the best printers preferred to import cast
type from the Amsterdam foundries. These mostly
seventeenth-century Dutch types were a source of
inspiration for Caslon. He quickly eclipsed all
other British typefoundries and brought an end to
the import of cast type from Holland. His letters
were also widely used in America and were used
to print the *American Declaration of Independence*.
His types were revived in England in the 1840's
and America in the 1850's and became so popular
that printers would say, 'When in doubt, use
Caslon'. William Caslon I died in 1766. He is the
most productive William Caslon. William Caslon II
began cutting type for his father's foundry in 1738
and eventually produced some good work, but he
never equalled his father in quality or quantity.
Their 1763 type specimen shows 56 types by
Caslon senior and 27 by his son. William Caslon II
ran the foundry, joined ca. 1775 by his son William
Caslon III who took charge on Caslon II's death in
1778. In 1792 William Caslon III sold his shares in
the foundry to his mother and sister-in-law (the
widow of bother Henry who died in 1788). With the
proceeds he bought the Salisbury Square type-
foundry of Joseph Jackson (1733–1792), who had
been apprenticed to Caslon II in 1748 and, the most
talented of the foundry's workmen, had set up on
his own as a punchcutter and typefounder in 1765.
Caslon III retired, apparently in 1804, leaving his
son William Caslon IV in charge. He sold the
foundry in 1818 to a new partnership Blake,
Garnett & Co. in Sheffield (later Stephenson,
Blake). The original Caslon foundry in Chiswell

Street continued under Henry Caslon I's widow,
from 1799 in partnership as Caslon and Cather-
wood. Her son Henry Caslon II (born in 1786)
succeeded her in the partnership and directed the
foundry. He acquired some materials, apparently
in 1817, from the foundry of William Martin.
From 1821 the foundry continued as Caslon and
Livermore. The type specimens of the 1810's and
1820's show many new 'fat face' and other bold
advertising types intended for use in striking
headings. But they also continue to show the
foundry's old non-Latin types, including Ethiopic,
Persian, Sanskrit and Hebrew. In 1839 Livermore
left the company and is replaced by the son of
Henry Caslon II, Henry William Caslon. In 1843 the
foundry revived Caslon Old Style for the Chiswick
Press and offered it for the general market in
their specimens in the 1850's. They had begun to
replace these types from ca. 1730 with more
modern types in 1796 and dropped the old ones
from their specimens around 1805, but now they
came back into fashion. Henry Caslon died in 1850
and in the same year the foundry acquired the
London office of the Wilson typefoundry in
Glasgow, and Alexander and Patrick Wilson be-
came co-owners of H.W. Caslon & Co. (as the
foundry was subsequently named). The new type
specimen from 1857 is very different in appearan-
ce to that of 1842. Very few types are the same,
with some originating in the Wilson Foundry. The
company met less success than formerly. In 1874
Henry William Caslon died and Thomas White
Smith, a former salesman at H.W. Caslon, became
the first non-Caslon to lead the company. After his
first involvement with Caslon, Smith worked at
Stephenson, Blake where he successfully opened a
London office and set up sales agreements in
foreign countries. The decision to ask him to take
over H.W. Caslon was a strategic one. Under
Smith's leadership the company once again
flourished. Smith was aware of the power of the
Caslon name and advised his three sons, who
joined the company in 1896, to change their
surnames to Caslon. In 1900 Smith retired and
handed over leadership of the company to his
sons. The foundry closed in 1936 after more than

200 years, Stephenson, Blake acquiring the good will and some of the punches and matrices in 1937. In 1998 Justin Howes set up H.W. Caslon & Company Limited with its only product the 'Expanded' version of ITC Founders Caslon. After Howes' death in 2005 the company ceased to exist and the Expanded Founders Caslon is no longer available. Most major type companies include a Caslon in their collections. Due to the wide distribution of its types and the firm's long lifespan, the Caslon Foundry is one of the most significant foundries in the history of typography.
Example typefaces: ATF Caslon, Adobe Caslon, ITC Founders Caslon, Caslon Old Face, Caslon 224, Caslon 540.
Situated in: London, Great Britain.
Website: n.a.

Compugraphic See Agfa/Compugraphic

Deberny & Peignot This French typefoundry was established in 1923 from two companies, Girard & Cie (successor to Laurent, established in 1818) and Peignot & Cie (successor to Leclerc, established in 1842). In 1826 the French author Honoré de Balzac (1799–1850) began his own printing company in Paris to produce his work. Financed by his mother and his mistress, Madame De Berny, he operated the office together with the typesetter André Barbier. In 1827, to gain complete control over all aspects of the printing process, he purchased the type foundry of Jean François Laurent, established in 1818. Laurent retained shares in the company. In 1828 the firm fell deep into debt due to Balzac's extravagant purchases. Barbier jumped the sinking ship and Balzac's mistress Louis-Antoinette-Laure De Berny (1777–1836) bought his shares. Balzac subsequently left the company to focus on his writing. His mistress then gave the company as a gift to her nineteen-year-old son Alexandre De Berny (1809–1881). He continued working with Laurent until 1840 and then bought him out and continued under the Deberny name. He spent fifty years enthusiastically casting type and printing books. In 1877 Charles Teleu (De Berny's illegitimate son) joined the company as a partner and inherited it completely after Alexandre De Berny's death in 1881. Teleu continued alone until 1914, adding a large number of typefaces to the company's collection. Teleu had no children and sought a partner for the business. His wife's brother Georges Peignot owned the rival type foundry Peignot & Cie, but she was against that partnership, so Teleu turned to Robert Girard, an old school friend who took over the company after Teleu's retirement under the new name Girard & Cie. Gustave Peignot established his type foundry in 1840, the year that Alexandre De Berny gained complete control over his foundry. Gustave Peignot had acquired René Leclerc's foundry at auction and then acquired the stocks of famous foundries such as that of Longien and Petitbon who subsequently left the industry. A year before his death in 1899, Peignot changed the company name to G. Peignot et fils. His son Georges Peignot was a gifted type designer and enlisted other designers to create new typefaces, such as Eugène Grasset who designed Grasset. This typeface was highly successful at the 1900 World Exhibition. Peignot also commissioned Georges Auriol to design Auriol and Robur. Peignot also extended his collection by acquiring matrices from other companies, including some historical Didot matrices from the Fonderie Générale. He produced the typefaces Cochin and Moreau-le-Jeune (1912–1914), important examples for type designers of the day, and a new 'Garamond', based on Jannon's seventeenth-century types at the Imprimérie Nationale. Four Peignot brothers died in the trenches during World War I and the company fell silent. Henry Menut took over direction of the firm from the minor heirs and he purchased new matrices, including some from the firm Doublet and Baskerville's original matrices from the firm Bertrand. In 1916 he changed the company name to Peignot & Cie. Georges Peignot's son learned the trade under Menut and oversaw the work his father left incomplete, including Naudin and Garamont. He left the running of the business to Menut and his cousin Pierre Payet. Peignot & Cie merged with the company Girard & Cie in 1923 and the com-

A spread from a Deberny & Peignot type specimen (1954).

pany continued as Deberny & Peignot. Charles Peignot continued to work as type designer within the company and designed Sphinx in 1924, a slab-serif, which was very much in fashion at the time. From 1924 he joined forces with typographer and critic Maximilien Vox, born as Samuel Théodore William Monod (1894–1974). Together they exerted a great influence on the French typography of the day. Charles socialised in Paris's avant-garde circles, joined the Union Des Artistes Modernes (UAM), together with Maximilien Vox, Eric Satie, Guillaume Apollinaire, Fernand Léger, Cassandre, Jean Cocteau, Le Corbusier and Sonia Delaunay. In 1926 Deberny & Peignot began publishing a quarterly, *Les Divertissements Typographiques*, sent free of charge to all their clients, to present specimens of their new types. In 1927 Peignot also began publishing the magazine *Arts et Métiers Graphiques*, which continued for twelve years until cut short by the Second World War. Encouraged by Vox, Charles Peignot licenced Paul Renner's Futura in 1929, issuing it under the name Europe and presenting

it in *Les Divertissements Typographiques* in 1931. The type company was extremely successful and issued an enlarged type specimen in 1935. The worldwide economic crisis and World War II limited activities, but the foundry issued a new specimen in 1951. Charles Peignot continued designing type until 1960, but with no successor in the family, the company was taken over by the Haas'sche Gießerei in Münchenstein, Switzerland. Deberny & Peignot's doors closed permanently in 1979. A.M. Cassandre, born as Adolphe Jean-Marie Mouron (1901–1968) also designed typefaces for Peignot, including the art-deco typeface Bifur, Acier, Ader Nord and Peignot. Designer Marcel Jacno designed Film in 1934, Scribe in 1937 and Jacno in 1950. Adrian Frutiger, who began working at Deberny & Peignot in 1953, designed Président, Phoebus, Ondine and Méridien. Around 1957, Deberny & Peignot put the Lumitype phototypesetting machine on the market, made in collaboration with the American firm Photon, and Adrian Frutiger revised many of the foundry's classic typefaces for use on the machine, includ-

ing Garamont, Baskerville and Bodoni. An advance trial specimen of Frutiger's Univers, Deberny & Peignot's most successful typeface, had already appeared in 1954, but the face was released in 1957. Charles Peignot was also a true ambassador of typography and proved it by returning the original Baskerville punches, which had come into his possession, to Great Britain as a gift for the University of Cambridge. Together with Maximilien Vox, John Dreyfus, Hermann Zapf, Roger Excoffon, Adrian Frutiger and several others, Peignot set up the ATypI (Association Typographique Internationale) in 1957. Peignot was its first chairman. The first and most important issue to be addressed was copyright protection for typefaces. The efforts in that area met little success, but the ATypI also introduced the orderly classification system Maximilien Vox had developed for use at Deberny & Peignot. Peignot left the ATypI in 1973, and the Prix Charles Peignot, still awarded today, was introduced in his honour.

Example typefaces: Grasset, Auriol, Bifur, Acier, Cochin, Peignot, Ondine, Méridien, Univers.

Situated in: Paris, France

Website: www.linotype.com

Didot Family A large family of publishers, paper merchants, typefounders and printers. François Didot established a printing office in 1713 in Essonnes, near Paris. Around 1783 his son François-Ambroise (1730–1804) proposed what was to become the continental standard Didot point system, basing it on a system introduced by the Académie Royale ca. 1694, and giving a larger point than that introduced by Fournier in 1737. His starting point was a fixed and defined measurement, the pied du roi (king's foot). He also had new types cut for his printing office, evolving in the years 1781–1784, the earliest types in the style that the Vox system calls didone, a combination of the names Didot and Bodoni. The first ones were cut by Vafflard, who also trained Didot's son Firmin Didot (1764–1836), who cut an important italic already in 1783 and was to cut the family's most famous types. In 1789 there

were no less than seven family members working in the family firm. Firmin's brother Pierre, one of the family's most important printers, also improved the technique of stereotyping, the casting of relief printing plates for whole pages by making a mould from pages of set type, which ensures that books can be re-printed relatively cheaply. Didot's new types of the 1780's were inspired by those of Englishman John Baskerville. Baskerville, with the papermaker James Whatman, had also developed the first wove paper, and at Didot's request the French papermaker Johannot studied English samples and successfully produced the first continental wove paper ca. 1780. Unlike Baskerville and Bodoni, the Didot also had a good reputation for the editorial quality of their books. Didot's new types are seen at their best beautifully printed on this wove paper. Firmin Didot was such a brilliant type cutter that he is the first to create a type family that increases in increments of half a point (10, 10.5, 11, 11.5 pt etc.). Over time he increased the contrast in his new designs and the thin lines became thinner and thinner. His didone from 1798 became the national French typeface, the epitome of neoclassicism, and Napoleon appointed him director of the Imprimerie Impériale in 1814. Didot's typefaces were subsequently used for Napoleon's *Code Civil* and were the most frequently used typefaces in France for many years. Firmin made one type exclusively for Napoleon, used only for one book. There were actually three or four separate typefoundries operated by members of the Didot family, though the first to begin, operated by F.-A. Didot, Firmin Didot and his sons, was also the last to close. Firmin's brother Pierre established one and had its types cut by Vibert, who had learned punchcutting under Firmin Didot. Vibert's stunning types appeared in Pierre Didot's 1819 type specimen, *Spécimen des nouveaux Caractères de la Fonderie et de l'Imprimerie de P. Didot, l'Aîné.* Firmin Didot died in 1836 at the age of 72. The Didot family greatly influenced French typography, printing, paper manufacture and book

ODE I.

AD VENEREM.

Intermissa, Venus, diu

Rursus bella moves. Parce, precor, precor!

Non sum qualis eram bonæ

Sub regno Cinaræ. Desine, dulcium

Mater sæva Cupidinum,

Circa lustra decem flectere mollibus

Iam durum imperiis. Abi

publishing. Due to the family's numerous innovations the Didot printing office became a place of pilgrimage for French printers and typographers. The Imprimerie Firmin Didot & Cie still exists today and is situated in Mesnil-sur-l'Estrée in Normandy, where Firmin died in 1836.

Example typefaces: Linotype Didot, HTF Didot, Didot LP, URW Firmin Didot.

Situated in: Essonnes (near Paris), France.

Website: www.linotype.com, www.myfonts.com

Dijck, Christoffel van Christoffel van Dijck (ca. 1601/05–1669), descended from Dutch Reformed refugees, was born in Dexheim in the German Palatine and had family ties with the Dutch refugee city of Frankenthal, where he was probably apprenticed to a goldsmith. By 1640 he was working as a journeyman goldsmith in Amsterdam. He set up an independent typefoundry on the Bloemgracht in 1647, cutting many of his types

himself. Financial troubles soon forced him to sell much of his property to satisfy creditors, but he managed to save some of his typographic materials. From the 1650's until his death in 1669 he carrried on with great success supplying his own types (including Armenian types he cut for the city's first Armenian press, one of the most important in the world) as well as types by Garamond, Granjon, Van den Keere and others. His son Abraham took over the foundry on his death but died in 1672. It passed to the Amsterdam printer Daniel Elsevier in 1673 and the Amsterdam Jewish printer Joseph Athias (also important for his Protestant English bibles) in 1681. In 1767 the punches and matrices were divided between Johannes Enschedé and the Ploos van Amstel brothers, whose materials went to Enschedé in 1799. By that time Van Dijck's types were out fashion, and most of his punches and matrices were defaced and sold for scrap in

PROEVEN
Van
LETTEREN,
Die gesneden zijn door Wylen
CHRISTOFFEL van DYCK,
Soo als de selve verkoft sullen werden ten huyse van de Weduwe Wylen
DANIEL ELSEVIER,
Op 't Water, by de Papenbrugh, in den Olmboom, op Woensdagh, den 5. Martii, 1681.

Part of a 1681 type specimen (reduced) for the sale of the typefoundry of Christoffel van Dijck's typefoundry, with many types cut by him. Picture from *Printing Types* by D.B. Updike (1937).

Beautiful DTL Elzevir italic swash capitals. Designed by Gerard Daniëls based on the work of Christoffel van Dijck, from a DTL type specimen.

1808. In those days historical materials were not of such great value. Enschedé still has punches and matrices for his Kleine Text italic. This italic served as the model for Monotype Van Dijck, first used in 1937, but for the roman Monotype turned to a 1671 edition of Ovid. Jan van Krimpen at Enschedé advised Monotype on the production. DTL Elzevir, issued by Dutch Type Library, is also a revival of Van Dijck's work and Günter Gerhard Lange at Berthold also supervised the design of an Elzévier revival.

Example typefaces: Monotype van Dijck, DTL Elzevir, Berthold Elzévir.

Situated in: Amsterdam, The Netherlands.

Website: n.a.

Dutch Type Library This type company was established by the type designer Frank Blokland in 1990 and began issuing typefaces after years of preparation. In addition to new designs, they also produce revivals of classics, primarily those stemming from Dutch typographic traditions. From the mid-1990's, the company began developing the DTL Fontmaster software package together with URW in Hamburg. Dutch Type Library is a truly digital firm that never produced cast metal type or analogue phototype. Their revivals of classic typefaces include the

sixteenth-century VandenKeere, seventeenth-century Elzevir and eighteenth-century Fleischmann, named after the original punchcutters, or in the case of Elzevir the typefounder, upon whose work they are based. The company has digitised Jan van Krimpen's Haarlemmer and Romulus, and Chris Brand's Albertina. New designs include Antares and Prokyon by Erhard Kaiser, Argo and Paradox by Gerard Unger, Caspari by Gerard Daniëls, Documenta by Frank Blokland, Dorian by Elmo van Slingerland and Unico by Michael Harvey. The unique DTL Fell is derived from the so-called Fell Types, a collection of punches and matrices acquired for and left to the Oxford University press by the English Bishop John Fell. He acquired some between 1670 and 1672 in Amsterdam and soon after brought a punchcutter to Oxford to cut others. This was Peter de Walpergen, who had been associated with the Voskens family. Fell acquired some of his matrices from the Van Dijck foundry. The DTL collection is of high quality, both aesthetically and technically.

Example typefaces: Fleischmann, Haarlemmer, VandenKeere, Argo, Prokyon, Documenta, Argo, Antares, Albertina, Elzevir.

Situated in: 's Hertogenbosch, The Netherlands.

Website: www.dutchtypelibrary.nl

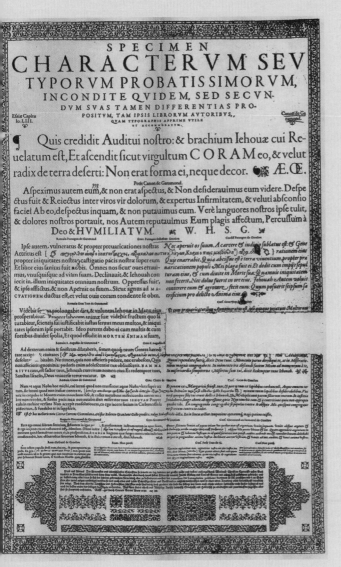

The famous Egenolff-Berner type specimen of 1592, used as a model for several revivals of Garamond's types.

Egenolff-Berner One of the oldest typefoundries began as the in-house foundry of the printer Christian Egenolff (1502–1555). Initially working in the printing industry in Strasbourg from 1528–1530, Egenolff moved to Frankfurt to become the city's first major letterpress printer. It is not clear when began assembling his collection of matrices and punches but he apparently began casting type for others as well. After his death, the family members Magdalena, Barbara and Maria Egenolff took over the firm until 1571 when the punchcutter Jacob Sabon (who had worked for them since 1557) married Judith, Christian's only daughter. In 1572 the foundry was separated from the printing office and put wholly under Sabon's charge. He died in 1580 and Judith married Konrad Berner, who ran the foundry, leaving it on his death in 1606 to his son Johann Berner, who died in 1626. In 1629 Johann's daughter Katherina married Johann Luther, family of the famous Martin Luther, and the foundry remained in the Luther family until 1780: Johann Erasmus Luther (1642–1683), his son Johann Nikolaus Luther (1662–1740), his son Heinrich Ehrenfried Luther (1700–1770) and his brother Johann Nikolaus Luther (1732–1805). The last two were educated as lawyers and left operations to a manager. With their large collection of excellent types they saw little need to introduce new ones in this period. The foundry had many Fraktur and Schwabacher types, used for setting German books, but it is now best known for types by the great French masters, especially romans by Garamond, italics by Granjon and Greeks by Granjon and Haultin and fleurons by Granjon, shown and mostly identified in Berner's 1592 type specimen. Stempel Garamond and to some degree Sabon were based on types in this specimen. Jean François Porchez also used it as reference material when he revised Sabon as Sabon Next for Linotype in 2002. The 1592 specimen is also famous for pairing Garamond's romans with Robert Granjon's italics, the concept of an italic as an adjunct to a roman then only beginning to emerge. The Luther family disposed of the foundry after 1780, but its types were by then out of date and the foundry never flourished again. In 1810 it ceased to exist. In 1926 D. Stempel AG produced a gift for its business relations in a limited circulation of three hundred copies. This is the book *Die Egenolff-Lutherische Schriftgiesserei in Frankfurt am Main und ihre geschäftlichen Verbindungen mit den Vereinigten Staaten von Amerika,* that gives a history of foundry.

Example typefaces: Linotype Luthersche Fraktur, Schwabacher, Garamond.

Situated in: Frankfurt am Main, Germany.

Website: n.a.

Elsevier This family of publishers and book printers originated in Leuven, where Louis Elsevier was born in 1546. He worked with Plantin in Antwerp in 1565 and moved to Leiden in 1580, where he worked as a bookbinder and publisher and died in 1617. His five sons continue to work in the same industry. The Leiden printing office, established in 1625, met its greatest fame under Bonaventure (1583–1652), son of Louis, and Abraham (1592–1652), son of Louis' son Matthijs. It closed in 1712. The Leiden printing office acquired matrices for a very small number of its types, but mostly bought cast type from various typefoundries. Most were sixteenth-century types by Garamond, Granjon and others, but they also used types by Nicolaes Briot, Christoffel van Dijck and other seventeenth-century punchcutters. Daniel Elsevier, who left the Leiden office to set up a separate printing office in Amsterdam, acquired Christoffel van Dijck's typefoundry in 1673.
Example typefaces: n.a.
Situated in: Leiden, The Netherlands.
Website: n.a.

Elsner + Flake Veronika Elser and Günther Flake had both worked for ten years in the type industry when they began their own company in 1986. They began producing digital typefaces and now have more than 2500 type grades in their collection. Some are extensions of existing typefaces from other foundries, adapted for other European languages such as Turkish and Central and Eastern European languages, but Hebrew and other non-Latin types can also be found in their collection. They also offer the Typoart collection (a former type foundry from the DDR), digitised by Elsner + Flake. Their own designs include Versa and Renova by Günther Flake, Thordis by Carlo Krüger and Günther Flake, Elysa and ABC Schrift by Hans Eduard Meier, Digital Sans and TV Nord by Veronika Elsner and Günther Flake and Today by Volker Küster.
Example typefaces: Today, Versa, Thordis, Elysa, ABC Schrift, Petras.
Situated in: Hamburg, Germany.
Website: www.fonts4ever.com

Emigre Emigre was founded in America in 1984 by Dutch designer Rudy Vanderlans and the Czech Zuzana Licko. That year saw the introduction of the first Apple Macintosh computer, which they start using immediately. Their first steps into the field of type design were shown in their own magazine *Emigre* that at the time had a cult status with graphic designers. It includes details of new developments in the industry and many innovative new designers worked on its production. Meanwhile, Vanderlans and Licko experimented with the possibilities presented by new tools and used *Emigre* as a testing platform. Legibility was not a prerequisite, and in this sense the magazine followed trends of the day. Emigre also asked other designers to create new typefaces and so their collection grew. In the 1990's it included many designs that can be described as display typefaces, but Licko quickly became distracted by ghosts from the distant past. She began making contemporary interpretations of classic designs, such as the Filosofia (Bodoni) and the Mrs Eaves (Baskerville). An extensive development process is visible in her work, from the angular designs of 1986 to the Filosofia and Mrs Eaves of 1996, not only in the shape of the letters but also in the technical possibilities available to her. Licko also created a number of unique sans-serifs, such as Triplex in 1989, Tarzana in 1998 and Solex in 2000. Several other designers who began building typefaces with bitmaps since the introduction of the Mac have become established type designers. Rodrigo Cavazos is one of them. He made a profession of his interest in typefaces by following internships with well-established designers and then making a number of typefaces at his own foundry Psy/Ops. He designed Eidetic for Emigre in 2000, a beautiful seriffed type. In 1999 Sybille Hagmann designed Cholla and Edward Fella created his famous characters the Fellaparts in 1993. Xavier Dupré designed Vista Sans in 2004 and won prizes with it in 2006 at the Type Directors Club in New York. In 1998 Emigre was awarded the Charles Nypels Prijs for innovative contributions to typography.

Example typefaces: Base Monospace, Citizen, Filosofia, Soda Script, Vista Sans, Eidetic.
Situated in: Berkeley, USA.
Website: www.emigre.com

Joh. Enschedé en Zonen The most important Dutch printing firm, type foundry and publishing office is undoubtedly Joh. Enschedé en Zonen in Haarlem. Established in or soon after 1703, it is still an active printing firm. It also has a company museum that was established in 1904. It has always been a family firm but there have been no family members on the board of directors since 1991. The company name has changed constantly over the years with the successive owners: Izaak Enschedé from 1703–1743, and then Izaak & Johannes Enschedé from 1743–1761, Johannes Enschedé from 1761–1777 and during the period 1777–1992 Joh. Enschedé en Zonen. The 'en Zonen' (and sons) was then dropped so that it was Joh. Enschedé from 1992 to 2003, when it became Koninklijke Joh. Enschedé. Unique to this company is that its history has always been well documented over the years. Pretty much every document has been archived with the result that the museum is a great source of information for those interested in the history of printing and typography in general. The museum houses an impressive 6400 type specimens from Dutch, French and German type foundries throughout the period 1600 to 2000, including ninety thought to be unique. Enschedé was an active typefoundry from 1743 to 1991. Its collection contains punches and matrices of around 6500 typefaces, of which the oldest date back to the 1490's. The cutters of most of the punches are documented. Among the museum's materials are the matrices of the Non Plus Ultra by Jules Didot, the smallest type ever cut (2.5 pt). As a printing firm, Joh. Enschedé has printed postage stamps for 140 countries as well as bank notes for the Nederlandsche Bank since 1814. Printed matter, trial proofs and proofs of colour tests are preserved in the collection as well as graphic work by famous designers such as Carel Adolph Lion Cachet, M.C. Escher and Ootje Oxenaar. There is also a comprehensive collection of printing blocks such as vignettes and ornaments, some of which are illustrated in Charles Enschedé's book, *Typefoundries in The Netherlands*, a revised 1978 translation of a book first printed in French in 1908. Charles started writing it in 1893 when the company celebrated its 150th anniversary. Some of the typographic material in the book was produced by or for Enschedé but the majority comes from the stocks acquired from other foundries. The museum also houses a library that includes the firm's own publications and type specimens, bibles and trade literature. Several unique machines and a large collection of tools are also included in the museum's exhibits. The typefoundry and its materials began in 1743 with the acquisition of the Wetstein foundry in Amsterdam, which had begun in 1735 with the acquisition of the foundry of Joan Michael Fleischmann, a gifted type cutter who set up a foundry in 1732 but preferred to operate as a freelance punchcutter. He worked for Wetstein, Enschedé and others. He had learned punchcutting in a Nürnberg typefoundry. Enschedé acquired types from Fleischman for eighteen years and eventually took over most of the types he cut for others, so that they have a nearly complete collection of his beautiful types. His designs became famous and are a source of inspiration to many other designers. Johannes Enschedé was a skilled woodcutter, which can be seen in many examples in the collection. The foundry

Emigre type specimen of 2008. The beautiful ligatures of the Mrs Eaves typeface by Zuzana Licko are shown here.

flourished under his leadership. Enschedé also acquired many punches and matrices cut by Jacques-François Rosart, many acquired in 1760 with the foundry of Nozeman & Co, who succeeded to Rosart's Haarlem foundry when he moved to Brussels. Enschedé also purchased types directly from Rosart. Izaak Enschedé died in 1761 and Johannes in 1780. In 1767 Johannes acquired many types from Jan Roman & Co. including fifteenth, sixteenth and seventeenth centuries matrices from the foundry of Christoffel van Dijck. In 1769 he purchased Hebrew types from Willem Cupy's foundry and in 1780 a few matrices and punches from the sale of the famous Voskens & Clerk foundry. A very favourable purchase for the son of Johannes, also named Johannes, was the entire stock of the Ploos van Amstel brothers in 1799, including collections by Hermanus Uytwerf, Izaak & Hendrik van der Putte and additional materials from Jan Roman & Co. and Willem Cupy. After the death of Johannes Enschedé II (1750–1799) leadership of the company passes to his widow Johanna Elisabeth and brother-in-law Abraham Enschedé. French typefaces became very popular at this time and interest in Dutch typefaces declined. In 1808, the firm therefore defaced many sets of historical matrices and sold them for scrap to raise money to buy many sets of new matrices, mostly from Gando in Paris. Later generations at Enschedé regret at this drastic economic decision. The French Revolution gave a fashionable flavour to the French typefaces of the day and interest later returned to the older typefaces. Some typefaces for exotic languages, floral designs, ornaments and several typefaces by Van Dijck were saved and remain in the collection. Fortunately, various collections were acquired after 1800 from the foundries Harmsen & Co. (acquired in 1818), successor to J. de Groot in The Hague, and Elix & Co., which owns many Dutch matrices from the collection of Anthonie & Hendrik Bruyn (acquired in 1847). They also purchased the entire matrix collection matrices of the famous punchcutter and typefounder J.F. Unger in Berlin. In his 1908 book, Charles Enschedé laments that the best type cutters are foreigners, and not of Dutch origin, with the exception of Voskens. His book *Typefoundries in The Netherlands* gives a good overview of the collection in possession of the Enschedé museum. Up to 1908 of course. Many famous type designers worked at Enschedé after this. One of the most significant was Jan van Krimpen (1892–1958) who designed Lutetia in 1923 with help from the punchcutter Paul Rädisch. Van Krimpen's Romaneé by was initially intended for use in publications by Enschedé and the publisher A.A.M. Stols but was later also sold to other printing offices. Van Krimpen's Romulus appeared in 1940 for the Monotype setting machine and the Spectrum, released in 1955, was made in collaboration with Monotype. The famous type designer Matthew Carter began an internship at Enschedé in 1955, learning punchcutting from Paul Rädisch. His father Harry Carter was a friend of Van Krimpen and he sent Matthew to The Netherlands. Sem Hartz (1912–1995) designed Emergo for Enschedé in 1949, which was produced but never put on the market. He designed Juliana in 1958 for Linotype, commissioned by Walter Tracy. In 1958, Bram de Does (born 1934) started working at Enschedé. He continued working here until 1988 with a brief period (1962/63) at the

These gothic textura letters (around 1493) are one of the oldest typefaces in the Enschedé Museum collection; they were cut by Henric Lettersnider of Rotterdam. They appear here in *Typefoundries in The Netherlands* (1978) printed from type cast in the original matrices.

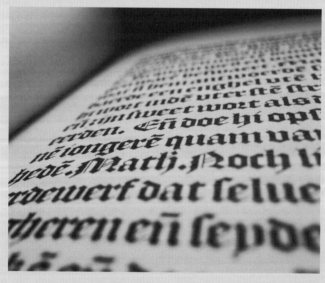

Within the image:

-line Pica Italic Titling Capitals No. 808.

ER KEERE.

ES VALLET.

glish-bodied Italic Titling Capitals No. 807.

ES BRIOT.

er Italic Titling Capitals No. 806.

ENRICX.

ic Titling Capitals No. 805.

ministe
Corn. N
some of
a Pica Ita
called to
partnersh
least the n
bought th
fine Orname
for initials (
In Brusse
ander, Duke
of the A

Spread from *Typefoundries In The Netherlands* by Charles Enschedé. On the left: roman titling types cut by Jacques-François Rosart. Enschedé bought them in 1758. On the right: a regular text page, hand set in Jan van Krimpen's Romanée.

publisher Querido. From 1982 he was able to develop his own typeface at Enschedé, Trinité designed in 1978 for the Bobst phototypesetting machine. Trinité was later released in digital form by The Enschedé Font Foundry (TEFF). He considers his best typographic work to be the book *Typefoundries in The Netherlands from the fifteenth to the nineteenth century: a history based mainly on material in the collection of Joh. Enschedé en Zonen in Haarlem*, the aforementioned publication from 1978 based on a book from 1908 written by Charles Enschedé. This book was set using the Romaneé by Jan van Krimpen.
Example typefaces: Lutetia, Romaneé, Romulus, Spectrum, Trinité.
Situated in: Haarlem, The Netherlands.
Website: n.a.

The Enschedé Font Foundry Established in 1991 by Peter Matthias Noordzij with the intention of bringing the traditional type designs by Joh. Enschedé en Zonen into the digital era. He began with Trinité by Bram de Does, digitising it and making it available in PostScript format. He added Lexicon, a new type also by Bram de Does, in 1992. Fred Smeijers designed the Renard, inspired by the typefaces of Hendrik van den Keere. Noordzij's father Gerrit Noordzij designed Ruse and his brother Christoph designed Collis in 2000. Burgundica by Gerrit Noordzij (designed in 1983) is a very accurate digital revival of the Burgundica Bastarda hand from 1450, which originated from the calligraphic workshop of Jacquemart Pilavaine in Bergen (Hainaut). Custom typefaces were also designed, such as a phonetic version of the

Lexicon for Van Dale Lexicografie. It is a high quality collection. Besides issuing typefaces, TEFF is involved in typographically related design.

Example typefaces: Trinité, Lexicon, Renard, Ruse, Collis, Burgundica.

Situated in: Hurwenen, The Netherlands.

Website: www.teff.nl

Calypso, which Roger Excoffon drew in 1958 for Fonderie Olive. Shown in a Letraset catalogue of transfer letters (1985). As far as we known, this typeface was never digitised.

Fonderie Olive This French type foundry was established in 1835 in Marseille. The most prominent designers to work there were Roger Excoffon (1910–1983) and François Ganeau (1912–1983). Excoffon is also known for his beautiful posters for Air France made during the 1960's and 70's. Excoffon was a public figure of the day and worked as a writer, illustrator, painter, publisher, journalist and also a type designer. He was a friend of Maximilien Vox. Born in Marseille, he moved to Paris at the age of nineteen. Directly after the war in 1945 he began working at the Fonderie Olive in Marseille, where his brother-in-law Marcel Olive was director. He also took on the publicity for the sale of the Olive typefaces and it suited him well. His first design was Chambord in 1945. Chambord is suspiciously similar to the successful Tourraine by Deberny & Peignot, Olive's biggest competitor. Although Peignot confronted Excoffon about this, he maintained it was an original design. Excoffon was extremely amiable and so quickly joined the ATypl, which Peignot had co-founded. Excoffon became art director at Olive in 1947 and around the same time he started his own advertising office in Paris. In 1951 Excoffon brought out a new design, the more original Banco, intended as a display typeface. Meanwhile François Ganeau, who was completing an internship at Olive, designed the Vendôme, though he had absolutely no experience in type design. Excoffon improved and refined the impressive design and made a beautiful and extensive type specimen to present it to printing companies. Excoffon's next typeface was Mistral in 1953, followed by Choc in 1955. Mistral is a script and the Choc a graphic. Mistral and Choc can be seen in countless locations throughout France, on the street, in shop windows, cars and other displays. Three years after Mistral and Choc he designed Diane, a script type derived from copper engravings. A completely different design is Calypso from 1958, which can in no way at all be described as conventional. In 1954 Olive hired José Mendoza y Almeida as Excoffon's assistant. This talented young type designer worked for Maximilien Vox from 1953 to 1954 and then at Olive until 1959. He is best known for Monotype Photina and ITC Mendoza, designs he made as freelance type designer after leaving Olive. Antique Olive by Excoffon began unusually with the very bold Nord grade which he designed for the Air France logo, a company where he also became the art director. Many type foundries at the time were working on sans-serif typefaces in reaction to the success of Haas's Helvetica and Deberny & Peignot's Univers. Marcel Olive and Roger Excoffon decided that the typeface used in the Air France logo should be used as starting point for the development of a new sans-serif typeface. Excoffon designed eleven grades for the Antique Olive that were released between 1962 and 1966. In 1978 Fonderie Olive was taken over by Haas'sche Schriftgießerei from Münchenstein near

Basel and ceased to exist as an independent type foundry.

Example typefaces: Chambord, Mistral, Vendôme, Choc, Diane, Calypso, Antique Olive.

Situated in: Marseille, France.

Website: www.linotype.com

Font Bureau This digital type company was established in 1989 by Roger Black and David Berlow to meet the demands of newspapers and magazines for unique, made-to-measure typefaces that perfectly represent their identity. Font Bureau has designed more than 1500 grades for a total of 300 publications. Some of these are available in their own collection. Font Bureau employs its own designers but also works with freelance designers so that they can make unique designs for every new project. Examples of their typefaces are Belizio from 1987 by David Berlow which is based on Egizio by Aldo Novarese, Agenda from 1993 by Greg Thompson, Interstate from 1993 (which has been used to set this text) and Poynter from 1997 by Tobias-Frere Jones, Kis from 2007 by David Berlow, Miller from 1997 by Matthew Carter, Whitman from 2003 by Kent Lew, Proforma from 1994 by Petr van Blokland and Zócalo from 2002 by Cyrus Highsmith. Almost all the designs are derived from classic examples. Kis refers back to

Poynter Old Style, pictured in *Font Bureau Type Specimens Third Edition* (2001).

seventeenth century designs by Nicolas Kis, Interstate is based on the road signposting typefaces of the Federal Highway Administration and Whitman on designs by W.A. Dwiggins and Eric Gill. There are also a number of Dutch revivals such as Nobel by De Roos and Juliana by Sem Hartz.

Example typefaces: Agenda, Interstate, Whitman, Miller, Poynter, Proforma.

Situated in: Boston, USA.

Website: www.fontbureau.com

FontShop International Erik and Joan Spiekermann establish this foundry in Berlin in 1989 together with Neville Brody and got off to a flying start with Erik Spiekermann's design of Meta. Originally intended as a replacement for the Helvetica as the corporate typeface for Deutsche Post, it was rejected by the client at the last moment, which was part of the reason the designers decided to begin their own type company. One of the first publications was a package called '5 Dutch Type Designers' comprising typefaces by Erik van Blokland, Max Kisman, Martin Majoor, Just van Rossum and Peter Verheul. At the time Spiekermann ran the successful design studio MetaDesign in Berlin and worked at FontShop on the side. He had many contacts in the world of type design and used them to find young designers to employ in his studio. Such designers who worked at MetaDesign before beginning independent careers are Lucas de Groot, Just van Rossum, Erik van Blokland and several more famous type designers. *Fuse* was a font project by Neville Brody and Jon Wozencroft whereby a collection of experimental fonts by different designers was compiled. The four chosen typefaces were presented in a box together with four posters made by the designers using their respective typefaces. They are collector's items containing typefaces by newcomers as well as by established designers such as Gerard Unger and Matthew Carter. The typefaces are still separately available at FontShop and have the prefix F (for *Fuse*) instead of the usual FF of FontFont that is used for the regular collection. There were eighteen *Fuse*

Type specimen of FF Strada by Albert Pinggera. One of the separate publications in the *FontFont-Focus*-series.

packages published before the experiment stopped in 2001. FontShop's regular collection now includes thousands of typefaces ranging from classic to experimental designs. The bestsellers at FontShop are Meta by Erik Spiekermann, DIN by Albert-Jan Pool, Dax by Hans Reichel and Scala by Martin Majoor. The recently renewed FF Dingbats, designed by Factor Design in Hamburg, also received a lot of interest. Right from the beginning FontShop paid a great deal of attention to type specimens. The yellow *Fontbook* is regularly updated and has reached enormous proportions. There is also a constant stream of brochures, magazines and publications about individual typefaces. The book *Made with FontFont* from 2007, written by Jan Middendorp and Erik Spiekermann, illustrates applications of typefaces in the collection from 1990.

Example typefaces: Meta, DIN, Scala, Quadraat, Legato, Profile, Fresco, Absara.

Situated in: Berlin, Germany.

Website: www.fontshop.com

The Foundry In 1990 David Quay (born in 1948) established The Foundry together with Freda Sack and Mike Daines. Quay had designed typefaces earlier for Letraset. His first really famous typeface was Quay Sans, designed for the Internatio-

nal Typeface Corporation (ITC) that was added to the collections of many type companies, including Linotype, Monotype and Elsner + Flake. In 1990 he began producing typefaces for his own company. Foundry Old Style was the first design, in 1990. It was based on a classic type cut by Nicholas Jenson. Foundry Sans followed in 1991, a humanistic sans-serif inspired by Stempel Garamond. Next came Wilson for which he looked to the Scottish types by Alexander Wilson. Foundry Journal from 1995 was actually a re-release of Quay Sans, where David Quay took the opportunity to improve upon an existing typeface. The vast majority of the characters were re-designed and the ultra-bold grade that ITC wanted was left out. Foundry Sterling from 2001, a humanistic sans-serif in the English tradition, was partially designed by Stuart de Rosario, a young designer who joined The Foundry in 2001. Foundry Origin from 2008 is a creation by Freda Sack and Stuart de Rosario and is a slab-serif or egyptian. Gridnik is a design by Wim Crouwel from the 1960's. It is included in the Architype 3-Collection with five other designs by Wim Crouwel. The Architype Collection is completely separate from the body text typefaces in the rest of the collection and is created to meet the demand for display and headline typefaces. It was created partly out of interest in historic typefaces from the twentieth century. This is why Bauhaus typefaces are included in the Architype 1, such as Architype Bayer, Renner, Van Doesburg, Tschichold, Bill and Van der Leck which carry the names of prominent designers from the period. Renner, for example, stems from the first, purely geometric designs by Paul Renner for the Futura. In Architype 2, typefaces from Architype 1 are extended with extra grades and Schwitters, Albers, Ballmer and Aubette are added. The greatest success of the series is undoubtedly the Architype 3 containing typefaces by Wim Crouwel and this was the reason for extending Gridnik, with Wim Crouwel's permission, into a complete typeface with four grades. A collaboration between Wim Crouwel and the Dutch interior designer Kho Llang Ie results in the design of Fabriek, a stencil letter in the trad-

ition of the Gridnik that is suitable to be laser-cut from a steel plate.

Example typefaces: Foundry Sans, Foundry Journal, Gridnik, Origin, Monoline, Wilson.
Situated in: London, Great Britain.
Website: www.foundrytypes.co.uk

Fournier, Family Jean Claude Fournier was apprenticed in the Jean Cot typefoundry in Paris and for the next thirty years managed the Le Bé typefoundry in Paris for the widow and then daughters of Guillaume Le Bé. His oldest son, Jean Pierre (1706–1783), also known as Fournier l'aîné (the elder), succeeded him and then purchased foundry in 1730. It was a foundry with an exceptional reputation and an exquisite collection of old types by Garamond, Granjon and the Le Bé's (Guillaume III's father and grandfather). The known specimens of the foundry are fragmentary and mostly show older faces. Fournier l'aîné's son Jean François, also known as Fournier fils, is known to have made a Greek typeface in 1767, which is linked to the existing collection. Jean-Claude's youngest surviving son, Pierre Simon Fournier le jeune (1712–1768), worked briefly in his older brother's foundry. He made delicate woodcut headpieces and later also typographic

Title page of a 1742 type specimen by Fournier le jeune. Picture from *Printing Types* by D.B. Updike (1937).

punches. In 1737 he issued the first public proposal for a typographic point system (though he may have known of the unpublished system developed ca. 1694), in response to the French government's 1723 plea for standardisation of type body sizes. He started applying it from 1742 and presents a definite version in his *Manuel Typographique* in 1764. The resulting measurement system remains difficult to put into practice in other foundries because his point was defined only by his own printed scale. F.-A. and Firmin Didot later promoted a system based on the standard pied du roi like the ca. 1694 system. In 1736 he opened his own type foundry. He published his first fully-fledged type specimen in 1742, a beautifully designed and produced publication in an oblong format, with fold-out pages for vignettes and ornaments. The typefaces made by Fournier le jeune include the typically angular connections between serif and stem and the italics are extremely elegant in design. Fournier had a passion for music and so also designed music type with round-head notes, one of the first that could be built up to represent polyphonic music. Pierre Simon operated his typefoundry from 1736 to 1768. He was proud of his collection and of the fact that he cut all the punches himself. His son Simon-Pierre followed in his footsteps. In 1780 and 1781 Simon-Pierre designed an italic for Benjamin Franklin Bache, grandson of the American 'founding father' Benjamin Franklin. Bache used this italic in his political publications such as the *Aurora* newspaper. Bache lived with his grandfather in France for a long time. Fournier's son is still recorded as a typefounder in 1815, but appears to have given up the trade and the foundry's materials were probably dispersed. Fournier le jeune made important contributions to the world of typography not only with his excellent and innovative types, by also through his writings and his promotion of the point system. Fournier was revived in 1927 by Monotype.
Example typefaces: Monotype Fournier
Situated in: Paris, France.
Website: n.a.

PAVLI IOVII NOVOCOMEN-
fis in Vitas duodecim Vicecomitum Mediolani Principum Præfatio.

ETVSTATEM nobi-
liffimæ Vicecomitum fami-
liæ qui ambitiofius à præalta
Romanorŭ Cæfarum origi-
ne, Longobardífq; regibus
deducto ftemmate, repete-
re contédunt, fabulofis pe-
nè initiis inuoluere viden-
tur. Nos autem recentiora
illuftrioráque, vti ab omnibus recepta, fequemur: có-
tentíque erimus infigni memoria Heriprandi & Gal-
uanii nepotis, qui eximia cum laude rei militaris, ci-
uilífque prudentiæ, Mediolani principem locum te-
nuerunt. Incidit Galuanius in id tempus quo Medio-

Part of the book *Vitae duodecim Vicecomitum Mediolani Principum* by Paolo Giovio, printed by Robert Estienne in 1549, with a fine woodcut initial from Geofroy Tory and a type from 1530 that served as one of the models for those cut by Claude Garamond and erroniously attributed to him in the 1920's. Vervliet, *The Palaeotypography of the French Renaissance* tentatively ascribes it to a mysterious 'Maitre Constantin'.

Garamond, Claude Garamond or Garamont (ca. 1510–1561) learned typefounding as an apprentice in Paris, probably ca. 1525–ca. 1530, where he also learned punchcutting from the printer Antoine Augereau (d. 1534). In the time of King François I, France in general and Paris in particular turned to Renaissance Italy for inspiration. A punchcutter (possibly a mysterious 'Maitre Constantin') working for the King's Printer Robert Estienne (types used from 1530) and Augereau (types used from 1531) cut beautiful new roman types based on those Griffo had cut for Aldus Manutius in Venice and particularly on the type of his 1495 *De Aetna*. These new Paris types remained largely restricted to these two printing offices, but from ca. 1535 Garamond began to copy them, first working in a printing office, but soon setting up as an independent punchcutter supplying various printers. Garamond continued to refine these forms over the next 25 years, producing some of the finest roman types in history. From 1540 to 1550 he cut three extensively ligatured Greek types (the Grecs du Roi) for Estienne, based on the handwriting of Angelus Vergecio, librarian to Francois I at Fontainebleau. When Garamond died in 1561, most of his punches, matrices and typefounding materials went to Guillaume Le Bé in Paris, but Plantin in Antwerp apparently bought a few sets (and later bought more from Le Bé) and André Wechel may have taken some to Frankfurt. In any case, before the end of the century there were large collections of Garamond's matrices in Le Bé's foundry in Paris, the Berner foundry in Frankfurt and in Plantin's Printing Office in Antwerp. Most of Plantin's still survive in the Plantin-Moretus Museum in Antwerp. Berner's famous 1592 type specimen continues to inspire new designs for various Garamonds. From the nineteenth century to the 1920's types cut by Jean Jannon in Sedan in the years 1614–1621, some preserved at the Imprimerie Royale (the caractères de l'Université), were attributed to Garamond and served as the basis for 'Garamond' revivals by Morris Fuller Benton for American

Type Founders and several others. When this attribution was proved wrong, Estienne's romans from the years 1530 to 1534 were mistakenly attributed to Garamond. Stempel Garamond and Adobe Garamond are based on the Berner specimen and on Plantin's punches and matrices.
Example typefaces: Grec du Roi, Garamond.
Situated in: Paris, France.
Website: n.a.

Gutenberg Although there has been a certain amount of discussion over who in the western world was actually the true inventor of printing with moveable type, it is generally accepted that this invention can be accredited to Johannes Gensfleisch zur Laden zum Gutenberg (ca. 1398–1468). This subject has also been the focus of some debate in The Netherlands in the past, but the books formerly attributed to the mythical Laurens Janszoon Coster are now generally dated ca. 1465. In his book *Fonderies de caractères et leur matériel dans les Pays-Bas du XVe au XIXe siècle* (later published in English as *Typefoundries in The Netherlands*) Charles Enschedé controversially gives the credit to Gutenberg and not the Dutchman Coster. Whatever the truth, it is clear that the quality of *Abecedarium*, the production of which Charles Enschedé accredits to Coster, is nowhere near as good as that of the beautiful 42-lined Gutenberg Bible from 1455. It is also noted that Belgium (Brito) and France (Waldfoghel) contested Gutenberg's invention and instead credited printers from their own country with this significant invention. Gutenberg did not really begin as a type designer, but more a printer with the goal of producing books more quickly and to a better standard. Until then, woodblocks were cut to print whole pages. Through wear of the wood, these forms could be used to print a maximum of several hundred pages. In comparison to copying script by hand, this was considered a huge improvement. But the new technique using moveable, separate characters meant the letters could be used over and over again and printing thousands of pages was no problem at all. It is thought that Gutenberg started experimenting with separate letters in Strasbourg around 1440 and that he called his research *Aventur und Kunst*. In 1444 he left Strasbourg and moved to Mainz. In 1448 Gutenberg borrowed one hundred and fifty guilders from his brother-in-law Arnold Gelthus, probably for a printing press, and

Part of a thirty line indulgence of 1455 that was most likely printed in Gutenberg's printing office in Mainz.

de facultatibus suis pie eroga merito huiusmodi indulgentis ga
pūtibz ltis testimonialibz est appensum Datū m opido Nusser) Anno dū

Forma plenissime absolutionis et ru

Misereatur tui &c. Dūs noster ihesus xps p sua sanctissimā et pi
aplor eis ac aucte aplica michi omissa et tibi ocessa Ego te absoluo ab o
excessibz criminibz atqz delictis quātūcūqz grauibz sedi aplice reservati
Alij sqz sentencijs censuris et penis eccliasticis á iure uel ab hoie promulga
indulgentiā et remissionē Inquātū claues sancte matris ecclie in hac pa

Forma plenarie remissionis in morti

Misereatur tui &c. Dūs noster ut supra Ego te absoluo ab omnib,
fideliū et sacramentis ecclesie Remittendo tibi penas purgatorij quas p
pctor tuor remissionē. Inquantū claues sancte matris ecclie in hac par

A page from the *Psalterium Benedictinum* (1459), printed by Fust and Schöffer.

later in 1449 another eight hundred guilders from businessman Johann Fust in Mainz for printing tools and other costs. Fust dealt in manuscripts and books and therefore saw the advantages of his investment. Fust's later son-in-law, Peter Schöffer, started working as Gutenberg's assistant. Peter Schöffer worked as calligrapher in Paris. The first letters that Gutenberg made are called the Donatus-Kalender letters, or the D-K letters. The letters are intended for a publication of the *Ars Grammatica*, a book of Latin grammar, written by Aelius Donatus, which at the time was used by students and was often called 'Donatus'. It consists of 128 pages, and was therefore not difficult to produce and had a guaranteed market in the education sector. For this he used the gothic serif letter commonly used in the scriptoria at the time. The capitals 'W', 'X', 'Y' and 'Z' are not used in Latin and together with the characters with accents and ligatures that are used in the scriptoria, he eventually made 202 different characters. Although no complete examples have been preserved and only loose sheets are known to exist, it is accepted that this was the first work printed using the moveable type method. It is dated to around 1450. Calendars are also printed with this typeface, hence the name Donatus-Kalender letters. Another publication from Gutenberg's experimental early days is known as the *Sybillenweissagung* or *Weltgericht*. The reason that it is accredited to Gutenberg is because it also makes use of the D-K letters, whereby the missing letters have been added such as a lowercase 'w'. As a lucrative sideline, Gutenberg also printed indulgences for the church (confessionalia in Latin), which church followers buy to absolve their sins for a certain period of time and which were used by the church to fund the 'holy' war with Turkey. In 1452 and 1453 Gutenberg borrowed another 800 guilders from Fust which he used to fund the typesetting and printing of his most significant work, the 42-line bible. The project became two thick books comprising 1275 pages in all. A total of 290 different characters were cut, including 83 ligatures, such as the 9-like

abbreviation for 'us'. This alone would have been a year's work for his type cutter Dünne. He therefore took on two more goldsmiths, Götz von Schlettstadt and Hans von Speyer, and so reduced the production time to four months. The bible is finally completed in 1454. Approximately 180 copies were made, around 150 on paper and around 30 on vellum. The paper came from Italy and 5000 calf hides were used to make the vellum. It is assumed that three setters simultaneously worked on the creation of three pages, the first was set, the second was printed and the third was disassembled. Calculations show that approximately 46,000 characters would have been needed for this. In contrast to handwritten texts, Gutenberg was the first to justify text to the right-hand margin, giving the printed text a neatly lined text both left and right. The first eight pages of the bible are set in 40 lines. Gutenberg then seems to have changed his mind and the rest of the pages are set in 42 lines, probably to minimise the total volume of the publication. In 1455 Fust and Gutenberg argued about the repayment of the loan. After a lawsuit, Fust and Schöffer took over the printing firm, at which time half the bibles printed came into Fust's possession. In 1457 Fust-Schöffer published the first known dated book using moveable type: the *Mainzer Psalter*. No mention is made of Gutenberg in this book. In 1467 Schöffer is named as sole owner (printer and publisher) in a volume of the *Summa theologiae* by Thomas van Aquino. Research is still being carried out into whether Gutenberg played any important role in its printing, but little is known for certain. It is known that he supplied printing letters for a bible to a printing firm in Bamberg in the mid-fifteenth century. His important innovations were recognised in 1465 by Archbishop Adolf von Nassau and he was rewarded with the title 'Hofmann'. The title came with an annual scholarship that continued until his death in 1468. In 1504 professor Ivo Wittig of the University of Mainz had a memorial plaque placed on the grave of the 'first ever typographer' with the text: *Joanni Gutenbergensi Moguntino, qui primus omnium literas*

aere imprimendas invenit, hac arte de orbe tot bene merenti, Ivo Wittigis hoc saxum pro monimento posuit 1504. The recognition of his invention of printing with moveable type and the great steps made in the evolution of printing were recorded. Although the type of the 42-line bible follows the forms of the textura hands commonly used in that day, the set work was of extremely high typographic quality. Hyphenation was so executed that the hyphens are aesthetically placed outside the justified text block. The word spacing and letter spacing were of very high quality and could also be viewed as an example for a great deal of computer typesetting. The alignment of the lowercase was exemplary, especially considering the technical limitations of the day. Gutenberg chose a lead alloy for the casting the letters and used manual casting methods. He made a steel punch for each letter, which he struck into a block of copper to make a matrix, which was then fixed in place in an adjustable mould and into which he poured the heated, liquid lead alloy. When the type was worn out he could easily cast a new, exact copy of it. This procedure was subsequently used throughout the world into the 1990's, pretty much un-altered and on large scale. An invention with a five hundred year lifespan!

Try re-creating that today ...

Example typefaces: Textura.

Situated in: Mainz, Germany.

Website: n.a.

To celebrate the 400th anniversary of Haas'sche Schriftgießerei in 1980, friends and colleagues were given an unusual piece of type to show how far the mechanical technique of making metal letters had evolved. The piece of type, 1 cicero or 12 Didot points square, contains the so-called Gutenberg song, a text with 357 characters. The black frame in the picture shows the printed text at the original size. Below the rod is a match, its head at the upper left.

Haas'sche Schriftgießerei

The French brothers-in-law Jean Exertier and Jacques Foillet opened a letterpress printing office in Basel in 1580. In 1586 they left Basel only to return in 1592 to start up as printers once again. Exertier died in 1607 and Johann Jacob Genath (1582–1654), who married his widow, purchased the firm. In 1617 Genath also took over the typefoundry of the late Peter Wieland from his widow. His son Johann Rudolf Genath (1638–1708) inherited the firm from his father and passed it on to his two sons. Johann Rudolf II took over the typefoundry. He had no children, so Johann Wilhelm Haas, who had work-ed for Genath since 1718, took over the foundry in 1745, succeeded at his death in 1764 by his son Wilhelm (1741–1800). In 1772 he developed an improved printing press, made completely of metal. In 1776 he created a system for typesetting maps by building them up from small standard elements. In 1800 his son Wilhelm Haas II (1766–1838) took over, followed in 1830 by his two sons Georg Wilhelm (1792–1853) and Karl Eduard (1801–1853). Two employees took over the foundry in 1852 and sold it in 1857 to Otto Stuckert (1824–1874). From 1866 to 1895 the foundry was owned by the Basler Handelsbank, which then sold to Fernand Vicarino. From 1904 Max Krayer was the owner and in 1921 it was rebuilt in Münchenstein. In 1924 the foundry produced Bodoni Neuschnitt, later also sold by Stempel and Berthold, which became known worldwide as Berthold Bodoni. In 1927 Stempel and Berthold acquired shares in the company. Haas then brought out several new typefaces: Caslon Antiqua and Kursiv in 1940 and Riccardo in 1941. In 1944, after the death of Max Krayer, Eduard Hoffmann took over as director and released Bravo and Graphique in 1945, Chevalier in 1946, Profil in 1947, Clarendon Kräftig and Fett in 1953 and Pro-Arte in 1954. In 1957 the Haas'sche Schriftgießerei released most significant contribution to typography, Neue Haas Grotesk, subsequently sold across the world by Stempel as Helvetica. In 1968 Alfred Hoffmann succeeded his father as director and under him Haas took over the French typefoundries Deberny & Peignot in 1972 and Fonderie Olive in Marseille in 1978, and the company celebrated its 400th anniversary in 1980. Finally, Haas took over Grafisk Compagni in Copenhagen in 1982. The Haas'sche Schriftgießerei closed its doors in 1989 and Linotype took over the name and the rights to the typefaces. The punches and matrices passed to Walter Fruttiger AG. In 1990 Linotype added Società Nebiolo in Turin to the list of takeovers.

Example typefaces: Bodoni Neuschnitt, Caslon Antiqua, Neue Haas Grotesk (Helvetica).

Situated in: Basel, Switzerland.

Website: www.linotype.com

Hell, Dr. Ing. Rudolf Rudolf Hell (1901–2002), a German inventor, created the Hellschreiber in 1929, forerunner of the fax machine, produced by Siemens. During the Second World War his company in Berlin manufactured coding machines for the German navy. After his company was destroyed by an Allied bombardment, he set up a new company after the war in the North-German city of Kiel where he invented the Klischograf, an electronic engraving machine with which images could be scanned and transformed into a halftone printing format. This made the publication of photographs in newspapers much easier. He developed this technique further and produced advanced drum scanners for scanning colour slides and photos and printing the separate colours out on film. He introduced an early version of the colour printer in 1963. He then applied his experience with electronic imaging to typography, producing the first fully digital typesetting machine, the Digiset, which he sold in 1965. It was marketed in America under the name Videocomp. The limited resolution demanded specially designed typefaces, so Hell set up its own design studio. Its first digital typeface was Digi Grotesk from 1965, based on a number of existing typefaces, such as the 'N' series inspired by Neuzeit Grotesk and the 'S' series, a kind of mixture of Akzidenz Grotesk, Univers and Futura. His next typeface was Digi Antiqua, which resembles Century and can be classified as a slab-serif. Olympia from the Hell Design Studio is a monospaced typeface, whereby all characters are equally spaced. These creations were all intended as alternatives to the typefaces offered by traditional manufacturers such as Linotype and Monotype. Aside from these productions, Hell's foundations lay not in the traditions of type manufacturers but in the electronics sector. The existing foundries were not eagre to invite this ugly duckling into their market and refused to grant licenses for their popular typefaces. Hell then asked famous type designers to create new typefaces for the Digiset. Marconi from 1973 by Hermann Zapf was the first digital typeface designed specifically for Digiset. Demos by Gerard Unger was the second in 1975. Kris Holmes designed Sierra in 1983 and Hans Eduard Meier designed Barbedor in 1984. Gerard Unger created the largest number of designs for Hell, including Praxis in 1977, Hollander in 1983, Flora in 1984 and Swift in 1985. The entire Bitstream collection was then made available on the Digiset. Siemens already owned 80% of Hell, purchased the remaining 20% in 1981 and sold the firm to Linotype in 1989. Linotype-Hell was subsequently taken over by Heidelberg Druckmaschinen AG in 1996 and is now part of Monotype Imaging. Rudolf Hell was very close to his employees, built company housing and was quick to introduce a pension plan. He was awarded numerous prizes for his achievements, including the Gutenberg-Preis in 1977.

Example typefaces: Digi Grotesk, Marconi, Demos, Praxis, Barbedor, Hollander, Flora, Swift.
Situated in: Kiel, Germany.
Website: www.linotype.com

International Typeface Corporation ITC was founded in 1970 by Aaron Burns, Herb Lubalin and Ed Rondthaler with the intention of designing typefaces that were not specifically made for a particular typesetting machine. Its roots were in New York advertising typography. All those involved in typography, in the widest sense of the word, were sent copies of the free, highly-acclaimed U&lc (Upper & lower case), printed on newsprint by ITC in 1973. It was a powerful marketing medium, designed by Herb Lubalin until his death in 1981. It contained interesting articles about its own typefaces but also about typography in general. Display typefaces were more prominent in the early editions but other beautiful typefaces were later added to the collection, contributed by almost all of the most respected type designers. Famous typefaces include Avant Garde Gothic by Herb Lubalin and Tom Carnase from 1977, Benguiat by Ed Benguiat from 1977, Cheltenham by Toni Stan from 1975, Galliard by Matthew Carter from 1978, Stone by Sumner Stone from 1987 and Officina by Erik Spiekermann and Ole Schäfer from 1990. ITC

ITC HAS OBTAINED THE RIGHTS TO CHARTER, A CLASSIC TYPEFACE DESIGNED BY MATTHEW CARTER

A spread from the *Upper & lower case* (*U&lc*) magazine of the International Typeface Corporation (ITC) with a design that is typical for printing on newsprint, with big, heavy letter forms (Winter 1993, vol. 20, no. 3). Pictured is the Charter, which Matthew Carter drew for his own digital type company Bitstream in 1987. In 1993, he granted ITC a license for the typeface, under the name ITC Charter.

produced only artwork, not fonts (which at that time required a different format for each type company), licensing its typefaces to manufacturers such as Linotype, Monotype, Bitstream and Adobe. In 2000 ITC was taken over by Agfa-Monotype and it has now become a part of Monotype Imaging. The collection consists of more than 1650 typefaces.

Example typefaces: Avant Garde Gothic, Benguiat, Souvenir, Fenice, Weidemann, Eras.

Situated in: Woburn, USA.

Website: www.itcfonts.com

Klingspor, Schriftgießerei Gebr. In 1892 Karl Klingspor (senior) took over the Rudhardsche Gießerei in Offenbach. This relatively unknown foundry was established in 1842. His son Karl Klingspor (1868–1950) was given leadership of the foundry from the start and was one of the first to ask artists to design typefaces for him. Art Nouveau artist Otto Eckmann designed the Art Nouveau typeface Eckmann in 1900. Peter Behrens, painter and artistic advisor to the German company AEG (Allgemeine Elektricitäts-Gesellschaft), then designed Offenbacher Fraktur

The brochure *Eine Deutsche Schrift* (1910), beautifully printed in black and several support colours in Gebr. Klingspor's in-house printing office. It shows the refinement that textura types had achieved in Germany. For nearly four years, Rudolf Koch and Karl Klingspor worked on the typeface. It shows beautiful initials, ornaments, decorations, frames and so-called pen strokes, in point sizes up to 120 pt.

and Behrensschrift in 1901. Heinz König had already designed Walthari in 1899 and created König Antiqua in 1905. In 1904 the brothers Karl and Wilhelm Klingspor took over the Rudhardsche Gießerei from their father and in 1906 changed the name to Gebr. Klingspor. In the same year they presented the new textura type Liturgisch by Otto Hupp in a type specimen comprising 148

pages, one of the most beautiful and extensive type specimens ever made up to that time for a single typeface. They released Behrens Antiqua by Peter Behrens in 1908, and Hupp Antiqua by Otto Hupp and Tiemann Mediaeval by Walter Tiemann in 1909. Karl Klingspor involved himself in every detail of type design and kept a close eye on the demand (or lack of it) for a particular typeface. He therefore asked the type designer Rudolf Koch to design a typeface and worked on it with him from 1906 to 1910. The result was the textura type Deutsche Schrift, issued in 1910 with many additional grades in the following years. Rudolf Koch subsequently played a significant role as type designer for Klingspor. In 1914 he designed Frühling, Maximilian Gotisch and Maximilian. The Klingspor collection included a great number of gothic types of refined design. In 1915 they acquired the F.W. Aßmann and Wilhelm Gronau foundries in Berlin and in 1917 agreed to collaborate with D. Stempel AG. In 1921 they issued the typefaces Deutsche Zierschrift by Koch and Narziß by Tiemann. Production increased during the following years and Tiemann and Koch created various typefaces, including Neuland and Tiemann Antiqua in 1923. After Wilhelm Klingspor's death they named a new typeface after him in 1924, Wilhelm Klingspor Schrift. 1927 saw the release of one of Rudolf Koch's most important typefaces, Kabel, a geometric sans-serif that appeared on the market only months after Futura and shows clear Bauhaus influences. Typefaces then appeared on an almost yearly basis, including Zeppelin by Rudolf Koch in 1929, Salut by Heinrich Mähler in 1931, Fichte Fraktur by Walter Tiemann in 1934 and Claudius by Rudolf Koch in 1937. Production pretty much stopped during the war and in 1944 the company was destroyed during a bombardment, with the loss of valuable type drawings and matrices. After the war they issued Offizin by Walter Tiemann in 1950, the same year that Karl Klingspor died. His cousin Karl Hermann Klingspor (1903–1986) succeeded him in 1951. Karlgeorg Höfer designed Salto for him in 1953 and Saltino a year later. The Klingspor Museum in Offenbach was established in the

same year in the grounds of the library owned by Karl Klingspor (www.klingspor-museum.de). A few further typefaces appeared before D. Stempel AG acquired the remaining shares of the company in 1956 and added parts of the type collection to their own. Most of Klingspor's typefaces are available in digital form.

Example typefaces: Deutsche Schrift, Wilhelm Klingspor Schrift, Koch Antiqua, Kabel.

Situated in: Offenbach, Germany.

Website: www.linotype.com and www.fraktur.com

Lettergieterij Amsterdam In 1851, Nicolaas Tetterode (1816–1894) bought the Breda type foundry Broese & Comp. (established ca. 1837) and moved it to Rotterdam, where he operated it under his own name. Broese & Comp.'s collection probably contained some material from the Antwerp foundry of C.J. Hartung, which had acquired a collection from a Paris foundry. Tetterode thus inherited a mixed bag from Broese with origins in France and Belgium, both countries that made many popular typefaces. N. Tetterode had its offices on the Jaffakade in Rotterdam from 1852 to 1856 and moved to the Bloemgracht in Amsterdam in 1857 after purchasing the Amsterdam typefoundry De Passe & Menne. It is the same canal where Blaeu, Van Dijck, Voskens and Bruyn used to practise the typefounder's trade. From about 1851, De Passe & Menne copied types from other foundries electrolytically, a relatively new procedure that was already common in the United States and Germany. In this way they could 'grow' matrices from a competitor's cast type without the need to cut punches. In 1854, Tetterode bought Le Blansch & Spaan in Rotterdam, which specialised in wood-engraved printing blocks (and probably castings made from them), and in 1857 the glyphography and electrolysis department of M.H. Binger & Zonen in Amsterdam. The (artistic) wood-engraver Charles Eduard Taurel made vignettes for Tetterode. Tetterode also produced stamps or punches for office and factory use, and adverts from 1859 show that besides type, they supplied letterpress printing equipment. Their biggest, and almost only, competitor in The

Netherlands was Joh. Enschedé en Zonen. Like Enschedé, Tetterode had a large number of non-Latin types, in part for use in the Dutch East Indies. The government helped stimulate these by subsidising part of the design of the faces and cutting of the punches. In 1892, the company is re-named the Amsterdamsche Lettergieterij. Nicolaas Tetterode's son Jan became the new general manager. Although in 1898 Tetterode announced that they had plenty of work, the company encountered competition from the Linotype typesetting machine. The first to be installed in continental European, in 1894, was in the Dutch printing office Gebr. Binger in Amsterdam. A year later, Binger had four. In 1899 Linotype claimed to have sold fifty machines in The Netherlands alone. As Linotype was primarily used for newspapers and magazines that use a lot of type, a large part of the market for foundry type disappeared. This was partly compensated by the increased demand for printed matter with typefaces for headings and other display type, for which the Linotype was not suitable. The market for printing equipment expanded with the increased need for printed matter, requiring the firm's relocation. In 1903, it moved to the Bilderdijkstraat in Amsterdam and changed its name to N.V. Lettergieterij Amsterdam. 'LA' quickly became a common abbreviation, even in publications. The company employed about one hundred people. The new building, designed by the architect Hartkamp, was so modern that the trade journal *Ons vakbelang* (Our trade interest) stated that employees had gone from hell to heaven. The number of typefounding machines increased from ten to forty in a short period of time and the sale of printing presses increased. The most important export markets were the Dutch East Indies and South Africa. While Enschedé mainly offered its own historical designs, LA predominantly sold designs by American Type Founders, like Jenson (re-named Kloosterschrift) and Cheltenham (under the name Moderne Elzevir). The American Inland Type Foundry allowed LA to sell its New Caslon on the Dutch market, where it was issued as Plantijn and Plantijn Mediaeval and cast from

Cover *Honderd jaren Lettergieterij in Amsterdam* (1951) to celebrate Lettergieterij Amsterdam's centenary, written by G.W. Ovink.

electrolytic matrices. LA also bought matrices from German typefoundries like Wagner & Schmidt, and later on farmed out some of the cutting of their own types to Germany as well. In 1907, they hired Sjoerd Hendrik de Roos (1877–1962), a graphic designer up to that point. His first designs for the Cheltenham type specimens in 1907 and for the Plantijn series in 1910 represent a big step forward in the company's promo material. In 1907, the first of De Roos's typefaces appeared, Bilderdijk initials. Two years later his first text typeface followed, Nieuw-Javaans, a Javanese type he designed in collaboration with P.J.W. Oly and whose punches were cut by Jan Wesselius. In 1916, De Roos also designed a new, monumental type specimen of more than seven hundred pages. Printing it took more than three

years. The type specimen seems inspired by the *American Specimen Book of Type Styles* (1912) by American Type Founders, with whom LA did regular business. In 1905, the company published the first issue of *Typografische Mededeelingen* to promote its typefaces and printing equipment. The magazine became very important as a platform for new printing techniques and applications and for the Dutch graphic design industry, in part because of the very practical articles De Roos contributed. In 1910, the company moved to a new building on the Da Costakade, where it established a typographic library with De Roos as librarian. The architect K.P.C. de Bazel, inspired by art nouveau, designed the library's interior and Th. Nieuwenhuis was responsible for the decorations of the wood panelling. In 1912, De Roos's

Spread from the *Letterproef der Letter-gieterij "Amsterdam" voorheen N. Tetterode* of 1916 after a design by S.H. de Roos.

Emblem on the front of the *Letterproef der Lettergieterij "Amsterdam" voorheen N. Tetterode* of 1916 with a cover design by S.H. de Roos.

first roman typeface appeared, Hollandsche Mediaeval with accompanying italic. This first true text typeface by De Roos was inspired by designs like the Tiemann Mediaeval by the Gebr. Klingspor. The punches were cut by Wagner & Schmidt in Germany, possibly chosen because of De Roos's lack of experience at the time. Hollandsche Mediaeval became a great success in The Netherlands. After this first text typeface, described as a true Dutch workhorse by many, De Roos made several new designs including Erasmus Mediaeval in 1923, Grotius in 1925, Egmont in 1933, Libra in 1938 and De Roos Roman and Italic in 1947. Apart from these, he designed the beautiful Zilvertype in 1915 for the bibliophile publisher and printer De Zilverdistel, run by J.F. van Royen and P.N. van Eck. In 1927, De Roos designed the typeface Meidoorn for his own publishing house, De Heuvelpers. De Roos worked for LA until 1941. In 1914, LA began selling Inter-type typesetting machines to the Dutch market, as a competitor to Linotype. Although De Roos was first critical about the quality of the type-setting machines in *Typografische Mededeelingen*, this critique died down and Hollandsche Mediae-val was adapted for the Intertype. LA also began producing more and more for the export market, especially Scandinavia and Belgium. In 1927, LA took a share in the Berlin type foundry H. Berthold AG and began selling Berthold typefaces under its own name. In 1929, De Roos adapted Berthold Grotesk, issued by LA as Nobel. The zeitgeist is clearly visible and compared to Berthold Grotesk, the adjustments to the new Nobel design show distinct influences from Paul Renner's Futura. Berthold also sold LA typefaces, including Hol-landsche Mediaeval. In 1941, the collaboration with Berthold ended. In 1926, Dick Dooijes began working for LA as De Roos's assistent. After a few years, De Roos allowed him to work more inde-pendently on the design of typefaces. The first typeface was Egmont, to which Dooijes significantly contributed. When De Roos left the firm in 1941, Dooijes took his position. In 1945, G.W. Ovink was appointed artistic advisor alongside Dooijes. LA also invited external designers to

draw typefaces. Around 1930, Jan Tschichold drew Transito, which was very similar to Futura Black. In 1940, Stefan Schlesinger from Austria designed Figaro (Hidalgo) and Rondo Script, not issued until 1947, due to the war. Other materials designed for LA include decorative frames by Anton Pieck, sport vignettes by Jan Lutz and Primula ornaments by Imre Reiner. In 1948, LA opened a branch in the United States to sell its products and distribute typefaces of other European typefoundries. In 1946, LA issued Studio, after a design of Dolf Overbeek, in 1951 Reiner Script by Imre Reiner and in 1956 Columbia by the American Walter H. McKay. LA had high hopes for this last, but it proved a commercial fiasco. In 1958, they issued Dick Dooijes's Mercator, a sans-serif that fit in with the then prevalent Swiss typography. Unfortunately, it was unable to compete with Helvetica and Univers that were available in a lot more grades. In 1961, José Mendoza y Almeida designed Pascal, a sans-serif with swelled strokes that falls under glyphics in the classification. For Almeida, this was a reaction against the 'monotonous Swiss type-faces'. In theory it might compete with Hermann Zapf's Optima, although it is less exuberant. In 1962, Dick Dooijes began work on his Lectura and in 1968, the type specimen appeared. Lectura is the same for hand setting and the Intertype to assure interchangeability in composition. It was no big success, partly because the end of the metal type era was near and phototypesetting machines emerging. LA in the meantime had merged with Bührmann-Tetterode and in 1968, Dick Dooijes left the company to become head of the Gerrit Rietveld Academie. In 1988, the type foundry officially closed. Fundición Tipográfica Neufville in Barcelona took over a number of matrices with the rights to sell type cast from them. Lectura and some other LA designs are now available in digital form.

Examples of typefaces: Hollandsche Mediaeval, Libra, Egmont, Columbia, Pascal, Lectura.
Situated in: Rotterdam, The Netherlands.
Website: n.a.

(Mergenthaler) Linotype Ottmar Mergenthaler (1854–1899) was born in Germany as a teacher's son. At first he wanted to become a watchmaker and trained with his step-uncle Louis Hahl. Adventure called, however, and in 1872 he embarked on the steamboat 'Berlin' and headed for Baltimore, in the United States. In Washington he worked for August Hahl, son of his previous employer in Germany, making measuring instruments, tools, electric equipment and clocks. The national Patent and Trademark Office is housed in Washington as well, and asked inventors to supply a model when applying for a patent. Building these models was a lucrative business for the Hahl Company. Because of an economic crisis, Hahl was forced to move to Baltimore, but retained its links with the Patent Office. In 1876, Charles Moore walked into the office and asked Hahl to help him with a patent for a keyboard machine to replace manual typesetting for newspapers. He was having problems making a prototype that worked. Mergenthaler set to work and perfected the design. In the end, the machine stamped letters on a cardboard surface. Mergenthaler was not satisfied but saw other possibilities. In 1878, he became a shareholder at Hahl's and in 1883, he established his own business. The work he did on Moore's typesetting machine had gripped him and he wanted to invent a machine that could both make matrices and cast metal type. In 1886, after a number of prototypes, he could show the *New York Tribune* a working machine, which he called the 'Blower'. The name was later changed to Linotype, a contraction of 'line of type', as the machines produce whole lines instead of separate pieces of type. In the nineteenth century, there were many inventors working on similar machines to replace the labour intensive manual typesetting. The problem was not so much in the assembly of the letters, but returning the separate matrices to their proper places in the magazine for reuse. Mergenthaler solved this problem by adding little pins that pass in front of a 'mechanic' reader and whose 'code' determines the place of the matrix in the magazine. Another problem was filling out

lines, which manual typesetters did by adding thin spacing material. Obviously, the new machines needed to do this quickly and economically as well. De matrices were placed in position on the line by entering the text via a keyboard, and the line was then filled out by means of double-wedge space bands. A number of investors bought up the lion's share of stock to produce this promising new machine. The Linotype met great success and quickly supplanted a large part of the trade in foundry type. Its biggest competitor was the Monotype typesetter. Machines by the smaller Intertype manufacturer were sold by Lettergieterij Amsterdam and were at first actually modified Linotype machines. Besides the Linotype and Monotype, there was a third machine, which Joseph Thorne developed around the same time as Mergenthaler and which came onto the market under different brand names: Thorne, Simplex and Unitype. The Unitype was sold by American Type Founders to keep part of the market for its typefaces. With the Unitype, type needed to be filled out manually because it did not have a wedge system like the Linotype. In 1906, the machine went out of production. There was yet another, fourth machine that never made it to the market because other manufacturers resisted its patent. This was the Rogers Typograph, introduced in 1890 by John R. Rogers. It also had a (round) wedge system for filling out lines of type. In 1891, Mergenthaler bought the company and its patents for the wedge system and with virtually no adjustments marketed the machine as the Linotype Junior. The wedge system for filling lines was the key to success and the main source of various court cases among the manufacturers. In the end, Mergenthaler solved this by buying the patent rights for 416,000 dollars from J.D. Schuckers, who was granted them by the court. In 1912, Hans Petersen produced the Linograph, which was a lot cheaper than the Linotype. Before the Linotype and similar machines, newspapers rarely had more than eight pages because it was physically impossible to manually set more pages in the short amount of time available. The Linotype

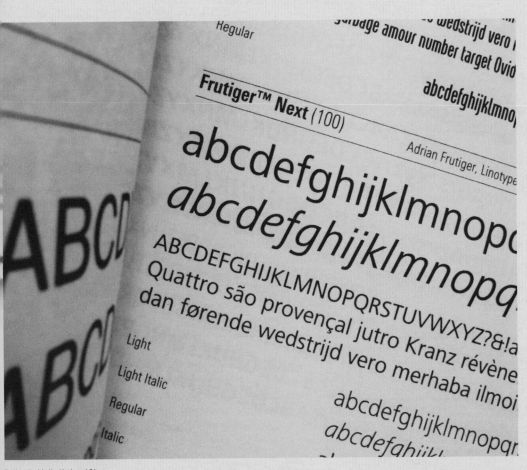

Frutiger Next in the Linotype *A-Z* type
specimen of 2006.

revolutionised the newspaper and magazine
business. Its German branch quickly became
the largest because of its collaboration with
D. Stempel AG (established in 1895), which supplied
the licenses for the typefaces and produced
matrices. In 1897, Linotype built another factory
in Altrincham, in the north-west of the UK. In
1899, Ottmar Mergenthaler died of tuberculosis.
The Linotype production continued and by 1904,
10,000 machines had been placed worldwide. In
the meantime, Stempel bough typographic mate-
rials from various type foundries that were floun-
dering, in part because of the advent of the type-
setting machine. In 1917, Stempel acquired the
majority share in the important foundry Gebr.
Klingspor. In the following years, they continued
to acquire foundries or shares in interesting com-
panies that produced typefaces. In 1925, Linotype
introduced the typeface Ionic. It was so success-

ful that it was used in three thousand publica-
tions in the space of eighteen months. In 1954,
one hundred thousand Linotype machines were
working all over the world. In 1956, Stempel com-
pletely took over and closed Gebr. Klingspor,
adding its important and modern type collection
to theirs. In the meantime, Linotype also took
over a number of foundries, including Genzsch &
Heyse in Hamburg, which had an interesting type
collection dating back to 1833. In 1966, Linotype
produced its first photosetting machine and
Stempel began producing typefaces for it. In 1970,
Stempel took over part of the typeface collection
of the C.E. Weber type foundry (established in
1827) in Stuttgart, after the company went bank-
rupt. In 1978, Linotype introduced the Linotron
202, a CRT typesetting machine. In 1985, Linotype
completely took over D. Stempel AG, and put the
company into liquidation. At the same time, Lino-

Part of the cover of the *Linotype Kompendium No. 1* from the 1985 series of publications called *Linotype Show*, which are placed in a kind of typecase. With this overview, 1400 typefaces were already available in digital form one year after the first Mac was introduced.

type took over D. Stempel AG's share in the Haas'sche Schriftgießerei, which included the Deberny & Peignot and the Fonderie Olive collections that Haas had previously acquired. In 1986, Linotype produced the Linotron 500 with a RIP (Raster Image Processor) that set entire pages. Together with Adobe and URW, Linotype was one of the first companies to produce PostScript fonts, in 1987. Linotype was taken over by investors and became Linotype AG. In 1988, the Linotron 2000 series was released with a PostScript RIP that could be fully controlled via a Mac. In 1989, Linotype bought all shares of Haas'sche Schriftgießerei and closed its doors, acquiring the rights to its type collection. In 1990, Linotype merged with Hell GmbH, formerly known as Dr. Ing. Rudolf Hell, to form Linotype-Hell AG. Hell's type collection with a great many designs by Gerard Unger was combined with the Linotype collection. In 1997, Linotype-Hell became part of the Heidelberg Group, and in 2006, Linotype was bought by Monotype Imaging. The fierce competitors from the beginning of the twentieth century have finally come together and Monotype Imaging is owner of the largest type collection in the world.

Examples of typefaces: Helvetica, Univers, Frutiger, Excelsior, Trade Gothic, Memphis.
Situated in: Baltimore, USA.
Website: www.linotype.com

LucasFonts After his training at the Koninklijke Academie van Beeldende Kunsten in The Hague, Lucas de Groot (1963 –) began work as a freelancer and in 1987, made an intermediate grade of the Frutiger, commissioned by Studio Dumbar. This introduced him to the process of interpolation for making intermediary grades. From 1989 to 1993, he worked for the Dutch company Premsela Vonk (now Edenspiekermann) where he was mainly responsible for housestyle design. He also learned to work on a Mac there. At BRS he designed Narsdesis, based on Glypha and produced for the logo of the Minstery of Transport, Public Works and Water Management. In 1993, he moved to Berlin where he began work for MetaDesign, Erik

Spiekermann's firm. At MetaDesign he also helped extend Meta, one of Spiekermann's designs. At night, he began working on a typeface he had designed at BRS, and used this semi-serif as the starting point for a new face, which he called Parenthesis. After amputating the serifs, he was left with a sans-serif. In this way he built a typeface family with a semi-serif, a seriffed and a sans-serif type. Since his German was not so good, limiting his social life, he worked nights and nights on end on the MetaDesign computer. When the font family was released by FontShop, Erik Spiekermann's type company, it contained 176 grades, the most extensive digital font to date. As FontShop deemed Parenthesis too long a name (because of the necessary additions), they shortened it to Thesis. Eventually, the separate fonts were called TheSans, TheSerif and TheMix. A combination of these three fonts was used for the new logo of the city of Berlin, designed by MetaDesign. Later, a condensed version was added to the Thesis family. On the basis of Thesis, De Groot also produced a number of 'Funfonts', as he calls them. These were first used by the firm Hard werken for the new design of the *Blvd* magazine. Some of these typefaces were later issued by FontShop as FF Jesus Loves You All and FF Nebulae. In 1994, the 'Pornography Issue' *Fuse 11*, an experimental font publication by FontShop, published the Multiple Master font F Move Me, a compilation of lightly pornographic drawings De Groot made during his Berlin nights, converted into a font. The user can make intermediate grades between the drawings and the traditional capital letters. De Groot himself made short animations of these transitions. In the meantime, the Thesis family had become an enormous success and, inevitably, some people criticised it for bearing too much resemblance to Caecilia by Peter Matthias Noordzij. De Groot defended himself by pointing out that types by him, Peter Matthias Noordzij, Jelle Bosma and other students of Gerrit Noordzij, all reflect their teacher's 'translation' theory about type's structural basis in handwriting. De Groot was now also drawing some fonts for MetaDesign during

the day, like FF Transit for the Berlin public transport company and Volkswagen Copy and Headline for the homonymous car manufacturer. For the Brazilian newspaper *Folha de São Paulo* he designed Folha. In 1996, De Groot left MetaDesign and established FontFabrik with Wim Westerveld. They wanted to apply themselves to the design of custom typefaces. For FontFabrik he designed Elletura (an adaptation of the Futura), Bell South (together with Roger van den Bergh) and Floris Newspaper as a heading type for the newspaper *Le Monde*. In 1997, he designed Agro for Studio Dumbar in The Hague, as an alternative to Frutiger, commissioned by the Ministry of Agriculture. In 1999, the licence with FontShop for the Thesis family expired and De Groot decided to start his own type company, LucasFonts. He was able to make a flying start with Thesis and a number of other fonts that he designed as custom typefaces on short term contracts, like Spiegel (for the German magazine *Der Spiegel*), TAZ (for the *Tageszeitung*), Sun Sans (for Sun

Microsystems), Corpid (the commercial version of Agro, designed for the Ministry of Agriculture) and Folha (for the newspaper *Folha de São Paulo*). After a legal dispute with MetaDesign's new direction, this last typeface had to be withdrawn. The Thesis family with some additions like the TheAntiqua and TheMono are still LucasFonts' best-selling fonts. Lucas de Groot also still actively designs custom typefaces, like Calibri and Consolas, made on behalf of Microsoft for the Clear Type project and included as part of Windows Vista. He made a typeface for Heineken, based on the five letters from its logo with the smiling 'e' (which Freddy Heineken apparently came up with himself during one of the meetings with his advertising company). And for the free *Metro* newspaper he made an adaptation of Corpid, which has since been extended to include Russian, Bulgarian and Greek versions for the *Metro* issues in those countries.
Examples of typefaces: TheSans, TheSerif, TheMix, TheAntiqua, Corpid, SpiegelSans, Calibri.
Situated in: Berlin, Germany.
Website: www.lucasfonts.com

Miller & Richard In 1809, William Miller, former foreman at the Alexander Wilson type foundry, began a type foundry in Edinburgh, William Miller & Co. In 1842 it was renamed Miller & Richard when his son-in-law Alan Richard joined the board of directors. From the start, the company was successful and cast, among others, the special typefaces for Bradshaw's Railway Guides. He issued a type specimen already in 1809, but the oldest known to survive dates from 1811. Richard Austin (1756–1832), one of the best English punch makers, alledgedly cut the didones for Alexander Wilson's type foundry and for William Miller, which later became famous as Scotch Roman. Miller & Richard's biggest success was the Old Style. The Miller & Richard Old Style was brought on the market around 1860 and was credited to Alexander C. Phemister (1829–1894) who was apprenticed to William Grandison, a punchcutter who worked for Miller & Richard as a freelancer. Caslon's types of ca. 1730 had been revived

A spread from the *Newspaper LucasFonts Catalog* of April 2000 with LF Sun, which was designed as custom typeface for Sun Microsystems.

12 POINT, No. 4.—Old Style.
Founts of any weight with or without Italic.
SCENES IN SOUTH AFRICA.—As you penetrate into a secluded valley in South Africa, the white washed farm houses gradually unfold themselves scattered at short intervals along the skirts of the hills, each mansion surrounded by plantations of oak and poplar, intermingled with groves and avenues of orange and lemon trees, and with orchards producing in exuberance almost every variety of fruit, European and Tropical;—while, 1234567890 1234567890 1234567890 1234567890

SCENES I
valley in S
unfold ther
the hills, ea
lar, interm
trees, and
variety of
around the
yards, slopi
oozes from

123456

Miller & Richard's Old Style in the type specimen *Miller & Richard Specimens of Modern, Old Style and Ornamental Type – Cast on Point Bodies* (around 1910). After Miller & Richard closed in 1951, Stephenson, Blake acquired a small part of its material.

privately in the 1840's and put on general sale in the 1850's, but to the nineteenth-century eye they looked too archaic for general use. Miller & Richard's Old Style therefore adapted them to the tastes of the day, mixing a touch of the didone into the Caslon-like features. It proved an enormous succes and other type foundries quickly copied it. In 1861, Phemister emigrated to the US and for two years worked for the Bruce Type Foundry, a Scottish foundry that came to New York in 1793. After that, he worked for the Dickinson Foundry in Boston where he cut a version of the Miller & Richard Old Style called Franklin Old Style. In 1872, he became co-owner of Dickinson and remained to his retirement in 1891. Typefoundries that make their own versions of the Miller & Richard Old Style include the Bruce Type Foundry (Antique No. 310), MacKellar (Old-style Antique), Keystone (Oldstyle Antique) and Hansen (Stratford Old Style). In 1901, Bruce issued a newly drawn version, Bartlet Oldstyle. American Type Founders took over his foundry in the same year, renaming it Bookman Oldstyle. Between 1934 and 1936, Bookman was perfected by Chauncy H. Griffith at the once more renamed Kingsley/ATF.

In 1938, Miller & Richard closed their London branch and the type foundry moved to Sheffield in Scotland. In 1951, after the death of Alan Miller Richard, the last partner, the company closed for good and Stephenson, Blake acquired a small part of the typographic material. Because of its popu-larity, Mergenthaler Linotype issued a Scotch Roman in 1903 and Monotype issued one in 1907. In 1993, David Berlow drew Scotch Roman for Font Bureau, based on the Scotch as cut by Richard Austin and cast by type founders Alexander Wilson and William Miller. In 1997, Matthew Carter designed Miller for Font Bureau as a revival of the early Miller typefaces.

Examples of typefaces: Scotch Roman, Miller & Richard Old Style.

Situated in: Edinburgh, Great Britain.

Website: n.a.

Monotype In 1887, Tolbert Lanston (1844–1913) ob-tained his first patent for a mechanical typeset-ting machine. Around that time, Ottmar Mergen-thaler was installing his first 'Blower' linesetting machine (later renamed Linotype) at the *New York Tribune*. In 1885, Linn Boyd Benton developed a

pantograph refined enough to cut text types. Type cutting and continuous scaling could now be executed in a fraction of the time. In 1886, the United States Type Founder's Association convened in Niagara and established one standardised measurement system, the Anglo-American point system, for type bodies, making it easier to use types from different foundries together. In a short space of time, a number of innovations thus paved the way for the mechanised production of printed matter with important boundary conditions like a uniform measurement system and a faster production of punches and matrices. In 1887, the Lanston Monotype Machine Company was officially established in Washington. J. Maury Dove was its first director. Dove was recommended to Lanston because he had a great network for attracting capital, necessary for setting up the industrial production of typesetting machines. From the start, the framework of the Monotype typesetting machine was different from that of the Linotype. As the names imply, the Monotype cast individual pieces of type while the Linotype cast whole lines (slugs). Both systems had their pros and cons. In case of a typo, the only thing that needed to be changed in the Monotype was one piece of type; for the Linotype, it was the entire line. The Linotype did work faster so it was more often used for newspapers and magazines. The Monotype furthermore had always worked with separate units for entering and producing the type material. Entering the type material is done by means of a keyboard that mechanically punched holes in paper tape. The paper tape was then run through a second machine that cast the type. The big advantage of working this way was that text could be entered more quickly and that the casting could be done continuously if enough paper tapes had been prepared. The first machine that Lanston sold worked with punches that stamped letters into cold strips of metal, using 196 different matrices. Spacing was inserted between letters and not, as with the Linotype, between words. Typographers still consider this a horror. Because of the limitations of punching in cold metal, Lanston

applied for a new patent in 1890 to cast individual pieces of type using hot-metal casting. He obtained the patent in 1896. To counteract the expected loss of their marketshare by the introduction of the Linotype and Monotype typesetting machines, a large number of independent type foundries merged in 1892. The American Type Founders was established. In subsequent years, more would follow. In 1896, Lanston Monotype issued their own typeface for the first time, the Modern Condensed Series 1. In 1897, a wedge construction for spacing lines was added to the Monotype machine. This made it possible to space only between words instead of also between letters, a qualitatively very necessary step that brought the Monotype a step closer to its competitor Linotype, even among critical typographers. Investments continued, however, and Monotype's directors decided to travel to London, where a machine was being delivered, to acquire some more capital. During the journey across the Atlantic, J. Maury Dove and Harold M. Duncan met Lord Dunraven from England who bought the British and colonial (excluding Canada) rights to the Monotype system. Monotype had always relied on external suppliers who required quick payment, so the new capital gave them room to further improve the Monotype. At the end of 1897, the Lanston Monotype Corporation was established in London, the English subsidiary company of Lanston Monotype Machine Company. In the same year, Linotype also erected a British factory, in Altrincham in the north-west of England. In 1899, Monotype built a factory in Salfords where typesetting machines from the US were tested, tuned and repaired and some machine parts produced. Frank H. Pierpont was appointed manager at Salfords. Fritz Steltzer was appointed director of the Type Drawing Office. The first typeface the English subsidiary produced was a Modern based on a design of the Miller & Richard foundry. In Salfords, a whole series of Benton-Waldo punchcutting machines was installed as well, for the production of matrices. In 1899, Harold M. Duncan was appointed director of the English subsidiary

Part of a so-called Monotype 'Matrix case'. These are the matrices used for casting separate pieces of metal type. They are made of copper because it melts at a higher temperature than the type metal. At the same time, it is soft enough that one can easily strike the steel punch into it.

company. In the same year, the company in the
United States moved from Washington to Callow-
hill, Philadelphia. Moulds and matrices were
initially produced in-house, but other materials
were still made externally. In 1902, the first issue
of the *Monotype Recorder* appeared, a famous
external house magazine. Sol Hess became the
first type designer at the American Monotype. In
1904, the English subsidiary acquired the rights
to supply every country outside North and South
America. In 1905, the American branch began
producing all machines in-house. In 1907, the
typeface Scotch Roman (Series 46) appeared and
the Benton-Waldo punchcutting machines were
replaces by new ones, made in Salfords after a
design by Frank H. Pierpont. They were eight
times faster than the old machines and more
accurate. In 1907, the Government Printing Office
in Washington already had 124 Monotype
machines in use, with 162 separate keyboards and
paper tape writers. In 1908, Frederic W. Goudy
designed the typeface Monotype 38E specially for
Life magazine. Later, it became known as Goudy
Light Old Style. In 1910, the first Greek Monotype
face appeared, the Greek Upright Series 90, based
on a design by the German type foundry Schelter
& Giesecke. A number of typefaces were introdu-
ced consecutively, including Veronese (Series 59)
in 1911 for the publisher J.M. Dent, Forum Title
(Series 274) designed by Frederic W. Goudy (also
1911), Plantin (Series 110) designed by Frank H.
Pierpont in 1913 and Caslon Old Face (Series 128)
in 1916. In 1913, the first Ludlow typesetting
system, intended primarily for larger sizes, was

THE PASTONCHI FACE
ITS ORIGIN

WHEN Francesco Pastonchi, one of the foremost poets and authors of
present day Italy, a few years ago discussed with some of his friends,
the plan of a new and exhaustive edition of the Italian Classics, he
described the chief requirements of this library in the following curt
sentence: — «This new collection must be comprehensive, be abso-
lutely reliable as regards the text in agreement with the latest cri-
ticism; it must have the greatest clearness and legibility of print,
and be beautiful in its outward form.»

what does clearness and legibility of print consist? Different

rise a legible and clear text; the

printed

installed at the Evening Post in Chicago. The Ludlow was a line casting machine without a keyboard. The compositor manually set the matrices for a line in order, placed it in the machine and cast the line, then returned the matrices manually to their compartments. The machine took more time to operate, but that was reflected in the price: the Ludlow was fifty percent cheaper than the Monotype. Another competitor, the International Typesetting Machine Company, producer of the Intertype linesetting machine, went bankrupt and the newly established Intertype Corporation bought all its stock. In 1918, Monotype and Linotype missed out on the delivery of 31 typesetting machines for the *New York Times*, which chose the Intertype instead. In 1919, Monotype began using the Anglo-American point system as standard and in 1920, Frederic W. Goudy succeded Joseph Hays as head of American Monotype's type design studio. In 1921, he drew their Garamont (Series 248). It was very different from the English Monotype's Garamond (Series 156). In 1922, Sol Hess became the director of typography at Monotype in the US and in 1923, Stanley Morison became the typographic advisor to Lanston Monotype in London. The latter appointment marked the start of a period in which a lot of new typefaces were introduced, including Cochin (Series 165), Baskerville (Series 169), Poliphilus (Series 170) and the Blado (Series 119). In 1924, Goudy designed Italian Old Style (Series 243), cut by Robert Wiebking. In that same year, Harold M. Duncan, general manager of the British branch, died and was succeeded by William Isaac Burch. From 1924, complete Monotype machines were produced in England. In 1925, Fournier (Series 185) and Goudy Heavyface (Series 380) appeared, designed by Frederic W. Goudy. In 1926, Lord Dunraven, chairman of the UK branch since 1897, died and was succeeded by Lord Askwith. In 1928, Pastonchi (Series 206) by Francesco Pastonchi and Eduardo Cotti was presented in an unusual type specimen, designed by Hans Mardersteig and printed by Arnoldo Mondadori on Officina Bodoni's handpress in Verona. In 1927, Beatrice Warde was appointed

editor of *Monotype Recorder* and, two years later, publicity manager of the Monotype Corporation Ltd. Her editorial pieces were later collected and, in 1955, published as *The Crystal Goblet*. In 1929, Centaur (Series 252) by Bruce Rogers appeared with an italic by Frederic Warde, based on an italic by Arrighi. The italic had originally been cut by hand for foundry type by Charles Plumet in 1925. In 1929, Perpetua (Series 239) and Gill Sans (Series 262) by Eric Gill appeared, Bembo (series 270), and Deepdene (Series 315) and Sans Serif Heavy by Frederic W. Goudy. In the same year, the American Monotype bought the Thompson Type Machine Company, which made typecasting machines for printing companies. The Thompson could cast type for hand setting using matrices from Linotype, Monotype, Ludlow and many others. It could also cast larger sizes. Both the US and the UK factory started producing the machines, which were sold with the slogan: 'every printer his own typefounder'. In 1930 Monoytpe issued Jan van Krimpen's Lutetia (Series 255), a design originally made for Joh. Enschedé en Zonen, and Bell (Series 341), based on Richard Austin's 1788 type, whose matrices survived at Stephenson, Blake. In 1931, the name of the British company was changed to Monotype Corporation Ltd. Monotype's most famous typeface, Times New Roman (Series 327), produced for the *The Times* in London in 1932 under the guidance of Stanley Morison, became available to others in 1933. In 1932, the Monotype was fitted with an automatic leading device that added extra white spaces (in the form of metal strips) so as to avoid handwork afterwards. In 1933, the Rockwell (Series 371) and the Monotype Walbaum (Series 374) appeared. In 1934, the first tele-typesetting machines were installed at the newspaper *The Scotsman*. Typesetting orders were sent from London to Edinburgh via data transmission and printed there. In 1936, Monotype issued Romulus (Series 458), originally designed by Jan van Krimpen for Enschedé. In that same year, Stanley Morison published his essay *First Principles of Typography* at Cambridge University Press. Frank H. Pierpont retired as works manager at the factory in

In the 1980's, Monotype issued type specimens designed as four-page folders, with a type specimen on the front and various sample settings on the back of the fold-out. This specimen of Monotype Bell (1988) was designed by David Quay. The typesetting was done on the Monotype Laser-comp typesetting machine.

Salfords. Under the supervision of Morsion, Ehrhardt (Series 453) appeared. Berthold Wolpe designed Pegasus (Series 508) in the same year and a year later, in 1938, Albertus (Series 481). In 1938, Matura (Series 496) by Imre Reiner appeared as well. In 1940, Sol Hess took over from Frederic W. Goudy as art director of American Monotype. In 1942, Lord Askwith, Chairman of the British Board of Directors and successor to Lord Dunraven, died. In the same year, the British Managing Director W.I. Burch died as well and was succeeded by H.L. Buckle. In 1946, the Alternate Gothic No. 2 by Sol Hess appeared and at the US Government Printing Office in Washington, the first Intertype photosetting machines were installed. Structurally, they were still very similar to a typecasting machine. In 1947, Frederic W. Goudy died. In 1948, E. Silcock succeeded H.L. Buckle as Managing Director of the British Mono-type Corporation. In 1952, the British arm of Monotype demonstrated the first Monophoto Filmsetter. This machine was hardly distinguishable from their traditional composing machines. In 1953, Sol Hess died and in 1954, the Monophoto Filmsetter was shown in the US for the first time. In 1955, Monotype issued Jan van Krimpen's Spectrum (Series 556), originally drawn for

Enschedé, and in the same year Will Carter's Klang (Series 593). In 1956, Stanley Morison retired and was succeeded by John Dreyfus. In 1957 Monotype introduced Dante (Series 592) by Giovanni Mardersteig (originally cut by Charles Malin for Officina Bodoni in 1955) and Castellar (Series 600) by John Peters. In the same year, the first Monophoto Filmsetter was installed at Government Press in South Africa. In 1958 they issued Eric Gill's Joanna (Series 478), originally cut for hand setting by the Caslon Foundry. The British Managing Director E. Silcock was succee-ded by Jack Matson. In 1959, they issued Pepita (Series 613) by Imre Reiner. In the United States, Hans Schneider was appointed Head of the Typo-graphy Department. In 1962, Monotype issued Univers (Series 689), first released in 1957, originally designed for Deberny & Peignot for hand setting and for the Photon/Lumitype photo-typesetting machine. Also in that year came Fontana (Series 403) by Giovanni Mardersteig and Octavian (Series 603) by Will Carter and David Kindersley. Apollo (Series 645) by Adrian Frutiger was specially designed for phototypesetting in 1962. In 1963, Horace Hart became President of the Lanston Monotype Machine Company in the US. In 1964, Monotype issued Albertina (Series 664) by Chris Brand, first used in 1966, at an exhibition on Stanley Morison at the Koninklijke Bibliotheek in Brussels. Like Apollo, it was availa-ble only for photosetting machines. In 1964, the American branch for the first time began impor-ting machines produced wholly in the UK. In 1966, Monotype issued Sabon (Series 669) by Jan Tschichold, the first typeface designed for simul-taneous release for Linotype, Monotype and hand set foundry type. In 1967, the Bulmer (Series 469) is published after an originally limited editions design of 1937. Monotype issued Fleet Titling (Series 632) by John Peters in 1967, when the Monophoto Filmsetter Mark 4 was introduced as well. It allowed hot metal composition and photo-setting side by side for both relief and offset printing. Stanley Morison died in 1967. In 1969, the first electronic Monophoto 600 Filmsetter was sold alongside the Monophoto Mark 5. Monotype's

American branch was liquidated in 1969 and Beatrice Warde died in the same year. Intertype discontinued the production of typecasting machines and Linotype stopped producing in the US. In 1970, Germany was the only country to regularly produce linecasting machines. In 1972, the Photina (Series 747) by José Mendoza y Almeida became Monotype's third new typeface for photosetting. In 1973, Monotype was taken over by one investor after the other and stripped financially. After a few rocky years, the company released the Monotype Lasercomp in 1976, the first commercially successful laser imagesetter with a raster image processor (RIP). In 1980 they issued Calvert (Series 806) by Margaret Calvert and Nimrod (Series 814) by Robin Nicholas. Roger Dray became the new Managing Director of Monotype and in 1982, John Miles succeeded John Dreyfus as Head of the typography department. In 1983, they issued Clarion (Series 917). In 1984, Apple introduced the Mac, starting a whole new era. In 1986, Monotype issued Cantoria (Series 962) by Ron Carpenter and Footlight (Series 1156) by Chong Wah. Monotype issued the laser image-setters Express and Pioneer. In that same year, Monotype returned to the stockmarket, thus obtaining the means to invest. In 1987, they issued Calisto (Series 1160) by Ron Carpenter and Abadi (Series 1193) by Chong Wah. René Kerfante succeeded John Latham as Head of the typography division. Monotype discontinued the production of typecasting machines in 1987. In 1988, the Prism laser imagesetter was launched, with accompanying PostScript RIP and (unhinted) PostScript Type 3 typefaces. In the US, Gerald Giampa bought up the matrices machines and remnants of the Lanston Monotype Machine Company and moved them to Vancouver. In 1989, the Adobe license to produce hinted PostScript Type 1 typefaces was made available, and Monotype at the same time made so-called Expert fonts with small capitals, old style figures and other typographic additions. In 1990, they issued Ellington (Series 1216) by Michael Harvey and Amasis by Ron Carpenter. After the release of the Amasis, Monotype stopped numbering typefaces. In the 1990s, Monotype released a number of laser imagesetters. In 1992, they issued Columbus by Patricia Saunders and in 1994, Ocean Sans MM by Chong Whay, the first Multiple Master typeface that had not been designed by Adobe. In 1995, they issued Sassoon, designed for use in children's books, by Rosemary Sassoon and Adrian Williams, and in 1996, the digital version of Pastonchi. In 1999, Agfa-Compugraphic bought Monotype and the company continued as Agfa-Monotype. In 2000, they acquired ITC. In 2004, the typeface components were sold to Ta Associates in Boston, and the company renamed Monotype Imaging. In 2006, Linotype was added to Monotype Imaging and, later that year, China Type Design Limited in Hong Kong.

Examples of typefaces: Centaur, Baskerville, Ehrhardt, Gill Sans, Perpetua, Joanna, Times New Roman.

Founded in: Washington, USA.

Website: www.fonts.com

Nebiolo In 1878, Giovanni Nebiolo bought Giacomo Narrizano's type foundry (established in 1852). In 1889, after the brothers Lazzaro and Giuseppe Levi joined the board of directors, the name changed to Nebiolo & Comp. A year later, Nebiolo began building printing presses. In 1899, they merged with the Urania firm and obtained a listing. In 1909, the name changed to Società Augusta. They took over a number of typefoundries and in 1916, reverted to the name Nebiolo & Comp. The company began designing their own typefaces in the 1930s under supervision of the painter Giulio da Milano. In 1936, Alessandro Butti (1893–1959) became artistic director and designed a large number of typefaces. In 1952, Aldo Novarese (1920–1995) began working for Nebiolo. Novarese designed many well-known typefaces for Nebiolo. In 1975, the design department closed. The most famous typefaces are Eurostile (1962, Novarese), Microgramma (1952, Novarese/ Butti), Egizio (1956, Novarese), Augustea (1951, Novarese/Butti), Torino (1908) and Stop (1971, Novarese). Torino is a revival of Bodoni. Other notable typefaces are Neondi (1935, da Milano), Resolut (1937, Brünnel),

Landi Echo (1939, Butti), Veltro (1931), Veltro Nero, Scritto a Lapis (1905). Americana (ca. 1945) was a script that has been digitised by Rebecca Alaccari as Pendulum (2005, Canada Type). Eurostile in capitals and lower-case letters is a successor to Microgramma that consisted solely of capitals, designed as a display type. Because of its popula-

rity, Novarese then designed Eurostile for reading texts. Later, a lower-case variety was added to the digital version of Microgramma that URW and Elsner + Flake had in their collection. When Helvetica and Univers were published, Nebiolo wanted to be able to offer a similar sans-serif. In 1958, Aldo Novarese therefore designed Recta with 21

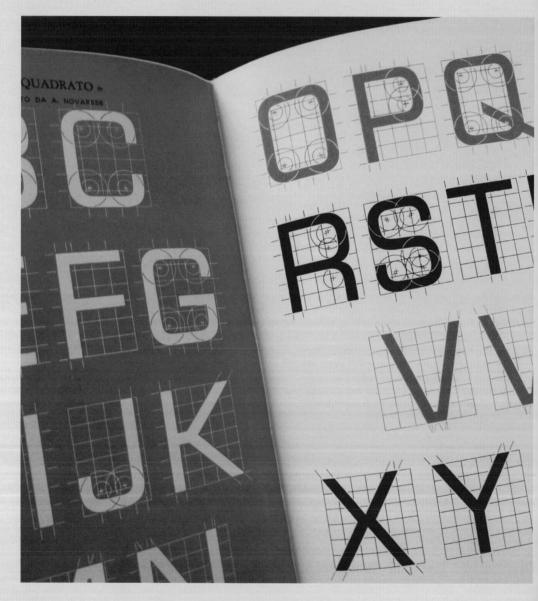

Nebiolo's Forma in the type specimen *Catalogo caratteri Nebiolo* from the 1960's. At the end of the synopsis, the alternative 'G', 'R' and 'a' are shown that give the typeface different stylistic characteristics.

grades. It was similar to Helvetica in style and had geometrical traits. In 1966, Forma was released, a sans-serif in the American gothic tradition, designed by committee with Novarese as designer and a number of graphic designers as its members. After each adjustment, the design was discussed by the committee. Forma's strokes flared slightly at their ends, like Optima but less pronounced. The Forma had a few alternative characters, like the 'G', 'R' and 'a' that are more geometrical and have a one-storey 'a', and a separate set that leaned more toward the American gothic, with a two-storey 'a' and the curious supporting leg on the 'G'. The thought behind it was that this way, the typeface could be used for different styles. The type specimens and catalogues were true masterpieces of design and were so much ahead of their time that even now, they do not look old-fashioned. Collectors pay a lot of money for them. Nebiolo also supplied the Nebitype type casting machine. The Nebitype was a linesetting machine, comparable to the Linotype, but without the keyboard input. The Nebitype was in that way more like the Ludlow, for which matrices also needed to be set by hand before the line was placed in the casting machine and cast.

Monotype sold the Nebitype in the US for a while as an alternative for smaller printing houses. In 1978, the company went bankrupt and the production of machines was taken over by Fiat. The foundry went to Italiana Caratteri in Bologna and Turin. In 1990, all punches, matrices and casting materials were taken over by Fruttiger AG in Münchenstein who also had all Haas'sche Schiftgießerei's and Linotype's type casting materials. The typeface licenses went to Linotype.
Examples of typefaces: Torino, Eurostile, Augustea, Microgramma, Egizio, Stop, Americana.
Situated in: Turin, Italy.
Website typefaces: n.a.

Neufville Digital In 1997, Neufville Digital set up as a joint venture of Bauer Types and Visualogik Technology & Design from The Netherlands. They wished to issue typefaces they had licensed and develop new, high quality typefaces to match the existing collection. Bauer Types was the successor to the Bauersche Gießerei and Fundición Tipográfica Neufville. During the 1970's, Neufville took over a number of companies like Ludwig & Mayer, Fonderie Typographique Française, Fundición Tipográfica Nacional and Fonderie Dib, bringing them a large collection of matrices by internationally renowned type designers. One of Neufville Digital's aims was to digitise typefaces that had only been available in metal type, like the 'Collection Grafía Latina'. One of their most famous typefaces is Paul Renner's Futura, redrawn as Futura ND. The 'Modern Collection' are new typefaces like Pragma by Christopher Burke and Fontana by Ruben Fontana. The Dutch company Visualogik took care of the high digital quality of the typefaces. For the history of Bauer, see Bauersche Gießerei.
Examples of typefaces: Futura, Aster, Beton, Candida, Dynamo, Erbar, Pragma, Fontana.
Situated in: Barcelona, Spain.
Website: www.neufville.com

Ourtype Type publisher Ourtype was established in 2002 by type designers Fred Smeijers and Rudi Geeraerts. Although Smeijers (1961–) designs his

typefaces completely digitally, he is still very fond of the past and the history of typography. He is so fascinated by it that he cuts his own punches to understand what it is like to manually produce a type from a form and counterform. In his book *Counterpunch*, published by Hyphen Press, he looks for links between past and present in the design of typefaces. Smeijers's type designs are often the result of studying classic examples. He often visits the Museum Plantin-Moretus in Antwerp to study its collection. He was educated at the arts academy in Arnhem, and in 1987 began working for the printer manufacturer Océ, who needed typefaces adapted for early laser printers. In 1991, he established the design firm Quadraat in Arnhem, together with Jan Willem den Hartog and Jan Erik Fokke. He named his first typeface after the firm and later added Quadraat Sans. Quadraat, with its classical proportions, was the result of all his trips to the Plantin-Moretus Museum. He himself thinks it belongs somewhere between Plantin and Times: lighter in colour than Plantin, but darker than Times. In 1993, he drew, together with Andrea Fuchs, the revival of Sjoerd Hendrik de Roos's Nobel, published by the Dutch Type Library. In 1993, he designed Renard for The Enschedé Font Foundry, a re-interpretation of Hendrik van den Keere's Canon roman. Van den Keere was a punch-cutter who made many types for Plantin. At the Museum, Smeijers was able to study the Garamond punches and matrices owned by Plantin. Renard shows a lot of Garamond's character traits. Renard's italic is a completely new design, but still fitting with Van den Keere's time and working method. In 1995, Smeijers collaborated with Peter Matthias Noordzij to digitise Jan van Krimpen's Romanée for The Enschedé Font Foundry. In 1998, he co-designed the typeface Arnhem for the Staatscourant, a daily publication of the Dutch government. He did this is collaboration with the Werkplaats Typografie at the arts academy in Arnhem. It was also a typeface with classical origins and which Smeijers likes to compare to the Romain du Roi, cut by Philippe Grandjean for the French king Louis XIV. In the

The cover of the first OurType type specimen (2004), in which Sansa Condensed Ultra Black catches the eye.

1990's, Smeijers worked for a while to re-design a number of product logos for Philips, the Philips Screen Font Family and the Philips Script. In 1998, he designed Fresco, a completely new typeface that was neither a revival nor a re-interpretation. Later, Fresco Sans followed. In 2001, Smeijers received the Gerrit Noordzij Prijs for his work and in 2002, he began his own company Ourtype with Rudi Geeraerts of FontShop Benelux. His designs that are distributed by Ourtype are Arnhem, Custodia, Fresco, Monitor, Sansa and Ludwig. Other designers who have worked for Ourtype are Peter Verheul with Versa (2004), Merel Matzinger with Eva (2008), André Leonardt with NeueSans (2006), Nikola Djurek with Amalia (2006), Artur Schmal with Parry and Parry Grotesk (2006), Thomas Thiemich with Alto (2008), Maurice Göldner with Meran (2008) and Hendrik Weber with Lirico (2008). It is a very nice collection, putting emphasis on typefaces for body texts.

Examples of typefaces: Arnhem, Fresco, Versa, NeueSans, Amalia, Custodia, Lirico, Monitor.
Situated in: De Pinte, Belgium.
Website: www.ourtype.com

Plantin-Moretus In 1549, Christoffel Plantin (1520 – 1589) settled in Antwerp and started working as a book binder. In 1555, he opened his printing

office, 'De gouden passer'. In 1576, he moved to the location of today's Plantin-Moretius Museum. From 1589, his son in law Jan I Moretus took over the business. Plantin brought together a remarkable collection of punches and matrices, many by the best sixteenth century masters and some commissioned by him. In 1876, after more than three hundred years, Edward Moretus sold the printing shop and its collection to the city of Antwerp, which opened it as a museum. There one can see many of the sixteenth century punches, matrices and moulds 'in the flesh', as well as books that used them and others. Many well-known punchcutters like Granjon and Hendrik van der Keere (in French Henri du Tour) cut types for Plantin, who also used materials by Garamond, Françoise Guyot, Guillaume Le Bé and many others. Famous books are the *Biblia Polyglotta* and the *Rariorum Stirpium Hispaniae Historia*. Monotype Plantin's name originated in the museum because Frank H. Pierpont of Monotype visited it at the beginning of the twentieth century and saw some beautiful sixteenth century typefaces. He based the 'Plantin' on a sixteenth century Granjon roman in the Museum's 1905 specimen, though Plantin himself never used the face. Pierpont put his own clear stamp on the face. In 1561, Plantin bought a few punches or matrices from the widow of Claude Garamond and later bought more Garamond materials from Guillaume Le Bé. When Adobe in the mid-1980's wished to produce a Garamond, designer Robert Slimbach went to Plantin-Moretus to study the material. The result appeared in 1989 as Adobe Garamond, one of the most beautiful revivals of the Garamond. Although the museum does not really have a place in an index of type companies, it has been of decisive importance because of its beautiful collection of punches, matrices and type. **Examples typefaces:** Original punches and matrices from Claude Garamond. **Situated in:** Antwerp, Belgium. **Website:** n.a.

A page with beautiful italics from a Latin edition of the book *Rariorum Stirpium Hispaniae Historia* (1616), printed by Plantin's grandson, Jan Moretus.

Porchez Typofonderie In 1994, Jean François Porchez started his own Porchez Typofonderie after having worked for the big Parisian communications firm Dragon Rouge. In that same year, he designed a new typeface for the French quality newspaper *Le Monde*. A lot of his work consists of custom typefaces for, among others, newspapers like *Le Monde* and the *Baltimore Sun*, but also for companies like Costa Crocieres, France Télécom, Louis Vuitton, Peugeot, RATP, and even the singer Beyoncé Knowles. It remains a one man company; he does, however, collaborate with other designers for specific tasks in the design and for the digitisation of the typeface. His 1995 FF Angie, issued

by FontShop, received the 1990 Morisawa Award, and he recieved the 1993 award for Apolline. For his own publishing house, he later drew Angie Sans, a sans-serif version of FF Angie. In 1997, he launched his own website as well as the family extension of his Le Monde typeface. In 1999, he designed the sans-serif Parisine for the Parisian transport company RATP and in the same year, he designed Costa for an Italian cruise company. Porchez's Ambroise of 2001 was a reference to François Ambroise Didot, the father of Firmin

Didot. Because of the name, it also referred to the Didots period around 1830. The typeface was an interpretation of a Didot, cut for Ambroise by his regular punchcutter Vibert. The condensed version was called Ambroise Firmin and the extra condensed version was called Ambroise François in a reference to members of this illustrious French printing family. Anisette is a typeface that is inspired by the work of A.M. Cassandre and especially his Banjo initials for Deberny & Peignot. In the original version, these were available only in one grade. Porchez designed Anisette with lower-case letters and with six grades from light and narrow to bold and wide. Beautiful ligatures that are remeniscent of Herb Lubalin's letter combinations for Avant Garde Gothic were part of the design. In 2005, he designed Deréon for the fashion brand of singer Beyoncé Knowles. It is an interpretation of Caledonia by W.A. Dwiggins and Porchez based his design on the Scottish typefaces by Bulmer and Martin of about 1790. In 2005, he also designed Mencken for the *Baltimore Sun*, a typeface in the didone style. The typefaces Le Monde and Parisine have been extended over the years and have become large type families. In 2002, Porchez made a revival of Tschichold's Sabon for Linotype and called it Sabon Next. In 1998, he received the prestigious Prix Charles Peignot and many of his designs win international awards. He is honorary chairman of the ATypI, which was created by the men he so admired: Charles Peignot and Maximilien Vox. He was chairman of ATypI from 2004–2007. Just like his examples Peignot and Vox, Porchez teaches and publicises about his trade.

Examples of typefaces: FF Angie, Le Monde, Angie Sans, Costa, Apolline, Ambroise, Anisette, Sabon Next.

Situated in: Malakoff (near Paris), France.

Website: n.a.

Robert Besley & Co The history of this typefoundry is a rich one. In 1757, Thomas Cottrell and Joseph Jackson began a foundry of their own after they were fired by William Caslon II after a wage conflict. Jackson, just beginning an

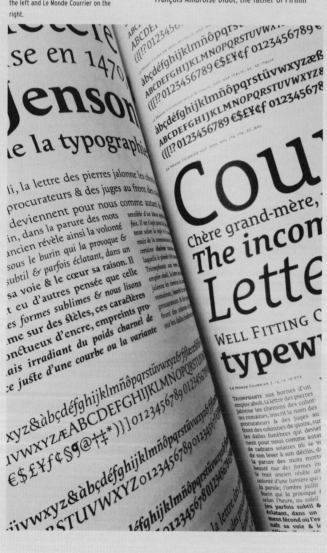

A spread from the *Spècimen de caractères & vignettes typographiques No 3* by Porchez Typofonderie (2001) with Apolline 2.0 on the left and Le Monde Courrier on the right.

ENGLISH CLARENDON ON GREAT PRIMER BODY.
Cast to range with ordinary Great Primer, the Figures to Em Quadrats.

PIRACY is the great sin of all manufacturing communities:—there is scarcely any Trade in which it prevails so generally as among TYPE FOUNDERS. Messrs. BESLEY & Co. originally introduced the Clarendon Character, which they registered under the Copyright of Designs' Act, but no sooner was the time of Copyright allowed by that Act expired, than the Trade was inundated with all sorts of Piracies and Imitations, some of them mere effigies of letters. Notwithstanding this, nearly all the respectable Printers in Town and Country who claim to have either taste or judgment, have adopted the original Founts, and treated the Imitations with the contempt they deserve.

On the left, the front of the Stephenson, Blake type specimen (1953) of the Thorowgood Fat Face Italic. On the right, the text of Besley's complaint about his colleagues' eagerness to copy.

illustrious career as a punchcutter, left for naval duty in 1759 but returned in 1763 before setting up on his own in 1765. Cottrell died in 1785 and his foundry appears to have been continued by Henry Fenwick. By at least 1794, however, it came into the hands of Cottrell's former apprentice, Robert Thorne, who had apparently worked on his own since 1785. After he moved the foundry to Fann Street in 1808, it was known as the Fann Street Foundry. When Thorne died in 1820, William Thorowgood bought it, supposedly with money he won in a lottery. Although Thorowgood had never worked in the field, the foundry flourished with Thorne's designs and new ones. In or before 1825 he acquired matrices for Fraktur and Russian types from the Breitkopf & Härtel type foundry in Leipzig. In 1828, he bought Edmund Fry's Type Street Foundry, which had a large collection of non-Latin typefaces and some of the oldest matrices surviving in England. Thorowgood was the first to call sans-serifs 'grotesques', a term still used in the UK and Germany. Around 1838, Robert Besley became a partner and continued the foundry as Robert Besley & Co. when Thorowgood retired in 1849. Besley's partner was the punchcutter Benjamin Fox, who cut the foundry's Court Hand and its famous Clarendon, patented for three years in 1845. After this time, other typefoundries immediately copied the Clarendon. This, of course, was not to Besley's liking and he even wrote an article accusing others of piracy. It is worth noting that in Blake and Stephenson's type specimen of 1833, a typeface similar to Fox's Clarendon already exists. It is, however, presented in outline and is less narrow than Besley's Claren-

don. The Clarendon was so successful that it became a generic name. In 1861, after Besley's retirement, his share was taken over by Charles Reed, and the company continued as Reed & Fox. In 1877, Fox died and the company continued as Charles Reed & Sons. After Reed's death, his sons ran the company for another few years. After Besley and Fox, the foundry brought out few innovative designs, mainly copying of Miller & Richard's typefaces. Later, the punches and matrices of Edmund Fry and Edward Prince were used for casting as well. In 1905, the company closed and the matrices and punches went to Stephenson, Blake.

Example typefaces: Domesday, Court Hand, Pica Egyptian, Thorowgood Fat Face, Clarendon.
Situated in: London, Great Britain.
Website: n.a.

Scangraphic In 1980, the German printing house Dr. Böger Duplomat (established in 1934) decided to make digital layout systems bringin together the knowledge of both printer and founder. Under the supervision of Knut Smeidel and Bernd Holthusen, they introduced their first product, the Scantext 1000. With the 1986 Scantext 2000, they beame one of the first companies to use the internal-drum imagesetter technique. In 1989, Mannes-mann AG, then one of the biggest industrial enterprises in Germany, took over Scangraphic from Dr. Böger, and they made the drum image-setter technique available for PostScript techno-logy. Scangraphic had begun developing its own typeface collection already in 1980. Although many of the approximately thousand typefaces by well-known designers had been licensed from other type companies, the collection was still very special because about 60% was available in two versions, the SB (Bodytype) and the SH (Super-type). The SB version was meant for texts up to 18 pt and the SH version for headings from 18 pt. Designers who designed exclusive fonts for Scan-graphic include Hermann Zapf with his 1987 Zapf Renaissance Antiqua, Volker Küster with his 1988 Today Sans Serif and Jelle S. Bosma with his 1988 Forlane. In the 1980's, URW digitised Scangraphic's

typefaces with Ikarus software. In those days, Jelle Bosma (Dutch) worked for Scangraphic and oversaw the digitisation at URW. In 1992, the collection was converted to PostScript Type 1 after Adobe published its specification. In 2004, Elsner + Flake took over the collection. Although no more new designs were added to the collection, every typeface has been adapted for OpenType and the euro-sign and the at-sign (@) have been added.

Examples of typefaces: Zapf Renaissance Antiqua, Today Sans Serif, Forlane.
Situated in: Wedel (near Hamburg), Germany.
Website: www.fonts4ever.com

J.G. Schelter & Giesecke Johann Andreas Gottfried Schelter and Christian Friedrich Giesecke established the typefoundry in Leipzig in 1819. Schelter left in 1839 and Giesecke died in 1850. The firm continued under Giesecke's sons, Karl Ferdinand (1817–1893) and Bernhard Rudolf (1826–1889). In 1863, they opened a Vienna branch, which in 1870 continued independently as Gießerei Meyer & Schleicher. In 1890, Bernhard's sons Rudolf Georg (shareholder from 1881 and employed at the company since 1876) and Dr.

The *Mustersammlung von J.G. Schelter & Giesecke Leipzig* (1886) also contains numerous ornaments and swash capitals cut with an almost painful precision and creativity.

Walter (at the company from 1890) took over. Previously, Georg worked for a couple of American type foundries and he introduced the more streamlined American system of working and casting. Around 1890, the company started producing printing presses. In 1890, Schelter & Giesecke owned, besides a large number of machines for other purposes like the production of printing presses, 105 casting machines, 30,000 punches and 290,000 matrices. The company employed 500 people. The electric drive of the machinery and the current for lighting was generated by two steam engines. In 1890, they acquired a manufacturer of wooden printing blocks, Th. Löhler from Mannheim. In 1930, Schelter & Giesecke became a listed company. For the period between 1819 and 1900, it is unknown what typefaces were exclusively designed for J.G. Schelter & Giesecke, and by whom. We know that, in the nineteenth century, most foundries used materials from previous centuries, partly cut after old examples, and that copying popular typefaces assumed large proportions. Besides having a whole series of gothic letters, as a proper German type foundry would have, Schelter & Giesecke developed a number of other typefaces in house. In 1882, they issued the sans-serif Schlanke Grotesk, a narrow sans-serif (misdated 1825 in several publications). The Schlanke Grotesk shows some similarities with the narrow Univers 39 that Adrian Frutiger drew about seventy years later. The book *Type Designs* by A.F. Johnson also mentions a Grotesk by J.G. Schelter & Giesecke with lower-case letters. Their beautiful 1896 type specimen has become a collector's item and the 1902 type specimen, *Allerlei Zierat* shows the beautiful, refined ornaments in various styles that were available at the type foundry. These type specimens show what the foundry could offer. Other sources are slightly less clear. A few designers are known to have worked for Schelter & Giesecke in the twentieth century. One of them is Georg Belwe, who designed the Belwe series and Shakespeare between 1912 and 1929. In 1927, Belwe designed Fleischmann for Ludwig Wagner. Albert Christoph Aus-

The *Mustersammlung von J.G. Schelter & Giesecke Leipzig* (1886) is a beautifully executed type specimen. The type collection is shown in sample settings with no complete alphabet, to temper the competition's eagerness to copy. The chapter title pages especially are adorned with beautiful ornaments.

purg designed Feenhaar for Schelter & Giesecke in 1913 and Gnom in 1914. Auspurg was an independent designer and worked for several foundries, including Lettergieterij Amsterdam. From 1930, Arno Drescher designed the Super Grotesk series as a competitor to Paul Renner's Futura. In 1924, Friedrich Hermann Ernst Schneidler designed Buchdeutsch and Schneidler in several versions, like Schneidler Fraktur, Latein, Schrägschrift and Mediaeval. Schneidler Mediaeval has been digitised and is available at Bitstream, Adobe and Linotype. In 1914, Schelter-Antiqua and Schelter-Kursiv in the German art nouveau series by Schelter & Giesecke were the inspiration for the design of the Souvenir by Morris Fuller Benton. For some letters, like g, s, v, w and y, he copied the curved parts with almost no adjustments. In the DDR after the Second World War, the company continued as part of Schriftguß KG (the former Gebr. Butter). In 1946, Schelter & Giesecke was expropriated and in 1948, Schriftguß KG

became 'Volkseigentum'. In 1951, it merged with Schriftguß Dresden to form VEB Typoart. A large part of the old punches and matrices of the various companies were destroyed during the war, so there was a great need for new typefaces. In 1951, Herbert Thanhäuser became artistic director of the design department at Typoart. In 1952, he introduced his first typefaces at Typoart: Meister-Antiqua and Technotyp, designed for the magazine Papier und Druck. In 1957, Albert Kapr designed Leipziger Antiqua for Typoart. In 1958, they added Liberta-Antiqua and Garamond Antiqua by Thannhäuser. In 1961, it absorbed Ludwig Wagner KG in Leipzig (established in 1902 by the talented punchcutter Ludwig Wagner) and the Norddeutsche Schriftgießerei in Berlin. Thannhäuser died in 1963 and Albert Kapr succeeded him. In 1967, Sabon Antiqua appeared, also available from many other companies. Typoart introduced two new typefaces in 1971 for use on the Linotron 505 photosetter, which was also

used in the DDR, Maxima by Gert Wunderlich and a revival of the Prillwitz-Antiqua by Albert Kapr. They produced photosetter font masters for both western (a.o. Diatype and Diacomp) and Russian (2NFA) photosetting machines. In 1987, Norbert du Vinage succeeded Albert Kapr. In 1988, they introduced five new typefaces: Kleopatra and Quadro by Erhard Kaiser, Biga by Fritz Richter, Zyklop by Fritz Kossack and Molli by Harald Brödel. In 1989, the Berlin wall fell and the trustees changed the company to Typoart GmbH. After most of the typefaces were digitised for TrueType and Post-Script, the company suddenly closed in 1995. In 2009, Elsner + Flake sold the digital typefaces with the consent of the entitled designers and owners such as Gert Wunderlich, Hildegard Korger, Erhard Kaiser, Karl-Heinz Lange, the Museum für Druckkunst in Leipzig, and Eckehart SchumacherGebler. Original drawings and punches and matrices have been transferred to the Museum and to Eckehart SchumacherGebler. **Examples of typefaces:** Schlanke Grotesk, Schelter-Antiqua, Super Grotesk, Belwe, Maxima. **Situated in:** Leipzig, Germany. **Website:** www.fonts4ever.com

D. Stempel AG David Stempel (1869–1927) established this German foundry in 1895 in Frankfurt, initially concentrating on the production of spacing material and rollers for printing presses. After taking over the Juxberg-Rust typefoundry in Offenbach, the company also began casting type. In 1898 Stempel's brother-in-law Wilhelm Cunz (1869–1951) and Peter Scondo (1854–1908) became company shareholders and in 1899 a machine factory was set up for the production of special machines and equipment. In 1900 Stempel was granted the exclusive right to produce matrices for Linotype GmbH, the European branch of the Mergenthaler Linotype Company in America. This agreement gave Linotype access to Stempel's type collection and gave Stempel the opportunity to produce matrices for both the Linotype and foundry type, a crucial expansion as foundry type died out. In 1901 they introduced pantographic punchcutting machines that took over a large

share of the production alongside the traditional manual manufacturing methods. In the first decades of the twentieth century they acquired a great number of other foundries, including Roos & Junge in Offenbach (1915), a majority share in Gebr. Klingspor in Offenbach (1917), Schriftgieße-rei Heinrich Hoffmeister in Leipzig (1918), the type foundry department of W. Drugulin in Leipzig (1919). Together with the Bauersche Gießereithe they acquired the firm Brötz & Glock (1919), and with H. Berthold AG the Schriftgießerei Poppel-baum in Vienna (1927) and a share in the Haas'sche Schriftgießerei in Münchenstein near Basel (1927), and with the Bauersche Gießerei and H. Berthold AG Schriftgießerei Genzsch & Heyse in Hamburg (1929). Together with Ludwig & Mayer and Gebr. Klingspor, they acquired the Benjamin Krebs Nachf. type foundry in Frankfurt. They established a Budapest branch in 1914, the Erste Ungarische Schriftgießerei, and later half the shares of this branch were presented to H. Ber-thold AG when Stempel collaborated with Berthold in Vienna under the name Berthold & Stempel GmbH. In 1941 the Mergenthaler Setzmaschinen-Fabrik GmbH in Berlin became the majority share-holder of D. Stempel AG. The production of machines for phototypesetting began in 1968, relatively late in comparison with rival companies. After David Stempel, Walter Cunz, son of Wilhelm Cunz, was the most prominent figure in the stormy developments at Stempel after the Second World War. Walter Cunz was also director of the printing company Trajanus and as such he was able to make contact with famous designers such as Hermann Zapf. Over the years Linotype acquires more and more shares in D. Stempel AG and in 1985 Stempel was completely taken over by Lino-type GmbH. Stempel produced several important typefaces. Kuenstler Schreibschrift was developed in 1902 for use in clichés produced electro-lytically. In 1904 they issued Reform-Grotesk in 26 grades and in 1909 the Amts-Antiqua by Hein-rich Hoffmeister. They issued various Fraktur types, including the Ehmke Fraktur by F.H. Ehmke in 1912. Additional types came with the foundries they acquired: Luthersche Fraktur, what they were

to call Janson Antiqua, and the Unger-Fraktur. Stempel Garamond, which remains to this day one of the industry's most important typefaces, was designed in 1924 under the direction of Rudolf Wolf and is considered one of the best revivals of Garamond's work. They published a comprehensive type specimen comprising 1200 pages in 1926. Neuzeit-Grotesk was created in 1928 in collaboration with Wilhelm Pischner and in the same year the wooden letters for Plak, designed by Paul Renner. Memphis by Rudolf Wolf appeared in 1929 and has been one of Stempel's most successful typefaces to date, along with Palatino. Paul Renner also designed Renner Antiqua in 1939. Hermann Zapf's Palatino was released in 1951 and his Melior in 1952. Zapf's wife, Gudrun Zapf-Von Hesse, designed Diotima in 1953. To mark the Stempel foundry's sixtieth anniversary in 1955, they published Hermann Zapf's *Manuale*

Typographicum, about a hundred typographic example pages printed with statements about typography in sixteen languages, all set in Stempel's types. In 1956 they acquired the remaining shares of Gebr. Klingspor in Offenbach, bringing Klingspor's type collection into their possession. In 1958 they released Herman Zapf's Optima and in 1960 acquired Max Miedinger's Neue Haas-Grotesk, better known as Helvetica. They introduced Jan Tschichold's Sabon at the 1967 DRUPA and Hans Eduard Meier's Syntax, one of the last new typefaces for metal type, in 1968. The casting of metal foundry type ceased in France in 1986 and all matrices were passed to Schriftenservice D. Stempel (www.schriftenservice-d-stempel.de) in the 'Haus für Industriekultur' at the Hessische Landesmuseum in Darmstadt. The type foundry was managed by Rainer Gerstenberg. The sales and marketing of digital typefaces moved to Eschborn in 1987 and in 1989 Linotype acquired the remaining shares of Haas'sche Schriftgießerei, passing control of the casting processes over to Walter Fruttiger AG. The typeface rights remained the property of Linotype, which was taken over by Monotype Imaging in 2006.

Example typefaces: Stempel Garamond, Plak, Renner Antique, Neuzeit Grotesk, Helvetica, Syntax, Kuenstler Script, Palatino, Optima, Melior, Sabon, Memphis, Diotima.
Situated in: Frankfurt, Germany.
Website: www.linotype.com

Stephenson, Blake This renowned English type foundry was established in 1818 by James Blake, William Garnett and John Stephenson. As the last British commercial typefoundry, its history is closely tied to that of British typefounding in general. Talbot Baines Reed writes in his *A History of the Old English Letter Foundries* that partly because of the good understanding between English printers and Dutch type founders, there were more Dutch than English typefaces in England between 1700 and 1720. It looked like everything about the Dutch work was better: the punches were more carefully finished, the typefaces were more beautiful in form, the matrices were better

A spread from a 1939 publication by D. Stempel AG that is partly a type specimen. The publication was made in celebration of Wilhelm Cunz's seventieth birthday.

callibrated and the metal of the typefaces was better than what could be produced in England at the time. The first to break this Dutch hegemony is William Caslon I. In 1730, he produced the first type specimen in which the typefaces are a match for the Dutch ones. Around 1760, printer and type cutter John Baskerville introduced some new designs as well. He had studied the typefaces of the French Imprimerie Royale, those of Fournier among others. Both he and Caslon greatly influenced their successors such as the Fry family, Robert Thorne and John Bell. As the 1800's approached, cracks begin to appear in the Caslon dynasty. William Caslon III wanted to innovate but did not get the space to do so. In 1792, he had himself bought out. Blake and Garnett set up their partnership to acquire the foundry of William Caslon IV, great grandson of Caslon I, but not his successor. Willem Caslon III had left his family foundry to acquire that of Joseph Jackson in 1792 (the two Caslon foundries competed for a quarter century), so Jackson's foundry, established in 1765 was Stephenson, Blake's direct ancestor. Two years after acquiring Jackson's foundry, Caslon III went bankrupt, but started again in Salisbury Square with Jackson's material and apparently sharing non-Latin types with his Caslon rivals. In 1804, his son William Caslon IV took over the company. Ever since Gutenberg it had been a problem to produce large typefaces that could not be made with punches. In 1810, Caslon IV announced what he called sanspareil matrices, where the letter was cut stencil-like in a thick metal plate and a solid metal plate mounted under it to form the matix. One of his first was a Fifteen Lines Pica (180 pt). Before that time these sizes were often cast in sand, a procedure that required a lot of finishing for each letter, but the use of sanspareil matrices soon spread through the foundries. It has been claimed that the Sheffield foundry Slater, Bacon and Co. (later Bower, Bacon and Bower) introduced the technique just before Caslon. Thomas Hansard called this invention in his book *Typographia* (1825): 'The greatest improvement in the art of typefounding that has taken place in modern times'. At Bower, Bacon and Bower, a certain John Stephenson was employed, a colleague of William Henry Garnett. In 1818, they made plans to start their own type foundry. When looking for a source of capital they met James Blake, from a file maker's family, who was prepared to invest in their newly formed company. As John Stephenson, then 28 years old, was the junior partner, the company was called Blake, Garnett and Company. Despite Caslon IV's success, he sold his foundry to them in 1818. They not only bought the punches, matrices and machines but even kept some of the employees. To make this purchase known, Blake, Garnett and Company published a type specimen in 1819 with the Caslon typefaces. A number of its pages are taken straight from the Caslon type specimen of 1816. Although the Caslon typefaces were selling very well, Blake, Garnett and Company start to introduce new typefaces including many of the new sanspareil typefaces. Most typefaces were, however, not very original, with a few exceptions like the Didone Trafalgar No 1 of 1819. The choice and the collection were enormous so business was booming. Garnett left the company in 1829 and it continued as Blake and Stephenson. Blake died in 1830 and Stephenson managed the foundry alone, Blake's heirs not taking an active part. In 1841, the name changed to Stephenson, Blake and Company. From 1850, John's son Henry Stephenson played a role in the company. Like his father, Henry was fanatical about quality, but he deemed it necessary to modernise and invest in casting machines that make manual casting partly redundant. In 1852, Bower Typefoundry (the former Bower, Bacon and Bower), their biggest competitor in Sheffield, closed down. In 1860, Stephenson, Blake acquired six casting machines already and in 1872, the number had grown to forty. In 1864, John Stephenson died. The Blake family remained shareholders and in 1894, Robert Greaves Blake, the founder's great-grandson, decided to enter the company. His sister Frances Blake married Henry Kenyon Stephenson (son of Henry) and so, through marriage, the families were linked once more. In 1865, they opened an

This picture of a facsimile edition of *Specimen of Modern Printing Types – Edmund Fry 1828* shows Twelve Lines Pica types. They were probably cast in sanspareil matrices. In 1906, Fry's collection went to Stephenson, Blake as part of the Reed collection.

office and warehouse in London. Because Thomas White Smith, who took charge of sales, was a former salesperson at the old Caslon foundry in Chiswell Street, his contacts aided the business, both in England and abroad. Warehouses and agents were even established in Australia, Canada and South Africa. Around 1890, power printing presses from the US become available and Lynn Boyd Benton's pantograph was further developed. Decades before they had been used for cutting of punches, pantographs were used to cut large wood type cheaply and mechanically. The production of sanspareil matrices slumped. Only six year later, Henry Stephenson installed the first Benton-Waldo pantograph for cutting type. Smith retur-

ned to the Caslon foundry and loyal employee in Sheffield, Elisha Pechy, took over the management of the London office and became the face of the company. He was so successful that the factory in Sheffield could not handle the production. He was also very active creatively, working on designs for ornaments and typefaces. He died in 1902, after having played a major role in the company for thirty years. In 1904, Henry Stephenson died as well, at the age of 77. His son Henry Kenyon and his brother-in-law Robert Greaves Blake took over management. The standardisation of measuring systems took place in 1898 and the Anglo-British point system was accepted by British type foundries under pressure from printing offices. In 1906, Stephenson, Blake established a woodworking shop that started producing its own wooden letters for bigger sizes. They also produced 'furniture' (spacing blocks for locking up type in formes) for the layout departments in printing shops. In 1914, the company could deliver sixty different wooden typefaces. In 1906, they took over the respected type foundry of Sir Charles Reed & Sons. Its historical collection included punches and matrices from the Fry, Fann Street, Thorowgood, Besley and other foundries. Reed continued to operate briefly under its own name but all the machines, punches and matrices went to Stephenson, Blake, making it the biggest and most respected type foundry in England. Its biggest competitor remained the Caslon Foundry with T.W. Smith as the new owner after the last Caslon heir died in 1874. The development of truly new typefaces was problematic for Stephenson, Blake. They bought most typefaces from external suppliers or freelancers. They were existing designs that are also used by other foundries. Around 1892, the talented punchcutter William Kirkwood began work in Sheffield. During his ten year employment, he made a number of new, successful typefaces. Kirkwood cut the successful Old Style No. 3. He also designed Condensed Athenian, Condensed De Vinne, Freehand, Veronese, Olympian and Booklet Italic. After he left, punchcutters came and went without living up to expectations. Kirkwood recommended his

pupil Karl Görner, who was to work for Stephenson, Blake from 1907 to 1959. Henry Stephenson never wanted to supply other type foundries with matrices or punches, but the new owners were less reluctant. Robert Greaves Blake searched the enormous Reed collection for usable material. They reissued Ronaldson, Italian, Old Style and Clarendon from the Reed foundry and what they dubbed Georgian Old Face appeared in the type specimen of 1907. They also tried to buy typefaces from the US, which was rapidly developing. When H.W. Caslon obtained the English rights for the popular Cheltenham by American Type Founders, Stephenson, Blake had to come up with an alternative. Before his death in 1902, Pechey had designed the not very succesfull Windsor series and on the basis of this typeface, they made an alternative to the Cheltenham: the Winchester series, which met demand for a while. In the wake of the Monotype and Linotype type-

setting machines, a fierce competition erupted and a continuous stream of newly designed typefaces started to flow, both from the US and from continental Europe. Stephenson, Blake licensed Westminster Old Style, De Vinne, Spartan, Clearface and other types from American Type Founders. In the meantime the Kelmscott Press and other independent publishing houses of the 'Private Press Movement' criticised Miller & Richard, H.W. Caslon and Stephenson, Blake in *The Times* for their copycat behaviour and their unwillingness to design new typefaces. The three big type foundries were part of the 'Typefounders Association', unofficially also called 'The Ring', because they fixed prices, prevented competitors from entering the market and made mutual agreements. These agreements also made for a certain laxity in the search for innovations. In 1920, H.W. Caslon had John Findley MacRae write the very successful book *Two Centuries of Type*

Stephenson, Blake tried to match Monotype's Gill Sans with Granby in 1930. It is shown here in the type specimen *Specimens of Printing Types from Stephenson Blake - The Caslon Letter Foundry Sheffield* of 1953. They used Caslon's respected name to encourage sales.

Winchester was Stephenson, Blake's alternative to Cheltenham, which was very popular in the US. Shown here in the 1924 Stephenson, Blake type specimen *Printing Types*.

Founding, designed and printed by George W. Jones for the 200th anniversary of the Caslon foundry. It was a beautifully designed document with the Caslon Old Face as the most important typeface. Everyone was enthusiastic and that was a reason for Stephenson, Blake to collaborate with the up-and-coming and wilful typographer, Robert Bertram Fischenden. He was commissioned to write a book for them, too, called *Letter Founding*. The book links Stephenson, Blake historically to the oldest English punchcutters and printers through the Reed collection. This is why they used the Fry type they dubbed 'Baskerville Old Face' for the text, a typeface that could stand up to Caslon Old Face. Once the book was finished, they began work on another important publication to promote the foundry: a seven hundred page type specimen. The printing needed to be perfect as well. Each printed letter was studied with a magnifying glass. If it was damaged or found not good enough, it was

replaced. *Printing Types* by Stephenson, Blake was published in 1924 and is seen as one of the most beautiful type specimen, ever made. 10,000 copies were printed, a few hundred bound in leather. Although the reactions were very positive, the production costs were so high that the management decided never to do it again. In 1930, Stephenson, Blake introduced the sans-serif Granby, reminiscent of the recently published Gill Sans by Eric Gill for Monotype. After the death of Sydney (Caslon) Smith, son of T.W. Smith and his father's successor at H.W. Caslon, business deteriorated and negotiations with Stephenson, Blake, begun and abandonned seventy years before, were resumed. In 1937, the stock, punches and matrices of the most popular Caslon typefaces were taken over by Stephenson, Blake. Of the old British type foundries, only Miller & Richard in Scotland remained as competitor. In 1952, after the death of Allan Miller Richard, that company closed down, too. Because of the rise of

typesetting machines like the Monotype, demand for foundry type declined. Stephenson, Blake tried to keep its head above water by exchanging licences of classics from their own collection for Monotype and Linotype licenses, like Baskerville Old Face for Linotype Garamond. They also struck a deal with Stanley Morison at Monotype who wanted to bring out Richard Austin's 1788 type for John Bell as Monotype Bell. Monotype issued it for typesetting machines, Stephenson, Blake for hand typesetting. It proved a success and the Perpetua by Eric Gill was issued in the same way. Starting with the successful Times New Roman, Monotype issued designs by Bruce Rogers, Eric Gill, Jan van Krimpen and a few other designers in record time. With envy, Stephenson, Blake watched the market make enthusiastic use of these typefaces. The advertising market, however, remained a booming business and an area where Stephenson, Blake could be important. They issued headline typefaces that could not be set on mechanical typesetting machines. Scripts and so-called Rondes, which were cast with a harder metal to make the hair lines last longer in printing, were specifically made for handsetting. It was no longer the large volumes of body type

that kept the company afloat, but more and more the special versions. As Helvetica and Univers swept the market in the early 1960's, however, Stephenson, Blake could offer no alternative. They also had no response to the advent of phototypesetting. In 1965, they issued Impact, Lectura and Adonis, Lectura (by Dick Dooijes) and Adonis (by André Cretton) in collaboration with Lettergieterij Amsterdam. The company remained in the hands of the Stephenson and Blake families but no longer cast type. In the late 1990s, after a number of very difficult years, the Type Museum in London acquired punches, matrices and much related material. This signaled the definitive end of the metal type era.

Examples of typefaces: Modern No. 20, Old Style No. 3, Windsor, Winchester, Verona, Granby.
Situated in: Sheffield, Great Britain.
Website: n.a.

Sweynheym & Pannartz Arnold Pannartz and Konrad Sweynheym were two fifteenth century printers. It is generally accepted that Sweynheym worked with Gutenberg from 1461–1464 and it is a general fact that both brought Gutenberg's invention to Italy. The Benedictine monastery in

De Civitate Dei by Aurelius Augustine, printed in 1470 in Subiaco by Sweynheym and Pannartz. On the right, for the purpose of comparison, a detail from the De Civitate Dei, printed in 1473 by Peter Schöffer (Gutenberg's assistent and successor). The differences between the two types are clear. On the right, the page contains heavy, vertical gothic rotunda characters, while on the left, the rounder forms break the vertical character and the letter image is already lighter. In later publications, Sweynheym and Pannartz's types became even lighter and less vertical.

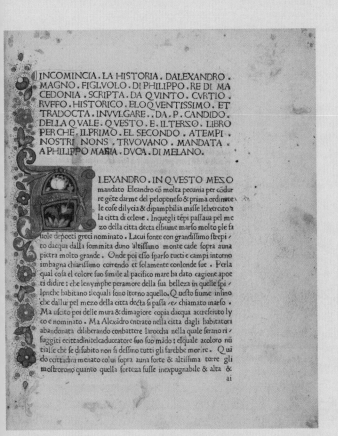

INCOMINCIA . LA HISTORIA . DALEXANDRO .
MAGNO . FIGLVOLO . DI PHILIPPO . RE DI MA
CEDONIA . SCRIPTA . DA QVINTO . CVRTIO .
RVFFO . HISTORICO . ELOQVENTISSIMO . ET
TRADOCTA . INVVLGARE . DA . P. CANDIDO .
DELLA QVALE . QVESTO . E . ILTERZO . LIBRO
PERCHE . ILPRIMO . EL SECONDO . A TEMPI .
NOSTRI NONS . TRVOVANO . MANDATA .
A PHILIPPO MARIA . DVCA . DI MELANO .

Opera from Lactantius, Lucius Coelius Firmianus, printed by Sweynheym and Pannartz in 1470 in Rome. The shapes of the letters are rounder and lighter than in their earlier types in Subiaco.

Subiaco is the cradle of the Italian printing trade and Sweynheym and Pannartz arrived there in 1464. The first surviving book by their hands is Cicero's *De Oratore* (1465). It was followed by the *De divinis Institionibus* by Lactantius (1465) and Augustine's *De civitate Dei* (1467). These books are special because they the first ones that were not printed in a gothic (textura, rotunda or bastarda) like Johann Gutenberg's books and those of his successors. In Italy, the less heavy and rounder roman types were to make their appearance. Sweynheym and Pannartz's first books used intermediate types, influenced by humanistic manuscript hands but still with gothic influences and not yet true roman types. The colour of the printed type on the page is therefore quite dark and in the beginning certainly comparable to Gutenberg's. In 1467, they left Subiaco and established themselves in Rome. The brothers Pietro and Francesco de' Massimi offered them their house and Giovanni Andrea Bussi, bishop of Aleria, became their chief editor and corrector of

classical manuscripts. The types they introduced there were much lighter in colour and were further removed from the gothic. These examples inspired many punchcuttters in Italy and Europe, becoming the model of the typeface for new times. Erhard Ratdolt introduced a true roman type in 1467 and more refined forms appeared in the books of the Da Spira brothers and then Nicholas Jenson, who introduced his splendid rendition in 1470. A few centuries later, William Morris was a well-known fan of these earliest books in roman or roman-like types and in 1890, he drew his Golden Type for the Kelmscott Press, directly based on Jenson's. Up to 1472, Sweynheym and Pannartz produced no less than twenty eight theological and classical works, such as the Bible, works by Virgil, Cicero and Thomas Aquinus. Their business like Gutenberg's, ran into financial problems. In 1472, they therefore requested support from Pope Sixtus IV. He granted it and they could continue their work. The produced another eighteen books before they separated in 1473. Pannartz continued printing and Sweynheym began engraving beautiful maps for the publication of *Cosmography* by Claudius Ptolemaeus. Unfortunately, he died in 1477, his work unfinished. His successor Arnold Buckinck finished his work and the atlas appeared in 1478. Pannartz died a year before him, in 1476.
Examples of typefaces: Monotype Golden, Monotype Centaur, Stephenson Blake Verona.
Situated in: Rome, Italy.
Website: n.a.

Typotheque Peter Bil'ak (1973 –) from Slovenia studied in Bratislava and Paris. In Bratislava he began work on typefaces that he presented at FontShop: Masterpiece, Craft and Atlanta, added to the then still young FontFont collection. They were typically experimental typefaces from the start of the digital era. At the Atelier National de Création Typographique in Paris, where he studied in 1995 and 1996, he designed Eureka. FontShop issued it in 1998 as FF Eureka, followed in 2000 by Eureka Sans. Eureka was designed to give space to the diacritics needed in the Slovak

and other Central European languages and there-fore had long ascenders and descenders. Without wanting to diminish Eureka's beautiful letter forms, the small x-height and the fairly wide spacing made it quite a difficult text typeface. In 1997, Bil'ak went to The Netherlands for a post-academic training at the Jan van Eyck Academy in Maastricht. He decided to stay in Holland and set up a design studio in The Hague. In 2001, he was commissioned by Rudi Baur Integral Design in Paris to design Fedra Sans. They wanted a Univers with more feeling. Fedra is a humanist sans-serif and looked much more mature than Eureka. Bil'ak described his sources of inspiration as 'polyhistorical' and the inconsistent slope in the design shows influences from Garamond. In 2003, he designed Fedra Serif and then extended the type family with Fedra Mono. Fedra Serif has a version A with short, and a version B with longer

ascenders and descenders. Fedra was the first typeface of his own type company Typotheque, which he started with his colleague and partner Johanna Bil'ak and which sells their own type-faces. Johanna designed the Jigsaw type family for Typotheque and Peter Bil'aks newest acqui-sition is Greta, an extensive text typeface that besides four variants in the text version, also has three 'grades' for each variant. So, for instance, the regular variant also has a lighter 'grade' and a darker 'grade'. One can therefore choose the 'grade' for newspaper paper that will give the best result on the often strongly absorbent paper. Besides his work as graphic designer and type designer, Peter Bil'ak publicises a lot and teaches. **Examples of typefaces:** Orbital, Masterpiece, Fedra Sans, Fedra Serif, Greta Text, Greta Display. **Situated in:** The Hague, The Netherlands. **Website:** www.typotheque.nl

A spread from the type specimen *Type Family Greta* (2007) by Typotheque, a new and extended type family by Peter Bil'ak.

Real Naked specimen of the Sauna type-face by Underware (2002).

Underware The odd one out. Underware was established in 2001 by postgraduate students at the KABK in The Hague. At the beginning they did not disclose the names of the designers and the first typeface Dolly was presented simply as a design by Underware. Later, the names of the partners in crime were of course made public: Bas Jacobs (Dutch, 1976–), Akiem Helmling (German, 1971–), Sami Kortemäki (Finnish, 1975–) joined in 2002 by Hugo Cavaleiro d'Alte (Portugese, 1975–). Dolly was Bas Jacobs's final project at the academy and partly for that reason a typically Dutch book typeface. A nice touch was that Underware presented each typeface in a booklet with the fonts on a CD. It was a new way of selling fonts. If the buyer started to actually use the fonts, he or she wouldl have to pay extra for the license, which was not that expensive. The second typeface was Sauna, based on Sami Kortemäki's final project. It was developed in collaboration with the others and issued in 2002. It was reminiscent of Cooper Black by Oswald Cooper (1921). Although in the first instance, it looks like a display typeface, the regular version is surprisingly legible. Graphic designer Piet Schreuders designed the accompanying booklet, which, partly because of the Finnish origins of the design, was printed on a synthetic material that feels like paper, so that it could survive use in a sauna. The custom typeface Ulrika was designed for a Finnish film and video production company and the typeface Stool for a Finnish printer. Unibody 8 (2003), as a screen typeface, was built up of pixels in a relatively coarse raster. A sans-serif version is available, called Auto. Special about this typeface is that each variant has three different cursives, ranging in style from slick to frivolous. So, depending on taste and circumstances, one can choose which to use. Bello is a script in the tradition of Roger Excoffon's Mistral. It is a carefully spaced type-face that gives the impression of connected handwritten text and contains nice typographic details such as ligatures. In the OpenType version Bello Pro they can be automatically inserted in the text. Bello is meant to be used together with

Dolly. And lastly the Fakir: It is a Fraktur typeface with very explicit forms. Not recommended for long reading texts, but definitely suitable for display applications. Besides doing workshops, Underware regularly publishes the irregularly issued '*pts.*' magazine, which Bas Jacobs began with Edwin Smet after their college days in Maastricht.
Examples of typefaces: Dolly, Sauna, Unibody.
Situated in: The Hague, The Netherlands.
Website: www.underware.nl

URW In his book *Type Now*, Fred Smeijers emphatically writes 'Outlines were invented in Hamburg, not in Silicon Valley'. By 'Hamburg' he meant the company URW, whose co-founder Peter Karow wrote a software programme that enabled drawings of typefaces to be converted to vector outlines by adding vector points to the drawing's contour with a manual digitiser. These outlines are then continuously scalable. This kind of software is in principle not meant for texts in smaller sizes, but more for big advertising letters

that measure a metre or over. In printing and typesetting companies, photosetting machines were already in use. The enlargement factor of the letters was limited. URW named the programme Ikarus after the mythical figure of Icarus who comes to close to the sun with his wings fixed with wax and plunges to his death, symbolic of the frequent crashing of the ambitious programme. The programme had to work with the limitations in calculation speed of computers of 1975, the year Ikarus was presented. When Linotype released the CRTronic in 1979, it worked with outline fonts instead of bitmap fonts like Hell's Digiset. This meant a huge job for URW. In 1979, Hell started working with outline fonts as well and used Ikarus to make them. Before that, the Digiset fonts were produced with a programme to edit the bitmaps pixel by pixel, for instance for Hermann Zapf's Marconi and Gerard Unger's Demos. At the start, URW digitised a large part the type collections of several type companies in outline, including Linotype and Adobe. But when Adobe released its BuildFont programme and FontoGrapher hit the market around 1990, URW lost a lot of revenue. In the beginning, the quality of typefaces made with Ikarus was better than that of typefaces made from scanned images in other programmes. Humans can see a deviation of about 0.03 mm in a curve, so drawing accurately is a must. And that is a skill the Ikarus operators obviously have. The drawing at URW is printed or cut at a size of 100 cm and checked visually for irregularities. At this size, a mistake is visible. Eventually, URW went bankrupt and was relaunched. URW++ was its new name and once more they tried to use knowledge and ability for personal gain. They built a typeface collection and invited type designers to make new designs. Hermann Zapf and his wife Gudrun Zapf-Von Hesse drew a whole series of typefaces for URW in the 1990s. Albert-Jan Pool from The Netherlands drew Imperial, Linear and Mauritius in 1994, Marc Musenberg designed the sans-serif Raldo in 2000, Maren Engelhardt designed Alpha in 2001 and Ekke Wolf Atlantic in 2003. URW++ also began selling typefaces by the Dutch Type Library (DTL)

and a few Germany companies. URW and DTL collaborated to develop new professional and affordable software on the basis of the Ikarus software. This became DTL Fontmaster, a programme with several modules for producing typefaces. Apart from FontLab, DTL FontMaster is now the most frequently used font production programme. URW++ has furthermore developed custom typefaces for various companies, including Daimler, Toshiba, Siemens, Deutsche Telekom, Deutsche Bahn, Thieme and Merck. The complete typeface collection contains several thousands of variants. Many of the most popular designs, formerly almost impossible to license, still appear here bearing alternative names, a vestige of the pre-PostScript days. URW Nimbus, for instance, is similar to Helvetica (URW even attributes it to Max Miedinger, Helvetica's original designer). The advantage is that they are relatively inexpensive, and the standard remains very high. Many typefaces by well-known type companies have, after all, been digitised at URW or by means of URW software. Although URW's own types have not really been innovative, it does deserve a place in this index because of its unique involvement in the digitisation of so many designs and its knowledge of typeface digitisation.

Examples of typefaces: Imperial, Linear, Mauritius, Raldo, Alcuin, Palladio, Antiqua, Grotesk.

Situated in: Hamburg, Germany.

Website: www.urw.de

Voskens, Family In 1641, the half-brothers Bartholomeus and Reinhard Voskens established a partnership in Amsterdam to cut punches, make matrices and tools for casting type, and set up their own typefoundry. They left Amsterdam in or soon after 1649 and probably worked in one or more German foundries, setting up their own foundries in Hamburg and Frankfurt respectively by the 1660's, though they kept up their contacts in Holland. Bartholomeus cut excellent Fraktur and schwabacher types, normal for books in German, and Reinhard cut romans and excellent

Two of the so-called Fell Types, collected for and bequeathed to the University Press at Oxford by Dr. John Fell, bishop of Oxford. He bought matrices for the smaller types from the Van Dijck and Vallet typefoundries in Amsterdam in the years 1670 to 1672. 1675/76 Fell brought a punchcutter to Oxford: Peter de Walpergen, who had worked in the East Indies with the Amsterdam punchcutter Hendrik Voskens. He cut the larger Fell romans and italics at Oxford; those shown were used in 1682.

italics in the latest fashion. Bartholomeus returned to Amsterdam by 1668 and died there in December 1669. His oldest son Hendrik may have continued the foundry, but probably died in the East Indies in 1671, so the next son Dirck and then his widow and sons ran the Amsterdam foundry. Hendrick, Dirck and Dirck's son Bartholomeus were also punchcutters. Reinhard Voskens remained in Germany, where the punchcutter

Johann Adolf Schmidt acquired his typefoundry from his widow, bringing some of his materials to Amsterdam in the late 1680's. The punchcutter Nicolaes Briot (ca. 1580/84 – 1626) had set up a typefoundry in Gouda in 1612 and moved it to Amsterdam in 1624/25, the city's first major independent typefoundry. He died in 1626 while preparing matrices for the great atlas printer Willem Jansz Blaeu, who was setting up his own

Double Pica Roman.

ABCDEFGHIKLMNOPQR
STVUWXYZ ABCDEFGHIK-

PAter noster qui es in cœlis, sanctificetur nomen tuum. Veniat regnum tuum: fiat voluntas tua, sicut in cœlo, ita etiam in terra. Panem nostrum quotidianum da nobis hodie. Et remitte nobis debita nostra, sicut & remittimus debitoribus nostris. Et ne nos inducas in tentationem, sed libera nos ab illo malo. AMEN.

Double Pica Italick.

AABCDEFGHIJKLMM
NOPQRSTVUWXYZ ÆÆ

PAter noster qui es in cœlis, sanctificetur nomen tuum. Veniat regnum tuum: fiat voluntas tua, sicut in cœlo, ita

in-house foundry. Blaeu came to an agreement with Briot's widow to acquire some of his matrices, but most remained with the widow and the foundry eventually passed to her foreman Jacques Vallet. Dirck Voskens and his brother-in-law Johannes Adamsz Coesvelt greatly expanded Bartholomeus Voskens's foundry by acquiring Vallet's foundry in 1673 and Blaeu's in 1678, reuniting the Briot materials. Dutch typefaces were very popular in England. When John Fell set up the Oxford University Press ca. 1672, for example, he acquired matrices from the Van Dijck and Vallet foundries in Amsterdam, and later brought over a punchcutter who had worked with Hendrik Voskens in the East Indies. Most of these 'Fell' types survive at the Oxford University Press. Dutch types by Briot and others also served as models for William Caslon. Dirck Voskens' son, Bartholomeus, the last punchcutter in the family, died in 1725, but the foundry remained in the family, under the name Voskens & Clerk, until 1780, when Adam Gerard Mappa bought most of

the materials and set up a foundry in Rotterdam and then Delft, which he took to the United States in 1790, selling it in 1794. By that time the romans and italics were very old fashioned, but Binny & Ronaldson in Philadelphia continued to show some of the other types in their early nineteenth-century specimens, and their successors became part of American Type Founders in 1892. None of the Voskens foundry's punches and matrices are known to survive in America, but a few sets acquired by Enschedé and others in 1780 do survive at Museum Enschedé.

Examples of typefaces: *Proef van Letteren*, Museum Enschedé.
Situated in: Amsterdam, The Netherlands.
Website: n.a.

Wetstein, Hendrik Floris Johann Heinrich Wetstein (1649–1726) from Basel, was apprenticed to Daniel Elsevier in Amsterdam, set up as a bookseller and publisher in 1676 and appears to have had his own printing office from ca. 1685 to his death in 1726. He acquired sets of matrices for some Greek types ca. 1690 that are supposed to originate in Basel and used to belong to Pistorius, a protestant clergyman from the sixteenth century. His two sons, Rudolph and Gerard continued the printing office and in 1735, Rudolph acquired a type foundry that the punchcutter Johann Michael Fleischman had begun in 1732. Fleischman continued to cut new types for the Wetstein foundry and for Johann Enschedé en Zonen after they bought the foundry from the Wetsteins in 1743. See the Enschedé entry in this index for the history of that type foundry.

Examples of typefaces: Museum Enschedé.
Situated in: Amsterdam, The Netherlands.
Website: n.a.

Greek typefaces in an H.F. Wetstein type specimen (about 1742). Although the Wetsteins had no typefoundry until 1735, they had earlier acquired matrices for several Greek types, including these, probably in the 1690s. Johann Michael Fleischmann later cut addition characters for some of them.

'Ίνα πληρωτῇ ὁ λόγος ὃν εἶπεν. 'Ότι οὓς δέδωκάς μοι, οὐκ ἀπώλεσα ἐξ αὐτῶν οὐδένα. Σίμων οὖν Πέτρος ἔχωνμάχαιραν, εἵλυπέκσεν αὐτήν, καὶ τὸν τὸ ἀρχιερέως δοῦζητειτε ἄφετε τὸ ὑπάγειν, καὶ ἀπέκοψε αὐτοῦ τό δεξιόν δυλῳ, τῳ ποτήριον ὃ δέδωκε μοι ὀσεύ-ἤ.ὶ-ή-ἤ ύ ΐύίΐϋ ὓ ῇ ὗ,ῖ.ῖ,ῖύ ὗέὺὺὺὺὺάέ.

Καὶ λέγων. Κύριε, ἐλέησον μου τὸν υἱὸν, ὅτι σεληνιάζεται, καὶ κακῶς πάσχει· πολλάκις γὰρ πίπτει εἰς τὸ πῦρ, καὶ πολλάκις εἰς τὸ ὕδωρ. Καὶ προσήνεγκα αὐτὸν τοῖς μαθηταῖς σου, καὶ οὐκ ἠδυνήθησαν αὐτὸν θεραπεῦσαι. 'Αποκριβεὶς δὲ ὁ 'Ιησοῦς, εἶπεν· 'Ω γενεὰ ἄπιστος καὶ διεσραμμένη, ἕως πότε ἔσομαι μεθ' ὑμῶν ἕως πότε ἀνέξομαι ὑμῶν; Φερετὲ μοι αὐτὸν ὧδε; Καὶ ἐπετίμησε αὐτῷ ὁ Ιησοῦς, καί ἐξήλθε ἀπ' ἀντοὺς ΑΒΓΔΕΖΗΘΙΚΛΜΝΞΟΠΡΣΤΥΦΧΨΩ

On the right: a page with 'No.' characters, for numbers, from the *Mustersammlung J.G. Schelter & Giesecke* (1886).

- 584

Nummer-Zeichen.†*

II. Garnitur.

№ 5781 (5 P.) № 5782 (6 P.) № 5783 (7 P.) № 5784 (8 P.) № 5785 (9 P.) № 5786 (10 P.) № 5787 (12 P.) № 5788 (14 P.) № 5789 (16 P.) № 5790 (20 P.) № 5791 (24 Pkte.) № 5792 (28 Pkte.) № 5793 (32 Pkte.) № 5794 (36 Pkte.)

5799 (84 Pkte.) 5798 (72 Pkte.) 5797 (60 Pkte.) 5796 (48 Pkte.) 5795 (42 Pkte.)

III. Garnitur.

№ 5762 (5 Pkte.) № 5763 (6 Pkte.) № 5764 (7 Pkte.) № 5765 (8 Pkte.) № 5766 (9 Pkte.) № 5767 (10 Pkte.) № 5768 (12 Pkte.) № 5769 (14 Pkte.) № 5770 (16 Pkte.)

№ 5771 (20 Pkte.) № 5772 (24 Pkte.) № 5773 (28 Pkte.) № 5774 (32 Pkte.) № 5775 (36 Pkte.) № 5776 (42 Pkte.)

5780 (84 Pkte.) 5779 (72 Pkte.) 5778 (60 Pkte.) 5777 (48 Pkte.)

IV. Garnitur.

№ 5800 (5 Pkte.) № 5801 (6 Pkte.) № 5802 (7 Pkte.) № 5803 (8 Pkte.) № 5804 (9 Pkte.) № 5805 (10 Pkte.) № 5806 (12 Pkte.) № 5807 (14 Pkte.) № 5808 (16 Pkte.)

№ 5809 (20 Pkte.) № 5810 (24 Pkte.) № 5811 (28 Pkte.) № 5812 (32 Pkte.) № 5813 (36 Pkte.) № 5814 (42 Pkte.)

5818 (84 Pkte.) 5817 (72 Pkte.) 5816 (60 Pkte.) 5815 (48 Pkte.)

J. G. SCHELTER & GIESECKE, LEIPZIG.

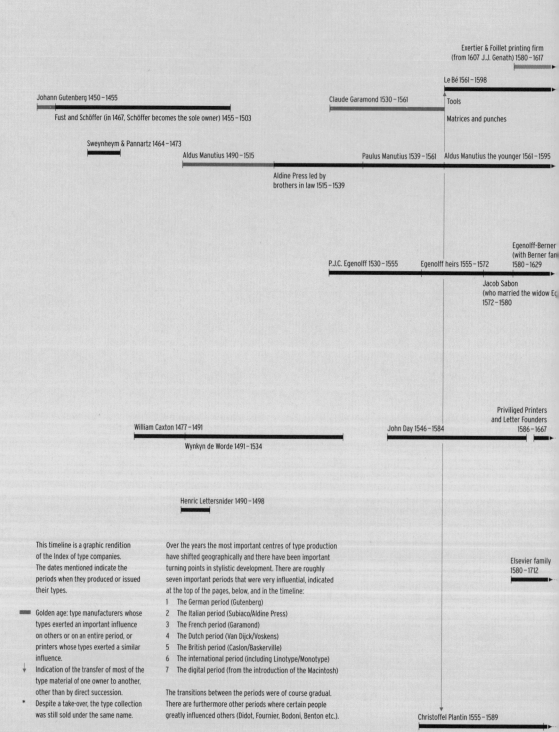

Timeline of type publishers

1450 **1475** **1500** **1525** **1550** **1575**

► Invention of western printing with movable metal type by Gutenberg.

► Period 1 ► Period 2 ► Period 3

Exertier & Foillet printing firm (from 1607 J.J. Genath) 1580 – 1617

Le Bé 1561 – 1598

Tools

Matrices and punches

Johann Gutenberg 1450 – 1455

Claude Garamond 1530 – 1561

Fust and Schöffer (in 1467, Schöffer becomes the sole owner) 1455 – 1503

Sweynheym & Pannartz 1464 – 1473

Aldus Manutius 1490 – 1515

Paulus Manutius 1539 – 1561 Aldus Manutius the younger 1561 – 1595

Aldine Press led by brothers in law 1515 – 1539

Egenolff-Berner (with Berner fan 1580 – 1629

P.J.C. Egenolff 1530 – 1555 Egenolff heirs 1555 – 1572

Jacob Sabon (who married the widow Eg 1572 – 1580

Priviliged Printers and Letter Founders 1586 – 1667

William Caxton 1477 – 1491

John Day 1546 – 1584

Wynkyn de Worde 1491 – 1534

Henric Lettersnider 1490 – 1498

Elsevier family 1580 – 1712

Christoffel Plantin 1555 – 1589

This timeline is a graphic rendition of the Index of type companies. The dates mentioned indicate the periods when they produced or issued their types.

Golden age: type manufacturers whose types exerted an important influence on others or on an entire period, or printers whose types exerted a similar influence.

Indication of the transfer of most of the type material of one owner to another, other than by direct succession.

Despite a take-over, the type collection was still sold under the same name.

Over the years the most important centres of type production have shifted geographically and there have been important turning points in stylistic development. There are roughly seven important periods that were very influential, indicated at the top of the pages, below, and in the timeline:

1 The German period (Gutenberg)
2 The Italian period (Subiaco/Aldine Press)
3 The French period (Garamond)
4 The Dutch period (Van Dijck/Voskens)
5 The British period (Caslon/Baskerville)
6 The international period (including Linotype/Monotype)
7 The digital period (from the introduction of the Macintosh)

The transitions between the periods were of course gradual. There are furthermore other periods where certain people greatly influenced others (Didot, Fournier, Bodoni, Benton etc.).

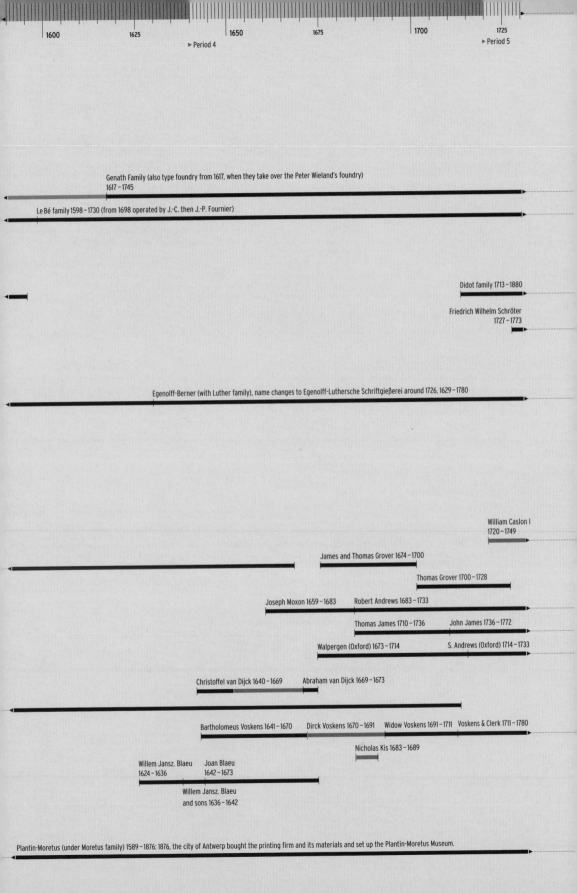

1600 1625 ► Period 4 1650 1675 1700 1725 ► Period 5

Genath Family (also type foundry from 1617, when they take over the Peter Wieland's foundry)
1617 – 1745

Le Bé family 1598 – 1730 (from 1698 operated by J.-C. then J.-P. Fournier)

Didot family 1713 – 1880

Friedrich Wilhelm Schröter
1727 – 1773

Egenolff-Berner (with Luther family), name changes to Egenolff-Luthersche Schriftgießerei around 1726, 1629 – 1780

William Caslon I
1720 – 1749

James and Thomas Grover 1674 – 1700

Thomas Grover 1700 – 1728

Joseph Moxon 1659 – 1683 Robert Andrews 1683 – 1733

Thomas James 1710 – 1736 John James 1736 – 1772

Walpergen (Oxford) 1673 – 1714 S. Andrews (Oxford) 1714 – 1733

Christoffel van Dijck 1640 – 1669 Abraham van Dijck 1669 – 1673

Bartholomeus Voskens 1641 – 1670 Dirck Voskens 1670 – 1691 Widow Voskens 1691 – 1711 Voskens & Clerk 1711 – 1780

Nicholas Kis 1683 – 1689

Willem Jansz. Blaeu Joan Blaeu
1624 – 1636 1642 – 1673

Willem Jansz. Blaeu
and sons 1636 – 1642

Plantin-Moretus (under Moretus family) 1589 – 1876: 1876, the city of Antwerp bought the printing firm and its materials and set up the Plantin-Moretus Museum.

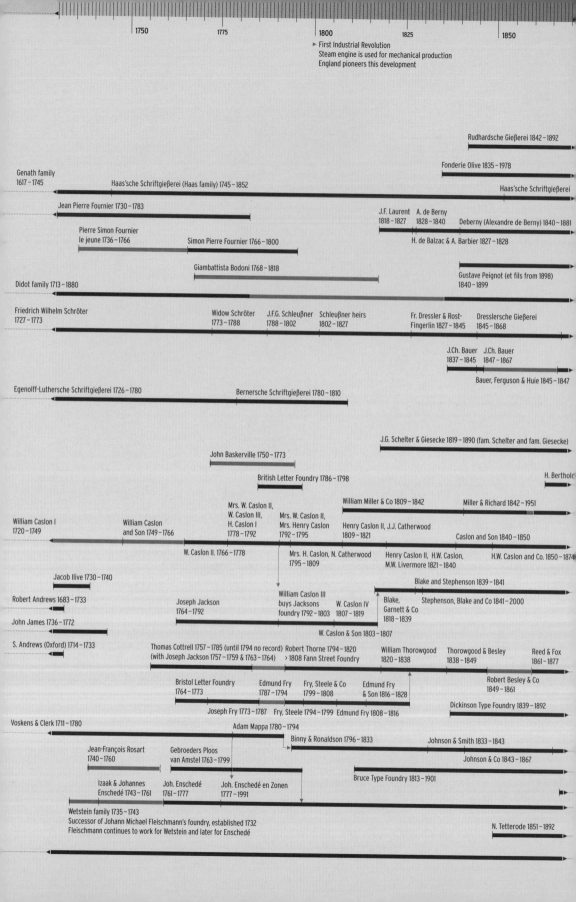

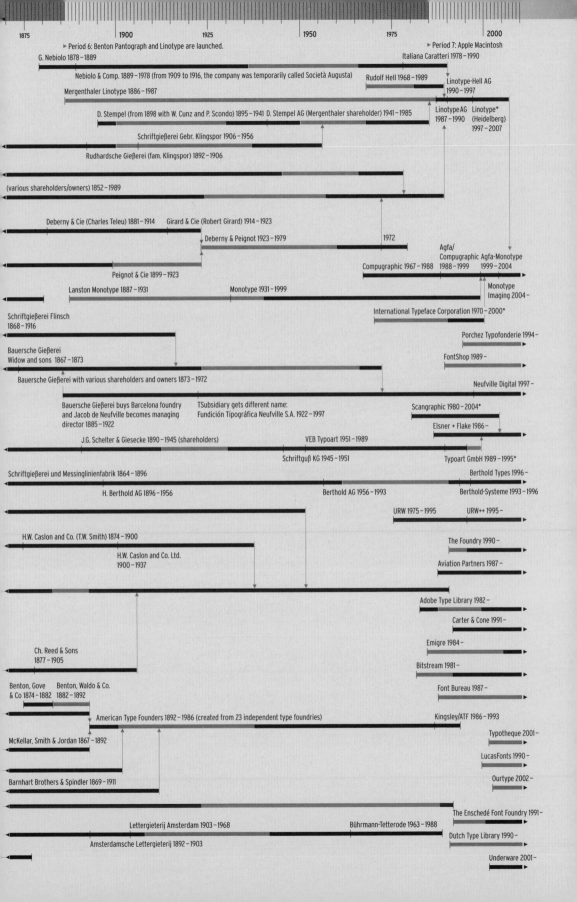

1875 1900 1925 1950 1975 2000

▶ Period 6: Benton Pantograph and Linotype are launched.
▶ Period 7: Apple Macintosh

G. Nebiolo 1878–1889
Italiana Caratteri 1978–1990

Nebiolo & Comp. 1889–1978 (from 1909 to 1916, the company was temporarily called Società Augusta)
Rudolf Hell 1968–1989
Linotype-Hell AG 1990–1997

Mergenthaler Linotype 1886–1987

D. Stempel (from 1898 with W. Cunz and P. Scondo) 1895–1941 D. Stempel AG (Mergenthaler shareholder) 1941–1985
Linotype AG 1987–1990
Linotype* (Heidelberg) 1997–2007

Schriftgießerei Gebr. Klingspor 1906–1956

Rudhardsche Gießerei (fam. Klingspor) 1892–1906

(various shareholders/owners) 1852–1989

Deberny & Cie (Charles Teleu) 1881–1914 Girard & Cie (Robert Girard) 1914–1923

Deberny & Peignot 1923–1979
1972

Peignot & Cie 1899–1923
Agfa/ Compugraphic 1988–1999 Agfa-Monotype 1999–2004
Compugraphic 1967–1988

Lanston Monotype 1887–1931 Monotype 1931–1999
Monotype Imaging 2004–

International Typeface Corporation 1970–2000*

Schriftgießerei Flinsch 1868–1916
Porchez Typofonderie 1994–

Bauersche Gießerei Widow and sons 1867–1873
FontShop 1989–

Bauersche Gießerei with various shareholders and owners 1873–1972
Neufville Digital 1997–

Bauersche Gießerei buys Barcelona foundry and Jacob de Neufville becomes managing director 1885–1922
Subsidiary gets different name: Fundición Tipográfica Neufville S.A. 1922–1997
Scangraphic 1980–2004*

Elsner + Flake 1986–

J.G. Schelter & Giesecke 1890–1945 (shareholders) VEB Typoart 1951–1989
Typoart GmbH 1989–1995*

Schriftguß KG 1945–1951

Schriftgießerei und Messinglinienfabrik 1864–1896
Berthold Types 1996–

H. Berthold AG 1896–1956 Berthold AG 1956–1993
Berthold-Systeme 1993–1996

URW 1975–1995 URW++ 1995–

H.W. Caslon and Co. (T.W. Smith) 1874–1900
The Foundry 1990–

H.W. Caslon and Co. Ltd. 1900–1937
Aviation Partners 1987–

Adobe Type Library 1982–

Carter & Cone 1991–

Ch. Reed & Sons 1877–1905
Emigre 1984–

Bitstream 1981–

Benton, Gove & Co 1874–1882 Benton, Waldo & Co. 1882–1892
Font Bureau 1987–

American Type Founders 1892–1986 (created from 23 independent type foundries) Kingsley/ATF 1986–1993

McKellar, Smith & Jordan 1867–1892
Typotheque 2001–

LucasFonts 1990–

Barnhart Brothers & Spindler 1869–1911
Ourtype 2002–

The Enschedé Font Foundry 1991–

Lettergieterij Amsterdam 1903–1968 Bührmann-Tetterode 1963–1988
Dutch Type Library 1990–

Amsterdamsche Lettergieterij 1892–1903
Underware 2001–

Glossary

This glossary lists most of the terms currently used in modern typography. It also includes some terms that are not discussed in this book but that used to be, or are still, used in the business. Refer to the general index to find the pages where these terms appear.

AAT format This is an abbreviation of Apple Advanced Typography software as a continuation of the QuickDraw GX technology. AAT is advanced software for the monitoring of ligatures, extensive support for languages such as Arabic and Indian languages, application of kerning for specific languages such as manuscript-style Arabic letters and automated substitution of specific letters such as swash capitals, small capitals and old-style figures. The typeface must be able to use AAT. Zapfino, Hoefler Text and Skia, which are delivered as standard with Apple OSX, are typefaces that can make use of the possibilities of AAT.

Accent symbols Diacritic symbols such as the acute accent and the grave accent, often used to give emphasis to a syllable or word.

Accents These are so-called diacritics that, when combined with a letter, give a different sound or emphasis. In European languages with Latin alphabets there are seventeen different accents, giving 88 possible letter combinations. The most commonly used are: umlaut (ü), acute accent (é), grave accent (è), circumflex (ê), cedilla (ç) and tilde (ñ). Some typefaces offer more accents, depending on the application of the font.

Acrobat Software programme by Adobe for making and reading Portable Document Format (PDF) files. These files are interchangeable and not dependant on user software, hardware or system software.

Adobe/ISO Typefaces with an Adobe/ISO set of characters support languages that use the Latin alphabet: Basque, Breton, Catalan, Danish, Dutch, English, Finish, French, Gaelic, German, Icelandic, Indonesian, Irish, Italian, Norwegian, Portuguese, Sami, Spanish, Swahili and various other African languages and Swedish. It is the standard character set of Adobe's PostScript Type 1 typefaces. It is a character set endorsed by the International Organisation for Standardisation (ISO).

Aesthetic programme In the 1980's it was possible to purchase an aesthetic programme for Berthold and Linotype's digital typesetting systems. This programme included detailed kerning tables and the option to apply left or right justification to a text. As such, round sides of letters would extend slightly beyond the margins, as would hyphens, full stops and commas. This visual justification was not initially available on computers but is included in new versions of software packages. It is also known as aesthetic justification.

Aesthetics This term comes from the Greek word 'aisthesis' which means sensory experience or feeling. It is generally used in a branch of philosophy referring to the existence of art or the existence of beauty.

Aligned right In a text which is flush right, the right margin visually forms a vertical line, while the left hand margin is ragged (irregular).

Alignment The way of setting text, especially regarding lines and justification. The alignment can be ranged left, ranged right, centred or justified.

Alternates As the number of characters in PostScript Type 1 and TrueType is limited to 256, alternate characters are supplied separately in an alternate version of the typeface. This is often the case in script types that use alternates to strengthen the impression that the text has been hand-written. In OpenType typefaces, these alternates are often included in the typeface and can be turned on in the 'Contextual-alternates' menu. See also *Character substitution*.

Ampersand This is the & symbol ('and' symbol). It originated as an e-t ligature for the Latin word 'et'. Jan Tschichold is the author of 'Formenwandlungen der &-Zeichen' in which the construction of this symbol is discussed.

Analogue 'Analogue' and 'digital' are terms referring to two ways of recording data. In the world of photography an analogue image is stored on film or other material while a digital image is stored as a digital file. The earliest photographic typesetters were analogue devices, storing visual images of the letters on film. Digital typesetters store digital data (which can be represented numerically) and construct images of the letters from the data. The first digital typesetter was the Digiset from the German firm Hell, 1965.

Anchor point Start point, end point, corner point or curve point of a Bézier curve. The use of these points makes it possible to define the form of a path or the of the boundary of a shape. Control handles are used in combination with the points of the curve in order to define the form of the curve. The shape can be a letter in PostScript form. In TrueType typefaces, so-called quadratic splines are used to construct the curve, with anchor points that have 'off-curve' control points instead of control handles.

And symbol See *Ampersand*.

Anglo-American point system The Anglo-Saxon counterpart of the Didot point system. It uses a pica subdivided into twelve points. The pica is slightly smaller than the cicero, so the Anglo-American point is slightly smaller than the Didot point. The Anglo-American point was set in America in 1886 at about 0.35146 mm, close to Fournier's 1737 point. In 1984/85, however, Apple Computer and Adobe PostScript rounded it up to make exactly 72 points per inch (so 1 point is about 0.3528 mm). The enormous influence of American companies on the international graphic industries has led to general adoption of this new point, which some call a DTP point.

Annotation Comment or remark on a text, added in the form of footnotes, endnotes, marginal or interlinear texts or in a list of points. They may be printed or written by hand.

Anti-aliasing This technique is used in typography to make the contours of letters appear smoother or to more closely approximate their intended shape or position. Pixels in low-resolution images, particularly on computer screens, give step-like contours to diagonal or curved lines. This is particularly visible with larger fonts. Anti-aliasing replaces the step-like contour with pixels that have a lighter colour value than the letter itself. The contour therefore actually becomes slightly less sharp, but as the pixels are so small this gives the impression that the contour lines are more fluent and, strangely enough, the letter appears to be smoother and more appealing. For body text this same technique has the opposite effect, making the text less readable.

Antimony Metal type is usually cast from a mixture of lead, tin and antimony. The antimony makes the alloy harder and stronger and (because it expands on solidifying whereas the other metals contract) ensures that the type reflects the exact form of the matrix and mould. Antimony also raises the melting temperature, so type for machine setting, which is cast on the fly and melted for re-use, usually contains less antimony. Type cast for hand-setting is generally harder and stronger due to higher levels of antimony.

Antiqua In Germany this term can refer to roman as opposed to italic or Fraktur but may or may not include an upright sans-serif (serifenlose Linear-Antiqua).

Antique French name for sans-serif.

Apostrophe Similar in form to a comma but placed higher and used to indicate the omission of one or more letters in a word, as in don't for do not; to indicate a possession, as in man's; or in some style manuals to indicate plurals with numbers, as in 3's.

Ascender height Usually the same as or slightly larger than the cap height (in many typefaces, the ascenders of letters such as the 'h' and the 'k' extend beyond the cap height). It differs from the term 'ascender' in that ascender denotes only the part that extends above the x-height, while the ascender height is the distance from the baseline to the tip of the ascender.

Ascender The part of a letter that extends above the x-height, as for instance with a 'k' or a 'd'.

ASCII Abbreviation for an encoding of 33 control characters and 95 visible characters of a typeface including punctuation marks and symbols whereby each control character and each symbol is coupled to a number between 0 and 127 (128 codes or 2^7). The abbreviation stands for American Standard Code for Information Interchange. As there are not enough codes available for all the symbols for some countries outside America, an extended ASCII-code that uses an extra bit was developed that has not been standardised. This makes 256(2^8) codes available, from 0 to 255, whereby the 95 visible symbols have the same code as with the standard ASCII.

Asterisk Generally used in text as a reference mark (*) to refer to footnotes or to indicate an omission. Also used to indicate a date of birth.

At sign This symbol (@) is now used primarily as a separating symbol in e-mail addresses.

ATypI Abbreviation for the Association Typographique Internationale, an organisation of type designers, typographers, teachers and manufacturers of machines and programmes in the world of typography, that protects the interests of its members (including copyright) and organises congresses and seminars.

Autotrace Automatic application on a computer by which the contours of a pixel or bitmap image are converted into a vector image.

AZERTY Standard layout of keyboards used in France and Belgium, the first letters on the first row being A, Z, E, R, T, Y. In The Netherlands, America and most countries using the Latin alphabet, the QWERTY keyboard is used.

Backslash Diagonal slash inclined to the left (\).

Bar (|) A symbol used on either side of a quantity in mathematics to denote its absolute value. Also used with several other names and functions.

Barcode A code of lines that can be scanned using a special reader, used to label or price items.

Base ten system See *Decimal system*.

Baseline grid Grid of virtual lines upon which letters stand and which define the line interval on a page. These lines are usually displayed on the screen in a different colour. They can be turned on and off during the design process.

Baseline The virtual line upon which most letters stand and below which descenders extend.

Basic or Master font See *Master font*.

Beard The supporting metal between the face of the letter and the shoulder of the shank of a piece of cast type.

Benton-linear Also called American grotesque or gothic. The term 'Benton-linear' takes its name from the type designer Morris Fuller Benton who first created this characteristic sans-serif with the typefaces News Gothic and Franklin Gothic. See also Grotesque, American.

Bézier curve The Bézier curve was popularized in 1962 by Frenchman Pierre Bézier for use in the design of car bodies. The curves were actually first conceived by Paul de Casteljau in 1959. In vector representations of typefaces, they are used to draw curves. These curves can be adjust-

ed by 'pulling' the selected control handles with the mouse. The curves drawn in this way can be made larger or smaller and remain completely smooth without diminishing in quality. This means that typefaces made in this way can be rendered at any desired size.

Bibliography List of publications compiled according to a previously decided criterion.

Binary code Computer code in a binary numbering system that uses only the numbers 0 and 1. The decimal numbers from 0 to 10 are represented with the binary codes: 0000, 0001, 0010, 0011, 0100, 0101, 0110, 0111, 1000, 1001, 1010.

Bit Combination of the words 'binary' and 'digit' (binary numeral). The smallest unit of data in a computer. It can represent the numbers 0 and 1, on or off, true or false, etc.

Bitmap font Fonts stored as a more or less direct record of the pixels that will make up the image, so that (in a device with a fixed raster) a bitmap is needed for each size. A Vector or Outline font can be used to generate bitmaps for various sizes or rasters. A PostScript Type 1 font includes both a Vector font (usually used for the printer), and a number of bitmap fonts (formerly usually used for the screen). Since most systems can now generate screen displays from Vector fonts, bitmap fonts have become more or less obsolete.

Bitmap Image in digital form whereby the colour of each pixel is recorded.

Bitstreams Digital information is sent to peripheral devices in bitstreams. These are collections of points indicating the size, colour and position of the pixels. Page layouts are sent to printers in bitstreams. The screen is, in fact, also a peripheral device that builds the image through use of bitstreams sent from the computer.

Blackletter The traditional English name for Textura. See also *Fraktur*.

Body size The size of the letter in the vertical direction between the highest point of the ascender and the lowest point of the descender, usually described in points. This is never exact as

there is often slightly more space in the design so that ascenders and descenders on adjoining lines do not touch each other when the line spacing is reduced. See also Solid.

Body text Text set using the body type. See also *Body type*.

Body type The typeface that is commonly used for the main text in publications with large amounts of text such as newspapers, magazines and books. In general the size used is between 8 and 14 pt.

Bounding box The white space in which a letter is designed. Its fixed vertical dimension is determined by the type body size, usually from just below the descender to just above the ascender, leaving a small amount of white space above and below. In metal type, the unused space on the shank of a piece of type was called the 'shoulder'. The width of the bounding box varies from letter to letter for most typefaces (narrow for an 'i' but wide for an 'm'), but monospaced fonts, where each letter occupies the same amount of space horizontally are used for most typewriters and a few other typefaces.

Bowl A curved part of a character that creates a 'counter', that is, an enclosed space as in 'e' and 'b', or an aperture as in 'c'. If the character has a stem, the stroke making the bowl may connect to it or leave a small gap (usually only at one end) giving an open or closed bowl.

Brace (or curly bracket) A non-alphabetical character used to group a number of items. They can be used in mirror-image pairs on either side of the group (like parentheses or brackets) or singly to link a vertical group on one side to a single item on the other. Used frequently in mathematical typesetting ({}).

Bracketted serif A serif that thickens where it joins the stem, usually resulting in a curve that fills in the interior angle (like a bracket between a wall and a shelf). Most seriffed typefaces have bracketted serifs, but most didones and many slab-serifs have unbracketted serifs (while the Clarendons have bracketted serifs).

Branching The place where the end of one stroke joins the middle of another, or where two strokes join one in a fork, in particular where a curved stroke joins the middle of a stem. When printed on highly absorbent paper, ink squash can fill in the acute angle of a branching, making the form indistinct. In some typefaces designed for small sizes, rough paper or difficult printing conditions, such as for telephone books, these acute joints are notched or otherwise modified to compensate for the ink squash, as in Bell Centennial by Matthew Carter.

Breve Diacritic symbol, curved in a bowl shape with the concave side up (˘), placed above a letter to indicate a short vowel. It is used in various languages and in phonetic notation.

British Standard British system of official standards, comparable to the German DIN and the Dutch NEN.

Bulk The thickness of paper in relation to its weight, usually noted when greater than usual. The bulk is specified by measuring the thickness of the paper in microns and dividing it by the weight in gr/m^2. A micron is 0.001 mm. Example: 115 grs paper with a thickness of 210 micron (0.210 mm) makes: 0.210 x 115 x 100 = 0.183 bulk. The number 100 expresses the standard value which is converted to 100 grs. With the value as indicated by the manufacturer, the thickness of the paper can be measured this way. The paper used for this book has a bulk of 0.13 (120 grs Munken Lynx). The thickness of a sheet of paper (two pages) is thus 1.2 x 0.13 = 0.156 = 156 micron. For 640 pages, this makes 320 x 156 = 49920 micron. In this case, the book block should be a rounded 50mm. This is a theoretical value that does not take small fluctuations in paper production into account. With a large number of sheets, a small variation in weight or bulk leads to big differences.

Bullet Typographic symbol (•) in the form of a small round dot that is used to emphasize text, for example in a summary or list.

Byte The smallest unit in a computer that can be written to or read from the memory. In most computers this unit comprises 8 bits. A kilobyte (kb) is 210 = 1024 bytes. With the advances in capacity of computer memory, these numbers are constantly increasing. In 1998 it was decided that these numbers should be rounded down. A megabyte (mb) is actually 1,048,576 bytes but for ease of use it has been fixed at 1,000,000 bytes.

Calligram A free form of text setting in which the text forms a picture or decorative form, named after the collection *Calligrammes* by Guillaume Apollinaire, dating from 1918. His poem *Il pleut* is the academic example of this style form, also subsequently used by Paul van Ostaijen in his collection *Bezette Stad*, in the poem *Romantisches café* by Hendrik Marsman and in works by El Lissitzky, Kurt Schwitters and Hendrik Werkman.

Calligraphy The Greek word 'kalos' means 'beautiful' and the word 'graphein' means 'to write'. Calligraphy is thus the art of beautiful writing. Until the invention of printing it was an essential element of work in monasteries, the writing of books and copying them by hand. Calligraphy has never completely disappeared but is now used in a different way. It has become an art form, practiced to extreme levels of perfection. Calligraphy is still included in the study method for type designers, introduced by Gerrit Noordzij at the academy in The Hague. Type designers such as Hermann Zapf and his wife Gudrun Zapf-Von Hesse used it to create their famous typefaces such as Zapf Chancery, Zapfino and Diotima and companies still use calligraphy for their graphic design work.

Canon of Villard In the thirteenth century, French architect Villard de Honnecourt developed a system of dividing pages into a kind of grid using diagonals stretching from corner to corner and whereby the height and width of both the left and right pages is divided into nine equal sections. The ratio of the page is 1 : √2 (DIN-format). The

ratio of the margins is 4 : 6 : 8 : 11. The type area is mirrored, which means the left and right pages are not the same.

Cap height Height in millimetres of a capital letter in a particular typeface. This is not directly related to the body size. The type company Berthold has attempted to define the size of a type by the cap height, but this practice has not been adopted by other companies.

Capitalis Monumentalis See *Roman Square Capital*.

Capitalis Quadrata See *Quadrata Capitals*.

Capitalis Romana Another name for the Roman Square Capital or Capitalis Monumentalis. See *Roman Square Capital*.

Capitalis Rustica See *Rustic Capitals*.

Capitals The uppercase letters of the alphabet.

Caption (version of a typeface) Name given to a special altered version of a typeface intended for setting small texts such as captions or notes. In general the Caption has less thick-thin contrast and the characters are drawn slightly wider and spaced slightly farther apart.

Carolingian minuscule Charles the Great was illiterate. He let others write for him. Yet he was very aware of the importance of script and was keen to streamline his communication methods, make them more uniform. In 768 he literally had a new, official half uncial written, by his clerk Alcuinus. The new script was given the name Carolingian minuscule.

Carriage return In design programmes and other text related software, the user can use a soft return, whereby the hyphen disappears as soon as the text continues, and a carriage return whereby the hyphen remains visible as a text continues. A hard return is in most cases not recommended because it remains visible in print work and can be missed in a last correction round.

Cathode Ray Tube This technique is also used in conventional television screens to project the image onto the inside of the screen. The very first cathode ray tube typesetters appeared on the market around 1960. Due to the limits on memory at the time they contained analogue images of the letters and scanned them as needed, an electron beam setting the letters on the phosphor of a series of tubes, which exposed the light sensitive paper. The first true digital typesetter, the Hell Digiset, stored the shapes of the letters as digital data and set its first trial words on Easter 1965. The Autologic APS-5 typesetter can illuminate one thousand lines per minute using this technique. This is unimaginably fast when compared to the days of hand typesetting. These machines can also enlarge or reduce the text and the tracking can be adjusted in fixed units.

CCTV font set A set of typefaces compiled by the company Bitstream, particularly for optimal readability as subtitles on television screens. Included in the CCTV Font Set is the Tiresias Screen font, specially developed for the Royal National Institute for the Blind (RNIB). The resolution of a standard television is 4% of that used to make a printed page. The current 'Full HD' LCD televisions double the resolution, still less than 10% of that used for a printed text. This is why easily readable typefaces are important.

Cedille A diacritic used in French, Catalan, Turkish and Portuguese and taking the form of a hook under a consonant. The most commonly used is the 'ç'. Originally this sound was written with a 'z' after the 'c'. Later it was written under the consonant and eventually the upper line disappeared.

Centred text When a text column is centred, each line is separately centred within the specified limits of the column. Since the lines vary in length, both left and right margins are irregular. Hyphenation is generally not suitable to this form of typesetting. When centred justification is used for a whole paragraph only the last line will be placed centrally. Hyphenation can be used in this case.

Central European (CE) Indication of the Central European character classification of a typeface. Particularly the characters with diacritics are extended because Central European languages use more of them.

Chapeau Professional term used in journalism for a heading set in a smaller type above the main, larger heading of an article.

Character substitution The automatic replacement of a character in a text, performed by the software. Also called 'glyph substitution' or 'contextual substitution'. 'Single substitution' is the simplest form. This is when a single character is replaced by another. An example of this is within the Arabic language when the form of a character can differ depending on whether it is used alone or at the beginning, middle or end of a word. Also in Asian texts, the form of characters can vary depending on whether they are to be read vertically or horizontally. 'Multiple substitution' replaces multiple characters with a single ligature. Examples of this are the 'fi' and the 'æ'. 'Alternate substitution' refers to the replacement of one character with another for purely aesthetic reasons. Examples of this are the application of more decorative capitals (swashes) or different variations of a certain letter within a script. Using more than one version of the letter 'e' in a word, for example, makes the text appear more handwritten. 'Contextual substitution' is the most advanced form in which various combinations of the described methods are applied. This technique is very useful when making texts. The most important instrument here is GSUB, the 'Glyph Substitution Table', which has to be created by the type designer or type company.

Charles Nypels Prize In 1985, ninety years after the birth of the typographer, publisher and author Charles Nypels, the Charles Nypels Foundation was set up. It has been awarding the Charles Nypels Prize since 1986. This came to an end in 2002 through a collaboration with the Jan van Eyck Academy. The foundation continued to work in the shadow of this academy. Laureats have included Dieter Roth, Walter Nikkels, Harry Sierman, Pierre di Sciullo, Emigre and LettError.

China clay A natural pigment used as filler primarily during the production of coated paper. It is a component of the coating or couche that is added at the paper mill. Other components of the coating are chalk (calcium carbonate) and starch.

Cicero Typographic unit of measurement that is divided into twelve Didot points. The cicero is also known as 'augustijn' in Dutch. The unit derives from the French pied du roi (king's foot). The Didot point has now been almost completely been replaced by the pica point.

Clan See *Type family*.

Clear Type rendering A development by Microsoft in 2000 using the application of various techniques to improve the readability of text on a screen. These techniques include heavy font hinting (adjusting the display of a font to fit into the pixel grid of the screen) and anti-aliasing. See also *Anti-aliasing*.

Clip Art fonts Typefaces that are not made for setting text but that comprise exclusively illustrations that can be accessed via the keyboard. Because of this they are referred to as typefaces. Some illustrative typefaces are actually not even recognisable as letters and are considered a grey area between alphabet and illustration.

Closed brackets See *Square brackets*.

Coating See *China clay*.

Codex Borgia A Mesoamerican divinatory manuscript, probably dating from the period preceding the Spanish conquest of Mexico between 1519 and 1521. It is named after the Italian cardinal Stefano Borgia who owned it. The manuscript contains only signs and symbols.

Colon Punctuation mark consisting of two dots (:).

Column A column is a defined space in a page layout in which the text and/or images are placed. A page can contain multiple columns, which normally form part of the page layout or grid.

Column arrangement The way in which text columns are placed on a page and their relation to each other. This can also be a single column. In most text-related software, the column arrangement is defined by entering values for the margins of a page and the space between the columns.

Column gutter The vertical space between two text columns.

Comma This punctuation mark indicates a short pause in a sentence. It is used to prevent mis-interpretations when reading a text and to make sentences less complicated. The rule of thumb is that a comma should be placed whenever a short pause can be heard when the sentence is read aloud. Other uses are: In English-speaking countries the comma is used to separate each group of three digits when representing large numbers. In other countries it is used instead of the point as the decimal separator.

Composing stick The compositor takes the metal letters from the type case and places them in the composing or typesetting stick in the correct order. The compositor uses the stick to compose a few lines which are then placed in a galley and later divided into pages and placed in a chase (frame) for printing.

Computer to plate (CTP) The direct transfer of images from the computer screen to the printing plate.

Contextual alternates See *Character substitution*.

Contextual character switching Under controlled conditions, a symbol or character in a text can be automatically replaced with another. Examples are ligatures and quotation marks. See *Character substitution* for a more detailed explanation.

Contextual kerning The automatic adjustment of the letter spacing between two 'glyphs'. See also *Glyph*.

Control handle Handle of an anchor point in a drawn curve. See also *Bézier curve*.

Copyright symbol The © symbol. It is used to indicate the protected, exclusive rights of an author. In America until 1989 one could claim no rights to a

text unless they were indicated using this symbol.

Corner point See *PostScript illustration*.

Counter The white space inside a letter. There is a difference between closed counters such as with 'o' or open counters such as with 'z' and 'u'.

Counterpunch A term used with regard to metal type. It refers to a steel punch or stamp that is struck into the face of another steel punch to make the interior white part(s) of a character. The punchcutter then uses gravers to cut the exterior of the character around it or them. The completed punch is then used to make a matrix.

Cuneiform script (Sumerian script) Between 3300 and 2900 BC, the script developed from a picto-graphic system in the south of Mesopotamia, in Sumer, present-day Iraq. Sumerian is the oldest preserved language of the Ancient Near East. The cuneiform script is written on clay tablets, in which wedge- and nail-shaped incisions are made with a reed stylus. A specific combination of incisions stands for one cuneiform character, which is itself a simplification of a pictogram or ideogram. Over the course of time, about 600 different cuneiform characters evolved.

Currency symbol A replaceable value symbol used in financial texts that refer to values of a non-specific currency or when the specific value sym-bol is not available. The older digital typefaces use a standard symbol (¤), but the symbol is not included in all typefaces.

Curve point An anchor point on a curve in a vector drawing or Bézier curve. See also *Bézier curve*.

Cyrillic typeface The alphabet used primarily for six Slavic languages: Russian, Ukrainian, Belarusian, Serbian, Macedonian and Bulgarian.

Dagger This Christian religious symbol (†) is used to indicate a date of death. Much discussion sur-rounds its use as many non-Christians deem it inappropriate. It is also used as a reference mark for footnotes. It is sometimes called an obelisk.

Dash Em dash (–) and en dash (-). A punctuation mark similar to a hyphen but longer in form. Used

to separate parts of a sentence. It can sometimes also be replaced with a comma or the sentence could be placed between parentheses. If a dash is used too often it can disturb the readability of a text. In some cases an en dash can replace the word 'to' (2 – 8 May) or serve as a minus sign (– 5°). It is often used in lists instead of a hyphen.

Decimal system A number system with ten as its base unit, whereby numbers are denoted using the numerals 0 to 9.

Degree symbol (°) The symbol represents 'degrees' in all meanings of the word. This can mean: indication of temperature, rotation of objects in computer programmes, angles and gps data. Sometimes also used as an alternative symbol for notes or references or as what originated as a superior 'o' in n° (number), 4° (quarto), etc.

Delta hinting Hinting is a technique for avoiding disturbing rounding errors in low-resolution digital type. The type designer pre-determines the position of points or the dimensions of certain features, such as the thickness of stems or of counters. In PostScript Type 1 this is only possible in the vertical and horizontal directions. With TrueType typefaces this is also possible in the diagonals. This advanced hinting is called delta hinting.

Demotic script An ancient Egyptian script. It was used for administrative and commercial texts and is the second of three scripts shown on the Rosetta Stone.

Descender length The length of that part of a letter which extends below the baseline, for example with the 'p' or 'g'.

Descender The descending strokes in letters such as 'j' and 'y'.

Descender The part of letter which extends below the baseline.

Detail typography See *Microtypography*.

Diacritics (diacritical marks) Symbols placed below or above letters to indicate their pronunciation. The rules for the pronunciation of words with these symbols can vary in different languages.

Diacritics include accent acute, accent grave and umlaut.

Diaeresis Diacritic used to indicate that two adjacent vowels should be pronounced as separate syllables. Examples are Noël and naïve.

Diagonal axis The distribution of thick and thin in a letter, so that a line drawn through the thin parts is diagonal rather than vertical. This originates in writing with a broad-nibbed pen, but has become a common style element in many typefaces that retain little trace of calligraphic origins.

Didot (romain) Category in the Thibaudeau classification which comprises typefaces with a hairline serif. Examples are Bodoni and Didot.

Didot system The graphic industry uses a measuring system based on the French 'pied du roi' (king's foot) divided and subdivided by twelves, so that the cicero is 1/72 and the Didot point is 1/864 of the pied du roi. The Anglo-American system used a pica divided into twelve Anglo-American points. Since the introduction of the computer, the Anglo-American system has predominated, but its point is now usually rounded up to about .353 mm to give 72 points to the inch. A Didot point is about 0.376 mm. The Anglo-American point is about 0.351 mm (giving 72.27 points to the inch).

Digitising The representation of a visible image or symbol in codes that can be read and processed electronically.

DIN format Fixed formats used for paper size. The ratio used in this format is $1 : \sqrt{2}$. A0 (1189 x 841 mm) has a surface area of one square metre. Each size smaller is exactly half. The weight of a sheet of A0 paper ($1m^2$) is the norm for indicating paper weight in grams. So a paper is described as 80 grams if a sheet of A0 weighs 80 grams (16 sheets of A4 paper = one sheet of A0 paper).

Dingbats A dingbat is an ornament, character or filling used in hand-set type. In the digital world they are symbols, ornaments or signs available as typefaces and accessed via the keyboard or via the 'glyphs' menu.

Diphthong Letter combinations, also known as gliding vowels. It refers to two adjacent vowels pronounced in the same syllable. Examples are 'eye' in English and the French word 'œil'.

Discretionary hyphen See *Hyphen*.

Display (typeface) A display typeface is created specifically for setting headings and is generally not suitable to be used for body text. Most type companies have a choice of styles in this category, from decorative to sober.

Display (version) A version of a typeface that has been adjusted for use in headings larger than 24 pt. In general the display version has more thick-thin contrast than the caption and text versions, the characters are slightly narrower and the spacing is slightly less.

Divina Proportione Also known as the golden ratio, it is often applied in art but is also often used in typography, for example for the division of a page. The ratio is 1 : 1.618. See also *Golden ratio*.

Dot matrix printer An impact printer with a grid of metal pins that strike an inked ribbon against the paper. The pins can be individually extended or retracted so that the dots they make form the different characters. For home printing, this technique has been replaced by inkjet printing. When carbon copies of forms are needed, or if printing has to be done at great speeds, matrix printers are still occasionally used.

Double byte coding OpenType uses a code system of 2 x 8 bits (8 bits = 1 byte) and can therefore comprise 65,536 characters, compared to the single byte coding of PostScript with 256 characters.

Double dagger (‡) A footnote reference mark, usually used for the third reference, after the asterisk and dagger.

Downstroke Term in handwriting, which consists of downstrokes and upstrokes. The upstrokes, when the pen moves upwards, are thinner than the downstrokes that go down and in which case the pressure on pen or feather is greater. These forms also recur in drawn typefaces. A good example is the capital 'A', with on the left, the upstroke, and on the right, the downstroke. The difference in width is clearly visible in the first Venetian seriffed types.

DPI Unit of print resolution, measured in dots per inch. The average resolution of an imaging plate (CTP) is 2500 dpi. The most common resolution for laserprinters is 300 dpi. This unit is also used to define the resolution of computer screens.

Drawing space See *Bounding box*.

Dry-transfer letters Procedure whereby letters are screen-printed in mirror image onto the back surface of a transfer sheet. A layer of adhesive is then applied over them. By laying the sheet on a surface (whether a piece of paper or an object) and rubbing the desired letter with a spatula, one releases the letter from the sheet and sticks it to the surface. In the 1980's this method was used to manually set short texts and headings. The most important suppliers were Mecanorma in France and Letraset in England. When the sale of the transfer sheets ceased in 1995, some of the typefaces designed especially for these companies were made available in digital form.

Duodecimal system See *Didot system* and *Pica system*.

Dutch Old Face In the seventeenth century French types by Garamond and Granjon were commonly used throughout Europe. Dutch printers also used types by Hendrik van den Keere in Ghent. Granjon and Van den Keere provided the most important models for the Dutch Old Face, developed in The Netherlands. It was slightly heavier than most French examples, has a larger x-height and occasionally has an irregular slant in the italics. Examples can be seen in some of the so-called Fell Types from the Oxford University Press and types by Briot, Van Dijck and Kis. Monotype Van Dijck (1937) is based on types cut by Van Dijck.

E-paper Abbreviation of 'electronic paper'. This is generally a flat screen used as a replacement for ink on paper. These screens are usually not

illuminated and have sufficient contrast to be read as a book in daylight.

East European (EE) A typeface whose character set has been adjusted for Eastern European languages. This usually concerns the accents and quotation marks that differ from the Western European character set. With the development of OpenType, whereby more characters can be included in a typeface, there is no longer a need for a separate variant.

Eaves, Sarah A friend of John Baskerville, she married Richard Eaves in 1724. He left her and their five children in 1743. She and the four surviving children then lived with John Baskerville for sixteen years. After her husband's death she married Baskerville in 1764. In those days, living together was frowned upon and Baskerville's reputation in puritan England suffered as a result. It even had a negative influence on his legacy after his death. Zuzana Licko van Emigre honoured Sarah when she named her interpretation of Baskerville's work Mrs Eaves in 1996.

Economy A term which is rather appropriate for the Dutch. Seventeenth century Dutch types were often slightly narrower than most earlier ones, with shorter ascenders and descenders. This way a page can hold more characters. It does mean that some of the elegance of, for example, the Garamonds disappears. But less pages also means lower printing costs for the seventeenth century printing nation. Economic typefaces are still made today. They ensure that fewer paper is needed while maintaining the same amount of characters on a page. The Dutchman Gerard Unger is known as the specialist in this area. His typeface Gulliver is seen as the most economic typeface in the world.

Economy of a typeface 13 ems (see also Em value) is a prevalent standard width for a lower-case alphabet. When typesetting a book, this standard width can influence the number of pages and, thus, the price of printing. In newspapers it is also important to get as many characters as possible on one page. Some designers, such as the Dutchman Gerard Unger, developed typefaces that cater to that need.

Editing phase This phase comes after the design of a typeface and refers to the digitisation of the design, the compilation of the glyph databases, the letter spacing and the creation of the kerning table.

Einheitsschrift In the Bauhaus period of the 1920's, designers wanted to use functionality to develop one particular, standardised typeface, without uppercase and lowercase letters and solely based on form. This Einheitsschrift was never created but an attempt was Herbert Bayer's Universal Alphabet and later the hugely popular Futura by Paul Renner that still had uppercase and lowercase letters.

Electronic setting Computer-aided typesetting using fonts that are stored as digital data and used on a computer screen with the use of a keyboard and can be transferred to a printer or saved in digital form as a print-ready file.

Ellipsis The punctuation mark (…) usually indicating an intentional omission of a word in the original text. It can also represent an implied thought.

Elzévir (romain) Category in the Thibaudeau classification which comprises typefaces with a triangular serif. An example is the Jenson.

Em This is equal in width to the type size being used; 1 em in a 10 pt typeface is 10 pt. The word spacing is usually a quarter of an em unit.

Em value A unit of measurement that is a sum of em spaces. A lowercase alphabet in Helvetica has a width of 13 em. At a font size of 18 pt this is 234 pt.

Em-quad The square of white that is as wide as the point size. The em-quad of a 12 pt letter is 12 x 12 pt.

Emoticon A symbol representing a certain emotion, comprised of a combination of punctuation marks and letters. They are used in e-mails, text messages and chat. A smiley :-) is an example of an emoticon.

En A unit of measurement equal to half the width of an em. For a type size of 10 pt the en value is 5 pt. See also *Em*.

Euro symbol When it became known that the euro was to be introduced, designers began including the symbol in new typefaces and adding it to existing ones. Some older typefaces do not include the symbol. In these cases, separate typefaces have been made which include the euro symbol in various styles.

Exclamation mark Punctuation mark (!) which is placed at the end of a sentence that is supposed to pronounced loudly or which is used to express suprise or irony. In Spanish, a sentence that ends in an exclamation mark is preceded by an inverted exclamation mark (¡).

Face (type) The form of a type as the reader sees it. Different faces in the same body size may appear very different in size. A face with a larger x-height (bigger lowercase letters) can look bigger than one with a smaller x-height. Weight can also influence the apparent size.

Face The visible parts of a letter. A letter consists of a form and white space. The white spaces enclosed within letters are also called counters, such as the eye or inside of the letter 'o'. A more open white space within a letter, such as 'c', is also known as the aperture. The form of the letter is the face. In the world of cast metal type, the face is the raised surface that is inked and printed, the shoulder is the non-printing flat surface around it at the top of the shank and the beard is the sloped supporting metal around the face.

Fibonacci numbers A sequence of numbers whereby each number is the sum of the previous two, beginning with 0 and 1. The sequence starts as follows: 0, 1, 1, 2, 3, 5, 8, 13, 21, 34, 55, 89, 144, 233, 377, 610, 987, 1597, 2584, 4181, 6765, 10946, etc. There is also a relationship between this sequence and the golden ratio, which is why this sequence is also used in design and architecture.

Figures See *Numerals*.

Figures, inferior Small numerals positioned as subscript text.

Figures, lining Numerals that rest on the baseline and have approximately the same height as capitals and align with them.

Figures, old style Numerals with a varying height and position in relation to the baseline, also called non-lining figures. They are better suited to body text than tabular figures and have a proportional spacing whereby there is no extra white space between the characters. These numerals are less well suited to situations where they appear one above the other or in lists, because the figures do not fit exactly below each other as monospaced figures do.

Figures, proportional A typeface comprises mainly non-proportional or monospaced figures that each have the same width so that they can be placed exactly under each other in a summary. Proportional figures can be old style figures or lining figures.

Figures, superior Small numerals placed as a superscript in the text.

Figures, tabular Used in tables and summaries whereby the numerals must fit exactly below each other with the same amount of white space.

File format Digital description of a document, illustration or image. Files made in a software programme are usually saved in a specific file format. They can also often be transferred into an interchangeable file format such as .pdf.

Fixation When reading, rapid eye movement (saccades) and fixation occurs. During fixation, the eye rests briefly and focuses sharply on between 8 and 12 letters, thereby recognising a word. This is followed by rapid movement of the eye during which the eye does not focus sharply. Fixation is heavily influenced by the spaces between words. See also *Saccade*.

Floral forms In the days of metal type, decorative designs were heavily influenced by nature. In the Art Nouveau era, elements of nature were almost always included not only in illustrations but also

in typefaces. Leaf and flower motifs were most commonly used.

Florentine inscriptions The design of Hermann Zapf's famous typeface Optima was inspired by the inscriptions on gravestones at Santa Croce in Florence. He made pencil rubbings of several letters on a bank note. Optima was used for the Vietnam Veterans Memorial in Washington DC, where visitors make similar rubbings, but now in remembrance of their loved ones.

Florin or guilder symbol The florin or the 1 guilder piece was the currency of The Netherlands from the thirteenth century until 2002. The symbol (f) is still included as standard character of a typeface.

Font format There are various font formats available, of which the most popular are PostScript Type 1, TrueType and OpenType.

Font Often used as a collective name for a typeface but actually referring only to a single style. The word font is in this book therefore used only to refer to a specific style within a typeface.

Font substitution If a font is not installed on a computer, the system software chooses a replacement itself. This can be Courier or Helvetica. In a number of cases a preference can be given for the substitute font, by the website programmers for example.

FontCreator Software used by Multiple Master typefaces that allows the user to create and add intermediate styles. Multiple Master typefaces are no longer available and the software does not work on Mac computers since the introduction of OSX. Intermediate styles can still be made on a computer with OS9 and then subsequently used on an OSX machine.

FontEditor One of the first public domain software programmes for the design of low-resolution typefaces built up of pixels. Used by Emigre, among others, for the like-named magazine.

FontLab Software for the digitisation of typefaces, kerning and conversion to various font formats.

FontMaster A set of nine help programmes for the digitisation of typefaces, compiled by Dutch Type Library and URW++ and based on the Ikarus software. The utilities are: BezierMaster, Ikarus-Master, ContourMaster, BlendMaster, DataMaster, TraceMaster, KernMaster, CompareMaster and OTMaster.

Fontographer Software for the digitisation of typefaces, kerning and the conversion to various font formats.

Footnotes See *Note*.

Fraction bar A slightly more slanted version of the slash (/), used to denote fractions.

Fractions Fractions can be written with a horizontal line between the two numbers or with a slanting dividing line (1/2). The fraction with a horizontal line must almost always be compiled in an illustration programme, whereas the fractions written with a slanting line are usually compiled using superior and inferior numbers with a slash between them. Some typefaces include special superior and inferior numbers that fit better into the body text. An example of this is the FF Profile numbers style. An OpenType typeface can include different kinds of fractions. An example of this is the Skia, delivered with Mac OS, which includes the most commonly used fractions with a horizontal line.

Fraktur One of several styles of gothic types. The very first books printed with separate letters used typefaces taken directly from the gothic manuscript hands of the day, with a heavy line and a vertical appearance. The Fraktur is an often decorative variant introduced ca. 1512/17 that became normal for German texts and remained so until 1941.

Freeware Software that can be used free of charge and can in general easily be downloaded.

French royal foot Also called pied du roi and successor to the French foot. Fournier based his points system on a non-standard foot defined only by his own scale. Didot popularized a typographic measuring system based on the standard pied du roi. In the various countries, a foot is

always about 300 mm. In order to measure uniformly, there has to be a reference. The Paris foot (pied du roi) measures 324.83938497 mm. According to legend, it is based on the length of Charles the Great's foot. The pied du roi is divided into 12 pouces (inches) or 144 lignes (lines). For typographic measurement each ligne was subdivided into 12 lignes seconde ca. 1694. Didot's point was exactly 2 lignes seconde. The pied geométrique, which has the same length as the pied du roi, is divided in 10 pouces and 100 lignes.

Full stop The most common places to use a full stop in a text are at the end of a sentence and after an abbreviation.

Functional white Designers call the white on a page functional white because it helps the reader navigate through the text, gives the text its place in relation to the background and because the use of white in the text (blank lines, indents, etc.) can have a positive influence on the readability of a text. The term was created to convince clients of the advantages of leaving parts of a page unprinted, even though this often means that a book or other publication increases in volume.

Galley proofs Before text is composed on a computer, it is practice to have page proofs made. On the basis of the page proofs a final choice is made about typeface, line spacing, point size and set width. Because computer types are made up of pixels as well and are lit from behind on the screen, most designers still make page proofs, but on their own laser printers that print in much smaller pixels. A visual image of a text on paper in the right paper size regularly changes opinions that are made based on a screen image. Especially the letter size in reference to legibility is difficult to gauge as the on-screen page is often displayed smaller or larger than in reality.

Garalde In the Vox classification, this letter form was developed in the French renaissance period. The word is a combination of the names Claude Garamond and Aldus Manutius. The garalde is often more decorative and slimmer than the humane from which it derives.

Geometric Linear Category from the Vox classification system. These are typefaces that are constructed (or give the impression of being constructed) of circles and squares. They derive from functionalism and movements such as Bauhaus and De Stijl. An example is the Futura by Paul Renner.

Glyph A glyph is a graphic element such as the 'fi' ligature. Most typefaces include this as a single figure. In practice a glyph can also take the form of a single figure, a numeral or a punctuation mark that appears in the glyphs menu of a programme.

Glyph substitution The automatic replacement of a symbol by the software programme so that a certain combination of letters that form a ligature are replaced by the compound form of the ligature, such as the 'ff' and 'fi'. Numerals in a table can also be automatically replaced by roman numerals and capitals replaced by swash capitals. Also minute and inch symbols, often used as quotation marks, are included as automatic replacement in many text programmes, according to the language. In design software this is often coupled to the use of OpenType typefaces.

Glyphic Also called Incise. This category in the Vox classification system displays affinity with letters cut in metal or stone. An example is the Albertus by designer Berthold Wolpe.

Glyphs window A window accessible from the menu that displays all the symbols available in a particular typeface. These can usually be entered into the text from the window. This is especially useful for symbols that do not appear on the keyboard.

Golden ratio A ratio of about 1 : 1.618. It is defined by making the relation between the larger and smaller quantities the same as that between the sum and the larger, that is: a : b = (a+b) : a. It is

denoted with the letter phi (ϕ). A rectangle whose sides have this ratio is called a 'golden rectangle'. The Greek mathematician Euclides was the first to write about it in the third century AD. It has been used aesthetically since the nineteenth century and the German author Adolf Zeising wrote about it in 1854 in his book *Neue Lehre von den Proportionen des menschlichen Körpers*. In the twentieth century, architect Le Corbusier used the golden ratio for his architectonic measurement system Modulor. It is also regularly used in grid systems for determining the layout of a page.

Gothic American name for early twentieth century sans-serifs. Also the name for a wide variety of styles of type, handwriting and lettering that derive from forms introduced during the Gothic era (ca. 1100–1500), including Textura, Fraktur, Civilité and others.

Gothic minuscule The standard gothic script, replacing the Carolingian minuscule in the Middle Ages. A minuscule script consists entirely of lower case letters. This one became popular around 1100 and was replaced around 1300 by the Textura.

Grades Not to be confused with styles. Grades are variations in the boldness of a typeface, used to ensure that it appears the same when printed on different kinds of paper. A typeface such as the Miller Daily, created for newspapers, has four grades, for example. Depending on the printing press and the paper used, a newspaper can choose one of the four. Within each grade, the usual styles are usually available; regular, bold and their respective italics.

Graffiti Public marking of a message in word and/or image. It can be scratched, drawn, painted or sprayed in a public space. There are examples from Greek and Roman times and some even consider the cave drawings in Lascaux and Alta Mira to be graffiti. These date to around 30,000 BC. The Greek word 'graphein' means 'to write' and is a related term. In a social context, there is a very thin line between vandalism and this art

form. One visual artist to have crossed over from street to art gallery was Keith Haring (1958–1990).

Grain direction See *Long grain paper*.

Graphical User Interface (GUI) An interface that allows the computer to present information on the screen and the user to give commands using pictograms, windows, menu structures and buttons. The basic principles were developed by Xerox Parc, Xerox's 'Palo Alto Research Centre'. The first successful commercial application was made by Apple, and Xerox received Apple shares in exchange for its use.

Greek alphabet The Latin alphabet has its origins in a western form of Greek. Greek letters are still used in western languages. The names of these symbols, such as alfa (A/α), bèta (B/β), gamma (Γ/γ), delta (Δ/δ), epsilon (E/ε), dzeta (Z/ζ), iota (I/ι), kappa (K/κ), lambda (Λ/λ), mu (M/μ), ksi (Ξ/ξ), rho (P/ρ), sigma (Σ/σ), theta (Θ/θ), tau (T/τ), phi (Φ/φ), chi (X/χ), psi (Ψ/ψ), omega (Ω/ω) and even the obsolete stigma (ς) are used in terms in our everyday language and many Greek letters are used in mathematics, physics and other sciences.

Grey silverfish, firebrat and silverfish These wingless insects are photophobic and live in heated buildings. In great numbers they can damage paper, wallpaper, books, magazines and clothes. They can be introduced to an environment through a variety of products. Silverfish eggs do not hatch below 22°C and most silverfish cannot survive in environments with a relative humidity of less than 50%.

Grey tone In typography this term refers to the relative contrast that a passage of text has compared to the carrier, which is usually white or light-coloured paper. This value can best be seen when two passages of text on two pages, differing in layout, are viewed from a distance with squinting eyes whereby the details disappear, like a blurry photo. Any alteration in line spacing, typeface, kerning and style of the typeface can give a different grey tone.

Grid A grid, as used in graphic design, is a two dimensional structure of lines and/or areas that serves as a guide for the layout of a page with text and images. Scribes in the Middle Ages would draw simple grids or guides on a page before beginning to write. The use of a grid helps give all pages of a book the same basic layout. After the Second World War, the functional movements, such as the so-called Swiss typography, brought advances in the use of the grid as a flexible system. Grid systems have also found their way into internet design, used to divide pages in a logical and structured manner.

Grid typography A completely grid-based typography.

Grid-fitting Fitting typefaces into a low-resolution grid system such as used by some printers and low resolution screens. This technique is also used on the screens of mobile telephones. The aim is to display a particular typeface with the available number of pixels and in doing so to conserve as much as possible of the character and readability of the typeface in question. Also known as 'hinting'.

Gripper edge The extra space needed around the edge of the sheet of paper where the gripper of the press grips and holds the paper and then feeds it into the press. In general it is not possible to print in this space.

Grotesk Another name for a sans-serif typeface, used in areas where Germanic languages are spoken. The term has become more commonly used since the introduction of Berthold's Akzidenz Grotesk.

Grotesque Another name for a sans-serif typeface first used by William Thorowgood in 1832.

Grotesque, American American version of a sans-serif typeface, also known as gothic. There are specific differences between the European and American sans-serifs. This has partly to do with the style of certain designers such as the American Morris Fuller Benton who designed Franklin Gothic and News Gothic. In the digital era the differences between European and American typefaces have lessened. See also Benton-linear.

Guillemets Quotation marks («») used in Germany and France. In « France » they are placed in the opposite direction as in » Germany «.

Gutenberg The first printer to apply a method using separate metal letters ca. 1450 in the German city Mainz. His best known work, the Gutenberg Bible, was published in 1455.

Háček Diacritic (š) meaning 'bracket' in Czech. It is used in Czech and several other East-European languages, a couple of Sami languages and for some words in Finnish.

Hairline serif Thin serif which is usually present in the Didones in Vox's classification.

Half uncial Late Roman script, originating from the minuscule script. The half uncial was used until the tenth century, as was the uncial. The half uncial, which consists of both upper and lower-case letters and has majuscules and minuscules, differs from the uncial which consists only of capitals.

Halftone paper Photographic paper on which grey tones can be reproduced. It was used in the graphic industry before light sensitive paper with high levels of contrast was available. In print work, halftones can only be reproduced using a screen. Halftone paper originates from the world of photography where a halftone print could be made by using negatives in a darkroom.

Halftone screen Before the introduction of digital image processing, photographs were usually screened by hand to convert the shades of light and dark into a pattern that gave the impression of shades but could be printed from inks without shades. A grid on a transparent screen, was placed against light sensitive material and the desired image projected onto the light sensitive material through the screen.

Hamburgefonstiv A commonly used test word which contains a large number of different characters and which gives a quick first impression of how a new font design looks in practice.

Handles See *Bézier curve*.

Handwriting Before the invention of the printing press around 1450, most texts were written by hand, usually with a quill pen. The very first printing types based their forms on handwritten models.

Hans Peter Willberg's Matrix Typeface classification that uses a matrix system, based on the so-called family relations between typefaces. The system focuses on style and form characteristics, while ignoring historical features.

Hash mark See *Number sign*.

Headband A decorative and often coloured band visible as a cord at the head or foot of a hard-cover book, between the book block and the back strip. Originally an integral part of the binding serving to fasten the sewing threads, headbands are now usually separate pieces added for aesthetic reasons.

Headline typefaces Also known as heading types or display typefaces, these are designed especially for setting short texts and headings. The most important factor here is not necessarily that the text is readable but that it is eye-catching.

Hebrew An ancient Semitic language and a related modern language that is one of the official languages of Israel. Hebrew is written from right to left. The Hebrew alphabet originally contained no vowels. Nowadays, small symbols (dots and dashes) are added under some letters to denote vowels. These symbols are called 'niqqud' or in English 'points' and are added to the consonant that precedes the vowel.

Hieratic This Egyptian script was used alongside hieroglyphs for 'normal' writing on papyrus.

Hieroglyphs Egyptian symbolic writing system comprising illustrations of animals, people, plants and signs that functioned as pictograms. The type specimen *Letterproef der „Lettergieterij" Amsterdam v/h N. Tetterode*, dating from 1916, actually includes hieroglyphs and even hieratic symbols. This is the result of the great interest in all things Egyptian after the translation of the Rosetta Stone by Champollion. Even earlier, in 1865, Tetterode became enthusiastic about producing metal type for hieratic characters, which had been written by Willem Pleyte, in the type specimen *Catalogue raisonné de types Égyptiens hiératiques de la fonde N. Tetterode à Amsterdam*. Pleyte was named curator of the Rijksmuseum in Amsterdam in 1869.

Hinting See *Delta hinting*.

Hiragana This is one of the four components of the Japanese writing system. It is a phonetic script consisting of 46 base characters, a few accented characters and several combined characters. Hiragana is the simplest of the Japanese scripts and is the first children will learn.

Historic letter classification Classification of typefaces based only on the period in which they were created.

Hook The part of a letter that extends from the curve of for instance the letter 'f' and the letter 'r'.

Humanistic Lineal Subcategory of sans-serif typefaces in the Vox classification system. The forms relate back to the classical Roman capitals for the uppercase letters and often to the early roman types for lowercase.

Humanistic or Humane In the Vox classification system, this term refers to the oldest known roman types, dating from the end of the fifteenth century. They still show influences from the humanist manuscript hands. A typical characteristic is that the cross bar of the lowercase 'e' is drawn at an upward slant. They are often called 'Venetian' in English.

Humanistic sans-serif See *Humanistic Lineal*.

Humanistic Minuscule A Renaissance manuscript hand deriving from the Carolingian minuscule. Roman capitals were sometimes used for headings or initials in the same manuscripts. A type based on this hand appeared in Rome ca. 1465, a predecessor to the first true roman types.

Hungarumlaut Also called double acute accent. Diacritic mark over the 'ő' and the 'ű', used in Hungarian. It denotes a long vowel.

Hybrid font family See *Mixed typefaces*.

Hybrid numerals Intermediate form between lining and old style figures. They are slightly smaller in size than the capitals and generally drawn between two lines, unlike old style figures that are more similar in form to lowercase letters, and similarly have ascenders and descenders. Examples of hybrid numerals are the Miller Text by Font Bureau and the Solex by Emigre.

Hyphen The smallest dash (-), used to indicate the division of a word at the end of a line. It is also used to join words together or to compound them.

Hyphenate To split a word into sections when it does not fit at the end of a line. Hyphenation and hyphenation rules differ per language.

Hyphenation table In most text related software, such as text and design programmes, tables are included with the preferred hyphenations in different languages. Normally the language used in the document must first be defined. When automatic hyphenation is selected the programme will use this definition. The hyphenation table can usually be edited and extended by the user.

Ideogram A diagram from the ideographic writing system. See *Ideographic script*.

Ideographic script Symbolic diagrams in the flat plane that form pictograms. This script originated from the picture writings made by pre-historic man in cave drawings. A further development was the hieroglyphic script of the Egyptians, which can actually contain much more information than the image implies at first sight. As such it is a more analytical script the ideographic script.

Illuminated capitals Decorative (often pictorial) hand-drawn initial capitals in books. They were particularly popular in manuscripts and incunables, increasing reading pleasure and making the pages more beautiful.

Impression Discernible imprint in paper, made by letterpress printing.The impression disappeared when offset printing was introduced as it is a planographic printing technique. In older books, the imprint is very noticeable, but in the nineteenth century a 'Kiss' impression became fashionable. One can also 'print' letterpress without ink, resulting in a 'blind impression'. Embossed printing is comparable to letterpress printing or relief print with movable type and is still performed with a so-called platen which also leaves a discernible imprint.

In register When a sheet is printed on both sides, or when one side has to be printed more than once (usually for the different colours in colour printing) the different printings are said to be 'in register' if they align properly in relation to each other. For sheets printed on both sides this is especially important when thin paper is used and the lines of text on the front and back are supposed to coincide.

Inch symbol The standard symbol (") should not be confused with double quotation marks.

Inch Unit of measurement used in English speaking countries. An inch is 25.4 mm. The length was defined in 1958 in the so-called 'Imperial units'. In 1959 this was adopted as standard in the USA, Great Britain and the British Empire. Before this, measurements were often derived from body parts, such as the foot and the thumb. The inch, like the thumb, derives from the width of the upper phalanx of the thumb of an adult man. With the introduction of the computer, the inch has also been introduced into other countries. The point system used on most computers is also coupled to the inch, with 72 pica points to an inch.

Indentation Extra white space at the beginning of a line. A typographic tool often used at the beginning of a paragraph. An indentation may be applied to the first line of a text only or to all lines except the first, as in this glossary (hanging indentation).

Index The index of a book or other publication is a list of important words and their corresponding page numbers.

Industrial Revolution This began in the eighteenth century in England, followed in the nineteenth century by America and the rest of Europe. The application of the steam engine resulted in the growth of small-scale, traditional workshops into large factories using industrial production methods. The second industrial revolution began around 1879 when electricity became available and the electrical motor was developed. The invention of the internal combustion engine and the very first crude oil pumps at the end of the nineteenth century also played an important role. The third industrial revolution took place in the 1950's with the introduction of the computer.

Initial The first letter of a word, sentence or chapter, often enlarged or decorated. This was a common practice in the Middle Ages to decorate or 'illuminate' a page. The initial letters of proper nouns are also capitalized.

Ink squash Ink always spreads slightly when printed on paper. The application of a coating or treating the paper with other compounds can help to reduce this. When more inexpensive paper such as newsprint or paper for a phone book is used, the typefaces are designed to compensate so that the text remains legible.

Ink trap An extra sharp point where the lines of a letter meet. See also *Branching*.

Inscriptional Capitals Another name for the Roman Square Capital. See Roman Square Capital.

Interpolated font A font that is generated by software to make a version in between two existing versions; the semi bold, for instance, which lies between the regular and the bold. In the past, each version needed to be drawn by hand. Manual corrections are usually still needed, but a large part of the drawing is done by the computer.

Interpolation In type design this means the process of taking two forms of a letter, for example a regular and a bold style, and using software to create new styles in between at the desired intervals.

Invisible characters Characters and symbols that can be switched on and off in layout programmes. When switched on, dots and other signs indicate whether a space was used (or, by accident, two), if there are non-breaking or breaking spaces, a return is indicated and a forced transition to the next column. By making these characters visible, the layout can be kept clean during design and layout, and it is easier to see if a document is well made.

ISO This International Organisation for Standardisation sets standards for many different things, including type and paper, often to encourage compatibility between different manufacturers. It is a collaboration between the national organisations of 156 countries. ISO stems from the Greek word 'isos' which means 'same'.

Jaggies Step-like representations of lines and curves, mostly visible on low-resolution screens or when pixel images are enlarged.

Japanese binding This is a method of binding whereby the pages of a book are joined in sets of four on the cut side. In Japan, thin rice paper used to be used, which was so thin and translucent that it could only be printed on one side. The fold was placed not in the spine of the book but on the outer side, which would normally be the cut edge. Nowadays this method is used because of the special character it adds to a book and can also be used to enhance the effect of transparent paper by printing on the inside.

Justification When a text is justified the lines are aligned to both the left and right margins. The increase in spacing should occur between the words and not between letters.

Kanji One of the four scripts used in Japan. It comprises logographic symbols that stem from Chinese. There are more than 50,000 kanji, but 'only' 1945 are used in Japanese.

Katakana One of the four scripts comprising the Japanese writing system. Signs in the Katakana are simpler in form than the Kanji and Hiragana

characters and have square, angular forms. It is a syllabic script whereby a different symbol is used for each syllable.

Kerning The placement of characters in a typeface in relation to each other. This is different for each typeface and the type designer must define the optimal distance between pairs of letters. The kerning can greatly influence the quality of a typeface. When applied poorly, spaces will appear within a word or letters of a word will touch each other. Each letter has a white space in which it can be drawn, called the bounding box. Both the width of this bounding box, together with the white space left and right of the letter, determine the space between letters, which gives good results for many letter combinations. For specific letter combinations a kerning table is made, which defines the deviant kerning pairs within a typeface. A good example of a deviant pair is the capital 'W' and the 'e'.

Kerning pairs See *Kerning*.

Kerning table Changing the amount of white space between individual pairs of letters from the default, usually in an attempt to make the spacing more regular. The typesetter may do this for particular cases or the type designer may provide a kerning table that the software can use. Although the number of kerning combinations has increased with the advancements in computer technology, it is also true that too much data within a typeface file actually slows its use, which in turn means it takes longer to print. For this reason, type companies often limit themselves in the number of kerning pairs. Adobe typefaces have approximately 280 kerning pairs for the PostScript Type-1 typefaces and the more exclusive Adobe Originals typefaces have around eight hundred. Yet it is still possible to come across language-related combinations that have not been catered for or a typesetter who wishes to use a particular combination in a different way. In certain design software (InDesign for example) a 'kerning table editor' can be used whereby kerning pairs can be edited or added per typeface. A certain amount of caution is required here, as alterations are then only made in the table of the typeface on the computer in question. If the document is opened elsewhere, with a non-edited version of the typeface, it can result in different placing of the text.

Kilobyte See *Byte*.

Laser imager Laser light has a coherent and narrow light beam which makes it ideal to light pressure plates or photosensitive film.

Laser printer Desktop publishing only became successful when three different technologies were combined: the computer, the editing programme and the laser printer (and laser imager). A laser printer translates a screen image to a paper print. To do so, a cylinder (the photo drum), covered with photosensitive silicon, is given a negative electric charge by means of static electricity. Then a laser (or LED) projects an image on the drum, whereby the drum loses its electric charge in the exposed areas. These are the non-printed (often blank) parts of a page. The drum then moves past the toner, which attracted by the electric charge. A positive charge causes the toner to transfer to the paper. The toner is bonded to the paper by means of heated fuser rolls.

Latin Language of the Latins who settled near Rome, Italy between 1200 and 1000 BC. Both the Romans and the Latins spoke Latin. After the fall of Roman Empire, Latin continued to be used in the Catholic Church and in scholarly writing, for anatomy and as the official, international language for scientific names of animals and plants.

Lay edge During the printing and finishing processes, a sheet of paper always has a fixed feed direction in the machine. In this way, any variations in the size of the sheet or differences caused by stretching or shrinking during the printing and finishing processes will have as little influence as possible on the finished size and colours of the end product. The same lay edge is also used

when the sheet undergoes multiple processes such as printing spot colours, spot varnish, foil printing or stencil work.

Layout Arranging of several elements in printed matter according to a certain plan. Components can consist of text, image, graphics, colour and decorative elements.

LCD Abbreviation of Liquid Crystal Display, a flat screen that uses less energy than cathode ray tube screens (CRT).

Leading This term derives from the days of metal type and is often confused with line spacing. Leading is the extra white that was added between the lines of metal type in the form of strips of lead or lead alloy. When noted correctly it is written as '+1' or '+2' whereby specifying how many extra points should be added between the lines.

Left alignment Text that is vertically aligned on its left-hand side. On the right-hand side, a ragged alignment is used, with or without word breaks.

Leg The downward diagonal strokes in letters like 'k' and 'R'.

Legibility Although this is a subjective criterion, certain rules for enhancing readability have been established since the invention of the printing press (and before that in the scriptoria). These rules were incorporated into typefaces. Examples are: spacing, word space, the relation between uppercase and lowercase letters, recognisable forms of letters and punctuation marks. In the layout trajectory, the graphic designer makes certain choices about, for instance page format, page layout, length of lines, typesetting methods, use of colour and placement of all stylistic elements. The whole determines the readability of the document (although this remains a subjective experience).

Letter spacing The amount of white spacing between letters. When designing a type, the designer also decides on the amount of white between letters, the letter spacing. See also Kerning. In most typesetting software, the letter spacing can be adjusted by entering a plus or minus value. These values are usually based on the so-called em square (see also Em), a white square in that particular point size.

Letterpress printing A common term for relief printing of type, woodcuts, clichés, etc. on a printing press.

License Usage permission. In case of a digital font, this permission is usually restricted to a few or a certain number of computers. A license can be expanded to incorporate multiple computers. Usually, a certain number of fonts are included in a computer's system software. In principle, use of these fonts is also restricted to the computer where the software is installed.

Ligatures Fixed character combinations, designed to avoid unattractive overlapping in normal print work of characters that could collide. In PostScript Type 1 and True Type fonts, ligatures are offered in a more extended form in separate fonts, because of the limitations on the number of characters in a font. In Open Type fonts, with the possibility of more than 65,000 characters, these can be inserted, and, if desired, replaced automatically.

Line length The maximum width a text is set to. Normative is the width of the column as indicated in the editing programme. In case of ragged right text, only a few lines will reach the maximum set width; the majority will be shorter. In case of justified text, lines are filled out with white spaces between words to make them fit the maximum set width. So lines of justified text are always the length of the set width that's been entered.

Line spacing The amount of vertical spacing between two lines in a text, measured from the baseline of the first line to the baseline of the second line.

Lineales Category for sans-serif typefaces in the Vox classification.

Lineales, constructed Subcategory of the sans-serif category in the Vox classification. Also called the geometrical lineales. An example is the Futura.

Linear text Text that runs more or less in a single continuing sequence, like a novel, as opposed to text where the reader is expected to make choices about how to navigate the text, as in a newspaper or a reference book.

Lining figures Numerals that are equal in size to the capitals of a typeface. In general these can be placed between two lines, just like the capitals, and do not contain ascenders and descenders like old style figures.

Lists Those parts of a text which are laid out differently and are distinguished from one another by, for example, indenting and a graphic element such as a dash or a bullet. If the text is presented point for point, this is called a list. The sentence introducing a list is usually terminated with a colon.

Logograms Ligatures where the combined letters have evolved a form of their own, as in the German sharp s (β) and the ampersand (&).

Long grain paper The paper fibre is parallel to the long side of the paper. This is also called the grain direction. The fibres are structured this way because the paper mass in the paper machine is poured out on a conveyor belt. The conveyor belt itself is a screen. Paper bends and folds more easily parallel to the grain and expands and contracts more with changes in humidity across the grain. The paper fibre in a book should therefore always parallel to the spine. This also makes for a book to stay open more neatly. Good quality handmade paper has virtually no grain direction.

Loop The lower curve in the classical two-storey lowercase 'g'.

Lorem Ipsum A fake text, used by designers to test what a typeface looks like in a certain layout, usually when the definitive text has not yet been delivered. The texts are in semi-Latin and are nonsensical. As the focus is on the design and not the content, the texts are not intended to have meaning. The first words of the Lorem ipsum are derived from the book *De finibus bonorum et malorum* (On the ends of good and evil) by Marcus Tullius Cicero, 45 BC. The internet offers lorem ipsum generators, in which the amount of text needed can be specified.

Lowercase The 'small' letters of the alphabet, also called minuscules. The term originates from the letterpress era. The movable type was stored in type cases in a rack and placed on the inclined top of a composing frame for use. Because most texts require more lowercase letters than capitals, the case containing the lowercase was placed directly before the compositor and that with the capitals higher (and therefore further away) on the incline, hence upper and lower case.

Machine coated paper (MC) One of the most widely used varieties of paper. It is smooth, easy to print on, and ink dries quickly on it. At the same time, it is vulnerable and stains easily when printed sheets are stacked. All in all, a true printer's paper; but only if it is glossy. Printers often nickname the matte version 'sandpaper' because of its tendency to set off ink when one sheet of paper slides across another. Very suitable for images and faithful colour reproduction, less so for text because of the sharpness, whiteness and reflection which have a negative impact on readability. The surface is coated with a layer containing china clay. This makes for good ink absorption and a quick drying process. A disadvantage is that, in case of folding, the top layer easily cracks. This is not so much a problem with books as the fold is on the spine.

Macron A diacritic sign that is placed under or above a letter and takes the shape of a line (ā).

Majuscule A capital letter. See also *Titling capitals*.

Making order (paper) Paper specially manufactured to the desired size, weight and feed direction may be more cost effective for a printer, but only for a minimum number of sheets or weight of paper in tons. For smaller quantities and products to be made within a tight deadline, it is common to use warehouse stock from the paper distributor.

Manuals Category in the Vox classification. A type-
face that has a handmade look but is less cursive
than a script type. An example is the Tekton.

Margin The space surrounding a publication's type
area. There are four margins: the inside or gutter
margin, the top or head margin, the fore-edge or
outer margin, and the bottom margin or foot
margin.

Marginal text Text which is placed outside the main
type area and which usually contains a clarifi-
cation of, or an addendum to the main text.

Masculine ordinal indicator Sign to indicate a
specific order: 1º (primo, firstly) and 2º (secundo,
secondly). See also *Degree*.

Master character outline Data that specifies the
outline of a character and can be used to gene-
rate images of the character in a wide variety of
sizes and for imaging systems with various
resolutions. Compare Bitmap fonts.

Master The basic typeface design from which a
digital file is created.

Mathematical characters The most common signs
and symbols are included in a typeface's standard
character set (for instance {<>}+-=√[...]). For more
elaborate applications, collections of characters
such as the Symbol font are available, with more
signs and symbols and a complete Greek
alphabet.

Matrix A small block, usually of copper, in which a
right-reading, sunken image of the letter is struck
using a steel punch with a raised, mirror image of
the letter cut on its end.

Measurement system In typography, several diffe-
rent measurement systems are used alongside
one another. There used to be more, but now-
adays only three are still in use. These are the
Anglo-American point system, the metric system
and the inch. Luckily, they have been standard-
ised so they are more easily converted into one
another. Most computer systems round up the
Anglo-American point so that there are 72 points
in an inch, and an inch equals 2.54 cm.

Mechanistics See *Slab-serif*.

Metal type era The era from about 1450, when
Gutenberg first began printing from movable

type, to the first few decades after World War II,
when metal type gradually died out in commer-
cial applications.

Metal type See *Sort*.

Metric system Uses the metre as measuring unit for
length, surface area and volume. A decree, issued
in 1795, introduced this system in the French
Republic of which The Netherlands (then the
Batavian Republic) were a client-state at that
time. The standardised metre (le mètre des
Archives) was produced in 1799. After Napoleon's
defeat at Waterloo in 1815, the introduction
slowed down and cities and provinces continued
to use their own measurements. In 1816, King
William I re-introduced the metric system in the
United Kingdom of The Netherlands (made up of
what are now Belgium, The Netherlands and the
Grand Duchy of Luxembourg). After the 1875
'Metre Convention', a great number of other
countries accepted the metric system. In 1975 it
was also introduced in Great Britain, Ireland,
Canada, South Africa, Australia and New Zealand.
In some cases, older measurement systems
remain in use. In 2009, the metric system was
still not accepted as standard in Liberia, Myanmar
and the United States of America.

MICR Magnetic Ink Character Recognition. MICR is a
technology for machine readable typefaces. It is
mainly used by banks for processing cheques.
This technique was developed by the American
Bankers' Association in 1965. Special typefaces
were designed, the CMC7 and the E13B, which are
printed with magnetic ink or toner. The printed
characters are then magnetised with the north
pole on the right-hand side. This makes the
characters legible, even if they have been over-
printed or stamped. The accuracy rate in readout
is higher than with optical character recognition
(see *OCR*).

Microtypography The typographic tweaking of a
typeset text after it has been divided into pages.
Avoiding widows or orphans is, of course, the first
thing a typographer will attempt. Although tweak-
ing can to a certain degree be done in a so-called
typogram, the correct use of punctuation marks,

manually adjusting letter spacing and checking the breaking of words are obligatory for any serious typographer. Checking the aesthetics of breakpoints, whether the text is not too ragged, or eliminating unsightly spaces in justified text are also improvements that enhance readability and are aesthetically pleasing to the eye. In medieval manuscripts and the Gutenberg Bible, such eye for detail is already present. See also Typographic detailing.

Minus sign The en or em dash is usually used to signify the minus sign. It can have different lengths in different typefaces. See *Dash*.

Minuscule Other term for lowercase letter. It was in 670 that the scribes in the Abbey of Luxeuil used a handwriting consisting of 'lowercase letters' which for the first time differed from capital letters not only in height, but also in form.

Mixed typefaces Letter families containing different categories from the Vox classification. An example is the Rotis Serif, SemiSerif, SemiSans and SansSerif.

Modular Category in the Vox+2 classification for display typefaces.

Modulor Design system by architect Le Corbusier, based on the golden ratio.

Monospaced A typeface whose letters and characters each have the same set-width. This is also called a non-proportional typeface. The first were designed for typewriters that moved the same distance forward with every letter typed. Well-known examples are Courier and Prestige Elite. Narrower letters such as the 'i' and the 'l' are often widened by adding serifs, while letters such as the 'm' and the 'w' are given a compressed form.

Mould side Paper always has two different sides. The mould side is the underside during manufacture, when it is in contact with the paper machine's wire screen or the hand papermaking mould. The paper slurry is distributed over this screen or mould. The mould side is always more structured than the felt side. After the paper comes out of the paper machine or the mould, it may be finished by passing it through two steel cylinders, the so-called calendering, which reduces the difference between the two sides. Calendering gives the paper a uniform thickness and it makes the surface smoother.

Multiple Master format This Adobe font technology works within the existing PostScript Type 1 format. From four 'primary' fonts, it is possible to create additional fonts with this technology, via the software programme FontCreator. With some typefaces, such as Adobe's Minion, it is also possible to apply visual corrections for different body sizes. It was a promising technology, but was not picked up by the market. In 1999, Adobe ceased the development and since Apple's OSX system software, the FontCreator can no longer be used on a Mac. Previously created fonts can still be used. And on an old Mac OS9 is it also possible to create new fonts.

Negative space The white in and surrounding a letter. For each shape that is used in a letter, the negative space is important, too. On the one hand in and around the letter, on the other in combination with the adjoining letter. In the metal type era, one is more aware of this because in making a punch, a counterpunch is used to strike the letter's interior white spaces into the punch. Type designer Fred Smeijers wrote *Counterpunch* on the subject, a book well worth reading.

Negative spacing A decrease in the distance between letters within a typeface. See also *Spacing*.

Neoclassicism Aesthetic movement from 1770 to 1830 with allusions to Greek and Roman art.

Non-proportional See *Monospaced*.

Note Comment that is relevant to a certain text element. It can be placed at the bottom of the page (footnote) or, collectively, at the end of a chapter. A note is usually indicated by superscript numbers or one or more asterisks (*). Other reference marks can also be used. In the past, a popular sequence was the asterisk (*), obelisk or dagger

(†), double dagger or diesis (‡) and section mark (§). See also Dagger.

Number sign The hash mark (#) is used to designate a number. It is widely used in the UK and USA; #10 then designates number 10. In case of mobile phones the sign is often used as a start or end symbol when entering data.

Numerals Figures or symbols used to represent numbers. The Arabic numerals are the most commonly used numerals in the world. They consist of ten symbols including the zero (0, 1, 2, 3, 4, 5, 6, 7, 8, 9). They originate not from Arabia but from India. An Indian mathematician introduced them to Arabia. The prominent Persian mathematician Al-Chwarizmi, also known as the grandfather of information technology, wrote significant works about algebra between 813 and 833 that were used in European universities as standard works until the sixteenth century.

Numerals, Roman The Arabic numeral system consists of ten characters. Roman numerals, however, are characters from the Latin alphabet that represent a value by being placed in a particular order next to each other. The year 2009, for example, is written as 'MMIX' whereby the 'M' stands for a thousand and the 'X' for ten. Placing an 'I' before the 'X' means that this must be subtracted from the ten. This is a relatively easy number to decipher. The number MCMXXXVI (1936) is slightly more difficult to decipher. This overview will help: M = 1000; D = 500; C = 100; L = 50; X = 10; V = 5; I = 1.

Object oriented programming language Programming language that describes typefaces and graphics as objects, that is, as distinct entities with particular properties, rather than merely specifying its pixels. An example of such a language is PostScript.

Oblique A roman is usually upright and an italic usually leans to the right. As the italic gradually took on the role of auxiliary to a roman it was assimilated to the roman in some respects. Some italics are concieved as sloped romans, though usually showing some variations. Sans-serif 'italics' often remain closer to a sloped or oblique version of the upright sans-serif. An example is Frutiger italic planned as an oblique by the designer, Adrian Frutiger. Linotype later commissioned him to add a separately drawn true italic for Frutiger Next. Sloping a roman on a computer is also called slanting. This is not recommended because it causes visible distortions.

Oblique type An italic typeface can be drawn as a separate italic or be made from the roman it is to accompany. The latter is also referred to as an oblique type or a sloped roman. It usually gives less contrast with the roman than a separately drawn italic.

OCR Optical character recognition. With help of a scanner, software can identify the letters in a text printed from type, allowing it to convert it into a text file. Because some characters resemble others, accurately coverting texts in this way is difficult with normal typefaces. Examples of typefaces that were specifically designed for OCR are OCR-A and OCR-B.

Octavo Format made by folding a sheet of paper three times to produce sixteen pages (eight leaves). The final size depends on the size of the sheet.

Off curve Control points, used in a TrueType drawing, which are located outside of the curve. They are more difficult to operate than the control handles in a PostScript drawing.

Off-white The most pleasant paper colour for reading materials.

Offset Planographic printing technique. The core of this technique is that the image carrier that transfers the ink is on the same height as the surrounding area of the printing form. It works on the principle that water does not mix with oil. The printing plate is attached to a cylinder and dampened. All non-image areas of the plate absorb water while the image areas do not. When the thick ink is subsequently applied by the ink

rollers, the non-image areas will repel the ink and the image areas will absorb it. The ink is then transferred to an offset cylinder with a rubber blanket, which in turn transfers the image to the paper. In full colour printing, this process is repeated four times – for cyan, magenta, yellow and black (key) – on four connected so-called printing towers.

Ogonek Diacritic symbol (˛) placed as a hook under certain letters in several languages. Ogonek is the Polish word for 'little tail', and exactly describes what this symbol looks like. In Polish, Old Church Slavonic, Navaho, Western Apache and Chirichahua, the symbol indicates a nasal pronunciation. This was also originally the case in Lithuanian, but the nasal sound has since disappeared and the ogonek now signifies a long vowel.

Old face A term used in type classification and as an addition to the names of certain typefaces, usually referring to revived historical types (or new types based on historical models) from Aldus's in 1495 to Calson's in the 1730's, but sometimes even including to the earlier humanes. The Caslon foundry introduced the term when they revived the eighteenth century roman and italic of William Caslon I for commercial sale (for example, in their 1854 specimen), but when American foundries revived the same Caslon types in 1856 they called them 'Old Style'. When Miller & Richard brought out a new type shortly before 1860, adapting the older Caslon style to the tastes of readers used to the didone, they called it 'Old Style' and explicitly contrasted it with the Caslon 'Old Face'.

Old style (roman & italic) See *Old face*.

Old style figures Numerals with ascenders and descenders like lowercase text, also called hanging figures. They integrate better with text than lining figures and are usually proportionally spaced, so that the white space between the digits is more even. They are less suitable for lists, charts and tables, since they do not align vertically.

Opacity The degree to which paper blocks light passing through it, expressed in percentages. Opaque paper lets a small amount of light through and transparent paper lets a lot through. This opacity is important in envelopes and in paper that is to be printed on both sides. Envelopes need to be as opaque as possible with the thinnest paper possible. To enhance opaqueness, titanium white (titanium dioxyde) is added to the paper. Opacity is measured according to the ISO-2471 standard. The measured value is expressed as a percentage. A higher percentage means a greater opacity (lower transparency).

OpenType A font technology, developed by Microsoft and Adobe, hailed in 1996 as the answer to Apple's QuickDraw GX. It has become an extension for the PostScript Type 1 format and the TrueType format. OpenType is a 'cross-platform' format and can be used on both Macs and Windows computers. It can contain 65,536 characters, as opposed to the 256 for PostScript Type 1 and TrueType fonts. This allows space for different language versions for each typeface, so suppliers of system software (such as Microsoft) can deliver the same system typefaces to each country. It no longer matters whether the software is supplied in Greece, Japan, Germany or Egypt; the typeface remains the same, but provides different characters for differently keyboard settings. Other possibilities of OpenType are geared more towards typographic fine tuning. The desired numerals (Old style, tabular, etc) can be specified, as well as small caps and ligatures, and alternative characters can be replaced automatically. To a large extent, this is possible in PostScript Type 1 and TrueType fonts, but only through separately supplied fonts with alternative characters. It is also possible to supply 'opticals' for several font sizes. Most type companies have already adapted their collection, to OpenType, but not all OpenType fonts optimally use all possibilities. The licensee should therefore pay attention to which characters are supplied. In

theory, it could be that a certain OpenType font has the same amount of characters as a TrueType font with the same name. The big companies usually provide at least a certain minimum number of characters with a standard OpenType font.

OpenType Pro-XSF Although OpenType fonts can offer a lot of new possibilities it does not mean that every possibility has been assimilated. Type companies, too, are only able to make limited use of the possibilities. Thus, a standard OpenType font usually supports most European languages, including Central and Eastern European ones. Small caps, an extensive set of ligatures and both old style and tabular figures are also usually supplied. Linotype supplies so-called OpenType Pro-XSF fonts with 387 characters for 48 western languages. The XSF (eXcellent Screen Fonts) addition means that in order to enhance screen display, delta hinting is applied to improve readability.

Operating system Software that makes it possible for a computer to work according to a certain logic. The most common are Microsoft Windows, Mac OS and Linux.

Optical alignment Layout programmes often have a possibility to optically align the margin. Pro-truding elements, such as serifs, extend beyond the margin, and round shapes extend slightly beyond it. Quotation marks and other punctuation marks are also placed outside the margin.

Optical correction In designing a typeface, one must pay attention to its visual effects. Because there are so many different forms that all visually influence one another, the designer must compensate for well-known effects (round shapes must extend beyond a line to appear to align with a flat shape on the line) and test the typeface by putting letters together and printing samples. The white space between letters is usually judged intuitively. Useful systems like the Tracy system (see *Tracy system*) have been developed that can serve as a guideline.

Opticals These are adjusted 'character outlines' of a typeface, for use in different body sizes. There are, for instance, adjusted drawings for captions, text, subheadings and display. It is a variation in the typefaces that derives from movable type, when punchcutters cut each size separately, adjusting the design for smaller body sizes to avoid closing up and optical sticking together of letters. Small sizes were made a bit wider and given a wider spacing. Larger sizes were made a bit narrower with a slightly tighter spacing. With the introduction of the pantograph and then phototypesetting, one master could be, and in phototypesetting usually was, used for all sizes. Most early digital fonts also used a single master for all sizes. Over the course of time, more and more (typographic) refinements were introduced. In OpenType typefaces, opticals can be automatically selected according to the body size. An example of a digital typeface with opticals is the Warnock Pro.

Ornaments Decorative elements in printed matter. Some typeset ornaments (fleurons or printer's flowers) are designed to suit a particular typeface and supplied with it.

Orphan An orphan is the first line of a paragraph at the bottom of a page or column. In general this should be avoided. See also *Widow*.

Outline A drawing of a typeface which hasn't been filled in with black or a colour. Most software for producing fonts works with outlines. Outline typefaces exist as well. They are specifically drawn with a white interior and a solid edge. Drawing software allows one to draw a line of a chosen width to on an outline originally intended for a solid typeface, but this is not recommended. It can cause incisions to fill in, which can change the shape of the letter. A type designer usually also adjusts the shape of a letter when designing an outline font.

Page Description Language (PDL) A resolution independent way of describing a page (text and layout). PostScript is the most widely used PDL. See also *PDF*.

Pantograph A device that can mechanically reduce or enlarge a drawing or relief. It revolutionised typography. Although pantographs existed in the seventeenth century and were used for making large wood type in the 1830s, Linn Boyd Benton patented an improved pantograph in 1885 and adapted it soon after to engrave matrices (it could also engrave steel punches that could be used to strike matrices). This allowed both the mass production of matrices and the production of matrices for various body sizes of type from a single pattern. Linotype introduced its hot-metal typesetting machine in 1886 and soon began using pantographs to produce matrices for it. Large or specialized printing offices had used mechanical typesetters and casters for decades, but now it became practical for an ordinary printer. This had an enormous impact on foundries. Punchcutters lost their jobs to the pantograph and the foundries were, as it were, replaced by the typesetting machine. A type designer draws an original of about an inch, which is then enlarged by the first pantograph, the delineating machine. Some pantographs even allowed the operator to modify the design, making it narrower, wider, thicker, thinner, or sloping it to make an italic. After this, the new drawing is shrunk on a second pantograph, on a metal plate with a wax layer. The engraving needle engraves the letter in wax. Through electrotyping, a layer of copper is deposited on the plate, where the letter is engraved. This way, a heightened letter is created to cut the punches on the Benton-Waldo pantograph.

Paper formats These are usually standardised and normalised. In Europe, DIN-A and DIN-B formats are standard. Formats for printing papers have slightly larger dimensions to allow for processing and trimming.

Paper thickness The thickness of paper, expressed in a thousandth of a millimetre or microns, important for determining the spine width of a book or other publication.

Papyrus Used as writing material in the Near East from about 3000 BC to 800 AD. Papyrus is produced from the Cyperus Papyrus, a grass like plant that grows in shallow and not too cold water. The stem is cut into strips and layered crossways. The stem's juice is used as glue and various processes (striking, hammering, pressing, rubbing and drying) are used to mash the whole together. The surface is then polished and treated with cedar oil.

Paragraph mark A standard character (¶) in pretty much every digital font. It can be used typographically to indicate the start or end of a paragraph. Sometimes called a pilcrow.

Parentheses These rounded brackets () are used in a sentence to help clarify, add explanations or to list alternate meanings without the use of the word 'or'.

PDF Portable Document Format, a standard for the exchange of digital documents that need to be reproduced in their original form. Layout, design and typography remain the same and will look the same on any computer or printer. The format was developed by Adobe. It has also become the standard for printed matter and most documents are delivered to designers and others in this format. One of the advantages is that all the elements (images, graphics, logos, typefaces and colour settings) are combined in one document and do not need to be supplied separately like with an edit programme.

Per mille sign This sign (‰) features in virtually every typeface but is not present on every keyboard lay-out.

Percent sign This sign (%) features in virtually every typeface and is present on any keyboard layout.

Phonetic symbols Symbols used to unequivocally specify the pronunciation of a word. Dictionaries often also give a phonetic transcription of the word in question.

Photographic typesetting After the days of metal type, the next step was photographic typesetting. Images of the typographic letters were produced

photographically on glass plates or film (usually transparent letters on a black background). The text was set by briefly projecting each letter onto photographic paper or film to expose it. This was a faster than hot metal typesetting and the types could be enlarged or reduced. One photographic master could be used to set all sizes up to about 18 pt. (the image would lose sharpness at larger sizes). For headline typefaces, masters were made with larger characters. Photographic typesetting was developed around 1950 and was replaced gradually by digital typesetters beginning with the 1965 Digiset by Hell.

Pi font Pi is an English printing term for metal type in disarray resulting from the accidental or careless breaking up of the set pages. The 'pi box' in a type case was a compartment where one kept odd sorts that had no designated compartment (normally, each character has its own compartment). It is no wonder then that most Pi fonts are a bit of a mess and can consist of various signs and symbols. It is, in short, a collective term for fonts or gradations with ornaments, symbols and pictograms, and sometimes characters. An example is the Symbol font, which has a Greek alphabet, mathematical signs and a few symbols.

Pictogram The word is a combination of the Latin word pictum (painted) and the Greek gramma (character). A pictogram is a stylised image that is used to indicate or give information. Pictograms are nearly always decorative and reflect the creator's style.

Pixel The smallest graphic element for displaying an image on a screen or printer, named by combining the first two syllables of 'picture element'. It is a single point (dot) on a computer screen or in a digital image. Many dots together create an image. Everything you see on a screen consists of a multitude of pixels. The measuring unit for digital photos, expressed in pixels, is ppi (pixels per inch). For printed matter and screens, dpi (dots per inch) is used. See also *Dpi*.

Plain text General design term for text that has no layout yet.

PostScript A programming language designed to describe a page for rendition on a screen or printing device: a Page Description Language (PDL). Special and innovative about the PostScript language, developed in 1982 by Adobe, is that it is platform and resolution independent. PostScript is one of the main reasons why desktop publishing developed so rapidly.

Postscript Also called epilogue, an extra concluding chapter or short note in a book.

PostScript drawing A drawing of a typeface in Bézier curves. The drawing consists of straight lines and curves, each running between two anchor points. In the case of curves, anchor points also have control handles that determine the shape of the curve and can be moved to adjust it.

PostScript Type 0, 1 and 3 Besides the page description language, PostScript has its own font technology for western typefaces: PostScript Type 1. The Type 1 fonts are different for Mac and Windows. Type 0 is almost exclusively used for complex Asian languages. Adobe first refused to disclose the specifications for Type 1 to third parties, so various typeface manufacturers used the license-free PostScript Type 3. However, the Type 3 typefaces do have some disadvantages: they do not contain hinting and the display on screens and with low resolution printers is of an inferior quality. When Apple developed and distributed the TrueType format in 1990, Adobe almost immediately disclosed the Type 1 specification.

Pound sign The pound sterling (£) is the currency unit in the UK. The official ISO code is GBP.

Prepress The phase in the production of printed matter that precedes the actual printing. Prepress includes the following actions: arranging the pages on the printer's sheet (imposition), denoting the grid lines, adjusting the dot gain for the paper to be printed, possibly last corrections

of the document and the production and preparation of the printing plates.

Primary fonts The basic fonts that are used with Multiple Master fonts for creating fonts in the FontCreator programme.

Prime symbol Vertical punctuation mark ('), which isn't an apostrophe or quotation mark. It is not in the form of a comma.

Printer's ruler A ruler that usually has several different measuring units, such as picas, Didot points and millimeters. Line widths can often be measured as well, and the grid of existing printed matter determined.

Private use characters Characters assigned numbers that have no standard characters, available for characters that fall outside the Unicode standard. That way, a type designer can insert his own characters, but it is also possible to, for instance, insert a client's logo in a modified typeface that was specifically designed for them.

Proportional A proportional typeface contains characters with each their own set width (which includes the white space to the left and right), as opposed to a monospaced typeface in which each character has the same set width, like a typewriter type.

Public domain software In general, this is software that has been placed in the public domain by its developers, and which is free from copyright or intellectual right restrictions.

Punch See *Matrix*.

Punctuation marks Non-alphabetic characters that belong to a typeface and help to clarify the meaning of a text or the way in which it would be spoken.

Punctuation The use of symbols in a text to clarify the structure of a sentence and to apply emphasis.

Quadratic splines The TrueType format makes use of quadratic splines to draw characters. The quadratic splines are controlled by points on the ends of tangents to the curve. Although it is possible to create similar curves to the Bézier ones used for PostScript typefaces, the quadratic splines are less easy to manipulate.

Quarto format made by folding a sheet of paper twice, making eight pages (four leaves). The final size depends on the size of the sheet.

Question mark A punctuation mark (?) at the end of a sentence to indicate that it is a question. It can also occur in the middle of a sentence (?), like this. The question mark is used after a direct question (How are you?), a question that doesn't require an immediate response (Could you please move?), or in a rhetorical question (How can I explain this?). In Spanish, an inverted question mark (¿) is also added before the sentence.

QuickDraw GX In 1995, Apple wished to further improve font technology in its system software and introduced QuickDraw GX. It is, in fact, a TrueType application hard-wired in the computer at system level. The GX font technology is, like TrueType, 16 bits (65,536 possible characters) and differentiates, for instance, between characters and glyphs (nowadays, the term 'glyph' is also used for individual characters). A character can be a letter, but also a number or a punctuation mark. A composite character or an edited combination of characters in a certain typeface is a single glyph but contains more than one character. QuickDraw GX differentiates between the two and a built-in software programme (state machine) can replace some glyphs with others, following specifications in the GX typeface. An 'f' followed by an 'i', for example, can be automatically replaced with the ligature 'fi'. As in TrueType and PostScript 1, the white space between letters can also be adjusted using so-called kerning tables, but the programme also contains 'class kerning' and 'contextual kerning'. In class kerning, the combinations of characters (glyphs) are grouped and provided with kerning instructions. In contextual kerning, white spaces are indicated for specific combinations of glyphs. Software developers made little use of the new technology signaling the end of QuickDraw GX. Apple did

subsequently incorporate the technology in the system software as Apple Advanced Typography (AAT).

Quill pen A writing instrument made from the shaft of a feather from a goose, swan or other bird. The five outer-most flight feathers of the left wing are used to make quills for right handed people for left handed people, the right wing is used. The curve in the feather ensures that the point is directed slightly away from the writer. The feather is cut at a slant and the marrow removed. The point is then hardened by soaking it in water and then in hot sand (170–180°C) until the point becomes transparent. The outer layer is then scraped off and the nib is cut to the correct width. As in a metal nib, a split ensures a constant flow of ink. Quill pens are still the preferred choice in the world of calligraphy.

Quire, section or gathering A group of leaves that form a physical unit within a book, usually a number of nested double leaves sewn or otherwise attached with the fold toward the spine. A single quire may be made from a folded whole sheet, more than one sheet, half a sheet, etc. Most books have 4, 8, 16, 24 or 32 pages. To make a book, a number of sections are piled on top of each other and then sewn or glued together. The term 'section' is also used in the world of newspapers. In this context it refers to four pages or a multiple of four.

Quotation mark Punctuation mark placed at the beginning and end of a word, quotation, piece of dialogue or phrase, used to indicate that the words do not originate with the narrator. The quotation mark before and after the words are called opening and closing quotation marks respectively. Their form varies according to the language being used. English quotation marks ('quote') – also called six-nine in reference to the form and placement of the marks – differ from those in many other languages. The German standard is to use guillemets (» quote «) or double quotation marks („quote") whereby the closing mark (two sixes) differs to the Dutch version (two nines). In French, Italian and Spanish, guillemets (« quote ») are generally used, but placed in the opposite direction to the German ones. In America double quotation marks are used ("quote"). A quote within a quote is denoted in a variety of ways. When double marks have already been used, single ones are used for the second quote, and vice versa ('this "quote" within a quote').

Ragged margin (text) In a text that is ranged left or ranged right with a ragged edge, one margin is aligned while the varying length of the lines makes the other margin irregular. This is called a ragged margin. A block of text is well composed when the irregular margin does not contain gaps that are too deep or lines that extend too far. Also, not too many consecutive lines should be of the same length. In other words, the ragged margin should not have any disturbing elements and its irregularity should be aesthetic.

Raster Image Processor (RIP) A RIP converts a PostScript file into a series of print instructions for a printer, photo typesetter or (offset) plate maker.

Re-release A new issue of an existing typeface. Where a revival is usually a new interpretation of an older typeface, a re-release simply makes an older typeface available again or gives it new publicity.

Reading comfort Every publication asks for a different approach. A novel reader wants be able to read a book without interferences or annoying interruptions. Someone who is looking something up in a dictionary measures reading comfort by the ease of finding the desired word, and the newspaper reader wants an easy page overview in order to choose his topic(s) of interest. In other words, reading comfort is dependent on the intended target audience. The designer has to judge the maximum reading comfort of each document separately.

Realist Category in the Vox classification for classifying typefaces. The realists are early neoclassical typefaces, created in the middle of the eighteenth century. They have a more severe, businesslike and sharper appearance than their predecessors. They are considered to be the first typefaces constructed with compass and rule. See also *Transitional*.

References A bibliography or list of references is a part of a publication listing books and other works cited in or used as sources for the publication, or recommended by the author for further reading.

Registered trademark The symbol for this is (®). A related symbol is the copyright symbol (©). See also *Trademark*.

Renaissance A cultural period in European history when literature, science and the arts are said to have blossomed. The Italian humanists who introduced the term regarded the Middle Ages as a period of decline, and saw their new golden age as a 'rebirth' of classical antiquity. The word renaissace literally means rebirth. The Renaissance started in Italy in the 14th century and then spread across Europe.

Resolution A term used in computer technology and digital image editing to indicate the pixel density of an image or an imaging device, or the sampling density of a scanner. The more pixels in a given area, the higher resolution. It actually refers to the resolving capacity of an optical device. See also *DPI*.

Return (carriage) See *Carriage return*.

Revival The reintroduction by a type company or printing office of an older type that had fallen out of use. A type might be revived by casting it again from surviving original matrices (with or without modifications, additional characters, etc.), or by producing a new type based (closely or distantly) on surviving materials or printed samples. In other words, revivals are often interpretations of older typefaces. Garamond has dozens of revivals, none of which are the same.

Ring A diacritic in the form of a circle above the a (å) in Danish, Norwegian and Swedish, among others, and above the u (ů) in Czech.

Rivers of white The wide gaps that occur in badly spaced block text are called rivers of white. They are especially visible as an undulating line when the text is held upside down.

ROM Abbreviation of Read-Only Memory. This is data, programmes, etc. stored permanently on a computer (usually containing the firmware) or CD. Firmware is software that is programmed into the hardware. This software is stored on a memory chip (ROM, PROM). In earlier forms it could not be modified, but it can now be re-programmed (EPROM, EEPROM). ROM nowadays consists of Flash memory that can be simply erased and rewritten.

ROM font A typeface located in the ROM and loaded when the computer is powered on. The typeface is normally used for the on-screen display of the menus and desktop.

Romaji One of the four writing systems that together form Japanese. As the word more or less shows, Romaji is the western alphabet that is used to describe concepts that do not have a Japanese translation. An English word sometimes pops up in a text written in Japanese characters.

Roman A style of type that originated in Italy, the first precursors dating from around 1465, combining a lowercase based on humanistic manuscript hands that evolved from the Carolingian minuscule with capitals based on Imperial Roman inscriptional capitals. Although the forms evolved over the centuries, they continued to be called roman through the didone period and to the present day. They are called Antiqua in Germany contrasting them with the Fraktur. Because romans are used with italics, the term 'roman' is also sometimes used for the upright (non-italic) version of a sans-serif, slab-serif, etc.

Roman alphabet Also called the Latin alphabet, used in western Europe and in may countries that are or have been influenced by western Europe.

Although a few letters now included (such as the 'J', 'K', 'U', 'W', 'Y' en 'Z') were not or not normally featured in the original Latin alphabet, the term 'Latin alphabet' usually denotes the current western version with 26 letters.

Roman cursive A cursive handwriting that was used by Romans to quickly write something down.

Roman numerals See *Numerals*.

Roman Square Capital Roman capital that was first drawn with a brush and then cut in stone with a chisel.

Rotunda A rounded gothic manuscript hand or type, marking the transition between the gothic minuscule and the humanistic minuscule dating from the fifteenth century.

Rub down letter See *Dry transfer letter*.

Rustic Capital A Roman capital letter written in italic with a quill, also known as 'farmers capital'.

Saccade Movement of the eye during reading. See Fixation.

Sans-serif A style of typeface or lettering without serifs (from French: sans = without), and usually with little or no contrast between thick and thin. William Caslon IV introduced the first sans-serif typeface in a single size (Two Lines English, or about 28 point) under the name Egyptian ca. 1812/14. It was based on Republican Roman inscriptional capitals and was quite geometric. Beginning in 1828 sans-serifs spread through other English foundries in a form influenced by the roman types of that day. Laurent & De Berny in Paris showed one in 1836, and William Thorowgood in London added a lowercase in 1834. The term 'sans-serif', used for the second such type in 1828, is the most common internationally. Most of the other terms used in various countries over the years, like the original 'Egyptian', allude to the style's antiquity or associations with nature: grotesque, antique, gothic. Since the 1920's sans-serifs have been associated with modernism and industrialism. See also slab-serif.

Scanning style of reading Style of reading when looking up information, for instance in an encyclopaedia, a bibliography or a dictionary.

Screen dump Image of (part of) a screen. When the image is saved, it has the same resolution as the screen.

Scribe or scrivener A person who makes written copies. In ancient times this was done by literate slaves called 'scriba'. In the Middle Ages, transcripts were usually made in monasteries in special rooms called scriptoria. It was common for a scribe to master several different styles of script. A scribe would usually use a quill.

Scriptoria (singular scriptorium) Writing rooms in monasteries where, before the introduction of printing from movable type, monks wrote and copied books. The word derives from the Latin 'scriptor', meaning copier or editor. One of the most copied books is the Bible.

Scripts Category in the Vox classification, usually with cursive letterforms that resemble handwriting.

Secret canon Also known as the Van de Graaf canon, this is an old way of dividing a page into pleasing proportions. The page proportions are 2 : 3 and the margin ratios are 2 : 3 : 4 : 6. The height of the text block is equal to the width of the page. J.A. van de Graaf discovered this ratio in medieval manuscripts and described them as comprehensive. The canon became popular with designers when Jan Tschichold described it in his books *The Properties of the Book* and *The Form of the Book*.

Section A section consists of several paragraphs and can have several sub-sections. A section can be indicated with a section mark.

Section mark This mark (§) is used to indicate a section. By adding a number, a complicated text can be structured. It is also used as a reference mark for (foot)notes.

Semicolon This punctuation mark (;) is used to indicate a connection between two sentences, and in lists and enumerations See also Lists. The

semicolon is a difficult punctuation mark and is often avoided by using a full stop or a comma.

Semitic The western alphabet is partly derived from the Semitic family. The Semitic languages form a north-eastern subfamily of the Afro-Asiatic languages. The most widely spoken Semitic languages are the Arabic, Amharic, Hebrew and Tigrinya. Maltese is also a partly Semitic language.

Serifs Non-structural parts protruding from the ends of many strokes in many typefaces. They evolved in Roman inscriptional capitals around the time of the transition from the Republic to the Empire (44 BCE) as entry or exit strokes in the letters, which were painted with a brush on the stone surface and then cut with a chisel. Manuscripts written with a pen evolved a very different style of serif, but when the two styles were combined in roman types, the manuscript-like serifs of the lowercase were gradually assimilated to the inscriptional-style serifs of the capitals.

Short-grain paper The fibers of the paper lie in the same direction as the short side of the sheet of paper. See also *Long grain paper*.

Shoulder The arched part of a lowercase n, m and h, sometimes also applied to the curve of 'f' and 'r', or even the top curve of a letter with a bowl connecting to a stem, as in a 'd'.

Shoulder The shank of a piece of cast metal type has the raised letter at one end, and its flat face is inked and printed on the press. The lower flat non-printing area around it is called the 'shoulder', while the supporting metal between the face and shoulder, with a sloped surface, is called the 'beard'.

Single byte coding (SBCS) See *Double byte coding*.

Single column A layout on a page whereby text is set in one column. This is often used in novels.

Sippe See *Type family*.

Slab-serif Also called Egyptian or, in the Vox classification, Mechanistic. The serifs are as broad as the lines of the letters which usually have little or no stroke contrast and are quite bold. The Figgins foundry in London introduced the first slab-serif types, with unbracketted serifs, ca. 1818. It was clearly a sans-serif with block-like serifs added, but it caught on more quickly than the sans-serif: By 1826 all English foundries offered a full range and continental foundries began to introduce them. The Clarendon, a variant with bracketted serifs, was patented in 1845.

Slash A slanting linear stroke, also known as the forward slash to differentiate it from the backslash. The slash is used to denote fractions (1/3), to indicate choices (man/woman), in abbreviations (S/E meaning single-engine) and to replace the word 'per' (km/h). The slash is also often used in internet addresses and in programming languages such as html-code.

Small capital figures Lining figures equal in size to the small capitals of a typeface.

Small capitals Smaller versions of capitals. These are not merely reduced capitals, but separately designed small capitals with an x-value that is generally higher than the lowercase letters. The stem weight is adjusted to suit the lowercase letters. They are used for texts containing lots of initials, abbreviations in capitals or words in capitals.

Soft return See *Return*.

Solid (unleaded) Type set solid, or unleaded type, is set with the distance from baseline to baseline equal to the body size. In metal type this meant the lines were set under each other without strips of lead in between. In practice this is written as 9/9 pt: a 9 pt letter with 9 pt line spacing.

Sort A single piece of metal type, usually made of a lead alloy, or all pieces of type that show the same glyph in the same size. If the type case has no more of one sort, the compositor is 'out of sorts'. The sort has a rectangular shank with the raised letter at one end. The measure of a sort from the feet on which it stands to the printing face of the letter is called the 'type height' and should be the same for all type used together.

The thickness of its shank in what would be the vertical direction on the printed page is called the 'body size' and the thickness of the shank in what would be the horizontal direction in the printed page (the width of the letter, including its white space) is called the set width, which varies from character to character. There is usually a notch, called the nick, at the front (or in France the back) of the shank, so the compositor can correctly orient the sort by feel.

Space The spacebar enters a blank area between two words. The word 'space' can also refer to the white space between two characters (see *Kerning*). The width of an em-space equals the measure of the body size, an en-space is half as wide, and spaces are commonly a third and other fractions of the em-space.

Spacing Also referred to as tracking. Increasing or decreasing the distance between letters for an entire passage of text, rather than between specific pairs (see *Kerning*). The tracking is usually specified in units of some fraction of the em, so that it scales with body size. Tracking should be applied with caution because it can have an effect on the integral characteristics of a text, which can affect readability. It is used more often in headings and sub-headings. In the world of microtypography it is more common to apply both increases and decreases in the spacing. The standard letter spacing of a typeface is based on the most commonly used body sizes of 9 to 12 pt. For headings larger than about 16 pt the tracking can be reduced and for type smaller than 7 pt it can be increased. This is a visual correction that was built into the better metal types but was largely lost with the arrival of photographic setting and the start of the digital era. Now type is once again being made that differentiates between body text and display sizes. Some typefaces even have multiple variations such as caption, text, subhead and display. In design software programmes (such as Adobe InDesign) it is often possible to define different spacing values for different body sizes. These definitions are then automatically applied to the whole document.

Spell checking Most text related software has the option to check a document's spelling in a chosen language.

Square brackets Rectangular brackets used mainly for additions in a text that are not written by the author [ed.] or to indicate omissions [...] in a quote.

Square capitals Roman capital letters. An upright alphabet that was mainly written with a quill on papyrus.

β Ligature in the German alphabet, called a 'scharfes s'. Designer Jan Tschichold stands by the theory that the 'β' is a ligature of the long 's' and the short 's', and that its origin can be seen in italic and Fraktur typefaces. In the Fraktur typefaces, the 'β' is a familiar sight, but in roman types used outside Germany it is rare. Although often called an 'Eszett' in German, or 'Eβ-Zett', it represents an ss in modern German, not an sz.

Standard metre In 1791, the standard metre was defined as one ten-millionth of the distance from the Equator to the North Pole, measured at sea level along the Paris Meridian. In 1798, the measurements were completed and recorded in 1799. It later turned out that the measurement was 0.02 mm too short because of a miscalculation in connection with the flattening of the earth, but the standard was not adjusted. In 1889, a new standard metre was produced, composed of 10% iridium and 90% platinum. This standard metre is kept at Sèvres, in France. The length remains the same, but is better defined because of the material that the metre bar is made of. In order to obtain an ever more precise definition, the metre was once more defined in 1960 as a fixed number of wavelengths of a krypton-86 radiation source, the atom in a vacuum. In 1983, the light of an iodine stabilised helium-neon laser became the 'recommended radiation' for designating the metre. Light in a vacuum is always the

same and thus produces the most accurate measurement. In laboratories, the metre is defined as 1,579,800.298728(39) wavelengths of helium-neon laser light in a vacuum.

Stem A letter's vertical, straight stroke. The capital 'H' has two stems, left and right.

Streamer A streamer is a short, provocative quote that is lifted out of a newspaper or magazine article. A streamer is not necessarily a literal reproduction of the text.

Style Level of boldness or kind of letter within a typeface. A style might be narrow, condensed, italic, extended, small capitals, or a series of symbols adapted to suit the particular typeface. In metal type most typefaces consisted simply of a roman, an italic and a bold style. Some typefaces also included a bold italic. In the digital era, the styles have been enormously extended, partly because creating an intermediate style is relatively easy with the software currently available. Styles are usually sold as packages or individually.

Styles, Character or Paragraph Typographic presettings in an editing programme that are constructed following a publication's basic design. These style sheets can be controlled by editing codes that the editor adds to the plain text, or during editing by clicking a typogram to make it valid for a paragraph or letter.

Subhead Term for a specially adapted style in a certain typeface for setting approximately 16 to 24 pt. headers. In general, a subhead has a greater thick-thin contrast than the caption and text versions, with narrower characters that are a bit more tightly spaced.

Subscript A smaller character ($_2$) shifted down so that it stands below the baseline, commonly used in formulas, mathematical applications or fractions. Subscripts are usually reduced from the normal characters, but this makes them too light in comparison to the rest of the text. The introduction of OpenType and the possibility of character substitution mean that more and more

small characters are specially drawn at an adjusted weight.

Substitution See *Font substitution*.

Superior a The superior letter a (a) features in nearly every typeface. It is used in Spanish abbreviations like Sa (señorita).

Superscript A smaller character set above the normal baseline. It is commonly used in formulas, mathematical application or fractions, but also for the trademark character (TM) and footnotes. Superscripts are usually reduced from the normal characters, but this makes them too light in comparison to the rest of the text. The introduction of OpenType and the possibility of character substitution mean that more and more small characters are specially drawn at an adjusted weight.

Swash capital A capital with added decorative elements like longer serifs, sweeping entry or exit strokes or other adornments, usually made only in italics. A few lowercase letters also appear in swash variants. An example is the Minion Pro with its complete swash style font. Characters can be replaced during layout through font substitution.

Swiss Style This style, also called the International Typographic Style, emerged around 1950 and was characterised by functionalism, austerity, clarity and objectivity, use of a grid and sans-serif typefaces like Akzidenz Grotesk and Helvetica. Important designers of the style are Max Bill, Jan Tschichold, Emil Ruder, Paul Rand, Joseph Müller-Brockmann and the Dutchman Wim Crouwel.

System font See *ROM font*.

Tabular figures See *Figures, tabular*.

Tag In the late 1960's, young people in New York copied some in Philadelphia who wrote their nicknames with markers on train carriages and subway trains. This quick signature is called a 'tag'. A 'throw up' is a big, detailed tag in one or two colours.

Tangent point An anchor point in a PostScript drawing of a letter. A tangent point, or point of

tangency, has a handle which is an extension of the straight line to allow for smooth transitions between a line and a curve. See also *Bézier curve*.

Template An example or pattern that is used as a basis for copying. A template can also be a pattern in an editing programme, or a skeleton document in a text programme, for example for a letter. See also *Grid*.

Text block A column of text. The print space can consists of one or more columns of text. Each column forms a text block.

Text box A text field in an editing programme, usually as big as the print space, divided into one or more columns with white space in between. On the so-called master page, it's often possible to make a text box. This text frame then automatically appears on every added page.

Text Font name in a typeface for setting a 9 to 16 pt text. In general, the text is the basis, and other fonts such as the caption (for, indeed, captions) or display font are adjusted for their width and thick-thin contrast, as well as for spacing.

Text overflow Something which occurs when adding texts and making corrections. Text overflow can have a number of consequences. The simple addition of a single punctuation mark, for instance, can mean that a line spills over to the next page and causes an orphan (see also *Orphan*). Or hard returns with their hyphens end up in the middle of a sentence, or result in half sentences. Adding text and corrections should therefore always be followed by carefully checking the subsequent texts.

Text typefaces Typefaces that are specifically designed for reading texts.

Text, centred See *Centred text*.

Text, justified See *Justified text*.

Text, left-aligining See *Left-aligned text*.

Text, right-aligning See *Right-aligned text*.

Thick-thin contrast (stroke contrast) The difference between the thin sections of a typeface and the thick sections. Didones such as Bodoni

and Didot have extemely high contrast, while some sans-serifs have none.

Thin A printed sample of a type is called thin when too little ink was used in printing, causing the outline to recede slightly. The effect on readability is especially detrimental for typefaces with thin lines, such as the Didones.

Thorn A character (Þ) that is used in Iceland and Old-English, but not in modern English.

Three-quarter height figures Numerals that are shorter than the lining figures but taller than the old-style figures. An example of a typeface using these numerals is the Miller Text by Matthew Carter. Some figures extend below the baseline and some extend up to the height of the capital.

Tilde A wavy diacritic, used in Spanish on the lower-case n (ñ) to indicate that it is followed by a 'y'-sound. In Portugese, the tilde is used with the a (ã) and o (õ) to indicate a nasal sound.

Titling capitals A typeface which is executed in capitals only. An example is the Trajan.

Top serif The serif at the topmost point of a letter's ascender.

Top Top of a letter. Also called apex if two diagonal strokes meet at a point.

Tracking A term used to describe the distance between letters. See also *Spacing*.

Tracy system A system by Walter Tracy, a typeface designer, that proposes a partly objective way to determine the letter spacing when designing a typeface.

Trademark The international symbol for this is (™). On the whole it is available in most typefaces as a standard symbol.

Trait d'union See *Hyphen*.

Transitional Category in the historical letter classification. Also called transitional roman. They first appear in the middle of the eighteenth century in France and England. Examples are Baskerville and Fournier.

Trema Another name for the diaeresis symbol.

Triplets A method for finding the right spacing of a typeface by placing three characters next to each

other. A few of these combinations in a particular order are needed to come to a balanced kerning or spacing.

TrueType A font format, published by Apple as a competitor to PostScript Type 1. The most obvious difference is that it uses one file for both bitmap and outline fonts. Moreover, the hinting in True-Type is more advanced (delta hinting) than in PostScript Type 1, and it is interchangeable between Windows and Mac OS. TrueType can also be extended from the 256 characters (as in Post-Script Type 1) to 65,536 characters. TrueType fonts are drawn using quadratic splines instead of cubic Bézier curves. OpenType makes use of both PostScript Type 1 and TrueType.

Type (cast) A collective noun referring to the pieces of metal type in a type case or set to make a page ready for printing.

Type case A wooden drawer or open-topped box with small compartments for storing cast metal type. Each country has a set and slightly different type case configuration, depending on the most frequently used letters in its language.

Type category A general stylistic group of typefaces with particular characteristics. In many cases, this is a certain category in a letter classification system, for instance scripts or lineales.

Type family All possible variations of a certain typeface, indicated by the same name. For instance, the Rockwell or the Helvetica.

Type family Sometimes known as a clan or by the German name 'Sippe'. This is a group of related typefaces designed to be used together, that do not fall into the same group or classification. An example of this is Thesis by Lucas de Groot, which has a sans-serif version as well as several seriffed variants.

Type specimen A printed sample of types offered for sale by a type company or shown by a printer to let potential customers seewhat types are in stock. A famous example is the 1592 Egenolff-Berner specimen, which provided the basis for some modern Garamond types. At the beginning of the twentieth century, when competition was fierce, some extraordinarily beautiful type specimens were made. In those days, editions of ten thousand copies or more were no exception.

Typeface classification A system for classifying typefaces so as to simplify both the user's choice and the types' presentation by type companies. The classification can be based the chronology of the historical models or on certain features in the form. The most important and most frequently used classification is the one by Vox, based on a mixture of chronology and form.

Typesetting instruction A description of all the details concerning the typography of any printed matter. Nowadays, this instruction is only really used when making a style manual, in which all the details of publications in a certain house style are recorded. But in this case too, it is common to just give templates for editing programs in which all the typograms and other data are laid down.

Uncial A majuscule or capital script used from 350 AD until 1300 AD. Most of the letters are quite round.

Uncoated paper General term for both wood-containing and wood-free paper without a coating. Is mainly used for novels, house style/corporate identity printed matter, envelopes and other applications for which the following characteristics are important: a less smooth and glossy surface and a reduced risk of damaging and creasing. Colour images are generally blander than when coated paper is used.

Underscore A line that is placed just below the baseline. It is the length of an en-dash.

Unicase A gradation of a typeface or a separate typeface in which upper- and lowercase forms are mixed together and all characters are drawn between two lines. An example is the Filosofia Unicase, in which only the 'J' and the 'Q' extend below the baseline.

Unicode An international standard for identifying graphic characters and symbols. It gives each

character and symbol a number. The standard is kept by the Unicode Consortium. At the moment, the standard encompasses around 100,000 standardised characters and around 900,000 reserved characters. When it turned out 65,536 codes (2^{16}) weren't enough, the number was increased to 1,114,111 codes.

Unjustified text The term is pretty clear. The lines are not justified. Lines can be flush left and ragged right (as is the case in this text) or flush right and ragged left.

Upstroke See *Downstroke*.

Vector font (outline font) A PostScript Type 1 font consists of a number of files. One of them is a bitmap file with hinted bitmap fonts and a vector font which is built up of outlines. The vector font is scalable and resolution independent. It is used in printing and for printed matter. In the case of TrueType fonts, the hinted bitmap font and the vector font are brought together in one file.

Venetian types Also called humanes in the Vox classification. See *Humanes*.

Vertical line This line (|) hardly occurs in normal texts but designers sometimes use it as a design element. It can also indicate line breaks in transcriptions. See also *Vertical bar*.

Vowel The opposite of a consonant.

Vox classification A classification, made by the Frenchman Maximilien Vox in 1954, originally intended to classify the Deberny & Peignot type collection for internal use. The Association Typographique International (ATypI) accepted it as a standard in 1962, and in 1967 the British Standards Classification of Typefaces (BS 2961:1967) followed. The British standard is less comprehensive than the ATypI-standard. In 1964 in Germany, the Deutsches Institut für Normung e.V (DIN) set the standard for typeface classification as DIN 16518. This standard is closely related to the Vox classification. The standards of each country are adjusted to take its typographic history into account. The manuals and scripts for instance are very popular in France, which is why they have two categories reserved for them. In Germany, the Fraktur scripts form an important group, so that category is subdivided into five subcategories. In this book the basic Vox classification hasn't been changed, but has been extended with a separate category for display typefaces (Vox+2) and one for ornaments, symbols and pictograms (Vox+3). Vox+4 is for non-Latin types.

Warehouse (paper) There are two ways to order paper: 'made to order' or from a distributor's warehouse. 'Made to order' usually means that the paper is produced in a paper factory according to certain specifications, which results in a longer delivery time. Standard warehouse paper usually only takes a day to deliver.

White line A line without letters or other characters, usually to separate two passages of text.

White space The white in and around the letter and in and around texts is just as much a design element as the printed part of a page. An equal distribution of white and the way the white is shaped deserve the same consideration as other elements that can be found on a page.

Widow The last line of a paragraph standing alone in a new column or on a new page. If this line is full or almost full, and is not followed immediately by a blank line, it is acceptable. Otherwise a solution should be found, especially if it is only one or a few words; the text should not remain in this form.

Word breaking See *Hyphenation*.

Word image In typographic terms, this means a word should form a unified whole without strange gaps or letters that stick together. If the letters are too widely spaced, the word image forms too slowly; if too tightly spaced, characters are difficult to distinguish from one another. As the process of reading consists of eye movements (saccades) and fixations, a reader will only be able to read quickly if word spaces and rest points are easily identified.

Word space The space between two words. A designer incorporates the default word space in a typeface. The word space is about a fourth to a third of an em-space. The width of an em-space has the same measure as the body size. For a 10 pt letter, the em-size is 10 x 10 pts.

x-height The height of the lowercase letter 'x'. It's an important feature because it (and letters of a similar height) largely determine the apparent size of a typeface. It is called x-height because the 'x' is generally easiest to measure. Letters such as the 'o' and the 'a' are more difficult to measure because of their protruding curves.

XSF font See *OpenType Pro-XSF*.

Z3 The first ever programme-controlled computer with a memory of 1 Kb, made by Konrad Zuse in 1941.

Bibliography

Dozens of books, type specimens and publications were used in the making of this book. The history of typography is, after all, largely based on the written and printed word. With this book, we stand on the shoulders of those who made the effort to commit to paper the knowledge and skills they acquired. Titles of books that have made an above-average contribution to Letter Fountain are rendered in red. Publications that are no longer available in bookstores can usually be found on the internet. Dictionaries, type specimens and special editions are grouped under separate headings. The bibliography is confined to book-like publications.

Otl Aicher, *Typographie*, Verlag Hermann Schmidt, Mainz 2005 (reprint of the second 1989 edition).

Maurice Annenberg, *Type Foundries of America and their Catalogs*, Oak Knoll Press, New Castle, Delaware, 1994 (new edition of the 1975 original).

Phil Baines and Andrew Haslam, *Type & typography*, Watson-Guptill Publications, New York 2002.

Geoff Barlow, *Typesetting and Composition*, Blueprint Publishing, London 1987.

Alan Bartram, *Five hundred years of book design*, The Yale University Press, New Haven 2001.

Alan Bartram, *Typeforms, a history*, The British Library/Oak Knoll Press, London/Newcastle 2007.

Konrad F. Bauer, *Werden und Wachsen einer deutschen Schriftgießerei*, Bauersche Gießerei, Frankfurt am Main 1937.

Paul A. Bennet, *Books and Printing: a treasury for typophiles*, The World Publishing Company, Cleveland/New York 1951.

Hanne Bergius, *Das Lachen DaDa's – Die Berliner Dadaïsten und ihre Aktionen*, Anabas Verlag, Gießen 1993.

John D. Berry, *Language Culture Type*, ATypI/Graphis, New York 2002.

Haico Beukers, *Op een rij gezet*, Holding Ed Bos bv, Amsterdam 1986.

Peter Bil'ak, *Illegibility*, Reese Bros., Pittsburgh 1995.

Peter Bil'ak, *Transparency*, Academy of Fine Arts & Design, Bratislava 1997.

Silja Bilz, *Type One, discipline and progress in typography*, Die Gestalten Verlag, Berlin 2004.

Lewis Blackwell, *20th century type*, Laurence King Publishers, London 2004.

Frank E. Blokland, Sebastiaan Smidt and Elmo van Slingerland, *The Monotype Recorder New Series/Volume 9 – The Dutch Connection*, Monotype Typography Ltd./Dutch type Library, 's-Hertogenbosch 1997.

Ton Bolder et al., *Typografie – uitgangspunten, richtlijnen, techniek*, GOC-Uitgeverij/Gaade Uitgevers, Amsterdam/Houten 1991.

Hans Rudolf Bosshard, *Der typografische Raster – The Typographic Grid*, Verlag Niggli AG, Sulgen 2000.

Hans Rudolf Bosshard, *Sechs Essays zu Typografie Schrift Lesbarkeit*, Verlag Niggli AG, Sulgen 1998.

Jan Boterman, *Berthold*, Projectgroep Zettechniek GVN, Amsterdam 1987.

Alexander Branczyk, Jürgen Siebert et al., *emotional_digital, Porträts internationaler Type-Designer und ihrer neuesten Fonts*, Verlag Hermann Schmidt, Mainz 1999.

Pieter Brattinga and Wim Crouwel, *New Alphabet*, Steendrukkerij de Jong & Co, Hilversum 1967.

Roy Brewer, *Eric Gill: The Man Who Loved Letters*, Frederick Muller Limited, London 1973 (The Ars Typographica Library).

Robert Bringhurst, *The Elements of Typographic Style*, Version 3.1, Hartley & Marks, Vancouver 2005.

Josef Müller-Brockmann, *Grid systems - Raster systeme*, Fourth edition, Verlag Niggli AG, Sulgen 1996 (first edition, 1981).

Christopher Burke, *Active literature, Jan Tschichold and New Typography*, Hyphen Press, London 2007.

Christopher Burke, *Paul Renner, the art of typography*, Hyphen Press, London 1998.

Max Caflisch, Gerard and Marjan Unger, *Gravisie 14 - Hoogtepunten van het letterontwerpen in Nederland – Hollands landschap met letters*, Van Boekhoven-Bosch, Utrecht 1989.

Harry Carter, *A view of early Typography, up to about 1600*, Oxford University Press, London 1969.

Harry Carter and Hendrik D.L. Vervliet, *Civilité Types*, The Oxford Bibliographical Society, Oxford, 1966.

Rob Carter, Ben Day and Philip Meggs, *Typographic Design: Form and Communication*, John Wiley & Sons, Hoboken 2001 (third edition).

Sebastian Carter, *Twentieth century type designers*, W.W. Norton & Company, New York/London 1995.

Edward M. Catich, *The Origin of the Serif*, Catfisch Press, Davenport 1968.

Sean Cavanaugh, *Type Design, Digitales Gestalten mit Schriften*, Midas Verlag, Zürich 1997.

Karen Cheng, *Designing Type*, Laurence King Publishing, London 2005 (also printed by Verlag Hermann Schmidt under the title *Anatomie der Buchstaben*, Mainz 2005).

Albert Corbeto, "Eighteenth Century Spanish Type Design", *The Library*, 10, pp. 272–297, The Bibliographical Society, London, 2009.

Anne Denastas and Camille Gallet, *Eine Einführung in die Typographie – An Initiation in Typography – Une Initation à la Typographie*, Verlag Niggli AG, Sulgen 2006.

Theodore Low De Vinne, *Correct Composition, observations on punctuation and proof-reading*, Oswald Publishing Company, New York 1916.

David Diringer, *The Alphabet - A Key to the History of Mankind*, Munshiram Manoharlal Publishers Pvt. Ltd., New Delhi 2005.

Robin Dodd, *From Gutenberg to OpenType*, Ilex, Lewes 2006.

Dick Dooijes, *Over de drukletterontwerpen van Sjoerd H. de Roos*, Bührmann-Ubbens Papier, Zutphen 1987.

Geoffrey Dowding, *An Introduction to the History of Printing Types*, The British Library/Oak Knoll Press, London, New Castle 1998 (reprint of the first 1961 edition).

Geoffrey Dowding, *Finer Points in the spacing and arrangement of type*, Wace & Company Limited, London 1954.

Ron Eason and Sarah Rookledge, *Rookledge's International handbook of typedesigners: a biographical directory*, Sarema Press (Publishers) Ltd., Surrey 1991.

Elizabeth L. Eisenstein, *The Printing Revolution in Early Modern Europe*, Cambridge University Press, Cambridge 1983.

Charles Enschedé, revised and annotated by Harry Carter, *Typefoundries in The Netherlands from the fifteenth to the nineteenth century*, Stichting Museum Enschedé, Haarlem 1978.

James Felici, *The Complete Manual of Typography, A Guide to Setting Perfect Type*, Peachpit Press, Berkeley 2003.

Friedrich Forssman and Ralf de Jong, *Detailtypographie*, Verlag Hermann Schmidt, Mainz 2002.

Friedrich Friedl, *Design-Klassiker – Die Univers von Adrian Frutiger*, Verlag form, Frankfurt am Main 1998.

Friedrich Friedl, *Theses about Typography 1900–59 – Statements on Typography in the Twentieth Century, Thesen zur Typografie 1900–59 – Aussagen zur Typografie im 20. Jahrhundert*, Linotype GmbH, Eschborn 1986.

Friedrich Friedl, *Theses about Typography 1960–84 – Statements on Typography in the Twentieth Century, Thesen zur Typografie 1960–84 - Aussagen zur Typografie im 20. Jahrhundert*, Linotype GmbH, Eschborn 1985.

Friedrich Friedl, Nicolaus Ott and Bernard Stein, *Typographie - when who how, wann wer wie, quand qui comment*, Könemann, Köln 1998.

Adrian Frutiger, *Buch der Schriften, Anleitungen für Schriftenentwerfer*, Marix Verlag, Wiesbaden 2005.

Edmund Fry (facsimile edition with a preface by David Chambers), *Specimen of Modern Printing Types by*

Edmund Fry, Printing Historical Society, London 1986 (first edition, 1828).

Nathan Gale, *Type 1, Digital Typeface Design*, Laurence King Publishing, London 2002.

Damien Gautier, *Gudrun Zapf von Hesse*, Mark Batty, Publisher, New York 2002.

Rudolf Paulus Gorbach, *Typografie professionell*, Galileo Press, Bonn 2001.

Frederic W. Goudy, *Typologia – Studies in Type Design & Type Making*, University of California Press, Berkeley 1940.

Nicolette Gray, *Lettering as Drawing*, Oxford University Press, London 1971.

M.H. Groenendaal, *Drukletters, hun ontstaan en hun gebruik*, N.V. De Technische Uitgeverij H. Stam, Haarlem/Antwerpen/Djakarta 1957 (fifth edition).

Hans A. Halbey, *Typographie, guide pratique*, Pyramyd, Paris 2001 (second edition).

Thomas Curson Hansard, *Typographia*, Baldwin, Cradock, and Joy, London 1825 (reprinted by Gregg Press Ltd, London, 1966).

Horace Hart, *Notes on a Century of Typography at the University Press Oxford 1693-1794*, Oxford University Press, Oxford 1970 (Fascimile of the first 1900 edition, revised by Harry Carter).

Roger D. Hersch, *Visual and Technical Aspects of Type*, Cambridge University Press, Cambridge 1993.

Jost Hochuli, *Das Detail in der Typografie*, Verlag Niggli AG, Sulgen 2005 (first edition by Compugraphic in 1987).

Wiebke Höljes, *Dreiklänge Schriftmischmusterbuch*, Verlag Hermann Schmidt, Mainz 2000.

Patrick de Hondt and Joep Pohlen, *Fresh Fonts*, Uitgeverij Fontana, Roermond 2002.

P.J. van der Horst, *Leestekenwijzer*, SDU uitgeverij, Den Haag 1990.

Allen Hutt, *Fournier, The Complete Typographer*, Frederick Muller Limited, London 1972 (The Ars Typographica Library).

André Jammes, *Les Didot: trois siècles de typographie et de bibliographie 1698-1998*, Agence Culture de Paris, Paris, 1998.

Andres Janser, *Frische Schriften – Fresh Type*, Museum für Gestaltung, Zürich 2004.

Jaspert, Berry and Johnson, *Encyclopedia of typefaces* (55th Anniversary Edition), Octopus Publishing Group, London 2008.

A.F. Johnson, *Type Designs, their history and development*, Grafton & Co, London 1959.

Edward Johnston, *Writing & Illuminating, & Lettering*, John Hogg, London 1917.

Herbert Jones, *Stanley Morison Displayed*, Frederick Muller Limited, London 1976 (The Ars Typographica Library).

Cees W. de Jong, Alston W. Purvis and Friedrich Friedl, *Creative Type, a sourcebook of classic and contemporary letterforms*, Inmerc, Wormer 2005.

Cees W. de Jong, Alston W. Purvis and Jan Tholenaar, *Type, A Visual History of Typefaces and Graphic Styles 1628–1900*, Volume 1, Taschen, Köln 2009.

Cees W. de Jong, Alston W. Purvis and Jan Tholenaar, *Type, A Visual History of Typefaces and Graphic Styles 1901–1938*, Volume 2, Taschen, Köln 2010.

Stephanie & Ralf de Jong, *Schriftwechsel*, Verlag Hermann Schmidt, Mainz 1997.

Roxane Jubert, *Typography and Graphic Design, From Antiquity to the Present*, Flammarion, Paris 2006.

David Jury, *What is Typography?*, Rotovision, Mies 2006.

John Kane, *A type primer*, Laurence King Publishing, London 2002.

Albert Kapr, *101 stellingen over de vorm van het boek*, Uitgeverij De Buitenkant, Amsterdam 1992.

Peter Karow, *Digital Formats for Typefaces*, URW Verlag, Hamburg 1987.

Michael Kern and Sieghart Koch, *Schrift vergleichen, Übersicht – Schrift auswählen, Schrift erkennen, Schrift finden*, Verlag Hermann Schmidt, Mainz 1991.

Robin Kinross, *Unjustified texts, perspectives on typography*, Hyphen Press, London 2002.

Manfred Klein, Yvonne Schwemer-Scheddin and Erik Spiekermann, *Type & Typographers*, SDU Uitgeverij, Den Haag 1991.

G. Knuttel, *De letter als kunstwerk, beschouwingen en confrontaties met andere gelijktijdige kunstuitingen van de Romeinse tijd tot op heden*, N.V. Lettergieterij „Amsterdam" voorheen N. Tetterode, Amsterdam 1951.

Huib van Krimpen, *Boek over het maken van boeken*, Gaade Uitgevers, Veenendaal 1986 (second edition).

Jan van Krimpen, *Over het ontwerpen en bedenken van drukletters*, Uitgeverij De Buitenkant, Amsterdam 1990 (Original title: *On devising and designing type*, 1957).

Els Kuijpers et al., *LettError*, Drukkerij Rosbeek, Nuth 2000.

Els Kuijpers, Pierre Bernard, Muriel Paris and Pierre di Sciullo, *Pierre di Sciullo, expériences graphiques et typographiques*, Drukkerij Rosbeek, Nuth 1995.

Willi Kunz, *Typography: Macro- and Microaesthetics*, Verlag Niggli AG, Zürich 2002 (third edition).

Indra Kupferschmidt, *Buchstaben kommen selten allein - Ein typografisches Handbuch*, Verlag Niggli AG, Sulgen 2003.

John A. Lane, *Early Type Specimens in the Plantin-Moretus Museum*, Oak Knoll Press/The British Library, Delaware/London 2004.

John A. Lane, *The Enschedé type specimens of 1768 & 1773 – Introduction and notes*, Stichting Museum Enschedé/The Enschedé Font Foundry/Uitgeverij De Buitenkant, Amsterdam 1993.

John A. Lane and Matthieu Lommen, *Letterproeven van Nederlandse gieterijen/Dutch Typefounders Specimens*, De Buitenkant, Amsterdam 1998.

Alexander Lawson, *Anatomy of a Typeface*, David R. Godine, Boston 2005.

Charlotte Lingen, Zuzana Licko, Rick Poynor, Rudy Vanderlans and Lorraine Wild, *Emigre*, Drukkerij Rosbeek, Nuth 1998.

Mathieu Lommen, *Letterrijk – Rijksoverheid Serif en Sans – Een letter van Peter Verheul*, Uitgeverij De Buitenkant, Amsterdam 2009.

Mathieu Lommen and John A. Lane, *Bram de Does, letterontwerper & typograaf*, Uitgeverij De Buitenkant, Amsterdam 2003.

Mathieu Lommen and Peter Verheul, *Haagse letters*, Uitgeverij De Buitenkant, Amsterdam 1996.

Richard Londin and James Mosley, *AZ Founder's London*, Friends of the St. Bride Printing Library, London 1998.

Simon Loxley, *Type: the secret history of letters*, I.B. Taurus & Co Ltd, London 2006.

Philipp Luidl, *Typografie Basiswissen*, Deutsche Drucker, Ostfildern 1996.

Philipp Luidl, *Typografie Praxisbeispiele*, Deutsche Drucker, Ostfildern 1999.

Ellen Lupton, *Thinking with type, a critical guide for designers, writers, editors & students*, Princeton Architectural Press, New York 2004.

John Man, *Gutenberg, How One Man Remade the World with Words*, John Wiley & Sons, New York 2002.

Egidio Marzona, M. and R. Fricke and Gerd Fleischmann, *Bauhaus, drucksachen, typografie, reklame*, Oktagon, Stuttgart 1995 (reprint of the 1984 edition).

Neil Macmillan, *An A-Z of type designers*, Laurence King, London 2006.

Hans Mardersteig, *The Pastonchi Face*, The Lanston Monotype Corporation, Verona 1928.

Ruari McLean, *The Thames & Hudson Manual of Typography*, Thames & Hudson, London 2000 (third edition).

John Findlay McRae, *Two Centuries of Typefounding – Annals of The Letter Foundry established by William Caslon in Chiswell Street, London, in the Year 1720*, George W. Jones (at The Sign of The Dolphin), London 1920.

Willi Mengel, *Die Linotype erreichte das Ziel*, Linotype GmbH, Berlin und Frankfurt am Main 1955.

Jan Middendorp, *Atelier René Knip*, A.R.K., Amsterdam 2004.

Jan Middendorp, *Dutch Type*, 010 Publishers, Rotterdam 2004.

Jan Middendorp and Erik Spiekermann, *Made with FontFont*, Mark Batty Publisher, New York 2007.

Roy Millington, *Stephenson, Blake, The Last of the Old English Typefounders*, Oak Knoll Press/The British Library, Delaware/London 2002.

Stephen Moye, *Fontographer, Type by Design*, MIS: Press, New York 1995.

Gustav Mori (with a preface by David Stempel and Wilhelm Cunz), *Die Egenolff-Lutherische Schriftgießerei in Frankfurt am Main und ihre geschäftlichen Verbindungen mit den Vereinigten Staaten von Nordamerika*, Schriftgießerei D. Stempel AG, Frankfurt am Main 1926.

Stanley Morison, *Grondbeginselen der Typografie*, Uitgeverij De Buitenkant, Amsterdam 1990 (third edition).

James Mosley, „A Specimen of Printing Types by William Caslon, London 1766: a facsimile with an introduction and notes", *Journal of the Printing Historical Society*, 16, London, 1983.

James Mosley, „French academicians and modern typography: designing new types in the 1690s", *Typography Papers*, 2, pp. 5–29, The University of Reading, Reading 1997.

James Mosley, „Giovan Franceso Cresci and the Baroque Letter in Rome", *Typography Papers*, 6, pp. 115–155, The University of Reading, Reading 2005.

James Mosley et al., *Le Romain du Roi: la typographie au service de l'État*, 1702–2002, Musée de l'imprimerie, Lyon, 2002.

James Mosley (Einleitung), *Ornamented Types: 23 Alphabets from the Foundry of Louis John Pouchée*, St. Bride Library, London, 1993.

James Mosley, *The Nymph and the Grot: the revival of the sanserif letter*, St. Bride Printing Library, London, 1999.

Lars Müller, *Helvetica*, Lars Müller Publishers, Baden, 2002.

Jutta Nachtwey, *Type is Money, Typografie in der Werbung*, Verlag form, Frankfurt am Main 1998.

Gerrit Noordzij, *Letterletter*, Hartley & Marks Publishers Inc., Vancouver 2000.

Aldo Novarese, *alfa-beta*, Progresso Grafico, Torino 1964.

Heidrun Osterer and Philipp Stamm, *Adrian Frutiger – Typefaces. The Complete Works*, Birkhäuser, Basel 2007.

G.W. Ovink, *Honderd jaren lettergieterij in Amsterdam*, N.V. Lettergieterij Amsterdam v/h N. Tetterode, Amsterdam 1951.

Imin Pao and Joshua Berger, *30 Essential Typefaces for a Lifetime*, Rockport Publishers, Gloucester 2006.

F.E. Pardoe, *John Baskerville of Birmingham, Letter-Founder & Printer*, Frederick Muller Limited, London 1975 (The Ars Typographica Library).

Muriel Paris, *Petit Manuel de Composition Typographique – Version 2*, Muriel Paris, Paris 2005.

Christopher Perfect and Gordon Rookledge (revised edition by Phil Baines with a preface by Adrian Frutiger), *Rookledge's International typefinder*, Sarema Press, Surrey 1991.

Joep Pohlen, *MiniQuest 01*, Uitgeverij Fontana, Roermond 2002.

Ari Rafaeli, *Book Typography*, Oak Knoll Press/The British Library, New Castle/London 2005.

Talbot Baines Reed (revised new edition by A.F. Johnson), *A History of the Old English Letter Foundries*, Faber and Faber, London 1887 (first print of the new 1952 edition).

J. Renkema, *Schrijfwijzer – Handboek voor duidelijk taalgebruik*, Staatsuitgeverij, Den Haag 1982.

Robert van Rixtel and Wim Westerveld, *Letters – een bloemlezing over typografie*, [z]oo producties, Eindhoven, 2001.

Andrew Robinson, *Die Geschichte der Schrift – Von Keilschriften, Hieroglyphen, Alphabeten und andere Schriftformen*, Verlag Paul Haupt, Bern 1996 (original title: *The Story of Writing*, Thames & Hudson, London 1995).

Sjoerd H. de Roos, with a preface by Jan P. Boterman, *Typografische geschriften 1907-1920*, SDU uitgeverij, Den Haag 1989.

Emil Ruder, *Typographie*, Verlag Niggli AG, Sulgen 2001 (seventh edition).

Prof. Jay Rutherford et al., *Typoart-Freunde*, Heinz Wohlers Verlag, Harrlach 2007.

John Ryder, *The Case for Legibility*, The Bodley Head, London 1979.

Daniel Sauthoff, Gilmar Wendt and Hans Peter Willberg, *Schriften erkennen*, Verlag Hermann Schmidt, Mainz 1997 (sixth edition).

Judith Schalansky, *Fraktur Mon Amour*, Verlag Hermann Schmidt, Mainz 2006.

John W. Seybold, *The World of Digital Typesetting*, Seybold Publications, Inc., Media 1984.

Harry N. Sierman e.a., *Linotype*, Projectgroep Zettechniek BNO, Amsterdam 1992.

Martijn Smeets, *Letterboekje 1*, Hogeschool voor de kunsten Arnhem, Arnhem 1993.

Martijn Smeets en Martin Majoor, *Letterboekje 2*, Hogeschool voor de kunsten Arnhem, Arnhem 1994.

Fred Smeijers, *Counterpunch, making type in the sixteenth century, designing typefaces now*, Hyphen Press, London 1996.

Fred Smeijers, *Type now*, Hyphen Press, London, 2003.

Erik Spiekermann, *Über Schrift*, Verlag Hermann Schmidt, Mainz 2004.

Erik Spiekermann & E.M. Ginger, *Stop Stealing Sheep & find out how type works*, Adobe Press, Indianapolis 1993.

Paul Stiff, *Typography Papers*, 5, Hyphen Press, London 2005.

Paul Stiff, *Typography Papers*, 6, The University of Reading, Reading 2005.

A.A.M. Stols, *Het werk van S.H. de Roos*, N.V. Lettergieterij „Amsterdam" voorheen N. Tetterode, Amsterdam 1942.

Hans van Straten, *Hendrik Nicolaas Werkman – De drukker van het paradijs*, J.M. Meulenhoff, Amsterdam 1963.

James Sutton and Alan Bartram, *An Atlas of Typeforms*, Lund Humphries, London 1968.

James Sutton and Alan Bartram, *Typefaces for Books*, New Amsterdam, New York 1990.

Cal Swann, *Language & Typography*, Lund Humphries, London 1991.

Cal Swann, *Techniques of Typography*, Lund Humphries, London 1969.

Geofroy Tory, *Champ Fleury. Art et Science de la Vraie Proportion des Lettres* (reprint), Bibliothèque de l'Image, Paris 1998.

Walter Tracy, *Letters of Credit, A View of Type Design*, David R. Godine, Boston 2003.

Karel F. Treebus, *Tekstwijzer – Een gids voor het grafisch verwerken van tekst*, Staatsuitgeverij, Den Haag 1983 (second edition).

Jan Tschichold, *De Proporties van het boek*, Uitgeverij De Buitenkant, Amsterdam 1991 (original title in Der Druckspiegel: *Die Proportionen des Buches*, Stuttgart 1955 und Intergrafia: *De Proporties van het boek*, Amsterdam 1955).

Jan Tschichold, *Meisterbuch der Schrift: ein Lehrbuch mit vorbildlichen Schriften aus Vergangenheit und Gegenwart für Schriftenmaler, Graphiker, Bildhauer, Graveure, Lithographen, Verlagshersteller, Buchdrucker, Architekten und Kunstschulen*, Otto Maier Verlag, Ravensburg 1999 (reprint of the second 1965 edition).

Jan Tschichold, *Vormveranderingen van het &-teken. In een hedendaagse context*, Uitgeverij De Buitenkant, Amsterdam 1993 (Original title: *Formenwandlungen der et-Zeichen*, Frankfurt 1953).

Gerard Unger, *Letters*, Uitgeverij De Buitenkant, Amsterdam 1994.

Gerard Unger, *Terwijl je leest*, Uitgeverij De Buitenkant, Amsterdam 1997.

Gerard Unger, „The Types of François-Ambroise Didot and Pierre-Louis Vafflard: a further investigation into the origins of the Didones", *Quaerendo*, 31, pp. 165-191, Brill, Leiden, 2001.

Daniel Berkeley Updike, *Printing Types, their History, Forms, and Use*, Volume I and II, Harvard University Press, Cambridge 1937 (second edition).

Chris H. Vermaas, Dawn Barrett, David Berlow, Matthew Carter et al., *Tobias Frere-Jones Gerrit Noordzij Prize Exhibition*, Uitgeverij De Buitenkant, Amsterdam 2009.

Hendrik D.L. Vervliet, *French Renaissance Printing Types: a conspectus*, The Printing Historical Society, London, 2010.

Hendrik D.L. Vervliet, *The Palaeotypography of the French Renaissance*, Brill, Leiden, 2008.

Hendrik D.L. Vervliet, *Sixteenth-Century Printing Types of the Low Countries*, Menno Hetzberger & Co, Amsterdam 1968 (translation and preface by Harry Carter).

Hendrik D.L. Vervliet & Harry Carter, *Type Specimen Facsimiles II – Plantin & Le Bé-Moretus*, University of Toronto Press, Toronto 1972 (English edition by: The Bodley Head Ltd., London 1972).

Lawrence W. Wallis, *Modern Encyclopedia of Typefaces 1960–90*, Lund Humphries, London 1990.

David Wardenaar (prefaced and annotated by Frans A. Janssen), *Zetten en drukken in de achttiende eeuw, David Wardenaar's beschrijving der Boekdrukkunst (1801)*, Frans A. Janssen, Krommenie 1982 (second edition).

Kurt Weidemann, *Wo der Buchstabe das Wort führt*, Cantz, Ostfildern 1994.

Wolfgang Weingart, *Typography*, Lars Müller Publishers, Baden 2000.

Hans Peter Willberg, *Wegweiser Schrift*, Verlag Hermann Schmidt, Mainz 2001.

Hans Peter Willberg and Friedrich Forssman, *Erste Hilfe in Typografie – Ratgeber für Gestaltung mit Schrift*, Verlag Hermann Schmidt, Mainz 2000.

Hans Peter Willberg and Friedrich Forssman, *Lesetypographie*, Verlag Hermann Schmidt, Mainz 1997.

Eldert Willems, *in 26 letters*, Vereeniging ter bevordering van de Belangen des Boekhandels, Amsterdam 1960.

Rudolf Wolf, *Vom Schriftschaffen der Schriftgießerei und Messinglinienfabrik D. Stempel AG Frankfurt am Main*, Schriftgießerei D. Stempel AG, Frankfurt am Main 1939.

Berthold Wolpe, *Vincent Figgins Type Specimens 1801 and 1815*, Printing Historical Society (fascimile), London 1967.

Alberto Zanlari et al., *Bodoni, celebrato a Parma* (second edition), Biblioteca Palatina, Parma 1963.

Dictionaries

F.C. Avis, *Typeface Terminology*, F.C. Avis, London 1965.

J.A. Brongers, *Boekwoorden woordenboek*, Uitgeverij De Buitenkant, Amsterdam 1996.

Georgine Calkoen, *Papier, technische woordenlijst voor grafisch geïnteresseerden* (Proost Prikkels Nr. 461), Proost en Brandt, Diemen 2009.

Annelies van Dijk, Andree Hollander en Jan Ris, *Het dtp handwoordenboek*, Addison Wesley Publishing Company, Amsterdam 1996.

Ken Garland, *Graphics, design and printing terms, an international dictionary*, Lund Humphries Publishers, London 1989.

C. Hofmann, *Typografen ABC*, Drukkerij Nieuw Leven, Den Haag 1944 (second edition).

Rudolf Hostettler et al., *The Printer's Terms*, Rudolf Hostettler/Alvin Redman Publishers, St. Gallen/London 1959 (third edition).

Helmut Kipphan, *Handbook of Print Media*, Springer Verlag, Berlin/Heidelberg 2001.

Huib van Krimpen, *Grafisch zakboek, hedendaagse grafische begrippen met vertalingen en registers in het Engels, Duits, Frans, Italiaans en Spaans*, Cantecleer, De Bilt 1988.

Huib van Krimpen and Rob van den Elzen, *Grafisch zakboek, Verklarend woordenboek van hedendaagse begrippen uit de grafische communicatie: uitgeverij, vormgeving, prepress, drukkerij en afwerking – Met vertalingen in Frans, Engels, Duits, Spaans en Italiaans*, Cantecleer, De Bilt 1995 (second revised edition).

Huib van Krimpen, *Vergeetboekje – Termen en begrippen uit de praktijk van de boekdruk*, De Buitenkant, Amsterdam 1999.

Print & Paper Europe, *Print & Paper Buyers' Handbook of Terms*, Whitmar Publications, Tunbridge Wells 2002.

Frank J. Romano and Richard M. Romano, *Encyclopedia of Graphic Communications*, Prentice Hall, Upper Saddle River 1998.

Hans Sleurink, *PrePress begrippengids*, Bohn Stafleu Van Loghum, Houten/Zaventem 1993.

Helmut Teschner, *Fachwörterbuch Drucktechnik*, Ott Verlag, Thun 1988.

Type specimens

Adobe Systems Incorporated, *Adobe Garamond*, Mountain View 1989.

Adobe Systems Incorporated, *Adobe Type Library Reference Book*, San José 1998.

Adobe Systems Incorporated, *Adobe Wood Type 1*, Mountain View 1990.

Adobe Systems Incorporated, *Charlemagne*, Mountain View 1989.

Adobe Systems Incorporated, *Minion*, Mountain View 1989.

Adobe Systems Incorporated, *Tekton*, Mountain View 1990.

Adobe Systems Incorporated, *Trajan*, Mountain View 1989.

Adobe Systems Incorporated, *Utopia*, Mountain View 1989.

American Type Founders Company, *American Specimen Book of Type Styles – Printing Machinery – Printing Materials*, Jersey City 1912.

Barnhart Brothers & Spindler, *Type*, Chicago.

Bauersche Gießerei, *Bauer Type Foundry*, Frankfurt am Main, Plusminus 1950.

Berthold & Callwey, *Berthold Types*, Berlin/München 1985.

Bitstream Inc., *Bitstream Typeface Library*, Cambridge 1989.

Compugraphic Europe et Cie, *Type*, Paris 1985.

Deberny & Peignot, *Specimen Général des Fonderies Deberny et Peignot*, Paris 1954.

Dutch Type Library, *Typespecimen Digital Fonts*, 's-Hertogenbosch 1995.

J. Enschedé, *Proef van Letteren – Welke gegooten worden in de Nieuwe Haerlemsche Lettergietery van J. Enschedé 1768*, Stichting Museum Enschedé/The Enschedé Font Foundry/ Uitgeverij De Buitenkant, Amsterdam 1993 (fascimile edition).

FontShop, *FontShop Catalog 1990*, Berlin 1990.

Edmund Fry, *Specimen of Modern Printing Types*, Printing Historical Society, London 1986 (reprint from 1828).

Lettergieterij Amsterdam v/h N. Tetterode, *Letterproef der Lettergieterij „Amsterdam" voorheen N. Tetterode*, Amsterdam 1916.

Linotype AG, *LinoTypeCollection*, Eschborn 1987.

Linotype GmbH, *A-Z*, Bad Homburg 2006.

Linotype Library GmbH, *FontExplorer Font Catalog*, Bad Homburg 1998.

Linotype Library GmbH, *Linotype GoldEdition 1.5*, Bad Homburg 2000.

Miller & Richard Type Foundry, *Point Specimen Book*, Edinburgh ca. 1910.

Monotype Corporation Ltd., *Specimen book of „Monotype" printing types*, London 1961–1970.

J.G. Schelter & Giesecke, *Muster-Sammlung von J.G. Schelter & Giesecke Schriftgiesserei, Messing-linienfabrik und Galvanoplastik, Fachtischlerei und Utensilienfabrik, Maschinenfabrik*, Leipzig 1886.

Società Nebiolo Torino, *Catalogo caratteri Nebiolo*, Turin (1969?).

Stephenson, Blake & Co Ltd., *Printing Types, Borders, Initials, Electros, Brass Rules, Spacing Material, Ornaments*, Sheffield 1924.

Stephenson, Blake, *Specimens of Printing Types from Stephenson, Blake, The Caslon Letter Foundry Sheffield*, Sheffield 1950.

The Bodley Head for Mackays of Chatham, *Type for books - A Designers Manual*, London 1976 (dritte Auflage).

The Font Bureau, *Font Bureau Type Specimen*, Boston 1995.

The Font Bureau, *Font Bureau Type Specimens*, Boston 2001.

Uitgeverij De Buitenkant, *Lexicon*, Amsterdam 1992.

U&lc (Upper & lower case), *Type Selection*, V + K Publishing/Uitgeverij Thoth/International Typeface Corporation, Laren 1992.

Underware, *Dolly*, Den Haag 2001 (Dolly typeface specimen).

Underware, *Real naked*, Den Haag 2002 (Sauna typeface specimen).

Special typographical publications

Andreas and Regina Maxbauer, *DTP-Typometer* (transparent printers ruler with four metal types in imprinted cover), Verlag Hermann Schmidt, Mainz 2004.

Joep Pohlen, *Mackie M* (metal printer's ruler with thread counter and measuring film in box, in German and Dutch), Uitgeverij Fontana, Roermond 1994.

Hans Reichardt, *Bleisatzschriften des 20. Jahrhunderts aus Deutschland* (PDF documentation on CD of type specimens in metal type), Spatium – Magazin für Typografie, Offenbach am Main 2008.

Hans Reichardt, *Bleisatzschriften des 20. Jahrhunderts International* (PDF documentation on CD of type specimens in metal type), Spatium – Magazin für Typografie, Offenbach am Main 2008.

Michael Wörgötter, *TypeSelect – Der Schriftenfächer*, (samples of fonts) Verlag Hermann Schmidt, Mainz 2005.

Colophon

The author would like to thank Geert Setola, co-author and co-designer of the previous editions, who was also a sparring partner for me at the beginning of this fourth edition. Part of the structure of previous editions is incorporated into this extended publication. The extract from the short-story Par[ad]is Revisité used for illustrative purposes, is also written by Geert Setola.

The author would also like to thank Ellie Pohlen (for her patience and support), Geert Setola and Monique Setola (for their contributions to this as well as previous editions), Dennis Schmitz (for standing in during the development of Letter Fountain), Marsha Emanuel, Pierre Bernard, Fokke Draaijer, Chris Brand, Herman Lampaert, Piet Cossee, Henk Gianotten, Otmar Hoefer, Marcel Simon, Evert Bloemsma, Mieke Rijnders, Monique Bullinga and Jan Willem den Hartog (for their support and advice).
The author is also indebted to: Adobe, FontShop, Emigre, Tetterode, Linotype GmbH, Monotype Typography, Dutch Type Library, Laura Meseguer, Andreu Balius and Porchez Typofonderie, for the provision of fonts.

To stay informed about upcoming TASCHEN titles, please request our magazine at www.taschen.com/magazine or write to TASCHEN America, 6671 Sunset Boulevard, Suite 1508, Los Angeles, CA 90028, USA; contact-us@taschen.com; Fax: +1-323-463-4442. We will be happy to send you a free copy of our magazine, which is filled with information about all of our books.

© 2011 TASCHEN GmbH
Hohenzollernring 53
D-50672 Köln
www.taschen.com

Text and design of the fourth editon: Joep Pohlen, Roermond
English translation: Judith Amsenga, Jo Gates
Editor: Martijn van Groningen, John A. Lane
Project management: Florian Kobler, Annick Volk, Cologne
Cover design: Joep Pohlen, Roermond

Printed in China
ISBN 978-3-8365-2509-1